CONTEMPORARY

CONCRETE

BUILDINGS

Philip Jodidio

CONTEMPORARY
CONCRETE
BUILDINGS

Zeitgenössische Bauten aus Beton
Bâtiments contemporains en béton

TASCHEN
Bibliotheca Universalis

CONTENTS

2012, *Chiaki Arai, Niigata City Konan Ward Cultural Center, Konan-ku, Japan*

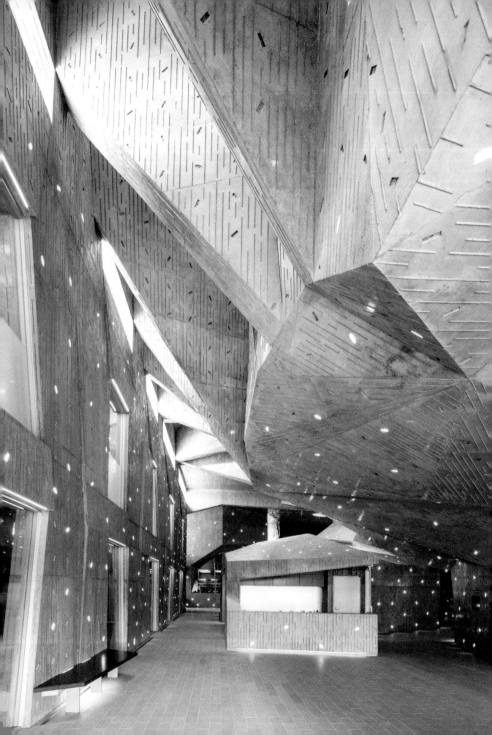

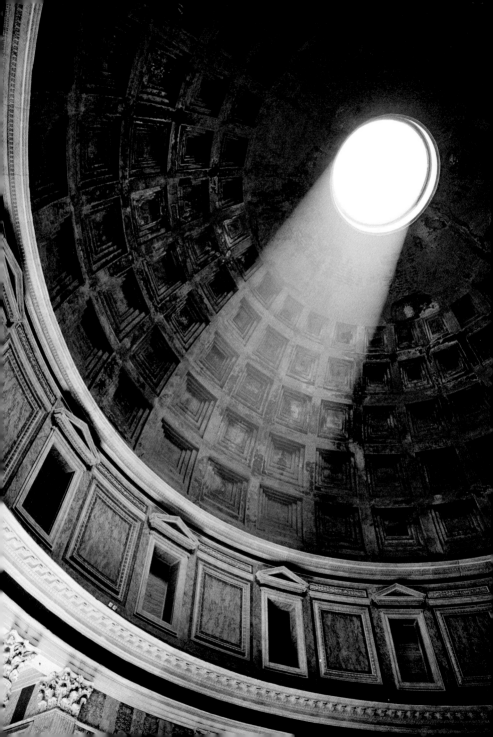

INTRODUCTION

ANCHORED IN THE EARTH

Concrete is a name applied to a remarkably wide range of substances used in construction, and, when it is properly handled, it is actually one of the noble materials of contemporary architecture. A kind of "liquid stone" at the outset, it is malleable, durable, and, in the right hands, capable of prodigious feats of engineering. Concrete is also referred to as cement in many cases, but, properly stated, cement is an ingredient of concrete. Portland cement (made with materials such as limestone, shale, iron ore, clay, or fly ash) is mixed with an aggregate such as sand, gravel, or crushed stone. When water is added the mixture begins a process called hydration, eventually hardening into a substance not unlike stone. This "curing" process can take several days, but the concrete itself actually continues to harden for a much longer period. Because moisture is part of the process, concrete can harden under water, but temperatures that are too high or too low can pose problems. Most importantly, concrete is, without a doubt, the most widely used man-made material.

WITH AND WITHOUT REBARS

It is known that the Egyptians employed a combination of lime and gypsum mortar in their construction, and that the Romans made concrete with sand, volcanic ash, and hydrated lime, calling it *opus caementicium* and employing it in such venerable and architecturally significant edifices as the Pantheon in Rome (ca. 126 A.D., page 8). It might be noted that the use of steel reinforcing rods was obviously not known to the Romans, and thus the Pantheon was built without any such method to increase the resistance of the concrete to tensile cracking. The rotunda with its inner diameter of 43.4 meters is made in good part of concrete, which shows some signs of cracking, but which nonetheless has withstood the structural challenges of time in a remarkable way. One key to this success was the use of light stones for the aggregate, generating lightweight concrete, a process that was apparently perfected as early as the middle of the first century B.C.[1] in his *Ten Books of Architecture,* one hundred and fifty years before the construction of the Pantheon, Vitruvius delved into the attributes of different types of mortar or cement. Since that time, this building material has made considerable progress, and produced a large number of variants. Reinforced concrete, perhaps the most widely used variant, is made with steel reinforcing bars (rebars) that are placed in the forms before the concrete is poured. This process greatly strengthens the substance, increasing its tensile strength and ductility, or ability to deform under stress. Later improvements have included epoxy coating for rebars, avoiding or delaying their corrosion.

An alternative, often much more expensive method involves in pouring concrete *in situ* in prepared usually wooden formwork that has rebars already put in place. With careful use, concrete that is poured *in situ* can give remarkably smooth and even beautiful results, as can be seen, for example, in the work of Tadao Ando in Japan. Smoothness is a factor of the aggregates used in the concrete, and also of the precision and surface of the formwork. Ando and others in Japan often employ a carefully lacquered wood for these forms. The finished surfaces are then treated with a fluoro-resin compound, a transparent paint that leaves a slightly glossy finish but serves to waterproof and protect concrete surfaces for 10 to 15 years. It is true that a natural process of erosion and degradation of concrete surfaces can make them particularly unattractive

*c.***126 A.D.,** *Pantheon, Rome, Italy*

after a number of years, but Ando's method seems to have proved its worth when surfaces and the quality of a building are really an issue.

EUROPEAN PIONEERS

The French played a significant role in the development of reinforced concrete. In 1853, the builder François Coignet completed a house on Rue Charles Michels in the 15th arrondissement of Paris that was made of iron-reinforced concrete. At the 1855 Paris Exhibition, Coignet predicted (rightly) that concrete would replace stone in most construction. It was actually a gardener, F. Joseph Monier, who patented reinforced concrete for use in flowerpots in 186 The French engineer François Hennebique (1842–1921) began working with ferroconcrete floor slabs in 1879, and, by 1892, he had patented a system integrating columns or beams into larger, monolithic concrete elements. This patent in some sense represents the advent of the modern building systems that have swept across the world since the late 19th century. By 1889, the first reinforced-concrete bridge had been built in the United States, in San Francisco. In 1903, Auguste Perret completed a building at 25 bis Rue Franklin in Paris using the Hennebique system, and, above all, the Théâtre des Champs-Élysées on Avenue Montaigne in 1913, marking the entry of reinforced concrete into the realm of "quality" contemporary architecture. At the same time, Perret brought concrete into his own vocabulary, Tony Garnier experimented on an even larger scale, as was the case in his Cité Industriel (1901–04), a utopian (concrete) community for 35 000 residents. Auguste Perret was also a pioneer in terms of the nature of the buildings he dared to imagine in concrete. His Notre-Dame-de-la-Consolation Church (Le Raincy, France, 1922–23, page 11) was the first church to be built in reinforced concrete, a material that was judged at the time too "vulgar" for such purposes.

Talented architects realized very early that concrete could give them new freedom in terms of design. In Barcelona, Antoni Gaudí worked with reinforced concrete in such seminal works as the Casa Batlló (1904–06; page 33) and the Casa Milà (1912). Originally built in 1877, the Casa Batlló was redesigned by the architect with irregular windows, and façades that employ local sandstone, glass, and ceramic tiles. Concrete here, as is often the case, was but one element in the architect's very individual relation with materials. Though some modern and contemporary architects have insisted on the "purity" of all-concrete structures, the material is often hidden in the structure of buildings, only to be covered (clad) in a more "noble" stone like marble or granite.

ELIMINATING THE NONFUNCTIONAL

A pupil of Hennebique, the Swiss engineer Robert Maillart was responsible for designing some of the most spectacular concrete bridges ever created. The critic Sigfried Giedion writes: "In designing a bridge, Maillart began by eliminating all that was nonfunctional; thus everything that remained was an immediate part of the structure. He did this by improving the reinforced-concrete slab until he had turned it into a new structural element. What Maillart achieved after that was based on one idea: that it is possible to reinforce a flat or curved concrete slab in such a manner as to dispense with the need for beams in flooring or solid arches in bridges. It is very difficult to determine the forces present in slabs of this nature by calculation alone […] The engineer's adoption of systems incapable of exact calculation is typical of the present day (as in shell concrete structures) and contrasts with the absolute, checked and proven calculations typical of Maillart's period."[2] Robert Maillart's

1923, *Auguste Perret,*
Notre-Dame-de-la-Consolation,
Le Raincy, France

Salginatobel Bridge (Schiers, Switzerland, 1930; page 21) was the first concrete bridge to be declared an International Historic Civil Engineering Landmark (1991).

PARABOLIC SHELLS AND MOVING FORMWORK

The prefabrication of concrete elements, involving reusable molds and off-site factory preparation, is one of the major methods employed in construction. Construction elements that are intended to bear significant loads, such as beams, columns, wall panels, segmented bridge units, or I-beam girders, can be "prestressed" at a predetermined level to improve their resistance to cracks and corrosion. The French structural engineer Eugène Freyssinet (1879–1962), although not the inventor of prestressed concrete, did much to make its use widespread. His Plougastel Bridge (1930), located near Brest in France, has three identical 180-meter concrete spans, showing the efficiency and, indeed, the elegance of prestressed concrete in such construction. Freyssinet's Airship Hangars (Orly, France, 1923; page 36) were built with thin parabolic reinforced-concrete shells. Demonstrating the enormous advances made in concrete construction in the early 20th century, Freyssinet employed moving formwork for the casting of in situ concrete.

Aside from its use in works that might best be classified as the product of engineering, such as bridges and airship hangars, concrete also made a notable appearance in buildings whose forms took full advantage of the "liquid" nature of the material. Moving in a different direction, Konstantin Melnikov designed the Rusakov Workers' Club (Moscow, 1927–28; page 22) with three cantilevered concrete blocks containing seating areas. Each of these blocks was conceived to be used as a separate auditorium. With its visible concrete, glass, and brick structure, the Workers' Club rightly brings to mind many more recent buildings, where flexibility and the use of concrete are in evidence.

MASTER OF THE THIN SHELL

Another engineer with a comparable series of accomplishments based on the use of concrete is Félix Candela from Mexico. His Celestino Warehouse (Mexico City, Mexico, 1955; page 32) did not make use of his preferred thin-shell structures, of which he built more than 800, but of umbrella concrete construction. "Perhaps his best-known innovation was the 'umbrella,' consisting of four paraboloids that transfer their loads to a central column. The efficiency of these structures brought Candela's company a steady flow of commissions to build roof industrial bays,"[3] such as that for Celestino. Candela's achievements may be less related to specifically natural models than those of Nervi for example, reaching further into mathematical constructs, though with an acute sense of practicality. As an exhibition at Princeton University Art Museum in 2008 underlined, Candela's earliest thin-shell forms "were not of the hyperbolic paraboloid (hypar) form, but of more traditional forms—funicular, conoidal, and cylindrical. It was only when he became confident, based on experience in the design, analysis, and construction of thin shells, that he started to create his art."[4] His shells were made with scaffolding, "a temporary structure of wood or metal that supports the form boards and wet concrete. These boards are placed on top of the scaffolding and allow the concrete when hardened to take its proper form. Once the forms are placed, steel reinforcing is added and finally the workers cast the concrete, typically four centimeters thick."[5] Another interesting example of the use of concrete in a residential context is the Milam Residence by Paul Rudolph (Jacksonville, Florida, 1959–61, page 23).

1975, *Paulo Mendes da Rocha,*
Serra Dourada Stadium, Goiânia,
Goiás, Brazil

1982, *Lina Bo Bardi,*
SESC Pompéia,
São Paulo, Brazil

ENGINEERS BUT ARCHITECTS AS WELL

The use of concrete has taken on new dimensions largely because of the inventiveness of a number of engineers or architects who followed in the footsteps of people like Freyssinet and Maillart. Engineers such as Pier Luigi Nervi (1891–1979) and Félix Candela (1910–97) pushed thin-shell concrete structures and other surprising uses of the material to its structural limits. They proved that concrete was capable of offering new forms to architecture. One of the greatest architects who employ edconcrete in innovative ways was, of course, the late Oscar Niemeyer (1907–2012).

His Palace of the Dawn (Palácio da Alvorada, Brasília, Brazil, 1958, page 35) is a case in point. Sitting alone at the end of a broad expanse of grass, it appears to float on shallow basins, its unusual curved columns scarcely touching the ground. Though its weightlessness is partly illusory because of hidden supports, the Palace of the Dawn is, in truth, a remarkable feat of architecture and engineering. Oscar Niemeyer collaborated closely with the engineer Joachim Cardoso to approach the utmost limits of structural feasibility in the pursuit of ideal proportions and lightness. The building is basically a rectangular glass prism hovering between thin slabs of concrete. There could be no further question about the real merits of concrete in contemporary architecture after the completion of the Palace of the Dawn. "I am not attracted to straight angles or to the straight line, hard and inflexible, created by man. I am attracted to free-flowing, sensual curves. The curves that I find in the mountains of my country, in the sinuousness of its rivers, in the waves of the ocean, and on the body of the beloved woman. Curves make up the entire Universe, the curved Universe of Einstein."[6] In this phrase, Oscar Niemeyer sums up his design philosophy, and he does not hesitate to call on the forms of nature, from the human body to the universe itself.

OTHER LATIN AMERICAN MASTERS

Two compatriots of Oscar Niemeyer, Lina Bo Bardi and Paulo Mendes da Rocha, have created powerful works in concrete that would seem to have few equivalents outside of Latin America. Born in Italy, Lina Bo Bardi moved to Brazil in 1948 and completed her Glass House there (São Paulo, 1948; page 24) the same year. This still very remarkable structure was built in what remained of the Mata Atlantica, the original rain forest in the Morumbi neighborhood of São Paulo. The glass volume is set between thin reinforced-concrete slabs supported by slender pilotis that allow the forest to remain untouched beneath the structure. Another of Lina Bo Bardi's significant buildings is the SESC Pompéia (São Paulo, 1982; page 13), the Pompéia Factory Leisure Center that combines a 1920s red-brick drum factory building with three enormous and unexpected concrete towers that are connected by suspended walkways.

Perhaps now better known to the general public than Lina Bo Bardi, Paulo Mendes da Rocha was the winner of the 2006 Pritzker Prize. The Pritzker jury citation read in part: "His signature concrete materials and intelligent, yet remarkably straightforward, construction methods create powerful and expressive, internationally recognized buildings. There is no doubt that the raw materials he uses in achieving monumental results have had influences the world over."[7] His Serra Dourada Stadium (Goiânia, Goiás, Brazil, 1975; page 12) represents an effort to transform the usually closed parameters of the football venue to open it to the city. The roof overhangs bleachers and support areas by 20 meters on each side, partially covering them. Enclosed galleries for offices and restaurants are symmetrically distributed at each end of the oval form of the stadium. Using his preferred concrete, the architect explains that he sought a "solution where popular entertainment and social comfort can coexist."

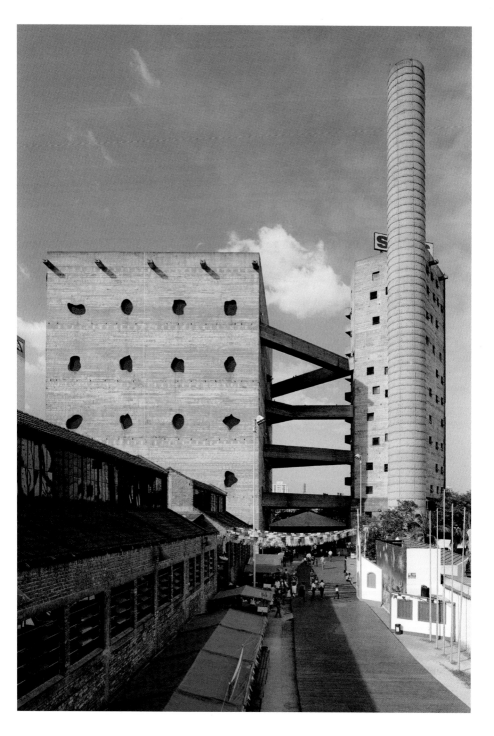

14

2003, *Richard Meier,*
Jubilee Church,
Rome, Italy

WRIGHT, BREUER, AND KAHN

Concrete has been an essential element in a number of other seminal works of modern architecture. Among these of course is Frank Lloyd Wright's Solomon R. Guggenheim Museum (New York, USA, 1959; page 29) where the architect quite simply made concrete do things it had never done before, giving it dimensions beyond the geometric. Wright explained: "These geometric forms suggest certain human ideas, moods, sentiments—as for instance: the circle, infinity; the triangle, structural unity; the spiral, organic progress; the square, integrity."[8] Just a few blocks from the Guggenheim, Marcel Breuer's Whitney Museum of American Art (1966, now called the Met Breuer, page 16) was built mainly with poured-in-place concrete. The architect certainly wanted to emphasize the weightiness of his materials, cladding the exterior in granite. Inside, three of the museum floors have suspended precast-concrete, open-grid ceilings, again showing that cast-in-place and precast concrete can be used in the same structure to different ends. Another seminal modern building in the United States is the Salk Institute (La Jolla, California, 1965). In an interesting reference back to its very origins, the concrete that the architect Louis Kahn used for these buildings was made with added volcanic ash, which gives it a warm tone ("pozzolanic" concrete). He stipulated that there was not to be any grinding or painting of the concrete. Aside from the basic concrete structure, only teak, lead, glass, and steel were used.

SHOT OUT OF A GUN OR POURED-IN-PLACE

The number of different types of concrete has has continued to increase, even in recent years. Innovations like "shot-crete" or "gunite," actually invented early in the 20th century, allow concrete to be projected at high velocity onto a prepared surface. Le Corbusier used gunite in the celebrated Chapel of Notre-Dame-du-Haut (Ronchamp, France, 1955; pages 26–27). Another, perhaps more significant invention is air-entrained concrete, which dates from the 1930s. This process consists in injecting tiny air bubbles into concrete in a proportion of 5% to 8% of the total volume. Air entrainment greatly improves resistance to freezing by relieving internal pressure and also increases resistance to salt or sulfates.

It remains that some of the most remarkable buildings in concrete are made with cast-in-place techniques. This is the case of Tadao Ando's buildings, where concrete, poured in very specialized ways, often with lacquered formwork, makes for a smoothness that seems to run contrary to the common perception of the material, which can remain rather industrial and rough. Tadao Ando's Church of the Light (Ibaraki, Osaka, Japan, 1989, page 18) is a small structure, but it certainly ranks as one of the masterpieces of modern concrete architecture. Essentially a rectangular concrete box intersected at a 15-degree angle by a freestanding wall, the chapel's most remarkable feature is the cruciform opening behind the altar that floods the interior with light. With floors and pews made of blackened cedar scaffolding planks, the Church of the Light projects an image of simplicity.

UNIVERSAL PRESENCE

Few modern buildings have had the visual and emotional impact of the Sydney Opera House (Sydney, Australia, 1958–73, page 15). Jørn Utzon's seminal work makes very substantial use of concrete, starting with the 588 piers that had to be sunk as much as 25 meters below the seabed. A series of precast-concrete shells, composed of spherical sections 75.2 meters in radius, form what must be the most iconic roof design in the world. The use of poured-in-place concrete was envisaged but ultimately

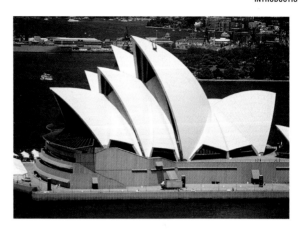

1973, *Jørn Utzon,*
Sydney Opera House,
Sydney, Australia

judged too costly. The techniques finally developed by Utzon and the engineers Arup had a considerable influence on subsequent concrete architecture designs. The Sydney Opera House became a UNESCO World Heritage Site on June 28, 2007, though at the time of its construction the design posed enormous problems, to the extent that the architect left Australia before it was finished. When Jørn Utzon won the 2003 Pritzker Prize, Thomas Pritzker, President of the Hyatt Foundation, stated: "New materials and technologies have opened new horizons in architecture [...] Jørn Utzon was a progenitor of these new horizons. In many respects his Sydney Opera House broke down barriers. It explained and expanded on what was possible. Frank Gehry, one of our jurors and Pritzker laureate, has said of Utzon: 'He made a building well ahead of its time, far ahead of available technology, and he persevered through extraordinary malicious publicity and negative criticism to build a building that changed the image of an entire country. It's the first time in our lifetime that an epic piece of architecture gained such universal presence.' Frank Gehry has also acknowledged that it was Utzon's groundbreaking effort that made it possible for him to build his Guggenheim in Bilbao."[9] Thin concrete shells also made their appearance in highly visible structures such as the Trans World Flight Center (1955–62, page 39) by Eero Saarinen. In Japan, the emergence of Kenzo Tange (page 30) as a considerable figure in the transformation of contemporary architecture largely based on concrete was marked by his Yoyogi Stadium (Shibuya, Tokyo, 1961–64). In England, Denys Lasdun (page 37) left his own indelible mark with the Royal National Theatre on London's Southbank (1976).

GRAVEL, CO_2, AND THERMAL MASS
As might be expected, the story of concrete is not all positive. Because it is used so widely, concrete has come under close examination in the area of pollution. The cement industry is, for example, a substantial producer of carbon dioxide, considered a "greenhouse gas." This is because cement must be heated to high temperatures during its manufacture. Industrial plants use kilns that can be 230 meters in length to heat crushed stone to over 1600° Celsius in the course of the production of "clinker" pellets that are a main ingredient of cement. Various alternatives have been proposed in order to reduce CO_2 emissions by concrete manufacturers, but, for the moment, about 900 kilos of CO_2 are emitted in the production of a ton of cement. The Italian firm Italcementi has designed a type of concrete that is meant to break down air pollutants thanks to the use of titanium dioxide that absorbs ultraviolet light. Richard Meier's Jubilee Church (Rome, Italy, 1996–2003; pages 14, 334) and his more recent Italcementi i.lab (Bergamo, Italy, 2005–12) were both made using Italcementi's white TX Active concrete. This high-strength reinforced concrete remains white because of its self-cleaning properties.
A 2001 scholarly report on the subject highlights other ways that concrete poses environmental problems: "Ordinary concrete typically contains about 12% cement and 80% aggregate by mass. This means that globally, for concrete making, we are consuming sand, gravel, and crushed rock at the rate of 10 to 11 billion tons every year. The mining, processing, and transport operations involving such large quantities of aggregate consume considerable amounts of energy, and adversely affect the ecology of forested areas and riverbeds. The concrete industry also uses large amounts of fresh water; the mixing water requirement alone is approximately one trillion liters every year."[10] The recycling of concrete is increasingly practiced, with rebars being removed by magnets from debris.
On the other hand, concrete, particularly when it is as thick as it is in the work of Tadao Ando, tends to reduce the need for heating or cooling because of its thermal mass. It is also said that the production of steel or even wood materials for

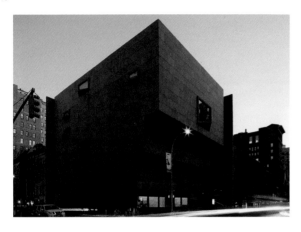

1966, *Marcel Breuer,*
Whitney Museum of American Art,
New York, USA

construction requires more energy use than concrete. Concrete in all its splendor is essential when it comes to building large structures, like dams capable of hydroelectric production, and thus helps to reduce greenhouse emissions and produce other forms of energy. Then, too, a well-built concrete building can last a very long time, surely often obviating the need to tear a building down and start all over, thus engendering even more pollution.

HIGHER, FURTHER, STRONGER

There are, of course, composite uses of such materials as steel with concrete. In these cases, the concrete surfaces are often destined to carry compression while the steel bears structural tension. Though steel has been the material of predilection for much construction of tall buildings, notably in the United States, concrete towers made with climbing formwork are also popular. A tall concrete building is defined as one where the main vertical and lateral structural elements and floor systems are made with concrete. Composite tall buildings combine steel and concrete, for example, using a concrete core.

The projects published in this volume, all dating from recent years, are not intended as a complete catalogue of the different ways of using concrete, but they do demonstrate a great variety, ranging from pure concrete buildings to structures where a significant part of the design makes use of the material. In this book, there are very large complexes, such as Steven Holl's Sliced Porosity Block (Chengdu, China, 2008–12; page 280), and structures on a much more intimate scale that are more like landscape design, such as the Selvika National Tourist Route (Havøysund, Finnmark, Norway, 2012; pages 34, 416) by Norwegian architects Reiulf Ramstad. The point is that concrete, as malleable and pervasive as it is, will continue to play a significant role in contemporary architecture for the foreseeable future. The new, more technically oriented forms of concrete serve only to expand and enhance this presence. Yes, concrete can be ugly, but it can also be soft to the touch, sensual, and heavy, anchored in the earth from which it comes

1 David Moore, *The Pantheon*, 1995; http://www.romanconcrete.com/docs/chapt01/chapt01.htm accessed on May 10, 2014. **2** Sigfried Giedion, *Space, Time and Architecture*, Harvard University Press, Cambridge, Massachusetts, 1976. **3** P. Cassinello, M. Schlaich, J. A. Torroja, "Félix Candela. In Memoriam (1910–1997). From Thin Concrete Shells to the 21st Century's Lightweight Structures," http://informesdelaconstruccion.revistas.csic.es/index.php/informesdelaconstruccion/article/viewFile/1033/1119 accessed on May 11, 2014. **7** http://www.pritzkerprize.com/2006/jury accessed on May 11, 2014. **8** Frank Lloyd Wright, in Angelica Rudenstein, *The Guggenheim Museum Collection: Paintings, 1880–1945*, Solomon R. Guggenheim Museum, New York, 1976. **9** http://www.pritzkerprize.com/2003/ceremony_speech2b accessed on May 11, 2014. **10** P. Kumar Mehta, "Reducing the Environmental Impact of Concrete," *Concrete International*, October 2001; http://ecosmartconcrete.com/docs/trmehta01.pdf accessed on August 14, 2013.

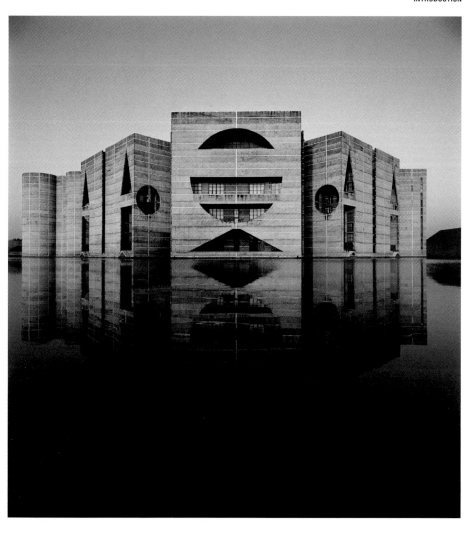

1983, *Louis Kahn,*
National Assembly Building,
Dhaka, Bangladesh

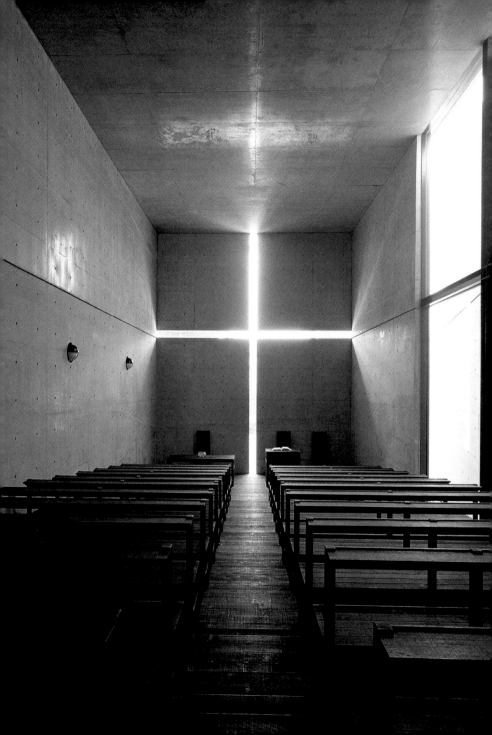

EINLEITUNG

IN DER ERDE VERANKERT

Beton ist der Name für eine ganze Reihe von Substanzen, die beim Bauen verwendet werden, und wenn man richtig mit ihnen umgeht, ist er eines der edelsten Materialien der modernen Architektur. Zu Beginn eine Art „flüssiger Stein", ist er formbar, dann sehr dauerhaft und führt, richtig angewendet, zu großartigen Ingenieurleistungen. Beton wird in vielen Fällen auch als Zement bezeichnet, aber, genauer gesagt, ist Zement ein Bestandteil des Betons. Portlandzement (hergestellt aus Materialien wie Kalkstein, Schiefer, Eisenerz, Lehm oder Flugasche) wird mit einem Zuschlagstoff gemischt, zum Beispiel Sand, Kies oder Schotter. Fügt man der Mischung Wasser hinzu, beginnt ein Prozess, den man Hydratation nennt und der schließlich zu einer dem Naturstein ähnlichen Substanz führt. Dieser Vorgang des „Abbindens" kann mehrere Tage dauern, doch setzt sich das Aushärtung noch viel länger fort. Weil Feuchtigkeit an diesem Prozess beteiligt ist, kann Beton unter Wasser härten, zu hohe oder zu niedrige Temperaturen können jedoch zu Problemen führen. Dennoch ist und bleibt Beton das am meisten verwendete künstlich hergestellte Baumaterial.

MIT ODER OHNE BEWEHRUNG

Es ist bekannt, dass die Ägypter eine Verbindung aus Kalk und Gipsmörtel für ihre Bauten benutzten und dass die Römer Beton aus Sand, Vulkanasche und gelöschtem Kalk herstellten, den sie opus caementicium nannten und für so ehrwürdige und architektonisch bedeutsame Bauten wie das Pantheon in Rom (um 126 n. Chr.; Seite 8) verwendeten. Es ist bemerkenswert, dass den Römern der Einsatz von stählernen Bewehrungselementen offensichtlich nicht bekannt war und das Pantheon daher ohne jegliches Verfahren zur Erhöhung der Widerstandskraft des Betons gegen Zugrissbildung errichtet wurde. Die Rotunde mit einem inneren Durchmesser von 43,4 m besteht überwiegend aus Beton, der zwar einige Andeutungen von Rissen zeigt, aber dennoch dem Zahn der Zeit gut widerstanden hat. Ein Grund für diesen Erfolg war die Verwendung eines Zuschlags aus leichtem Naturstein, wodurch Leichtbeton entstand – ein Verfahren, das offenbar schon Mitte des 1. Jahrhunderts v. Chr. perfekt beherrscht wurde.[1] 150 Jahre vor der Errichtung des Pantheons behandelte Vitruv in seinen „Zehn Büchern über Architektur" die Eigenschaften der verschiedenen Arten von Mörtel oder Zement. Seit jener Zeit hat dieses Baumaterial beträchtliche Fortschritte gemacht, und es gibt viele Varianten. Stahlbeton, die wohl verbreitetste Variante, wird mit Bewehrungsstäben hergestellt, die in die Schalung eingesetzt werden, bevor der Beton gegossen wird. Dieser Prozess verstärkt das Material erheblich und erhöht seine Zugfestigkeit und Dehnbarkeit oder die Fähigkeit, sich unter Belastung zu verformen. Zu späteren Verbesserungen gehört die Epoxidharzbeschichtung der Bewehrungseisen, um damit deren Korrosion zu vermeiden oder zu verzögern.

Ein alternatives, oft viel teureres Verfahren ist der Betonguss vor Ort in vorbereitete, gewöhnlich hölzerne Schalungen, in die die Bewehrungsstäbe bereits an der entsprechenden Stelle eingefügt wurden. Mit sorgfältig ausgeführtem Ortbeton lassen sich bemerkenswert glatte und ästhetisch anspruchsvolle schöne Ergebnisse erzielen, wie zum Beispiel die Bauten von Tadao Ando in Japan zeigen. Die Glätte wird von den Zuschlägen zum Beton bestimmt, aber auch von der Präzision und der

1989, *Tadao Ando,*
Church of the Light, Ibaraki,
Osaka, Japan

1930, *Robert Maillart,*
Salginatobel Bridge,
Schiers, Switzerland

Oberfläche der Schalung. Ando wie auch andere japanische Architekten verwenden für ihre Schalungen häufig ein sorgfältig lackiertes Holz. Die Flächen werden dann mit einer Fluorokunststoff-Verbindung behandelt – einem transparenten Anstrich, der ihnen einen leichten Glanz verleiht, aber sie auch wasserfest macht und den Beton für 10 bis 15 Jahre schützt. Es trifft zu, dass Betonflächen durch den natürlichen Erosionsprozess und die Verwitterung nach einigen Jahren hässlich werden können. Aber Andos Methode scheint sich im Hinblick auf die Oberflächen und die Qualität eines Bauwerks wirklich bewährt zu haben.

EUROPÄISCHE PIONIERE

Die Franzosen spielten eine wichtige Rolle bei der Entwicklung des Stahlbetons. 1853 errichtete der Bauunternehmer François Coignet ein Haus aus Stahlbeton in der Rue Charles Michels im 15. Arrondissement von Paris. Auf der Pariser Weltausstellung von 1855 sagte Coignet (zutreffend) voraus, dass Beton bei fast allen Bauvorhaben den Naturstein ersetzen werde. Schließlich war es ein Gärtner, F. Joseph Monier, der 1867 ein Patent für Stahlbeton zur Verwendung für Blumentöpfe einreichte. Der französische Ingenieur François Hennebique (1842–1921) begann 1879, mit Bodenplatten aus Eisenbeton zu arbeiten, und 1892 ließ er ein System patentieren, das Stützen oder Balken in größere, monolithische Betonelemente integrierte. Dieses Patent steht in gewissem Sinn für das Aufkommen der modernen Bausysteme, die sich seit Ende des 19. Jahrhunderts über die ganze Welt verbreiteten. 1889 wurde die erste Stahlbetonbrücke der USA in San Francisco ausgeführt. 1903 errichtete Auguste Perret nach dem Hennebique-System ein Gebäude in der Rue Franklin 25 bis in Paris und vor allem 1913 das Théâtre des Champs-Élysées in der Avenue Montaigne, das den Eintritt des Stahlbetons in den Bereich der „hochklassigen" modernen Architektur bedeutete. Zur gleichen Zeit, als Perret den Beton in sein Vokabular aufnahm, experimentierte Tony Garnier in noch größerem Maßstab bei seiner Cité Industriel (1901–04), einer utopischen Gemeinschaftsanlage für 35 000 Bewohner mit Beton. Auch Auguste Perret erwies sich als Pionier in Bezug auf die Art der Bauten, die er in Beton zu planen wagte. Seine Kirche Notre-Dame-de-la-Consolation (Le Raincy, Frankreich, 1922–23; Seite 11) war der erste Kirchenbau aus Stahlbeton, einem Material, das man damals als zu „vulgär" für einen solchen Zweck ansah.

Begabte Architekten erkannten schon früh, dass der Beton ihnen ungeahnte Freiheiten im Entwurf bieten könnte. In Barcelona arbeitete Antoni Gaudí bei so zukunftsweisenden Bauten wie der Casa Batlló (1904–06; Seite 33) und der Casa Milà (1912) mit bewehrtem Beton. Die ursprünglich 1877 errichtete Casa Batlló wurde von Gaudí umgestaltet mit unregelmäßigen Fenstern und Fassaden aus örtlichem Sandstein, Glas und Keramikfliesen. Hier, wie häufig auch anderswo, bildet der Beton nur ein Element im sehr individuellen Verhältnis des Architekten zu den Materialien. Obgleich einige moderne und zeitgenössische Architekten den „Purismus" reiner Betonbauten betont haben, bleibt dieser Baustoff häufig im Tragwerk der Gebäude verborgen und wird von einem „edleren" Naturstein wie Marmor oder Granit verdeckt oder verkleidet.

DIE AUFHEBUNG DES NICHTFUNKTIONALEN

Ein Schüler von Hennebique, der Schweizer Ingenieur Robert Maillart, war für die Planung einiger der spektakulärsten jemals errichteten Betonbrücken verantwortlich. Der Kritiker Sigfried Giedion schrieb: „Maillart schaltete in einer Decke oder bei einer Brücke alle passiven Elemente aus, jeder Teil wurde ein aktiver Bestandteil der Konstruktion. Dies gelang aufgrund einer neuen Methode: indem Maillart die Eisenbetonplatte als neues strukturales Bauelement durchbildete. Maillarts spätere

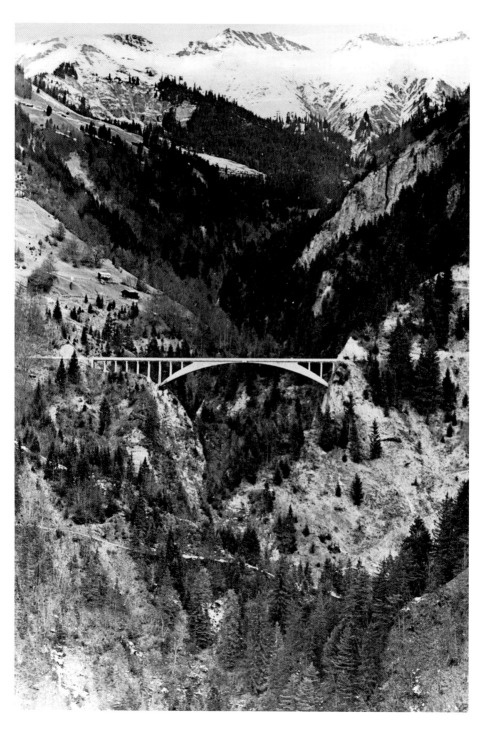

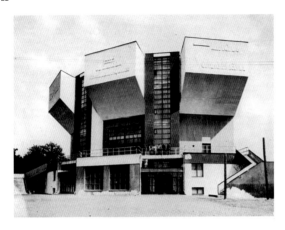

1928, *Konstantin Melnikov,*
Rusakov Workers' Club,
Moscow, Russia

Leistung beruhte auf der Vorstellung, dass es bei Brücken möglich sein müsse, eine flache oder gekrümmte Betonplatte so zu bewehren, dass man auf Deckenträger oder massive Bogen verzichten könne. Es ist sehr schwer, die in solchen Platten herrschenden Kräfte nur durch Berechnung zu bestimmen […] Die Übernahme des Ingenieurs von Systemen, die keiner exakten Kalkulation fähig sind, ist (wie bei Schalenkonstruktionen aus Beton) für die heutige Zeit typisch und widerspricht den für Maillarts Zeit typischen, absolut überprüften und bewährten Berechnungen."[2] Maillarts Salginatobel-Brücke (Schiers, Schweiz, 1930, Seite 21) war die erste Betonbrücke, die zum Weltmonument International Historic Civil Engineering Landmark erklärt wurde (1991).

PARABELFÖRMIGE SCHALEN UND GLEITSCHALUNG

Die Fertigteilbauweise mit Betonelementen einschließlich wiederverwendbarer Schalungen und industrieller Vorfertigung außerhalb der Baustelle ist eine der am häufigsten im Bauen angewendeten Methoden. Bauelemente, die beträchtliche Lasten tragen müssen, zum Beispiel Träger, Stützen, Wandplatten, Segmentbrückenteile oder Doppel-T-Träger, können auf ein vorbestimmtes Niveau „vorgespannt" werden, um ihre Resistenz gegen Risse und Korrosion zu verbessern. Der französische Bauingenieur Eugène Freyssinet (1879–1962) trug viel zur Verbreitung des Spannbetons bei, obgleich er nicht sein Erfinder war. Seine Plougastel-Brücke (1930) bei Brest in Frankreich hat drei identische, 180 m lange Brückenbogen und zeugt von der Effizienz und sogar der Eleganz des Spannbetons in einem solchen Bauwerk. Freyssinets Luftschiffhallen (Orly, Frankreich, 1923; Seite 36) wurden mit dünnen parabelförmigen Schalen aus Stahlbeton erbaut. Er demonstrierte die gewaltigen Fortschritte des Betonbaus am Anfang des 20. Jahrhunderts, indem er Gleitschalung für Ortbeton verwendete.

Abgesehen von seiner Verwendung für Konstruktionen wie Brücken und Flugzeughangars, die man als Ingenieurbauwerke bezeichnet, trat der Beton jetzt auch vermehrt in Bauten auf, deren Formen von der „flüssigen" Konsistenz des Materials profitierten. Der sich in eine völlig andere Richtung bewegende Konstantin Melnikow plante den Arbeiterklub Rusakov (Moskau, 1927–28, Seite 22) mit drei auskragenden Betontrakten, die Zuschauerbereiche enthalten. Jeder von ihnen konnte getrennt für Aufführungen genutzt werden. Mit seiner sichtbaren Konstruktion aus Glas und Backstein erinnert dieser Arbeiterklub an jüngere, flexible Bauten aus Beton.

EIN MEISTER DER DÜNNWANDIGEN SCHALE

Ein weiterer Ingenieur mit vergleichbaren Leistungen in der Betonnutzung war der Mexikaner Félix Candela. Sein Lagerhaus Celestino (Mexiko-Stadt, 1955; Seite 32) war keiner der von ihm bevorzugten Schalenbauten, von denen er über 800 ausgeführt hat, sondern eine Schirmkonstruktion. „Seine vielleicht bekannteste Innovation war der ‚Schirm' aus vier Paraboloiden, die ihre Lasten auf eine zentrale Stütze ableiten. Die Effizienz dieser Konstruktionen sicherte Candelas Firma ständige Aufträge für die industrielle Fertigung von Dachelementen"[3], wie derjenigen für Celestino. Candelas Leistungen sind wohl weniger als Nervis auf spezifische Vorbilder aus der Natur bezogen; vielmehr reichen sie in den mathematischen Bereich, obgleich er auch einen ausgesprochenen Sinn fürs Praktische hatte. Wie auf einer Ausstellung im Princeton University Art Museum 2008 betont wurde, waren Candelas früheste dünnwandigen Schalenbauten „keine hyperbolischen Paraboloid-Schalen, sondern eher traditionelle Formen – Hänge-, kegelförmige oder zylindrische Konstruktionen. Erst als er mehr Erfah-

1961, *Paul Marvin Rudolph,*
Milam Residence, Jacksonville,
Florida, USA

rungen in Entwurf, Analyse und Ausführung dünnwandiger Schalen gesammelt hatte, begann er mit der Erschaffung seiner Kunstwerke."[4] Seine Schalen wurden mithilfe eines Gerüsts errichtet, „einer temporären Holz- oder Metallkonstruktion, welche die Schalbretter und den Frischbeton trägt. Diese Bretter werden auf das Gerüst gelegt und geben dem Beton beim Härten die gewünschte Form. Wenn die Schalung verlegt ist, fügt man die Bewehrung hinzu, und dann gießen die Arbeiter den üblicherweise 4 cm starken Beton."[5] Ein weiteres interessantes Beispiel für die Anwendung von Beton im Wohnbau ist das Haus Milam von Paul Rudolph (Jacksonville, Florida, 1959–61, Seite 23).

INGENIEURE, ABER AUCH ARCHITEKTEN

Die Verwendung von Beton hat durch den Einfallsreichtum vieler Ingenieure und Architekten, die in die Fußstapfen von Erfindern wie Freyssinet und Maillart getreten sind, neue Dimensionen angenommen. Die Ingenieure Pier Luigi Nervi (1891–1979) und Félix Candela (1910–97) führten dünne Betonschalenkonstruktionen und andere erstaunliche Anwendungsformen dieses Materials bis an die Grenzen des statisch Möglichen. In jedem Fall bewiesen sie, dass Beton in der Architektur neue Formen möglich machte. Einer der großen Architekten, die Beton auf innovative Weise nutzten, war sicher der kürzlich verstorbene Oscar Niemeyer (1907–2012).

Sein Präsidentenpalast Palácio da Alvorada (Brasília, 1958; Seite 35) ist ein typisches Beispiel dafür. Er steht frei am Rand einer großen Rasenfläche und scheint über flachen Wasserbecken zu schweben; seine ungewöhnlich gekrümmten Stützen berühren kaum den Boden. Obgleich diese Schwerelosigkeit wegen verborgener Auflager täuscht, ist das Gebäude zweifellos ein bemerkenswertes Werk der Architektur und des Ingenieurbaus. Oscar Niemeyer arbeitete eng mit dem Ingenieur Joachim Cardoso zusammen, um zum Erreichen idealer Proportionen und Leichtigkeit bis an die äußersten Grenzen der statischen Möglichkeiten zu gehen. Der Palast ist im Grunde ein gläsernes Prisma auf rechtwinkligem Grundriss, das zwischen dünnen Betonscheiben schwebt. Nach dessen Fertigstellung konnte es keine Zweifel mehr über die wahren Vorzüge des Betons für die moderne Architektur geben. „Ich bin kein Freund der von Menschen geschaffenen gestreckten Winkel oder der harten und unflexiblen geraden Linien. Ich bin ein Freund frei fließender, die Sinne ansprechender Kurven. Der Kurven, die ich in den Bergen meiner Heimat, in den Windungen ihrer Flüsse, in den Wellen des Ozeans finde und am Körper der geliebten Frau. Aus Kurven besteht das ganze Universum, das gekrümmte Universum Einsteins."[6] In diesem Satz hat Oscar Niemeyer seine Entwurfsphilosophie zusammengefasst und nicht gezögert, sich auf die Formen der Natur – vom menschlichen Körper bis zum gesamten Universum – zu berufen.

WEITERE LATEINAMERIKANISCHE MEISTERARCHITEKTEN

Zwei Landsleute Niemeyers, Lina Bo Bardi und Paulo Mendes da Rocha, haben eindrucksvolle Bauten in Beton geschaffen, wie sie außerhalb Lateinamerikas kaum zu finden sind. Die in Italien geborene Lina Bo Bardi zog 1948 nach Brasilien und errichtete dort im gleichen Jahr ihr Glashaus (São Paulo, 1948, Seite 24). Dieser noch heute sehr eindrucksvolle Bau wurde in einem Restgebiet der Mata Atlantica errichtet, dem ursprünglichen Regenwald im Morumbi-Viertel von São Paulo. Das gläserne Volumen ist zwischen dünne, von schlanken Piloten getragene Stahlbetonscheiben gesetzt, wodurch der Wald unter dem Gebäude unberührt bleiben konnte. Ein weiteres bedeutendes Bauwerk von Lina Bo Bardi ist das SESC Pompéia (São Paulo,

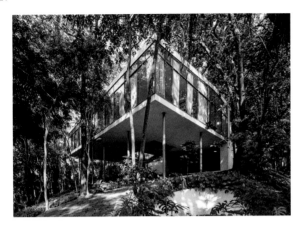

1948, *Lina Bo Bardi,*
Glass House, São Paulo, Brazil

1982; Seite 13), das Freizeitzentrum der Firma Pompéia, das einen roten Backsteinbau der ehemaligen Fassfabrik aus den 1920er-Jahren mit drei gewaltigen und unerwarteten Betontürmen vereint, die durch aufgehängte Laufgänge miteinander verbunden sind.

Paulo Mendes da Rocha ist dem allgemeinen Publikum wohl besser bekannt als Lina Bo Bardi, da ihm 2006 der Pritzker-Preis verliehen wurde. Ein Auszug aus der Beurteilung des Preisgerichts lautet: „Mit den für ihn typischen Betonbaustoffen sowie seinen intelligenten und bemerkenswert unkomplizierten Baumethoden schafft er kraftvolle und ausdrucksvolle, international angesehene Bauwerke. Zweifellos haben die großartigen Ergebnisse der von ihm verwendeten Rohmaterialien weltweiten Einfluss ausgeübt."[7] Sein Stadion Serra Dourada (Goiânia, Goiás, Brasilien, 1975; Seite 12) ist ein Versuch, die üblicherweise geschlossenen Austragungsorte von Fußballspielen zur Stadt hin zu öffnen. Das Dach kragt auf beiden Seiten um 20 m über die Tribünen und Auflagerflächen aus und überdeckt sie zum Teil. An beiden Seiten des ovalen Stadions sind symmetrisch geschlossene Galerien für Büros und Restaurants angeordnet. Zur Verwendung des von ihm bevorzugten Betons erklärt der Architekt, dass er nach „einer Lösung zur Koexistenz von populärer Unterhaltung und sozialem Wohlbefinden" gesucht habe.

WRIGHT, BREUER UND KAHN

Beton bildete auch ein entscheidendes Element bei einer Anzahl weiterer bedeutender Werke der modernen Architektur. Zu diesen gehört natürlich Frank Lloyd Wrights Solomon R. Guggenheim Museum (New York, 1959; Seite 29). Hier gab der Architekt dem Beton schlicht Aufgaben, die dieser noch nie übernommen hatte, indem er in geometrische und darüber hinausgehende Dimensionen vorstieß. Wright erklärte dazu: „Diese geometrischen Formen verweisen auf bestimmte menschliche Vorstellungen, Stimmungen, Gefühle – wie zum Beispiel der Kreis: die Unendlichkeit; das Dreieck: die statische Einheit; die Spirale: der organische Fortschritt; das Quadrat: Integrität."[8] Nur wenige Häuserblocks vom Guggenheim Museum entfernt wurde Marcel Breuers Whitney Museum of American Art (1966; Seite 16, heute Met Breuer genannt) überwiegend aus Ortbeton errichtet. Der Architekt wollte sicherlich die Schwere seiner Materialien betonen und wählte eine Außenverkleidung aus Granit. Im Innern haben drei der Museumsgeschosse abgehängte, vorgefertigte, offene Rasterdecken aus Beton, die ebenfalls zeigen, dass man vor Ort gegossenen und vorgefertigten Beton im selben Gebäude mit unterschiedlichen Ergebnissen verwenden kann. Ein weiteres bedeutendes Bauwerk in den Vereinigten Staaten ist das Salk Institute (La Jolla, Kalifornien, 1965). In einem interessanten Rückgriff auf die wahren Ursprünge dieses Materials verwendete der Architekt Louis Kahn Beton mit einem Zuschlag aus Vulkanasche, der den Bauten eine warme Tönung (wie „Puzzolanerde") verleiht. Er verlangte, dass der Beton weder geschliffen noch gefärbt werden durfte. Außer dem Grundbaustoff Beton kamen nur Teak, Blei, Glas und Stahl zum Einsatz.

AUS DER PISTOLE GESCHOSSEN ODER VOR ORT GEGOSSEN

Die Anzahl verschiedener Betonarten nahm bis in die heutige Zeit ständig zu. Innovationen wie das Betonspritzverfahren wurden erst Anfang des 20. Jahrhunderts erfunden und ermöglichen das Aufspritzen von Beton bei hoher Geschwindigkeit auf eine vorbereitete Fläche. Le Corbusier verwendete Spritzbeton für seine berühmte Kapelle Notre-Dame-du-Haut (Ronchamp, Frankreich, 1955; Seite 26–27). Eine vielleicht noch bedeutendere Erfindung ist der Luftporenbeton, der aus den 1930er-Jahren stammt. Bei diesem Verfahren werden kleine Luftblasen in den Beton eingefügt mit einem Anteil von 5 bis 8 Prozent

des Gesamtvolumens. Die Einführung von Luftporen verbessert die Frostfestigkeit, indem sie den Innendruck ausgleicht, und erhöht zudem die Widerstandsfähigkeit gegen Salz oder Sulfate.

Nach wie vor wird die Mehrzahl der bemerkenswerten Betonbauten in Ortbeton errichtet. Dies gilt auch für die Bauwerke von Tadao Ando, für die der Beton auf besondere Weise gegossen wird, häufig in lackierte Schalungen, um eine Glätte zu erreichen, die der allgemeinen Wahrnehmung widerspricht, dass dieser Baustoff oft einen groben und industriellen Charakter hat. Tadao Andos Kirche des Lichts (Ibaraki, Osaka, Japan, 1989, Seite 18) ist nur klein, zählt aber mit Sicherheit zu den Meisterwerken der modernen Architektur. Das besondere Merkmal dieser Kapelle, die im Grunde aus einer rechtwinkligen, im 15-Grad-Winkel von einer frei stehenden Mauer durchschnittenen Betonkiste besteht, ist die kreuzförmige Öffnung hinter dem Altar, die den Innenraum mit Licht durchflutet. Diese Kirche mit Fußboden und Bestuhlung aus geschwärzten Zedernholz-Gerüstbohlen ist von schlichter Eleganz.

WELTWEITE PRÄSENZ

Nur wenige moderne Gebäude übten eine derartige visuelle und emotionale Wirkung aus wie das Opernhaus in Sydney (Australien, 1958–73; Seite 15). Jørn Utzons zukunftsweisendes Bauwerk besteht großteils aus Beton; so schon die 588 Pfeilern, die 25 m in den Meeresboden versenkt werden mussten. Eine Anzahl vorgefertigter Schalen, zusammengesetzt aus Kugelaus-schnitten mit einem Radius von 75,2 m, bildet die wohl eindrucksvollste Dachform der Welt. Ursprünglich war die Verwendung von Ortbeton vorgesehen, der sich dann aber als zu kostspielig erwies. Die schließlich von Utzon und den Ingenieuren von Arup entwickelte Technik hatte einen großen Einfluss auf spätere Architekturplanungen aus Beton. Das Opernhaus Sydney wurde am 28. Juni 2007 zum Weltkulturerbe der Unesco ernannt, obgleich die Ausführung des Entwurfs seinerzeit gewaltige Probleme ver-ursacht hatte, aufgrund derer der Architekt Australien vor Vollendung des Gebäudes verließ. Als er 2003 den Pritzker-Preis erhielt, erklärte Thomas Pritzker, der Präsident der Hyatt Foundation: „Neue Materialien und Technologien haben der Architektur neue Horizonte eröffnet […]. Utzon war ein Vorläufer dieser neuen Vorstellungen. In vieler Hinsicht überwand er mit seinem Opernhaus in Sydney große Hindernisse. Es erklärte und erweiterte die Möglichkeiten. Frank Gehry, einer unserer Juroren und selbst Pritzker-Preisträger, hat über Utzon gesagt: ‚Er machte ein Bauwerk, das seiner Zeit weit voraus war, weit voraus den verfügbaren Techno-logien, und trotz einer außergewöhnlich bösartigen Publicity und negativer Kritik hielt er am Bau des Opernhauses fest, welches das Image des ganzen Landes verändert hat. Erstmals in unserer Zeit hat ein episches Architekturwerk eine derart weltweite Präsenz gewonnen.' Gehry hat auch bestätigt, dass Utzons bahnbrechende Leistung sein Guggenheim in Bilbao erst möglich gemacht hat."[9] Dünne Betonschalen faden sich nun in sehr auffälligen Konstruktionen, wie dem Trans World Flight Center von Eero Saarinen in New York (1955–62, Seite 39). In Japan ist Kenzo Tanges (Seite 30) maßgeblicher Einfluß auf die Veränderung moderner Architektur eindeutig mit der Nutzung von Beton, wie bei seiner Yoyogi-Sporthalle (Shibuya, Tokio, 1961–64) verbunden und in London initiierte Denys Lasdun (Seite 37) beim Royal National Theatre an der South Bank (1976) eine neue Entwicklung.

KIES, CO_2 UND THERMISCHE MASSE

Natürlich, war die Geschichte des Betons nicht immer nur positiv. Aufgrund der häufigen Nutzung, wurden Aspekte der Umweltverschmutzung durch Beton gründlich geprüft. Die Zementindustrie zum Beispiel produziert erhebliche Mengen

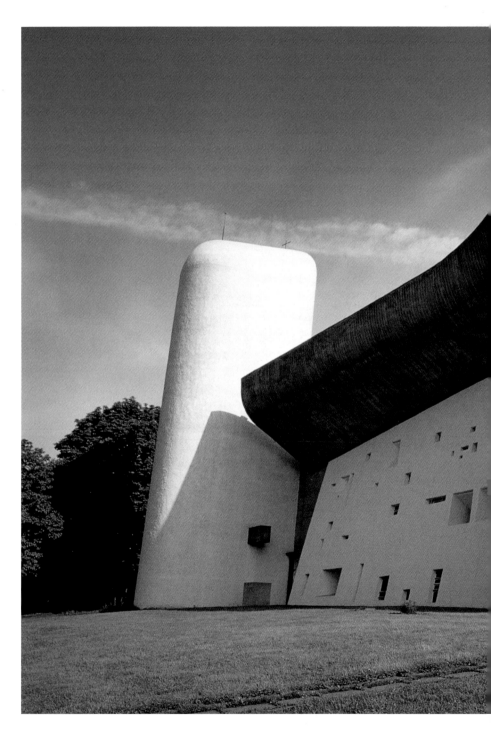

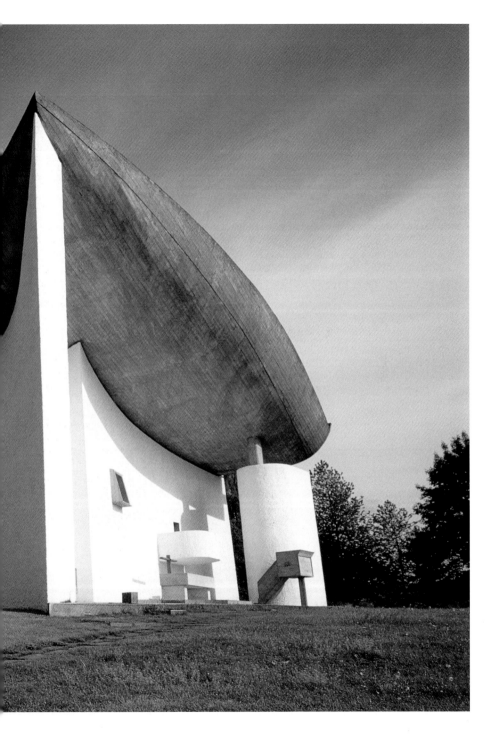

28

Previous spread:
1955, *Le Corbusier,*
Chapel of Notre-Dame-du-Haut,
Ronchamp, France

1959, *Frank Lloyd Wright,*
Solomon R. Guggenheim Museum,
New York, USA

Kohlendioxid, sog. Treibhausgas, weil Zement bei seiner Herstellung stark erhitzt werden muss. Fabriken haben bis zu 230 m lange Brennöfen, um den Schotter für die Produktion von „Klinker", den Hauptinhaltsstoff des Zements, auf über 1600 Grad Celsius zu erhitzen. Zwar haben Betonproduzenten Alternativen vorgeschlagen, um den CO_2-Ausstoß zu reduzieren, aber zur Zeit werden bei der Produktion von 1 t Zement immer noch ca. 900 kg CO_2 ausgestoßen. Die italienische Firma Italcementi hat einen Betontyp herausgebracht, der durch Verwendung von Titandioxid, das ultraviolettes Licht absorbiert, Luftverschmutzung vermeiden soll. Für Richard Meiers Jubiläumskirche (Rom, 1996–2003; Seite 14, 334) wie auch für sein Italcementi i.lab (Bergamo, 2005–12) wurde weißer TX-Active-Zement von Italcementi verwendet. Dieser hochfeste, weiße Stahlbeton soll aufgrund seiner selbstreinigenden Eigenschaften weiß bleiben.

Ein wissenschaftlicher Bericht zu diesem Thema aus dem Jahr 2001 verweist auf weitere Umweltprobleme, die der Beton verursacht: „Üblicher Beton besteht normalerweise aus etwa 12 Prozent Zement und 80 Prozent Zuschlagmasse. Dies bedeutet, dass wir global für die Produktion von Beton, Sand, Kies und Schotter im Umfang von 10 bis 11 Milliarden t pro Jahr verbrauchen. Der Abbau, die Aufbereitung und der Transport solch großer Mengen von Zuschlägen verbrauchen große Mengen von Energie und wirken sich nachteilig auf die Ökologie von Wäldern und Flussbetten aus. Die Betonindustrie verbraucht auch sehr viel Frischwasser; allein der Bedarf an Anmachwasser beträgt annähernd 1 Trillion l pro Jahr."[10] Gegenwärtig wird immer mehr Beton recycled; dabei werden die Armierungseisen mit Magneten aus dem Schutt entfernt. Andererseits kann Beton, besonders wenn er so stark ist wie in den Bauten von Tadao Ando, mit seiner thermischen Masse den Bedarf an Heizung oder Kühlung reduzieren. Man sagt auch, dass die Produktion von Stahl oder sogar von hölzernen Baustoffen mehr Energie verbrauche als Beton. Der Beton in all seiner Pracht ist das wichtigste Baumaterial für Großbauten, zum Beispiel Staudämme für Wasserkraftwerke, die emissionsärmer Elektrizität herstellen können als andere Stromproduktionsformen. Und schließlich ist ein Gebäude aus Beton sehr langlebig; oft lassen sich dadurch Abriss und Neubau und folglich noch mehr Luftverschmutzung vermeiden.

HÖHER, WEITER, STÄRKER

Es gibt natürlich auch Verbundkonstruktionen aus Materialien wie Stahl und Beton. In solchen Fällen müssen die Betonflächen häufig Druckkräfte tragen, der Stahl dagegen Zugkräfte. Obgleich Stahl das bevorzugte Material für den Bau der meisten Hochhäuser, vor allem in den Vereinigten Staaten, ist, werden oft auch Betontürme mit Kletterschalung errichtet. Bei einem Betonhochhaus bestehen die vertikalen und lateralen Bauelemente sowie das Deckensystem aus Beton.

Die im vorliegenden Band vorgestellten, alle aus den letzten Jahren stammenden Beispiele sollen keinen vollständigen Katalog der verschiedenen Nutzungsarten von Beton darstellen; vielmehr demonstrieren sie eine große Vielfalt, von reinen Betonbauten bis zu Gebäuden, bei denen ein großer Teil aus diesem Material besteht. In diesem Buch gibt es sehr große Komplexe – zum Beispiel Steven Holls Sliced Porosity Block (Chengdu, China, 2008–12; Seite 280) – sowie Gebäude viel kleineren Maßstabs, die einer Landschaftsgestaltung näherkommen, wie zum Beispiel die nationale Touristenroute Selvika (Havøysund, Finnmark, Norwegen, 2012; Seite 34, 416), geplant von dem norwegischen Architekturbüro Reiulf Ramstad. Entscheidend ist, dass Beton – so formbar und so verbreitet, wie er ist – auch in Zukunft eine wichtige Rolle in der zeitgenössischen Architektur spielen wird. Die neuen, technischer orientierten Betonarten dienen zur Verbreitung und Verstärkung dieser Präsenz. Gewiss, Beton kann hässlich sein, aber er kann auch sanft in der Berührung sein, sinnlich oder aber schwer wie die Erde, aus der er stammt.

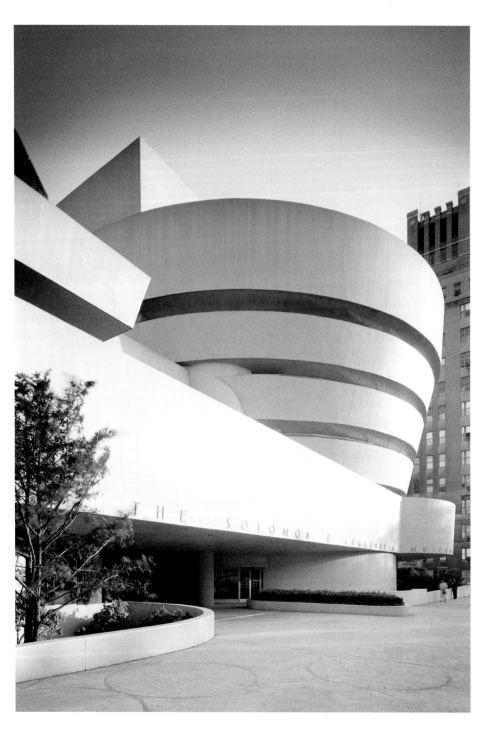

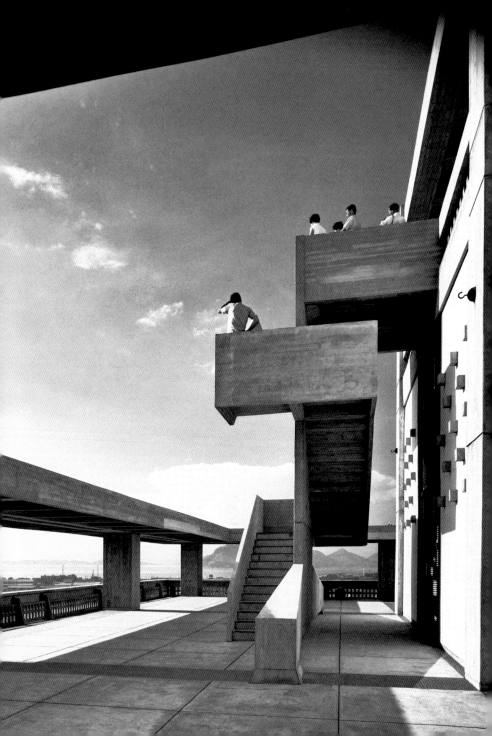

INTRODUCTION

SOLIDEMENT ANCRÉ

Le nom de béton est appliqué à une gamme étonnamment large de matériaux employés en construction mais, utilisé correctement, c'est l'un des matériaux les plus nobles de l'architecture contemporaine. Rappelant d'abord une «pierre liquide», il est malléable, de longue durée et peut permettre de prodigieux exploits de génie, placé dans les bonnes mains. Souvent aussi, le terme de béton est employé en lieu et place de ciment alors qu'à proprement parler, le ciment est un ingrédient du béton – obtenu en mélangeant du ciment Portland (fait de matériaux tels que le calcaire, le schiste, le minerai de fer, l'argile ou des cendres volantes) à un agrégat tel que le sable, le gravier ou les pierres concassées. L'ajout d'eau au mélange initie un processus appelé hydratation à l'issue duquel le béton durcit pour former une substance qui rappelle la pierre. Ce «séchage» peut durer plusieurs jours mais le durcissement, lui, se poursuit encore très longtemps. L'humidité joue un rôle dans le processus, le béton durcit parfois à l'eau, mais des températures trop élevées ou trop basses peuvent être problématiques. Le plus important reste que le béton est sans aucun doute le matériau artificiel le plus utilisé au monde.

ARMÉ OU NON

On sait que les Égyptiens employaient déjà un mélange de chaux et de mortier de gypse et que les Romains eux aussi fabriquaient du béton à partir de sable, de cendres volcaniques et de chaux hydratée : appelé *opus caementicium*, il a été utilisé dans des édifices aussi réputés et éminents sur le plan architectural que le Panthéon de Rome (vers 126 apr. J.-C., page 8). On notera cependant que les Romains ne connaissaient manifestement pas l'usage des barres d'armature en acier et que le Panthéon a été construit sans aucune méthode particulière pour accroître la résistance du béton à la fissuration par traction. La rotonde, au diamètre intérieur de 43,4 mètres, est faite en grande partie de béton qui, s'il montre quelques craquelures, n'en a pas moins défié le temps de manière remarquable. L'une des clés de cette réussite réside dans le choix de pierres légères pour l'agrégat afin d'obtenir un béton lui aussi plus léger, un procédé qui semble avoir été mis au point et maîtrisé dès le milieu du premier siècle av. J.-C. [1]. Un siècle et demi plus tôt, Vitruve avait étudié en détail les qualités des différents types de mortier ou ciment dans ses *Dix livres d'architecture*. Les progrès considérables accomplis depuis ont donné naissance à de nombreuses variétés de béton. La plus utilisée, le béton armé, est constituée de barres de renfort (barres d'armature) en acier qui sont placées dans les coffrages avant de couler le béton. Cela permet de consolider le matériau en accroissant sa résistance à la traction et sa ductilité – ou capacité à se déformer sous contrainte. L'une des dernières évolutions en date consiste à recouvrir les barres d'armature d'un revêtement époxy afin d'éviter, ou de retarder, leur corrosion.

Une autre méthode, souvent beaucoup plus onéreuse, consiste à couler le béton *in situ* dans des coffrages préparés à cet effet, généralement en bois, avec les barres d'armature déjà en place. Employé avec précaution, le béton coulé *in situ* peut donner des résultats au lissé remarquable d'une grande beauté, tels qu'on en voit par exemple dans l'œuvre de Tadao Ando au Japon. L'aspect lisse dépend des agrégats qui composent le béton, mais aussi de la précision et de la surface du

1958, *Kenzo Tange,*
Kagawa Prefectural Government
Hall, Takamatsu, Japan

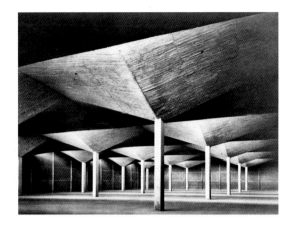

1955, *Félix Candela,
Celestino Warehouse,
Mexico City, Mexico*

1906, *Antoni Gaudí,
Casa Batlló, Barcelona, Spain*

coffrage. Ando, et d'autres architectes japonais, emploient souvent des coffrages en bois soigneusement verni. Les surfaces finies sont ensuite traitées avec un composé de résine fluorée, une peinture transparente qui permet un fini légèrement brillant tout en étanchéifiant les surfaces de béton et les protégeant pendant 10 à 15 ans. En effet, s'il est vrai que l'érosion naturelle et la dégradation du béton peuvent le rendre particulièrement peu attrayant au bout de quelques années, la méthode d'Ando semble avoir fait ses preuves dès lors que la surface et la qualité d'un bâtiment importent.

LES PIONNIERS EUROPÉENS

Plusieurs Français ont joué un rôle essentiel dans le développement du béton armé. En 1853, l'industriel François Coignet construit une maison en béton armé de fer rue Charles Michels, dans le XVᵉ arrondissement de Paris. En 1855, il prédit (avec raison) à l'Exposition universelle de Paris que le béton remplacera la pierre dans la plupart des constructions. C'est cependant un jardinier, F. Joseph Monier, qui déposera le premier brevet pour l'emploi du béton armé dans des bacs à fleurs en 1867. En 1879, l'ingénieur français François Hennebique (1842–1921) commence à utiliser des dalles de sols en béton ferreux et, en 1892, il fait breveter un système à colonnes ou poutres intégrées à des éléments de béton monolithiques de grande taille. C'est en quelque sorte l'avènement de la construction moderne qui a déferlé sur le monde depuis la fin du XIXᵉ siècle. En 1889, le premier pont en béton armé est construit à San Francisco. En 1903, Auguste Perret construit un bâtiment au 25 bis rue Franklin, à Paris, en utilisant la méthode Hennebique et, surtout, en 1913, le théâtre des Champs-Élysées avenue Montaigne marque l'entrée du béton armé dans l'architecture contemporaine « de qualité ». Enfin, au moment où Perret introduit le béton dans son expression, Tony Garnier s'y essaie à plus grande échelle avec sa Cité industrielle (1901–04), un projet communautaire (en béton) utopique pour 35 000 habitants. Perret est aussi un pionnier en ce qui concerne la nature des bâtiments qu'il aura l'audace d'imaginer en béton. Son église Notre-Dame-de-la-Consolation (Le Raincy, France, 1922–23, page 11) est la première église jamais construite en béton armé, un matériau alors jugé trop « vulgaire » pour ce type d'usage. Les architectes de talent ont réalisé très tôt que le béton pouvait aussi leur offrir une liberté nouvelle en termes de conception.

À Barcelone, Antoni Gaudí a utilisé le béton armé dans des réalisations aussi riches et originales que la maison Batlló (Casa Batlló, 1904–06, page 33) et la maison Milà (Casa Milà, 1912). La première, construite en 1877, a été uniquement revue par Gaudí qui lui a ajouté des fenêtres irrégulières et une façade comportant du grès local, du verre et des carreaux de céramique. Le béton n'est ici, comme souvent, que l'une des composantes de la relation très personnelle qu'entretenait l'architecte avec les matériaux. Et si certains architectes modernes et contemporains ont insisté sur la « pureté » des constructions tout en béton, il reste malgré tout souvent dissimulé dans les structures des bâtiments pour être recouvert de pierres plus « nobles » tels le marbre ou le granite.

ÉLIMINER CE QUI N'EST PAS FONCTIONNEL

C'est un élève de Hennebique, l'ingénieur suisse Robert Maillart, qui est l'auteur des ponts en béton les plus spectaculaires jamais créés. Le critique Sigfried Giedion écrit à son propos : « Pour concevoir ses ponts, Maillart commence par éliminer tout ce qui n'est pas fonctionnel, ce qui reste fait donc directement partie de la structure. Pour cela, il a amélioré la dalle en béton armé pour en faire un nouvel élément structurel. » Les réalisations ultérieures de Maillart sont toutes basées sur une

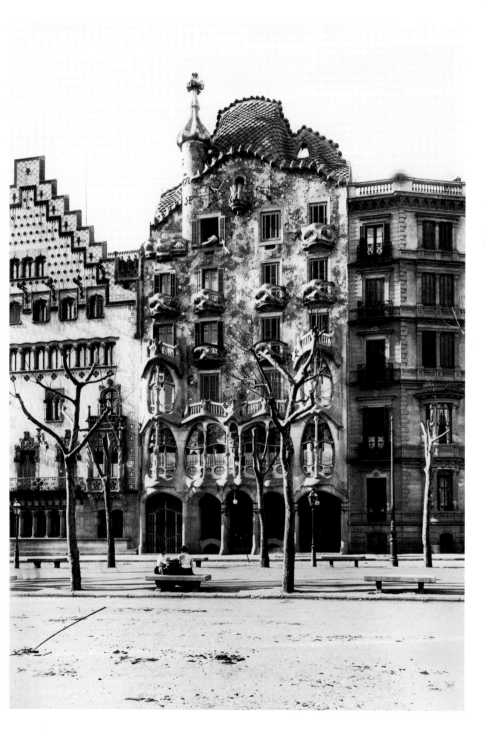

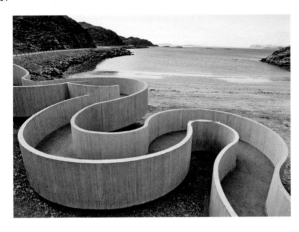

2012, *Reiulf Ramstad,*
Selvika National Tourist Route,
Havøysund, Finnmark, Norway

même idée, à savoir qu'il est possible de renforcer une dalle de béton plate ou cintrée de manière à rendre superflu tout besoin de poutres au niveau du sol ou d'arches solides pour les ponts. Il est cependant très difficile de déterminer par le seul calcul les forces qui s'exercent dans des dalles de cette nature. [...] L'adoption par l'ingénieur de systèmes incapables d'estimations exactes est aujourd'hui typique (notamment dans les structures en coque de béton) et contraste avec les calculs absolus, vérifiés et avérés caractéristiques de l'époque de Maillart [2].» Le pont de Salginatobel (Schiers, Suisse, 1930, page 21) est le premier pont en béton à avoir été couronné monument historique mondial du génie civil (1991).

DES COQUES PARABOLIQUES AUX COFFRAGES MOBILES

La préfabrication des éléments de béton, qui permet des moules réutilisables et une préparation industrielle hors site, est l'une des principales méthodes employées dans la construction. Les éléments destinés à supporter des charges importantes, tels que poutres, colonnes, parois, segments de ponts ou poutrelles en I, peuvent être « précontraints » à un niveau prédéterminé pour accroître leur résistance au craquelage et à la corrosion. L'ingénieur et constructeur français Eugène Freyssinet (1879–1962) a beaucoup contribué à répandre l'usage du béton précontraint même s'il n'en est pas l'inventeur. Son pont de Plougastel (1930), près de Brest, comporte trois arches de béton identiques de 180 mètres de portée et incarne l'efficacité autant que l'élégance réelle du béton précontraint dans ce type de construction. Les hangars d'aviation de Freyssinet (Orly, France, 1923, page 36) ont quant à eux été construits avec de fines coques paraboliques en béton armé. Démonstration des avancées énormes réalisées au début du XXe siècle, le béton *in situ* a été coulé avec des coffrages mobiles.

En plus de son utilisation dans des ouvrages classés au mieux comme produits du génie, notamment des ponts et hangars d'aviation, le béton fait aussi une apparition notable dans des bâtiments dont les formes tirent pleinement parti de sa nature « liquide ». Dans une autre direction, Konstantin Melnikov a imaginé pour le Club des ouvriers de Roussakov (Moscou, 1927–28, page 22) trois blocs de béton en encorbellement contenant chacun des espaces assis. Chacun des trois blocs a été conçu pour être utilisé comme un auditorium indépendant. Avec sa structure apparente de béton, verre et brique, le Club rappelle avec raison de nombreux bâtiments plus récents qui mettent en avant la flexibilité et l'usage du béton.

LE MAÎTRE DE LA COQUE MINCE

Le Mexicain Félix Candela est un autre architecte dont les réalisations comparables sont fondées sur l'usage du béton. Son entrepôt Celestino (Mexico, 1955, page 32) ne comporte aucune de ses structures favorites à coque mince, dont il a bâti plus de 800, mais une construction de béton en forme de parapluie. « Son innovation sans doute la plus connue est le "parapluie" composé de quatre paraboloïdes qui transfèrent leurs charges à une colonne centrale. Le bon fonctionnement de ces structures vaudra à la société de Candela un flux régulier de commandes de couvertures industrielles [3] » comme celle de Celestino. Les réalisations de Candela sont sans doute moins proches de modèles spécifiquement naturels comme par exemple celles de Nervi, leur construction est plus mathématique, mais avec un sens pratique très développé. Comme l'a montré une exposition au musée de l'université de Princeton en 2008, les premières coques minces de Candela «ne présentaient pas la forme paraboloïde hyperbolique (hypar), mais des formes plus traditionnelles – funiculaires, conoïdes et cylindriques. C'est seulement lorsqu'il a pris confiance, sur la base de son expérience de la conception, de l'analyse et de

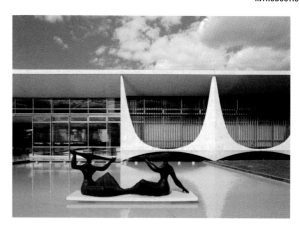

1958, *Oscar Niemeyer,*
Palace of the Dawn,
Brasília, Brazil

la construction de coques minces, qu'il a commencé à créer son art. [4] » Ses coques sont réalisées à l'aide d'échafaudages, « une structure temporaire de bois ou métal qui porte les panneaux donnant la forme à l'ensemble et le béton humide. Ces panneaux sont placés en haut des échafaudages et permettent au béton de prendre sa forme finale une fois durci. Lorsque les formes sont mises en place, l'armature d'acier est ajoutée et les ouvriers peuvent enfin couler le béton, généralement épais de 4 centimètres. [5] » Un autre exemple intéressant de l'utilisation du béton dans un cadre résidentiel est la Résidence de Milam de Paul Rudolph (Jacksonville, Floride, 1959–61, page 23).

DES INGÉNIEURS ET DES ARCHITECTES

L'utilisation du béton a pris de nouvelles dimensions, en grande partie du fait de l'inventivité de nombreux ingénieurs et architectes qui ont suivi les traces de Freyssinet, Maillart et leurs pareils. Les ingénieurs Pier Luigi Nervi (1891–1979) et Félix Candela (1910–97) ont ainsi poussé à leurs limites structurelles les constructions à voile mince et d'autres emplois étonnants du béton. Ils ont prouvé que le béton pouvait ouvrir des formes nouvelles à l'architecture. Oscar Niemeyer (1907–2012) est, bien sûr, l'un des grands architectes qui a innové avec le béton.

Son palais de l'Aube (Palácio da Alvorada, Brasília, 1958, page 35) est un exemple typique. Isolé à l'extrémité d'une vaste étendue d'herbe, il semble flotter au-dessus de bassins d'eau peu profonde, ses colonnes aux surprenantes courbes touchant à peine le sol. Cette apesanteur est cependant en partie illusoire, le Palácio da Alvorada s'appuie sur des supports cachés et constitue véritablement un exploit remarquable en matière d'architecture et de génie. Oscar Niemeyer a collaboré étroitement avec l'ingénieur Joachim Cardoso pour approcher les limites les plus extrêmes de la faisabilité structurelle dans sa recherche des proportions et de la légèreté idéales. Le bâtiment est en fait un prisme de verre rectangulaire suspendu entre de fines dalles de béton. Depuis le Palácio da Alvorada, les mérites du béton dans l'architecture contemporaine ne peuvent plus sérieusement être mis en doute. « Ce n'est pas l'angle droit qui m'attire, ni la ligne droite, dure, inflexible, créée par l'homme. Ce qui m'attire, c'est la courbe libre et sensuelle, la courbe que je rencontre dans les montagnes de mon pays, dans le cours sinueux de ses fleuves, dans la vague de la mer, dans le corps de la femme préférée. L'univers tout entier est fait de courbes, c'est l'univers courbe d'Einstein. [6] » Avec ces mots, Oscar Niemeyer résume sa philosophie, n'hésitant pas à faire appel aux formes de la nature, du corps humain à l'univers lui-même.

AUTRES MAÎTRES LATINO-AMÉRICAINS

Deux compatriotes d'Oscar Niemeyer, Lina Bo Bardi et Paulo Mendes da Rocha, ont eux aussi créé des œuvres puissantes en béton qui n'ont apparemment guère d'égal hors d'Amérique latine. Née en Italie, Lina Bo Bardi est arrivée au Brésil en 1948 et y a construit la Maison de verre (São Paulo, 1948, page 24) la même année. La construction, toujours remarquable, a été bâtie dans ce qui restait de la Mata Atlantica, la forêt tropicale, dans le quartier de Morumbi. Le volume de verre est placé entre de minces dalles de béton armé portées par de fins pilotis qui permettent de conserver la forêt intacte en-dessous. Autre œuvre significative de Lina Bo Bardi, le centre culturel SESC Pompéia (São Paulo, 1982, page 13) dans l'usine Pompéia réunit une fabrique de tambours en briques rouges des années 1920 et trois énormes et surprenantes tours de béton reliées par des passages suspendus.

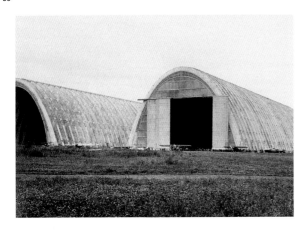

1923, *Eugène Freyssinet,*
Airship Hangars, Orly, France

Paulo Mendes da Rocha a remporté le prix Pritzker 2006. La citation du jury note : « Sa signature de béton et ses méthodes de construction astucieuses mais remarquablement directes donnent naissance à des bâtiments puissants et expressifs qui jouissent d'une reconnaissance internationale. Il est évident que les matériaux bruts auxquels il a recours pour des résultats monumentaux ont exercé une influence dans le monde entier. [7] » Son stade Serra Dourada (Goiânia, Goiás, Brésil, 1975, page 12) incarne la tentative de transformer le caractère généralement clos du terrain de football pour l'ouvrir à la ville. Le toit surplombe les gradins et les espaces destinés au public sur 20 mètres de chaque côté et les couvre en partie. Des galeries fermées destinées à accueillir bureaux et restaurants sont disposées symétriquement à chaque extrémité de la forme ovale. L'architecte a utilisé son béton de prédilection et explique qu'il a cherché une « solution pouvant faire coexister le loisir populaire et le confort social ».

WRIGHT, BREUER ET KAHN

Le béton est un élément essentiel dans bon nombre d'autres ouvrages originaux de l'architecture moderne. C'est le cas, bien sûr, du musée Solomon R. Guggenheim (New York, 1959, page 29) par Frank Lloyd Wright où l'architecte parvient avec simplicité à faire faire au béton des choses qu'il n'avait jamais faites avant pour une dimension géométrique, et même au-delà. Wright explique : « Ces formes géométriques évoquent certaines idées humaines, des humeurs ou sentiments – par exemple : le cercle, l'infinité ; le triangle, l'unité structurelle ; la spirale, le processus organique ; le carré, l'intégrité. [8] » À quelques rues du Guggenheim, le musée Whitney d'art américain (1966, page 16, maintenant appelé le Met Breuer) par Marcel Breuer a été construit essentiellement en béton coulé en place. L'architecte a sans doute voulu souligner le poids de ses matériaux et a revêtu l'extérieur de granite. À l'intérieur, trois des étages du musée présentent des plafonds suspendus en béton préfabriqué à grille flottante, démontrant une fois encore que le béton coulé sur place et le béton préfabriqué peuvent être utilisés dans la même structure à des fins différentes. L'Institut Salk (La Jolla, Californie, 1965) est un autre bâtiment moderne très original aux États-Unis. L'architecte Louis Kahn a utilisé, pour une référence intéressante aux toutes premières origines du matériau, un béton auquel ont été ajoutées des cendres volcaniques (pouzzolanes) pour lui donner un ton plus chaud. Il a spécifié qu'aucun doucissage ou peinture du béton n'était prévu et à part la structure de base en béton, les seuls matériaux utilisés sont le teck, le plomb, le verre et l'acier.

PROJETÉ OU COULÉ SUR PLACE

Le nombre de types de béton n'a cessé d'augmenter, et ce encore récemment. Des méthodes innovantes comme le « béton projeté » ou la « gunite », inventées dès le début du XXᵉ siècle, consistent notamment à projeter le béton à grande vitesse sur une surface préparée à cet effet. Le Corbusier a utilisé la gunite dans sa célèbre chapelle Notre-Dame-du-Haut (Ronchamp, France, 1955, pages 26–27). Le béton à air occlus est une autre invention, peut-être plus importante encore, qui date des années 1930. Il s'agit d'injecter de minuscules bulles d'air dans le béton dans une proportion de 5 à 8 % du volume total. L'occlusion d'air accroît considérablement la résistance au gel en diminuant la pression intérieure, ainsi que la résistance au sel ou aux sulfates.

Il n'en reste pas moins que certains des bâtiments en béton les plus remarquables ont été construits avec des techniques de coulage sur place. C'est notamment le cas des œuvres de Tadao Ando auxquelles le béton, moulé selon des méthodes extrêmement spécialisées, souvent dans des coffrages en bois verni, donne un aspect lisse qui semble contraire à la perception

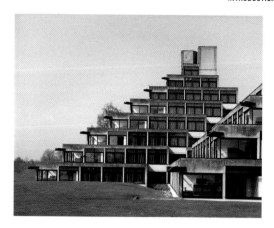

1968, *Denys Lasdun,*
Halls of Residence, University of
East Anglia, Norwich, UK

courante du matériau, plus souvent industriel et brut que lisse. L'église de la Lumière (Ibaraki, Osaka, Japon, 1989, page 18) est une petite structure, mais elle se place sans aucun doute parmi les chefs-d'œuvre de l'architecture moderne en béton. Constituée pour l'essentiel d'un bloc de béton rectangulaire coupé à un angle de 15 degrés par un mur isolé, sa caractéristique la plus remarquable est l'ouverture en forme de croix derrière l'autel qui inonde l'intérieur de lumière. Avec ses sols et ses bancs en planches d'échafaudage de cèdre noirci, la chapelle renvoie une image de grande simplicité.

UNE PRÉSENCE UNIVERSELLE

Peu de bâtiments modernes ont eu l'impact visuel et émotionnel de l'Opéra de Sydney (1958–73, page 15). L'œuvre riche et originale de Jørn Utzon fait un usage substantiel du béton, à commencer par les 588 piliers qu'il a fallu enfoncer jusqu'à 25 mètres sous le fond de la mer. Une série de coques de béton préfabriquées, composées de sections sphériques de 75,2 mètres de rayon, forment ce qui est sans doute la toiture la plus emblématique du monde. L'emploi de béton coulé en place avait été envisagé, mais finalement jugé trop onéreux. Les techniques mises au point par Utzon et les ingénieurs Arup ont considérablement influencé l'architecture en béton ultérieure. L'Opéra de Sydney a été inscrit au patrimoine mondial de l'U.N.E.S.C.O. le 28 juin 2007, alors même que sa conception a posé d'énormes problèmes au moment de la construction – à tel point que l'architecte a quitté l'Australie avant la fin. Lorsque Jørn Utzon remporte le prix Pritzker 2003, Thomas Pritkzer, président de la Fondation Hyatt, déclare : « Les nouveaux matériaux et les nouvelles technologies ont ouvert de nouveaux horizons à l'architecture. [...] Jørn Utzon est l'un des créateurs de ces nouveaux horizons. Son opéra a fait tomber des barrières à bien des égards. Il a démontré et a développé ce qui était possible. Frank Gehry, membre du jury et lauréat du prix Pritzker, a dit à son propos : "Il a réalisé un bâtiment très en avance sur son temps comme sur les technologies disponibles et a persévéré, malgré une publicité extrêmement malveillante et des critiques négatives, à construire un bâtiment qui a changé l'image de tout un pays. C'est la première fois de notre vie qu'une réalisation architecturale aussi extraordinaire arrive à une présence aussi universelle. Gehry a aussi souligné que les efforts révolutionnaires d'Utzon ont rendu possible la construction du musée Guggenheim à Bilbao. [9] » De fines plaques de béton ont fait leur apparition dans des structures très visibles comme au Centre Trans World Flight (1955–62, page 39) de Eero Saarinen. Au Japon, l'émergence de Kenzo Tange (page 30) comme une personalité importante dans la transformation de l'architecture contemporaine, largement basée sur le béton, a été concrétisée par son Stade Yoyogi (Shibuya, Tokyo, 1961–64). En Angleterre, Denys Ladsum (page 37) a laissé son empreinte indélibile avec le Royal National Théâtre de Southbank à Londres (1976).

DU GRAVIER, DU CO$_2$ ET LA MASSE THERMIQUE

On pourrait s'y attendre, l'histoire du béton n'est pas seulement positive. Du fait de son usage généralisé, il a fait l'objet d'examens approfondis en ce qui concerne la pollution. L'industrie du ciment produit notamment de grandes quantités de dioxyde de carbone, considéré comme un « gaz à effet de serre ». En effet, le ciment doit être chauffé à des températures élevées au cours de sa fabrication : les cimenteries industrielles disposent de fours dont la longueur peut atteindre 230 mètres pour chauffer les pierres concassées à plus de 1600 degrés Celsius et produire des granules de « scories » qui sont l'un des principaux composants du ciment. Les fabricants ont proposé plusieurs alternatives pour réduire les émissions de CO$_2$ mais la production d'une tonne de ciment émet toujours près de 900 kilos de CO$_2$. L'entreprise italienne Italcementi a mis au point un type de béton censé décomposer

38

1962, *Eero Saarinen,*
Trans World Flight Center,
John F. Kennedy International
Airport, New York, USA

les polluants atmosphériques à l'aide de dioxyde de titane qui absorbe le rayonnement ultraviolet. L'église du Jubilé (Rome, 1996–2003, pages 14, 334) de Richard Meier et, plus récemment, son i.lab pour Italcementi (Bergame, Italie, 2005–12) sont tous les deux construits avec le béton TX Active d'Italcementi. Ce béton armé blanc à haute résistance est également conçu pour rester blanc grâce à ses propriétés photocatalytiques autonettoyantes. Un rapport scientifique de 2001 sur le sujet met en lumière d'autres problèmes environnementaux posés par le béton : « Le béton ordinaire contient normalement environ 12 % de ciment et 80 % d'agrégat en masse. À l'échelle mondiale, cela veut dire que pour faire du béton, nous utilisons du sable, du gravier et des roches concassées à hauteur de 10 à 11 milliards de tonnes par an. Les opérations d'extraction, de transformation et de transport de quantités aussi énormes d'agrégat consomment des quantités tout aussi énormes d'énergie et ont un effet défavorable sur l'écologie des régions forestières et des lits de rivières. L'industrie du béton consomme également beaucoup d'eau potable, la seule eau de gâchage correspond à environ un billion de litres chaque année. [10] » Le recyclage du béton est cependant de plus en plus répandu – les barres d'armature sont alors retirées des débris au moyen d'aimants.

D'un autre côté, le béton, surtout lorsqu'il est aussi épais que dans les travaux de Tadao Ando, contribue à réduire les besoins en chauffage ou climatisation en raison de sa masse thermique élevée. On dit aussi que la production d'acier, ou même de bois de construction, consomme plus d'énergie que celle du béton. Le béton dans toute sa splendeur est également le matériau par excellence lorsqu'il s'agit de construire des structures d'envergure comme des barrages – qui produisent de l'hydroélectricité et donc contribuent à réduire les émissions de gaz à effet de serre produites par d'autres formes d'énergie. De plus, un bâtiment en béton bien construit peut durer très longtemps et évite certainement dans bien des cas de devoir raser et rebâtir, ce qui cause encore plus de pollution.

TOUJOURS PLUS HAUT, PLUS LOIN, PLUS SOLIDE

Bien sûr, l'usage mixte de matériaux tels que l'acier peut aussi être associé au béton. Les surfaces en béton sont alors souvent destinées à supporter la compression, tandis que les barres métalliques doivent résister à la tension structurelle. Si l'acier reste le matériau de prédilection pour la plupart des bâtiments hauts, notamment aux États-Unis, les tours en béton érigées à l'aide de coffrages grimpants sont elles aussi très répandues. Un bâtiment haut en béton est par définition un bâtiment dont les principaux éléments structurels verticaux et latéraux sont en béton, ainsi que les sols.

Les projets publiés ici, tous récents, n'ont pas pour but d'établir un catalogue des différentes possibilités d'utiliser le béton, ils en montrent simplement une grande variété, des bâtiments entièrement en béton aux structures dont il représente une partie significative du design. On trouve dans ce livre des complexes immenses – comme le Sliced Porosity Block de Steven Holl (Chengdu, Chine, 2008–12 ; page 280) – et des structures aux dimensions beaucoup plus resserrées qui relèvent plus du paysagisme – comme l'aire de repos de Selvika sur la route touristique nationale de Havøysund (Havøysund, Finnmark, Norvège, 2012, pages 34, 416) par les architectes norvégiens Reiulf Ramstad. Il faut dire que le béton, malléable et répandu comme il l'est, va continuer de jouer un rôle significatif en architecture contemporaine dans un futur prévisible. Les formes nouvelles plus techniques ne font qu'accroître et mettre en valeur sa présence. Alors oui, le béton peut être affreux, mais il peut aussi être doux au toucher, sensuel et lourd, solidement ancré dans le sol d'où il vient.

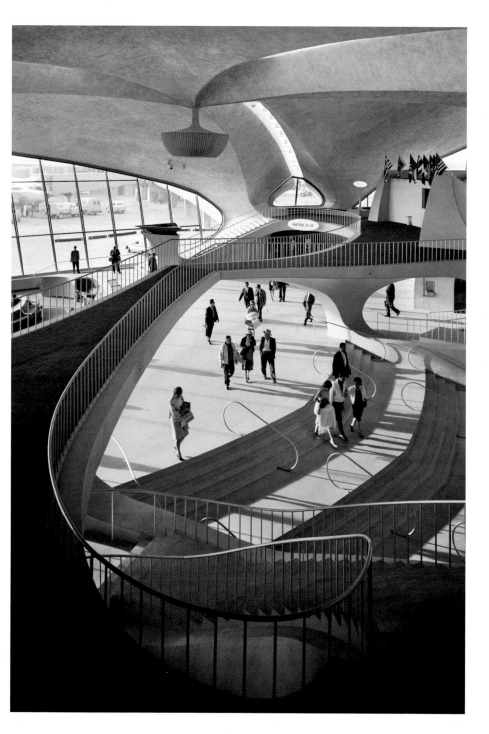

ACEBO X ALONSO

VICTORIA ACEBO was born in Ponferrada, Spain, in 1969. She received her degree as an architect from ETSA Madrid in 1995 and has wirked as a Professor at the European University of Madrid since 2003. This is also the case for **ÁNGEL ALONSO**, born in Santander, Spain, in 1966, who also obtained his degree from ETSAM in 1995. They created Acebo X Alonso in 1995. Aside from the National Museum of Science and Technology, MUNCYT (A Coruña, 2004–07/2012, published here), they have also worked on the Varsavsky House (Madrid, 2003–07). Earlier work includes the Terzagui House (Salamanca, 1996–98); the L-C House (Santander, 1997–99); and the M-U Houses (Guipúzcoa, 1999–2002), all in Spain.

VICTORIA ACEBO wurde 1969 in Ponferrada, Spanien, geboren. Sie schloss ihr Architekturstudium 1995 an der ETSA in Madrid ab. Seit 2003 hat sie eine Professur an der Europäischen Universität in Madrid. Dies trifft auch auf **ÁNGEL ALONSO** zu, der 1966 in Santander, Spanien, geboren wurde und seinen Abschluss ebenfalls 1995 an der ETSA Madrid machte. 1995 gründeten sie das Büro Acebo X Alonso. Außer dem Nationalen Museum für Wissenschaft und Technologie MUNCYT (A Coruña, 2004–07/2012, hier vorgestellt) haben sie das Haus Varsavsky (Madrid, 2003–07) gebaut. Zu ihren früheren Werken zählen das Haus Terzagui (Salamanca, 1996–98), das Haus L-C (Santander, 1997–99) und die Häuser M-U (Guipúzcoa, 1999–2002), alle in Spanien.

VICTORIA ACEBO, née à Ponferrada (Espagne) en 1969, a reçu son diplôme d'architecture de l'ETSA Madrid en 1995. Elle est professeur à l'Université européenne de Madrid depuis 2003. C'est aussi le cas d'**ÁNGEL ALONSO**, né à Santander (Espagne) en 1966, également diplômé de l'ETSAM en 1995. Ils ont fondé Acebo X Alonso en 1995. En dehors du Musée national des sciences et technologies, MUNCYT (La Corogne, 2004–07/2012, publié ici), ils ont travaillé sur les projets de la maison Varsavsky (Madrid, 2003–07). Parmi leurs réalisations antérieures, toutes en Espagne : la maison Terzagui (Salamanque, 1996–98) ; la maison L-C (Santander, 1997–99) et les maisons M-U (Guipúzcoa, 1999–2002).

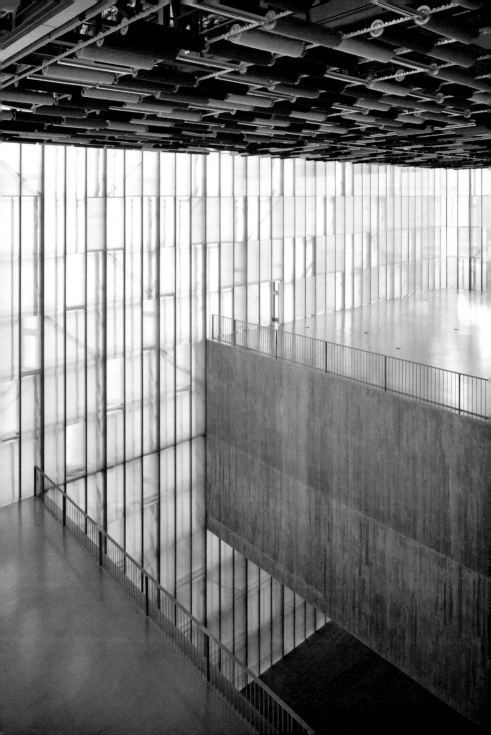

NATIONAL MUSEUM OF SCIENCE AND TECHNOLOGY, MUNCYT

A Coruña, Spain, 2004–07/2012

*Area: 6034 m². Client: Diputación A Coruña.
Cost: €9 million.*

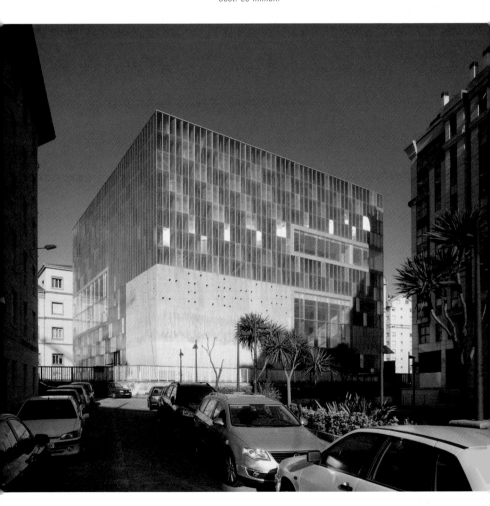

The full, cubic volume of the structure is enlivened by various, sometimes irregular, surface treatments.

Das gewaltige kubische Volumen des Baus wird durch die unterschiedliche, manchmal auch ungleichmäßige Oberflächenbehandlung belebt.

Le volume entièrement cubique du bâtiment s'anime de divers traitements de surface, de nature parfois irrégulière.

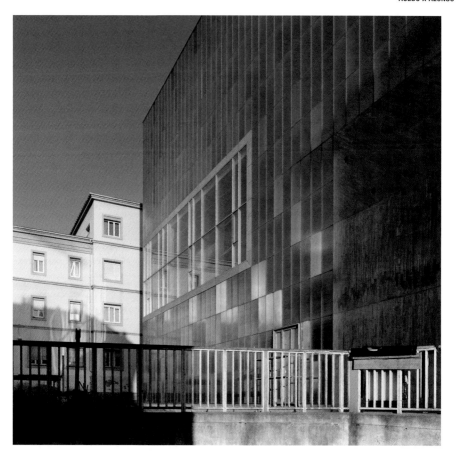

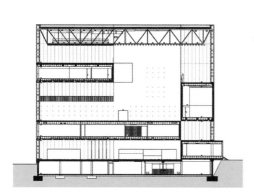

The architects were the winners of an international competition, whose original program included a dance school and a museum on the same site. They proposed a single volume, but with differentiated space. They explain: "We had the chance to add, subtract, divide, but we chose to multiply. The strange concrete form contains the school, while the outer surface, the space between the form and the limit, contains the museum." A series of concrete boxes contains the functions of the school, while the museum is set around these concrete volumes, with six different height spaces, forming a continuous space. Outer refracting glass panels are attached to aluminum frames using structural silicone in a system that was tested to withstand winds of 200 kilometer per hour. The architects used 1000 colored cylinders made of glass wool, a material sometimes employed in industrial spaces with significant mechanical noise levels. They explain: "We disposed them with four different colors to provoke some kind of vibrating topography. They hide the different layers that compose the technical floor: air conditioning, maintenance paths, lighting." For complex economic reasons not linked to the work of the architects, this building, originally to be called the A Coruña Arts Center, has now become the new **NATIONAL MUSEUM OF SCIENCE AND TECHNOLOGY**, or MUNCYT, and opened to the public in May 2012.

Die Architekten hatten einen internationalen Wettbewerb gewonnen, dessen ursprüngliches Programm eine Tanz-schule und ein Museum auf demselben Grundstück vorsah. Sie schlugen ein zusammenhängendes Volumen vor, jedoch mit getrennten Bereichen. Dazu ihre Erklärung: „Wir hatten die Chance zu addieren, zu subtrahieren, zu dividieren, aber wir beschlossen zu multiplizieren. Die fremdartige Betonform enthält die Schule, während das Museum die Außenflä-che, den Raum zwischen der Form und der Begrenzung, einnimmt." Die Schule ist in mehreren Betonkisten unterge-bracht; das Museum ist um diese herum angeordnet und besteht aus sechs Räumen unterschiedlicher Höhe, die einen zusammenhängenden Bereich bilden. Die äußeren lichtbrechenden Glastafeln sind an Aluminiumrahmen befestigt, wobei konstruktives Silikon in einem System verwendet wurde, das Windstärken von 200 km/h widerstehen kann. Die Architekten benutzten 1000 farbige Zylinder aus Glaswolle, einem Material, das gelegentlich für Industrieräume mit hohem Lärmpegel verwendet wird. Sie erklären: „Wir legten sie in vier verschiedenen Farben an, um eine quasi vibrierende Topografie zu erzielen. Sie verbergen die verschiedenen Schichten, die im Technikgeschoss enthalten sind: Klimaanlage, Wartungsgänge, Beleuchtung." Aus verschiedenen wirtschaftlichen Gründen, die nichts mit der Arbeit der Architekten zu tun haben, wurde aus dem ursprünglich als Kunstzentrum von A Coruña bezeichneten Gebäude das neue **NATIONALMUSEUM FÜR WISSENSCHAFT UND TECHNOLOGIE** (MUNCYT), das im Mai 2012 eröffnet wurde.

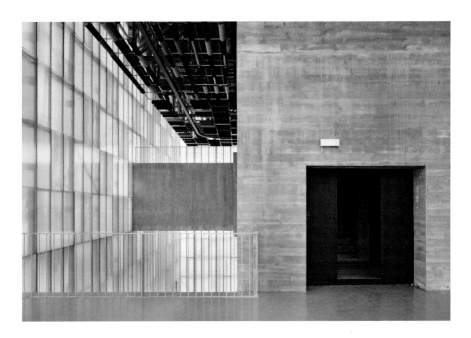

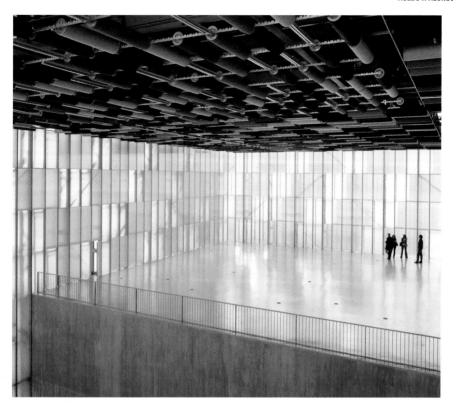

The broad, open interior spaces seen here before the installation of the Science Museum facilitated the transition from the earlier scheme that called for a dance school and museum.

Die weiten, offenen Innenräume, hier vor der Einrichtung des Wissenschaftsmuseums, erleichterten die Umplanung des ursprünglichen Entwurfs für eine Tanzschule und ein Museum.

Les vastes volumes intérieurs ouverts – vus ici avant l'installation du Musée des sciences – ont facilité l'adaptation des plans prévus antérieurement pour une école de danse et un musée.

Ce projet est l'aboutissement d'un concours dont le programme original comprenait une école de danse et un musée. Les architectes ont proposé un volume unique, mais différencié. «Nous avions la possibilité d'ajouter, de soustraire, de diviser, mais avons décidé de multiplier. L'étrange forme en béton contient l'école, tandis que l'espace supérieur, situé entre la base et le sommet du bâtiment, contient le musée», expliquent-ils. Une série de boîtes en béton accueille les diverses fonctions de l'école, tandis que le musée qui s'organise autour d'elles comprend six volumes de hauteurs différentes, mais formant un espace continu. Les panneaux de verre réfléchissants des façades sont fixés sur des cadres d'aluminium par un silicone structurel, selon une technique qui les rend capables de résister à des vents de 200 km/h. Les architectes ont par ailleurs mis en place 1000 cylindres en laine de verre – matériau habituellement utilisé dans les environnements industriels à haut niveau sonore. Ils expliquent: «Nous les avons agencés en quatre couleurs différentes pour créer une sorte de topographie vibrante. Ils dissimulent les différentes strates des plafonds techniques: climatisation, coursives de maintenance, éclairage.» Pour des raisons économiques complexes, non liées à l'intervention des architectes, ce bâtiment, appelé à l'origine le Centre des arts A Coruña, est devenu le nouveau **MUSÉE NATIONAL DES SCIENCES ET TECHNOLOGIES** (MUNCYT), qui a ouvert au public en mai 2012.

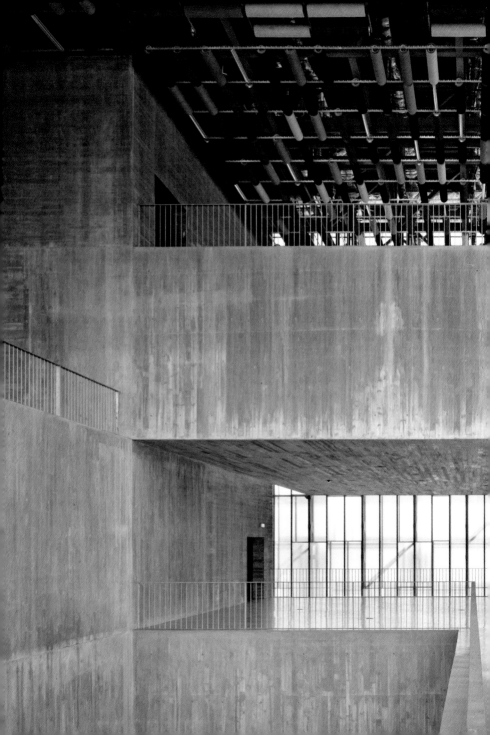

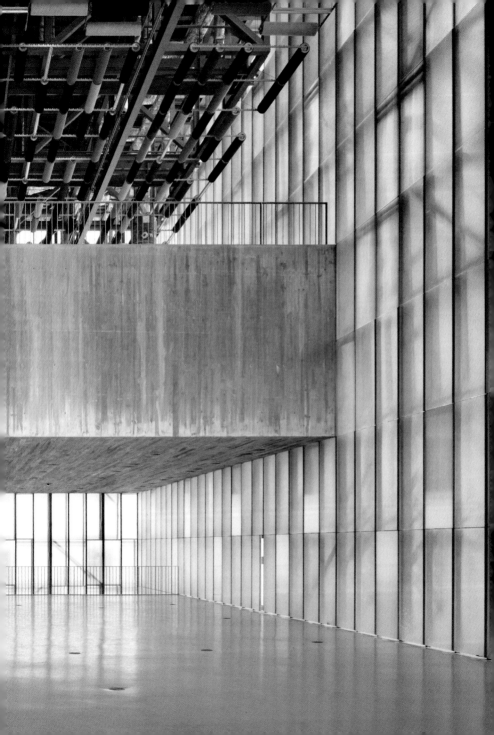

STAN ALLEN

STAN ALLEN received his B.A. from Brown University (1978), a B.Arch degree from Cooper Union (1981), and an M.Arch degree from Princeton (1988). He started his career in the office of Richard Meier (1981–83) and then worked for Rafael Moneo in Madrid and Cambridge, Massachusetts (1984–87). He created his own firm, SAA/Stan Allen Architect, in 1991 and also became a Principal and Director of the collaborative, interdisciplinary firm Field Operations (1999–2003). He was an Assistant Professor of Architecture (1990–97) and then Associate Professor of Architecture (1998–2002) at Columbia University GSAP. He was Dean and George Dutton Class of '27 Professor at the School of Architecture, Princeton University, from 2002 to 2012. Recent projects include the Taichung Gateway Park (Taichung, Taiwan, 2007); CCV Chapel (Tagaytay, Philippines, 2007–08, published here); Salim Publishing House (Paju Book City, South Korea, 2009); Taichung Infobox (Taichung, Taiwan, 2011); and Block/Tower, a projected residential refit of an office tower in Manhattan (New York, USA, 2013).

STAN ALLEN machte seinen B.A. an der Brown University (1978), anschließend einen B.Arch. an der Cooper Union (1981) und schließlich einen M.Arch. an der Universität Princeton (1988). Seine Laufbahn begann im Büro von Richard Meier (1981–83), anschließend war er für Rafael Moneo in Madrid und Cambridge, Massachusetts, tätig (1984–87). Sein eigenes Büro SAA/Stan Allen Architect gründete er 1991. Darüber hinaus war er Seniorpartner und Direktor des interdisziplinären Büros Field Operations (1999–2003). Allen war Lehrbeauftragter (1990–97) und außerordentlicher Professor für Architektur (1998–2002) an der Graduate School of Architecture der Columbia University. Von 2002 bis 2012 war er Dekan an der Fakultät für Architektur in Princeton und hat die Professur „George Dutton Class of '27" inne. Zu seinen jüngsten Projekten zählen der Taichung Gateway Park (Taichung, Taiwan, 2007), die CCV-Kapelle (Tagaytay, Philippinen, 2007–08, hier vorgestellt), der Sitz des Salim-Verlags (Paju Book City, Südkorea, 2009), die Taichung Infobox (Taichung, Taiwan, 2011) sowie Block/Tower, der Umbau eines Bürogebäudes in Manhattan zu einem Wohnbau (New York, 2013).

STAN ALLEN a obtenu sa licence en arts à la Brown University (B.A., 1978), sa licence en architecture à la Cooper Union (B.Arch., 1981) et son master en architecture à Princeton (M.Arch., 1988). Il débute sa carrière dans l'agence de Richard Meier (1981–83), puis travaille pour Rafael Moneo à Madrid et Cambridge, dans le Massachusetts (1984–87). Il fonde sa propre agence, SAA/Stan Allen Architect, en 1991 et devient également directeur de l'agence multidisciplinaire Field Operations (1999–2003). Il est maître-assistant en architecture (1990–97), puis professeur associé en architecture (1998–2002) à la GSAP de l'université Columbia. Il a été doyen et professeur « George Dutton Class of '27 » de l'École d'architecture de Princeton de 2002 à 2012. Ses projets récents comprennent le parc Taichung Gateway (Taichung, Taïwan, 2007); la chapelle CCV (Tagaytay, Philippines, 2007–08, publié ici); le siège de la maison d'édition Salim (Paju Book City, Corée du Sud, 2009); la Taichung Infobox (Taichung, Taïwan, 2011) et Block/Tower, un projet de rénovation d'une tour de bureaux à Manhattan (New York, 2013).

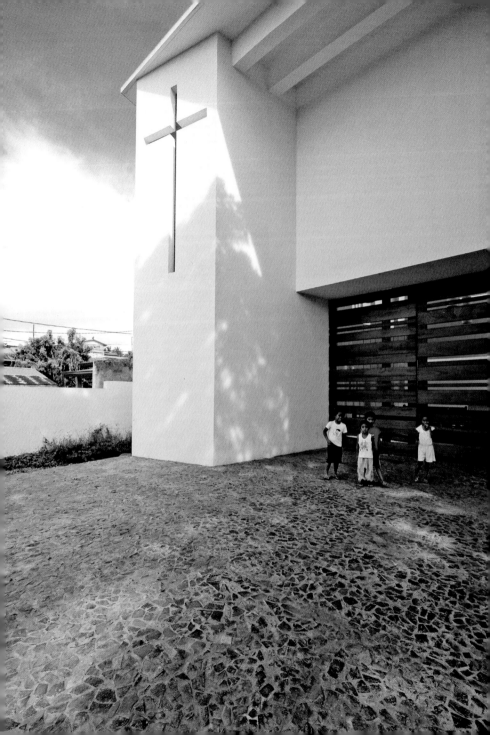

CCV CHAPEL

Tagaytay, Cavite, Philippines, 2007–08

Area: 240 m². Client: Ricardo Delgado and CCV Foundation. Cost: $250 000.
Collaboration: Carlos Arnaiz (Project Architect), David Orkand, Marc McQuade.

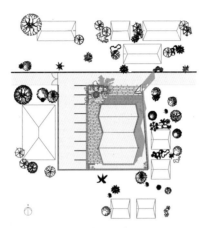

This very small **CCV CHAPEL** marks the entrance to the campus of the Chosen Children's Village Foundation, a non-profit organization "dedicated to the creation of a home environment for physically and mentally challenged children." Designed and built by professionals who donated their services, the structure had a small budget and was erected in a tropical area with a high earthquake risk. "Our response," says the architect, "is a simple pavilion created out of a single line that folds back on itself. The walls are canted in plan for structural stiffness; the resulting figure embraces the congregation and frames the altar. In elevation, the walls are treated like screens to allow for natural air circulation and to filter the strong sunlight." Built largely with cast-in-place concrete, the seven-meter-high space creates a considerable effect.

Die ausgesprochen kleine **CCV KAPELLE** bestimmt den Eingang zum Campus der Chosen Children's Village Foundation, einer gemeinnützigen Organisation, die sich die „Schaffung eines Heims für körperlich und geistig behinderte Kinder" zur Aufgabe gemacht hat. Der Bau, geplant und realisiert von Fachleuten, die ihre Arbeit kostenlos zur Verfügung stellten, musste mit einem kleinen Budget auskommen und wurde in einer tropischen Gegend errichtet, die stark erdbebengefährdet ist. „Unsere Reaktion darauf", so der Architekt, „war ein schlichter Pavillon, der von einer einzigen, in sich gefalteten Linie umrissen wird. Die Kanten der Wände schieben sich in den Grundriss hinein, was dem Bau zusätzliche Steifigkeit verleiht; die so entstandene Form umfängt die Gemeinde und rahmt den Altar. Im Aufriss wirken die Mauern wie Wandschirme. Sie lassen natürliche Belüftung zu und filtern das starke Sonnenlicht." Die überwiegend aus Ortbeton erbaute Kapelle wirkt mit ihrer Höhe von 7 m durchaus beeindruckend.

Cette très petite **CHAPELLE CCV** marque l'entrée du campus de la Fondation Chosen Children's Village, une organisation caritative « dédiée à la création d'un lieu d'accueil pour des enfants handicapés physiques ou mentaux ». Conçu et construit par des professionnels bénévoles, ce bâtiment était doté d'un budget modeste et situé dans une zone tropicale à haut risque sismique. « Notre réponse, dit l'architecte, est un simple pavillon créé à partir d'une ligne unique se repliant sur elle-même. Les murs sont obliques pour solidifier la structure ; la forme obtenue enlace l'assemblée et encadre l'autel. En élévation, les murs sont traités comme des écrans qui permettent une circulation naturelle de l'air et filtrent la forte lumière. » L'espace de 7 m de haut, largement construit en béton coulé sur place, produit un bel effet.

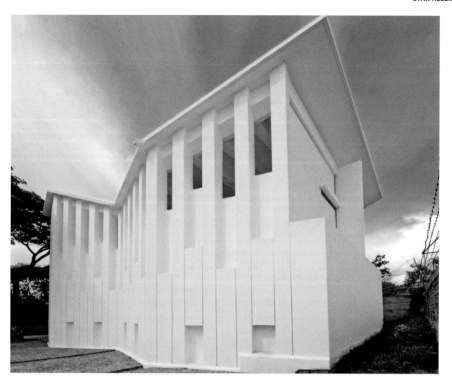

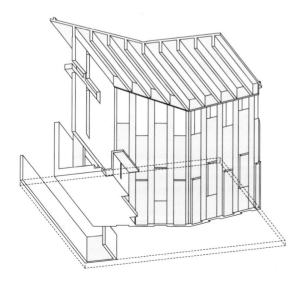

The unusual, columnar design of the chapel gives it a musical appearance, with varying roof heights and openings beneath the roof plane. On the left page a site plan and an axonometric drawing on this page.

Die ungewöhnliche Stützenoptik der Kapelle mit ihren unterschiedlichen Dachniveaus und Fensteröffnungen unterhalb der Dachlinie weckt musikalische Assoziationen. Auf der linken Seite ein Lageplan und hier eine Axonometrie.

Avec ses ouvertures de hauteur variable sous un toit, lui aussi de hauteur variable, le dessin inhabituel de la chapelle évoque des orgues basaltiques. Sur la page a gauche un plan et ici une axiométrie.

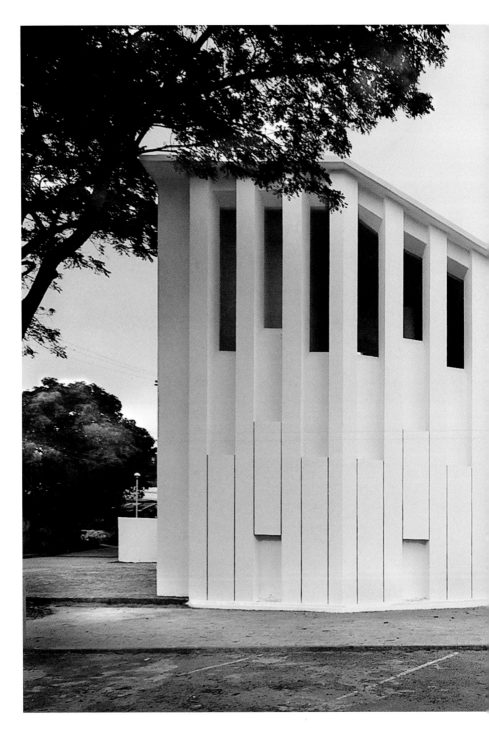

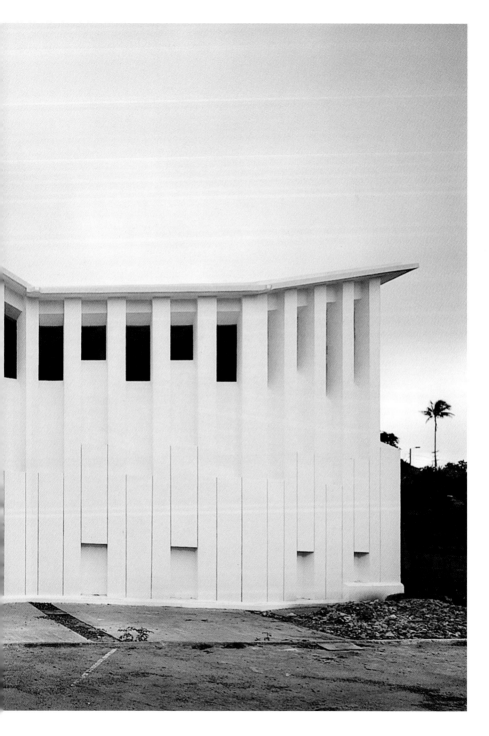

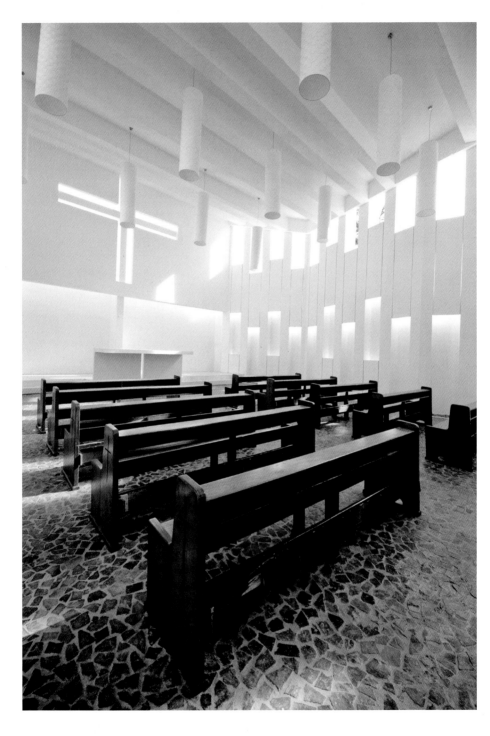

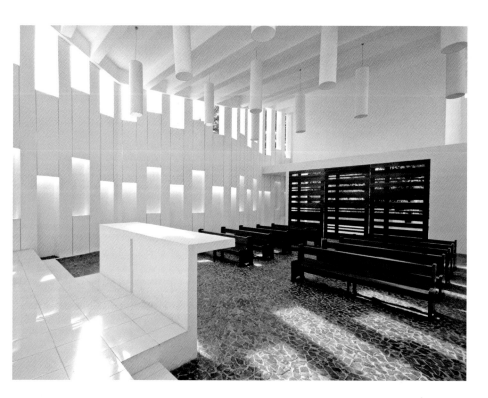

The orchestration of light and white forms is contrasted with the darker wooden entry and pews, and the irregular stone paving.

Das Zusammenspiel von Licht und weißen Elementen kontrastiert mit dem dunklen Holz der Eingangstür und der Kirchenbänke sowie der unregelmäßigen Bodenpflasterung.

L'orchestration blanche des formes et de la lumière contraste avec le bois sombre de l'entrée et des bancs et le pavement en pierres irrégulières.

TADAO ANDO

Born in Osaka in 1941, **TADAO ANDO** was self-educated as an architect, largely through his travels in the United States, Europe, and Africa (1962–69). He founded Tadao Ando Architect & Associates in Osaka in 1969. He has received the Alvar Aalto Medal, Finnish Association of Architects (1985); the Medaille d'Or, French Academy of Architecture (1989); the 1992 Carlsberg Prize; and the 1995 Pritzker Prize. He has taught at Yale (1987), Columbia (1988), and Harvard (1990). Notable buildings include: Rokko Housing (Kobe, 1983–93); Church on the Water (Hokkaido, 1988); Japan Pavilion Expo '92 (Seville, Spain, 1992); Forest of Tombs Museum (Kumamoto, 1992); and Suntory Museum (Osaka, 1994), all in Japan unless stated otherwise. Recent work includes the Awaji Yumebutai (Awajishima, Hyogo, Japan, 1997–2000); the Pulitzer Foundation for the Arts (St. Louis, Missouri, USA, 1997–2000); and the Modern Art Museum of Fort Worth (Texas, USA, 1999–2002). More recently, Tadao Ando completed the Stone Sculpture Museum (near Bad Kreuznach, Germany, 1996–2010); the Lee Ufan Museum (Naoshima, Kagawa, Japan, 2007–10); the Ando Museum (Naoshima, Kagawa, Japan, 2012–13); and the Shanghai Poly Theater (Shanghai, China, 2014).

TADAO ANDO wurde 1941 in Osaka geboren. Als Architekt ist er Autodidakt und bildete sich in erster Linie durch seine Reisen in den USA, Europa und Afrika zwischen 1962 und 1969. 1969 gründete er in Osaka das Büro Tadao Ando Architect & Associates. 1985 erhielt er die Alvar-Aalto-Medaille des finnischen Architektenverbands, 1989 die Medaille d'Or der französischen Académie d'Architecture, 1992 den Carlsberg-Preis sowie 1995 den Pritzker-Preis. Er lehrte an den Universitäten Yale (1987), Columbia (1988) und Harvard (1990). Zu seinen beachtenswerten Bauten zählen: die Rokko-Wohnanlage (Kobe, 1983–93), die Kirche auf dem Wasser (Hokkaido, 1988), der japanische Pavillon auf der Expo '92 (Sevilla, Spanien, 1992), das Museum im Gräberwald (Kumamoto, 1992) und das Suntory Museum (Osaka, 1994), alle in Japan, sofern nicht anders vermerkt. Neuere Bauten sind u. a. das Awaji Yumebutai (Awajishima, Hyogo, Japan, 1997–2000), die Pulitzer Foundation for the Arts (St. Louis, Missouri, USA, 1997–2000) und das Modern Art Museum in Fort Worth (Texas, 1999–2002). Weitere jüngere Projekte sind das Steinskulpturenmuseum (nahe Bad Kreuznach, Deutschland, 1996–2010), das Lee-Ufan-Museum (Naoshima, Kagawa, Japan, 2007–10), das Ando-Museum (Naoshima, Kagawa, Japan, 2012–13) und das Shanghai Poly Theater (Schanghai, China, 2014).

Né à Osaka en 1941, **TADAO ANDO** *est un architecte autodidacte formé en grande partie par ses voyages aux États-Unis, en Europe et en Afrique (1962–69). Il fonde Tadao Ando Architect & Associates à Osaka en 1969. Parmi ses prix et distinctions : la médaille Alvar Aalto de l'Association finlandaise des architectes (1985) ; la médaille d'or de l'Académie d'architecture (Paris, 1989) ; le prix Carlsberg (1992) et le prix Pritzker (1995). Il a enseigné à Yale (1987), Columbia (1988) et Harvard (1990). Il a notamment réalisé : les immeubles d'appartements Rokko (Kobé, Japon, 1983–93) ; l'église sur l'eau (Hokkaido, Japon, 1988) ; le pavillon japonais de l'Expo '92 (Séville, Espagne, 1992) ; le musée de la Forêt des tombes (Kumamoto, Japon, 1992) et le musée Suntory (Osaka, Japon, 1994). Plus récemment, il a conçu le Awaji Yumebutai (Awajishima, Hyogo, Japon, 1997–2000) ; la Fondation Pulitzer pour les Arts (St. Louis, Missouri, 1997–2000) et le Musée d'art moderne de Fort Worth (Texas, 1999–2002). Ses interventions plus récentes comprennent : le musée de la Sculpture sur pierre (près de Bad Kreuznach, Allemagne, 1996–2010) ; le musée du Mémorial Shiba Ryotaro (Higashiosaka, Osaka, 1998–2001/2010) ; le musée Lee Ufan (Naoshima, Kagawa, 2007–10) ; le musée Ando (Naoshima, Kagawa, Japon, 2012–13) et et le Poly Theater de Shanghai (Chine, 2014).*

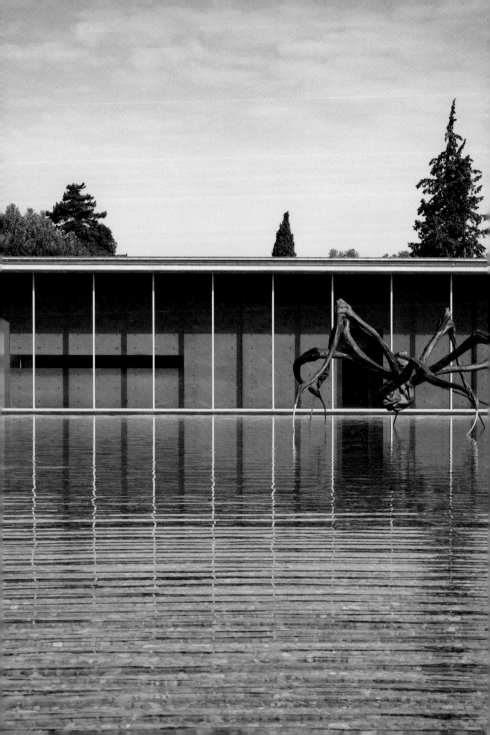

CHÂTEAU LA COSTE ART CENTER

Le Puy-Sainte-Réparade, France, 2008–11

Area: 5020 m². Client: SCEA Château la Coste.
Collaboration: Tangram Architects.

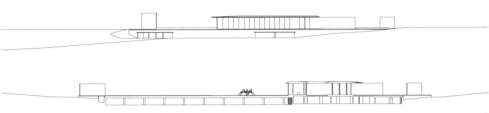

Located 15 kilometers north of Aix-en-Provence, the **CHÂTEAU LA COSTE ART CENTER** is part of an ambitious effort to convert an existing winery into a "garden museum comprised of outdoor sculptures and pavilions." Jean Nouvel and Frank O. Gehry have also participated in the project, as have a number of well-known artists such as Richard Serra, Louise Bourgeois, Sean Scully, and Hiroshi Sugimoto. The total area of the domain involved is 191 hectares. Tadao Ando states: "I conceived the master plan concept and the plans for the central art center facility, a chapel built into restored ruins, and a wooden pavilion for displaying an installation that I had also designed." The Art Center has a 4000-square-meter reflecting pool that is placed over parking facilities for 100 vehicles. As is frequently the case with Tadao Ando, most visible surfaces of the building, aside from the glazed ones, are in exposed concrete with a fluorine resin coating. Interior floors are in chiseled basalt. The actual Art Center has a triangular or wedge-shaped design and a double-layered structure of concrete and glass. It serves as a gateway for visitors, and contains a small bookshop and café spaces.

Das 15 km nördlich von Aix-en-Provence gelegene **CHÂTEAU LA COSTE ART CENTER** ist Teil eines ehrgeizigen Projekts zum Umbau einer bestehenden Weinkellerei in ein „Gartenmuseum mit Freiluftskulpturen und Pavillons". Jean Nouvel und Frank O. Gehry sind ebenfalls am Projekt beteiligt, ebenso eine Reihe bekannter Künstler wie Richard Serra, Louise Bourgeois, Sean Scully und Hiroshi Sugimoto. Die Gesamtfläche der Domäne beträgt 191 ha. Tadao Ando erklärt: „Von mir stammen das Masterplankonzept und die Pläne für das zentrale Kunstzentrum, eine Kapelle in den restaurierten Ruinen und ein hölzerner Pavillon zur Ausstellung einer ebenfalls von mir gestalteten Installation." Das Kunstzentrum hat einen 4000 m² großen Wasserspiegel, der über dem Parkhaus mit 100 Stellplätzen angelegt wurde. Wie häufig bei Tadao Ando der Fall, sind die meisten sichtbaren Flächen des Gebäudes – mit Ausnahme der verglasten Teile – aus Sichtbeton mit einer Beschichtung aus Fluorharz. Die Böden im Innenbereich sind aus geschliffenem Basalt. Der Bau des Kunstzentrums hat eine dreieckige oder keilförmige Gestalt und eine zweischichtige Struktur aus Beton und Glas. Es dient als Empfangsbereich für Besucher und enthält eine kleine Buchhandlung und ein Café.

Situé à 15 km au nord d'Aix-en-Provence, le **CHÂTEAU LA COSTE CENTRE D'ART** fait partie d'un effort ambitieux pour convertir un domaine viticole en un «jardin musée de sculptures en plein air et de pavillons». Jean Nouvel et Frank Gehry y ont également participé, avec de nombreux artistes connus dont Richard Serra, Louise Bourgeois, Sean Scully et Hiroshi Sugimoto. La surface totale du domaine est de 191 hectares. Tadao Ando explique: «J'ai dessiné le plan directeur et les plans du bâtiment central, une chapelle construite parmi des ruines restaurées, ainsi qu'un pavillon en bois pour exposer une installation que j'ai créée.» Le Centre d'art comporte un bassin réfléchissant de 4000 m², placé au-dessus du parking conçu pour 100 véhicules. Comme souvent chez Tadao Ando, la plupart des surfaces visibles du bâtiment, à l'exception de celles qui sont vitrées, sont en béton apparent revêtu d'une résine fluorée. Les sols intérieurs sont en basalte ciselé. Le Centre d'art lui-même a une forme triangulaire ou cunéiforme et présente une structure à double couche de béton et verre. Il tient lieu d'entrée pour les visiteurs et abrite une petite librairie et des espaces café.

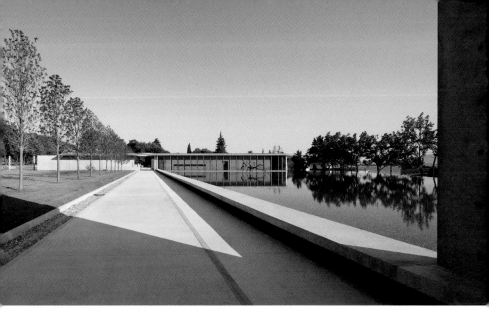

The Art Center seen from two different angles, with the large basin that covers the parking area of the complex. Left, elevation drawings show the very horizontal nature of the composition.

Das Kunstzentrum, aus zwei unterschiedlichen Blickwinkeln gesehen, mit dem großen Bassin über der Tiefgarage der Anlage. Links: Die Ansichten zeigen die betont horizontale Ausrichtung der Komposition.

Le Centre d'art vu sous deux angles différents avec son vaste bassin qui recouvre le parking du complexe. À gauche, les plans en élévation montrent le caractère fortement horizontal de l'ensemble.

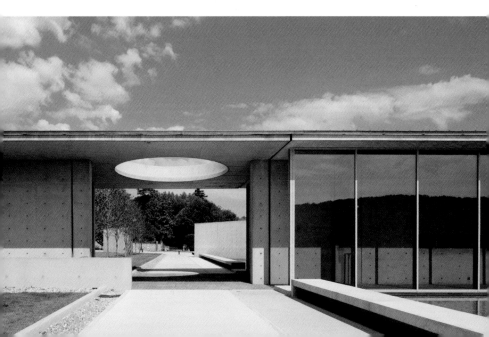

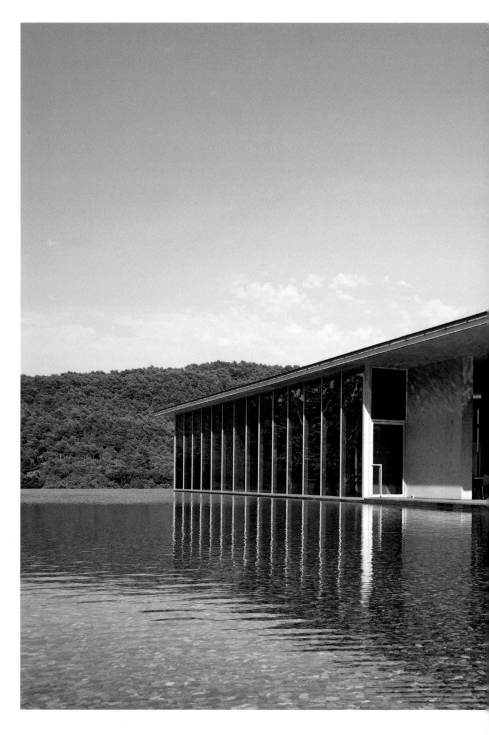

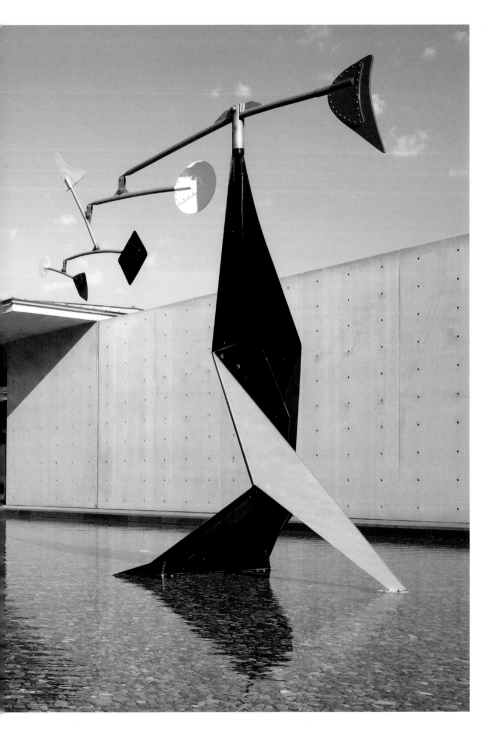

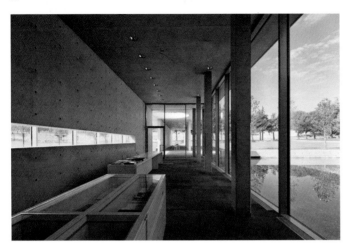

Nearly surrounded by water, the Art Center boasts a café-restaurant with tables that can be placed outdoors in warm months. On the right, a basin with a sculpture by the Japanese photographer Hiroshi Sugimoto.

Das fast ganz vom Wasser umgebene Kunstzentrum beherbergt auch ein Café-Restaurant, dessen Tische in der warmen Jahreszeit draußen aufgestellt werden können. Rechts: Ein Wasserbecken mit einer Skulptur des japanischen Fotografen Hiroshi Sugimoto.

Presque entièrement entouré d'eau, le Centre d'art est fier de son café-restaurant dont les tables peuvent être sorties pendant les mois les plus chauds. À droite, bassin avec une sculpture du photographe japonais Hiroshi Sugimoto.

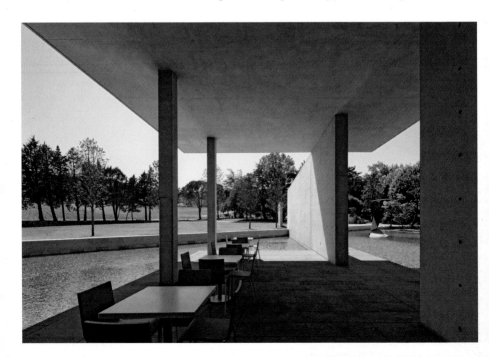

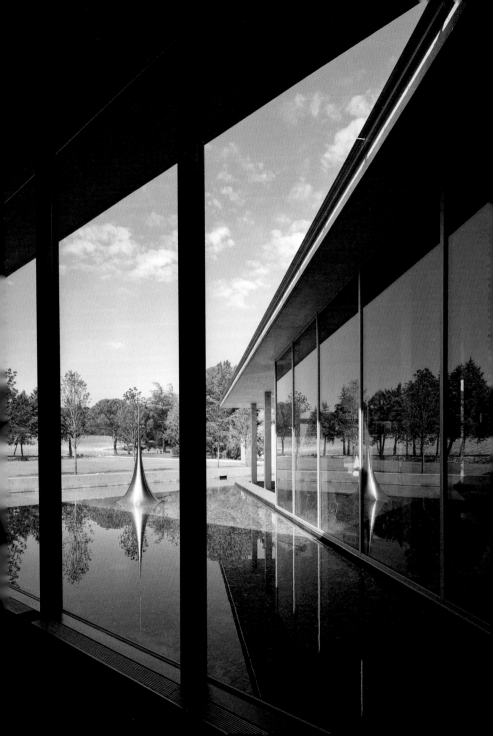

CHICHU ART MUSEUM

Naoshima, Kagawa, Japan, 2000–04

Area: 2573 m². Client: Naoshima Fukutake Art Museum Foundation.

A number of Tadao Ando's projects have involved digging into the earth. As he said in 2003: "I have an almost unconscious inclination towards underground spaces. Whatever the nature of the site, I try to create architecture that is never imposing on its environment... Working on underground space links up with the search for the origins of architecture" (see "Reflections on Underground Space," in: *L'Architecture d'Aujourd'hui*, May–June 2003). Located on a hillside just opposite Benesse House (the Naoshima Contemporary Art Museum), the **CHICHU ART MUSEUM** was intended for a small number of works of art, some of which were designed specifically for the spaces. Once within the Chichu Art Museum, visitors are invited to follow a circuitous route past strong concrete walls alternating with open courtyards in the purest style of Tadao Ando. The only view to the exterior (aside from the sky seen in the courtyards and in the artists James Turrell's installation) comes at the end of the visit in a magnificent café looking out to the Inland Sea. Ando collaborated closely with the client, the curator Yuji Akimoto, Turrell, and Walter De Maria. The result is one of the most astonishing and spiritual of Tadao Ando's works, where architecture, art, and nature truly come together.

Mehrere Projekte Tadao Andos sind teilweise in die Erde hineingegraben. 2003 bemerkte er: „Ich habe eine fast unbewusste Neigung zu unterirdischen Räumen. Wie auch immer das Grundstück aussehen mag, versuche ich Architektur zu schaffen, die nie dominanter ist als ihre Umgebung ... An unterirdischen Räumen zu arbeiten, schlägt den Bogen zurück zu den Ursprüngen der Architektur" (vgl. Reflections on Underground Space, in: „L'Architecture d'Aujourd'hui", Mai–Juni 2003). Das **KUNSTMUSEUM CHICHU** liegt auf einem Hügel unmittelbar gegenüber dem Benesse House (in dem sich das Naoshima Contemporary Art Museum befindet) und war für eine Anzahl von Kunstwerken vorgesehen, von denen einige speziell für die neuen Räume geschaffen wurden. Haben die Besucher das Kunstmuseum Chichu betreten, werden sie eingeladen, einem kreisförmigen Rundgang zu folgen, der sich an den für Tadao Ando so typischen Betonmauern und offenen Innenhöfen entlangzieht. Der einzige Blick nach draußen (abgesehen vom Himmel, der in den Innenhöfen und in der Installation von James Turrell zu sehen ist) bietet sich am Ende des Rundgangs in einem großartigen Café mit Aussicht auf die Inlandsee. Ando arbeitete eng mit dem Auftraggeber, dem Kurator Yuji Akimoto, mit Turrell und Walter De Maria zusammen. Das Ergebnis ist eines der erstaunlichsten und spirituellsten Werke Andos, in dem Architektur, Kunst und Natur wahrhaft zueinander finden.

Un certain nombre de projets de Tadao Ando ont déjà impliqué le creusement du sol et l'enfouissement. Comme il déclarait en 2003 : « J'ai un penchant presque inconscient pour les espaces souterrains. Quelle que soit la nature du site, j'essaie de créer une architecture qui ne s'impose jamais dans son environnement... Travailler sur un espace souterrain est lié à la recherche des origines de l'architecture » (cf. « Reflections on Underground Space », dans *L'Architecture d'Aujourd'hui*, mai–juin 2003). Situé à flanc de colline, juste en face de la maison Benesse (Musée d'art contemporain de Naoshima), le **MUSÉE D'ART CHICHU** a été conçu pour ne présenter qu'un nombre d'œuvres réduit dont certaines ont été spécialement réalisées pour ses salles. Une fois entrés dans le musée, les visiteurs sont invités à suivre un parcours qui se déroule entre de puissants murs de béton alternant avec des cours ouvertes du plus pur style Ando. La seule vue sur l'extérieur (en dehors du ciel visible des cours et de l'installation de James Turrell) est un panorama sur la mer Intérieure que l'on admire du magnifique café situé en fin de visite. Ando a étroitement collaboré avec le commissaire, Yuji Akimoto, Turrell et Walter De Maria. C'est l'une de ses réalisations les plus étonnantes et plus empreintes de spiritualité : l'architecture fusionne ici avec l'art et la nature.

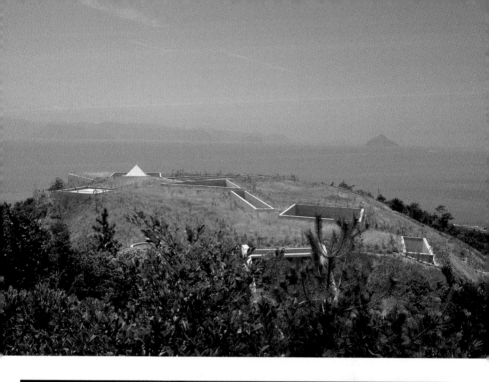

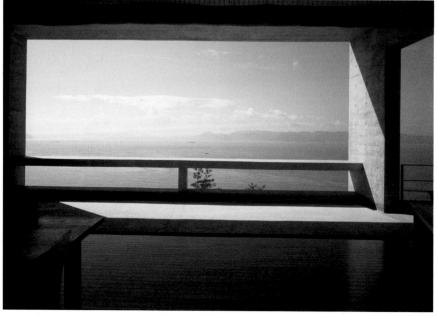

66

The plan of the museum shows
its skewed, yet geometric lines.
Open courtyards allow for light
and air to penetrate the entrance
sequence (below).

Le plan du musée est géométri-
quement articulé en oblique. Les
cours ouvertes laissent pénétrer
l'air et la lumière dans la séquence
de l'entrée (ci-dessous).

Anhand des Grundrisses wird die
schiefe und doch geometrische
Linienführung des Museums deut-
lich. Offene Innenhöfe lassen Licht
und Luft in den Eingangsbereich
hinein (unten).

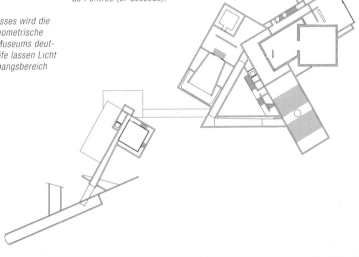

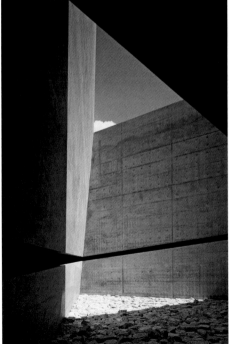
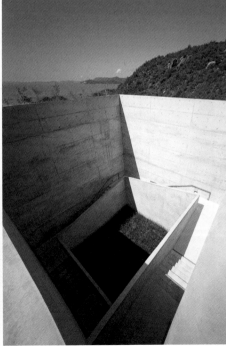

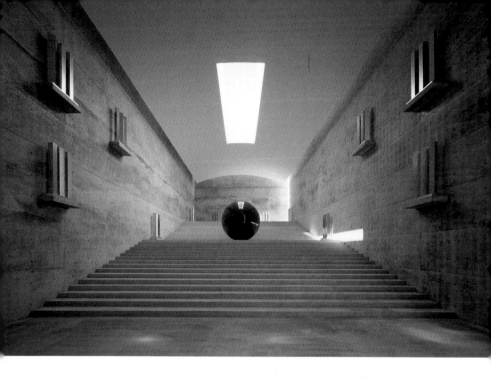

Above, the space designed in col-
laboration between the architect, the
artist, and the curator houses Walter
De Maria's Time/Timeless/No Time.
Right, a plan showing the museum
with the outline of former salt pans
leading down the hill to the sea.

Der Raum (oben) wurde in enger
Zusammenarbeit von Architekt,
Künstler und Kurator gestaltet
und präsentiert Walter De Marias
Installation „Time/Timeless/No
Time". Rechts ein Grundriss, der
das Museum und den Verlauf alter
Salzpfannen den Hügel hinunter
bis zur See zeigt.

Ci-dessus, un espace conçu en
collaboration entre l'architecte,
l'artiste et le commissaire du musée
accueille Time/Timeless/No Time,
œuvre de Walter De Maria. À droite,
un plan montre le musée et les
contours d'anciens marais salants
descendant de la colline vers la mer.

CHIAKI ARAI

CHIAKI ARAI was born in 1948 in Shimane, Japan. He received his B.Arch from Tokyo City University (1971) and his M.Arch degree from the University of Pennsylvania (1972). In 1974 he worked in the office of Louis Kahn, and created his own firm in Tokyo in 1980. He is a Professor at Tokyo City University and has lectured at the University of Pennsylvania (1998). Recent work of his firm includes the Tonami Village Museum Information Center (Toyama, 2006); Ofunato Civic Culture Center and Library (Ofunato, Iwate, 2009); Karakida Community Center (Tokyo, 2010); Yurihonjo City Cultural Center, Kadare (Yurihonjo, Akita, 2008–11); Niigata City Konan Ward Cultural Center (Konan-ku, Niigata, 2010–12, published here); Mihama Culture Center (Mihama-cho, Fukui, 2012); Hachijo-jima Government Office Building and Civic Hall (Tokyo, 2013); and the Niitsu Culture Hall (Akiha-ku, Niigata, 2013), all in Japan.

CHIAKI ARAI wurde 1948 in Shimane, Japan, geboren. Seinen B.Arch. machte er an der Universität von Tokio (1971) und seinen M.Arch. an der University of Pennsylvania (1972). 1974 arbeitete er im Büro von Louis Kahn und gründete 1980 seine eigene Firma in Tokio. Er ist Professor an der Universität von Tokio und hat auch an der University of Pennsylvania gelehrt (1998). Zu den neueren Bauten seines Büros zählen: das Informationszentrum des Tonami Village Museum (Toyama, 2006), das Kulturzentrum und die Bibliothek in Ofunato (Ofunato, Iwate, 2009), das Gemeindezentrum Karakida (Tokio, 2010), das Kulturzentrum der Stadt Yurihonjo, Kadare (Yurihonjo, Akita, 2008–11), das Kulturzentrum Niigata City Konan Ward (Konan-ku, Niigata, 2010–12, hier vorgestellt), das Kulturzentrum Mihama (Mihama-cho, Fukui, 2012), das Regierungsgebäude und die Stadthalle Hachijo-jima (Tokio, 2013) und die Kulturhalle Niitsu (Akiha-ku, Niigata, 2013), alle in Japan.

CHIAKI ARAI est né en 1948 à Shimane, au Japon. Il est titulaire d'un B.Arch. de l'université de Tokyo (1971) et d'un M.Arch. de l'université de Pennsylvanie (1972). Il a travaillé dans l'agence de Louis Kahn (1974) avant de créer la sienne à Tokyo en 1980. Il est professeur à l'université de Tokyo et a également donné des cours à l'université de Pennsylvanie (1998). Ses réalisations récentes comprennent le Centre d'information du musée villageois de Tonami (Toyama, 2006) ; le Centre culturel et bibliothèque municipaux d'Ofunato (Iwate, 2009) ; le Centre communautaire de Karakida (Tokyo, 2010) ; le Centre culturel de Yurihonjo (Yurihonjo, Akita, 2008–11) ; le Centre culturel Konan Ward de Niigata (Konan-ku, Niigata, 2010–12, publié ici) ; le Centre culturel de Mihama (Mihama-cho, Fukui, 2012) ; la salle municipale et le siège du gouvernement Hachijo-jima (Tokyo, 2013) et la salle culturelle Niitsu (Akiha-ku, Niigata, 2013), toutes au Japon.

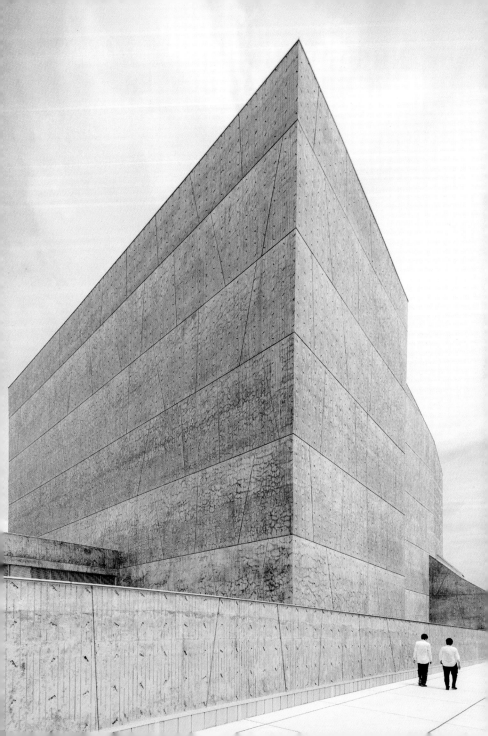

NIIGATA CITY KONAN WARD CULTURAL CENTER

Konan-ku, Niigata, Japan, 2010–12

Area: 5000 m². Client: Niigata City.
Collaboration: Ryoichi Yoshizaki, Miroku Arai, Chiaki Hamamatsu, Yoshihiko Murase.

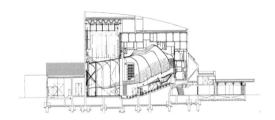

The **NIIGATA CITY KONAN WARD CULTURAL CENTER** contains a multipurpose theater, library, local museum, and community center, and seeks to emphasize the merit of combining four different programs. Each of the four zones is connected by a circulation corridor called "Cross Street." The elaborate and uneven walls are used to distribute air-conditioning ducts and lighting. Sliding walls allow adjoining spaces to be combined or separated as required. The architect explains that "individual rooms, such as a music practice room, are organized as vertically nested structures, and the gap between the nested structure and the skylights on the roof fills up Cross Street with soft light. It is not a consistent, but an inconsistent space." The multipurpose theater seating 407 people is dotted with 700 circles that provide light and acoustic control of the space. The architects designed a movable acoustic reflector for the stage that allows for the stage to have an added three meters of depth. They describe the yellow-green, brown, and orange color scheme of the theater as having been inspired by rice plants.

Der **NIIGATA CITY KONAN WARD CULTURAL CENTER** enthält ein Mehrzwecktheater, eine Bibliothek, ein lo-kales Museum sowie ein Gemeindezentrum und soll die Vorzüge einer Verbindung von vier verschiedenen Funktionen bestätigen. Alle vier Bereiche sind durch einen Erschließungskorridor miteinander verbunden, der als „Cross Street" bezeichnet wird. Die sorgfältig ausgeführten, unebenen Wände dienen auch zur Aufnahme der Lüftungskanäle und der Beleuchtungskörper. Durch Schiebewände lassen sich benachbarte Räume nach Bedarf verbinden oder abtrennen. Der Architekt erläutert, dass „einzelne Räume, etwa der Übungsraum für Musiker, wie vertikal verschachtelte Strukturen angelegt sind und die Lücke zwischen der verschachtelten Struktur und den Oberlichtern im Dach die Cross Street mit mildem Licht erfüllt. Es ist kein einheitlicher, sondern ein inkonsistenter Bereich." Das Mehrzwecktheater hat 407 Plät-ze und ist mit 700 Kreisöffnungen versehen, die zur Belichtung dienen und die Akustik kontrollieren. Die Architekten planten einen beweglichen akustischen Reflektor für die Bühne, durch den diese zusätzliche 3 m an Tiefe gewinnt. Sie geben an, dass die Farbpalette des Theaters in Gelbgrün, Braun und Orange von Reispflanzen inspiriert worden sei.

Le **NIIGATA CITY KONAN WARD CULTURAL CENTER** comprend un théâtre à usage multiple, une bibliothèque, le musée local et un centre communautaire, il cherche à souligner les mérites d'associer quatre programmes différents. Chacune des quatre zones est reliée par un couloir appelé « Cross Street ». Les murs inégaux et complexes servent aussi à la circulation des conduites d'air conditionné et à l'éclairage. Des parois coulissantes permettent d'associer ou de séparer au besoin des espaces adjacents. L'architecte explique que « les pièces individuelles, notamment les salles de musique, forment des structures gigognes verticalement, tandis que l'espace entre elles et les lucarnes percées dans le toit baignent Cross Street d'une lumière douce. Ce n'est pas un espace cohérent, plutôt un espace inconstant ». Le théâtre de 407 places est marqué de 700 petits cercles qui fournissent l'éclairage et assurent l'acoustique. Les architectes ont par ailleurs conçu un réflecteur acoustique mobile pour la scène qui lui ajoute 3 m de profondeur. La gamme jaune vert, marron et orange du théâtre leur a été inspirée par les plants de riz.

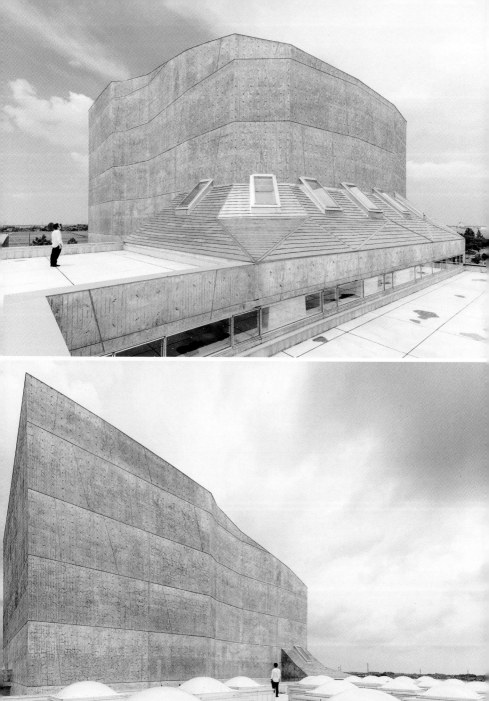

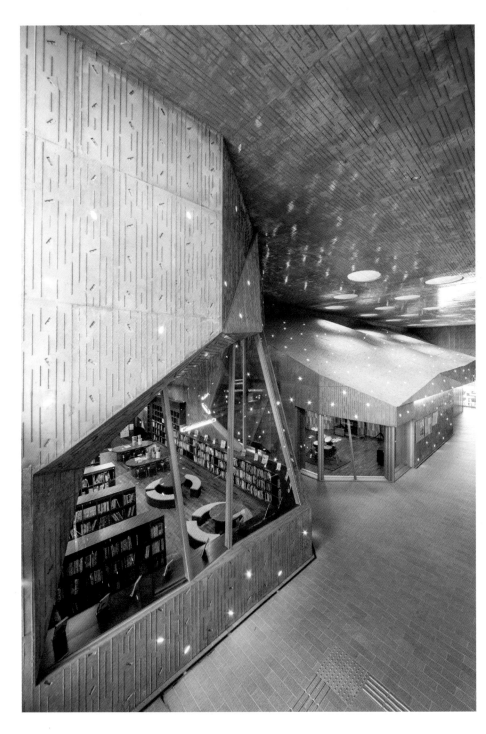

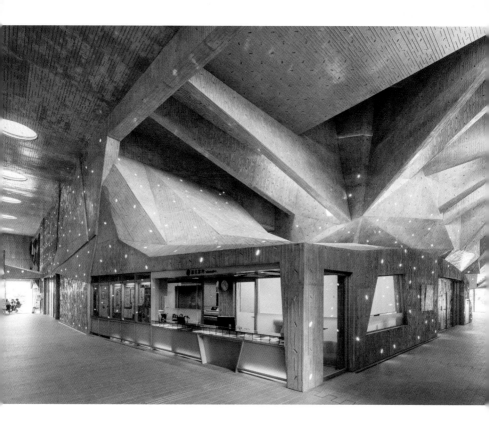

The unexpected forms and lighting of the interior are difficult to classify in the context of contemporary architecture, which is to say that they are quite original.

Die überraschenden Formen und die Lichtführung im Inneren sind schwer in den Zusammenhang der zeitgenössischen Architektur einzuordnen; sie sind sehr originell.

Les formes et l'éclairage inattendus de l'intérieur sont difficiles à classifier dans le contexte de l'architecture contemporaine, ce qui témoigne de leur originalité.

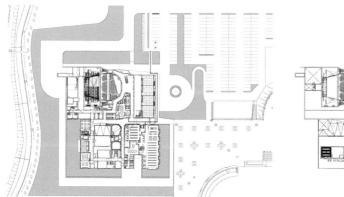

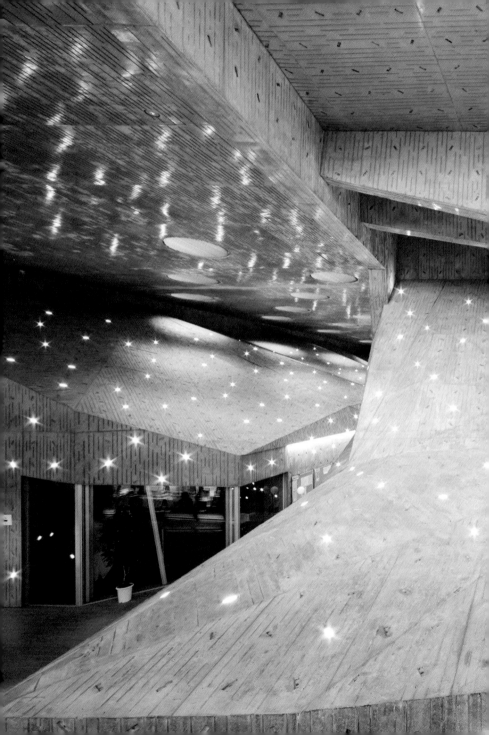

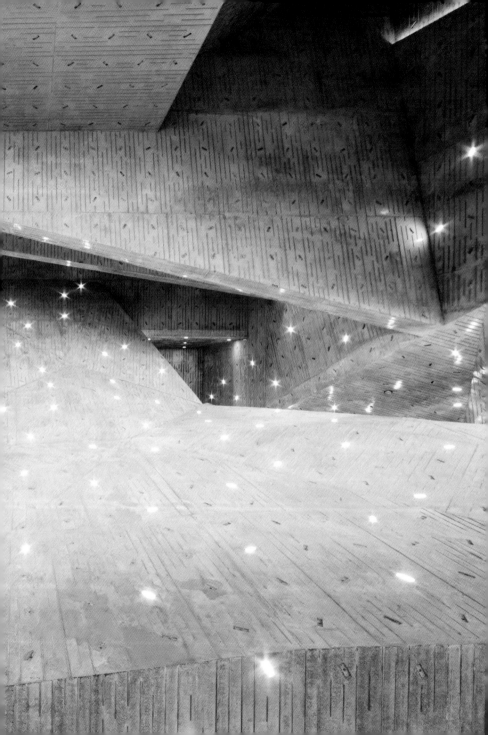

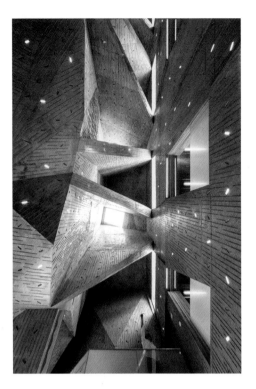

What appears to be a jumble of
angled forms is in fact a highly
sophisticated use of concrete as well
as architectural form. A library space
is surrounded by angled forms yet
has a simple, "clean" plan.

Was hier wie ein Wirrwarr aus ecki-
gen Formen erscheint, ist tatsächlich
eine höchst ausgeklügelte Nutzung
von Beton zur architektonischen
Formgestaltung. Der Bibliotheks-
bereich ist von verwinkelten Formen
umgeben und hat doch einen
„klaren" Grundriss.

Ce qui donne l'impression d'un
fouillis de formes anguleuses est en
réalité une utilisation extrêmement
raffinée du béton et une forme
architecturale en soi. L'espace
bibliothèque est entouré de formes
anguleuses, mais son plan est
simple et « net ».

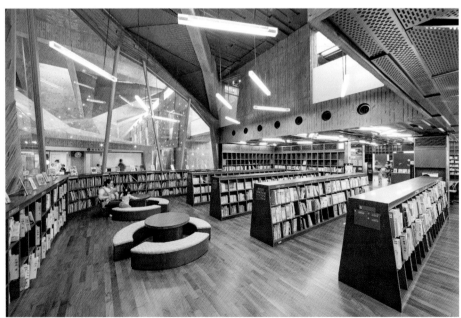

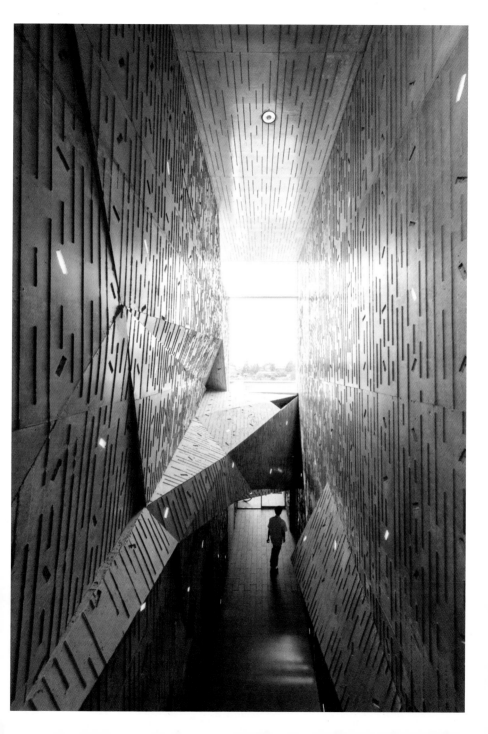

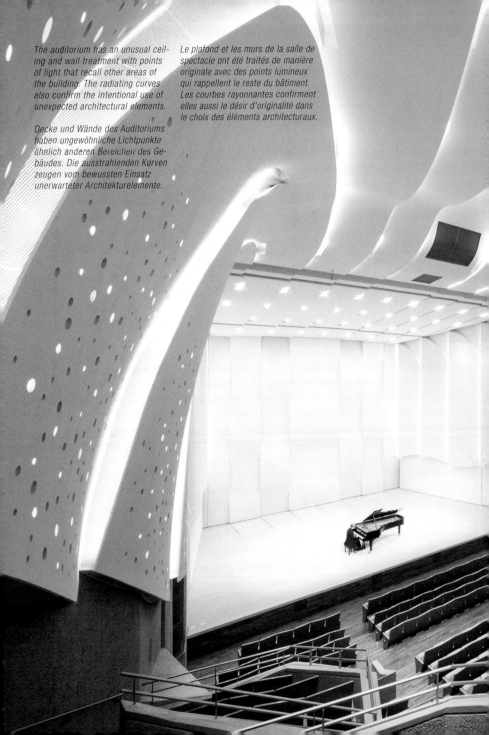

The auditorium has an unusual ceiling and wall treatment with points of light that recall other areas of the building. The radiating curves also confirm the intentional use of unexpected architectural elements.

Decke und Wände des Auditoriums haben ungewöhnliche Lichtpunkte ähnlich anderen Bereichen des Gebäudes. Die ausstrahlenden Kurven zeugen vom bewussten Einsatz unerwarteter Architekturelemente.

Le plafond et les murs de la salle de spectacle ont été traités de manière originale avec des points lumineux qui rappellent le reste du bâtiment. Les courbes rayonnantes confirment elles aussi le désir d'originalité dans le choix des éléments architecturaux.

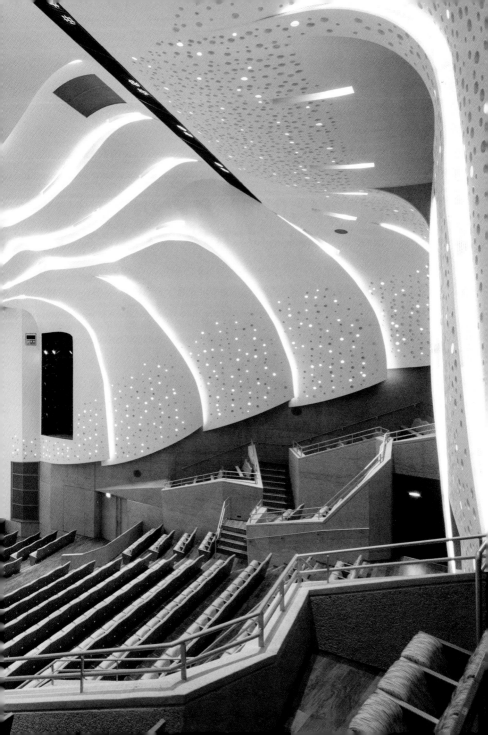

ALEJANDRO ARAVENA / ELEMENTAL

ALEJANDRO ARAVENA graduated as an architect from the Universidad Católica de Chile (UC) in 1992. Born in 1967, he studied history and theory at the IUAV University in Venice (Italy, 1992–93). He created Alejandro Aravena Arquitectos in 1994. Between 2009 and 2015 he was a member of the Pritzker Prize Jury; in 2010 he was named International Fellow of RIBA; and in 2016 he won the Pritzker Prize. Since 2006 he has been Executive Director of ELEMENTAL, a group of architects that today includes Alejandro Aravena, **GONZALO ARTEAGA** (born in 1977), **JUAN IGNACIO CERDA** (born in 1980), **DIEGO TORRES** (born in 1979), and **VÍCTOR ODDÓ** (born in 1975). With ELEMENTAL he designed the Quinta Monroy Social Housing (Iquique, 2003–04); Metropolitan Promenade and Children's Park for the Chilean Bicentennial (Santiago, Chile, 2010–12); the Anacleto Angelini Innovation Center at UC (Santiago, Chile, 2012–13, published here); a building for Novartis in Shanghai (China, 2010–14); the reconstruction of the city of Constitución (Chile, 2010–15); the Linear Park in Calama's Copper Mining Town (Chile, 2012–18); and the Teheran Stock Exchange (Iran, 2012–).

ALEJANDRO ARAVENA geboren 1967, beendete 1992 sein Architekturstudium an der Universidad Católica de Chile (UC). Danach studierte er Geschichte und Theorie an der Universität IUAV in Venedig (1992–93). 1994 gründete er das Büro Alejandro Aravena Arquitectos. Von 2009 bis 2015 war er Mitglied der Jury für den Pritzker-Preis; 2010 wurde er zum International Fellow des Royal Institute of British Architects (RIBA) ernannt, und 2016 gewann er selbst den Pritzker-Preis. Seit 2006 ist er Geschäftsführer von ELEMENTAL, einem Architektenteam, zu dem aktuell Alejandro Aravena, **GONZALO ARTEAGA** (geboren 1977), **JUAN IGNACIO CERDA** (geboren 1980), **DIEGO TORRES** (geboren 1979) und **VÍCTOR ODDÓ** (geboren 1975) gehören. Mit ELEMENTAL plante er die Sozialwohnungen Quinta Monroy (Iquique, Chile, 2003–04), den Paseo Metropolitano und den Parque Bicentenario de la Infancia (Santiago, Chile, 2010–12), das Centro de Innovación Anacleto Angelini an der UC (Santiago, Chile, 2012–13, hier vorgestellt), ein Gebäude für die Firma Novartis in Schanghai (China, 2010–14), den Wiederaufbau der Stadt Constitución (Chile, 2010–15), den Parque Periurbano der Kupferminenstadt Calama (Chile, 2012–18) und die Börse in Teheran (Iran, seit 2012).

ALEJANDRO ARAVENA est diplômé en architecture de l'Universidad Católica de Chile (UC) (1992). Né en 1967, il a étudié l'histoire et la théorie à l'université IUAV de Venise (1992–93). Il a créé Alejandro Aravena Arquitectos en 1994. Il a été membre du jury du prix Pritzker de 2009 à 2015 et a été nommé International Fellow du RIBA en 2010. Il a gagné le prix Pritzker en 2016. Depuis 2006, il dirige ELEMENTAL, un groupe d'architectes composé d'Alejandro Aravena, **GONZALO ARTEAGA** (né en 1977), **JUAN IGNACIO CERDA** (né en 1980), **DIEGO TORRES** (né en 1979) et **VÍCTOR ODDÓ** (né en 1975). Il a conçu avec ELEMENTAL les logements sociaux de Quinta Monroy (Iquique, 2003–04) ; la Promenade métropolitaine et le parc de jeux conçus pour le bicentenaire du Chili (Santiago, Chili, 2010–12) ; le Centre de l'innovation Anacleto Angelini pour l'UC (Santiago, Chili, 2012–13, publiée ici) ; un bâtiment pour Novartis à Shanghai (2010–14) ; la reconstruction de Constitución (Chili, 2010–15) ; le Parque Periurbano de la ville aux mines de cuivre de Calama (Chili, 2012–18) et la Bourse de Téhéran (Iran, 2012–).

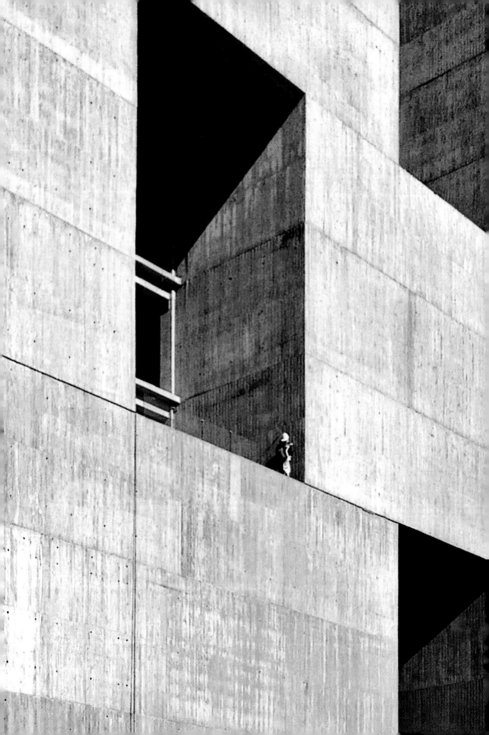

UC INNOVATION CENTER—ANACLETO ANGELINI

Santiago, Chile, 2012–13

Area: 8176 m². Client: Grupo Angelini and Pontificia Universidad Católica de Chile.
Cost: $18 million. Collaboration: Samuel Gonçalves, Cristián Irarrázaval, Álvaro Ascoz.

The architects explain: "We proposed a rather opaque construction toward the outside, which is also efficient for Santiago's weather with higher energy demands in summer compared to winter, that is, more expensive to cool than to heat; and then, a very permeable architecture inside with a central atrium that visually connects the floors and fills the space with natural light. Having the structure and the shafts on the perimeter of the building reverts the typical curtain-wall building layout and concentrates openings in very specific points in the form of elevated squares." The architects have sought to avoid a "greenhouse effect" with this building at the same time as they have used cutting-edge technology to protect the structure against strong local seismic forces. A vertical atrium allows users to have a sense of the rest of the **UC INNOVATION CENTER**. The architects state: "Finally, we thought an innovation center should avoid being trendy. Furthermore, austerity in the architectural language was desirable for a center aimed to create new businesses. The monolithic character, both timeless and austere, led us to choose concrete because it is simultaneously the structure and the finishing of the building. This kind of liquid stone ages well and matches naturally what we decided had to be the compositional principle of the complex: weight."

Die Architekten erläutern: „Wir schlugen ein nach außen recht undurchlässiges, für Santiagos Klimaverhältnisse auch energieeffizientes Gebäude vor, das im Sommer höheren Energiebedarf hat als im Winter, das heißt, die Kühlung ist aufwendiger als die Heizung. Innen ist die Architektur sehr durchlässig mit einem zentralen Atrium, das die Geschosse optisch miteinander verbindet und den Raum mit natürlichem Licht erfüllt. Wegen des außen angebrachten Tragwerks und der Schächte verändert sich die für Bauten mit Vorhangfassade typische Anordnung, die Öffnungen konzentrieren sich an bestimmten Stellen in Form hoher Rechtecke." Die Planer haben bei diesem Gebäude einen „Treibhauseffekt" vermieden und zugleich modernste Technologie dazu genutzt, es gegen die starken Erdbeben in diesem Gebiet zu sichern. Das vertikale Atrium bietet den Nutzern einen Eindruck vom gesamten **UC INNOVATION CENTER**. „Und schließlich meinten wir," so die Architekten, „ein Innovationszentrum sollte es vermeiden, aktuellen Trends zu folgen. Außerdem war eine nüchterne Architektursprache für ein Zentrum geboten, das neue Geschäftsbereiche erschließen soll. Der monolithische, sowohl zeitlose als auch strenge Charakter bestimmte unsere Entscheidung für Beton, weil er Tragwerk und Außenfläche des Bauwerks zugleich bildet. Diese Form flüssigen Steins altert gut und passt genau zu dem von uns gewählten Entwurfsprinzip für diesen Bau: Schwere."

Les architectes expliquent : « Nous avons choisi une construction plutôt opaque vers l'extérieur pour une bonne efficacité sous le climat de Santiago, avec des besoins énergétiques plus élevés en été qu'en hiver, et donc plus chère à refroidir qu'à chauffer, et une architecture très perméable à l'intérieur avec un atrium central qui raccorde visuellement les différents niveaux et emplit l'espace de lumière naturelle. Le fait d'avoir placé la structure porteuse et les trémies sur le périmètre du bâtiment permet d'inverser le schéma typique à mur-rideau et de concentrer les ouvertures en des points très spécifiques des cubes surélevés. » Ils ont cherché à éviter l'« effet de serre », tout en ayant recours à des technologies de pointe pour protéger l'ensemble des puissantes forces sismiques locales. L'atrium vertical donne aux utilisateurs une vision et une perception du reste du **CENTRE D' INNOVATION UC**. Les architectes déclarent : « Enfin, nous avons pensé qu'un centre dédié à l'innovation ne se devait pas de suivre les tendances du moment. De plus, l'austérité était de mise pour l'architecture d'un établissement destiné à créer de nouvelles entreprises. Le caractère monolithique, à la fois intemporel et austère, nous a fait opter pour le béton qui fournit la structure et les finitions du bâtiment. Cette forme de pierre liquide vieillit bien et se marie naturellement à l'élément que nous avions choisi pour former le principe de la composition : le poids. »

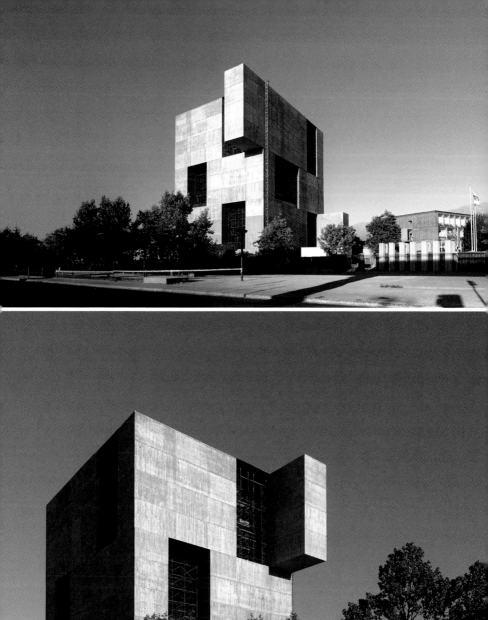
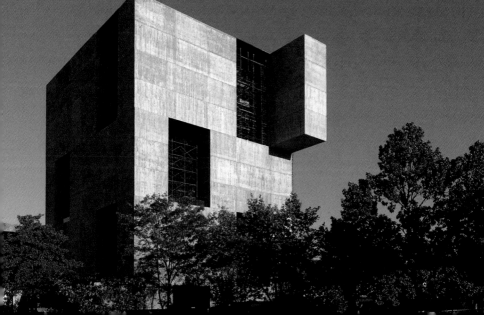

The plans display a puzzle-like arrangement of rectangular or square forms, recalling the block-like assemblage of the exterior of the building. Below, in an internal courtyard, wood, glass, and steel alternate in this image taken at the end of construction.

Die Grundrisse zeigen eine ver-winkelte Anordnung rechteckiger oder quadratischer Formen, die der blockhaften Zusammenfügung der äußeren Gestalt des Gebäudes entsprechen. Unten: Diese Aufnahme eines Innenhofs kurz vor Fertig-stellung zeigt den Wechsel von Holz, Glas und Stahl.

Les plans affichent la disposition de type puzzle des formes rectan-gulaires ou carrées qui rappellent les blocs assemblés de l'extérieur. Ci-dessous, une cour intérieure photographiée à la fin de la construction où alternent le bois, le verre et l'acier.

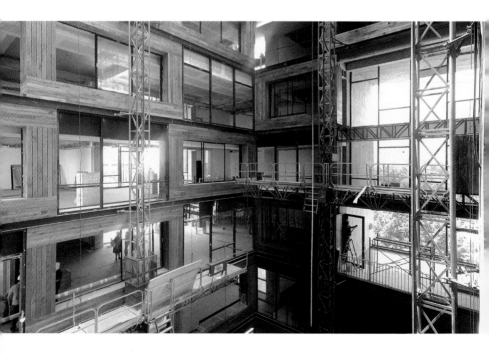

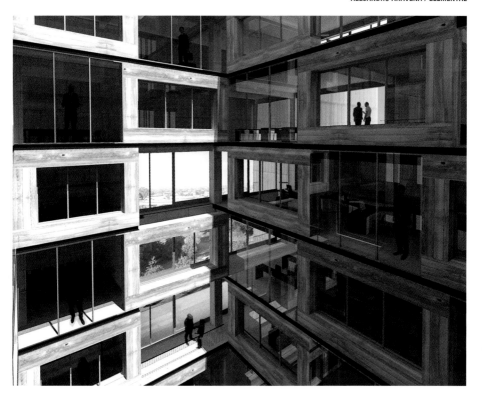

ARCHEA

Archea was founded in Florence, Italy, in 1988 by **LAURA ANDREINI** (born in Florence in 1964), **MARCO CASAMONTI** (born in Florence in 1965), and **GIOVANNI POLAZZI** (also born in Florence, in 1959). Since 1997, Marco Casamonti has been the Editor in Chief of the international architecture magazine *Area*, and, since 1999, he has been coeditor with Paolo Portoghesi of the magazine *Materia*, both of which are published by the Sole 24 ORE group. Archea now includes 100 architects, who work in offices in Florence, Milan, Rome, Beijing, São Paulo, and Dubai. The founding partners were joined in 1999 by **SILVIA FABI**, who coordinates the design activities of Studio Archea in Florence. Work by the firm includes a Municipal Library (Nembro, Italy, 2007); the Albatros Camping Ground (San Vincenzo, Livorno, 2007); Edison Library (Livorno, 2008); new Town Hall (Merate, Lecco, 2009); Municipal Library and Auditorium (Curno, Bergamo, 2009); B3 Pavilion, Urban Best Practices Area, Universal Exhibition (Shanghai, China, 2010); Green Energy Laboratory (Shanghai, China, 2012); and the Antinori Winery (San Casciano Val di Pesa, Florence, 2007–12, published here) and the CDD Center for Disabilities (Seregno, 2009–13), all in Italy unless stated otherwise.

Archea wurde 1988 in Florenz von **LAURA ANDREINI** (geboren 1964 in Florenz), **MARCO CASAMONTI** (geboren 1965 in Florenz) und **GIOVANNI POLAZZI** (geboren 1959 ebenfalls in Florenz) gegründet. Marco Casamonti ist seit 1997 Chefredakteur der internationalen Architekturzeitschrift „Area" und seit 1999 mit Paolo Portoghesi Herausgeber der Zeitschrift „Materia", die beide von der Gruppe Sole 24 ORE publiziert werden. Zu Archea gehören inzwischen 100 Architekten, die in Büros in Florenz, Mailand, Rom, Peking, São Paulo und Dubai arbeiten. Zu den Gründungspartnern gesellte sich 1999 **SILVIA FABI**, die die Planungstätigkeit des Studio Archea in Florenz koordiniert. Zu den ausgeführten Bauten des Büros zählen: eine Stadtbücherei (Nembro, 2007), die Campinganlage Albatros (San Vincenzo, Livorno, 2007), die Bibliothek Edison (Livorno, 2008), ein neues Rathaus (Merate, Lecco, 2009), eine Stadtbücherei mit Auditorium (Curno, Bergamo, 2009), der Pavillon B32, Urban Best Practices Area an der Weltausstellung (Schanghai, China, 2010), das Green Energy Laboratory (Schanghai, 2012), die Weinkellerei Antinori (San Casciano, Val di Pesa, Florenz, 2007–12, hier vorgestellt) und das CDD-Behindertenzentrum (Seregno, 2009–13), alle in Italien, sofern nicht anders angegeben.

Archea a été fondé à Florence en 1988 par **LAURA ANDREINI** (née à Florence en 1964), **MARCO CASAMONTI** (né à Florence en 1965) et **GIOVANNI POLAZZI** (né à Florence en 1959). Marco Casamonti est le rédacteur en chef depuis 1997 de la revue internationale d'architecture *Area* et corédacteur avec Paolo Portoghesi depuis 1999 du magazine *Materia*, tous deux édités par le groupe Sole 24 ORE. Archea emploie aujourd'hui 100 architectes dans des agences à Florence, Milan, Rome, Pékin, São Paulo et Dubaï. **SILVIA FABI** a rejoint les partenaires fondateurs en 1999 et coordonne les activités de design du Studio Archea de Florence. Leurs réalisations comprennent une bibliothèque municipale (Nembro, 2007) ; le terrain de camping Albatros (San Vincenzo, Livourne, 2007) ; la bibliothèque Edison (Livourne, 2008) ; le nouvel hôtel de ville (Merate, Lecco, 2009) ; la bibliothèque municipale et auditorium (Curno, Bergame, 2009) ; le pavillon B32, Zone des meilleures pratiques urbaines, Exposition universelle (Shanghai, Chine, 2010) ; le laboratoire des énergies vertes (Shanghai, Chine, 2012) ; le domaine viticole Antinori (San Casciano Val di Pesa, Florence, 2007–12, publiée ici) et le Centre pour handicapés CDD (Seregno, 2009–13), toutes en Chine sauf si spécifié.

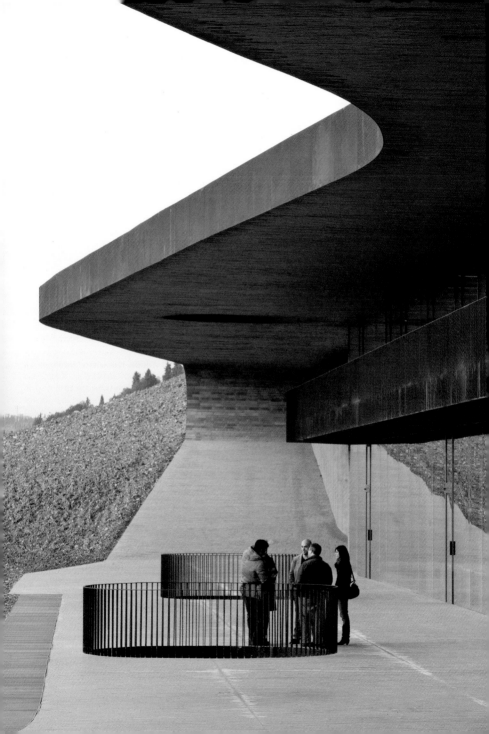

ANTINORI WINERY

Bargino, San Casciano Val di Pesa, Florence, Italy, 2007–12

Area: 39 700 m². Client: Marchesi Antinori.

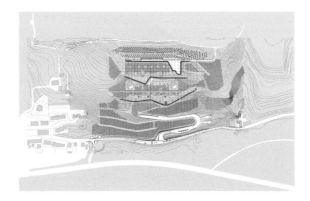

Set in the Chianti area halfway between Florence and Siena, the **ANTINORI WINERY** is an attempt to express the symbiosis between culture, work, and the natural environment. "The purpose of the project," state the architects, "was to merge the building and the rural landscape; the industrial complex appears to be a part of the latter thanks to the roof, which has been turned into a plot of farmland cultivated with vines, interrupted along the contour lines by two horizontal cuts which let light into the interior and provide those inside the building with a view of the landscape…" A good part of the interior is thus below grade, with the section revealing that the building descends, like the grapes, from the point of arrival to an underground barrel vault area for fermentation. The complex includes a restaurant, auditorium, museum, library, wine-tasting areas, and a sales outlet.

Die in der Chianti-Region auf halber Strecke zwischen Florenz und Siena gelegene **WEINKELLEREI ANTINORI** ist ein Versuch, die Symbiose zwischen Kultur, Arbeit und natürlicher Umwelt auszudrücken. „Das Ziel dieses Projekts", erklären die Architekten, „ist die Einbettung des Gebäudes in die ländliche Umgebung; der industrielle Komplex wirkt wie ein Teil derselben durch das Dach, das zu einem mit Reben bepflanzten Stück Ackerland wird. Am Rand ist das Dach durch zwei horizontale Ausschnitte unterbrochen, die Licht in das Innere einlassen und von dort einen Blick in die Landschaft gewähren …" Ein großer Teil der Innenräume liegt unter Geländehöhe; der Schnitt zeigt, dass das Gebäude – wie auch die Weinstöcke – den Hang hinabführt, vom Ort der Ankunft bis zum unterirdischen Gewölbe mit den Fässern zur Gärung. Die Anlage umfasst auch ein Restaurant, ein Auditorium, ein Museum, eine Bibliothek, Verkostungsräume und einen Verkaufsbereich.

Situé dans la région de Chianti, à mi-chemin entre Florence et Sienne, le **DOMAINE VITICOLE ANTINORI** représente une tentative d'exprimer la symbiose qui règne entre culture, travail et environnement naturel. Selon les architectes, « l'objectif était de faire fusionner le bâtiment et le paysage rural ; le complexe industriel semble faire partie de ce dernier grâce à son toit qui a été conçu comme une parcelle de terre agricole plantée de vignes et interrompue sur le pourtour par deux découpures horizontales qui y font entrer la lumière et offrent une vue du paysage aux personnes à l'intérieur… » Le bâtiment est construit en grande partie en dessous du niveau du sol, la vue en coupe montrant son mouvement descendant qui correspond à celui du raisin, du point d'arrivée à une salle souterraine à voûte en berceau destinée à la fermentation du vin. Le complexe comporte un restaurant, un auditorium, un musée, une bibliothèque, des espaces de dégustation et un point de vente.

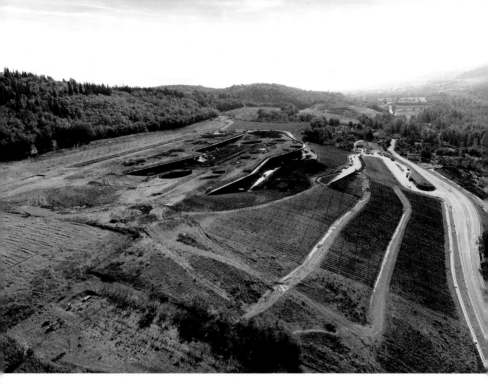

Fitting into its natural hillside site almost like an archaic object, the building is full of openings and curves as the pictures on this page demonstrate. Left, a site plan.

Das Gebäude fügt sich, fast wie ein archaisches Objekt, in das natürliche Hügelland ein. Wie die Abbildungen auf dieser Seite zeigen, ist es reich an Öffnungen und Krümmungen. Links ein Lageplan.

Encastré dans le site naturel de collines tel un objet archaïque, le bâtiment abonde en courbes et ouvertures. À gauche, un plan de situation.

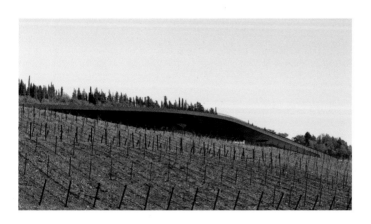

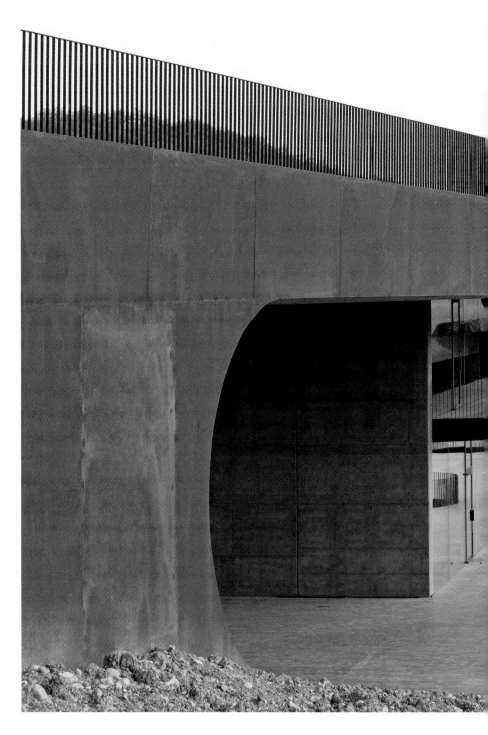

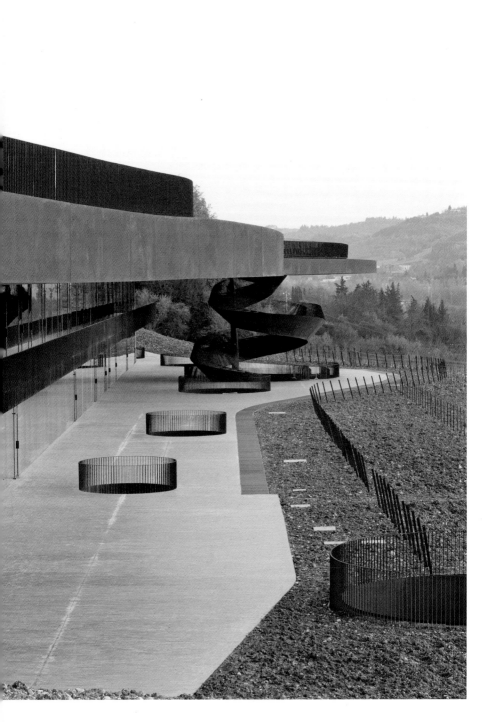

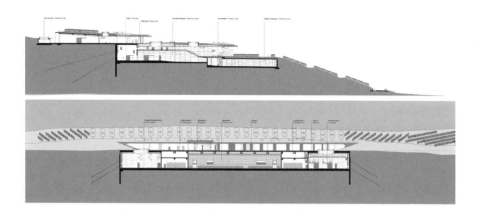

Section drawings show the insertion of the structure into its hillside site. Two images place an emphasis on the large round openings with which the architects have punctuated otherwise opaque surfaces and volumes.

An den Schnitten ist die Einfügung in das hügelige Gelände ablesbar. Die beiden Fotos konzentrieren sich auf die großen, runden Öffnungen, mit denen die Architekten die ansonsten geschlossenen Flächen und Volumen durchbrochen haben.

Les plans en coupe montrent comment la structure est intégrée à la colline. Deux photos mettent en avant les larges ouvertures rondes dont les architectes ont ponctué des surfaces et volumes sinon opaques.

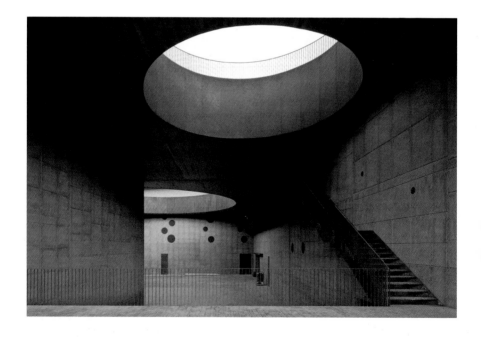

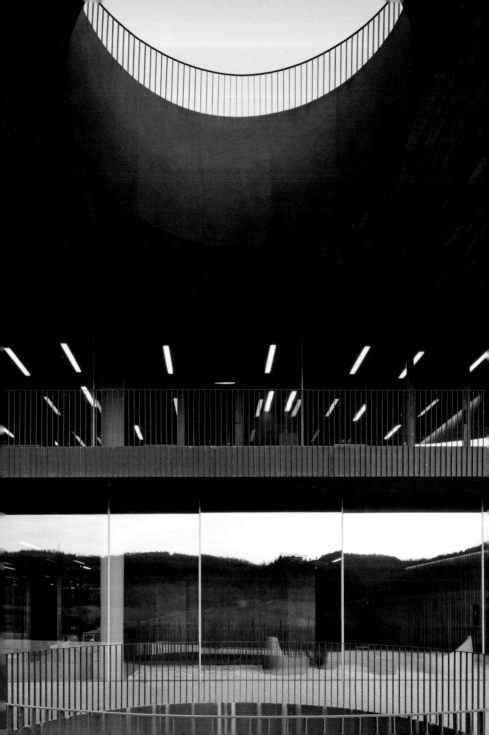

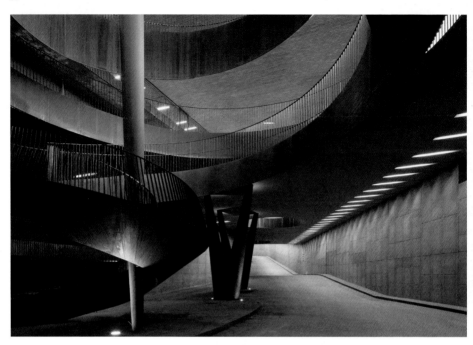

Together with circular openings, the building also has such unexpected features as the spiral staircase seen on these two pages. Below, plans show the levels of the structure as they are inserted into their vineyard environment.

Außer diesen runden Öffnungen zeichnet sich das Gebäude durch weitere ungewöhnliche Merkmale aus, wie die auf dieser Doppelseite abgebildete Wendeltreppe. Unten: Die Pläne zeigen die Einfügung der Ebenen des Gebäudes in die umgebenden Weinberge.

En plus des ouvertures circulaires, le bâtiment présente des éléments inattendus tel l'escalier en colimaçon qu'on voit ici. Ci-dessous, les schémas montrent la manière dont les différents niveaux du complexe sont insérés au vignoble.

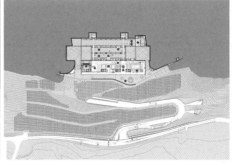

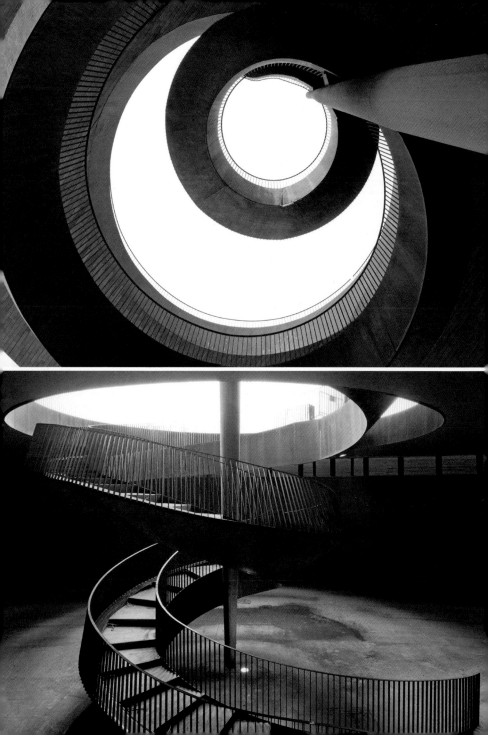

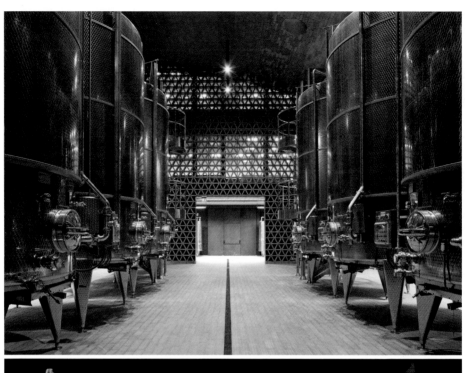
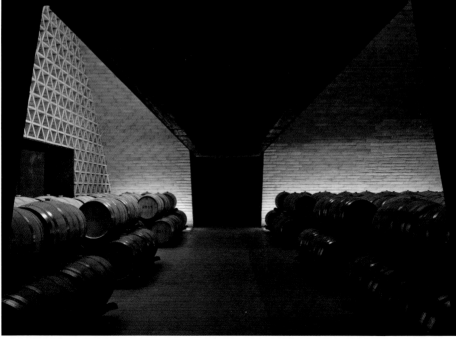

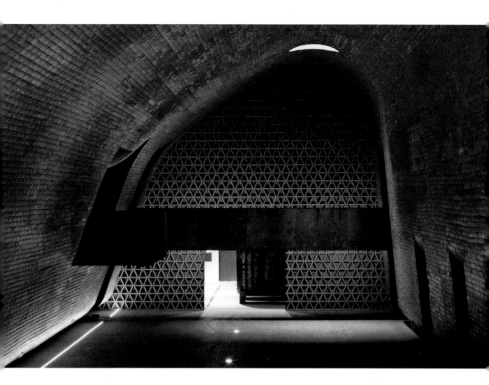

The architects have clearly mastered the use of theatrical lighting in connection with strong, surprising forms. Left below, the vats and barrels used for maturing the wine. Irregular forms also enliven the interior spaces.

Den Architekten ist die Nutzung von theatralischer Beleuchtung in Verbindung mit starken, eindrucksvollen Formen meisterhaft gelungen. Links unten: Die zur Reifung des Weines verwendeten Bottiche und Fässer. Die asymmetrischen Formen tragen zur Belebung der Innenräume bei.

Les architectes ont fait un usage parfaitement maîtrisé d'un éclairage théâtral, associé à des formes surprenantes et fortes. À gauche ci-dessous, les cuves et fûts où vieillit le vin. L'irrégularité des formes donne elle aussi vie aux espaces intérieurs.

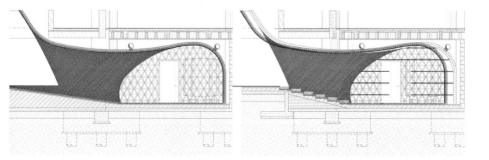

ARTECHNIC

KOTARO IDE was born in Tokyo, Japan, in 1965. He graduated from the Department of Architecture of the College of Art and Design at Musashino Art University (Tokyo, 1989). He worked in the office of Ken Yokogawa Architects from 1989 to 1994 and established his own office, ARTechnic architects, in 1994. His main works include the SMD House (Zushi, Kanagawa, 1995); Oak Terrace Apartment Building (Ota, Tokyo, 1997); YMM House (Suginami, Tokyo, 1999); MSO House (Shibuya, Tokyo, 2000); Cherry Terrace Library (Shibuya, Tokyo, 2002); Manazuru Studio (Manazuru, Kanagawa, 2003); YMG House (Yokohama, Kanagawa, 2003); NKM House (Shibuya, Tokyo, 2005); Shell (Karuizawa, Nagano, 2008); M&M Rosie (Tokyo, 2009); Breeze (Tokyo, 2011–12, published here); YNO House (Tokyo, 2012); and the Ito Animal Hospital (Ito, Shizuoka, 2013), all in Japan.

KOTARO IDE wurde 1965 in Tokio geboren. Er studierte bis 1989 an der Architekturabteilung der Akademie für Kunst und Design der Kunstuniversität Musashino (Tokio). Von 1989 bis 1994 arbeitete er im Büro von Ken Yokogawa Architects und gründete 1994 seine eigene Firma, ARTechnic architects. Zu seinen wichtigen Projekten zählen: das Haus SMD (Zushi, Kanagawa, 1995), das Apartmenthaus Oak Terrace (Ota, Tokio, 1997), das Haus YMM (Suginami, Tokio, 1999), das Haus MSO (Shibuya, Tokio, 2000), die Bibliothek Cherry Terrace (Shibuya, Tokio, 2002), das Studio in Manazuru (Manazuru, Kanagawa, 2003), das Haus YMG (Yokohama, Kanagawa, 2003), das Haus NKM (Shibuya, Tokio, 2005), Shell (Karuizawa, Nagano, 2008), M&M Rosie (Tokio, 2009), das Apartmenthaus Breeze (Tokio, 2011–12, hier vorgestellt), Haus YNO (Tokio, 2012) und die Tierklinik in Ito (Shizuoka, 2013), alle in Japan.

KOTARO IDE est né à Tokyo en 1965. Il est diplômé du département d'architecture du collège d'art et design à l'université d'art Musashino (Tokyo, 1989). Il a travaillé dans l'agence Ken Yokogawa Architects de 1989 à 1994 avant d'ouvrir la sienne, ARTechnic architects, en 1994. Ses principales réalisations comprennent la maison SMD (Zushi, Kanagawa, 1995) ; l'immeuble d'appartements Oak Terrace (Ota, Tokyo, 1997) ; la maison YMM (Suginami, Tokyo, 1999) ; la maison MSO (Shibuya, Tokyo, 2000) ; la bibliothèque Cherry Terrace (Shibuya, 2002) ; le studio Manazuru (Manazuru, Kanagawa, 2003) ; la maison YMG (Yokohama, Kanagawa, 2003) ; la maison NKM (Shibuya, 2005) ; la villa Shell (Karuizawa, Nagano, 2008) ; M&M Rosie (Tokyo, 2009) ; l'immeuble Breeze (Tokyo, 2011–12, publié ici) ; la maison YNO (Tokyo, 2012) et l'hôpital vétérinaire d'Ito (Shizuoka, 2013), toutes au Japon.

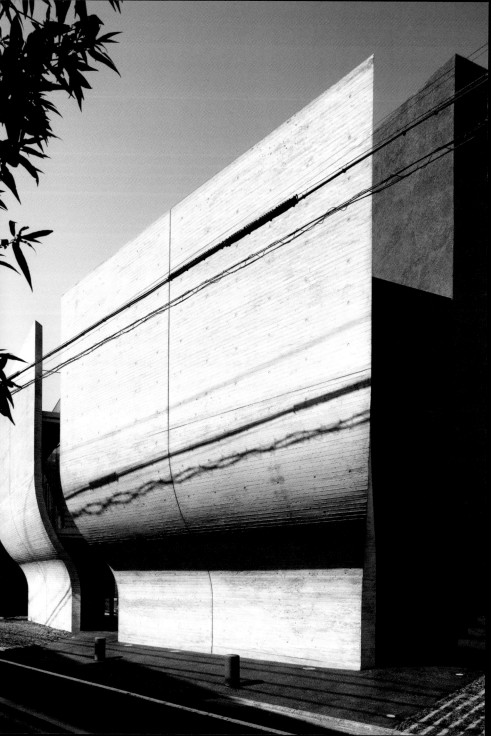

BREEZE

Setagaya, Tokyo, Japan, 2011–12

Area: 1252 m². Client: Daizawa Court.

Reaching a maximum height of 9.9 meters, the imposing apartment structure **BREEZE** has three floors plus a small basement. The reinforced-concrete structure has an exterior finish in concrete covered by polystyrene thermal insulation board. The architect imagines this as "a building that sits in mute repose, like an impassive signpost." He compares the interior to a "secret rock cave" or a "space like a private beach, enclosed by a soaring rock face." He says: "My concept was to create a space that would provide a bolt-hole for personal rest and relaxation, while still being able to benefit from the convenience of the city center—an ideal private spot in the heart of the city." Located on a heavily traveled side road, the structure has buffering walls on two sides and an open south-facing side. In what he describes as a "multiple-storied terrace-house design," Kotaro Ide has taken the commercial appeal and appearance of the structure well into account. "This project," he states, "was one that I developed independently, from the decision on the location itself through to planning. The specifications of the building were also selected with total life-cycle costs in mind. While selecting a finish that would be maintenance free to the greatest degree possible, I made the bold decision to use an exterior insulation and finishing system (which is coated onto the exterior wall) in order to retouch the exterior easily at predetermined periods during the building life cycle as a means of keeping these rental units looking fresh and appealing."

Das imponierende, 9,9 m hohe Apartmenthaus **BREEZE** hat drei Geschosse und ein kleines Untergeschoss. Die Stahlbetonkonstruktion hat Außenwände aus Beton, die mit Wärmedämmplatten aus Polystyrol verkleidet sind. Der Architekt stellt sich das Projekt vor als „ein Gebäude, das still vor sich hinsteht wie ein teilnahmsloser Wegweiser". Das Innere vergleicht er mit einer „verborgenen Felsenhöhle" oder einem „Bereich wie ein privater Strand, der von steilen Felsen umschlossen ist". Er sagt: „Mein Konzept war die Planung von Wohnräumen, die Rückzugsorte zur Erholung und Ruhe darstellen, aber trotzdem den Vorzug der Nähe zum Stadtzentrum bieten – ein idealer privater Standort im Herzen der Stadt." Das in einer stark befahrenen Nebenstraße gelegene Gebäude hat an zwei Seiten schalldämpfende Wände und eine nach Süden orientierte offene Fassade. Kotaro Ide hat bei seiner, in seinen Worten, „mehrgeschossigen Reihenhausplanung" auch den wirtschaftlichen Aspekt eines ansprechenden Erscheinungsbilds berücksichtigt. „Dieses Projekt", erläutert er, „habe ich völlig unabhängig geplant, von der Wahl des Standorts bis zum fertigen Entwurf. Auch bei der Wahl der technischen Details habe ich die dauerhaften Unterhaltskosten bedacht. Auf der Suche nach einem weitgehend wartungsfreien Anstrich traf ich die mutige Entscheidung für eine äußere Isolierung und ein Beschichtungssystem der Außenwand, um das Gebäude im Verlauf seiner Lebensdauer einfach renovieren zu können und dieses Mietshaus frisch und ansprechend erscheinen zu lassen."

L'imposant complexe de logements **BREEZE** d'une hauteur maximale de 9,9 m a trois étages et un petit sous-sol. Les finitions extérieures de la structure en béton armé sont en béton recouvert d'un panneau en polystyrène pour l'isolation thermique. L'architecte l'a imaginé comme un « bâtiment en position assise de repos convenu, tel un impassible poteau indicateur ». Il compare l'intérieur à une « caverne rocheuse secrète » ou un « espace rappelant une plage privée close par une paroi rocheuse qui s'élance vers le ciel ». Il explique encore : « Mon idée était de créer un refuge où se reposer et se détendre sans pour autant renoncer à profiter des avantages du centre-ville – un espace privé idéal au cœur de la cité. » Situé sur une route latérale très fréquentée, l'ensemble est ouvert vers le sud et doté de murs insonorisés sur deux côtés. Kotaro Ide a parfaitement tenu compte de l'attrait commercial et de l'apparence dans ce qu'il décrit comme un design de « maison à terrasse à plusieurs étages ». « J'ai développé ce projet, explique-t-il, en totale indépendance, du choix de l'emplacement à la conception. Les spécifications du bâtiment ont été choisies en fonction du coût total du cycle de vie. En optant pour un revêtement qui exige le moins d'entretien possible, j'ai pris la décision audacieuse d'une isolation et d'un système de finitions extérieurs (sur le mur extérieur) afin de pouvoir le ravaler facilement à des dates prédéterminées du cycle de vie du bâtiment pour conserver un aspect frais et attirant aux différentes unités locatives. »

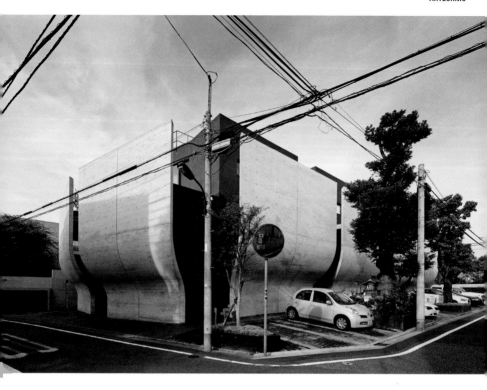

The upward curving exterior walls of the house give the impression of being blown upwards by an invisible source of air. Below, a site plan.

Die nach außen gebogenen Außenwände des Hauses wirken, als wären sie von einem unsichtbaren Luftzug nach oben geblasen worden. Unten ein Lageplan.

Les murs extérieurs à courbe ascendante donnent l'impression d'être poussés vers le haut par une source d'air invisible. Ci-dessous, un plan de situation.

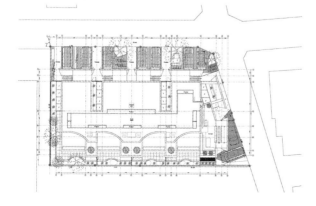

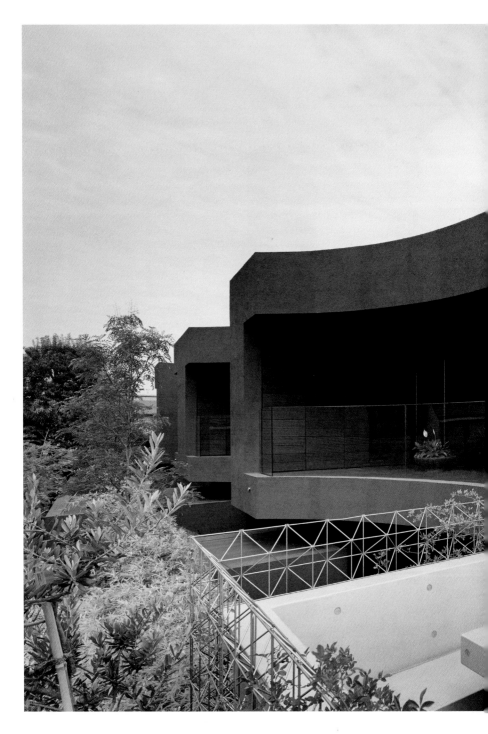

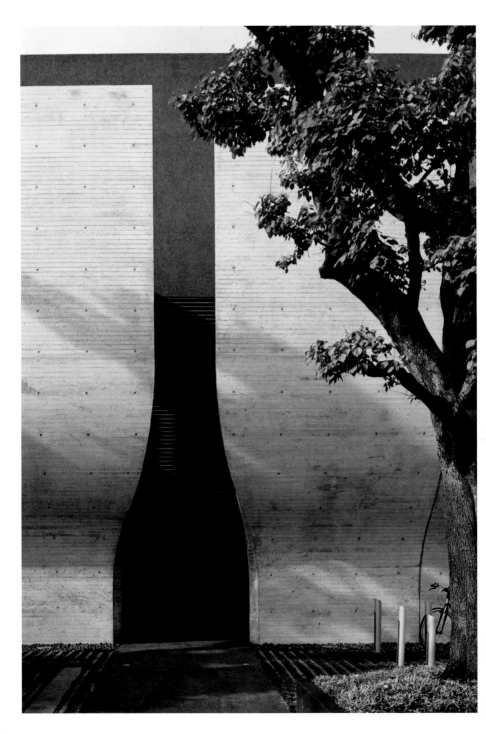

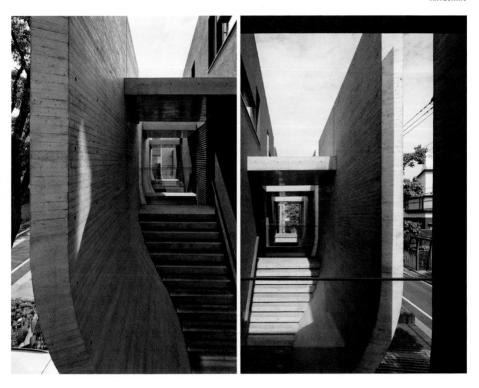

The strong external concrete walls form a kind of veil for the passages, seen above, but also for the rear of the house and its large openings (left page). Below, elevation drawings.

Die starken Außenwände aus Beton bilden, wie oben zu sehen, eine Art Schale für die Durchgänge, aber auch für die Rückseite des Hauses mit ihren großen Öffnungen (linke Seite). Unten: Ansichten.

Les épais murs extérieurs en béton forment comme une voile pour les passages entre les logements, ci-dessus, mais aussi pour l'arrière de la maison et ses vastes ouvertures (page de gauche). Ci-dessous, plans en élévation.

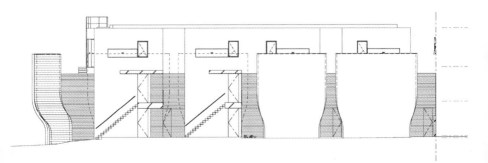

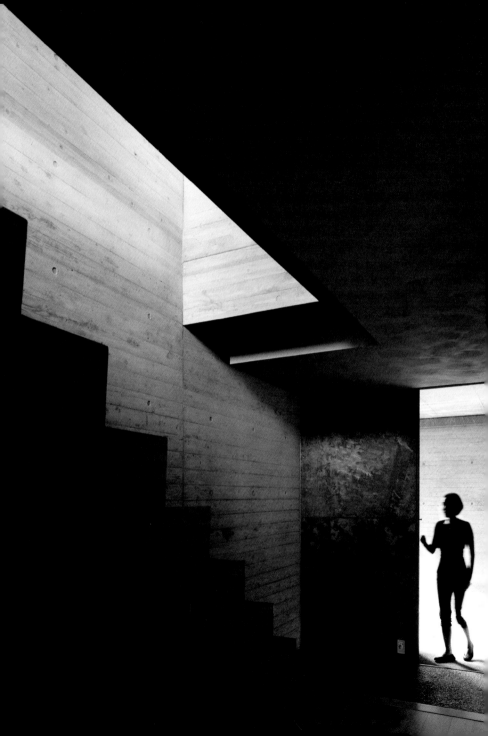

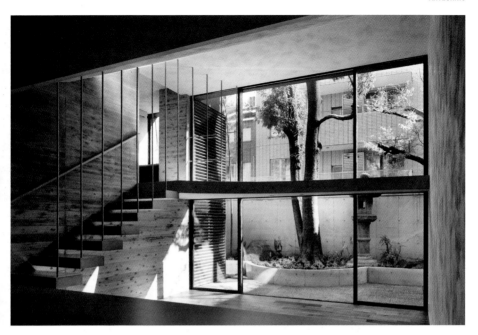

Hard concrete surfaces and different sources of natural light offer a study in contrasts (left page). Above, high windows open to a rear garden. Below, plans of the house.

Feste Betonflächen und unterschiedliche natürliche Lichtquellen bieten die Gelegenheit zum Studium von Kontrasten (linke Seite). Oben: Hohe Fenster öffnen sich zu einem rückwärtigen Garten. Unten: Grundrisse des Hauses.

Les dures surfaces de béton et les différentes sources de lumière naturelle sont des modèles de contrastes (page de gauche). Ci-dessus, les hautes fenêtres ouvrent sur un jardin à l'arrière. Ci-dessous, plans de la maison.

The architect makes use of slabs of concrete for a stairway (below). Here and elsewhere heavy materials are made to seem surprisingly light. The angled street-side walls seen from above provide for external terraces.

Der Architekt verwendet Betonplatten für eine Treppe (unten). Hier wie auch an anderer Stelle wirken die schweren Materialien erstaunlich leicht. Die kantigen, hier von oben gesehenen Wände an der Straßenseite dienen zur Ausbildung von Außenterrassen.

L'architecte a construit un escalier en dalles de béton (ci-dessous). Là comme ailleurs, des matériaux lourds prennent un caractère étonnamment léger. Les angles des murs latéraux côté rue forment des terrasses, vues ici du dessus.

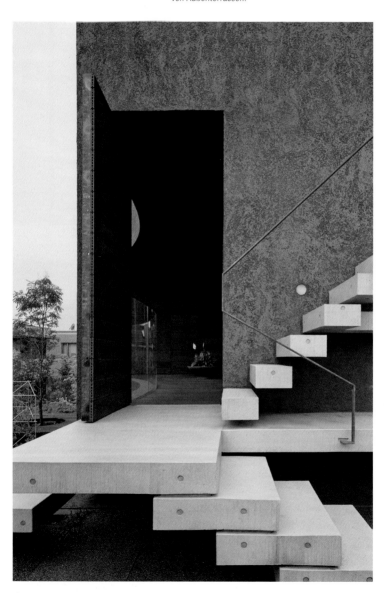

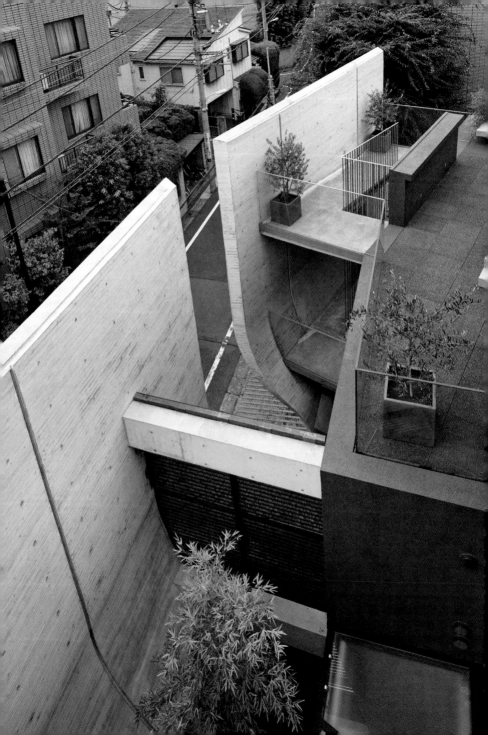

BAK

MARÍA VICTORIA BESONÍAS was born in Madrid, Spain, in 1947. She received a degree in Architecture and Urbanism from the University of Buenos Aires in 1975. In 2012, she received the Lifetime Achievement Award (Premio a la Trayectoria) from the Senate of Buenos Aires Province. **GUILLERMO DE ALMEIDA** was born in Buenos Aires in 1945. He obtained a degree in Architecture and Urbanism from the University of Buenos Aires (1975). He taught architecture at the University of Buenos Aires and the University of Morón. Between 2000 and 2012 María Besonías and Guillermo de Almeida (now working as Besonías Almeida Architects) joined Luciano Kruk to form BAK Architects, after 25 years of independent architectural work. **LUCIANO KRUK** (now working as Luciano Kruk Architects) was born in 1974 in Buenos Aires. He received a degree in Architecture and Urbanism from the University of Buenos Aires in 2000. Aside from the Cher House (Mar Azul, Villa Gesell, Buenos Aires, 2010, published here) and the BB House (Mar Azul, Villa Gesell, Buenos Aires, 2011), their work includes the EEUU Building (Buenos Aires, 2009); Besonías Almeida House (Barrio La Grevilea, Ituzaingó, Buenos Aires, 2010); Costa Esmeralda House (Costa Esmeralda, Buenos Aires, 2011); and the Carassale House (Costa Esmeralda, Buenos Aires, 2012), all in Argentina.

MARÍA VICTORIA BESONÍAS wurde 1947 in Madrid geboren. Sie erwarb ihr Diplom für Architektur und Städtebau 1975 an der Universität von Buenos Aires. Im Jahr 2012 wurde ihr vom Senat der Provinz Buenos Aires der Preis für ihr Lebenswerk (Premio a la Trayectoria) verliehen. **GUILLERMO DE ALMEIDA** wurde 1945 in Buenos Aires geboren. 1975 machte er seinen Abschluss in Architektur und Städtebau an der Universität von Buenos Aires. Er lehrte Architektur an den Universitäten von Buenos Aires und von Morón. Von 2000 bis 2012 waren María Besonías und Guillermo de Almeida (die heute als Besonías Almeida arquitectos firmieren) mit Luciano Kruk verbunden, mit dem sie, nach 25 Jahren unabhängiger Architekturtätigkeit, BAKarquitectos gegründet hatten. **LUCIANO KRUK** (der jetzt als Luciano Kruk Arquitectos firmiert) wurde 1974 in Buenos Aires geboren. Sein Diplom für Architektur und Städtebau erwarb er 2000 an der Universität Buenos Aires. Zu ihren Projekten zählen, außer dem Haus Cher (Mar Azul, Villa Gesell, Buenos Aires, 2010, hier vorgestellt) und dem Haus BB (Mar Azul, Villa Gesell, Buenos Aires, 2011), das EEUU-Gebäude (Buenos Aires, 2009), das Haus Besonías Almeida (Barrio La Grevilea, Ituzaingó, Buenos Aires, 2010), das Haus Costa Esmeralda (Costa Esmeralda, Buenos Aires, 2011) und das Haus Carassale (Costa Esmeralda, Buenos Aires, 2012), alle in Argentinien.

MARÍA VICTORIA BESONÍAS est née en 1947 à Madrid. Elle est diplômée en architecture et urbanisme de l'université de Buenos Aires (1975). Elle a reçu en 2012 le prix pour l'ensemble de son œuvre (Premio a la Trayectoria) du sénat de la province de Buenos Aires. **GUILLERMO DE ALMEIDA** est né en 1945 à Buenos Aires où il a obtenu son diplôme d'architecture et urbanisme (1975). Il a enseigné l'architecture à l'université de Buenos Aires et à celle de Morón. Après 25 ans de travail en indépendant, lui et María Besonías (qui travaillent désormais sous le nom de Besonías Almeida arquitectos) ont rejoint Luciano Kruk pour former BAKarquitectos entre 2000 et 2012. **LUCIANO KRUK** (qui travaille aujourd'hui sous le nom de Luciano Kruk Arquitectos) est né en 1974 à Buenos Aires. Il est diplômé en architecture et urbanisme de l'université de Buenos Aires (2000). Outre la maison Cher (Mar Azul, Villa Gesell, Buenos Aires, 2010, publiée ici) et la maison BB (Mar Azul, 2011), ils ont réalisé le bâtiment EEUU (Buenos Aires, 2009) ; la maison Besonías Almeida (Barrio La Grevilea, Ituzaingó, Buenos Aires, 2010) ; la maison Costa Esmeralda (Costa Esmeralda, Buenos Aires, 2011) et la maison Carassale (Costa Esmeralda, 2012), tous en Argentine.

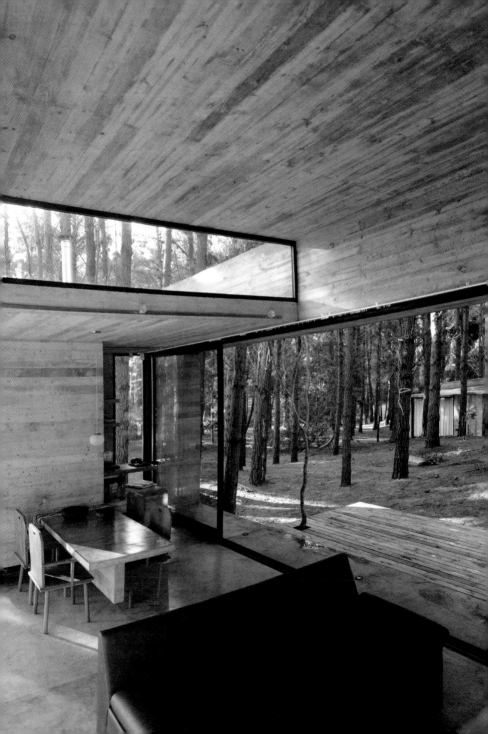

CHER HOUSE

Mar Azul, Villa Gesell, Buenos Aires, Argentina, 2010

Area: 105 m². Client: Alejandro Chernov.
Collaboration: Leandro Pomies.

Set on a 600-square-meter site (20 x 30 meters), this summer residence stands at the edge of the urban forest of Mar Azul, an area of dunes with acacia and pine trees. The clients, a couple with two teenage children, wanted the house to be integrated into the landscape and to take advantage of views of the forest. **CHER HOUSE** has two bedrooms and two bathrooms. The architects created a system of half levels in order to take advantage of the undulating topography of the site. The house is acceded to on the main floor via a concrete staircase. The master bedroom is half a level up. A double-height space below is partially buried in the dune, as is a semi-sunken courtyard. The architects state: "The house is developed within a concrete and glass prism that highlights the different levels…H21 concrete was used with the addition of a fluidifier so that the mixture, requiring little water to harden, is very compact and does not require sealing. The interior walls of hollow bricks are plastered and painted with white latex; floor cloths are also from concrete screed divided with aluminum plates." Aside from a double bed, couches, and chairs, all the furniture in the house is made of concrete.

Dieses Sommerhaus wurde auf einem 600 m² großen Grundstück (20 x 30 m) am Rand des städtischen Forstes von Mar Azul, einem mit Akazien und Kiefern bestandenen Dünengelände, errichtet. Die Bauherren, ein Ehepaar mit zwei Kindern im Teenageralter, wollten das Haus in die Landschaft integrieren und den Blick auf den Wald genießen. **CHER HAUS** hat zwei Schlafräume und zwei Badezimmer. Die Architekten planten ein System von Zwischengeschossen, um die wellige Topografie des Geländes zu nutzen. Das Gebäude wird vom Hauptgeschoss über eine Betontreppe erschlossen. Das Elternschlafzimmer liegt ein halbes Geschoss darüber. Ein doppelgeschosshoher Raum darunter ist zum Teil in der Düne versenkt, ebenso ein tiefer gelegter Innenhof. Die Architekten erklären: „Das Haus entfaltet sich in einem Prisma aus Beton und Glas, das die unterschiedlichen Ebenen betont … Der verwendete Beton ist H21 mit Zusatz eines Verflüssigers, sodass die Mischung nur wenig Wasser zur Härtung benötigt. Sie ist sehr kompakt und muss nicht versiegelt werden. Die Innenwände aus Lochziegeln sind verputzt und mit weißer Latexfarbe gestrichen; der Bodenbelag ist aus Betonestrich, aufgeteilt mit Aluminiumplatten." Außer einem Doppelbett, Sofas und Stühlen ist alles Mobiliar im Haus aus Beton.

Cette résidence d'été a été construite sur un terrain de 600 m² (20 x 30 m) en lisière de la forêt municipale de Mar Azul, dans une zone de dunes plantée d'acacias et de pins. Les clients, un couple et leurs deux enfants adolescents, souhaitaient une maison intégrée au paysage qui leur permette de profiter des vues de la forêt. **MAISON CHER** comporte deux chambres et deux salles de bains. Les architectes ont créé un système de demi niveaux pour exploiter la topographie vallonée du site. Un escalier en béton donne accès à l'étage principal. La chambre à coucher principale est située un demi niveau plus haut. Plus bas, un espace double hauteur est partiellement enterré dans la dune, ainsi qu'une cour semi encastrée. Les architectes expliquent : « la maison se déploie à l'intérieur d'un prisme de béton et verre qui met en valeur les différents niveaux… Nous avons utilisé du béton H21 auquel nous avons ajouté un fluidifiant pour obtenir un mélange très compact qui a besoin de peu d'eau pour durcir et ne nécessite aucune étanchéification. Les murs intérieurs en briques creuses ont été plâtrés et enduits de latex blanc ; les sols sont également revêtus d'une chape de béton divisée par des plaques d'aluminium. » A l'exception du lit double, des canapés et des chaises, tout le mobilier est également en béton.

In its forest setting the house presents itself as an elegant assemblage of concrete volumes, glass, and wood. While concrete is often called "cold," the architects succeed in making the house welcoming with their juxtaposition of materials.

In der Waldumgebung präsentiert sich das Haus als elegantes Ensemble aus Beton, Glas und Holz. Während Beton oft als „kalt" gilt, ist es den Architekten gelungen, dieses Haus durch die Gegenüberstellung der Materialien einladend zu gestalten.

Dans son cadre forestier, la maison apparaît tel un élégant assemblage de volumes en béton, verre et bois. Malgré la froideur souvent attribuée au béton, les architectes sont parvenus à rendre la maison accueillante avec l'association d'autres matériaux.

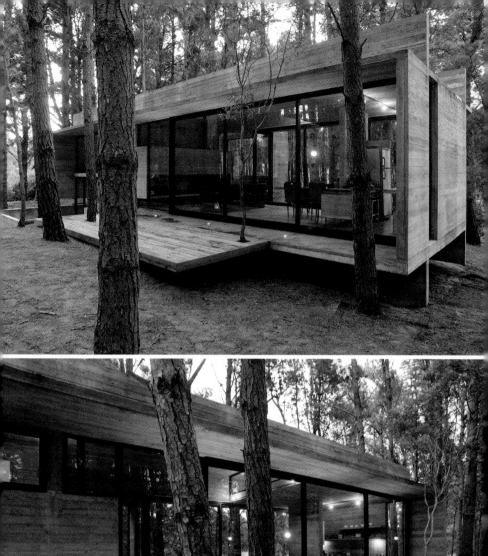
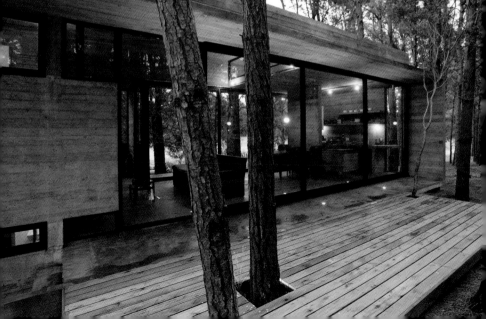

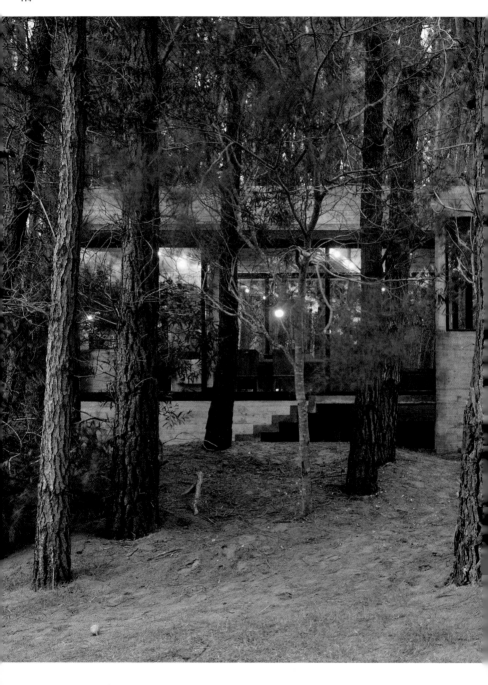

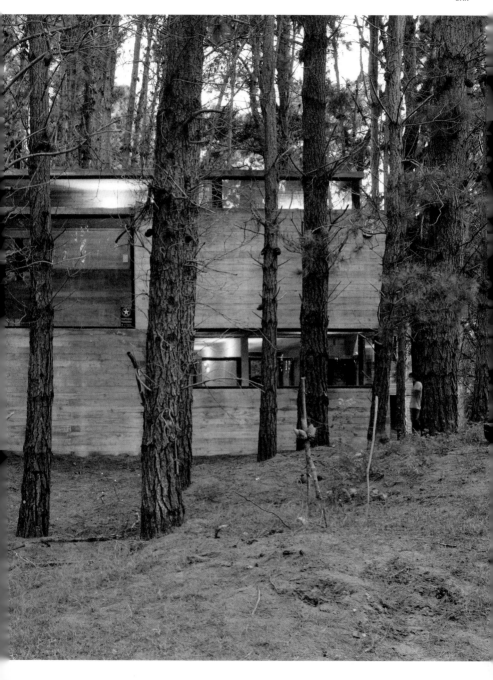

Concrete surfaces appear to be
folded which undoubtedly lightens
their presence. Open glazed
surfaces are willfully contrasted
with long slit windows. On the right
page below a section drawing of
the house.

Die Betonflächen erscheinen wie
gefaltet, wodurch sie zweifellos
leichter wirken. Offene, verglaste
Flächen bilden einen beabsichtigten
Kontrast zu den langen Fenster-
schlitzen. Unten rechts: ein Schnitt
durch das Haus.

Les surfaces de béton semblent
pliées comme du papier, ce qui
allège incontestablement leur pré-
sence. Les surfaces vitrées ouvertes
contrastent volontairement avec de
longues fenêtres étroites. En bas
à droite, un schéma en coupe de la
maison.

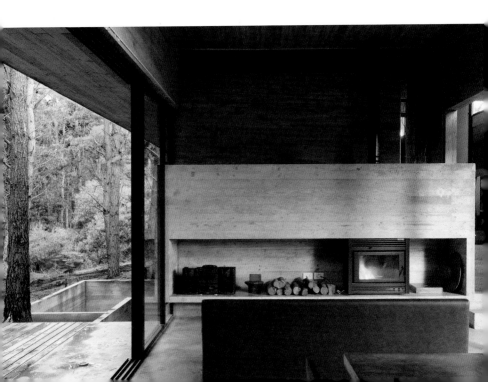

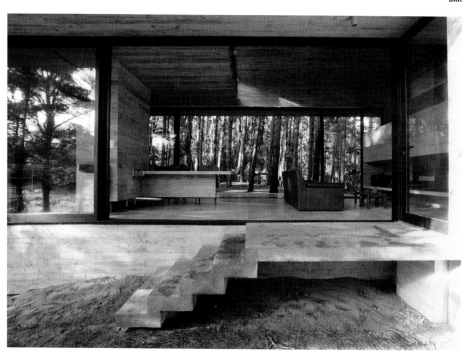

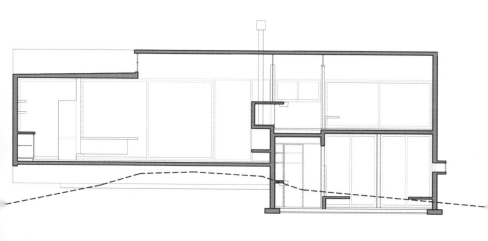

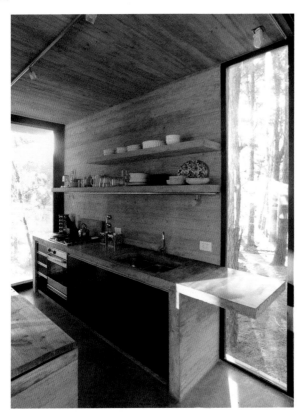

By inserting broad windows where they are not always to be expected, the architects make their concrete surfaces seem almost paper-thin (right page). Below, floor plans.

Durch die Anordnung großer Fenster an unerwarteten Stellen gelingt es den Architekten, die Betonflächen fast papierdünn erscheinen zu lassen (rechte Seite). Unten: Grundrisse.

En insérant de larges fenêtres à des endroits inattendus, les architectes ont donné aux surfaces de béton une apparence aussi fine que du papier (page de droite). Ci-dessous, plans au sol.

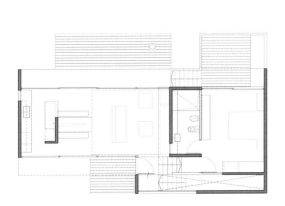

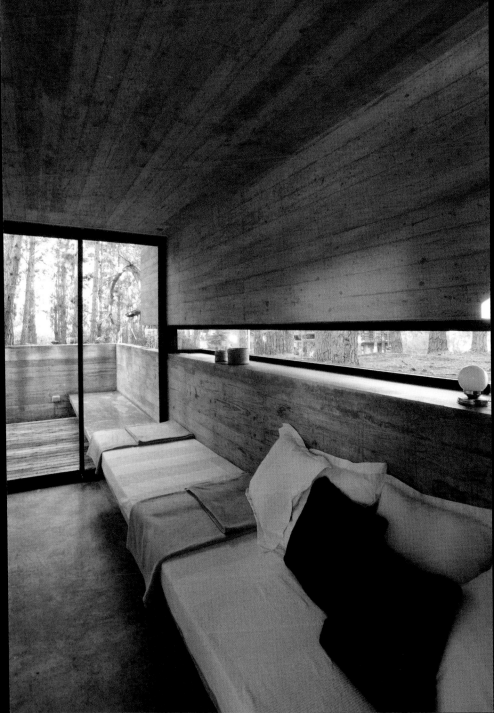

BARCLAY & CROUSSE

JEAN-PIERRE CROUSSE was born in Lima, Peru, in 1963. He was educated at the Universidad Ricardo Palma in Lima and at Milan Polytechnic in Italy, where he received a European architecture degree (1989). **SANDRA BARCLAY** was born in Lima in 1967 and also studied at the Universidad Ricardo Palma, before getting a French architecture degree (D.P.L.G.) at the École d'Architecture de Paris-Belleville (1993). Their built work includes the reconstruction of the Musée Malraux (Le Havre, France, 1999); B House (Cañete, Peru, 1999); the M House (Cañete, Peru, 2001); an office building in Malakoff (Paris, France, 2003); and a renovation of the city hall of Épinay-sur-Seine (France, 2004). More recently, they have worked on a 170-unit housing project (Nantes, France, 2009); the F House (Lima, Peru, 2009–10); the Vedoble Houses (Cañete, Peru, 2008–11, published here); Montreuil Student Apartments (Paris, France, 2011); the Museo Paracas (Ica, Peru, 2012); and the Lugar de la Memoria (Lima, Peru, 2010–13).

JEAN-PIERRE CROUSSE wurde 1963 in Lima geboren. Er studierte an der Universidad Ricardo Palma in Lima und am Mailänder Polytechnikum, wo er seine Studien mit einem europäischen Architekturdiplom abschloss (1989). **SANDRA BARCLAY** wurde 1967 in Lima geboren, studierte ebenfalls zunächst an der Universidad Ricardo Palma und schloss ihr Studium mit einem französischen Architekturdiplom (D. P. L. G.) an der École d'Architecture de Paris-Belleville (1993) ab. Zu ihren realisierten Bauten zählen das Musée Malraux (Le Havre, Frankreich, 1999), die Casa B (Cañete, Peru, 1999), die Casa M (Cañete, Peru, 2001), ein Bürogebäude in Malakoff (Paris, Frankreich, 2003) und die Sanierung des Rathauses in Épinay-sur-Seine (Frankreich, 2004). Jüngere Projekte des Büros sind ein Wohnbauprojekt mit 170 Wohneinheiten (Nantes, Frankreich, 2009), die Casa F (Lima, Peru, 2009–10), die Casas Vedoble (Cañete, Peru, 2008–11, hier vorgestellt), Studentenwohnungen in Montreuil (Paris, Frankreich, 2011), das Museo Paracas (Ica, Peru, 2012) sowie der Lugar de la Memoria (Lima, Peru, 2010–13).

JEAN-PIERRE CROUSSE, né à Lima (Pérou) en 1963, a étudié à l'université Ricardo Palma de Lima et à l'École polytechnique de Milan où il a obtenu un diplôme européen d'architecte (1989). **SANDRA BARCLAY**, née à Lima en 1967, a également étudié à l'université Ricardo Palma de Lima et obtenu son diplôme d'architecte D.P.L.G. à l'École d'architecture de Paris-Belleville (1993). Leurs réalisations comprennent la reconstruction du musée André Malraux (Le Havre, France, 1999) ; la maison B (Cañete, Pérou, 1999) ; la maison M (Cañete, Pérou, 2001) ; l'immmeuble de bureaux à Malakoff (Paris, France, 2003) et la rénovation de l'hôtel de ville d'Épinay-sur-Seine (France, 2004). Plus récemment, ils ont réalisé un immeuble de 170 appartements (Nantes, France, 2009) ; la maison F (Lima, Pérou, 2009–10) ; les maisons Vedoble (Cañete, Pérou, 2008–11, publiées ici) ; des logements pour étudiants à Montreuil (France, 2011) ; le musée Paracas (Ica, Pérou, 2012) et le Lugar de la Memoria (Lima, Pérou, 2010–13).

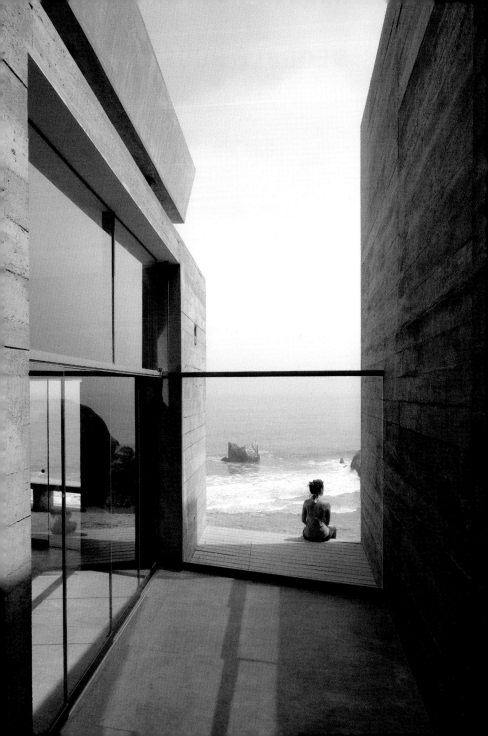

VEDOBLE HOUSES

Cañete, Peru, 2008–11

Area: 917 m². Cost: $720 000.

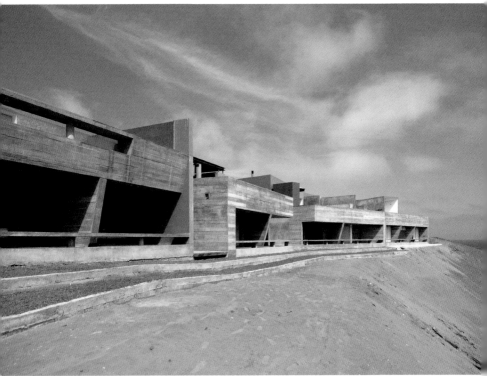

The rough concrete and long, wide openings give these houses something of the appearance of defensive bunkers from a distance, and yet they are fully open to the ocean.

Durch den rauen Sichtbeton und die niedrigen breiten Fassadenöffnungen wirken die Häuser von Weitem wie Festungsanlagen, öffnen sich jedoch vollständig zum Meer.

Vues de loin, les vastes ouvertures des façades de ces maisons en béton leur donnent un aspect de bunkers, mais de bunkers généreusement ouverts sur l'océan.

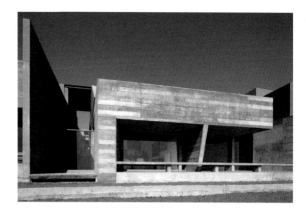

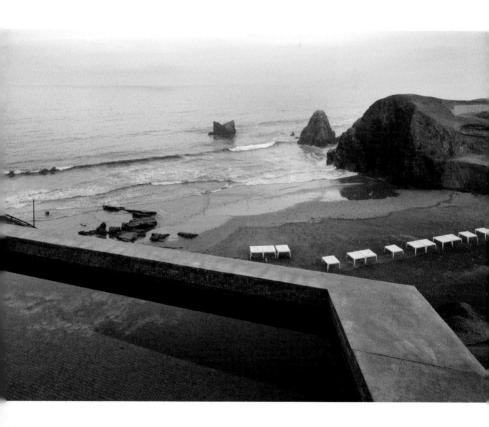

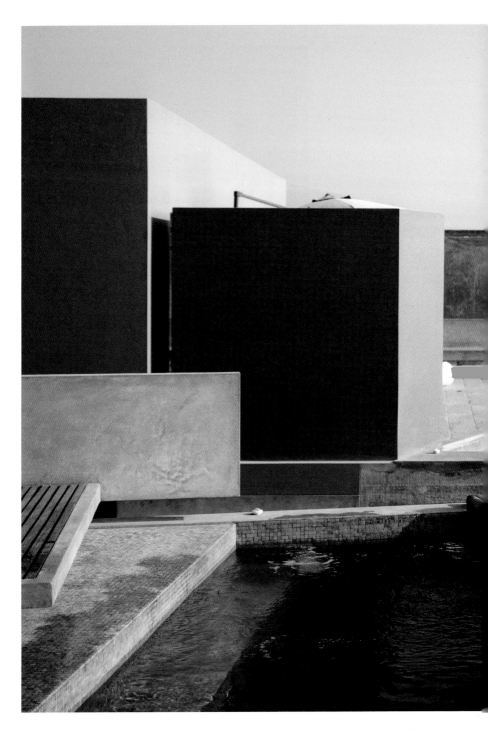

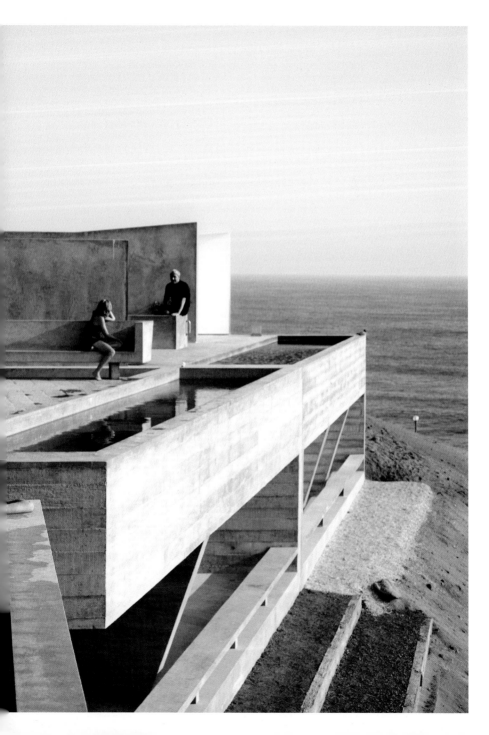

Located on a cliff above La Escondida Beach in the province of Cañete, this project is made up of four summer houses. The architects explain: "These houses were not designed at the same time, nor were they conceived as a whole, but they share the same approach to the site, to the extraordinary climate of this region, and their relationship to the landscape." They describe the **VEDOBLE HOUSES** as "inhabited platforms" where "cracks" have been created to provide for open stairs and common patios. An ochre or "sand" color with rough exposed concrete was used to avoid the effects of layers of dust from the nearby desert. In fact, the location of the houses, on a line between the ocean and the desert, defines their character, with such elements as long narrow pools that create a link between the two environments.

Der Komplex aus vier Sommerhäusern in der Provinz Cañete liegt an einem Steilabhang über dem Strand von La Escondida. Die Architekten führen aus: „Der Entwurf für die Häuser entstand nicht zeitgleich, sie wurden auch nicht als Gesamtensemble konzipiert, teilen aber dieselbe Ausrichtung auf dem Grundstück, das außergewöhnliche Klima der Region und ihr Verhältnis zur Landschaft." Sie beschreiben die **VEDOBLE HÄUSER** als „bewohnte Plattformen" mit „Zwischenräumen" für offene Treppen und gemeinschaftliche Terrassen. Die mit Sichtbeton kombinierten, ocker- bzw. sandfarben gestrichenen Oberflächen kaschieren die auffälligen Sandablagerungen aus der nahegelegenen Wüste. Tatsächlich prägt die landschaftliche Lage die Bauten, die wie ein Band zwischen Ozean und Wüste liegen; lange schmale Schwimmbecken fungieren als Bindeglied zwischen den beiden klimatischen Zonen.

Ces quatre résidences d'été ont été édifiées au sommet d'une falaise dominant la plage de La Escondida. « Ces maisons n'ont été ni conçues en même temps, ni comme un ensemble, expliquent les architectes, mais partagent une approche identique du site, du climat extraordinaire de cette région et une même relation au paysage. » Ils décrivent les **RÉSIDENCES VEDOBLE** comme des « plateformes habitées » entre lesquelles auraient été aménagées des « fissures » pour implanter des escaliers ou des patios communs. La couleur ocre ou sable et le béton brut ont été choisis pour limiter les effets de la poussière de sable venue du désert voisin. En fait, la situation de ces maisons sur une mince ligne de relief entre l'océan et le désert définit leur caractère, certains éléments comme les piscines allongées faisant le lien entre ces deux environnements naturels.

Below, the houses seen from the beach on top of their rather arid hillside.

Unten die Häuser auf dem Kamm des wüstenähnlichen Steilabhangs, vom Strand aus gesehen.

Ci-dessous, les maisons perchées au sommet de la falaise aride, vues de la plage.

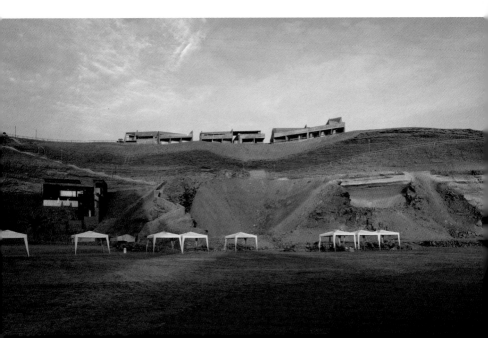

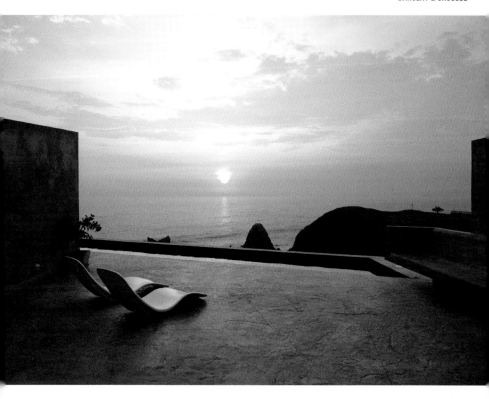

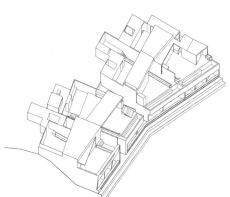

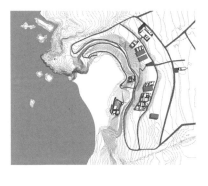

An axonometric drawing and site plan give an idea of the alignments and locations of the houses. Above, a terrace at sunset.

Axonometrie und Lageplan geben eine Vorstellung von der Anordnung und Lage der Häuser. Oben eine der Terrassen bei Sonnenuntergang.

Cette axonométrie et le plan de situation font comprendre les alignements et les articulations des maisons. En haut, une terrasse au coucher du soleil.

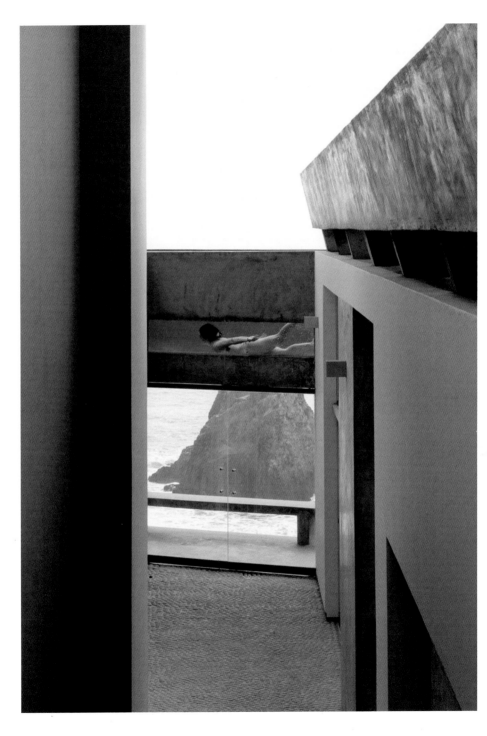

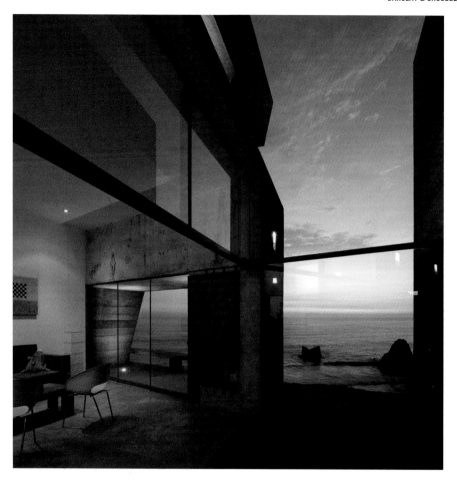

Even if they appear to be rather rough from the outside, the houses provide for considerable comfort in this unexpected setting. Here, inside and outside seem to come together as one in the house.

Trotz ihrer von außen so strengen Anmutung bieten die Häuser gehobenen Komfort in ungewöhnlicher Lage. Hier gehen Innen- und Außenraum fließend ineinander über.

Même si elles peuvent sembler un peu « brutes » vues de l'extérieur, ces maisons offrent un confort remarquable dans leur cadre étonnant. Ici, l'intérieur et l'extérieur semblent ne faire qu'un.

Left, a swimming pool passes above a terrace.

Links ein Pool, der als Brücke eine der Terrassen quert.

À gauche, une piscine passe au-dessus d'une terrasse.

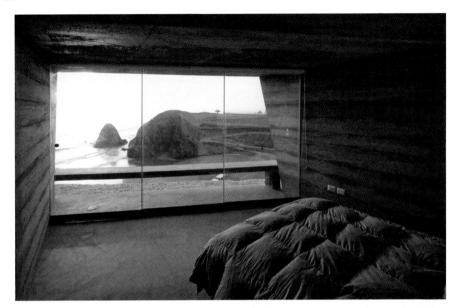

Full-height glazing offers a
stunning view of the shoreline
from one of the bedrooms. Right,
a concrete stair rises toward
the daylight, like a slit through
the concrete of the house.

Dank raumhoher Verglasung bietet
dieses Schlafzimmer einen beein-
druckenden Panoramablick auf den
Strand. Rechts eine Sichtbeton-
treppe, die wie ein Schnitt durch
den Baukörper zum Licht führt.

Dans une des chambres, une baie
vitrée toute hauteur offre une vue
stupéfiante sur la côte. À droite,
un escalier en béton monte vers la
lumière telle une fente entaillant le
béton de la maison.

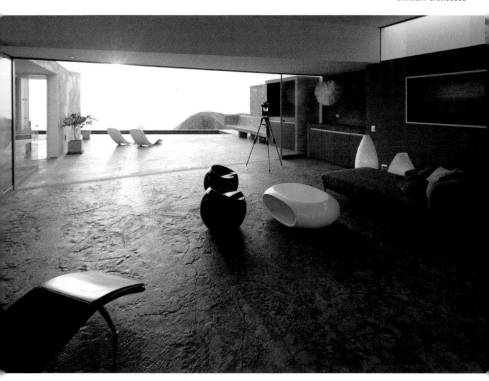

Above, a living area is directly con-
nected to the outside terrace thanks
to sliding windows. Below, section
drawings of the houses show their
insertion into the hillside.

Ein Wohnbereich (oben) ist durch
Schiebefenster direkt mit der
Terrasse verbunden. Querschnitte
(unten) illustrieren die Einbindung
der Häuser in das Hanggrundstück.

Ci-dessus : le séjour se trouve ici
directement dans la continuité de
la terrasse grâce à des baies vitrées
coulissantes. En bas : coupes mon-
trant l'insertion des maisons dans
le flanc de la colline.

HAGY BELZBERG

HAGY BELZBERG received his M.Arch degree from the Harvard GSD and began his professional career with explorations of non-standardized construction methodology involving digital manufacturing. In 2000, he was awarded the contract to design the interior space of Frank Gehry's Walt Disney Concert Hall, where he utilized digital machining and prefabrication to work within the complex existing structure. In 2008, he was selected as an "Emerging Voice" by the Architectural League of New York. His work includes the 20th Street Offices (Santa Monica, California, 2009); the Los Angeles Museum of the Holocaust (Los Angeles, California, 2003–10, published here); Kona Residence (Kona, Hawaii, 2010); 9800 Wilshire Boulevard Offices (Beverly Hills, California, 2012); City of Hope Cancer Research Museum (Duarte, California, 2013); and the Occidental College Center for Global Affairs (Los Angeles, California, 2013), all in the USA.

HAGY BELZBERG schloss sein Studium mit einem M.Arch. an der Harvard GSD ab und forschte zu Beginn seiner Laufbahn zu Konstruktionsmethoden mit nicht-standardisierten Bauteilen und digitaler Fertigung. 2000 gewann er die Ausschreibung für den Innenausbau der Walt Disney Concert Hall von Frank Gehry. Dort arbeitete er mit digitalen Fertigungsmethoden und digitaler Vorfertigung, um dem komplexen Bau gerecht zu werden. 2008 zeichnete ihn der Architektenverband New York als „Neues Talent" aus. Zu seinen Projekten zählen Büros an der 20th Street (Santa Monica, Kalifornien, 2009), das Holocaust-Museum in Los Angeles (Kalifornien, 2003–10, hier vorgestellt), die Kona Residence (Kona, Hawaii, 2010), Büros am 9800 Wilshire Boulevard (Beverly Hills, Kalifornien, 2012), das City of Hope Museum für Krebsforschung (Duarte, Kalifornien, 2013) sowie das Occidental College am Center for Global Affairs (Los Angeles, Kalifornien, 2013), alle in den USA.

HAGY BELZBERG a obtenu son diplôme de M.Arch. à la Harvard GSD et entamé sa carrière professionnelle par l'exploration de méthodologies de constructions non standard dont les techniques de fabrication pilotées par ordinateur. En 2000, il a été chargé de l'aménagement intérieur du Walt Disney Concert Hall de Frank Gehry où il a utilisé des techniques d'usinage numérique et de préfabrication pour s'adapter à la structure complexe. En 2008, il a été désigné « Voix émergente » par l'Architectural League de New York. Parmi ses réalisations, toutes aux États-Unis : les bureaux de la 20ᵉ Rue (Santa Monica, Californie, 2009) ; le Musée de l'Holocauste de Los Angeles (Los Angeles, 2003–10, publié ici) ; la Kona Residence (Kona, Hawaï, 2010) ; les bureaux du 9800 Wilshire Boulevard (Beverly Hills, Californie, 2012) ; le Musée de la recherche sur le cancer City of Hope (Duarte, Californie, 2013) et l'Occidental College Center for Global Affairs (Los Angeles, 2013).

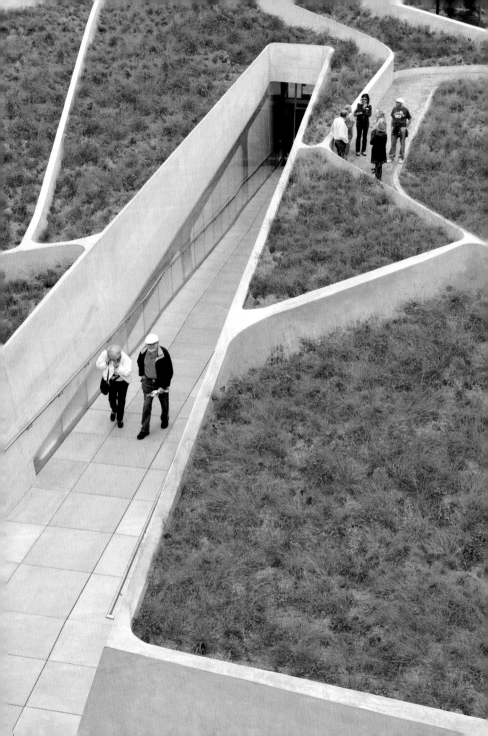

LOS ANGELES MUSEUM OF THE HOLOCAUST

Los Angeles, California, USA, 2003–10

Area: 1394 m². Client: E. Randol Schoenberg.
Cost: $14.8 million.

Completed in November of 2010, the new building for the **LOS ANGELES MUSEUM OF THE HOLOCAUST** is located within a public park adjacent to the existing Los Angeles Holocaust Memorial in Los Angeles. The museum is dedicated to commemoration and education, providing free education to the entire community with special consideration to underserved and underfunded schools, as well as to the Greater Los Angeles school system. The museum has one of the largest green roofs in Southern California and was certified LEED Gold by the US Green Building Council. The structure is embedded into the park landscape, allowing the green roof to occupy a maximum amount of area and providing thermal insulation. The green roof is entirely watered using an underground source. Exterior lighting comes from off-the-grid LED solar light poles that save as much as 75% in energy consumption. Products with recycled content account for 20% of the material costs. Embedded rebars contain 80% recycled content. Over 75% of the building benefits from natural daylight and views to the outdoors. The structure emerges from the park landscape as a single, curving concrete wall that splits and cuts into the ground to form the entry. Inside, the concrete forms intentionally evoke the images of bones. The land, owned by the city of Los Angeles, was donated solely because of the subterranean design scheme.

Das **HOLOCAUST-MUSEUM IN LOS ANGELES**, fertiggestellt im November 2010, liegt in einem Park in unmittelbarer Nachbarschaft zum Holocaust Memorial in Los Angeles. Das Museum versteht sich als Gedächtnisstätte und bietet Bildungsprogramme an, darunter kostenfreie Veranstaltungen für kommunale Einrichtungen, insbesondere für Schulen mit geringem kulturellen Angebot und Schulen aus dem Großraum Los Angeles. Das Museum mit einer der größten begrünten Dachanlagen Südkaliforniens wurde mit einem LEED-Zertifikat in Gold ausgezeichnet. Das Dach des in den Park eingebetteten Gebäudes nimmt einen Großteil der bebauten Fläche ein und sorgt zugleich für Wärmedämmung. Das begrünte Dach wird ausschließlich mit Grundwasser bewässert. Vom Stromnetz unabhängige LED-Solar-Lichtsäulen sorgen für Licht im Außenraum, wodurch der Energieverbrauch um bis zu 75 % gesenkt werden konnte. 20 % des Budgets entfielen auf recycelte Baumaterialien. So bestehen die integrierten Bewehrungsstäbe aus 80 % Recyclingmaterial. Über 75 % des Gebäudes werden mit Tageslicht versorgt und bieten einen Ausblick in die Umgebung. Der Bau erhebt sich aus der Landschaft wie eine einzelne geschwungene Betonmauer, die sich aufteilt und in die Erde einschneidet, um den Eingang zu bilden. Im Inneren sollen die Betonformen an Knochen erinnern. Das städtische Baugelände wurde nur wegen der unterirdischen Planung der Anlage freigegeben.

Achevé en novembre 2010, le nouveau bâtiment du **MUSÉE DE L'HOLOCAUSTE DE LOS ANGELES** est situé dans un jardin public adjacent au mémorial de l'Holocauste. Il est consacré à la commémoration et à l'éducation et propose des cours gratuits à l'ensemble de la communauté, en prenant spécialement en considération les écoles défavorisées et sous-financées, ainsi que le système scolaire du grand Los Angeles. Le musée possède l'un des plus vastes toits végétalisés du Sud de la Californie et a été certifié LEED or par l'US Green Building Council. La structure a été enterrée afin que le toit occupe l'espace maximal, tout en assurant l'isolation thermique. Sa végétation est entièrement irriguée par une source souterraine. L'éclairage extérieur est assuré par des lampadaires solaires à LED non raccordés au réseau qui permettent d'économiser jusqu'à 75 % d'énergie. Les produits recyclables représentent 20 % des frais de matériel. Les barres d'armature enterrées sont recyclables à 80 %. Plus de 75 % du bâtiment reçoit la lumière du jour et a vue sur l'extérieur. La structure émerge du paysage du parc tel un mur de béton simple et courbe qui s'entrecoupe et entaille le sol afin de former l'entrée. À l'intérieur, les formes de béton évoquent intentionnellement des images d'ossements. Le terrain, propriété de la ville de Los Angeles, a uniquement été donné en raison du concept souterrain.

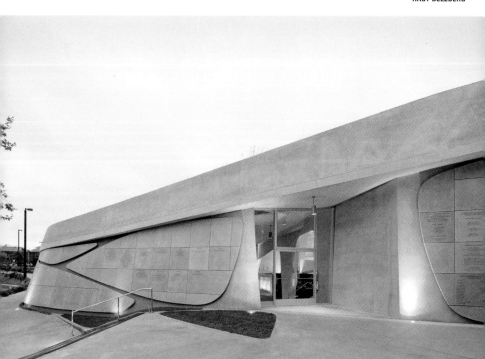

An entrance appears as hardly more than a slit in the earth reached by a sloped concrete and glass-lined walkway. Below, drawings show the way the structure is inserted into the earth.

Der Eingang wirkt eher wie ein Spalt in der Erde und wird über einen steilen, von Beton und Glas eingefassten Fußweg erreicht. Unten: An den Zeichnungen lässt sich ablesen, wie das Gebäude in das Gelände eingefügt ist.

L'entrée semble juste une fente dans la terre où l'on pénètre par une chaussée en pente de béton doublé de verre. Ci-dessous, les schémas montrent comment l'ensemble est enterré.

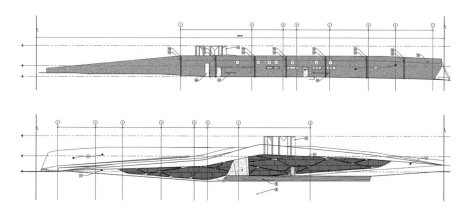

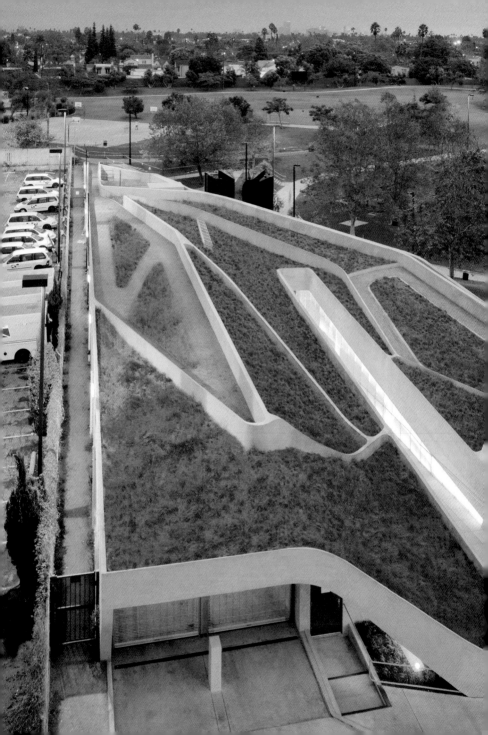

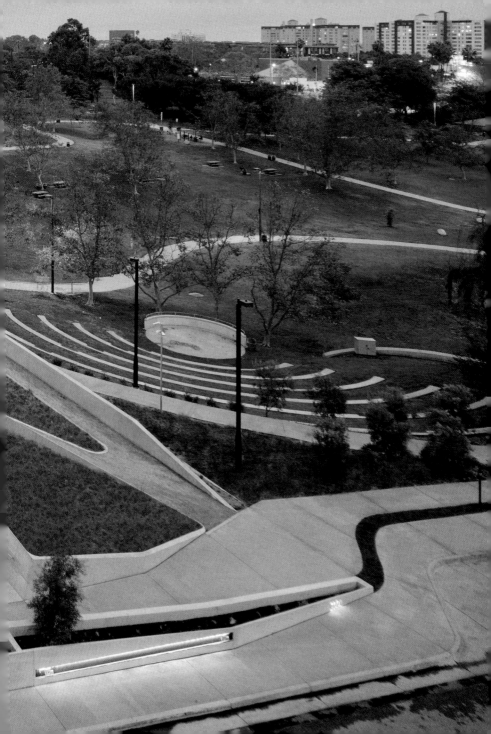

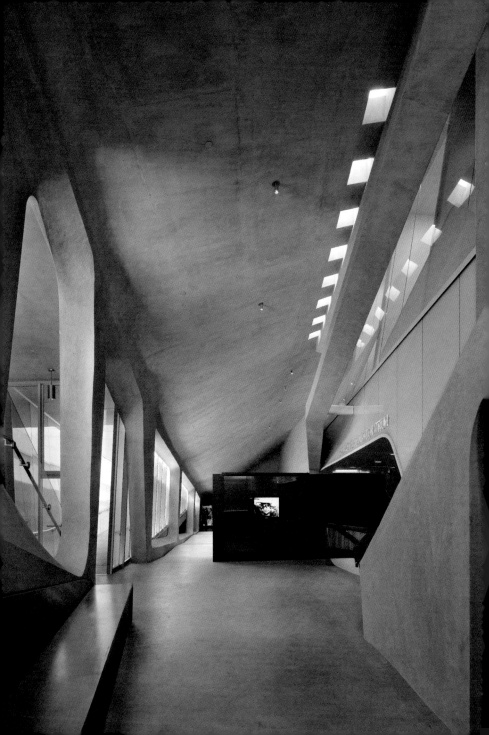

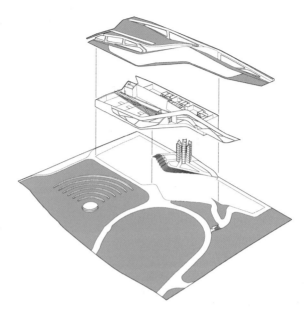

Without resorting to the strong destabilization of spaces employed by Daniel Libeskind in his Jewish Museum in Berlin, Belzberg makes his point by digging into the earth, allowing in some natural light.

Belzberg Architects entschieden sich, im Gegensatz zur starken Destabilisierung der Räume von Daniel Libeskind im Jüdischen Museum in Berlin, dafür, das Gebäude in die Erde einzugraben, aber sorgen dennoch für ein gewisses Maß an natürlicher Belichtung.

Sans avoir recours à la déstabilisation extrême des espaces utilisée par Daniel Libeskind au Musée juif de Berlin, Belzberg convainc en enterrant son bâtiment tout en laissant la lumière du jour y pénétrer.

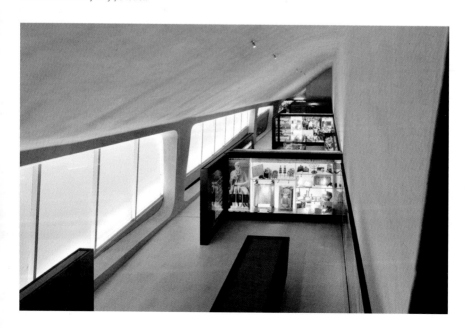

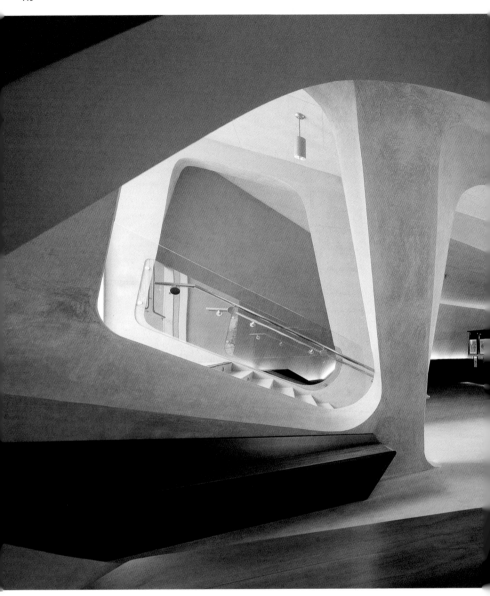

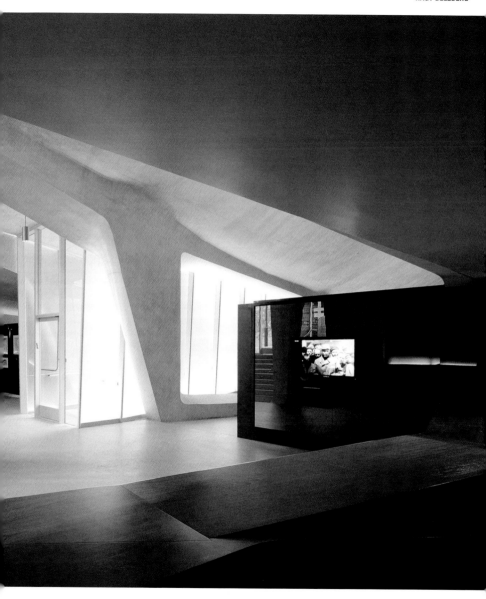

The continuous concrete walls have openings that allow natural light into the gallery or lobby spaces as seen in this image.

Wie diese Abbildung zeigt, haben die durchgehenden Betonwände Öffnungen, die natürliches Licht in die Ausstellungsbereiche und die Eingangshalle einlassen.

Les murs ininterrompus de béton sont percés d'ouvertures qui font entrer la lumière du jour dans les salles d'exposition ou les espaces d'accueil.

TATIANA BILBAO

TATIANA BILBAO was born in Mexico City in 1972. She graduated in Architecture and Urbanism from the Universidad Iberoamericana (Mexico City) in 1996. In 2004, she created Tatiana Bilbao S.C., with projects in China, Spain, France, and Mexico. In 2005, she cofounded the urban research center MXDF with Derek Dellekamp, Arturo Ortiz, and Michel Rojkind, and also became a Professor of Design at the Universidad Iberoamericana. In 2010, two new Partners, David Vaner and Catia Bilbao, joined her firm. She curated the Ruta del Pelegrino, or Route of the Pilgrim (with Derek Dellekamp), a 117-kilometer pilgrimage route where numerous architects created stopping points and small buildings, from Ameca to Talpa de Allende (Jalisco, Mexico, 2009–11). Her built work includes Ajijic House, Chapala Lake (Jalisco, 2011); Casa Ventura (Monterrey, 2011–12, published here); Ciudadela, offices and headquarters of the National Library of Mexico (Mexico City, 2012); B3, B7, and B8—three housing complexes in the "Ilot A3" project (Lyon, France, 2013–18); the Culiacán Botanical Garden (Culiacán, 2011–14, also published here); Veracruz Towers (Veracruz, 2011–12); and Casa Demialma (Zihuatanejo, Joluta, 2011–14), all in Mexico unless stated otherwise.

TATIANA BILBAO wurde 1972 in Mexiko-Stadt geboren. 1996 beendete sie ihr Studium der Architektur und des Städtebaus an der Universidad Iberoamericana (Mexiko-Stadt). 2004 gründete sie Tatiana Bilbao S. C. mit Projekten in China, Spanien, Frankreich und Mexiko. 2005 gründete sie mit Derek Dellekamp, Arturo Ortiz und Michel Rojkind das städtebauliche Forschungszentrum MXDF und wurde zur Professorin für Design an der Universidad Iberoamericana berufen. 2010 traten zwei neue Partner, David Vaner und Catia Bilbao, in das Büro ein. Tatiana Bilbao war (mit Derek Dellekamp) Kuratorin der Ruta del Pelegrino, eines 117 km langen Pilgerwegs von Ameca nach Talpa de Allende, für den zahlreiche Architekten Haltepunkte und kleine Gebäude entwarfen (Jalisco, Mexiko, 2009–11). Zu ihren ausgeführten Bauten zählen: Haus Ajijic am Chapalasee (Jalisco, 2011), die Casa Ventura (Monterrey, 2011–12, hier vorgestellt), Ciudadela, Bürogebäude und Hauptsitz der Nationalbibliothek von Mexiko (Mexiko-Stadt, 2012), B3, B7 und B8 – drei Wohnkomplexe im Projekt „Ilot A3" in Lyon (Frankreich, 2013–18), der Botanische Garten in Culiacán (2011–14), die Veracruz-Türme (Veracruz, 2011–12) und die Casa Demialma (Zihuatanejo, Joluta, 2011–14), alle in Mexiko, sofern nicht anders angegeben.

TATIANA BILBAO est née à Mexico en 1972. Elle possède un diplôme en architecture et urbanisme (1996) de l'Universidad Iberoamericana (Mexico). Elle a créé Tatiana Bilbao S.C. en 2004 avec des projets en Chine, en Espagne, en France et au Mexique. En 2005, elle a fondé le centre de recherches urbaines MXDF avec Derek Dellekamp, Arturo Ortiz et Michel Rojkind et est devenue professeur de design à l'Universidad Iberoamericana. Deux nouveaux partenaires ont rejoint l'agence en 2010, David Vaner et Catia Bilbao. Tatiana Bilbao a coordonné (avec Derek Dellekamp) la Ruta del Pelegrino, la Route du pèlerin, un chemin de pèlerinage de 117 km où de nombreux architectes ont créé des haltes et de petits bâtiments, d'Ameca à Talpa de Allende (Jalisco, Mexique, 2009–11). Ses réalisations déjà construites comprennent la maison Ajijic au bord du lac de Chapala (Jalisco, 2011) ; la Casa Ventura (Monterrey, 2011–12, publiée ici) ; Ciudadela, des immeubles de bureaux et siège de la Bibliothèque nationale de Mexico (Mexico, 2012) ; B3, B7 et B8 – trois complexes résidentiels de l'« Îlot A3 » (Lyon, France, 2013–18) ; le jardin botanique de Culiacán (2011–14) ; les tours Veracruz (Veracruz, 2011–12) et la Casa Demialma (Zihuatanejo, Joluta, 2011–14), toutes au Mexique sauf si spécifié.

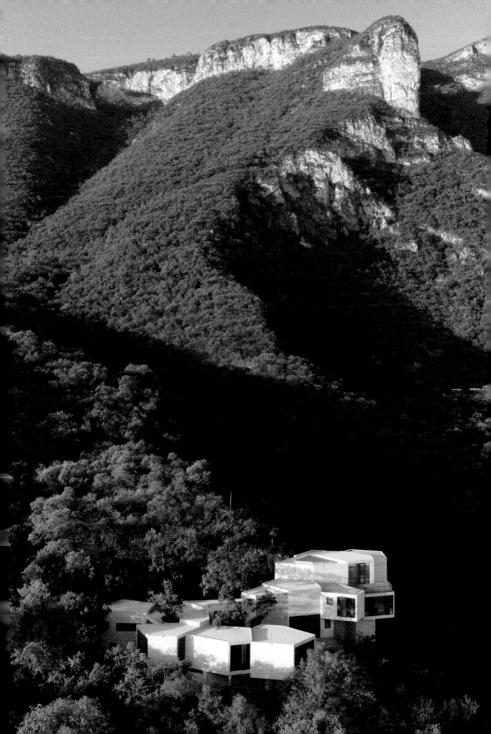

CASA VENTURA

Monterrey, Mexico, 2011–12

Area: 854 m².

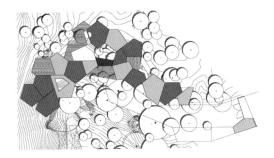

The **CASA VENTURA** is a family house set on a sloped, one-hectare site in the suburbs of Monterrey, with a panoramic view of the city. The client wanted a residence with a clear distinction between public and private spaces, as well as an orientation that would provide passive energy savings. The architects state: "The site reminds us of the image of the modernist houses of the 1950s, photographed by Julius Shulman. This reference was a starting point and an inspiration to begin our design." Each part of the program is inscribed in a pentagon that is adapted or "deformed" according to the site and to the movement of residents. The flatter part of the site is used for public space while the private areas are in closer contact with the hilly topography—a spiral staircase unites the two zones. Concrete "in its most apparent and natural form" was used to increase the sense of "belonging to the location." The architects also state that the design is inspired by funguses that grow on trees and "somehow become part of them."

Das Einfamilienhaus **CASA VENTURA** steht auf einem 1 ha großen Hanggrundstück in einem Vorort von Monterrey mit Panoramaaussicht auf die Stadt. Der Bauherr wünschte sich ein Haus mit klarer Trennung von öffentlichen und privaten Räumen sowie einer Ausrichtung, die passive Energieeinsparung ermöglicht. Die Architektin erläutert: „Der Bauplatz erinnerte mich an die Grundstücke der modernistischen Häuser der 1950er-Jahre, die Julius Shulman fotografiert hat. Dieser Bezug war der Ausgangspunkt und eine Anregung für unseren Entwurf." Jedes Element des Programms ist in ein Fünfeck eingeschrieben, das dem Gelände und der Bewegung der Bewohner entsprechend angepasst oder „deformiert" wurde. Der ebenere Teil des Grundstücks ist für die öffentlichen Räume genutzt, während die privaten Bereiche sich mehr der hügeligen Topografie anpassen – eine Wendeltreppe vereint beide Zonen. Beton „in seiner sichtbarsten und natürlichsten Form" wurde benutzt, um das Gefühl zu verstärken, dass „der Bau zum Standort gehört". Die Architektin sagt auch, dass der Entwurf von den Pilzen inspiriert sei, die auf Bäumen wachsen und „irgendwie zum Teil derselben werden".

La maison familiale **CASA VENTURA** est située sur un terrain en pente d'un hectare dans la banlieue de Monterrey, avec vue panoramique sur la ville. Le client souhaitait une construction avec des espaces privés et publics clairement séparés et une orientation permettant des économies d'énergie passive. Pour les architectes : « Le site nous rappelle les maisons modernistes des années 1950 photographiées par Julius Shulman. Cette référence a été un point de départ et une source d'inspiration. » Les différentes parties de l'ensemble sont inscrites dans un pentagone adapté ou « déformé » selon le site et l'évolution des habitants. La partie la plus plane du terrain est occupée par l'espace public, tandis que les zones privées sont plus proches de la topographie vallonnée – un escalier en colimaçon relie les deux. Le béton « dans sa forme la plus apparente et naturelle » a été utilisé pour renforcer le sentiment d'« appartenance au site ». Les architectes ont également déclaré s'être inspirés de champignons qui poussent sur les arbres et « finissent d'une certaine manière par en faire partie ».

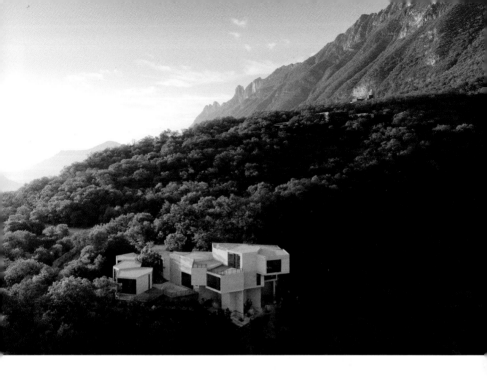

The house appears as a cluster of interconnected irregular pentagons. This fact is most clearly seen in the site on the left.

Das Haus wirkt wie eine Zusammenstellung unregelmäßiger, miteinander verbundener Fünfecke. Dies ist auf dem Lageplan links deutlich erkennbar.

La maison fait penser à un groupe de pentagones irréguliers communiquant les uns avec les autres, une impression illustrée encore plus clairement par le plan de situation à gauche.

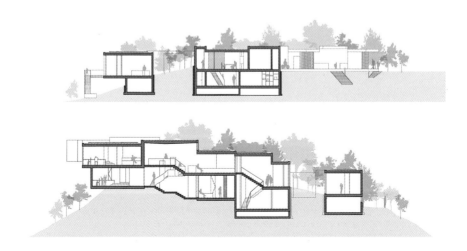

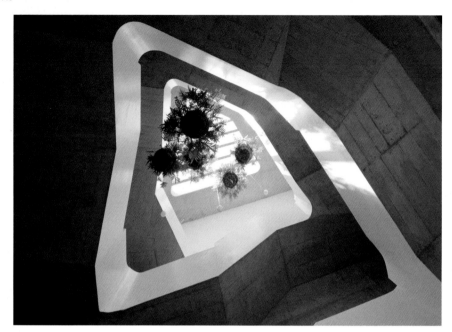

The way the volumes of the house are stepped into and over the hilly site is seen in the drawings below. The inner courtyard seen on the right or in the image above shows how Tatiana Bilbao succeeds in bringing elements of nature into the esign despite its overall geometric development.

Wie auf den Zeichnungen unten ablesbar, wurden die Baumassen des Hauses abgestuft in und auf das Hanggrundstück gesetzt. Der rechts und oben sichtbare Innenhof zeigt, wie Tatiana Bilbao natürliche Elemente in den geometrischen Gesamtplan integriert hat.

On voit sur les schémas ci-dessous comment les différents volumes sont échelonnés dans et sur le terrain vallonné. La cour intérieure photographiée ici montre bien comment Tatiana Bilbao parvient à intégrer des éléments naturels malgré un déploiement globalement géométrique.

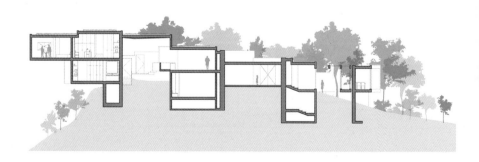

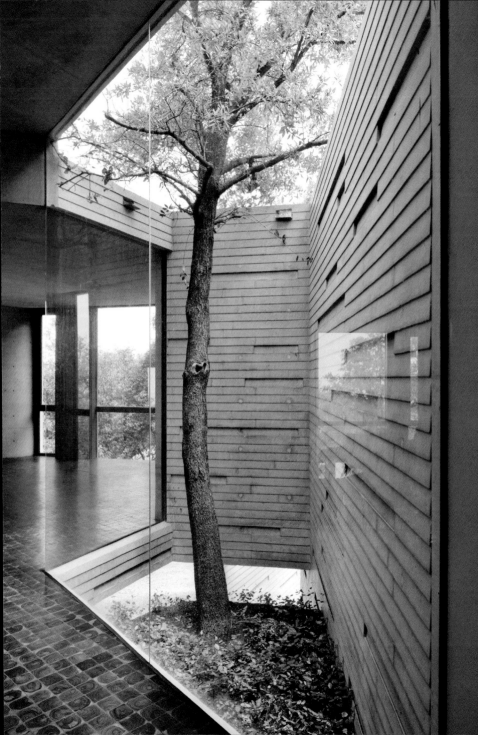

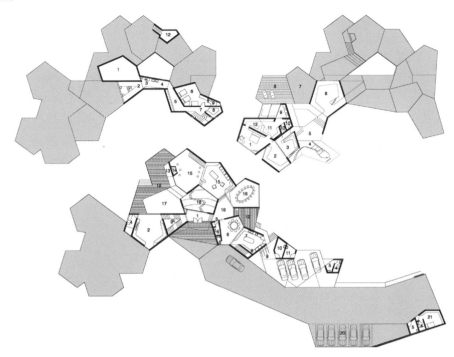

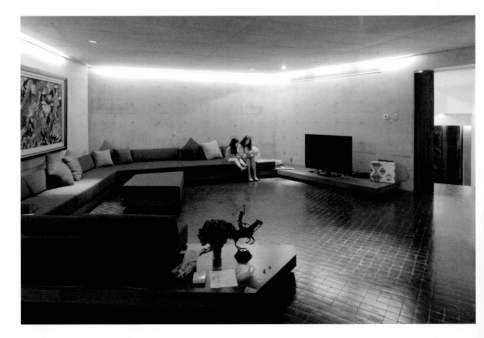

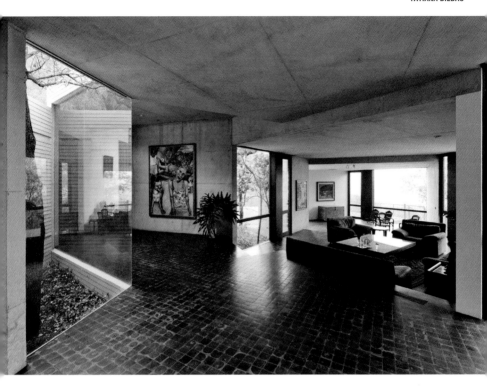

Above, by alternating fully glazed surfaces with concrete walls and tiled floors the architect creates continual spatial surprises.

Oben: Durch den Wechsel von voll verglasten Oberflächen mit Betonwänden sowie gefliesten Böden bildet die Architektin überraschende Raumfolgen.

Ci-dessus, en faisant alterner les surfaces entièrement vitrées avec les murs de béton et les sols carrelés, les architectes créent un espace qui surprend sans cesse.

Left page, a living area is essentially defined by concrete walls, but light comes in from above. The drawings show the levels of the structure.

Linke Seite: Der Wohnbereich wird überwiegend von Betonwänden eingefasst; Licht fällt von oben ein. Die Pläne zeigen die verschiedenen Ebenen des Gebäudes.

Page de gauche, l'espace séjour est défini essentiellement par ses murs de béton, mais éclairé par en haut. Les schémas montrent les différents niveaux de la structure.

BNKR

BNKR is a Mexico City–based architecture, urbanism, and research office founded by Esteban Suárez in 2005 in partnership with his brother Sebastian Suárez. **ESTEBAN SUÁREZ** was born in 1978 in Mexico City and received degrees in Architecture and Urban Planning from the Universidad Iberoamericana (Mexico City) in 2004. In 2005, he founded Bunker Arquitectura—BNKR. **SEBASTIAN SUÁREZ**, born in 1981 also in Mexico City, studied communications science at the Universidad Nuevo Mundo (UNUM) in Mexico City. He joined BNKR in 2006 as a Partner and Creative Director. In 2012, he was named Senior Partner and CBO. **MARCELL IBARROLLA**, born in 1987, studied philosophy at the UP in Mexico City, before obtaining a degree in Architecture. He joined Bunker Arquitectura in 2009 as project architect and in 2012 was named Partner and CMO of the firm. Aside from the Sunset Chapel (Acapulco, 2011, published here), their work includes the Alviento Apartments (Acapulco, 2008); the Guzmán Fountain Plaza (Guzmán City, Jalisco, 2009); Hotel Filadelfia (Mexico City, 2010); and Musas Amphitheater (Hermosillo, Sonora, 2011), all in Mexico.

BNKR ist ein Büro für Architektur, Städtebau und Forschung in Mexiko-Stadt, das 2005 von Esteban Suárez in Partnerschaft mit seinem Bruder gegründet wurde. **ESTEBAN SUÁREZ** wurde 1978 in Mexiko-Stadt geboren und beendete 2004 sein Studium der Architektur und Stadtplanung an der Universidad Iberoamericana (Mexiko-Stadt). 2005 gründete er Bunker Arquitectura – BNKR. **SEBASTIAN SUÁREZ** wurde 1981 ebenfalls in Mexiko-Stadt geboren und studierte Kommunikationswissenschaften an der Universidad Nuevo Mundo (UNUM) in Mexiko-Stadt. 2006 trat er als Partner und Kreativdirektor bei BNKR ein. 2012 wurde er Seniorpartner und Mitglied der Geschäftsleitung. **MARCELL IBARROLLA**, geboren 1987, studierte Philosophie an der Universidad Panamericana (UP) in Mexiko-Stadt, bevor er sein Diplom in Architektur machte. 2009 trat er bei Bunker Arquitectura als Projektarchitekt ein und wurde 2012 zum Partner und Marketingleiter der Firma ernannt. Außer der Sunset Chapel (Acapulco, 2011, hier vorgestellt) zählen zu ihren ausgeführten Projekten: die Alviento Apartments (Acapulco, 2008), die Plaza Las Fuentes (Ciudad de Guzmán, Jalisco, 2009), das Hotel Filadelfia (Mexiko-Stadt, 2010) und das Amphitheater Musas (Hermosillo, Sonora, 2011), alle in Mexiko.

BNKR est un bureau d'architecture, urbanisme et recherches basé à Mexico, fondé par Esteban Suárez en 2005 en partenariat avec son frère Sebastian Suárez. **ESTEBAN SUÁREZ** est né en 1978 à Mexico et titulaire de diplômes en architecture et urbanisme (2004) de l'Universidad Iberoamericana (Mexico). Il a fondé Bunker Arquitectura – BNKR en 2005. **SEBASTIAN SUÁREZ**, né en 1981 à Mexico, a fait des études en sciences de la communication à l'Universidad Nuevo Mundo (UNUM) de Mexico. Il a rejoint BNKR en 2006 en tant que partenaire et directeur créatif. Il a été nommé associé principal et CBO en 2012. **MARCELL IBARROLLA**, né en 1987, a fait des études de philosophie à l'Universidad Panamericana (UP) de Mexico avant d'obtenir un diplôme en architecture. Il a rejoint Bunker Arquitectura en 2009 en tant qu'architecte projets et en a été nommé partenaire et directeur marketing en 2012. Outre la Sunset Chapel (Acapulco, 2011, publiée ici), leurs réalisations comprennent les appartements Alviento (Acapulco, 2008) ; la place de la Fontaine de Guzmán (Guzmán, Jalisco, 2009) ; l'hôtel Filadelfia (Mexico, 2010) et l'amphithéâtre Musas (Hermosillo, Sonora, 2011), toutes au Mexique.

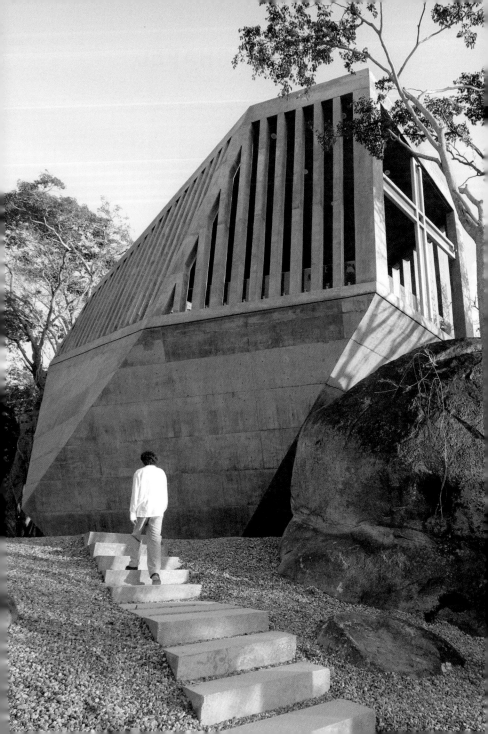

SUNSET CHAPEL

Acapulco, Mexico, 2011

Area: 120 m².

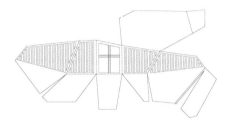

The **SUNSET CHAPEL** was intended to mourn the passing of loved ones. The client wished to take advantage of spectacular views from the site, and the sun had to set exactly behind the altar cross (which is possible twice a year at the equinoxes). And, the architects add: "A section with the first phase of crypts had to be included outside and around the chapel. Metaphorically speaking, the mausoleum would be in perfect utopian synchrony with a celestial cycle of continuous renovation." Because a very large boulder to the west blocked views of sunsets from the site, the design called for it to be elevated by five meters, creating a footprint just half the size of the upper level. The architects conclude: "Acapulco's hills are made up of huge granite rocks piled on top of each other. In a purely mimetic endeavor, we worked hard to make the chapel look like 'just another' colossal boulder atop the mountain."

Die **SONNENUNTERGANGSKAPELLE** war als Ort der Trauer um Verstorbene gedacht. Der Bauherr wollte die spektakuläre Aussicht des Geländes ausnutzen; die Sonne sollte exakt hinter dem Altarkreuz untergehen (was nur zweimal im Jahr an den Tagundnachtgleichen möglich ist). Und die Architekten ergänzen: „Mit dem ersten Bauabschnitt sollte ein Teil der Krypta außen und um die Kapelle hinzugefügt werden. Bildlich gesprochen, sollte sich das Mausoleum in vollkommenem, utopischem Einklang mit einem überirdischen Zyklus der beständigen Erneuerung befinden." Weil ein sehr großer Felsblock an der Westseite den Anblick des Sonnenuntergangs behinderte, haben die Architekten den Bau um 5 m angehoben, sodass der Grundriss nur die halbe Größe des Obergeschosses bildet. Abschließend erklärten sie: „Acapulcos Berge bestehen aus gewaltigen, übereinandergeschichteten Granitfelsen. In rein mimetischer Absicht haben wir uns sehr bemüht, dass die Kapelle ‚nur wie ein weiterer' kolossaler Felsblock auf dem Berg aussieht."

La **CHAPELLE DU COUCHER DU SOLEIL** était au départ vouée à pleurer le départ des êtres aimés. Le client souhaitait tirer parti des vues extraordinaires, avec le soleil qui devait se coucher juste derrière la croix de l'autel (ce qui se produit deux fois par an aux équinoxes) et, complètent les architectes : «Une partie comprenant la première phase de la crypte devait être incluse à l'extérieur et autour de la chapelle. Métaphoriquement parlant, le mausolée serait ainsi en parfaite synchronie utopique avec un cycle céleste de renouvellement permanent.» Or, un énorme rocher à l'ouest empêchait toute vue du soleil couchant depuis le site, de sorte que la chapelle a dû être surélevée de 5 m pour une empreinte au sol deux fois plus petite que le niveau supérieur. Les architectes expliquent en conclusion que «les collines d'Acapulco sont constituées d'énormes blocs de granite empilés les uns sur les autres. Notre tentative est purement mimétique et nous avons travaillé dur pour que la chapelle ressemble simplement à "un autre" énorme bloc au sommet d'une montagne».

Strong, unexpected forms mark this design that seems to sit in precarious balance on its stone base. A drawing above presents the building like an unfolded model.

Kräftige, ungewöhnliche Formen kennzeichnen diesen Bau, der in fragilem Gleichgewicht auf seiner steinernen Basis steht. Die Zeichnung oben zeigt das Gebäude wie ein sich entfaltendes Modell.

Les formes massives et insolites dominent dans cette conception qui semble posée en équilibre instable sur sa base de pierre. Le schéma ci-dessus fait apparaître le bâtiment comme un modèle qui n'aurait pas été déplié.

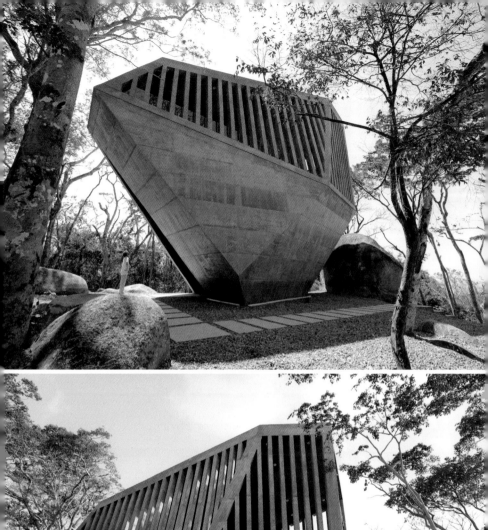
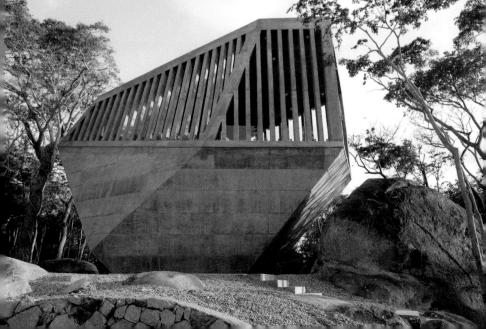

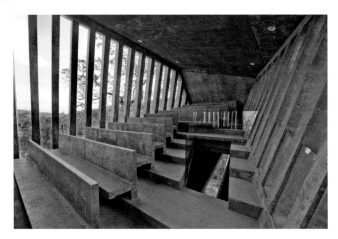

Concrete is also the material used inside the chapel, which admits generous natural light. Its numerous openings obviate any sense of enclosure or oppression that might result from the concrete surroundings.

Beton dominiert auch das Innere der Kapelle. Der großzügig mit natürlichem Licht erfüllte Raum ist mit zahlreichen Öffnungen versehen. Dadurch wird jede einschließende oder bedrückende Wirkung vermieden, die vom umgebenden Beton ausgehen könnte.

Le béton est aussi le matériau utilisé à l'intérieur de la chapelle où il laisse généreusement pénétrer la lumière naturelle. Les ouvertures multiples préviennent toute impression d'enfermement ou d'oppression que cet entourage de béton pourrait sinon susciter.

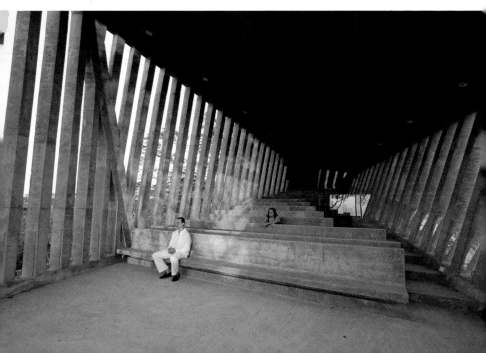

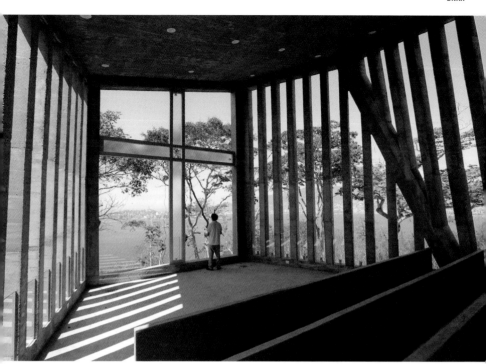

The vertical band windows culminate in this broad view of the water with a cross inscribed in it. Though the chapel's form is unusual and exuberant, the interior is simply focused on this cross.

Das vertikal strukturierte Fensterband führt zum offenen, durch ein eingelassenes Kreuz geprägten Ausblick auf das Wasser. Obgleich die Kapelle eine ungewöhnliche und ausladende Form hat, ist der Innenraum auf dieses Kreuz ausgerichtet.

Les fenêtres en bandes verticales culminent dans cette vue panoramique sur l'eau portant inscrite une croix. Malgré la forme insolite et originale de la chapelle, l'intérieur est centré très simplement sur cette croix.

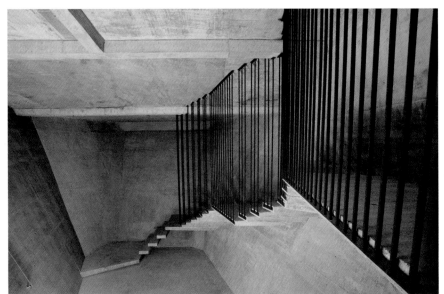

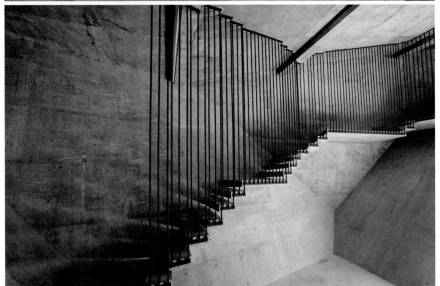

Above, a stairway in concrete seems to be suspended from a screen of metal bars. The design shows how malleable concrete can be in the right hands.

Oben: Eine Treppe aus Beton wirkt wie an einer Zwischenwand aus Metallstangen aufgehängt. Der Entwurf zeigt, wie formbar Beton in den richtigen Händen sein kann.

Ci-dessus, un escalier en béton semble suspendu à un rideau de barres métalliques. L'ensemble illustre parfaitement la souplesse du béton lorsqu'il est placé dans de bonnes mains.

Seen from a different angle the concrete slabs of the stairway seem to hover in space, while natural light emphasizes the angled architectural forms.

Aus einem anderen Blickwinkel scheinen die Betonplatten der Treppe im Raum zu schweben, während das natürliche Licht die scharfen Architekturformen hervorhebt.

Vues sous un angle différent, les dalles de béton qui forment l'escalier semblent flotter dans l'espace, tandis que la lumière naturelle met en valeur les formes anguleuses de l'architecture.

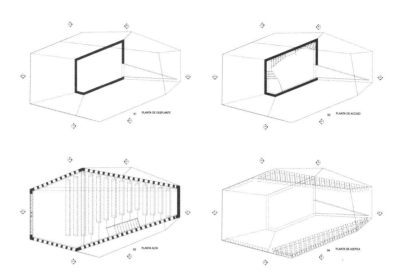

01 PLANTA DE DESPLANTE

02 PLANTA DE ACCESO

03 PLANTA ALTA

04 PLANTA DE AZOTEA

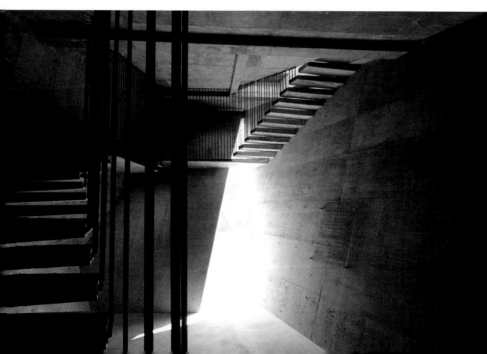

BUCHNER BRÜNDLER

Buchner Bründler Architects was established by Daniel Buchner and Andreas Bründler in Basel in 1997. Born in Berneck, Switzerland, in 1967, **DANIEL BUCHNER** graduated from the University of Applied Sciences in Basel in 1993, and worked for Morger & Degelo Architects in Basel before creating the present firm. He was a Guest Professor at the EPFL in Lausanne in 2008 and Guest Lecturer at the ETH in Zurich from 2010 to 2012. **ANDREAS BRÜNDLER** was born in 1967 in Sins, Switzerland. He graduated from the University of Applied Sciences in Basel in 1993 as well, working with Miller & Maranta Architects in Basel, prior to establishing the current partnership with Buchner. He was also a Guest Lecturer at the ETH in Zurich from 2010 to 2012. They have built houses in Büren (2000–02); Blonay (2001–02); and Aesch (2003–04); and the Set & Sekt Retail Store and Bar (Basel, 2007). The pair participated in artist Ai Weiwei's scheme for a public park in Jinhua (China, 2006–07) and also in his Ordos project (Ordos, Mongolia). They designed the Swiss Pavilion for Expo 2010 in Shanghai (China); and Chienbergreben House (Gelterkinden, 2011–12, published here), all in Switzerland unless otherwise.

Das Büro Buchner Bründler Architekten wurde 1997 von Daniel Buchner und Andreas Bründler in Basel gegründet. **DANIEL BUCHNER**, 1967 in Berneck in der Schweiz geboren, beendete 1993 sein Studium an der Hochschule für Angewandte Wissenschaften in Basel und arbeitete danach im Architekturbüro Morger & Degelo in Basel, bis er seine derzeitige Firma gründete. 2008 war er Gastprofessor an der Ecole Polytechnique Fédérale in Lausanne und 2010–12 Gastdozent an der Eidgenössischen Technischen Hochschule (ETH) in Zürich. **ANDREAS BRÜNDLER** wurde 1967 in Sins, Schweiz, geboren. Er studierte ebenfalls bis 1993 an der Hochschule für Angewandte Wissenschaften in Basel und arbeitete im Architekturbüro Miller & Maranta in Basel, bevor er die Partnerschaft mit Buchner einging. Auch er war 2010–12 Gastdozent an der ETH in Zürich. Das Büro hat Wohnhäuser in Büren (2000–02), Blonay (2001–02) und Aesch (2003–04) gebaut sowie den Concept Store Set & Sekt mit Bar (Basel, 2007). Beide Partner waren am Entwurf des Künstlers Ai Weiwei für einen öffentlichen Park in Jinhua (China, 2006–07) sowie an dessen Projekt für Ordos (Ordos, Mongolei) beteiligt. Sie planten außerdem den Schweizer Pavillon für die Expo 2010 in Schanghai (China) und das Haus Chienbergreben (Gelterkinden, 2011–12, hier vorgestellt), alle in der Schweiz, sofern nicht anders angegeben.

L'agence Buchner Bründler Architekten a été créée par Daniel Buchner et Andreas Bründler à Bâle en 1997. Né à Berneck, en Suisse, en 1967, **DANIEL BUCHNER** est diplômé de l'Université des sciences appliquées de Bâle (1993) et a travaillé pour Morger & Degelo Architects à Bâle avant de fonder l'entreprise actuelle. Il a été professeur invité à l'EPFL de Lausanne en 2008 et a donné des conférences à l'ETH de Zurich de 2010 à 2012. **ANDREAS BRÜNDLER** est né en 1967 à Sins, en Suisse. Il est également diplômé de l'Université des sciences appliquées de Bâle (1993) et a travaillé avec Miller & Maranta à Bâle avant son partenariat actuel avec Buchner. Il a également donné des conférences à l'ETH de Zurich de 2010 à 2012. Ils ont construit des maisons à Büren (2000–02) ; Blonay (2001–02) et Aesch (2003–04), ainsi que le magasin et bar Set & Sekt (Bâle, 2007). Ils ont participé au projet de l'artiste Ai Weiwei pour le parc de Jinhua (Chine, 2006–07) et à son projet à Ordos (Mongolie). Ils ont créé le pavillon de la Suisse pour l'Exposition universelle de 2010 à Shanghai et la maison Chienbergreben (Gelterkinden, publiée ici, 2011–12), toutes en Suisse sauf si spécifié.

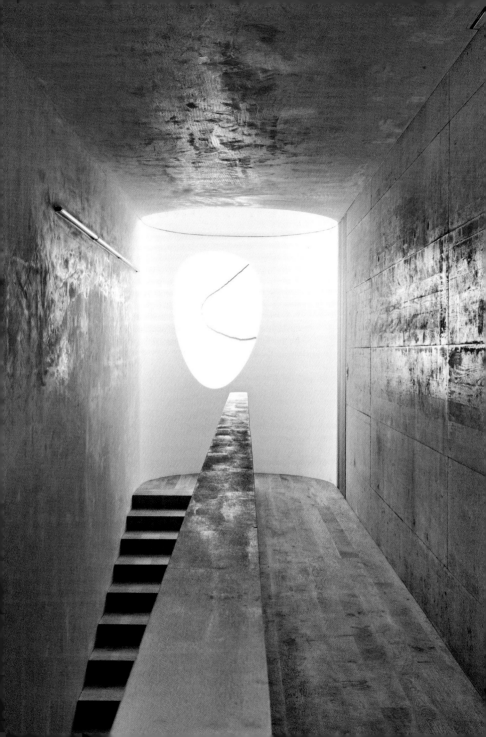

CHIENBERGREBEN HOUSE

Gelterkinden, Switzerland, 2011–12

Area: 335 m². Collaboration: Jenny Jenisch, Daniel Ebertshäuser.

The site of this two-story **CHIENBERGREBEN HOUSE** is situated near the town's agricultural area and a community center. The living area is on the ground floor, with bedrooms, bathrooms, and a wellness area above. The architects explain: "An entrance area in front of the house forms the starting point to a continuous layering of space, parallel to the slope. The room sequence develops from a compressed forecourt to open space through a linear alignment of the main residential functions. Continuous glazing enables broad panoramic views. The three-sided, windowless façade has a sculptural look." A terrace stretches across the width of the building and integrates a planter. The horizontal formwork of the concrete is visible, and interior walls and ceilings are also made of exposed concrete. The architects state: "The material's raw feel is complemented by the interior design in oak, which, together with the oak flooring, defines the interior landscape. The extensive formwork makes for a uniform atmosphere."

Das Grundstück dieses zweigeschossigen **HAUS CHIENBERGREBEN** liegt nahe dem landwirtschaftlich genutzten Gelände der Stadt und einem Gemeindezentrum. Der Wohnbereich befindet sich im Erdgeschoss, Schlafzimmer, Bäder und Wellnessräume liegen darüber. Die Architekten erläutern: „Ein Eingangsbereich an der Vorderseite des Hauses bildet den Ausgangspunkt für eine durchgehende Schichtung des Raumes parallel zum Hang. Die Raumfolge entwickelt sich vom verdichteten Vorhof zum offenen Bereich durch eine lineare Aneinanderreihung der wichtigen Wohnfunktionen. Durchgehende Verglasung bietet weite Panoramaaussichten. Die drei fensterlosen Fassaden sind plastisch ausgebildet." Eine Terrasse mit integriertem Pflanzbecken erstreckt sich über die ganze Breite des Hauses. Die horizontale Schalung des Betons ist sichtbar belassen, und auch die Innenwände und Decken sind aus Sichtbeton. Die Architekten erläutern: „Die raue Wirkung des Materials wird ergänzt durch die Innenausstattung in Eiche, die mit dem Fußboden aus gleichem Holz die innere Atmosphäre bestimmt. Die vielen Schalungsabdrücke erzeugen ein einheitliches Erscheinungsbild."

Le site occupé par le **MAISON CHIENBERGREBEN** à deux étages jouxte la zone agricole de la ville et un centre communautaire. Le séjour est au rez-de-chaussée, avec des chambres, salles de bains et un espace bien-être au-dessus. Les architectes expliquent: «Une entrée à l'avant de la maison donne le départ à un dégradé continu de l'espace parallèle à la pente du terrain. L'enfilade des pièces prend son essor à partir d'une avant-cour resserrée vers un espace ouvert à travers l'alignement des principales fonctions résidentielles. Le vitrage continu ouvre de vastes vues panoramiques. La façade à trois côtés sans fenêtres présente une apparence sculpturale.» Une terrasse plantée se déploie sur toute la largeur du bâtiment. Le coffrage horizontal du béton est visible, les murs intérieurs et les plafonds sont également en béton apparent. Les architectes déclarent: «La sensation brute dégagée par le matériau est complétée par l'aménagement intérieur en chêne qui définit le paysage intérieur avec le plancher de chêne. L'ampleur du coffrage confère une atmosphère unique à l'ensemble.»

The exterior of the building fully assumes its concrete materiality, offering an almost enigmatic, sculptural presence close to other buildings that are more traditional.

Die Außenform des Gebäudes übernimmt alle Eigenschaften des Materials Beton und hat eine fast rätselhafte, plastische Präsenz, ganz in der Nähe traditionellerer Gebäude.

L'extérieur du bâtiment assume pleinement la matérialité du béton qui lui confère une présence sculpturale presque énigmatique à côté des autres bâtiments plus traditionnels.

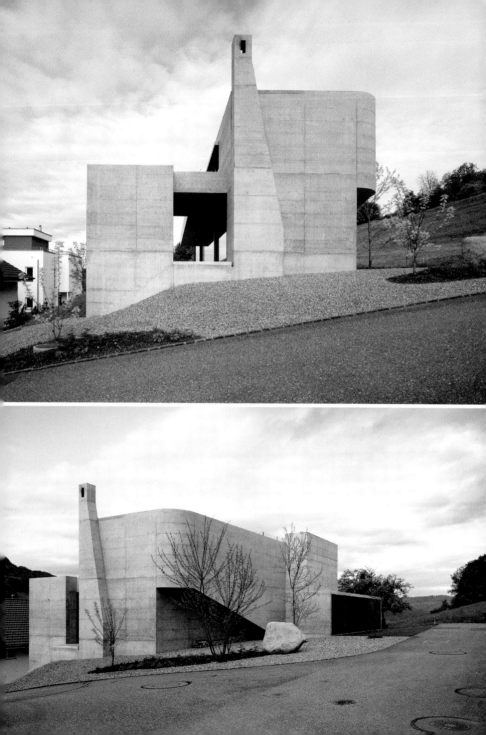

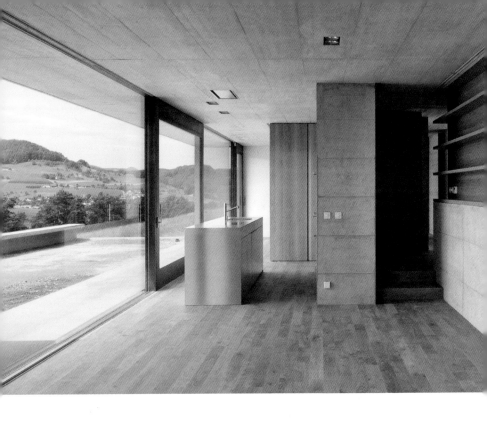

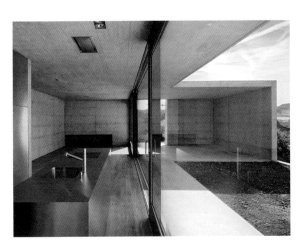

Concrete is also present inside the house, but its grayness is alleviated by the use of wood and generous glazed surfaces.

Beton ist auch im Innern des Hauses präsent; seine graue Färbung wird jedoch durch die Verwendung von Holz und durch großzügige Verglasung zurückgedrängt.

Le béton est également présent à l'intérieur de la maison, mais le gris en est adouci par l'utilisation du bois et les vastes surfaces vitrées.

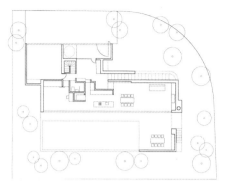
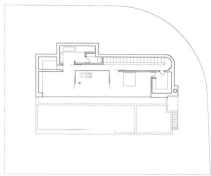

Plans show the way one space essentially blends into the next. In the interiors, the architects show the same sense of sculptural volume that is seen from the outside.

Die Grundrisse zeigen, wie die Räume ineinander übergehen. Im Innern erreichen die Architekten die gleiche plastische Wirkung der Volumen wie bei der äußeren Gestalt.

Les plans montrent comment les espaces se fondent successivement et singulièrement l'un à l'autre. Les architectes ont fait preuve du même sens des volumes sculpturaux à l'intérieur qu'à l'extérieur.

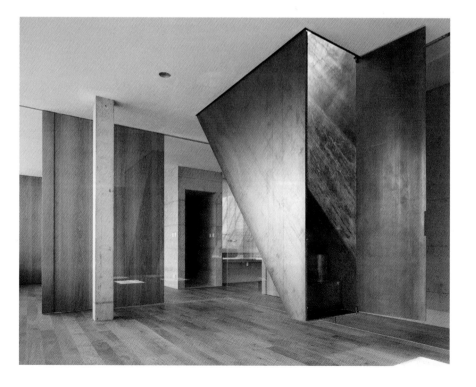

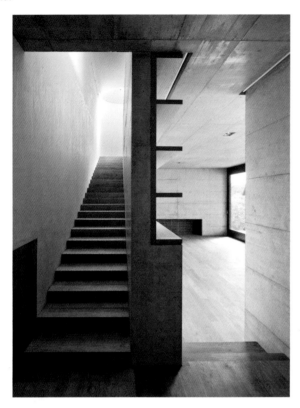

The bathroom seen to the right takes the use of concrete even further, confirming a certain coldness which emerges from the house as it is seen from the outside.

Im rechts sichtbaren Badezimmer geht die Verwendung von Beton noch weiter und bestätigt eine gewisse Kühle, die das Haus von außen betrachtet ausströmt.

La salle de bains, à droite, va encore plus loin dans l'utilisation du béton et reprend la relative froideur qui émane de la maison vue de l'extérieur.

Although there is a certain austerity in the design, the frequent presence of wood and also the admission of natural light bring spaces to life. Below, a section drawing.

Obgleich den Entwurf eine gewisse Strenge kennzeichnet, erfüllen das viele Holz wie auch die großzügige natürliche Belichtung die Räume mit Leben. Unten: Schnitt.

Malgré une certaine austérité dans le design, la présence abondante du bois et la lumière naturelle donne vie aux espaces. Ci-dessous, un schéma en coupe.

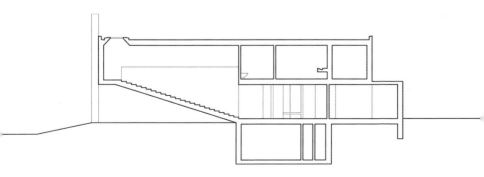

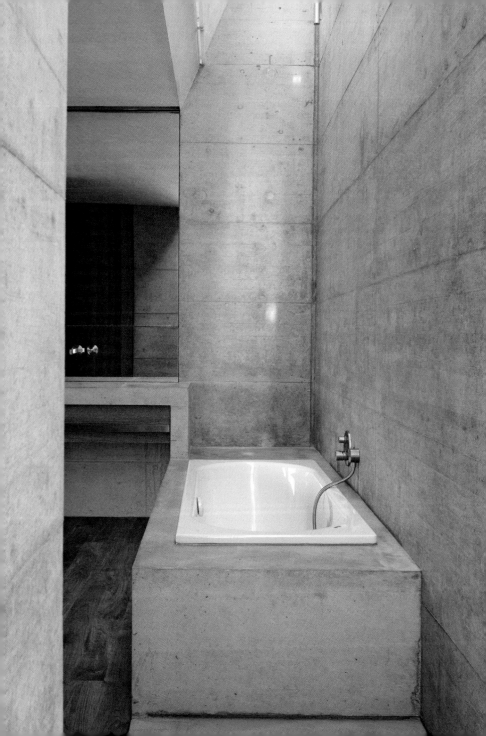

GONÇALO BYRNE & BARBAS LOPES

GONÇALO BYRNE was born in Alcobaça, Portugal, in 1941. He received his Diploma in Architecture from the ESBAL (Lisbon). Recent work of Gonçalo Byrne includes the renovation and expansion of the Machado de Castro National Museum (Coimbra, 1999–2012); Civic Center and Square "Eça de Queiroz" (Leiria, 2006–12); and the conversion of the "Cidadela de Cascais" into a Hotel (Cascais, 2008–12), all in Portugal. **PATRICIA BARBAS** and **DIOGO LOPES** have worked in partnership since 2003 and established their own office in 2006. Born in 1971 in Luanda, Angola, Patricia Barbas graduated from the FA-UTL (Lisbon), before working in the offices of Aires Mateus, Gonçalo Byrne, and João Pedro Falcão de Campos. Diogo Lopes was born in Lisbon, Portugal, in 1972 and also received his architecture degree from the FA-UTL, with a doctorate from ETH Zurich. Barbas Lopes have worked on the Polytechnical Theater (Lisbon, 2009–11); Goethe Salon (Lisbon, 2012); and the Príncipe Real Palazzina (Lisbon, 2013–), all in Portugal. The two firms worked together on the Thalia Theater (Lisbon, Portugal, 2009–12, published here).

GONÇALO BYRNE wurde 1941 in Alcobaça, Portugal, geboren. Sein Diplom für Architektur erwarb er an der Universität ESBAL (Lissabon). Zu seinen neueren Projekten zählen: die Sanierung und Erweiterung des Nationalmuseums Machado de Castro (Coimbra, 1999–2012), das Bürgerzentrum und der Platz „Eça de Queiroz" (Leiria, 2006–12) und der Umbau der „Cidadela de Cascais" in ein Hotel (Cascais, 2008–12), alle in Portugal. **PATRICIA BARBAS** und **DIOGO LOPES** arbeiten seit 2003 als Partner zusammen und eröffneten 2006 ihr eigenes Büro. Die 1971 in Luanda, Angola, geborene Patricia Barbas arbeitete nach Abschluss ihres Studiums an der Technischen Universität Lissabon (FA-UTL) in den Büros von Aires Mateus, Gonçalo Byrne und João Pedro Falcão de Campos. Diogo Lopes wurde 1972 in Lissabon geboren, erwarb sein Diplom ebenfalls an der FA-UTL und promovierte an der ETH Zürich. Barbas Lopes arbeiteten am Polytechnischen Theater (Lissabon, 2009–11), dem Goethe-Salon (Lissabon, 2012) und dem Palazzina Principe Real (Lissabon, 2013–), alle in Portugal. Zusammen arbeiteten die beiden Büros am Thalia Theater (Lissabon, 2009–12, hier vorgestellt).

GONÇALO BYRNE est né en 1941 à Alcobaça, au Portugal. Il est diplômé en architecture de l'ESBAL (Lisbonne). Ses réalisations récentes comprennent la rénovation et extension du musée national Machado de Castro (Coimbra, 1999–2012) ; le centre civique et la place « Eça de Queiroz » (Leiria, 2006–12) et la reconversion en hôtel de la citadelle de Cascais (2008–12), toutes au Portugal. **PATRICIA BARBAS** et **DIOGO LOPES** travaillent en partenariat depuis 2003 et ont ouvert leur agence en 2006. Née en 1971 à Luanda, en Angola, Patricia Barbas est diplômée de la FA-UTL (Lisbonne) et a ensuite travaillé dans les agences d'Aires Mateus, Gonçalo Byrne et João Pedro Falcão de Campos. Diogo Lopes est né à Lisbonne en 1972, il est également diplômé en architecture de la FA-UTL et a obtenu un doctorat à l'ETH Zurich. Barbas Lopes ont travaillé au Théâtre polytechnique (Lisbonne, 2009–11) ; au salon Goethe (Lisbonne, 2012) et au Palazzina du Príncipe Real (Lisbonne, 2013–), tous au Portugal. Les deux agences ont collaboré au théâtre Thalia (Lisbonne, 2009–12, publié ici).

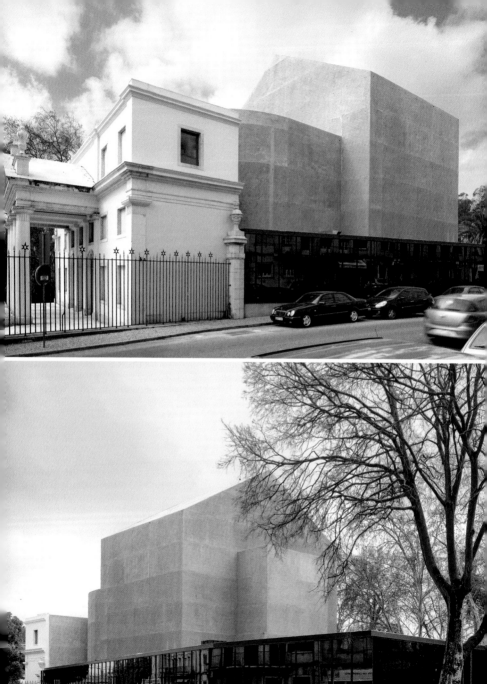

THALIA THEATER

Lisbon, Portugal, 2009–12

Area: 1600 m². Client: Portuguese Ministry of Education and Science.
Cost: €2.7 million. Collaboration: AFAconsult.

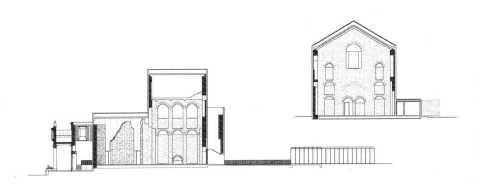

The architects, from two different generations, were asked to work on the remains of a formerly private Neoclassical theater situated near the city zoo. They covered what remained of the original 1843 building, which had been nearly destroyed by fire in 1862, with a terra-cotta concrete shell and added a single-story fully glazed pavilion serving as a multipurpose space. The original volumes of the theater with its 23-meter-high stage were retained as "voids." The front portico and marble sphinxes were restored, together with the original inscription *Hic Mores Hominum Castigantur* (Here the Deeds of Men Shall Be Punished). The architects state: "The reconversion of the **THALIA THEATER** in Lisbon combines the old and new parts of the building into an urban ensemble with views to the nearby zoo. It brings back the presence of the past as a place for fantasy, imagination, and civic life."

Die aus zwei Generationen stammenden Architekten waren gefordert, dieses Projekt mit den Überresten eines früher privat betriebenen, neoklassizistischen Theaters neben dem städtischen Zoo zu planen. Sie überdeckten das, was vom ursprünglichen Gebäude von 1843 übriggeblieben und von einem Brand 1862 nahezu zerstört worden war, mit einer Schale aus Terrakotta-Beton und fügten einen eingeschossigen, voll verglasten Pavillon an, der als Mehrzweckraum dient. Das ursprüngliche Volumen mit der 23 m hohen Bühne blieb als „Luftraum" erhalten. Der Eingangsportikus und die Marmorsphinxen wurden restauriert, ebenso die alte Inschrift „Hic Mores Hominum Castigantur" (Hier werden die Taten der Menschheit bestraft). Die Architekten erklären: „Der Umbau des **THALIA-THEATER** in Lissabon verbindet die alten und neuen Teile des Gebäudes zu einem städtebaulichen Ensemble mit Ausblicken zum benachbarten Zoo. Er bringt die Präsenz der Vergangenheit zurück als einen Ort der Fantasie, der Vorstellungskraft und des bürgerlichen Lebens."

Les architectes, de deux générations différentes, ont été réunis pour travailler sur les vestiges d'un ancien théâtre privé néoclassique, près du zoo de Lisbonne. Ils ont recouvert d'une coque de béton couleur terre cuite ce qui restait du bâtiment original de 1843, presque entièrement détruit par un incendie en 1862, et lui ont adjoint un pavillon de plain-pied entièrement vitré qui sert d'espace polyvalent. Les volumes d'origine du théâtre et sa scène haute de 23 m ont été conservés et forment des « vides ». Le portique à l'avant et les sphinx de marbre ont été restaurés, ainsi que l'inscription d'origine *Hic Mores Hominum Castigantur* (Ici seront punis les méfaits des hommes). Les architectes déclarent : « La reconversion du **THÉÂTRE THALIA** de Lisbonne associe les anciennes et les nouvelles parties du bâtiment en un ensemble urbain avec vue sur le zoo voisin. Cela réintroduit la présence du passé en tant que lieu de fantaisie, imagination et vie civile. »

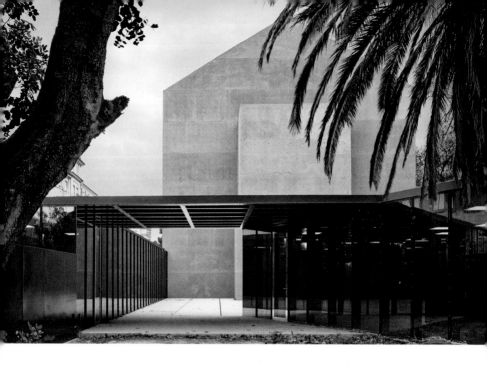

The terra-cotta concrete shell added by the architects seems to project the image of a traditional building, and yet its largely blank surfaces are decidedly modern. Drawings on the left show the enclosure of the older structure.

Die von den Architekten hinzuge-fügte Bauhülle aus Terrakotta-Beton bietet scheinbar das Bild eines traditionellen Gebäudes, aber dennoch sind die überwiegend blinden Flächen eindeutig modern. Die Zeichnungen links zeigen die Umbauung des alten Gebäudes.

La coque de béton couleur terre cuite qu'ont ajoutée les architectes semble projeter l'image d'un bâtiment traditionnel, alors même que ses surfaces majoritairement aveugles sont résolument modernes. Les schémas à gauche montrent comment l'ancienne structure a été recouverte.

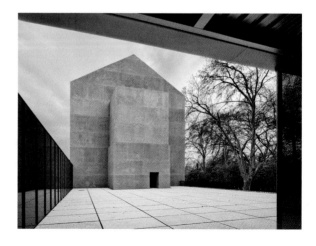

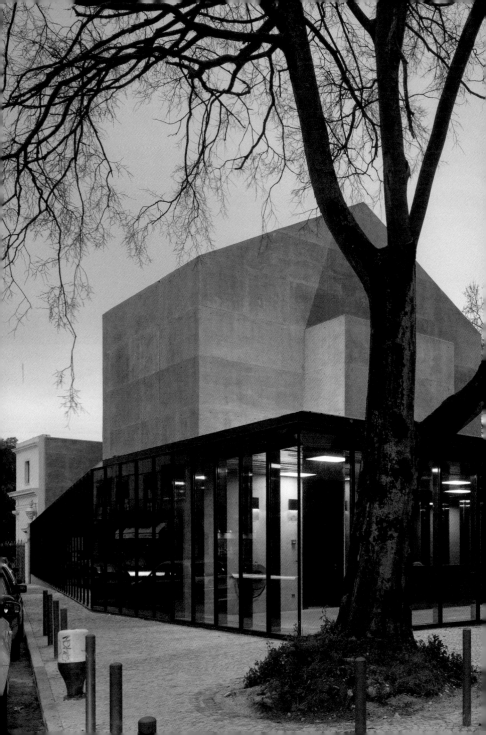

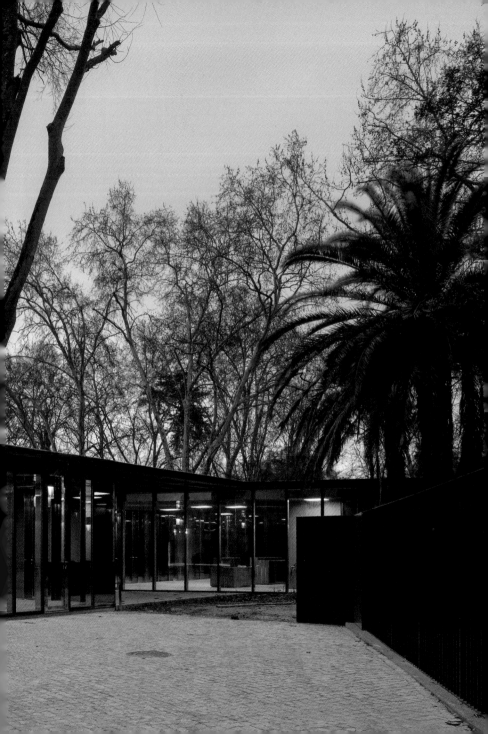

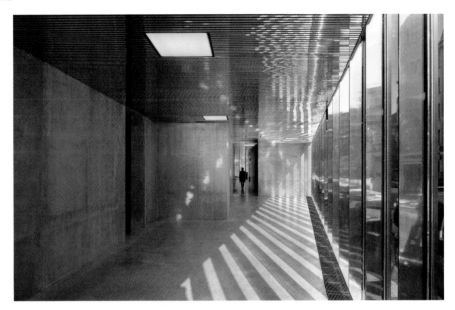

The former windows of the theater are left open with dramatic lighting effects. Below, a plan shows both the thicker old walls and the new.

Die früheren Fenster des Theaters wurden offen gelassen und bewirken dramatische Lichteffekte. Unten: Ein Grundriss zeigt sowohl die stärkeren alten Wände wie auch die neuen.

Les anciennes fenêtres du théâtre ont été laissées ouvertes et créent des effets d'éclairage spectaculaires. Ci-dessous, le plan représente à la fois les anciens murs plus épais et le nouveau.

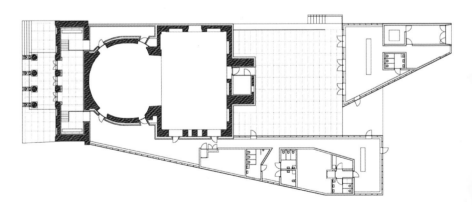

Interior walls are restored but retain the feeling of age of the original building. Thin black metal beams carry the lighting system.

Die Innenwände wurden restauriert, wirken aber immer noch wie aus der Zeit des ursprünglichen Gebäudes. Dünne, schwarze Metallstangen tragen das Beleuchtungssystem.

Les murs intérieurs ont été restaurés mais conservent le caractère ancien du bâtiment original. De fines poutrelles en métal noir portent le système d'éclairage.

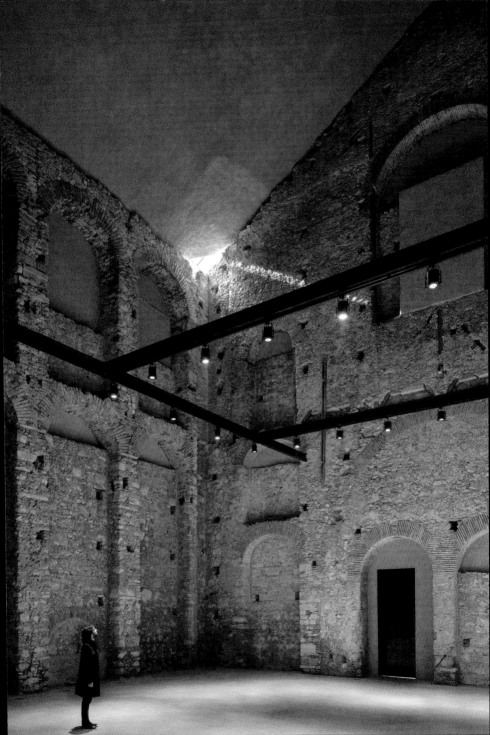

SANTIAGO CALATRAVA

Born in Valencia, Spain, in 1951, **SANTIAGO CALATRAVA** studied art and architecture at the ETSA of Valencia (1968–73) and engineering at the ETH in Zurich (doctorate in Technical Science, 1981). He opened his own architecture and civil engineering office the same year. Santiago Calatrava received the American Institute of Architects (AIA) 2005 Gold Medal. His built work includes Gallery and Heritage Square, BCE Place (Toronto, Ontario, Canada, 1987); the Torre de Montjuïc (Barcelona, Spain, 1989–92); the Kuwait Pavilion at Expo '92, Seville, and the Alamillo Bridge for the same exhibition (Seville, Spain); the Lyon Saint-Exupéry TGV Station (Lyon, France, 1989–94); the Oriente Station in Lisbon (Portugal, 1998); the City of Science and Planetarium (1996–2000) and the Opera in Valencia (Spain, 2004); the Sondica Airport (Bilbao, Spain, 1990–2000); a bridge in Orléans (France, 1996–2000); Bodegas Ysios (Laguardia, Álava, Spain,1998–2001) and Tenerife Auditorium (Santa Cruz de Tenerife, Spain, 1997–2003, published here). Current projects include the Y. Z. Hsu Memorial, Performing Arts Building and Art & Design School Yuan Ze University (Taipei, Taiwan, 2008–15); the Mons Station (Mons, Belgium, 2004–15); and the Transportation Hub for the new World Trade Center site in New York (USA, 2002–16).

SANTIAGO CALATRAVA, geboren 1951 in Valencia, Spanien, studierte an der dortigen ETSA Kunst und Architektur (1968–73) sowie Bauingenieurwesen an der ETH Zürich, wo er 1981 promovierte. Im selben Jahr gründete er sein Architektur- und Ingenieurbüro. 2005 wurde Calatrava mit der Goldmedaille des American Institute of Architects (AIA) ausgezeichnet. Zu seinen realisierten Bauten gehören der Gallery and Heritage Square, BCE Place in Toronto (Kanada, 1987), die Torre de Montjuïc (Barcelona, Spanien 1989–92), der Kuwait-Pavillon und die Alamillo-Brücke für die Expo '92 in Sevilla (Portugal), der TGV-Bahnhof des Flughafens Lyon Saint-Exupéry (Frankreich, 1989–94), der Oriente-Bahnhof in Lissabon (Portugal, 1998), die Ciudad de las Artes y de las Ciencias (1996–2000) sowie das Opernhaus Palau de les Arts Reina Sofía in Valencia (Spanien, 2004), der Flughafen Sondica in Bilbao (1990–2000), eine Brücke in Orléans (Frankreich, 1996–2000), die Bodegas Ysios (Laguardia, Álava, Spanien,1998–2001) und das Auditorium von Teneriffa (Santa Cruz de Tenerife, Spanien, 1997–2003, hier vorgestellt). Neuere Projekte sind das Y.-Z. Hsu-Memorial-Gebäude, das Performing Arts Building und die Hochschule für Kunst und Design der Universität Yuan Ze in Taipeh (Taiwan, 2008–15), der Bahnhof von Mons (Belgien, 2004–15) sowie der Verkehrsknotenpunkt des neuen World Trade Center in New York (USA, 2002–16).

Né à Valence (Espagne) en 1951, **SANTIAGO CALATRAVA** a étudié l'art et l'architecture à l'ETSA de Valence (1968–73) et l'ingénierie à l'ETH de Zurich (doctorat en sciences techniques, 1981). Il a ouvert son agence d'architecture et d'ingénierie civile la même année. En 2005, il a reçu la médaille d'or de l'American Institute of Architects (AIA). Parmi ses réalisations : le Gallery and Heritage Square, BCE Place (Toronto, Canada, 1987) ; la tour de Montjuïc (Barcelone, Espagne, 1989–92) ; le pavillon du Koweï et le pont de l'Alamillo pour l'Expo '92 (Séville, Espagne) ; la gare de TGV de l'aéroport de Lyon Saint-Exupéry (Lyon, France, 1989–94) ; la gare de l'Orient à Lisbonne (1998) ; la Cité des sciences et le planétarium (1996–2000) et l'opéra de Valence (Espagne 2004) ; l'aéroport de Sondica (Bilbao, Espagne, 1990–2000) ; un pont à Orléans (France, 1996–2000), les Bodegas Ysios (Laguardia, Álava, Espagne,1998–2001) et l'Auditorium de Tenerife (Santa Cruz de Tenerife, Espagne, 1997–2003, publié ici). Ses projets actuels incluent le mémorial Y. Z. Hsu, le bâtiment des arts du spectacle et de l'école d'art et de design de l'université Yuan Ze (Taipei, Taïwan, 2008–15) ; la gare de Mons (Belgique, 2004–15) et le nœud ferroviaire du nouveau World Trade Center à New York (États-Unis, 2002–16).

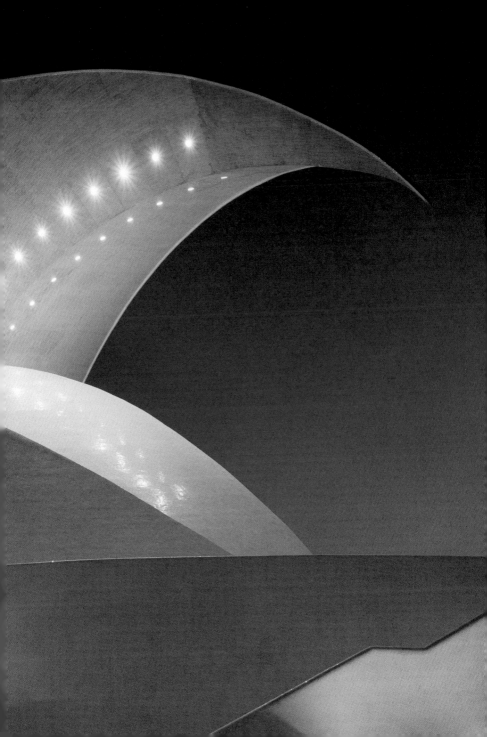

TENERIFE AUDITORIUM

Santa Cruz de Tenerife, Spain, 1997–2003

Building area: 17 270 m².
Client: City of Santa Cruz, Tenerife. Cost: €66 million.

King Juan Carlos of Spain inaugurated the **TENERIFE AUDITORIUM** on September 26, 2003. The auditorium is located on the waterfront in the Los Llanos area of Santa Cruz, the capital of Tenerife and the second most populous city in the Canary Islands. Situated between the Marine Park and the edge of the port, the auditorium connects the city to the ocean and creates a significant urban landmark. The auditorium is the new home of the Orquesta Sinfónica de Tenerife (Tenerife Symphony Orchestra). Its principal components are a 1660-seat concert hall, which can be adapted to accommodate opera performances, and a 428-seat hall for chamber music. The program also provides for public amenities (café, cloakrooms, etc.), backstage facilities (dressing rooms, rehearsal rooms, etc.), and separate structures for parking and offices. In addition to its primary function, the auditorium also serves as a conference center and exhibition hall. The most expressive element of the design is the roof: a free-standing concrete structure known as the "Wing." Rising from a base 60 meters wide at the side of the building that faces the city, the Wing sweeps upward in a curve to a height of 60 meters. As it rises, pointing northeast toward the auditorium's public plaza and the ocean, the Wing narrows and thins, terminating in a spear-shaped tip located 98 meters from the base of its arc. Though described as a wing, this arc and the auditorium itself recall Calatrava's frequent fascination with the form of the eye and eyelid. Tenerife Auditorium is acoustically unique, since it is conical. Reflection of sound from the ceiling is provided by a series of convex reflectors.

Das **AUDITORIUM VON TENERIFFA** wurde am 26. September 2003 vom spanischen König Juan Carlos eingeweiht. Es wurde im Uferbezirk Los Llanos von Santa Cruz, der Hauptstadt von Teneriffa und zweitgrößten Stadt der Kanarischen Inseln, erbaut. Zwischen Marine-Park und Hafen gelegen, verbindet das Gebäude die Stadt mit dem Meer und bildet damit einen wichtigen städtebaulichen Markierungspunkt. Das Auditorium, die neue Heimat des Sinfonieorchesters von Teneriffa, besteht in der Hauptsache aus einem Konzertsaal mit 1660 Sitzen, der für Opern- und Bühnenproduktionen angepasst werden kann, und einem Saal mit 428 Sitzen für Kammermusikaufführungen. Außerdem gehören zu dem Komplex öffentliche Räume wie ein Café sowie Künstler- und Proberäume und eigene Gebäudeteile für Büros. Neben seiner eigentlichen Funktion bietet das Auditorium auch Räume für Konferenzen und Ausstellungen. Das auffallendste Gestaltungsmerkmal ist das Dach: Ausgehend von einem 60 m breiten Sockel an der zur Stadt hin gelegenen Gebäudeseite schwingt sich diese „Flügel" genannte Betonkonstruktion bogenförmig zu einer Höhe von 60 m hinauf. Dieser nach Nordosten auf den öffentlichen Platz des Auditoriums und den dahinter liegenden Atlantik ausgerichtete Flügel läuft, immer schmaler und dünner werdend, 98 m über dem Sockel in einer lanzenförmigen Spitze aus. Auch wenn er als Flügel bezeichnet wird, erinnert dieser Bauteil wie auch das Auditorium selbst an die bei Calatravas Arbeiten häufig zum Ausdruck kommende Faszination des Architekten für die Form des Auges und des Augenlids. Das Auditorium bietet dank seiner konischen Form eine einmalige Akustik, wobei die Klangreflexion von der Decke durch eine Reihe konvexer Rückstrahler erfolgt.

C'est le 26 septembre 2003 que le roi Juan Carlos a inauguré l'**AUDITORIUM DE TENERIFE** sur le front de mer du quartier de Los Llanos à Santa Cruz, capitale de Tenerife et deuxième plus grande ville des Canaries. Entre le Parc marin et l'extrémité du port, l'Auditorium, qui abrite l'Orchestre symphonique de Tenerife, est un monument urbain faisant le lien entre la ville et l'océan. Il se compose pour l'essentiel d'une salle de concert de 1660 places, adaptable à des représentations d'opéra et de théâtre, d'une salle quasi triangulaire de 428 places pour la musique de chambre, d'un café, de vestiaires, d'installations en coulisses (loges, salles de répétition, etc.) et d'un bâtiment indépendant pour les bureaux et les parkings. L'ensemble sert également de centre de conférence et de hall d'expositions. L'élément le plus expressif est le toit, structure autoporteuse en béton appelée l'«Aile», qui s'élève d'une base de 60 m de large, face à la ville selon une courbe qui monte jusqu'à 60 m de haut. Orientée vers le nord-est et la place de l'Auditorium au-dessus de l'océan, l'Aile se termine à son apogée en forme de pointe de lance, à 98 m de la base de l'arc. Même si l'architecte parle d'aile, cet arc et l'auditorium lui-même rappellent sa fascination pour la forme de l'œil et de la paupière. L'acoustique de la salle conique, dans laquelle le son est réfléchi par le plafond et est renvoyé par une succession de réflecteurs convexes, est exceptionnelle.

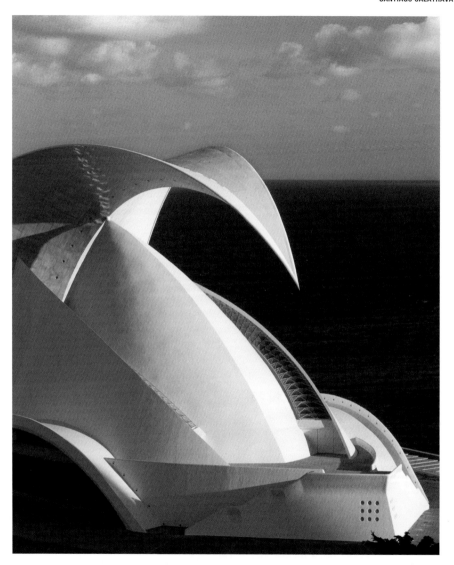

Seen against the background of the ocean the unexpected form of the building stands out. Indeed, Calatrava systematically produces buildings that are personal expressions of form.

Vor dem Hintergrund des Meeres tritt die ungewöhnliche Form des Gebäudes deutlich hervor. Calatrava entwirft systematisch Bauwerke nach seinem persönlichen Verständnis von Form.

Sur fond d'océan la forme surprenante du bâtiment ne manque pas d'attirer l'attention. Calatrava produit systématiquement des réalisations qui sont son expression personnelle de la forme.

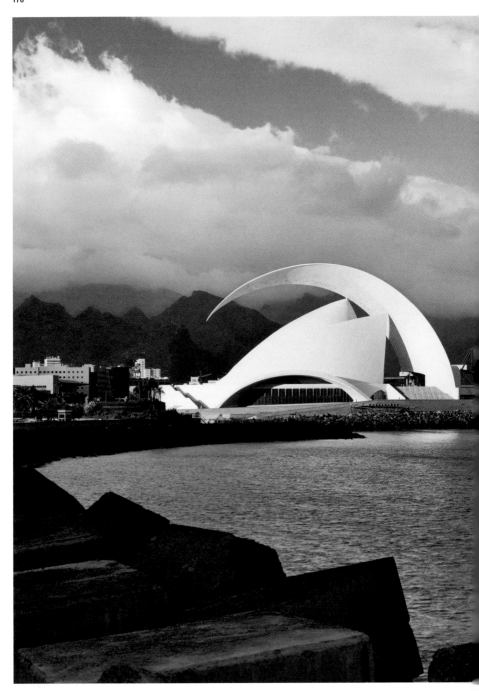

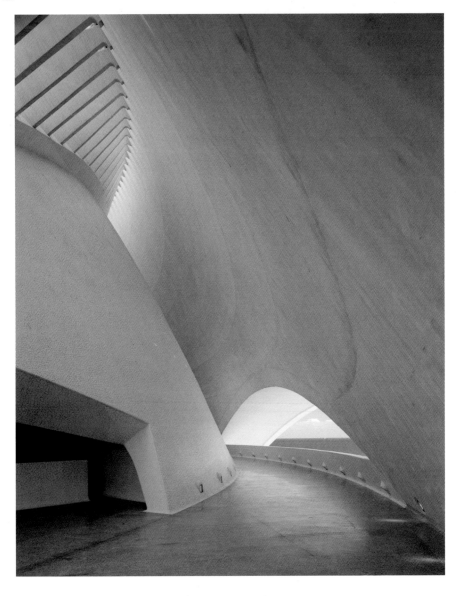

Seen from various angles the
building takes on a decidedly
anthropomorphic aspect.

Aus verschiedenen Blickwinkeln
zeigt das Gebäude einen stark an-
thropomorphen Aspekt.

Vu sous différents angles, le
bâtiment adopte une apparence
résolument anthropomorphe.

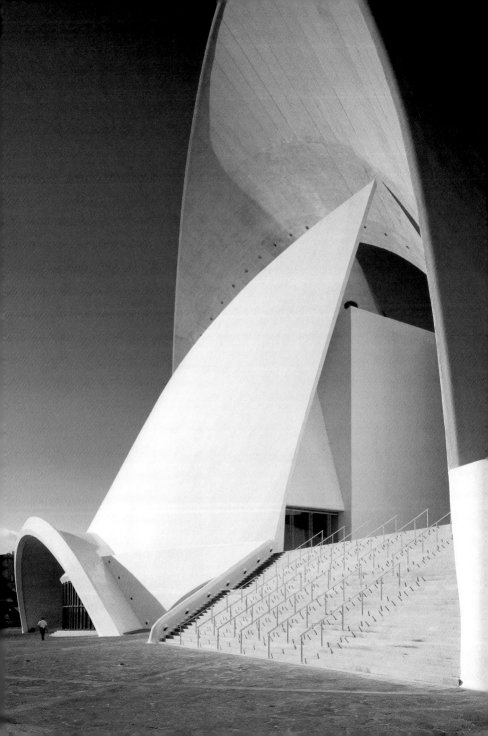

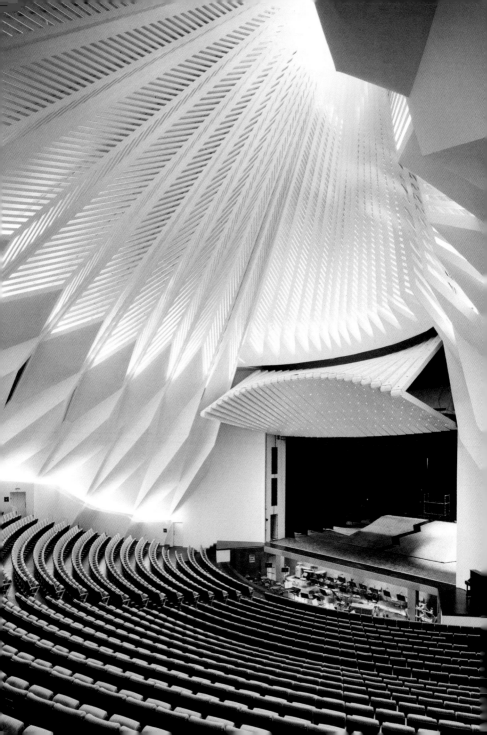

Inside the auditorium, a starburst pattern also brings to mind natural mineral or animal forms.

Im Innern des Auditoriums erinnert ein strahlenförmiges Muster an natürliche mineralische oder tierische Formen.

À l'intérieur de l'auditorium, un motif étoilé rappelle lui aussi des formes naturelles, minérales ou animales.

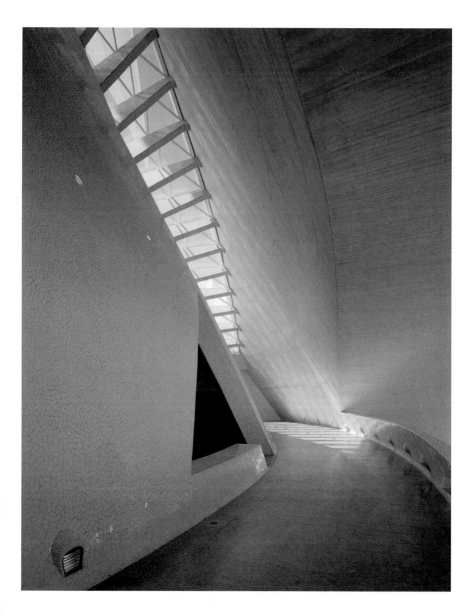

CARUSO ST JOHN

ADAM CARUSO and **PETER ST JOHN** created their office in London in 1990. Having received his Diploma in Architecture from McGill University (Montreal), Adam Caruso worked with Florian Beigel and Arup Associates prior to 1990. Peter St John completed his studies at the Bartlett and then at the Architectural Association (London, 1984). He worked in the offices of Richard Rogers, Florian Beigel, Dixon Jones, and Arup Associates up until 1990. The architects were noted as early as 1995 when they won the competition for the New Art Gallery and Public Square in Walsall (UK, 2000). They completed the Gagosian Gallery (Britannia Street, London, UK, 2006) and, for the same client, a gallery in Paris (France, 2009), as well as exhibition designs for the artist Thomas Demand (Dublin, Ireland 2008; Berlin, Germany 2009). They also created the design of the Frieze Art Fair (London, UK, 2008–10). Caruso St John completed Nottingham Contemporary in 2009 (Nottingham, published here); Chiswick House Café (London, 2006–10); and Tate Britain (London, Millbank Project, 2006–13), all in the UK.

ADAM CARUSO und **PETER ST JOHN** gründeten 1990 ihr Büro in London. Adam Caruso arbeitete davor, nach Erwerb seines Architektur-Diploms an der McGill University (Montreal), bei Florian Beigel und Arup Associates. Peter St John beendete 1984 sein Studium an der Bartlett School of Architecture und an der Architectural Association (London). Er arbeitete bis 1990 in den Büros von Richard Rogers, Florian Beigel, Dixon Jones und Arup Associates. Die Architekten wurden schon 1995 bekannt, als sie den Wettbewerb für die New Art Gallery and Public Square in Walsall gewannen (Großbritannien, 2000). Sie entwarfen die Gagosian Gallery (Britannia Street, London, Großbritannien, 2006) und für denselben Bauherrn eine Galerie in Paris (Frankreich, 2009) sowie Ausstellungskonzepte für den Künstler Thomas Demand (Dublin, Irland, 2008; Berlin, Deutschland, 2009). Außerdem gestalteten sie die Frieze Art Fair (London, 2008–10). Caruso St John plante 2009 das Nottingham Contemporary (Nottingham, hier vorgestellt), das Chiswick House Café (London, 2006–10) und die Tate Britain (London, Millbank Project, 2006–13), alle in Großbritannien.

ADAM CARUSO et **PETER ST JOHN** ont créé leur agence à Londres en 1990. Diplômé en architecture de l'université McGill (Montréal), Adam Caruso a travaillé avec Florian Beigel et Arup Associates jusqu'en 1990. Peter St John a fait ses études à la Bartlett, puis à l'Architectural Association (Londres, 1984). Il a travaillé dans les agences de Richard Rogers, Florian Beigel, Dixon Jones et Arup Associates jusqu'en 1990. Les deux architectes ont été remarqués dès 1995 lorsqu'ils ont gagné le concours pour la galerie New Art et la place de Walsall (Royaume-Uni, 2000). Ils ont ensuite construit la galerie Gagosian (Britannia Street, Londres, Royaume-Uni, 2006) puis, pour le même client, une galerie à Paris (France, 2009) et ont conçu des expositions pour l'artiste Thomas Demand (Dublin, Irlande, 2008 ; Berlin, Allemagne, 2009). Ils ont également créé le design de la Frieze Art Fair (Londres, 2008–10). Caruso St John ont achevé le musée Nottingham Contemporary en 2009 (Nottingham, publié ici) ; le café Chiswick House (Londres, 2006–10) et la Tate Britain (Londres, projet Millbank, 2006–13), tous au Royaume-Uni.

NOTTINGHAM CONTEMPORARY

Nottingham, UK, 2009

Area: 3500 m². Client: Nottingham City Council.
Cost: £14 million.

Set in the central Nottingham area called the Lace Market, this structure makes reference to the 1960s artist-run spaces of downtown New York, but also to the work of figures such as Gordon Matta-Clark. It is in this spirit that the architects state: "In our design, we set out to offer a wide range of interiors that will have the variety and specificity of the found spaces of a factory or warehouse, within a new building: rooms that will challenge the installation and production of contemporary art and offer new ways for performers and audiences to interact." Adam Caruso explains: "The exterior image for **NOTTINGHAM CONTEMPORARY** is inspired by the 19th-century buildings of Nottingham and, in particular, by the impressive façades of the Lace Market, where hard brick forms a robust shell to the repetitive structural frames of the warehouse buildings. The toughness of these façades was originally about durability and low maintenance but the rigor of their repetitive pattern and precise material assembly also lend a dignity to the streets of the quarter. The façades of Nottingham Contemporary are developed as a continuous patterned surface of pale green, precast concrete elements. Terra-cotta façades by Louis Sullivan, in particular the Guarantee Building (1896) in Buffalo, have served as a model for our façades."

Dieses im zentralen, Lace Market genannten Bereich von Nottingham gelegene Gebäude nimmt Bezug auf die in den 1960er-Jahren von Künstlern betriebenen Orte in Downtown New York, aber auch auf das Werk von Personen wie Gordon Matta-Clark. In diesem Sinne erklären die Architekten: „Mit unserem Entwurf wollten wir eine große Bandbreite von Räumen bieten, die in einem Neubau die Vielfalt und Besonderheit von Orten aufweist, die man sonst in Fabriken oder Lagerhäusern findet – Räume, die zur Installation und Produktion zeitgenössischer Kunst herausfordern und neue Möglichkeiten der Interaktion von Darstellern und Zuschauern bieten." Adam Caruso erläutert: „Das äußere Erscheinungsbild von **NOTTINGHAM CONTEMPORARY** ist von den Bauten in Nottingham aus dem 19. Jahrhundert beeinflusst und ganz besonders von den eindrucksvollen Fassaden des Lace Market, wo harte Ziegel eine robuste Schale für die sich wiederholenden Konstruktionen der Lagerhäuser bilden. Diese Fassaden sollten ursprünglich nur besonders widerstandsfähig und pflegeleicht sein, aber die Strenge der sich wiederholenden Gliederung und die exakte Materialverarbeitung verleihen den Straßen dieses Quartiers auch eine gewisse Würde. Die Fassaden des Nottingham Contemporary bestehen aus durchgehend strukturierten Flächen aus mattgrünen Betonfertigteilen. Die Terrakottafassaden von Louis Sullivan, vor allem von seinem Guarantee Building (1896) in Buffalo, dienten als Vorbilder für unsere Fassaden."

Situé dans le quartier central de Nottingham appelé Lace Market, le bâtiment fait référence aux lieux courus des artistes dans le New York des années 1960, mais aussi au travail de créateurs tels que Gordon Matta-Clark. C'est dans cet esprit que les architectes déclarent : « Notre design vise à offrir dans un nouveau bâtiment toute une série d'intérieurs qui présentent la variété et la spécificité des espaces qu'on trouve dans une usine ou un entrepôt : des pièces qui stimulent l'installation et la production d'art contemporain et ouvrent des voies nouvelles d'interaction entre interprètes et publics. » Adam Caruso explique encore que « l'aspect extérieur de **NOTTINGHAM CONTEMPORARY** est inspiré des bâtiments du XIXᵉ siècle qu'on voit à Nottingham, en particulier les imposantes façades de Lace Market où la brique dure forme une enveloppe solide autour des charpentes et structures toutes identiques des entrepôts. La dureté de ces façades se voulait au départ durable et facile à entretenir, mais la rigueur de leurs motifs répétés et la précision des assemblages confèrent aussi une certaine dignité aux rues du quartier. Les façades de Nottingham Contemporary ont été conçues comme une surface à motifs continus formée d'éléments en béton préfabriqué vert pâle. Les façades terre cuite de Louis Sullivan, surtout celle du Guarantee Building (1896) à Buffalo, nous ont servi de modèles. »

The architects are known for their relatively austere approach and these views of Nottingham Contemporary confirm that impression.

Die Architekten sind bekannt für ihre relativ strengen Entwürfe, und diese Abbildungen vom Nottingham Contemporary bestätigen das.

Les deux architectes sont connus pour leur approche plutôt austère, une impression confirmée par ces vues de Nottingham Contemporary.

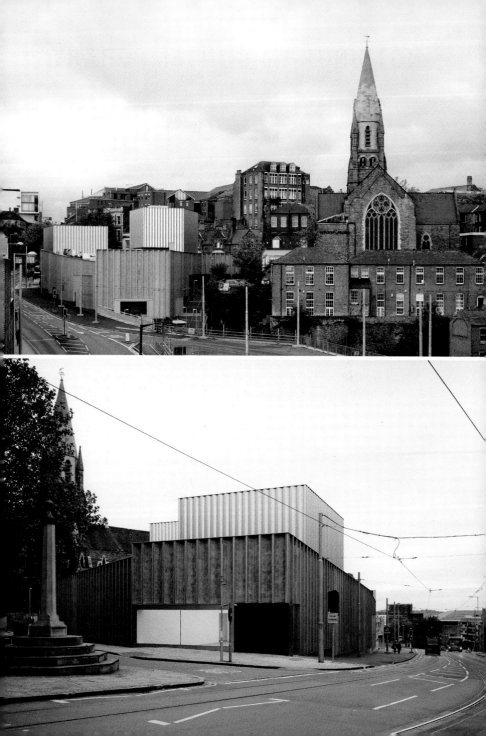

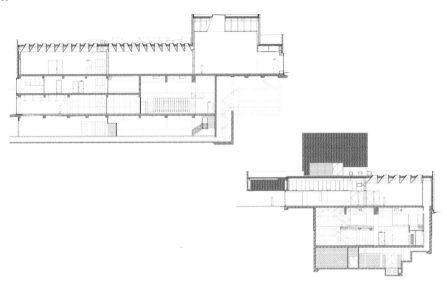

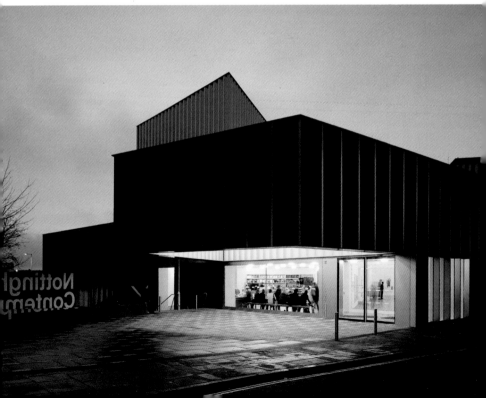

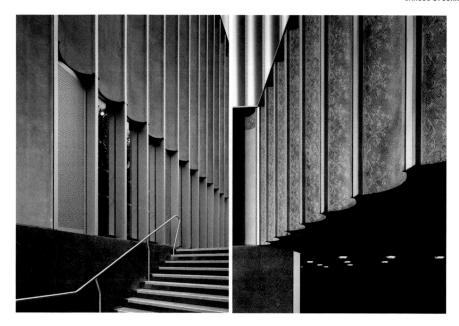

The architects refer to "toughness" in their façade designs, but also integrate their own impression of local architecture. The rhythm and relative blankness of the façades gives them a modern appearance that is not in contradiction with older buildings.

Bei der Fassadengestaltung legen die Architekten Wert auf „Robustheit", nehmen jedoch auch ihre eigenen Vorstellungen von lokaler Architektur auf. Der Rhythmus und die relative Leere der Fassaden lässt sie modern erscheinen, was aber nicht im Widerspruch zu älteren Bauten steht.

Les architectes évoquent la «dureté» de leur façade, mais y intègrent aussi leur interprétation personnelle de l'architecture locale. Le rythme et le vide relatif des façades leur confèrent une apparence moderne pourtant pas en contradiction avec celles des bâtiments plus anciens.

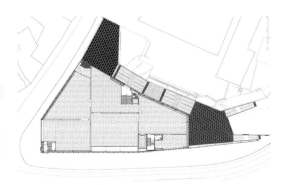

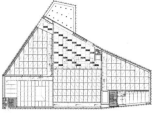

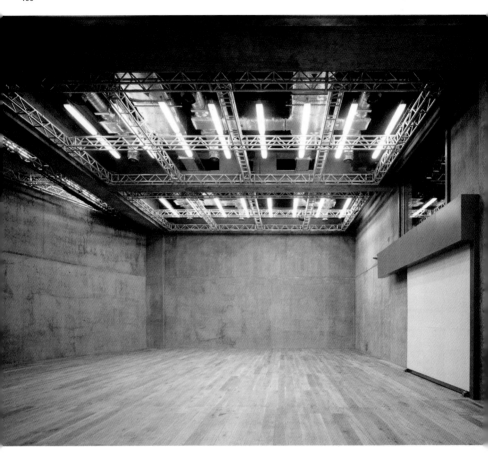

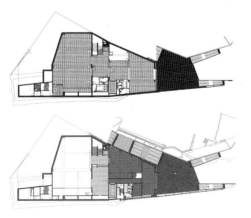
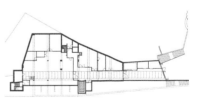

*Interior spaces reveal a hard edge
that is in keeping with exterior
façades. Concrete is very much
present, but elements such as the
wooden floors or the café design
(below) bring an obvious sense
that the design has been carefully
thought out and balanced.*

*Die Innenräume sind ebenso kom-
promisslos wie die Außenfassaden.
Der Beton ist überall präsent. Ge-
wisse Elemente wie die Holzfußbö-
den oder die Ausstattung des Cafés
(unten) bestätigen den Eindruck,
dass der Entwurf sorgfältig durch-
dacht und ausgewogen ist.*

*Les espaces intérieurs expriment un
côté dur qui correspond aux façades
extérieures. Le béton est très pré-
sent, mais certains éléments comme
le sol en bois ou le design du café
(ci-dessous) montrent de manière
certaine que l'ensemble a été soi-
gneusement pensé et équilibré.*

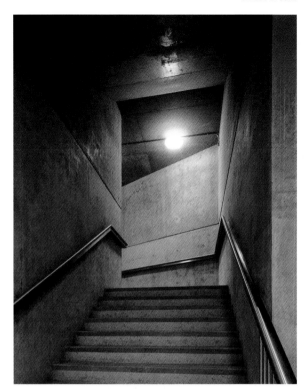

MATTEO CASARI

MATTEO CASARI was born in 1978 and graduated in architecture from Milan Polytechnic in 2005. He has been a member of the Order of Architects of Bergamo since 2006. In 2007, he created Matteo Casari Architects with **VALENTINA GIOVANZANI** (born in 1978). They have participated in numerous competitions, including first prize in a competition organized by the town of Dalmine (near Bergamo) for the design of Piazza Vittorio Emanuele III and Piazza Santa Maria d'Oleno. In 2010, the office was the winner of the "27/37 International Festival of Young Italian Architects" at the Italian Pavilion at Expo 2010 (Shanghai, China). They are presently working on a new residential complex in Trezzo (Milan, 2010–), as well as the renovation of buildings in Verdellino (Bergamo, 2012–) and Carloforte (Carbonia-Iglesias, Sardinia, 2012–), all in Italy. They have also completed a house in Urgnano (Bergamo, Italy, 2011–12, published here).

MATTEO CASARI wurde 1978 geboren und studierte bis 2005 Architektur an der Polytechnischen Universität in Mailand. Seit 2006 ist er Mitglied der Architektenvereinigung von Bergamo. Im Jahr 2007 gründete er mit **VALENTINA GIOVANZANI** (geboren 1978) das Büro Matteo Casari, das an vielen Wettbewerben teilgenommen hat. In einem von der Stadt Dalmine (bei Bergamo) ausgeschriebenen Wettbewerb für die Gestaltung der Piazza Vittorio Emanuele III und der Piazza Santa Maria d'Oleno erhielt das Büro den ersten Preis, und 2010 war es der Gewinner des „27/37 International Festival of Young Italian Architects" im italienischen Pavillon auf der Expo 2010 (Schanghai). Zurzeit arbeiten die Architekten an einer neuen Wohnanlage in Trezzo (Mailand, 2010–) sowie an der Sanierung von Bauten in Verdellino (Bergamo, 2012–) und Carloforte (Carbonia-Iglesias, Sardinien, 2012–), alle in Italien. Zudem realisierten sie ein Wohnhaus in Urgnano (Bergamo, Italien, 2011–12, hier vorgestellt).

MATTEO CASARI est né en 1978 et est diplômé en architecture de l'École polytechnique de Milan (2005). Il est membre de l'Ordre des architectes de Bergame depuis 2006. Il a créé Matteo Casari Architects avec **VALENTINA GIOVANZANI** (née en 1978) en 2007. Ils ont participé à de nombreux concours et ont notamment remporté le premier prix de celui organisé par la ville de Dalmine (près de Bergame) pour l'aménagement des places Vittorio Emanuele III et Santa Maria d'Oleno. L'agence a gagné en 2010 le « 27/37 Festival international des jeunes architectes italiens » au pavillon de l'Italie pour l'Exposition universelle de Shanghai. Ils travaillent actuellement à un nouveau complexe résidentiel à Trezzo (Milan, 2010–), ainsi qu'à la rénovation de bâtiments à Verdellino (Bergame) et Carloforte (Carbonia-Iglesias, Sardaigne, 2012–), le tout au Italie. Ils ont également achevé une maison à Urgnano (Bergame, Italie, 2011–12, publiée ici).

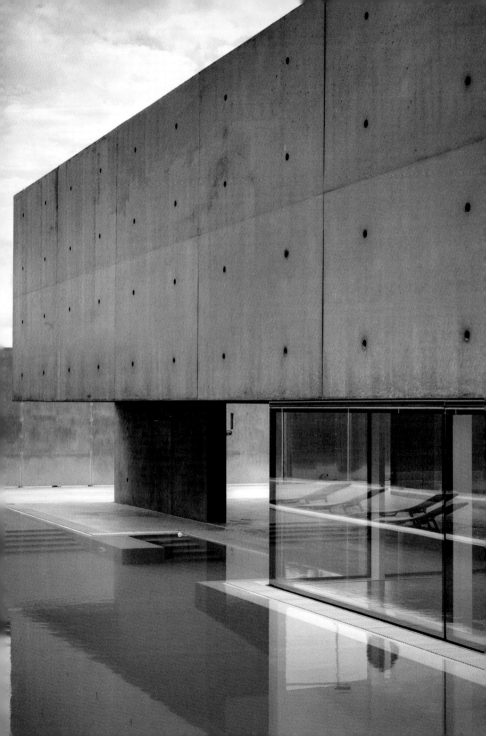

HOUSE

Urgnano, Bergamo, Italy, 2011–12

Area: 350 m². Collaboration: Raffaele Rota, Silvia Previtali.

This **HOUSE** stands on a small lot in a residential area that is expanding in the town of Urgnano, which is 45 kilometers northeast of Milan and 11 kilometers south of Bergamo. The architect describes the desired relationship of the house to the heterogeneous neighborhood as "mute." He states: "The anthracite concrete box, raised a meter and a half above the ground, only allows one entry… Outside, what is not concrete is glass." Most of this glass is at ground level, with the imposing concrete block of the upper part of the house seeming to hover in minimalist splendor above. The only element not contained in the austere concrete box is a swimming pool that runs along one side of the rectangular house. The areas around the house are unadorned, with no trees or other objects to distract from its clean and powerful lines.

Dieses **HAUS** wurde auf einem kleinen Grundstück in einem wachsenden Wohngebiet der Stadt Urgnano errichtet, die 45 km nordöstlich von Mailand und 11 km südlich von Bergamo liegt. Der Architekt beschreibt den gewünschten Bezug des Hauses zu seiner heterogenen Nachbarschaft als „stumm". Er erklärt: „Der anthrazitfarbene Betonkasten wurde um 1,5 m vom Erdboden angehoben, sodass nur ein Eingang möglich war … Außen ist alles, was nicht aus Beton ist, aus Glas." Der größte Teil dieses Glases befindet sich im Erdgeschoss. Der imposante Betonblock des oberen Hausteils scheint in minimalistischer Pracht darüber zu schweben. Das einzige nicht in der strengen Betonkiste enthaltene Element ist der Swimmingpool an einer Seite des rechtwinkligen Hauses. Der Außenbereich ist völlig undekoriert, weder Bäume noch andere Objekte lenken von den klaren und kraftvollen Linien des Hauses ab.

La **MAISON** a été construite sur un petit lopin dans une zone résidentielle en expansion de la ville d'Urgnano, à 45 km au nord-est de Milan et 11 km au sud de Bergame. L'architecte qualifie de « tacite » le rapport voulu de la maison à son voisinage disparate. Il explique que « le cube en béton anthracite, surélevé à un mètre et demi au-dessus du sol, permet une seule entrée… À l'extérieur, tout ce qui n'est pas en béton est en verre. » La plus grande partie de ce vitrage se trouve au niveau du sol, tandis que l'imposant bloc de béton qui forme la partie supérieure de la maison semble flotter par-dessus dans toute sa splendeur minimaliste. Le seul élément à ne pas être inclus dans l'austère cube de béton est la piscine qui longe l'un des côtés de la construction rectangulaire. L'espace qui entoure la maison est entièrement nu, sans aucun arbre ni autre objet pour distraire le regard des lignes nettes et puissantes de l'architecture.

Section drawings show the architecture stepping down, but above, it seems to be almost in levitation above the terrace and pool.

Schnittzeichnungen zeigen die abgestufte Architektur, die jedoch oben fast über Terrasse und Pool zu schweben scheint.

Les schémas en coupe montrent l'étagement vers le bas de l'architecture, alors que la partie supérieure de la maison donne presque une impression de lévitation au-dessus de la terrasse et de la piscine.

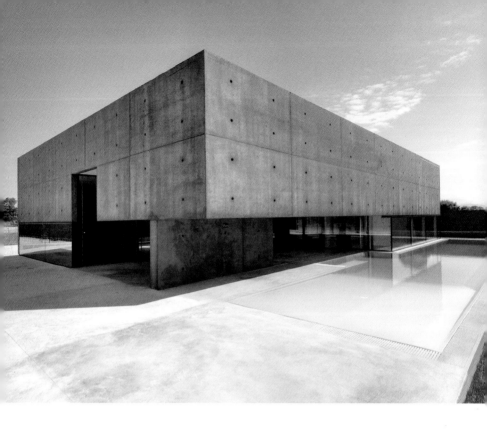

Here the concrete mass is notched to make a passageway, further allowing residents to question or wonder about the real weight of the blocks that seem to hover without support.

Hier ist die Betonmasse einge-schnitten, um einen Durchgang zu schaffen und die Bewohner über das wahre Gewicht der Betonblöcke nachdenken zu lassen, die unge-stützt zu schweben scheinen.

Ici, la masse de béton est entaillée pour créer un passage – le poids réel des blocs semblant flotter sans support constitue une source d'interrogation ou d'émerveillement pour les habitants de la maison.

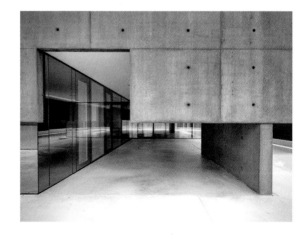

The apparently solid concrete mass of the house sits above a largely glazed ground level where a pool also alleviates the weight of the upper section.

Die scheinbar dichte Betonmasse des Hauses steht auf einem überwiegend verglasten Erdgeschoss, wo ein Pool den oberen Bereich leichter erscheinen lässt.

La masse de béton d'apparence massive est posée sur un niveau inférieur largement vitré avec une piscine pour alléger encore le poids de l'étage.

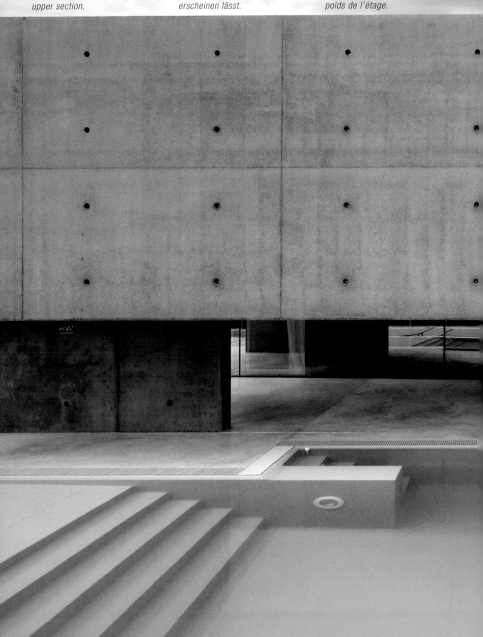

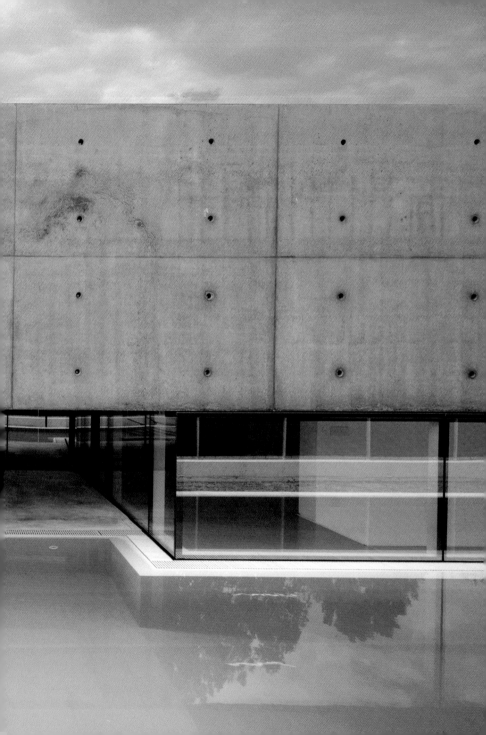

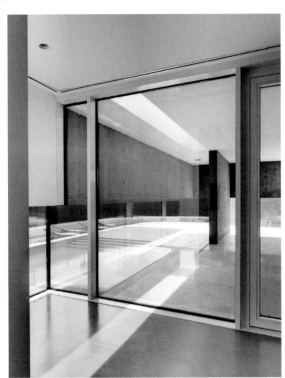

The interiors maintain the same
simplicity of materials and play on
the opacity and transparency seen
in the exterior. A sheltered pool
also continues the theme of water
developed on the outside.

Auch in den Innenräumen blei-
ben – ebenso wie im äußeren
Erscheinungsbild – die Schlichtheit
der Materialien und das Spiel mit
Geschlossenheit und Transparenz
gewahrt. Mit einem Innenpool wird
das außen präsente Thema Wasser
wieder aufgenommen.

L'intérieur conserve la même sim-
plicité des matériaux et les mêmes
jeux d'opacité et de transparence
que l'extérieur. Une piscine sous
abri reprend elle aussi le thème de
l'eau développé à l'extérieur.

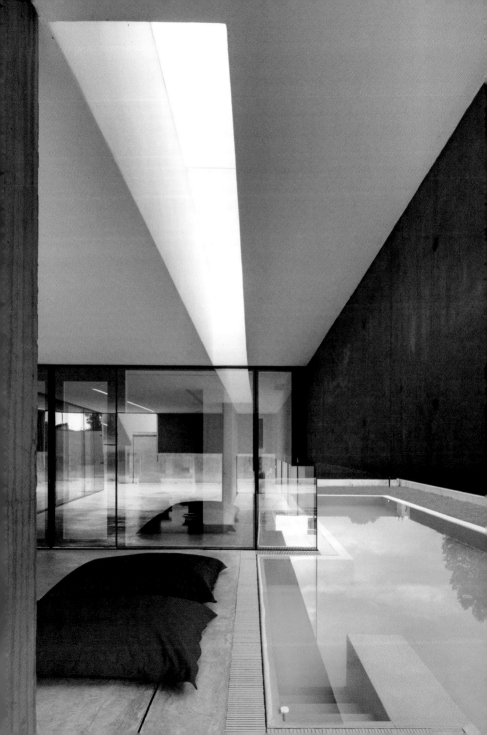

DAVID CHIPPERFIELD

Born in London in 1953, **DAVID CHIPPERFIELD** obtained his Diploma in Architecture from the Architectural Association (London, 1977). He worked in the offices of Norman Foster and Richard Rogers, before establishing David Chipperfield Architects (London, 1985). Built work includes the River and Rowing Museum (Henley-on-Thames, UK, 1989–97); Des Moines Public Library (Des Moines, Iowa, USA, 2002–06); the Museum of Modern Literature (Marbach am Neckar, Germany, 2002–06, published here); the America's Cup Building "Veles et Vents" (Valencia, Spain, 2005–06); the Empire Riverside Hotel (Hamburg, Germany, 2002–07); the Liangzhu Museum (Liangzhu Cultural Village, China, 2003–07); the Neues Museum (Museum Island, Berlin, Germany, 1997–2009); the City of Justice Law Courts (Barcelona, Spain, 2002–09); and the Anchorage Museum at Rasmuson Center (Anchorage, Alaska, USA, 2003–09). The office has completed Museum Folkwang (Essen, Germany, 2007–10); the Peek & Cloppenburg Flagship Store (Vienna, Austria, 2006–11); and their offices in Berlin (Germany, 2011–13, also published here). Chipperfield recently completed the Ansaldo City of Cultures (Milan, Italy, 2000–15); and the Amorepacific Headquarters (Seoul, South Korea, 2010–17).

Der 1953 in London geborene **DAVID CHIPPERFIELD** erwarb sein Diplom für Architektur an der Architectural Association (London, 1977). Er arbeitete in den Büros von Norman Foster und Richard Rogers, bis er David Chipperfield Architects (London, 1985) gründete. Zu seinen ausgeführten Projekten gehören das River and Rowing Museum (Henley-on-Thames, Großbritannien, 1989–97); die Des Moines Public Library (Des Moines, Iowa, USA, 2002–06), das Literaturmuseum der Moderne (Marbach/Neckar, Deutschland, 2002–06, hier vorgestellt), das America's Cup Building „Veles et Vents" (Valencia, Spanien, 2005–06), das Empire Riverside Hotel (Hamburg, Deutschland, 2002–07), das Liangzhu Museum (Liangzhu Cultural Village, China, 2003–07), das Neue Museum (Museumsinsel, Berlin, Deutschland, 1997–2009), das Justizviertel in Barcelona (Spanien, 2002–09) und das Anchorage Museum im Rasmuson Center (Anchorage, Alaska, USA, 2003–09). Das Büro realisierte das Museum Folkwang (Essen, Deutschland, 2007–10), den Flagshipstore Peek & Cloppenburg (Wien, Österreich, 2006–11) und die eigenen Büros in Berlin (Deutschland, 2011–13, hier vorgestellt). Neuere ausgeführte Bauten sind die Ansaldo City of Cultures (Mailand, Italien, 2000–15) und die Hauptverwaltung der Firma Amorepacific (Seoul, Südkorea, 2010–17).

Né à Londres en 1953, **DAVID CHIPPERFIELD** est diplômé en architecture de l'Architectural Association (Londres, 1977). Il a travaillé pour Norman Foster et Richard Rogers avant de créer David Chipperfield Architects (Londres, 1985). Ses réalisations comprennent : le musée de l'Aviron (Henley-on-Thames, Royaume-Uni, 1989–97) ; la bibliothèque de Des Moines (Des Moines, Iowa, États-Unies, 2002–06) ; le Musée de la littérature moderne (Marbach am Neckar, Allemagne, 2002–06, publié ici) ; le bâtiment de l'America's Cup « Veles et Vents » (Valence, Espagne, 2005–06) ; l'hôtel Empire Riverside (Hambourg, Allemagne, 2002–07) ; le musée de Liangzhu (village culturel de Liangzhu, Chine, 2003–07) ; le Neues Museum (île des Musées, Berlin, Allemagne, 1997–2009) ; la Cité de la justice (Barcelone, Espagne, 2002–09) et le musée d'Anchorage du Centre Rasmuson (Anchorage, Alaska, États-Unies, 2003–09). L'agence a réalisé : le musée Folkwang (Essen, Allemagne, 2007–10) ; le magasin-phare de Peek & Cloppenburg (Vienne, Austriche, 2006–11) et les bureaux de l'agence à Berlin (Allemagne, 2011–13, également publié ici). Ses bâtiments récents comprennent : la Cité des cultures Ansaldo (Milan, Italie, 2000–15) et le siège d'Amorepacific (Séoul, Corée du Sud, 2010–17).

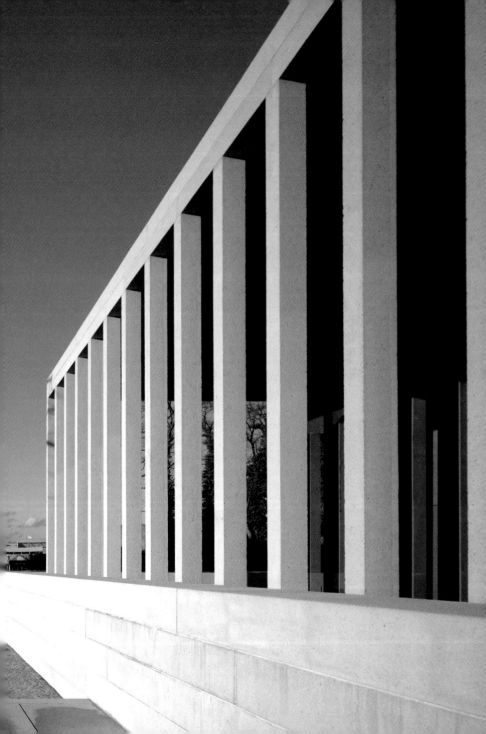

MUSEUM OF MODERN LITERATURE

Marbach am Neckar, Germany, 2002–06

*Floor area: 3800 m². Client: Deutsches Literaturarchiv Marbach, Prof. Dr. Ulrich Raulff,
Dr. Heike Gfrereis, Dr. Roland Kamzelak. Collaboration: Alexander Schwarz,
Harald Müller, Martina Betzold, Barbara Koller, Laura Fogarasi, Hannah Jonas.*

Inaugurated by Germany's Federal President Horst Köhler on June 6, 2006, this new **MUSEUM OF MODERN LITERATURE** is located in Marbach, the birthplace of Friedrich Schiller, and overlooks the Neckar River. Offering panoramic views of the landscape, the structure is "embedded in its topography" and makes full use of the steep slope of the site near the National Schiller Museum. A pavilion-like volume on the uppermost level marks the entrance to the museum, leading down toward dark timber-paneled exhibition galleries. In the galleries, only artificial light is used, given the light-sensitivity of the books and works on paper it houses. "At the same time," the architects explain, "each of these environmentally controlled spaces borders onto a naturally lit gallery, so as to balance views inward to the composed, internalized world of texts and manuscripts with the green and scenic valley on the other side of the glass." As is often the case, Chipperfield uses sober materials such as fair-faced concrete, sandblasted reconstituted stone with limestone aggregate, limestone, wood, felt, and glass to give the solid, modern feeling that he masters so well.

Dieses vom deutschen Bundespräsidenten Horst Köhler am 6. Juni 2006 eingeweihte neue **LITERATURMUSEUM DER MODERNE** liegt hoch über dem Neckar in Marbach, dem Geburtsort Friedrich Schillers. Der „in seine Topografie eingebettete Bau" bietet Panoramablicke auf die umgebende Landschaft und nutzt seine Lage auf dem Steilhang unweit des Schiller-Nationalmuseums vollkommen aus. Ein pavillonartiger Baukörper auf der obersten Ebene markiert den Museumseingang und führt hinunter zu den mit dunklem Holz verschalten Ausstellungsräumen. Angesichts der Lichtempfindlichkeit von Büchern oder allgemein von Arbeiten auf Papier wird in den Galerien nur Kunstlicht verwendet. „Gleichwohl", erläutern die Architekten, „grenzt jeder dieser klimakontrollierten Räume an eine Galerie mit Tageslicht, um so einen Ausgleich zwischen den Blicken nach innen auf die Welt der Texte und Manuskripte und auf das auf der anderen Seite der Glaswand gelegene grüne, malerische Tal herzustellen." Wie so häufig verwendet Chipperfield nüchterne Materialien wie Sichtbeton, sandgestrahlten Kunststein mit Kalksteinzuschlag, Kalkstein, Holz, Filz und Glas, um die für ihn so typische, kompakt-moderne Anmutung zu erzeugen.

Inauguré le 6 juin 2006 par le président allemand Horst Köhler, le nouveau **MUSÉE DE LA LITTÉRATURE MODERNE** situé à Marbach, lieu de naissance de Friedrich Schiller, donne sur le Neckar. Offrant des vues panoramiques sur le paysage, le bâtiment est « incrusté dans la topographie » et met pleinement à profit la pente de son terrain, à proximité du Musée national Schiller. Le volume en pavillon au niveau supérieur marque l'entrée qui conduit en descendant vers les galeries d'exposition lambrissées de bois sombre. Elles ne reçoivent qu'un éclairage artificiel en raison de la forte sensibilité des livres et des œuvres sur papier à la lumière. « En même temps, explique l'architecte, chacun de ces espaces à environnement contrôlé borde une galerie à éclairage naturel de façon à équilibrer les vues vers l'intérieur sur l'univers composé et intériorisé des textes et des manuscrits et celles de la belle vallée verte de l'autre côté des vitrages. » Comme souvent, Chipperfield utilise des matériaux sobres comme une pierre reconstituée en béton à agrégats de calcaire sablé doux au toucher, de la pierre calcaire, du bois, du feutre et du verre pour aboutir à cette impression de modernité et de solidité qu'il maîtrise si bien.

Standing like a temple on its stone plinth, the Museum of Modern Literature renews the vocabulary of classical architecture and brings it into the realm of the modern.

Das gleich einem Tempel auf seinem steinernen Sockel stehende Literaturmuseum der Moderne erneuert die Formensprache der antiken Architektur und transponiert sie in die Moderne.

Se dressant comme un temple sur une plinthe de pierre, le Musée de la littérature moderne renouvelle le vocabulaire de l'architecture classique qu'il transfère dans la sphère moderne.

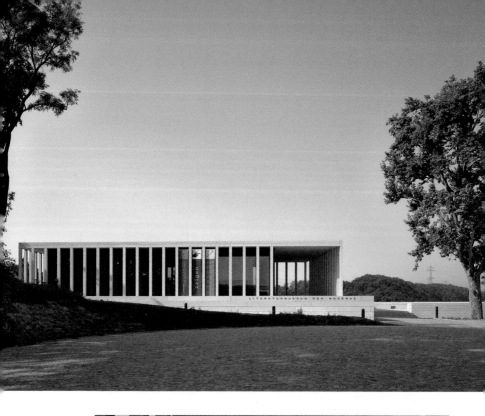

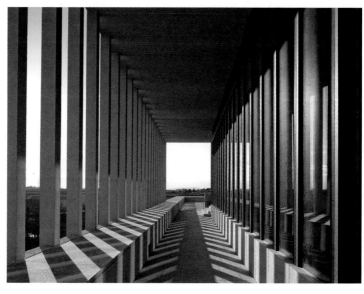

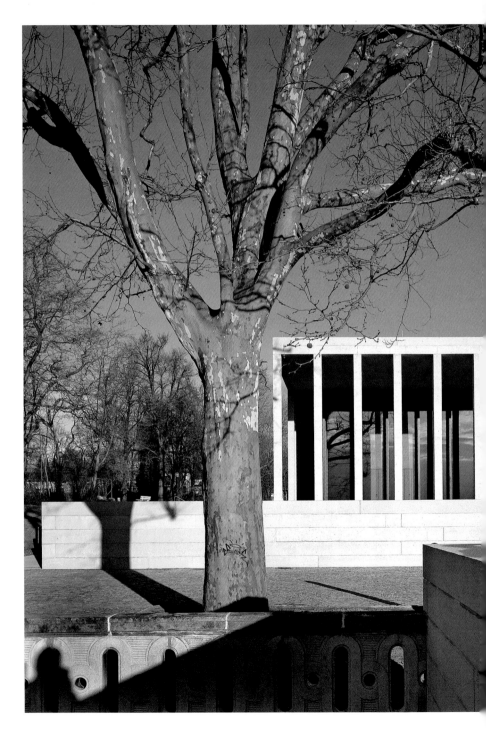

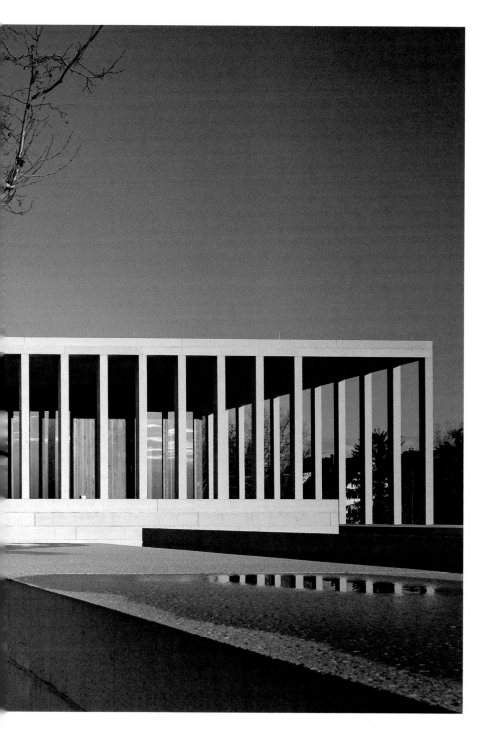

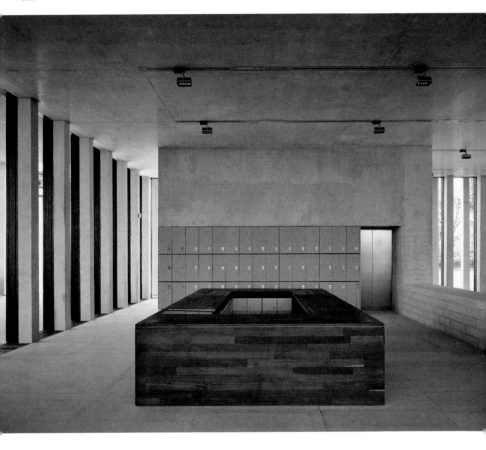

The interior of the museum, like its exterior, is strict and rather austere, with natural light giving variety and life to the spaces where it is admitted.

Die Innenräume des Museums wirken wie das Äußere streng und recht nüchtern, wobei das Tageslicht in den dafür vorgesehenen Räumen für Abwechslung und Belebung sorgt.

Comme pour l'extérieur, l'intérieur du musée est d'aspect strict, presque dur. L'éclairage naturel apporte à l'occasion la variété et la vie dans les volumes.

Chipperfield is known for paring down his architecture to the essentials. In this instance, rectilinear severity is the rule.

Chipperfield ist dafür bekannt, seine Architektur auf das Wesentliche zu reduzieren. In diesem Fall dominiert geradlinige Schlichtheit.

David Chipperfield est réputé pour une architecture qui va à l'essentiel. Ici, règne la ligne droite dans toute sa sévérité.

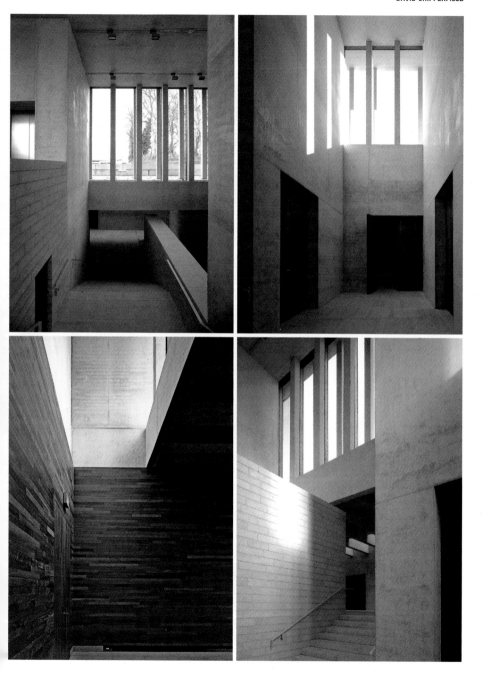

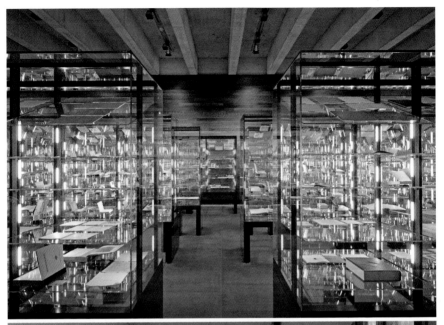

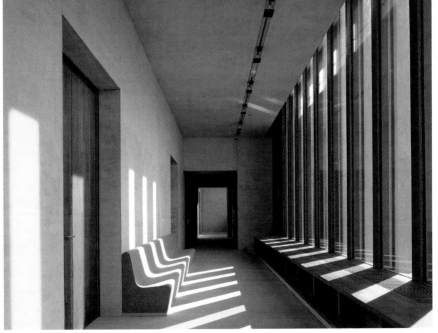

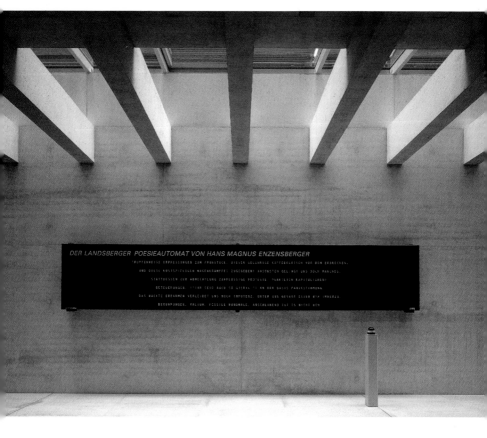

The architect uses horizontal beams as well as columns on the building's exterior, creating a sense of lightness out of the fundamental solidity of the structure.

Der Architekt verwendet horizontale Balken ebenso wie Pfeiler am Außenbau, die der ausgeprägten Stabilität des Gebäudes zu einer gewissen Leichtigkeit verhelfen.

L'architecte utilise les poutres horizontales dans le même esprit que les colonnes extérieures. Il crée une impression de légèreté à partir d'une structure fondamentalement massive.

Light penetrates interior spaces in carefully calculated ways, creating a sense of variety in the stillness of the architecture.

Licht fällt in wohlüberlegter Weise in die Innenräume ein und sorgt für Abwechslung in einer unbewegten Architektur.

La lumière apporte la diversité dans les volumes intérieurs selon des chemins calculés, tandis que l'architecture en elle-même reste froide.

JOACHIMSTRASSE

Berlin, Germany, 2011–13

Area: 1800 m². Client: David Chipperfield Architects.

Built as the Berlin offices of the architect, this complex is made with exterior walls of insulating concrete. Interiors are finished with concrete floors and ceilings. Doors, light partition walls, and installations are in contrasting painted wood paneling. Located in the former East Berlin, the site at **JOACHIMSTRASSE** is near Hackesche Höfe, and occupies a deep plot in an urban block that was greatly damaged during the war. The area is a dense mixture of historic and pre-fabricated concrete buildings, with refurbishment of some structures undertaken as of the 1990s. The architects have added four concrete blocks to an existing brick building. Although the lines of new residential buildings on the street are strict, they correspond to proportions of neighboring structures. Two cubic blocks of different heights were added in the middle of the plot, conserving a sense of a typical prewar courtyard design. A two-story volume serves as a canteen and links to the existing building underground. The taller four-story structure in the center of the complex provides meeting rooms and is directly linked to the older building.

Die Außenwände dieses Komplexes für das Berliner Büro der Architekten bestehen aus Wärmedämmbeton. Die Innenräume haben Betonböden und -decken. Türen, leichte Trennwände und Einrichtungen sind im Gegensatz dazu aus lackiertem Holz. Das Gebäude an der **JOACHIMSTRASSE** liegt im früheren Ostberlin, nahe den Hackeschen Höfen, und nimmt ein tiefes Grundstück in einem städtischen Block ein, der im Krieg weitgehend zerstört wurde. Das Gebiet ist eine dichte Mischung aus historischem Bestand und Betonplattenbauten. Einige davon wurden in den 1990er-Jahren saniert. Die Architekten haben einem bestehenden Backsteinbau vier Betonblöcke hinzugefügt. Obgleich die Formen des neuen Wohngebäudes an der Straße streng sind, entspricht es in den Proportionen der benachbarten Bebauung. Zwei kubische Blöcke unterschiedlicher Höhe wurden in der Mitte des Bauplatzes errichtet, wodurch etwas vom typischen Charakter der Vorkriegsbebauung mit Innenhöfen erhalten blieb. Ein zweigeschossiger Trakt dient als Kantine und verbindet die bestehende Bebauung im Kellergeschoss. Das höhere, viergeschossige Gebäude in der Mitte der Anlage enthält Konferenzräume und ist direkt mit dem Altbau verbunden.

Construit pour accueillir les bureaux berlinois de l'architecte, les murs extérieurs de ce complexe sont en béton isolant. Des sols et des plafonds en béton apportent la touche finale à l'intérieur, tandis que, par contraste, les portes, les cloisons plus légères et les aménagements sont en panneaux de bois peints. Situé dans l'ancien Berlin-Est, à proximité des Hackesche Höfe, le site à **JOACHIMSTRASSE** occupe le fond d'un bloc qui a été détruit en grande partie pendant la guerre. La zone constitue un mélange très dense de constructions en béton anciennes et préfabriquées, certaines ayant été remises à neuf dans les années 1990. Les architectes ont ajouté quatre blocs en béton au bâtiment existant en briques. Les lignes du nouvel immeuble résidentiel sont plutôt sévères côté rue, mais elles correspondent malgré tout aux proportions des structures voisines. Deux blocs cubiques de différentes hauteurs ont été placés au milieu du terrain et conservent l'impression d'une cour berlinoise typique de l'avant-guerre. Un autre volume de deux étages accueille une cantine et relie en sous-sol les bâtiments existants. Enfin, l'immeuble plus haut au centre du complexe, à quatre étages, contient des salles de réunion et est directement relié au bâtiment plus ancien.

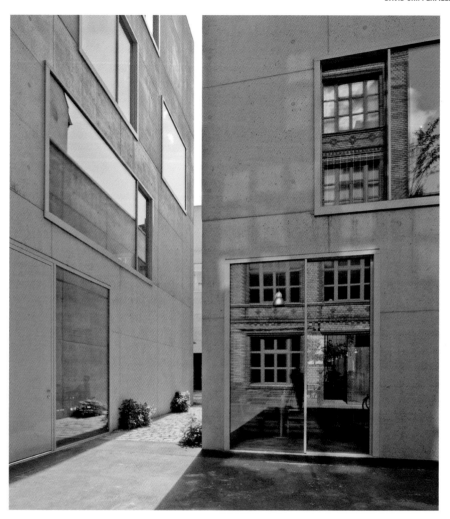

Above, a reflection of the old brick building is seen in the window of one of the new structures.

Next page, the bar/cafeteria of the offices contrasts long concrete surfaces with a wooden bench and simple hanging light fixtures.

Oben: Spiegelung des alte Back-steinbaus im Fenster eines der Neubauten.

Nächste Seite: Die Bar/Cafeteria der Büros mit einer hölzernen Bank und schlichten Hängeleuchten kontras-tiert mit den langen Betonwänden

Ci-dessus, le reflet de l'ancien bâti-ment en briques dans la fenêtre de l'une des nouvelles constructions.

Page prochaine, le bar/cafétéria des bureaux fait contraster de longues surfaces de béton, un banc de bois et de simples lampes suspendues.

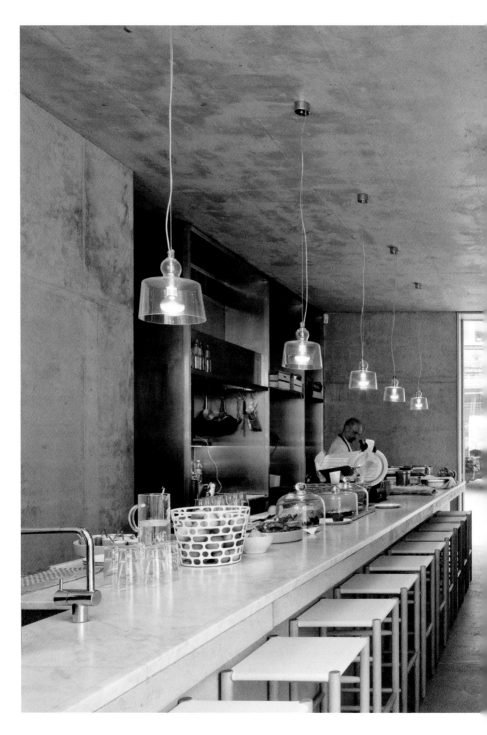

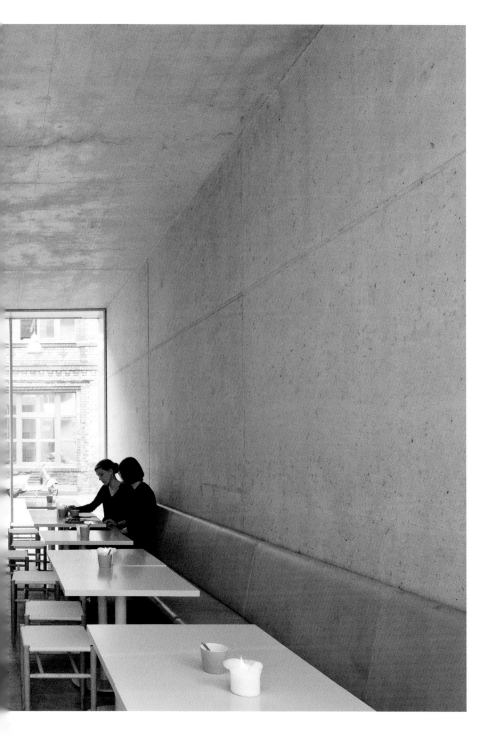

As seen from the street, the residential part of the complex coordinates roof alignments with its neighbors, but takes on a different window rhythm.

Von der Straßenseite zeigt sich, dass die Dachlinie im Wohnbereich der Anlage der benachbarten Bebauung folgt, der Rhythmus der Fenster ist jedoch ein anderer.

Côté rue, la partie résidentielle du complexe présente une toiture alignée avec celle des bâtiments voisins, seules les fenêtres changent le rythme.

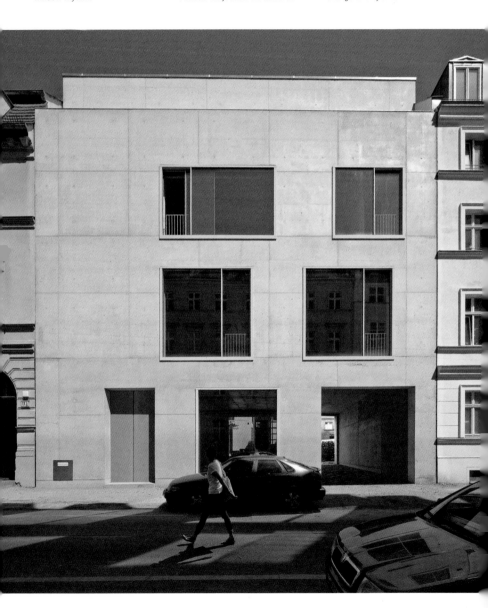

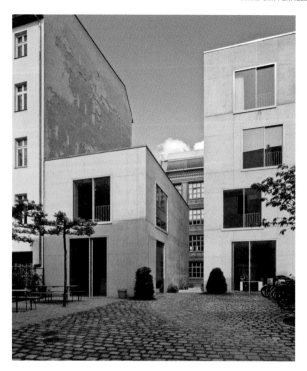

Within the courtyard that is used in warmer months the offices assume the feeling of a small, sheltered village square. Below, section drawings show the relation of the new structures to nearby buildings.

Der in der wärmeren Jahreszeit genutzte Innenhof vermittelt den Eindruck eines kleinen, geschützten Dorfplatzes. Unten: Die Schnitte zeigen den Bezug der Neubauten zur benachbarten Bebauung.

Dans la cour intérieure utilisée pendant les mois les plus chauds de l'année, on se sent comme sur la petite place ombragée d'un village. Ci-dessous, vues en coupe qui montrent le rapport des nouvelles structures et des bâtiments voisins.

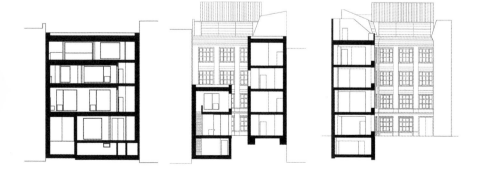

DIENER & DIENER

ROGER DIENER was born in 1950 in Basel, Switzerland, and studied at the ETH in Zurich (1970–75). In 1976, he joined the firm that his father, Marcus Diener, had created in Basel in 1942. He became a Partner in the firm, which was renamed Diener & Diener Architects in 1980. Roger Diener heads the firm, based in Basel and Berlin, working since 2011 with Terese Erngaard, Andreas Rüedi, and Michael Roth. Their work includes the Hotel Schweizerhof and Migros shopping center (Lucerne, Switzerland, 1995–2000); the renovation and extension of the Swiss Embassy in Berlin (Germany, 1995–2000); housing for Java Island, Amsterdam (the Netherlands, 1995–2001); as well as overall planning and new construction for the University of Malmö (Sweden, Phase 1, 1997–2005). Recent work includes the Novartis Pharma Headquarters (Basel, Switzerland, 2003–05); New East Wing Expansion of the Museum of Natural History (Berlin, Germany, 2005–10); the Rewers Rahbek House (Falster, Denmark, 2010–11); the Shoah Memorial Drancy (Drancy, France, 2006–12, published here); Markthalle Tower (Basel, Switzerland, 2007–12); and the Champfèr Houses (Champfèr, Switzerland, 2008–13).

ROGER DIENER wurde 1950 in Basel geboren und studierte an der Eidgenössischen Technischen Hochschule (ETH) in Zürich (1970–75). 1976 trat er in die Firma ein, die sein Vater Marcus Diener 1942 in Basel gegründet hatte. Er wurde Partner dieses Büros, das 1980 in Diener & Diener Architekten umbenannt wurde. Roger Diener leitet die in Basel und Berlin ansässige Firma und arbeitet seit 2011 mit Terese Erngaard, Andreas Rüedi und Michael Roth zusammen. Zu ihren ausgeführten Projekten zählen das Hotel Schweizerhof und das Einkaufszentrum Migros (Luzern, Schweiz, 1995–2000), die Sanierung und Erweiterung der Schweizer Botschaft in Berlin (1995–2000), die Wohnbauten Java Island (Amsterdam, Niederlande 1995–2001) sowie die Gesamtplanung und Neubauten für die Universität Malmö (Schweden, 1. Stufe, 1997–2005). Neuere Bauten sind die Hauptverwaltung des Pharmakonzerns Novartis (Basel, Schweiz, 2003–05), der neue Ostflügel des Museums für Naturkunde (Berlin, Deutschland, 2005–10), das Haus Rewers Rahbek (Falster, Dänemark, 2010–11), die Shoah-Gedenkstätte in Drancy (Frankreich, 2006–12, hier vorgestellt), der Markthalle-Tower (Basel, Schweiz, 2007–12) und die Häuser in Champfèr (Schweiz, 2008–13).

ROGER DIENER est né en 1950 à Bâle et a fait ses études à l'ETH de Zurich (1970–75). En 1976, il a rejoint la société que son père, Marcus Diener, avait fondée à Bâle en 1942. Il en est devenu l'un des associés et elle a été rebaptisée Diener & Diener Architects en 1980. Il dirige l'agence basée à Bâle et Berlin, avec Terese Erngaard, Andreas Rüedi et Michael Roth. Leurs réalisations comptent notamment l'hôtel Schweizerhof et le centre commercial Migros (Lucerne, Suisse, 1995–2000) ; la rénovation et l'extension de l'ambassade de Suisse à Berlin (Allemagne, 1995–2000) ; un logement sur l'île Java à Amsterdam (Pays-Bas, 1995–2001), ainsi que le plan global et une nouvelle construction pour l'université de Malmö (Suède, phase 1, 1997–2005). Parmi leurs projets récents : le siège de Novartis Pharma (Bâle, Suisse, 2003–05) ; la nouvelle extension de l'aile orientale du Musée d'histoire naturelle (Berlin, Allemagne, 2005–10) ; la maison Rewers Rahbek (Falster, Danemark, 2010–11) ; le mémorial de la Shoah de Drancy (France, 2006–12, publié ici) ; la tour de la Markthalle (Bâle, Suisse, 2007–12) et les maisons de Champfèr (Suisse, 2008–13).

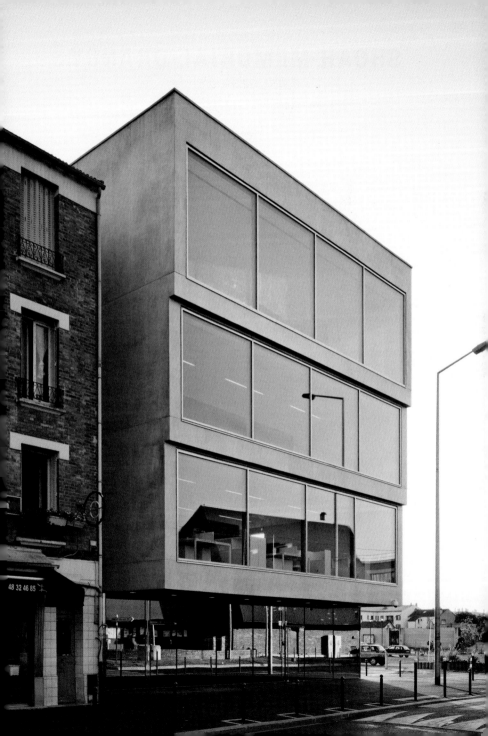

SHOAH MEMORIAL DRANCY

Drancy, France, 2006–12

Area: 2635 m². Client: Mémorial de la Shoah. Cost: $8.5 million.
Collaboration: Eric Lapierre (Local Architect), Agence Fluo/Heller Enterprises (Exhibition Design).

Under the Vichy regime, from 1941 to 1944, French and foreign Jews were deported from Drancy to extermination camps, where nearly 76 000 died. The central internment camp was set up in the Paris suburb of Drancy, in the Cité de la Muette housing complex, which had been designed and built between 1932 and 1934 by Eugène Beaudouin and Marcel Lods, with Jean Prouvé. In 2006, the Mémorial de la Shoah Foundation launched a competition for a memorial to be located near to the former camp. Inaugurated in 2012, the **SHOAH MEMORIAL** by Diener & Diener is a compact volume occupying a small plot on Avenue Jean Jaurès opposite the Cité de la Muette. Conference rooms are located on two underground levels. The ground-floor gallery is dedicated to an introduction to the Shoah. The first floor accommodates archives and offices, and the second floor is used for educational activities. The top floor is dedicated to the view: the fully glazed front of the floor directs visitors' eyes toward the square and the actual site of the Cité de la Muette. The façade built from reinforced, smooth, white concrete and glass is staggered. The ground-floor façade is clad with reflecting glass, angled so the square of the Cité de la Muette, which is diagonally across the street, is seen as a mirror image.

Unter der Vichy-Regierung wurden 1941 bis 1944 französische und ausländische Juden aus Drancy in Vernichtungslager deportiert, wo fast 76 000 von ihnen starben. Das zentrale Internierungslager wurde im Pariser Vorort Drancy eingerichtet, in der Wohnanlage Cité de la Muette, die 1932 bis 1934 von Eugène Beaudouin und Marcel Lods mit Jean Prouvé geplant und gebaut worden war. Im Jahre 2006 schrieb die Stiftung Mémorial de la Shoah einen Wettbewerb für die **SHOAH GEDENKSTÄTTE** nahe dem früheren Lager aus. Das 2012 eingeweihte Gebäude von Diener & Diener ist eine kompakte Baumasse auf einem kleinen Grundstück an der Avenue Jean Jaurés gegenüber der Cité de la Muette. Die Tagungsräume liegen in zwei Untergeschossen. Die Galerie im Erdgeschoss bietet eine Einführung in die Ereignisse der Shoah. Im ersten Obergeschoss sind die Archive und Büros untergebracht; das zweite Obergeschoss wird für Informationsveranstaltungen genutzt. Die oberste Etage ist nur der Aussicht gewidmet: Die voll verglaste Front dieses Geschosses leitet den Blick der Besucher zum Areal der heutigen Cité de la Muette und ihrem Platz. Die Fassade aus glattem, weißem Stahlbeton und Glas ist abgestuft. Im Erdgeschoss ist die Fassade mit reflektierendem Glas verkleidet; sie liegt diagonal zur gegenüberliegenden vom Platz der Cité de la Muette, der sich in ihr spiegelt.

Sous le régime de Vichy, de 1941 à 1944, les Juifs français et étrangers ont été déportés de Drancy vers les camps d'extermination où près de 76 000 sont morts. Le camp d'internement central se trouvait à Drancy, en banlieue parisienne, dans le complexe résidentiel de la Cité de la Muette, construit en 1932–34 par Eugène Beaudouin et Marcel Lods avec Jean Prouvé. En 2006, la Fondation pour la **MÉMOIRE DE LA SHOAH** a organisé un concours pour un mémorial à proximité de l'ancien camp. Le bâtiment de Diener & Diener, inauguré en 2012, est un volume compact qui occupe un petit terrain avenue Jean Jaurès, en face de la Cité de la Muette. Les salles de conférences occupent les deux niveaux souterrains. La galerie du rez-de-chaussée présente une introduction à la Shoah. Le premier étage abrite les archives et les bureaux, tandis que le deuxième est consacré aux activités pédagogiques. Le dernier étage est voué à la vue : l'avant entièrement vitré oriente le regard des visiteurs vers le square et le site de la Cité de la Muette actuelle. La façade en béton armé, lisse et blanc, et verre présente des niveaux décalés, celle du rez-de-chaussée est revêtue de verre réfléchissant et est orientée de sorte que le square de la Cité de la Muette, de l'autre côté de la rue en diagonale, s'y reflète comme dans un miroir.

The function of the Memorial would be hard to guess from its physical appearance, which is quite normal, aside from the slight play on window surfaces or the gradual extension forward as the building rises.

Die Funktion der Gedenkstätte lässt sich kaum von ihrem Erscheinungsbild ablesen, das sehr normal wirkt, abgesehen von dem leichten Spiel mit den Fensterflächen oder der allmählichen Verbreiterung des Baus nach oben hin.

L'apparence physique du mémorial ne permet guère de deviner la fonction qui est la sienne, tant elle est relativement « normale », à l'exception du jeu discret avec les surfaces des fenêtres ou de l'avancée progressive du bâtiment vers le haut.

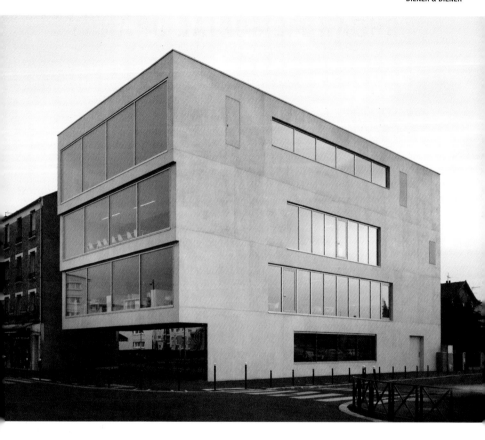

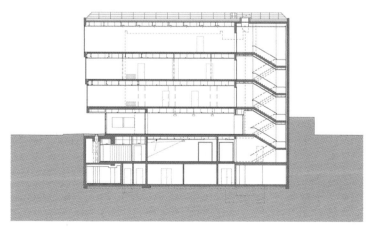

220

The top-floor windows (below) look out onto the location of the Cité de la Muette housing complex, which was used as an internment camp during World War II. Right, the ground-floor gallery with floor plans.

Les fenêtres du dernier étage (ci-dessous) donnent sur le complexe résidentiel de la Cité de la Muette, utilisé comme camp d'internement pendant la Seconde Guerre mondiale. À droite, galerie du rez-de-chaussée et plans des différents étages.

Die Fenster im obersten Geschoss (unten) sind zur Wohnanlage Cité de la Muette orientiert, die im Zweiten Weltkrieg als Internierungslager diente. Rechts: Die Galerie im Erdgeschoss mit Grundrissen.

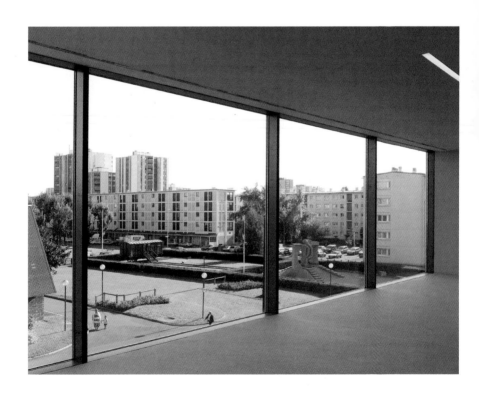

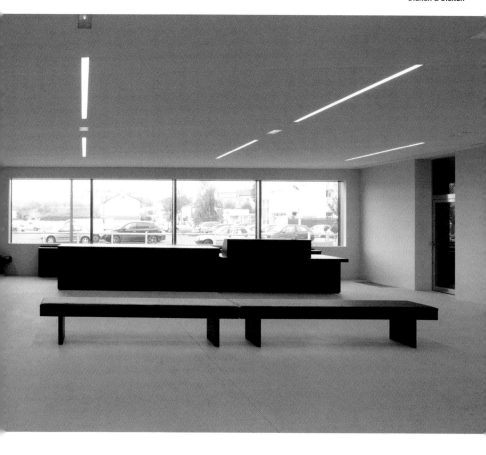

SHUHEI ENDO

Born in Shiga Prefecture, Japan, in 1960, **SHUHEI ENDO** obtained his Master's degree from the Kyoto City University of Art in 1986. He worked after that with the architect Osamu Ishii and established his own firm, the Endo Shuhei Architect Institute, in 1988. His work has been widely published and he has received numerous prizes, including the Andrea Palladio International Prize in Italy (1993). He is currently Professor at the Graduate School of Architecture, Kobe University. His work includes Slowtecture S (Maibara, Shiga, 2002); Growtecture S (Osaka, 2002); Springtecture B (Biwa-cho, Shiga, 2002); Bubbletecture M (Maibara, Shiga, 2003); Rooftecture C (Taishi, Hyogo, 2003); Rooftecture H (Kamigori, Hyogo, 2004); and Bubbletecture O (Maruoka, Fukui, 2004). In 2007, he completed Bubbletecture H (Sayo-cho, Hyogo, 2006–07); Slowtecture M (Miki-city, Hyogo); and Rooftecture M's (Habikino City, Osaka), all in Japan. More recent work includes Looptecture A (Minami Awaji, Hyogo, 2010–12, published here); Rooftecture OT2 (Osaka, 2012); and Arktecture M (Himeji, Hyogo, 2013), all in Japan.

Der 1960 in der Präfektur Shiga in Japan geborene **SHUHEI ENDO** erwarb 1986 seinen Master an der Kyoto City University of Art. Danach arbeitete er für den Architekten Osamu Ishii und gründete 1988 sein eigenes Büro, das Endo Shuhei Architect Institute. Über seine Bauten wurde viel geschrieben, und er hat zahlreiche Preise erhalten, darunter den Internationalen Andrea-Palladio-Preis in Italien (1993). Gegenwärtig hat er eine Professur an der Graduate School of Architecture der Universität Kobe. Zu seinen ausgeführten Projekten zählen Slowtecture S (Maibara, Shiga, 2002), Growtecture S (Osaka, 2002), Springtecture B (Biwa-cho, Shiga, 2002), Bubbeltecture M (Maibara, Shiga, 2003), Rooftecture C (Taishi, Hyogo, 2003), Rooftecture H (Kamigori, Hyogo, 2004) und Bubbletecture O (Maruoka, Fukui, 2004). Im Jahr 2007 stellte er Bubbletecture H (Sayo-cho, Hyogo, 2006–07), Slowtecture M (Miki City, Hyogo) und Rooftecture M's (Habikino City, Osaka) fertig, alle in Japan. Neuere Projekte sind Looptecture (Minami Awaji, Hyogo, 2010–12, hier vorgestellt), Rooftecture OT2 (Osaka, 2012) und Arktecture M (Himeji, Hyogo, 2013), alle in Japan.

Né dans la préfecture de Shiga, au Japon, en 1960, **SHUHEI ENDO** a obtenu son master de l'Université des arts de Kyoto en 1986. Il a ensuite travaillé pour l'architecte Osamu Ishii et fondé sa propre agence, Endo Shuhei Architect Institute, en 1988. Son œuvre a été largement publiée et a reçu de nombreuses distinctions, dont le prix Andrea Palladio International en Italie (1993). Il enseigne actuellement à l'École supérieure d'architecture de l'université de Kobé. Parmi ses réalisations : Slowtecture S (Maibara, Shiga, 2002) ; Growtecture S (Osaka, 2002) ; Springtecture B (Biwa-cho, Shiga, 2002) ; Bubbletecture M (Maibara, Shiga, 2003) ; Rooftecture C (Taishi, Hyogo, 2003) ; Rooftecture H (Kamigori, Hyogo, 2004) et Bubbletecture O (Maruoka, Fukui, 2004). Parallèlement à Bubbletecture H (Sayo-cho, Hyogo, 2006–07), il a achevé Slowtecture M (Miki-city, Hyogo) et Rooftecture M (Habikino City, Osaka) en 2007, tous au Japon. Ses projets plus récents comprennent Looptecture A (Minami Awaji, Hyogo, 2010–12, publié ici) ; Rooftecture OT2 (Osaka, 2012) et Arktecture M (Himeji, Hyogo, 2013), tous au Japon.

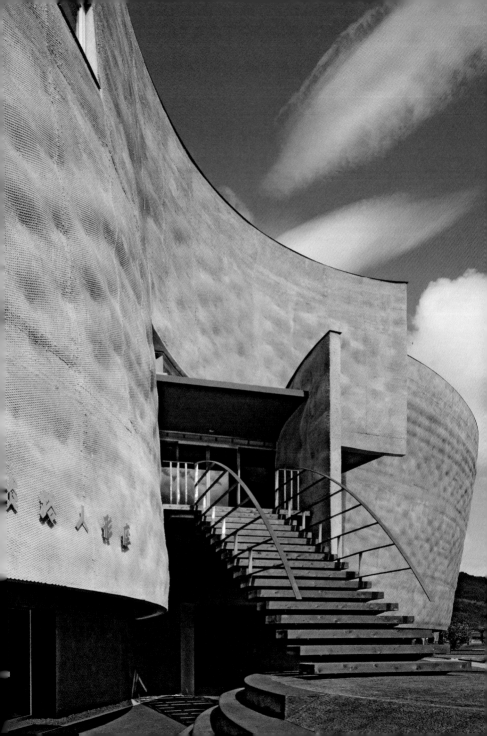

LOOPTECTURE A

Minami Awaji, Hyogo, Japan, 2010–12

Area: 1894 m².

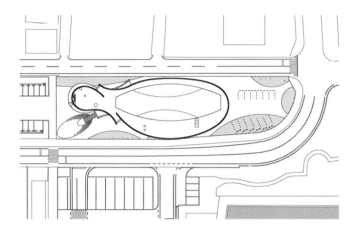

This theater is located on Awaji Island, which is known as the birthplace of the Japanese traditional puppet-play "Ningyo-Joruri." A company of professional performers is based in **LOOPTECTURE A**. The architect employed exposed concrete in a corrosion-resistant steel-mesh mold, allowing the creation of a three-dimensional curved surface that appears to be "soft." The plan of the structure resembles a slightly deformed figure 8, or perhaps a fish. The structure is, in fact, intended primarily as a tsunami refuge for local populations. Its main entrance is on the second floor. Opposite this entrance, the upper southern wall opens out in the direction of the sea. A curved interior wall finished in black wood leads to the 200-seat theater. There is little artificial light in this area. The auditorium wall is finished in traditional old Japanese Kawara roof tiles.

Die Insel Awaji, auf der dieses Theater liegt, ist der Überlieferung nach der Geburtsort des traditionellen japanischen Puppenspiels „Ningyo Joruri". **LOOPTECTURE A** ist der Standort einer professionellen Puppenspielergruppe. Der Architekt verwendete Sichtbeton mit korrosionsbeständiger Bewehrung aus Stahlgeflecht, um eine dreidimensional gekrümmte Fläche zu gestalten, die „weich" wirkt. Der Grundriss des Gebäudes ähnelt einer leicht verformten Acht oder vielleicht eher einem Fisch. Tatsächlich soll der Bau in erster Linie bei einem Tsunami als Zufluchtsort für die Bevölkerung dienen. Der Haupteingang liegt auf der zweiten Ebene. Ihm gegenüber ist die Südwand zum Meer geöffnet. Eine geschwungene, mit schwarzem Holz verkleidete Innenwand führt zum Theater mit 200 Sitzplätzen. In diesem Bereich gibt es nur wenig künstliche Beleuchtung. Die Wände des Auditoriums sind mit traditionellen, alten japanischen Kawara-Dachziegeln verkleidet.

L'île d'Awaji où se trouve ce théâtre aurait, selon la tradition, donné naissance au spectacle de marionnettes traditionnel japonais, le « Ningyo-Joruri ». Une troupe de marionnettistes professionnels est basée dans le **LOOPTECTURE A**. L'architecte a utilisé du béton apparent et un moule à mailles en acier inoxydable qui lui a permis de créer une surface tridimensionnelle courbe d'apparence « douce ». Le plan rappelle un 8 légèrement déformé, ou peut-être un poisson. Le bâtiment a en fait été d'abord conçu comme un refuge pour les populations locales en cas de tsunami. L'entrée principale est au deuxième étage. En face, le haut mur sud s'ouvre vers la mer. Un mur intérieur incurvé aux finitions de bois noir mène au théâtre de 200 places. La lumière artificielle est très réduite. Les parois de l'auditorium sont ornées d'anciennes tuiles japonaises kawara, utilisées traditionnellement pour les toits.

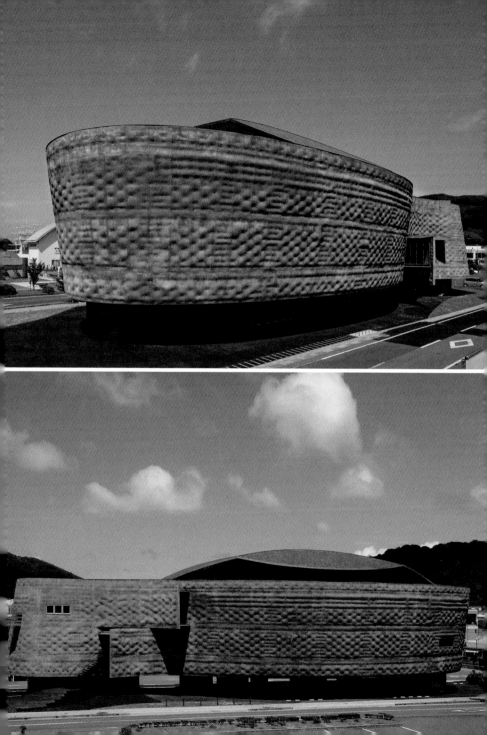

ANTÓN GARCÍA-ABRIL & ENSAMBLE STUDIO

ANTÓN GARCÍA-ABRIL was born in Madrid, Spain, in 1969. He graduated from the ETSA of Madrid in Architecture and Urbanism in 1995 and went on to receive a doctorate from the same institution in 2000. Rafael Moneo was a family friend, and García-Abril worked in the office of Santiago Calatrava (1992) and in that of Alberto Campo Baeza (1990–94). He created his first firm in 1995, and his present one, Ensamble Studio, in 2000. The name of his firm is derived from a term used in architecture, "assemble," and the musical term "ensemble." His completed projects include the Musical Studies Center (Santiago de Compostela, 2002); Concert Hall and Music School (Medina del Campo, 2003); Valdés Studio (Madrid, 2004); Martemar House (Málaga, 2003–05); SGAE Central Office (Santiago de Compostela, 2005–07); Berklee Tower of Music (Valencia, 2007); and Paraiso Theater (Shanghai, China, 2007). More recent projects include Hemeroscopium House (Madrid, 2007–08, published here); Lyric Theater (Mexico City, Mexico, 2008); the Fleta Theater (Zaragoza, 2008); the Cervantes Theater (Mexico City, Mexico, 2012); and the Reader's House (Madrid, 2012), all in Spain unless otherwise indicated.

ANTÓN GARCÍA-ABRIL wurde 1969 in Madrid geboren. Sein Studium der Architektur und Stadtplanung schloss er 1995 an der ETSA in Madrid ab, wo er 2000 promovierte. Rafael Moneo war ein Freund der Familie. García-Abril arbeitete sowohl für Santiago Calatrava (1992) als auch für Alberto Campo Baeza (1990–94). Sein erstes eigenes Büro gründete er 1995, sein heutiges Büro, Ensamble Studio, folgte 2000. Der Name des Büros leitet sich von den architektonischen bzw. musikalischen Begriffen „assemble" (montieren) und Ensemble ab. Zu seinen realisierten Projekten zählen das Zentrum für musikalische Studien (Santiago de Compostela, 2002), eine Konzerthalle und Musikschule (Medina del Campo, Spanien, 2003), das Studio Valdés (Madrid, 2004), die Casa Martemar (Málaga, 2003–05), die SGAE-Zentrale (Santiago de Compostela, 2005–07), die Torre de la Música (Valencia, 2007) und das Paraiso-Theater (Schanghai, China, 2007). Jüngere Projekte sind das Haus Hemeroscopium (Las Rozas, Madrid, 2007–08, hier vorgestellt), das Teatro Lírico (Mexiko-Stadt, Mexiko, 2008), das Fleta-Theater (Saragossa, 2008), das Cervantes-Theater (Mexiko-Stadt, Mexiko, 2012) sowie die Casa del Lector (Madrid, 2012), alle in Spanien, soweit nicht anders vermerkt.

ANTÓN GARCÍA-ABRIL est né à Madrid, en 1969. Il obtient son diplôme en architecture et urbanisme en 1995, puis son doctorat en 2000 à l'ETSA de Madrid. Rafael Moneo est un ami de la famille et García-Abril travaille chez Santiago Calatrava (1992) et chez Alberto Campo Baeza (1990–94). Il crée sa première agence en 1995 et, en 2000, Ensamble Studio, son agence actuelle, qui tire son nom de la fusion du terme d'architecture « assembler » et du terme musical « ensemble ». Ses projets réalisés comprennent le Centre de hautes études musicales (Saint-Jacques de Compostelle, 2002) ; une salle de concert et une école de musique (Medina del Campo, 2003) ; le Valdés Studio (Madrid, 2004) ; la maison Martemar (Málaga, 2003–05) ; les bureaux du SGAE (Saint-Jacques de Compostelle, 2005–07) ; la Torre de la Música (Valence, 2007) et le théâtre Paraiso (Shanghai, Chine, 2007). Leurs récents projets comprennent la maison Hemeroscopium (Madrid, 2007–08, présenté ici) ; le Teatro Lírico (Mexico, Mexique, 2008), le théâtre Fleta (Saragosse, 2008) ; le théâtre Cervantes (Mexico, Mexique, 2012) et la Casa del Lector (Madrid, 2012), tous en Espagne, sauf si spécifié.

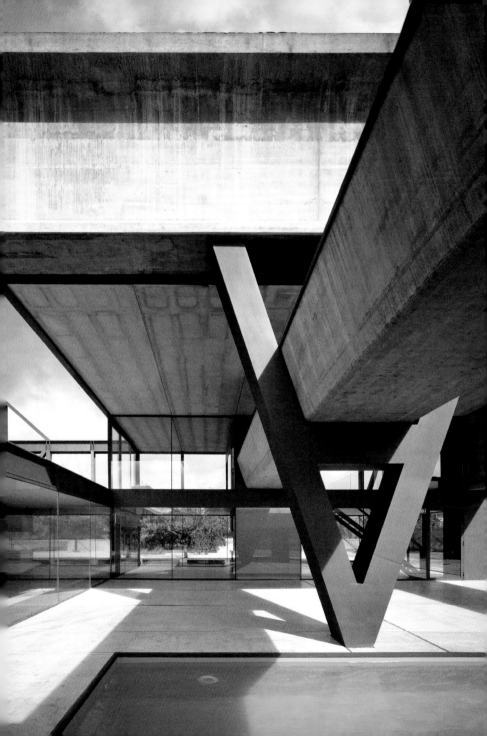

HEMEROSCOPIUM HOUSE

Las Rozas, Madrid, Spain, 2007–08

Floor area: 300 m². Client: Hemeroscopium S.L.
Collaboration: Elena Pérez (Associate Architect), Javier Cuesta (Quantity Surveyor).

The name "Hemeroscopium" is Greek for the place where the sun sets, "an allusion to a place that exists only in our mind, in our senses. It is constantly moving and mutable, but is nonetheless real. It is enclosed, delimited and suggested by the horizon, though it is defined by light and only takes place in a precise moment of time." The architect has placed the beams in an ascendant spiral of seven heavy structural elements that grows lighter as it rises. The juncture of these beams made of a combination of reinforced precast and cast-in-place concrete appears to be simple but demanded complex engineering calculations. "It took us a year to figure out the way to make the equilibrium between elements possible and only seven days to build the structure," says the architect. In rather poetic terms, García-Abril explains, "Thus, an astonishing new language is invented where form disappears and naked space is created. Space, its nudity and emptiness, is framed by a solid and dense structure. The **HEMEROSCOPIUM HOUSE** materializes equilibrium with what we ironically call the G point, a 20-ton granite stone, the expression of the force of gravity, a counterweight to the whole structure's mass." Indeed, the enormous block of granite the architect refers to sits on top of the house, a reminder of the forces at play.

Der aus dem Griechischen stammende Begriff Hemeroscopium bezeichnet den Ort, an dem die Sonne untergeht, „eine Anspielung auf einen Ort, der nur in unserem Kopf, in unseren Sinnen existiert. Er ist unablässig in Bewegung, im Wandel und dennoch real. Er ist umschlossen, umgrenzt und angedeutet durch den Horizont, obwohl er nur vom Licht definiert wird und sich zu einem ganz bestimmten Zeitpunkt ereignet". Der Architekt positionierte die Träger zu einer aufsteigenden Spirale aus sieben schweren Konstruktionselementen, die mit zunehmender Höhe leichter wird. Die Verbindung dieser Träger, teils aus vorgefertigten Stahlbetonelementen und teils aus Ortbeton gegossen, wirkt einfach, erforderte jedoch komplexe statische Berechnungen. „Wir brauchten ein Jahr, um das Gleichgewicht zwischen den Elementen zu berechnen, und nur sieben Tage, um den Bau zu errichten", berichtet der Architekt. Auf recht poetische Weise erklärt García-Abril: „Und so erfanden wir eine erstaunliche neue Sprache, in der die Form schwindet und bloßer Raum entsteht. Der Raum, seine Nacktheit und Leere, wird von einer massiven und dichten Struktur umschlossen. Das **HAUS HEMEROSCOPIUM** erreicht sein Gleichgewicht durch einen 20 t schweren Granitblock, den wir ironisch den G-Punkt nennen, ein Ausdruck der Schwerkraft, ein Gegengewicht zur Masse der Gesamtkonstruktion." Und tatsächlich liegt der gewaltige Granitblock, den der Architekt erwähnt, oben auf dem Haus und erinnert an die Kräfte, die hier im Spiel sind.

Le mot « Hemeroscopium », issu du grec, signifie « lieu où se couche le soleil » : « C'est une allusion à un lieu qui n'existe que dans nos têtes et nos sens. Il se déplace et se transforme constamment, mais n'en est pas moins réel. C'est un lieu clos, délimité et suggéré par l'horizon, bien qu'il soit défini par la lumière et n'apparaisse qu'à un moment précis de la journée. » L'architecte a disposé les poutres en spirale ascendante composée de sept lourds éléments structuraux qui s'allègent peu à peu. La jonction entre ces poutres et le béton armé préfabriqué ou coulé sur place semble simple, mais a demandé des calculs d'ingénierie très complexes. « Il nous a fallu un an pour trouver l'équilibre entre ces éléments, mais sept jours seulement pour les monter », précise l'architecte. En termes assez poétiques, García-Abril explique : « Ainsi s'est élaboré un étonnant nouveau langage dans lequel la forme disparaît et un espace nu se crée. L'espace – sa nudité et son vide – est cadré par une structure dense et massive. La **MAISON HEMEROSCOPIUM** matérialise un équilibre avec ce que nous appelons ironiquement le point G, qui est un rocher de granit de 20 tonnes exprimant la force de gravité et faisant contrepoids à toute la structure. » Cet énorme bloc de granit, posé en partie supérieure de la maison, rappelle en effet les forces en jeu.

The Hemeroscopium House is made up of a series of architectural or engineering challenges, including its stacked beam design and the massive block of stone that tops this assemblage.

Das Haus Hemeroscopium entstand aus der Bewältigung verschiedener architektonischer und statischer Herausforderungen, darunter die gestapelten Träger und der massive Steinblock, der die Komposition krönt.

La maison Hemoroscopium accumule les défis architecturaux ou techniques, comme le montre son empilement de poutres énormes et le bloc de pierre massif qui le couronne.

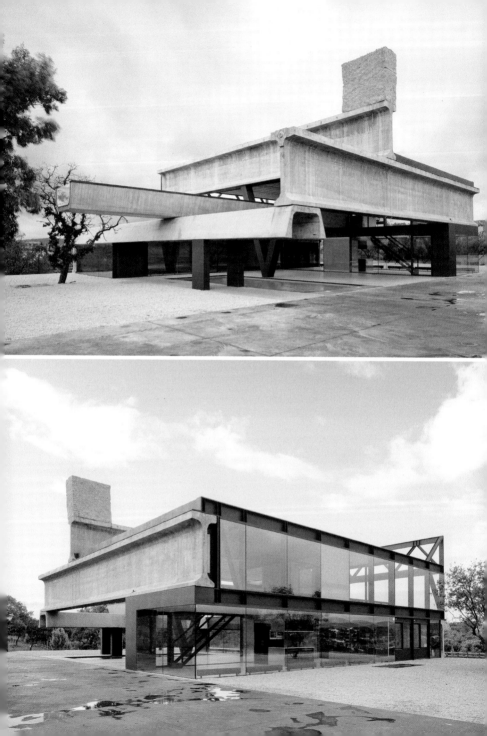

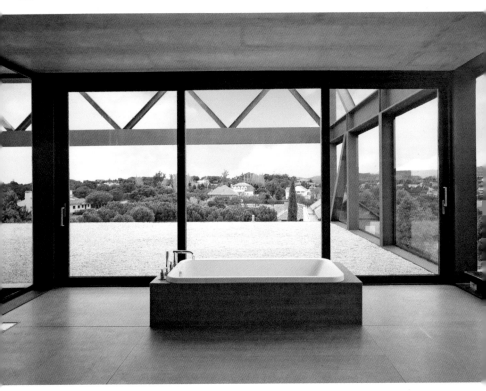

The volumes formed by the stacked elements of the house are simple and modern in appearance, even if the weightiness of the beams sometimes gives an impression of a careful balance that goes beyond the call of solidity.

Die von den gestapelten Elementen definierten Räume sind schlicht und modern. Dennoch lässt die Schwere der Träger vermuten, dass es beim sorgsamen Austarieren der Konstruktion vielleicht um mehr ging als um bloße Stabilität.

Les volumes formés par l'empilement d'éléments architecturaux sont d'aspect simple et moderne, même si la lourdeur des poutres donne parfois l'impression d'un équilibre calculé qui dépasse les simples nécessités de la solidité.

With a plan that is rigorously
geometric, and essentially square,
the architect nonetheless creates
a series of unremitting surprises in
his search for excessive dimensions.

Dans ce plan rigoureusement géo-
métrique de forme essentiellement
carrée, l'architecte réussit à multi-
plier les surprises dans sa recherche
de dimensionnements extravagants.

Trotz des streng geometrischen,
im Grunde quadratischen Grundrisses
gelingt es dem Architekten bei sei-
nem Streben nach exzessiven Dimen-
sionen immer wieder zu überraschen.

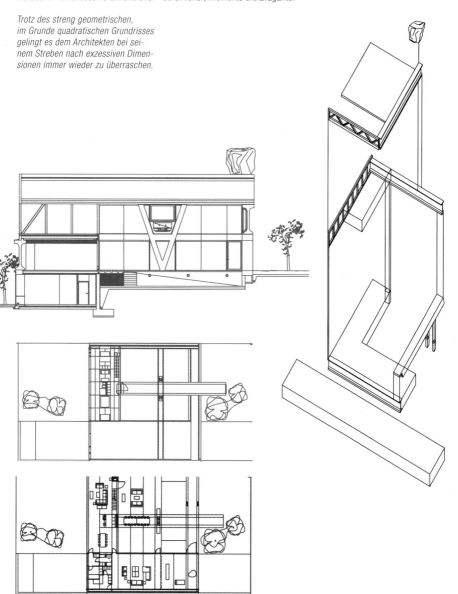

MANUELLE GAUTRAND

Born in 1961, **MANUELLE GAUTRAND** received her degree in Architecture in 1985. She created her own office in 1991 in Lyon and moved it to Paris in 1994. She has taught at the École Spéciale d'Architecture in Paris (1999–2000), at the Paris-Val-de-Seine University (2000–03), and participates in numerous student workshops outside France. In 2001, she was selected to participate in the limited competition for the François Pinault Contemporary Art Museum that was to be located on the Île Seguin near Paris. Her built work includes a 72-meter-long pedestrian bridge (Lyon, 1993); five highway toll booths (in the Somme region on the A16 highway, 1998); and the Theater of the National Center for Dramatic Arts (Béthune, 1998). Her recent work includes "Solaris", a 100-unit sustainable apartment building and socio-cultural center in Rennes (2006); an administrative complex in Saint-Étienne (2005–07); Espace Citroën (Paris, 2007); the extension and restructuring of LaM, the Lille Museum of Modern, Contemporary and Outsider Art (Villeneuve D'Ascq, 2006–09, published here); and the Gaîté Lyrique Digital Arts and Music Center in Paris (2007–10), all in France. Other work includes the Palace Theater 2 (Béthune, 2010–14) and the Hipark Hotel (Paris, 2009–16).

MANUELLE GAUTRAND, geboren 1961, schloss ihr Architekturstudium 1985 ab. 1991 gründete sie ihr eigenes Büro in Lyon, mit dem sie 1994 nach Paris übersiedelte. Gautrand lehrte an der École Spéciale d'Architecture in Paris (1999–2000) sowie der Universität Paris-Val-de-Seine (2000–03) und ist an zahlreichen Studentenworkshops außerhalb Frankreichs beteiligt. 2001 wurde sie zum Wettbewerb für das François-Pinault-Museum für zeitgenössische Kunst eingeladen, das auf der Île Seguin unweit von Paris gebaut werden sollte. Zu ihren realisierten Projekten zählen eine 72 m lange Fußgängerbrücke (Lyon, 1993), fünf Autobahn-Mautstationen (an der A16 in der Region Somme, 1998) sowie das Theater des staatlichen Zentrums für darstellende Künste (Béthune, 1998). Jüngste Projekte sind u. a. „Solaris", ein nachhaltiges Apartmentgebäude mit 100 Wohneinheiten und soziokulturellem Zentrum in Rennes (2006), ein Verwaltungskomplex in Saint-Étienne (2005–07), der Espace Citroën (Paris, 2007), die Erweiterung und Neustrukturierung des LaM, des Museums für moderne, zeitgenössische und Outsider-Kunst in Lille (Villeneuve d'Ascq, 2006–09, hier vorgestellt) sowie die Gaîté Lyrique, das Zentrum für digitale Kunst und Musik in Paris (2007–10), alle in Frankreich. Weitere Werke sind das Theater Palace 2 (Béthune, 2010–14) und das Hipark Hotel (Paris, 2009–16).

Née en 1961, **MANUELLE GAUTRAND** a obtenu son diplôme d'architecte en 1985. Elle a créé son agence à Lyon en 1991 avant de s'installer à Paris en 1994. Elle a enseigné à l'École spéciale d'architecture de Paris (1999–2000), à l'université Paris-Val de Seine (2000–03) et participe à de nombreux ateliers d'étudiants en dehors de la France. En 2001, elle a été sélectionnée pour participer au concours restreint organisé pour le Musée d'art contemporain François Pinault qui devait être édifié sur l'île Seguin aux portes de Paris. Parmi ses réalisations, toutes en France : une passerelle piétonnière de 72 m de long (Lyon, 1993) ; cinq péages d'autoroute (département de la Somme sur l'A16, 1998) et le théâtre du Centre dramatique national de Béthune (1998). Plus récemment, elle a réalisé « Solaris », un immeuble durable de 100 appartements et centre socioculturel à Rennes (2006) ; un complexe administratif à Saint-Étienne (2005–07) ; l'Espace Citroën (Paris, 2007) ; l'extension et la restructuration du LaM, Lille Métropole, musée d'art moderne, d'art contemporain et d'art brut (Villeneuve d'Ascq, 2006–09, publié ici) et la Gaîté lyrique, Centre des arts numériques et des musiques actuelles (Paris, 2007–10), le tout en France. Ses projets actuels incluent le théâtre Le Palace 2 (Béthune, 2010–14) et l'hôtel Hipark (Paris, 2009–16).

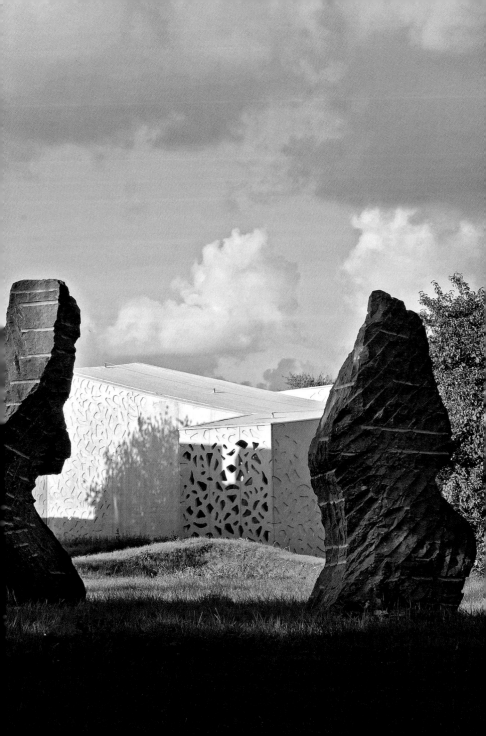

LAM, LILLE MUSEUM OF MODERN, CONTEMPORARY AND OUTSIDER ART

Villeneuve d'Ascq, France, 2006–09

Area: 11 600 m² (total); 3200 m² (new structure); 4000 m² (exhibition area).
Client: Lille Métropole Communauté Urbaine. Cost: €30 million.
Collaboration: Yves Tougard (Project Architect).

The project involved the refurbishment and extension of the **LILLE MODERN ART MUSEUM, LAM**, located in a park at Villeneuve d'Ascq. The original building, designed by Roland Simounet in 1983, is already a listed structure. The architect states that the aim was to build up the museum "as a continuous and fluid entity," by adding new galleries dedicated to a collection of Art Brut (Outsider Art) works, and a complete refurbishment of the existing building. The extension wraps around the north and east sides of the existing building in a "fan-splay of long, fluid, and organic volumes." On one side, the ribs "stretch in close folds to shelter a café-restaurant that opens to the central patio; on the other, the ribs are more widely spaced to form the five galleries for the Art Brut collection." Gautrand states that her scheme meant to both engage and respect the older building, all the more so that Simounet's influence is still felt here and elsewhere.

Das Projekt umfasste die Sanierung und Erweiterung des **MUSEUMS FÜR MODERNE KUNST IN LILLE, LAM**, im Park von Villeneuve d'Ascq. Der Altbau, entworfen 1983 von Roland Simounet, steht bereits unter Denkmalschutz. Die Architekten erklären, ihr Ziel sei gewesen, das Museum „als fortlaufende und fließende Einheit" zu konzipieren, als sie neue Ausstellungsräume für eine Sammlung mit Art Brut (Outsider Art) anbauten sowie das gesamte Gebäude einer Sanierung unterzogen. Der Anbau umfängt die Nord- und Ostseite des Altbaus wie ein „ausgebreiteter Fächer aus lang gestreckten, fließenden, organischen Baukörpern". Auf einer Seite bleiben die Rippen des Fächers „eng gefaltet und schützen ein Café und Restaurant, das sich zum zentralen Patio öffnet, auf der andere Seite sind die Rippen weiter gespreizt und bilden die fünf Ausstellungsräume für die Art-Brut-Sammlung". Gautrand betont, ihr Konzept sei darauf angelegt, den älteren Bau einzubinden und zu respektieren, zumal Simounets Einfluss hier wie andernorts noch immer spürbar ist.

Ce projet portait sur la rénovation et l'extension du **MUSÉE D'ART MODERNE DE LILLE, LAM**, situé dans le parc de Villeneuve d'Ascq. Le bâtiment d'origine, édifié par Roland Simounet en 1983, avait déjà été classé monument historique. L'objectif de l'architecte était de faire de ce musée « une entité fluide et continue » en ajoutant de nouvelles galeries consacrées à la collection d'art brut et en restaurant entièrement l'existant. L'extension enveloppe les ailes nord et est des installations antérieures en un « éventail de volumes organiques fluides et allongés ». D'un côté, ces plis « s'étirent sous forme fermée pour accueillir un café-restaurant s'ouvrant sur le patio central, de l'autre ils s'espacent davantage pour constituer les cinq galeries de la collection d'art brut ». Pour Gautrand, ce projet veut à la fois respecter l'ancien bâtiment et se confronter à lui, d'autant plus que l'influence de Simounet reste vivace, ici et ailleurs.

Gautrand took up the challenge of adding to a building by Roland Simounet—an architect respected in France—and came away from Lille with a triumph.

Gautrand stellte sich erfolgreich der Herausforderung, einen Erweiterungsbau für das Museum von Roland Simounet zu entwerfen, einen in Frankreich renommierten Architekten.

Manuelle Gautrand a relevé le défi d'agrandir une réalisation de Roland Simounet, architecte très respecté en France, et a quitté Lille auréolée de succès.

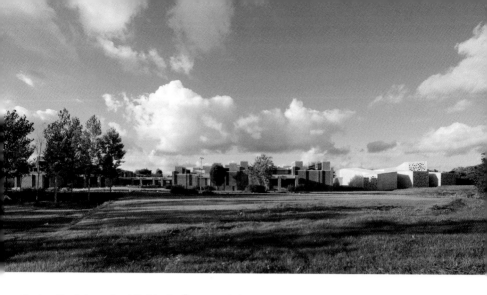

The transition between the old building and the new is readily apparent in terms of surface treatment and the geometry of the blocks added by Gautrand, but the two elements now constitute a whole.

Der Übergang zwischen Alt- und Neubau ist dank Oberflächenbehandlung und Geometrie der von Gautrand entworfenen Volumina leicht erkennbar. Dennoch bilden beide Bauabschnitte inzwischen ein Ganzes.

La transition entre le bâtiment existant et le nouveau est marquée par les matériaux et la géométrie particulière des blocs créés par l'architecte, mais l'ensemble constitue néanmoins un tout.

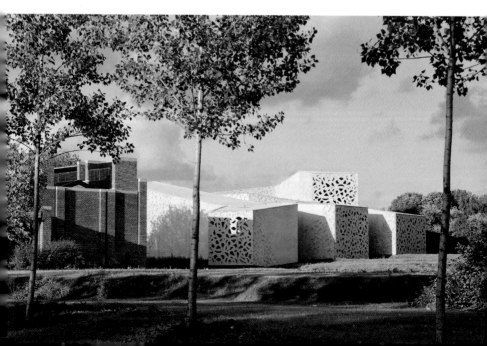

236

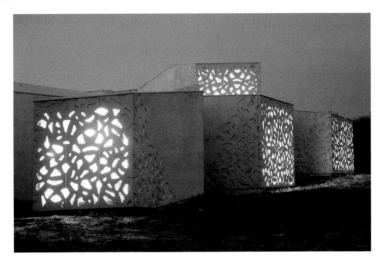

A site plan shows the juxtaposition of the older elements and the new. Above and on the right page, the cutout pattern used by Manuelle Gautrand for the façades of her extension, and two exhibition galleries.

Auf dem Lageplan ist das Nebeneinander von alten und neuen Bauabschnitten zu erkennen. Oben und rechts im Bild das Scherenschnittmotiv, das Gautrand für die Fassaden ihres Anbaus entwarf, sowie ein Blick in zwei Ausstellungsräume.

Le plan de situation montre la juxtaposition des bâtiments anciens et nouveaux. Ci-dessus et page de droite, les effets lumineux du découpage des façades selon un motif dessiné par Manuelle Gautrand, et les deux nouvelles galeries d'exposition.

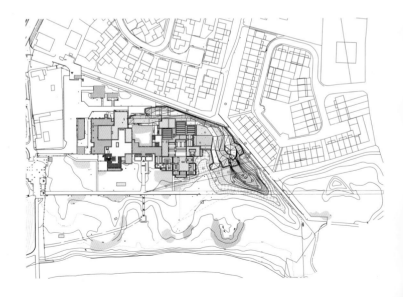

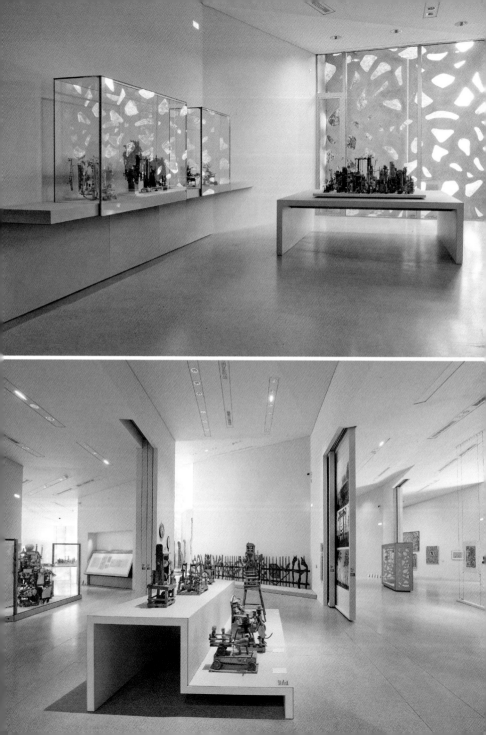

ANNETTE GIGON / MIKE GUYER & ATELIER WW

Born in 1959, **ANNETTE GIGON** received her diploma from the ETH in Zurich in 1984. She worked in the office of Herzog & de Meuron in Basel (1985–88), before setting up her own practice (1987–89) and creating her present firm with Mike Guyer in 1989. Born in 1958, **MIKE GUYER** also graduated from the ETH in 1984, and worked with Rem Koolhaas (OMA, 1984–87), and taught with Hans Kollhoff at the ETH (1987–88). Their built work includes the Oskar Reinhart Collection (Römerholz, Winterthur, 1997–98); the Albers/Honegger Collection (Mouans Sartoux, France, 2001–03); the Henze & Ketterer Gallery Kunst-Depot (Wichtrach, 2002–04); Lagerstrasse Office Building, Europaallee 21 (Zurich, 2007–13); and the Würth Haus Rorschach (Rorschach, 2009–13), all in Switzerland unless otherwise indicated. The Löwenbräu-Areal Arts Center (Zurich, Switzerland, 2006–12, published here) was realized in collaboration with the Zurich firm **ATELIER WW**. Kurt Hangarter, Walter Wäschle, Urs Wüst, and Rolf Wüst make up atelier ww, which has ample experience adapting industrial sites in residential zones and has won various competitions in this field.

ANNETTE GIGON, geboren 1959, erwarb 1984 ihr Diplom an der Eidgenössischen Technischen Hochschule (ETH) in Zürich. Sie arbeitete im Büro Herzog & de Meuron in Basel (1985–88), bevor sie ihre eigene Firma (1987–89) und 1989 ihr jetziges Büro mit Mike Guyer gründete. **MIKE GUYER**, geboren 1958, studierte ebenfalls bis 1984 an der ETH. Er arbeitete danach bei Rem Koolhaas (OMA, 1984–87) und lehrte dann mit Hans Kollhoff an der ETH (1987–88). Zu ihren ausgeführten Bauten zählen: die Sammlung Oskar Reinhart (Römerholz, Winterthur, 1997–98), die Sammlung Albers/Honegger (Mouans Sartoux, Frankreich, 2001–03), das Kunst-Depot Henze & Ketterer (Wichtrach, 2002–04), das Bürogebäude Lagerstrasse, Europaallee 21 (Zürich, 2007–13) und das Würth Haus Rorschach (Rorschach, 2009–13), alle in der Schweiz, sofern nicht anders angegeben. Das Kunstzentrum Löwenbräu-Areal (Zürich, Schweiz, 2006–12, hier vorgestellt) wurde in Zusammenarbeit mit den Züricher **ATELIER WW** ausgeführt. Kurt Hangarter, Walter Wäschle, Urs Wüst und Rolf Wüst bilden atelier ww, das viel Erfahrung in der Umnutzung von Industrieanlagen in Wohngebieten und auf diesem Gebiet mehrere Wettbewerbe gewonnen hat.

Née en 1959, **ANNETTE GIGON** est diplômée de l'ETH de Zurich (1984). Elle a travaillé dans l'agence Herzog & de Meuron à Bâle (1985–88) avant d'ouvrir son propre cabinet (1987–89), puis de créer la société actuelle avec Mike Guyer en 1989. Né en 1958, **MIKE GUYER** a également obtenu son diplôme à l'ETH en 1984 et a ensuite travaillé avec Rem Koolhaas (OMA, 1984–87) avant d'enseigner avec Hans Kollhoff à l'ETH (1987–88). Leurs réalisations déjà construites comprennent la rénovation de la collection Oskar Reinhart (Römerholz, Winterthur, 1997–98) ; le musée pour la collection Albers/Honegger (Mouans Sartoux, France, 2001–03) ; le dépôt d'art de la galerie Henze & Ketterer (Wichtrach, 2002–04) ; l'immeuble de bureaux Lagerstrasse, Europaallee 21 (Zurich, 2007–13) et la maison Würth (Rorschach, 2009–13), toutes en Suisse sauf si spécifié. Le Centre d'art de l'espace Löwenbräu (Zurich, Suisse, 2006–12, publié ici) a été réalisé en collaboration avec l'agence de Zurich **ATELIER WW.** Kurt Hangarter, Walter Wäschle, Urs Wüst et Rolf Wüst constituent atelier ww qui possède une expérience considérable de la réutilisation de sites industriels situés dans des zones résidentielles et a gagné plusieurs concours dans ce domaine.

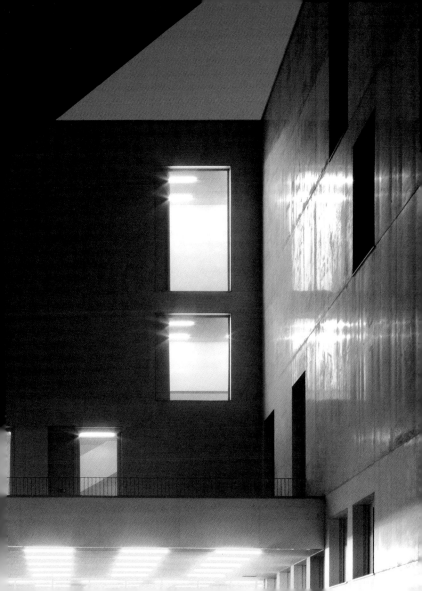

LÖWENBRÄU-AREAL ARTS CENTER

Zurich, Switzerland, 2006–12

Area: 11 875 m² (previously 7787 m²).
Client: PSP Swiss Property.

Annette Gigon / Mike Guyer and atelier ww were co-winners of the 2003 competition to design this complex that contains exhibition areas for use by public and private institutions as well as galleries with event rooms, offices and ancillary rooms, and a central connecting hall. The new buildings—the Arts Center (2012), an office building (2013), and a residential tower (2013–14)—were conceived as lateral and vertical extensions to the protected buildings of the former Löwenbräu brewery, which was renovated and converted. **THE LÖWENBRÄU ART COMPLEX** is an association of public and private art institutions and commercial galleries that started operating out of the former Löwenbräu brewery site in 1996. A new story to the existing building provides extra exhibition space for the Kunsthalle Zurich. The Migros Museum of Contemporary Art occupies new exhibition areas on the ground and first floors of the old building. The new west wing has three floors of freely divisible exhibition space with lateral windows and a spacious events room on the first floor with adjacent outdoor terrace. All exhibition areas in the new and old buildings feature the same concrete flooring throughout, with white walls and ceilings. The newly built sections are in cast ultra-white concrete.

Annette Gigon / Mike Guyer und atelier ww gewannen 2003 gemeinsam den Wettbewerb für diesen Komplex, der Ausstellungsbereiche für öffentliche und private Institutionen sowie Galerien mit Veranstaltungs-, Büro- und Nebenräumen sowie eine zentrale Verbindungshalle enthält. Die Neubauten – das Kunstzentrum (2012), ein Bürogebäude (2013) und ein Wohnhaus (2013–14) – wurden konzipiert als horizontale und vertikale Erweiterungen der denkmalgeschützten Gebäude der früheren Löwenbräu-Brauerei, die umgenutzt und renoviert wurden. Das **LÖWENBRÄU-KUNSTAREAL** ist ein Verbund öffentlicher und privater Kunstinstitutionen und kommerzieller Galerien, die seit 1996 vom früheren Gelände der Löwenbräu-Brauerei operieren. Ein neues Geschoss bietet zusätzliche Ausstellungsfläche für die Kunsthalle Zürich. Das Migros Museum für Gegenwartskunst nutzt neue Ausstellungsbereiche im Erd- und ersten Obergeschoss des alten Gebäudes. Der neue Westtrakt hat drei Geschosse mit frei aufteilbaren Ausstellungsräume mit Seitenfenstern und einem großen Veranstaltungssaal mit Außenterrasse im ersten Stock. Alle Galerieräume in den alten und neuen Gebäuden sind mit den gleichen Betonfußböden sowie weißen Wänden und Decken ausgestattet. Die neuen Bauteile sind aus ultraweißem Gussbeton.

Annette Gigon / Mike Guyer et atelier ww ont remporté ex aequo le concours organisé en 2003 pour ce complexe qui regroupe des espaces d'expositions destinés à des institutions publiques ou privées, des galeries et salles de spectacles, bureaux et salles pour le personnel, ainsi qu'un hall communicant central. Les nouvelles constructions d'expositions – le Centre d'art (2012), un immeuble de bureaux (2013) et un immeuble d'habitation (2013–14) – ont été conçues comme des extensions latérales et verticales des bâtiments classés de l'ancienne brasserie Löwenbräu, rénovée et reconvertie. Le **COMPLEXE ARTISTIQUE LÖWENBRÄU** est une association d'institutions artistiques publiques et privées et de galeries commerciales qui ont démarré leur activité sur le site de l'ancienne brasserie en 1996. Un nouvel étage offre un espace d'exposition supplémentaire à la Kunsthalle de Zurich. Le musée Migros d'art contemporain occupe de nouvelles salles d'exposition au rez-de-chaussée et au premier étage de l'ancien bâtiment. La nouvelle aile ouest présente trois étages d'espace cloisonnable à volonté aux fenêtres latérales et de spacieuses salles au premier étage avec terrasse adjacente pour organiser divers événements. Les espaces d'expositions présentent tous le même sol de béton, dans les nouveaux comme dans les anciens bâtiments, ainsi que des murs et plafonds blancs. Les parties rajoutées sont moulées en béton ultra-blanc.

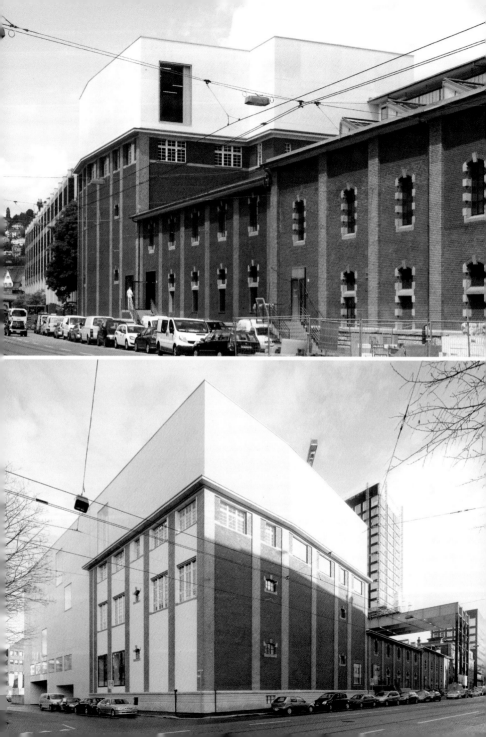

242

Exhibition galleries assume something of the "white box" mode with very simple walls, unadorned door openings, and gray concrete floors.

Die Ausstellungsräume folgen in gewisser Weise dem Prinzip des White Cube mit sehr schlichten Wänden, undekorierten Türöffnungen und grauen Betonböden.

Avec leurs murs très simples, leurs ouvertures nues et leurs sols de béton gris, les galeries d'exposition ont quelque chose du modèle du « cube blanc ».

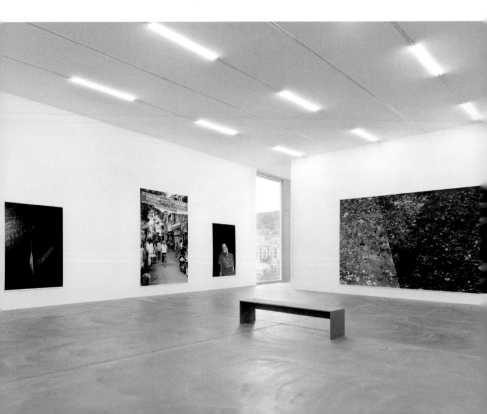

With fluorescent band lighting and some natural light admitted (above right), the interiors seen here are efficient and relatively straightforward. Below, a general plan.

Mit Leuchtstoffröhren und etwas natürlichem Licht (oben rechts) sind die hier gezeigten Innenräume funktional und relativ unkompliziert gestaltet. Unten: ein Gesamtplan.

Les intérieurs vus ici dégagent une impression d'efficacité et de relative simplicité de par l'éclairage fluorescent en bande et la lumière naturelle qui y pénètre (en haut à droite). Ci-dessous, plan d'ensemble.

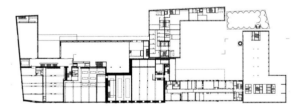

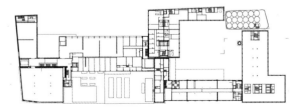

With a hint of the original fenestration, the empty gallery above gives some indication that the building itself is not brand new.

Mit einer Andeutung der ursprünglichen Fenstergestaltung weist die leere Galerie (oben) darauf hin, dass das Gebäude selbst auch nicht brandneu ist.

Ci-dessus, un rappel discret des fenêtres d'origine dans la galerie vide indique que le bâtiment n'est pas flambant neuf.

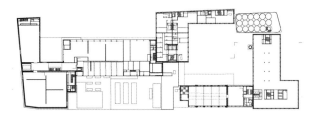

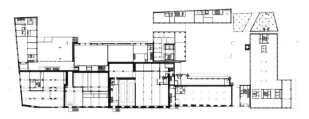

Large black doors mark the gallery areas below, where white walls and ceilings nonetheless dominate. Plans of each level show the complexity and extent of the complex.

Große, schwarze Türen kennzeichnen die Ausstellungsbereiche, die dennoch von weißen Wänden und Decken dominiert werden. Die Grundrisse der verschiedenen Ebenen zeigen die Komplexität und die Größe der Anlage.

De larges portes noires marquent les différents espaces d'expositions, tous cependant dominés par des murs et plafonds blancs. Les plans des différents niveaux montrent la complexité et l'étendue de l'ensemble.

ZAHA HADID

ZAHA HADID (1950–2016) studied Architecture at the Architectural Association (AA) in London, beginning in 1972, and was awarded the Diploma Prize in 1977. She then became a partner of Rem Koolhaas in OMA and taught at the AA. She also taught at Harvard, the University of Chicago, in Hamburg, and at Columbia University in New York. In 2004, Zaha Hadid became the first woman to win the Pritzker Prize. As well as the exhibition design for The Great Utopia (Solomon R. Guggenheim Museum, New York, USA, 1992), her work includes the Vitra Fire Station (Weil am Rhein, Germany, 1990–94); the Lois & Richard Rosenthal Center for Contemporary Art (Cincinnati, Ohio, USA, 1999–2003); Phaeno Science Center (Wolfsburg, Germany, 2001–05); the Central Building of the new BMW Assembly Plant in Leipzig (Germany, 2005); and the MAXXI, the National Museum of 21st Century Arts (Rome, Italy, 1998–2009). More recent projects include the Sheik Zayed Bridge (Abu Dhabi, UAE, 2003–10); the Guangzhou Opera House (Guangzhou, China, 2005–10); the Aquatics Center for the London 2012 Olympic Games (London, UK, 2005–11); the CMA CGM Tower (Marseille, France, 2008–11); and the Messner Mountain Museum Corones (Enneberg/Pieve di Marebbe, Italy, 2015). Her office continues to operate under Patrik Schumacher.

ZAHA HADID (1950–2016) studierte ab 1972 Architektur an der Architectural Association (AA) in London und erwarb 1977 den Diploma Prize. Dann wurde sie Partnerin von Rem Koolhaas beim OMA und lehrte an der AA. Sie lehrte auch in Harvard, an der University of Chicago, in Hamburg und an der Columbia University. 2004 gewann Zaha Hadid als erste Frau den Pritzker Prize. Außer der Ausstellungsgestaltung „The Great Utopia" (Solomon R. Guggenheim Museum, New York, USA, 1992) zählen zu ihren Werken das Feuerwehrhaus auf dem Vitra-Gelände (Weil am Rhein, Deutschland, 1990–94), das Lois & Richard Rosenthal Center for Contemporary Art (Cincinnaty, Ohio, USA, 1999–2003), das Phaeno Science Center (Wolfsburg, Deutschland, 2001–05), das BMW-Zentralgebäude in Leipzig (Deutschland, 2005) und das MAXXI, Museo nazionale delle arti del XXI secolo (Rom, Italien, 1998–2009). Neuere Projekte sind die Scheich Zayed Brücke (Abu Dhabi, Vereinigte Arabische Emirate, 2003–10), das Opernhaus in Guangzhou (Guangzhou, China, 2005–10), das Aquatics Center für die Olympischen Spiele in London 2012 (London, Großbritannien, 2005–11), der CMA CGM Tower (Marseille, Frankreich, 2008–11) und das Messner Mountain Museum (Enneberg/Pieve di Marebbe, Italien, 2015). Zaha Hadids Büro wird unter Patrik Schumacher weitergeführt.

ZAHA HADID (1950–2016) a étudié l'architecture à l'Architectural Association (AA) de Londres de 1972 à 1977, date à laquelle elle a reçu le prix du diplôme. Elle est ensuite devenue partenaire de Rem Koolhaas à l'OMA et a enseigné à l'AA, ainsi qu'à Harvard, à l'université de Chicago, à Hambourg et à l'université Columbia à New York. En 2004, elle a été la première femme à remporter le très convoité prix Pritzker. Outre la conception de l'exposition The Great Utopia (Solomon R. Guggenheim Museum, New York, États-Unie, 1992), elle a réalisé le poste d'incendie pour Vitra (Weil am Rhein, Allemagne, 1990–94) ; le Centre Lois & Richard Rosenthal pour l'art contemporain (Cincinnati, Ohio, États-Unis, 1999–2003) ; le Centre scientifique Phaeno (Wolfsburg, Allemagne, 2001–05) ; le bâtiment central de la nouvelle usine BMW à Leipzig (Allemagne, 2005) et le Musée national des arts du XXIe siècle MAXXI (Rome, Italie, 1998–2009). Ses projets plus récents comprennent le pont Cheik Zayed (Abou Dhabi, EAU, 2003–2010) ; l'Opéra de Canton (Chine, 2005–10) ; le Centre des sports aquatiques pour les Jeux olympiques de Londres 2012 (Royaume-Uni, 2005–11) ; la tour CMA CGM (Marseille, France, 2008–11) et le Messner Mountain Museum Corones (Enneberg/Pieve di Marebbe, Italie, 2015). Son agence poursuit son oeuvre sous la direction de Patrik Schumacher.

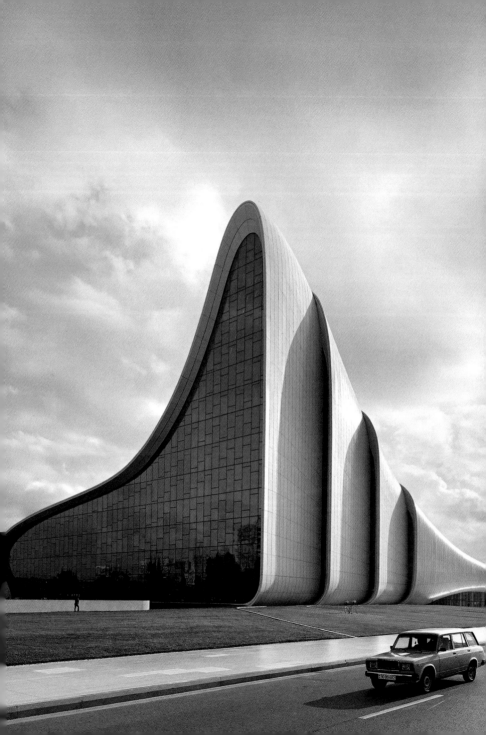

HEYDAR ALIYEV CULTURAL CENTER

Baku, Azerbaijan, 2007–13

Floor area: 52 417 m².
Client: The Republic of Azerbaijan.

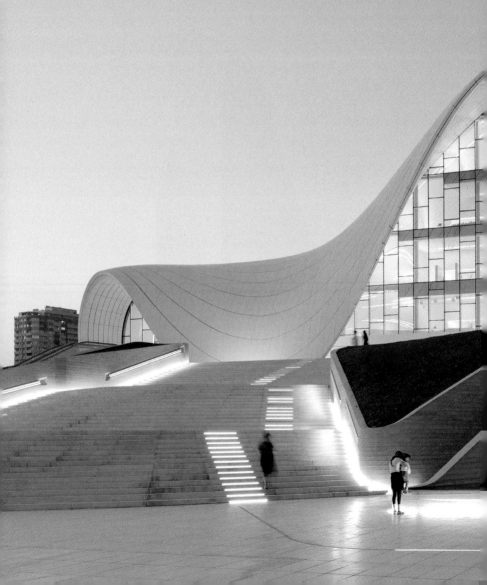

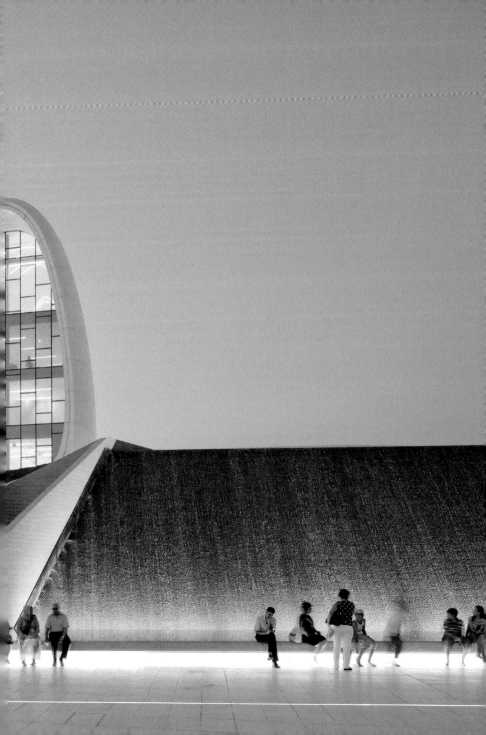

This mixed-use cultural center has a total floor area of 101 801 square meters and a 15 514-square-meter footprint. The structure houses a conference hall with three auditoriums, a library, and a museum. **HEYDAR ALIYEV CULTURAL CENTER** is named after a former president of Azerbaijan. The architect describes the design as a "fluid form which emerges by the folding of the landscape's natural topography and by the wrapping of individual functions of the center." The functions and the entrances are represented by folds in a continuous surface. The museum faces a landscaped area and has a glass façade that emphasizes the permeability of the architecture, where the "interior is an extension of the natural topography." The library faces north, controlling natural light. Ramps and bridges connect the library with the other elements of the overall program. The center was inaugurated on March 11, 2012, by the current president of Azerbaijan, Ilham Aliyev, who happens to be a son of Heydar Aliyev, but this was considered a "soft" opening. The actual opening of the building, delayed by a fire in late 2012, occurred in 2013.

Das Kulturzentrum mit gemischter Nutzung hat eine Gesamtnutzfläche von 101 801 m² auf einer Grundfläche von 15 514 m². Untergebracht sind hier eine Kongresshalle mit drei Auditorien, eine Bibliothek und ein Museum. Benannt ist das **HEYDAR ALIYEV KULTURZENTRUM** nach einem ehemaligen Präsidenten Aserbaidschans. Die Architektin beschreibt den Entwurf als „fließende Form, die sich aus den Faltungen der natürlichen Topografie der Landschaft entwickelt und die verschiedenen Funktionen des Zentrums umschließt". Funktionen und Eingänge werden durch Faltungen in der fließenden Gebäudehaut markiert. Das Museum orientiert sich zu Grünflächen und hat eine Glasfassade, die zugleich Durchlässigkeit signalisiert und den „Innenraum als Erweiterung der Topografie" präsentiert. Um den Lichteinfall zu regulieren, wurde die Bibliothek nach Norden ausgerichtet; Rampen und Brücken verbinden sie mit den übrigen Bereichen des Gesamtprogramms. Am 11. März 2012 wurde das Zentrum vom aserbaidschanischen Präsidenten Ilham Aliyev (dem Sohn Heydar Aliyevs) vorab eingeweiht. Die offizielle Eröffnung verzögerte sich 2012 durch einen Brand und erfolgte 2013.

Dédié au précédent président de l'Azerbaïdjan, le **CENTRE CULTUREL HEYDAR ALIYEV** représente une surface totale de 101 801 m² pour une emprise au sol de 15 514 m². Il abrite un centre de conférences comptant trois auditoriums, une bibliothèque et un musée. Zaha Hadid présente ce projet comme « une forme fluide qui émerge des plis de la topographie naturelle du paysage et enveloppe les différentes fonctions du Centre ». Ces fonctions et les différentes entrées sont matérialisées par des plis mis en forme dans une surface continue. La façade du musée qui donne sur une aire paysagée met en évidence la perméabilité de cette architecture dans laquelle « l'intérieur est une extension de la topographie naturelle ». La bibliothèque est orientée au nord pour mieux contrôler l'éclairage naturel. Des rampes et des passerelles la relient à d'autres éléments du programme. Le Centre a été l'objet d'une « préinauguration » le 11 mars 2012 par le président actuel du pays, Ilham Aliyev, fils de Heydar Aliyev, mais son ouverture définitive, retardée par un incendie fin 2012, n'a eu lieu qu'en 2013.

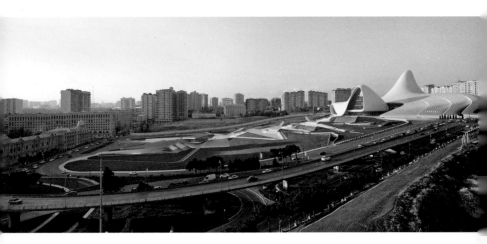

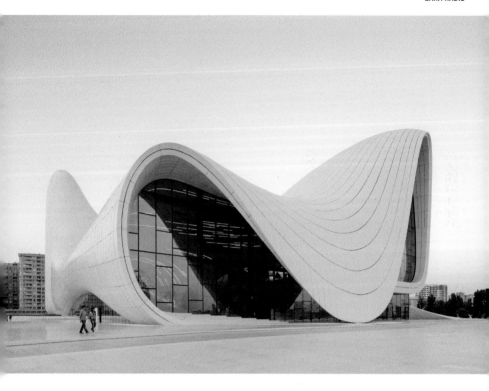

Above, an image of the entrance area of the structure, with remarkable swooping curves. Below, a drawing shows the geological or topographic nature of the design, a bit like folded hills.

Im Bild oben ist der Eingangsbereich mit seinen bemerkenswerten geschwungenen Kurven zu sehen. Unten: Der geologische oder topografische Bezug des Entwurfs zur Natur erinnert ein wenig an Hügel.

Ci-dessus, vue de l'entrée de la structure aux remarquables courbes descendantes. Ci-dessous, le schéma montre la nature géologique ou topographique de la conception qui rappelle un plissement de collines.

The elevation drawing reveals the full, very unexpected shape of the building. Below and on the right page, the outer curves of the building express its internal environment with natural light penetrating through narrow strips that follow the roof's undulation.

Der Aufriss zeigt die vollständige, überraschende Form des Bauwerks. Unten auf der Seite und rechts bestimmen die äußeren geschwungenen Formen auch den Innenraum, denn natürliches Licht fällt durch schmale Streifen, die die Wellenform des Dachs aufgreifen.

Le plan en élévation révèle la forme pleine et totalement inattendue de la construction. Ci-dessous et page de droite, les courbes de l'extérieur reflètent l'intérieur aux fentes étroites qui suivent l'ondulation du toit pour laisser entrer la lumière du jour.

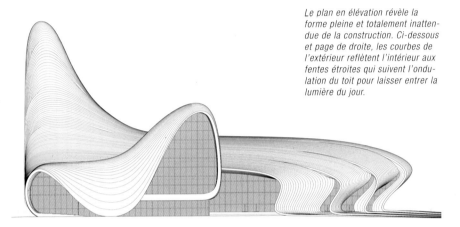

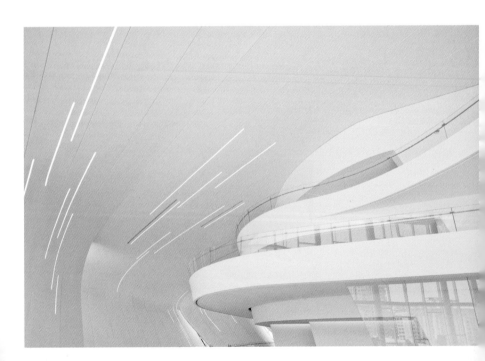

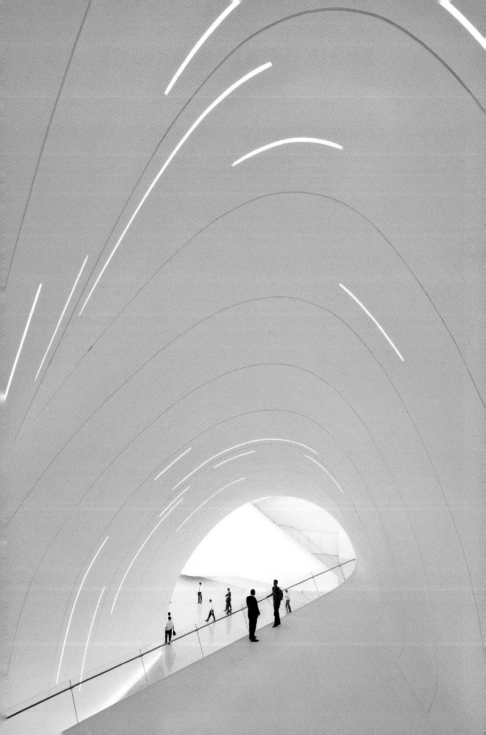

SHEIKH ZAYED BRIDGE

Abu Dhabi, UAE, 2003–10

Length: 842 m. Client: Abu Dhabi Municipality.

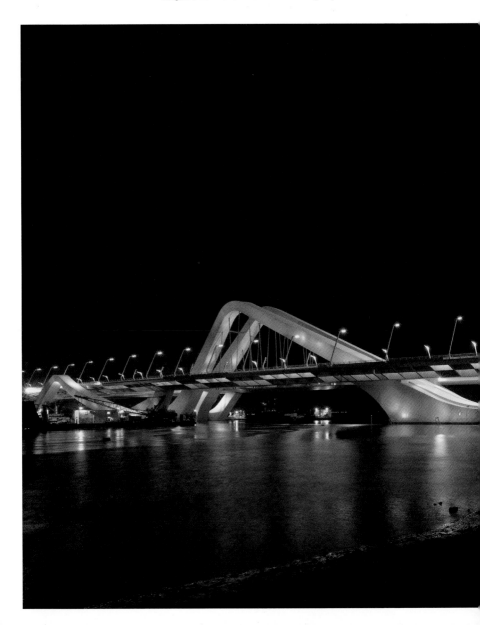

As seen from a distance, or from beneath its arches, the bridge has something of a living presence, perhaps like a great snake that undulates above and below the surface of the water.

Aus der Ferne und unterhalb der Bögen wirkt die Brücke fast wie ein Lebewesen, vielleicht wie eine große Schlange, die auf- und abtaucht, während sie sich durchs Wasser schlängelt.

Vu à distance, ou de sous son tablier, le pont prend une présence presque vivante, tel un énorme serpent qui ondulerait à la surface des eaux.

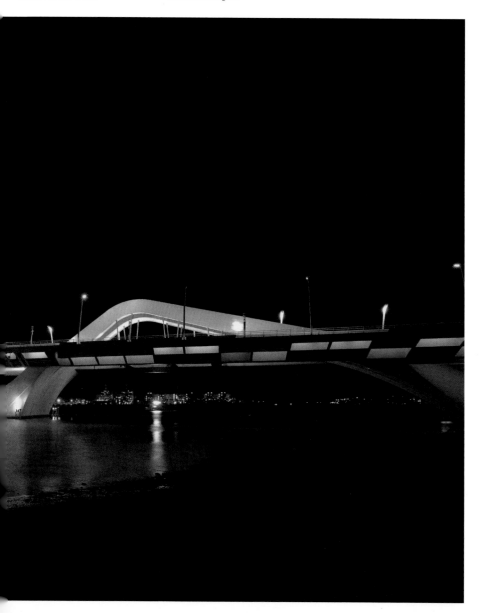

Named after the founder of the United Arab Emirates (UAE), the **SHEIKH ZAYED BRIDGE** connects Abu Dhabi Island to the mainland. It is 842 meters long, 64 meters high, and 61 meters wide, carrying two segments of four-lane highway. As the architect describes the design: "A collection, or strands of structures, gathered on one shore, are lifted and 'propelled' over the length of the channel. A sinusoidal waveform provides the structural silhouette shape across the channel." Though others, such as Santiago Calatrava, have long designed asymmetrical bridges, this span represents a clear departure from common practice. Engineering proved very complex, and the overall time from design to opening early in 2011 was exceptionally long. With its slowly changing colors at night, the bridge represents a real landmark for those driving into Abu Dhabi.

Die nach dem Gründer der Vereinigten Arabischen Emirate (VAE) benannte **SCHEICH ZAYED BRÜCKE** verbindet Abu Dhabi Island mit dem Festland. Das 842 m lange, 64 m hohe und 61 m breite Bauwerk besteht aus zwei Segmenten mit einer jeweils vierspurigen Fahrbahntrasse. Die Architektin beschreibt ihren Entwurf wie folgt: „Eine Sammlung oder vielmehr verschiedene bauliche Stränge bündeln sich an einer Uferseite, werden angehoben und über die gesamte Breite des Wasserweges ‚geschleudert'. Eine sinusförmige Welle definiert die Silhouette des Tragwerks über dem Kanal." Obwohl längst andere, darunter auch Santiago Calatrava, asymmetrische Brücken entworfen haben, unterscheidet sich diese Spannkonstruktion zweifellos stark von der üblichen Brückenbaupraxis. Die ingenieurtechnische Planung erwies sich als hochkomplex, weshalb die Spanne zwischen Entwurfsbeginn und Eröffnung der Brücke Anfang 2011 ungewöhnlich lang war. Mit ihren langsamen Farbwechseln bei Nacht ist die Brücke ein echtes Wahrzeichen für alle, die Abu Dhabi per Auto erreichen.

Nommé en l'honneur du fondateur des Émirats arabes unis, le **PONT CHEIKH ZAYED** relie l'île d'Abou Dhabi au continent. De 842 m de long, 64 m de haut et 61 m de large, il accueille huit voies d'autoroute. L'architecte présente ainsi le projet : « Un bloc ou écheveau de structures regroupées sur une rive est soulevé et propulsé à travers la largeur du chenal. La silhouette structurelle évoque une vague sinusoïdale… » Si d'autres architectes, comme Santiago Calatrava, ont depuis longtemps dessiné des ponts asymétriques, cet ouvrage représente néanmoins une rupture avec les pratiques traditionnelles. Son ingénierie s'est révélée très complexe et la durée totale de réalisation, de la conception à son inauguration en 2011, a été extrêmement longue. Changeant lentement de couleur pendant la nuit, ce pont est devenu un véritable emblème d'Abou Dhabi.

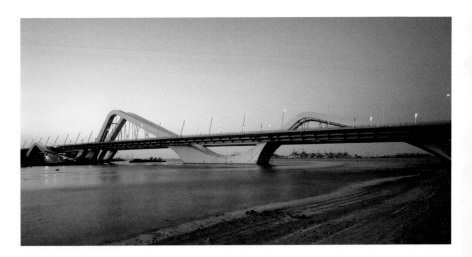

On the main road into Abu Dhabi Island, the bridge stands near the monumental Sheikh Zayed Mosque.

Die Brücke liegt an der zentralen Zufahrtsstraße zur Hauptinsel von Abu Dhabi, unweit der Scheich-Zayed-Moschee.

Le pont se déploie à proximité de la monumentale mosquée Sheikh Zayed sur la route principale d'accès à l'île d'Abou Dhabi.

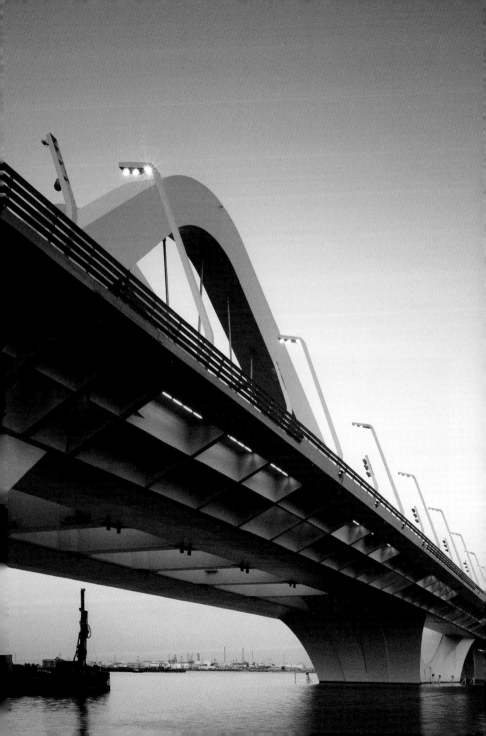

258

*Despite its unusual and complex
geometry, the bridge serves its au-
tomobile functions without any dis-
turbance to the usual flow of traffic.
Right, one of the bright colors that
the bridge takes on during the night.*

*Malgré sa géométrie complexe et
inhabituelle, le pont remplit par-
faitement ses fonctions d'ouvrage
de liaison. À droite, exemple
de ses éclairages nocturnes de
couleur vive.*

*Trotz ihrer ungewöhnlichen und kom-
plexen Geometrie wird die Brücke
den Anforderungen des täglichen
Verkehrsaufkommens vollauf gerecht.
Rechts eine der intensiven Farben, in
die die Brücke nachts getaucht ist.*

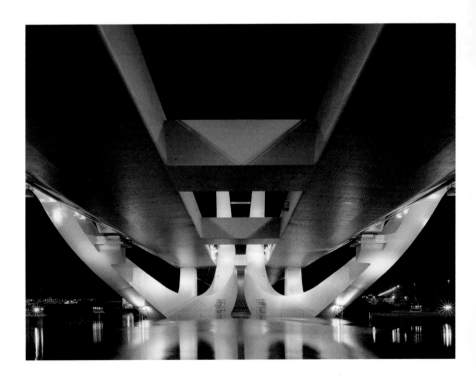

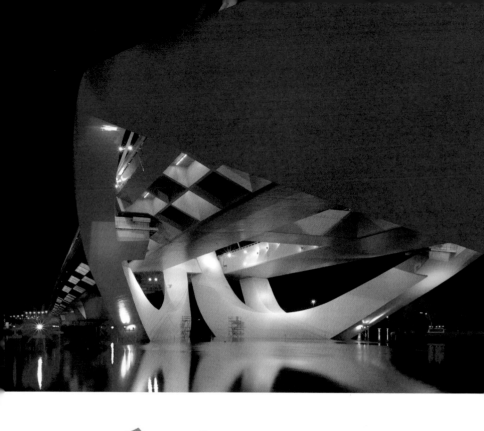

HERZOG & DE MEURON

JACQUES HERZOG and **PIERRE DE MEURON** were both born in Basel, Switzerland, in 1950. They received degrees in Architecture from the ETH Zurich in 1975, after studying with Aldo Rossi, and founded their partnership in Basel in 1978. The partnership has grown over the years: **CHRISTINE BINSWANGER** joined the practice as Partner in 1994, successively followed by **ASCAN MERGENTHALER** in 2004 and **STEFAN MARBACH** in 2006. Herzog & de Meuron won the 2001 Pritzker Prize, and both the RIBA Gold Medal and Praemium Imperiale in 2007. Many of their projects are public facilities, such as the Tate Modern in London (UK, 1994–2000), and the development of its extension (2005–16); the Schaulager (Münchenstein, Switzerland, 2000–03, published here); the National Stadium for the 2008 Olympic Games in Beijing (China, 2002–08); and TEA, Tenerife Espacio de las Artes (Santa Cruz de Tenerife, Spain, 2003–08, also published here). Among their latest works are the new Parrish Art Museum in Water Mill (New York, USA, 2010–12); the Pérez Art Museum Miami (Miami, Florida, USA, 2006–13); the New Hall 1 for Messe Basel (Switzerland, 2010–13); the Ricola Kräuterzentrum (Laufen, Switzerland, 2014); Nouveau Stade de Bordeaux (Bordeaux, France, 2015); and the Elbphilharmonie Hamburg (Hamburg, Germany, 2016).

JACQUES HERZOG und **PIERRE DE MEURON** wurden beide 1950 in Basel geboren. Sie beendeten 1975 ihr Architekturstudium an der Eidgenössischen Technischen Hochschule (ETH) in Zürich bei Aldo Rossi und begannen 1978 in Basel ihre Partnerschaft. Diese hat sich im Lauf der Jahre erweitert: **CHRISTINE BINSWANGER** trat ihr 1994 bei, gefolgt von **ASCAN MERGENTHALER** 2004 und von **STEFAN MARBACH** 2006. Herzog & de Meuron gewannen 2001 den Pritzker-Preis und 2007 die RIBA-Goldmedaille und den Praemium Imperiale. Viele ihrer Projekte sind öffentliche Einrichtungen, wie etwa die Tate Modern in London (Großbritannien, 1994–2000) sowie die Entwicklung ihrer Erweiterung (2005–16), das Schaulager (Münchenstein, Schweiz, 2000–03, hier vorgestellt), das Nationalstadion für die Olympischen Spiele 2008 in Peking (China, 2002–08) und das TEA, Tenerife Espacio de las Artes (Santa Cruz de Tenerife, Spanien, 2003–08, hier vorgestellt). Zu den neuesten Bauten gehören das neue Parrish Art Museum in Water Mill (New York, USA, 2010–12), das Pérez Art Museum Miami (Miami, Florida, USA, 2006–13), die neue Halle 1 für die Messe Basel (Schweiz, 2010–13), das Ricola Kräuterzentrum (Laufen, Schweiz, 2014), das Nouveau Stade de Bordeaux (Bordeaux, Frankreich, 2015) und die Elbphilharmonie Hamburg (Deutschland, 2016).

JACQUES HERZOG et **PIERRE DE MEURON** sont tous les deux nés à Bâle en 1950. Ils sont diplômés en architecture de l'ETH de Zurich (1975) après avoir étudié avec Aldo Rossi et créé leur partenariat à Bâle en 1978. L'association s'est agrandie au fil des ans : **CHRISTINE BINSWANGER** a rejoint l'agence en 1994, suivie par **ASCAN MERGENTHALER** en 2004 et **STEFAN MARBACH** en 2006. Herzog & de Meuron a gagné le prix Pritzker 2001, puis la médaille d'or du RIBA et le Praemium Imperiale en 2007. Nombre de leurs projets sont des institutions publiques, telle la Tate Modern à Londres (Royaume-Uni,1994–2000) et son extension (2005–16) ; le Schaulager (Münchenstein, Suisse, 2000–03, publié ici) ; le stade national pour les Jeux olympiques de Pékin 2008 (Chine, 2002–08) et le TEA, Tenerife Espacio de las Artes (Santa Cruz de Tenerife, Espagne, 2003–08, publié ici). Leurs dernières réalisations sont le nouveau Parrish Art Museum de Water Mill (New York, 2010–12) ; le Pérez Art Museum Miami (Miami, Floride, États-Unis, 2006–13) ; la nouvelle halle 1 de la foire de Bâle (Suisse, 2010–13) ; le Ricola Kräuterzentrum (Laufen, Suisse, 2014) ; le Nouveau Stade de Bordeaux (Bordeaux, France, 2015) et la Elbphilharmonie Hamburg (Hambourg, Allemagne, 2016).

SCHAULAGER
Münchenstein, Switzerland, 2000–03

Area: 20 000 m². Client: Laurenz Stiftung, Basel.

The **SCHAULAGER** is an unusual facility located at the periphery of the city of Basel. It is intended for the storage of the Emanuel Hoffmann Foundation collection. Today the Emanuel Hoffmann Foundation contains works by over 150 artists. The early acquisitions of the collection, dating from the 1930s on—by Arp, Dalí, Delaunay, Klee, Ernst, or the Belgian Expressionists—long ago became classics of modern art and have their established place in art history. Today, the Foundation "aims to buy works of art looking to the future, and not yet generally understood in the present." The works of art are stored in optimal conditions, with occasional visitors or scholars allowed to view specific works on request. The architects chose to create a "heavy" building as opposed to the lightweight structures that have become more popular for such use in other locations. The thick walls and floors of the building give it a large amount of thermal "inertia," meaning that it retains heat in winter and does not warm quickly in summer. Measuring 28 meters high, the Schaulager has two exhibition floors, used once a year for such artists as Jeff Wall (2005), and three storage floors. The exhibition area of the facility is 4300 square meters, the storage space is 7244 square meters, with the basic storage units measuring 32 square meters each. Some rooms however are up to six times larger, 771 square meters of art handling space and 800 square meters of administrative offices are also part of the project. Two large 44-square-meter LED screens are the only exterior indication of the function of the structure. They show images related to art and the once-yearly public exhibitions held in the Schaulager. The smooth white walls and bare concrete floors of the interior contrast with the rough exterior cladding containing pebbles from the construction site. This is by no means a "warm" building in the sense that it is spare and sparsely decorated, but it makes a strong statement for a new relationship between architecture and the conservation of contemporary art.

Das **SCHAULAGER** in einem Vorort von Basel ist eine ungewöhnliche Einrichtung. Hier bewahrt die Emanuel Hoffmann-Stiftung ihre Sammlung mit Werken von mehr als 150 Künstlern auf. Die frühen Erwerbungen datieren aus den 1930er-Jahren – Werke von Arp, Dalí, Delaunay, Klee, Ernst und den belgischen Expressionisten – und sind längst Klassiker der modernen Kunst mit einem festen Platz in der Kunstgeschichte. Heute will die Stiftung „Kunstwerke erwerben, die in die Zukunft weisen und in der Gegenwart noch kein breites Verständnis finden". Die Kunstwerke werden unter optimalen Bedingungen gelagert, und Besucher, Studenten und Wissenschaftler können auf Anfrage einzelne Werke sehen. Die Architekten entschieden sich für ein „schweres" Gebäude im Gegensatz zu den leichtgewichtigen Bauten, die andernorts für eine solche Nutzung bevorzugt werden. Die massiven Wände und Böden des Gebäudes halten im Winter die Wärme, und im Sommer erwärmt sich das Gebäude nur langsam. Zwei Ebenen des 28 m hohen Schaulagers werden einmal im Jahr für Ausstellungen – so 2005 für Jeff Wall – genutzt. Dazu gibt es drei Lagerebenen. Die Ausstellungsfläche des Gebäudes bemisst sich auf 4300 m², die Lagerebenen auf 7244 m², wobei die einzelnen Lagereinheiten jeweils 32 m² umfassen. Einige Räume sind allerdings bis zu sechsmal so groß. 771 m² Fläche für die Arbeit mit den Kunstwerken und 800 m² Verwaltungsbüros sind ebenfalls Teil des Projekts. Zwei großformatige LED-Schirme mit 44 m² sind die einzigen äußeren Indikatoren für die Funktion des Gebäudes. Sie zeigen Bilder, die in Bezug zur Kunst und den jährlich stattfindenden, öffentlichen Ausstellungen stehen. Die glatten, weißen Wände und nackten Betonfußböden des Inneren stehen im Gegensatz zur rauen, mit Kieseln von der Baustelle angereicherten Verkleidung der Außenwände. Es handelt sich hier keineswegs um ein „warmes" Gebäude, das lediglich einfach und sparsam ausgestattet ist, sondern es setzt ein Zeichen für eine neue Beziehung zwischen Architektur und dem Umgang mit zeitgenössischer Kunst.

La Fondation **SCHAULAGER**, en banlieue de Bâle, est un équipement de type nouveau consacré à la conservation d'œuvres d'art de la Fondation Emanuel Hoffmann qui possède des œuvres de plus de 150 artistes. Ses premières acquisitions remontent aux années 1930 avec des œuvres d'Arp, Dalí, Delaunay, Klee, Ernst ou des expressionnistes belges, devenues depuis des classiques de l'art moderne. Aujourd'hui, la Fondation « a pour objectif d'acheter des œuvres d'art regardant vers le futur, même si elles ne sont pas encore comprises ». Les œuvres sont conservées dans des conditions optimales, les visiteurs ou chercheurs pouvant les voir sur demande. Les architectes ont choisi de créer un bâtiment « lourd » par opposition aux structures « légères » qui sont généralement favorisées en d'autres lieux. L'épaisseur des murs et des plateaux présente une très importante inertie thermique puisqu'ils retiennent la chaleur en hiver et ne se réchauffent que lentement en été.

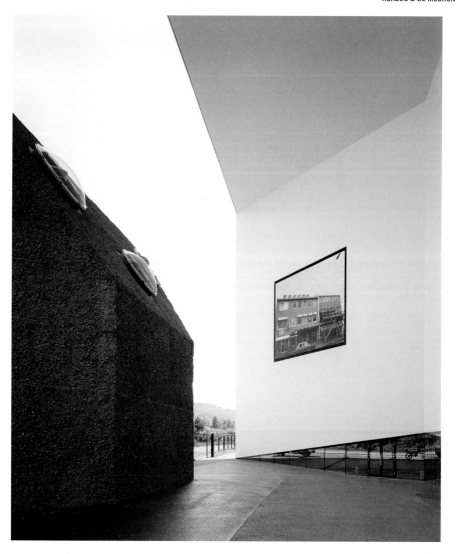

De 28 m de haut, la Fondation possède deux niveaux d'exposition (4300 m²), utilisés une fois par an pour des artistes comme Jeff Wall en 2005, et trois niveaux de réserves (7244 m²), chaque unité de stockage mesurant 32 m². Certaines salles sont six fois plus vastes, avec 771 m² consacrés à des ateliers techniques et 800 m² aux bureaux administratifs. Deux importants écrans LED de 44 m² qui diffusent des images d'art contemporain constituent la seule indication extérieure de la fonction du bâtiment. Ils présentent des images sur l'art et l'exposition publique annuelle organisée dans les lieux. Les murs blancs lisses et les sols en béton brut de l'intérieur contrastent avec l'habillage brut de l'extérieur qui intègre des cailloux trouvés sur le chantier. Aménagé dans un esprit d'économie épurée, ce bâtiment n'est certainement pas convivial au sens courant du terme, mais instaure une relation nouvelle entre l'architecture et la conservation de l'art contemporain.

In the plans below, the basement level is on the left, the ground floor in the middle and the first upper floor on the right.

Die Pläne unten zeigen das Untergeschoss (links), das Erdgeschoss (Mitte) und den ersten Stock (rechts).

Sur les plans ci-dessous, le niveau du sous-sol est à gauche, le rez-de-chaussée au milieu et le premier étage à droite.

The external walls of the Schaulager were made from layers of concrete with pebbles extracted from the building's site during excavation.

Die Außenmauern des Schaulagers wurden aus Betonschichten errichtet, deren Oberfläche mit Kieseln aus der Baugrube angereichert wurde.

Les murs extérieurs du Schaulager sont réalisés en couches de béton auquel ont été incorporés des cailloux extraits des fouilles des fondations.

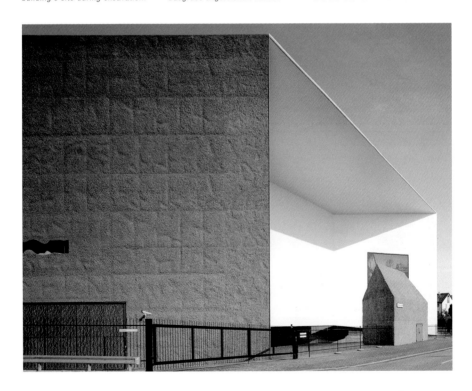

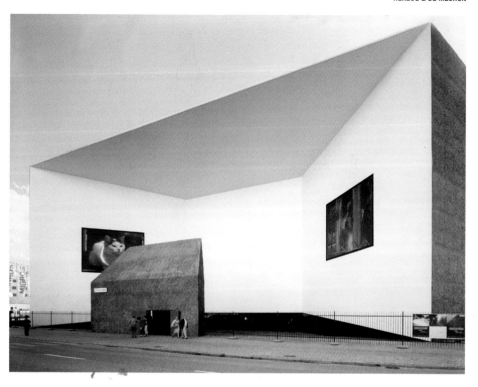

Although it is not located far from the center of Basel, the building stands out as a singularity in an area that is occupied largely by commercial buildings. A strong contrast marks the different façades.

Obgleich dieses Gebäude nicht weit vom Zentrum Basels entfernt ist, fällt es in einem weitgehend von kommerzieller Bebauung bestimmten Gebiet als singuläres Bauwerk auf. Die einzelnen Fassaden sind sehr unterschiedlich.

Bien qu'il soit proche du centre-ville de Bâle, le bâtiment se détache singulièrement dans une zone où dominent surtout les bâtiments commerciaux. Les différentes façades sont marquées par un fort contraste.

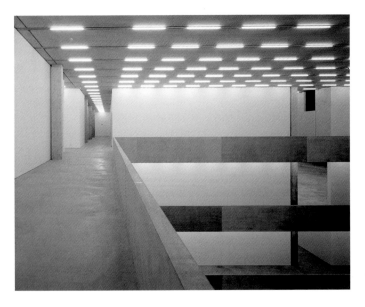

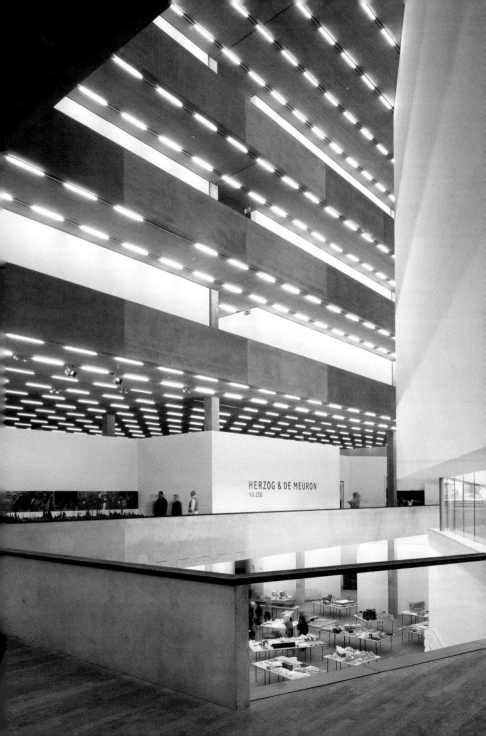

HERZOG & DE MEURON
NO.250

TEA

Tenerife Espacio de las Artes, Santa Cruz de Tenerife, Spain, 2003–08

Area: 20 600 m² (gross floor area). Client: Cabildo Insular de Tenerife, Santa Cruz de Tenerife, Spain.
Collaboration: Virgilio Gutiérrez Herreros Arquitecto, Santa Cruz de Tenerife, Spain.

The **TEA** opened on October 31, 2008, on a site that measures 8800 square meters. The four-level structure is 160 meters long, 65 meters wide and 18 meters high. It has three exhibition zones, for temporary exhibitions, photography, and the permanent Oscar Dominguez collection. A 194-seat auditorium, library, café/restaurant, museum shop, and open-air event space and plaza are also part of the program. Two permanent art installations are located in the library: *El Patio* (Mural on Patio Wall) by Juan Gopar and *te01-te09 y 10 h 38 m / -25°*, a wall installation of 10 large-scale photographs by Thomas Ruff. From the plaza, visitors enter the building through a lobby that contains the café, shop, and ticket counters. A spiral staircase leads to the upper skylight and lower museum levels, where the galleries have six-meter ceiling heights or more. The Center of Photography is set on the lower level and is more intimate in scale. The plaza cuts through the reading areas of the library. The architects state: "The building typology of our design for the TEA is based on courtyards. The elongated courtyards are important in many ways, providing daylight, views, and orientation for the visitors and users of the museum spaces and the library. One of them, between the office and museum wings of the building complex, is planted with typical plants of the island."

Das am 31. Oktober 2008 eröffnete **TEA** steht auf einem 8800 m² großen Gelände. Das viergeschossige Gebäude ist 160 m lang, 65 m breit und 18 m hoch. Es hat drei Ausstellungsbereiche: für Wechselausstellungen, für Fotografie und für die ständig gezeigte Sammlung Oscar Dominguez. Das Programm umfasst außerdem ein Auditorium mit 194 Plätzen, eine Bibliothek, ein Café/Restaurant, einen Museumsshop, einen Außenbereich für Veranstaltungen und eine Plaza. In der Bibliothek befinden sich zwei permanente Kunstwerke: *El Patio* (ein Wandgemälde im Patio) von Juan Gopar und *te01-te09 y 10 h 38 m /-25°*, eine Wandinstallation mit zehn großen Fotografien von Thomas Ruff. Von der Plaza aus betreten Besucher das Gebäude durch eine Lobby, die das Café, den Shop und den Ticketschalter enthält. Eine Wendeltreppe führt zu der durch Oberlichter erhellten oberen und zur unteren Museumsebene mit einer Deckenhöhe von jeweils über 6 m. Das Zentrum für Fotografie liegt auf dem unteren Niveau und ist intimer. Die Plaza schneidet durch den Lesesaal der Bibliothek. Die Architekten erklären: „Die Typologie unseres Entwurfs für das TEA beruht auf Innenhöfen. Diese länglichen Höfe sind in vielerlei Hinsicht von Bedeutung: Sie bieten den Besuchern und Nutzern von Museum und Bibliothek Licht, Ausblicke und Orientierung. Einer der Höfe des Komplexes zwischen dem Büro- und dem Museumstrakt ist mit inseltypischen Gewächsen bepflanzt."

Construit sur un terrain de 8800 m², le **TEA** a ouvert ses portes le 31 octobre 2008. Ce bâtiment de quatre niveaux mesure 160 m de long par 65 m de large et 18 m de haut. Il s'organise en trois zones d'expositions : manifestations temporaires, photographie et collection permanente Oscar Dominguez. Un auditorium de 194 places, un café-restaurant, une boutique, une bibliothèque, un espace pour manifestations en plein air et une place complètent le programme. Deux œuvres d'art sont présentées en permanence dans la bibliothèque : *El Patio* (fresque murale sur mur de patio) de Juan Gopar et *te01-te09 y 10 h 38 m / -25°,* une installation murale de dix photographies grand format de Thomas Ruff. Les visiteurs accèdent au bâtiment à partir de la place par un hall qui contient la billetterie, le café et la boutique. Un escalier en colimaçon mène aux niveaux inférieurs et supérieurs du musée, ces derniers éclairés par des faîtières. Les galeries possèdent des plafonds de 6 m de haut, voire plus. Le Centre de la photographie est installé au niveau inférieur, d'échelle plus intime. La place coupe les salles de lecture de la bibliothèque. «La typologie constructive de notre projet pour le TEA repose sur les cours. Ces cours allongées sont importantes à maints égards : elles fournissent la lumière du jour, offrent des vues, ainsi que des moyens d'orientation pour les visiteurs et les utilisateurs des espaces muséaux et de la bibliothèque. L'une d'elles, entre les ailes des bureaux et le complexe du musée, est plantée de végétaux typiques de l'île », précisent les architectes.

As always, Herzog & de Meuron create a surprising dialogue of forms and surfaces, not quite like anything ever seen before, and yet fully coherent with their own œuvre.

Wie immer erzeugen Herzog & de Meuron einen überraschenden Dialog der Formen und Flächen, der ohne Beispiel ist und dennoch ganz im Einklang mit ihrem bisherigen Werk steht.

Comme toujours, Herzog & de Meuron créent un surprenant dialogue entre les formes et les surfaces, qui n'est pas semblable à ce que l'on a pu voir chez eux précédemment mais reste néanmoins parfaitement cohérent avec leur œuvre.

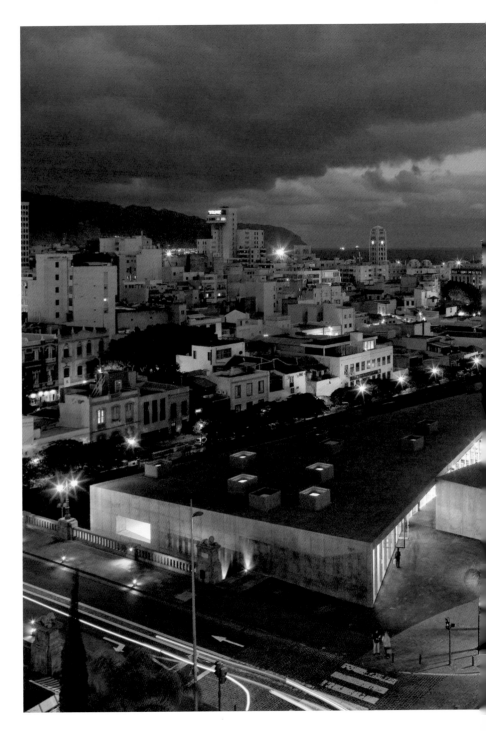

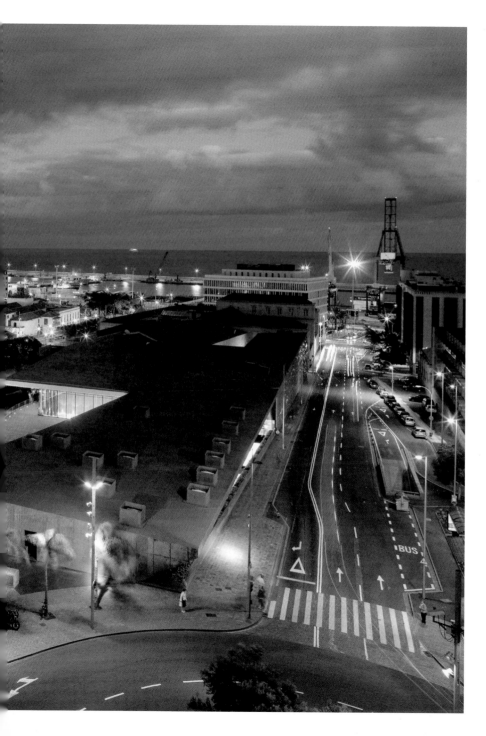

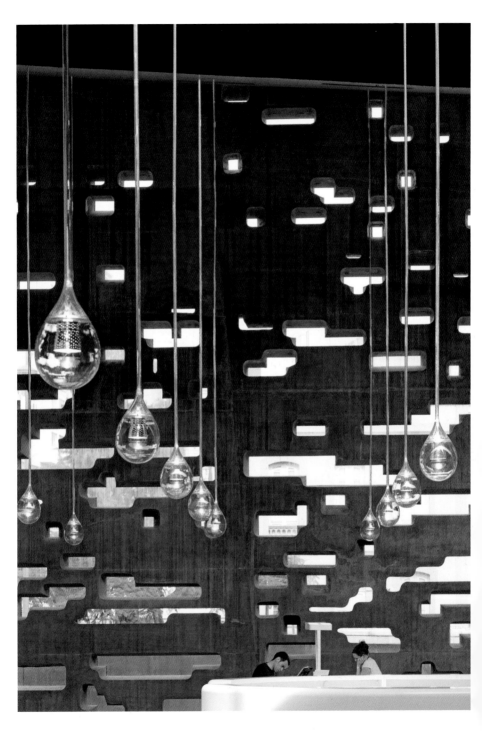

Suspended light fixtures and the irregular pattern of wall openings imagined by the architects enliven this space, creating a rhythm that is musical in its essence.

Die von den Architekten gestalteten Hängeleuchten und das unregelmäßige System der Wandöffnungen beleben diesen Raum und erzeugen einen im Grunde musikalischen Rhythmus.

Les luminaires suspendus et la disposition irrégulière des ouvertures de formes variées dans les murs imaginées par les architectes animent cet espace et créent un rythme de nature musicale.

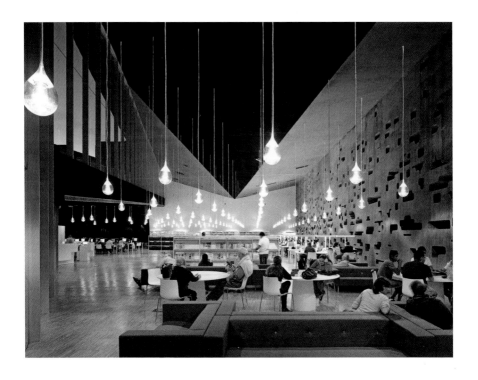

*High, lightly framed glazing offers
an almost entirely transparent wall
(below), while interior spaces are
open to natural light.*

*Hohe Verglasung in leichter
Rahmung führt zu einer fast
vollständig transparenten Wand
(unten), während in die Innen-
räume natürliches Licht fällt.*

*De hautes parois vitrées aux
encadrements discrets ont permis
d'obtenir un mur presque entière-
ment transparent (ci-dessous). Les
espaces intérieurs s'ouvrent à la
lumière naturelle.*

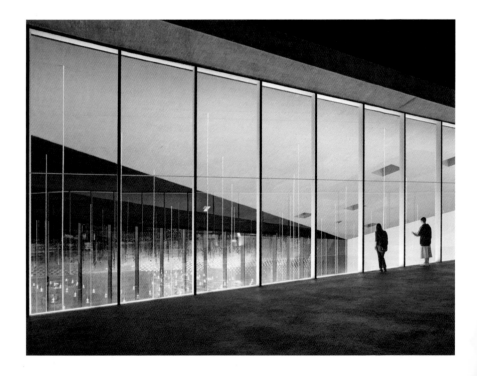

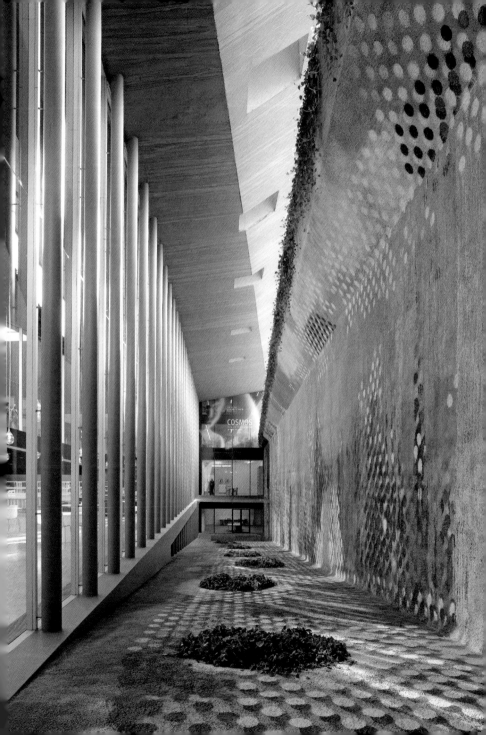

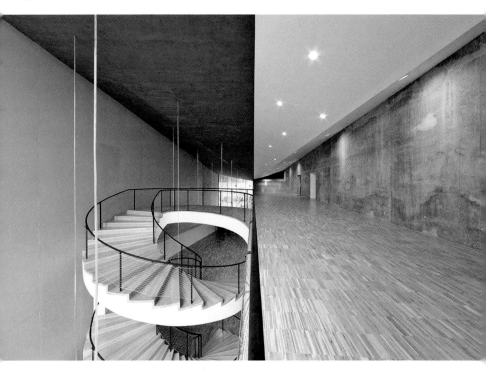

The lightness of the spiral staircase contrasts with the large, flat surfaces of the walls and ceiling. Light is opposed to textured, but otherwise nearly blank volumes.

Eine leichte Wendeltreppe ist ein Gegengewicht zu den großen, ebenen Wandflächen und der Decke. Das Licht bildet einen Kontrast zu den strukturierten, aber ansonsten fast leeren Räumen.

Un escalier en colimaçon contraste par sa légèreté avec les importants plans rectilignes des murs et des plafonds. La lumière joue sur des volumes texturés mais presque aveugles.

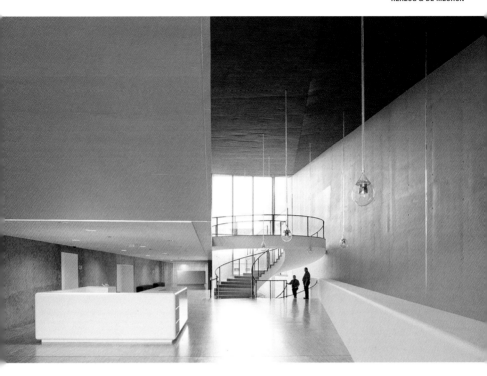

The spiral staircase contrasts with more linear elements, as can be seen in the plan below, where essentially rectangular volumes are the rule.

Wie der Grundris unten zeigt, steht die Wendeltreppe im Kontrast zu den lineareren Elementen der rmeist rechtwinkligen Volumina.

L'escalier en colimaçon contraste avec des éléments plus rectilignes, comme le montre le plan ci-dessous marqué par l'orthogonalité.

STEVEN HOLL

Born in 1947 in Bremerton, Washington, **STEVEN HOLL** obtained his B.Arch degree from the University of Washington (1970). He studied in Rome and at the Architectural Association in London (1976). He began his career in California and opened his own office in New York in 1976. His notable buildings include Void Space/Hinged Space, Housing (Nexus World, Fukuoka, Japan, 1991); Stretto House (Dallas, Texas, USA, 1992); Makuhari Housing (Chiba, Tokyo, Japan, 1997); Chapel of Saint Ignatius, Seattle University (Seattle, Washington, USA, 1997); Kiasma Museum of Contemporary Art (Helsinki, Finland, 1998); an extension to the Cranbrook Institute of Science (Bloomfield Hills, Michigan, USA, 1999); and Y-House (Catskills, New York, USA, 1997–99). Recent projects include Cité de l'Océan et du Surf (with Solange Fabião, Biarritz, France, 2005–10); the Nanjing Museum of Art and Architecture (China, 2008–10); the Vanke Center/Horizontal Skyscraper (Shenzhen, China, 2008–10); Daeyang Gallery and House (Seoul, South Korea, 2010–12); Marina Zaytunay Bay (Beirut, Lebanon, 2013); Glasgow School of Art, Seona Reid Building (Glasgow, UK, 2009–14); and the Visual Arts Building, University of Iowa (Iowa City, 2010–16), all in the USA, unless stated otherwise.

STEVEN HOLL, geboren 1947 in Bremerton, Washington, absolvierte seinen B.Arch. an der University of Washington (1970) und studierte darüber hinaus in Rom sowie an der Architectural Association in London (1976). Nach beruflichen Anfängen in Kalifornien gründete er 1976 ein Büro in New York. Zu seinen meistbeachteten Projekten zählen die Wohnanlage Void Space/Hinged Space (Nexus World, Fukuoka, Japan, 1991), das Stretto House (Dallas, Texas, 1992), die Wohnanlage Makuhari (Chiba, Tokio, Japan, 1997), die Sankt-Ignatius-Kapelle, Seattle University (Seattle, Washington, 1997), das Kiasma Museum für zeitgenössische Kunst (Helsinki, Finnland, 1998), eine Erweiterung des Cranbrook Institute of Science (Bloomfield Hills, Michigan, 1999) sowie das Y-House (Catskills, New York, 1997–99). Aktuellere Projekte sind u. a. die Cité de l'Océan et du Surf (mit Solange Fabião, Biarritz, Frankreich, 2005–10), das Nanjing Museum für Kunst und Architektur (China, 2008–10), das Vanke Center/Horizontaler Wolkenkratzer (Shenzhen, China, 2008–09), ein Haus mit Galerie Daeyang (Seoul, Südkorea, 2010–12), die Marina Zaytunay Bay (Beirut, Libanon, 2013), das Seona Reid Building der Glasgow School of Art (Glasgow, , 2009–14) und das Visual Arts Building der Universität von Iowa (Iowa City, 2010–16), alle in den USA, sofern nicht anders angegeben.

Né en 1947 à Bremerton (État de Washington), **STEVEN HOLL** a obtenu son diplôme de B.Arch. à l'université de Washington (1970). Il a étudié à Rome et à l'Architectureal Association de Londres (1976), a débuté sa carrière en Californie et ouvert son agence à New York la même année. Parmi ses réalisations les plus notables : l'immeuble d'appartements Void Space/Hinged Space (Nexus World, Fukuoka, Japon, 1991) ; la Stretto House (Dallas, Texas, 1992) ; les logements Makuhari (Chiba, Tokyo, 1997) ; la chapelle Saint-Ignace, université de Seattle (Seattle, Washington, 1997) ; le Musée d'art contemporain Kiasma (Helsinki, Finlande, 1998) ; une extension de l'Institut des sciences de Cranbrook (Bloomfield Hills, Michigan, 1999) et la Y-House (Catskills, New York, 1997–99, publiée ici). Ses réalisations récentes comptent : la Cité de l'océan et du surf (avec Solange Fabião, Biarritz, France, 2005–10) ; le Musée d'art et d'architecture de Nankin (Chine, 2008–10) ; le Vanke Center/Gratte-ciel Horizontal (Shenzhen, Chine, 2008–09) ; la galerie et résidence Daeyang (Séoul, Corée du Sud, 2010–12) ; la marina de la baie Zaytunay (Beyrouth, Liban, 2013) ; le bâtiment Seona Reid de la Glasgow School of Art (Glasgow, Écosse, 2009–14) et le bâtiment des arts visuels de l'université de l'Iowa (Iowa City, 2010–16), tous aux Etats-Unis sauf si spécifié.

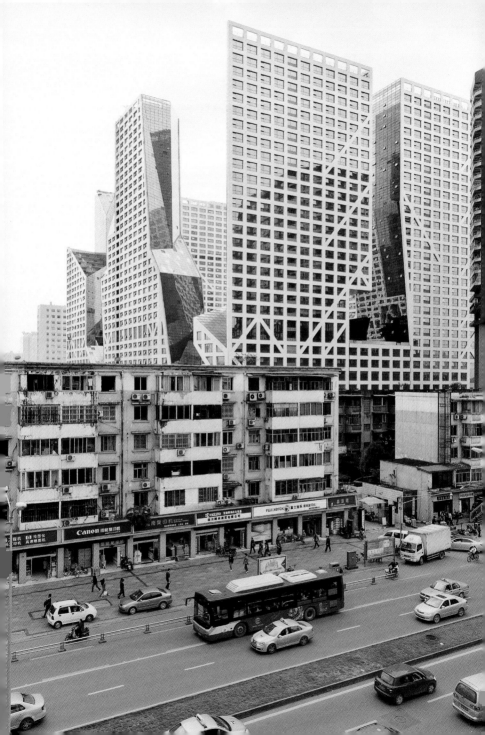

SLICED POROSITY BLOCK

Chengdu, China, 2008–12

Area: 310 000 m². Client: CapitalLand China.

The client for this "Raffles City" project situated in the center of Chengdu, CapitalLand China, selected the architect by direct commission. The complex includes five towers with offices, serviced apartments, a hotel, cafés, and restaurants. Steven Holl has sought to create a "metropolitan public space," taking into account such factors as sunlight exposure for the "slices" in the overall block. Built with an exoskeletal white concrete structure, the complex forms three internal "valleys" apparently inspired by the poems of Du Fu (710–770). Double-fronted shops open to the street and a shopping center also contribute to what the architect calls "micro-urbanism." Two other features of the complex are the Light Pavilion by the architect Lebbeus Woods and Christoph Kumpusch—"an experimental space, that is, one that gives us the opportunity to experience a type of space we haven't experienced before"—and a Local Art Pavilion by the Chinese sculptor Han Meilin. The **SLICED POROSITY BLOCK** is heated and cooled with 468 geothermal wells, while the large ponds in the plaza harvest recycled rainwater. High-performance glazing, energy-efficient equipment, and the use of regional materials are among the other methods used to attain a LEED Gold rating.

Der Bauherr dieses Projekts einer „Raffles City" im Zentrum von Chengdu, CapitalLand China, erteilte dem Architekten einen Direktauftrag. Die Anlage besteht aus fünf Türmen mit Büros, möblierten Apartments, Geschäften, einem Hotel, Cafés und Restaurants. Steven Holl wollte einen „großstädtischen öffentlichen Raum" schaffen und dabei die Sonneneinstrahlung in alle „Slices", alle Scheiben, des Gesamtblocks berücksichtigen. Der weiße Betonbau mit Außenskelett enthält drei innen liegende „Täler", die offenbar von den Gedichten Du Fus (710–770) inspiriert wurden. Zur Straße geöffnete Geschäfte und ein Einkaufszentrum sind Beiträge zu dem vom Architekten so bezeichneten „Mikro-Städtebau". Zwei weitere Merkmale der Anlage sind der Lichtpavillon von dem Architekten Lebbeus Woods und Christoph Kumpusch – „ein experimenteller Bereich, das heißt einer, der uns einen Raumtypus erleben lässt, den wir noch nie erlebt haben" – und ein Kunstpavillon des chinesischen Bildhauers Han Meilin. Der **SLICED POROSITY BLOCK** wird mit 468 geothermischen Sonden beheizt und gekühlt, die großen Teiche auf der Plaza fangen Regenwasser auf. Hochwertige Verglasung und energieeffiziente Ausstattung sowie die Verwendung regionaler Materialien gehören zu den Faktoren, die eine LEED-Goldzertifizierung rechtfertigten.

Le client du projet « Raffles City » au centre de Chengdu, capitale provinciale chinoise, a choisi directement l'architecte. Le complexe comprend cinq tours de bureaux, des appartements avec services, des commerces de détail, un hôtel, des cafés et des restaurants. Steven Holl a voulu créer un « espace public métropolitain » prenant en compte des facteurs tels que l'exposition au soleil pour les « tranches » coupées dans les blocs. La structure est dotée d'un exosquelette en béton blanc et forme trois « vallées » intérieures qui auraient été inspirées par les poèmes de Du Fu (710–770). Des boutiques à deux vitrines ouvrent sur la rue et un centre commercial contribue aussi à former ce que l'architecte appelle un « micro-urbanisme ». Les deux autres éléments du complexe sont le Pavillon de lumière par l'architecte Lebbeus Woods et Christoph Kumpusch – « un espace expérimental, ou un espace qui donne la possibilité d'aborder un type d'espace jamais rencontré auparavant » – et un pavillon consacré à l'art local par le sculpteur chinois Han Meilin. Le **SLICED POROSITY BLOCK** est chauffé et climatisé par 468 puits géothermiques, tandis que l'eau de pluie recyclée est recueillie dans les vastes plan d'eau de la placette. Le vitrage haute performance, les équipements à rendement énergétique élevé et l'utilisation de matériaux locaux ont contribué à conférer la note LEED or au complexe.

With surprising angles and openings laid over a rigorous exoskeleton that serves as the window grid, the buildings of Steven Holl stand out and attract attention.

Mit überraschenden Winkeln und Öffnungen über einem strengen Außenskelett, das auch als Fenstersystem fungiert, heben sich Steven Holls Bauten von anderen ab und erregen Aufmerksamkeit.

Avec leurs angles étonnants et leurs ouvertures par-dessus un exosquelette très strict qui forme la grille des fenêtres, les bâtiments de Steven Holl attirent l'attention.

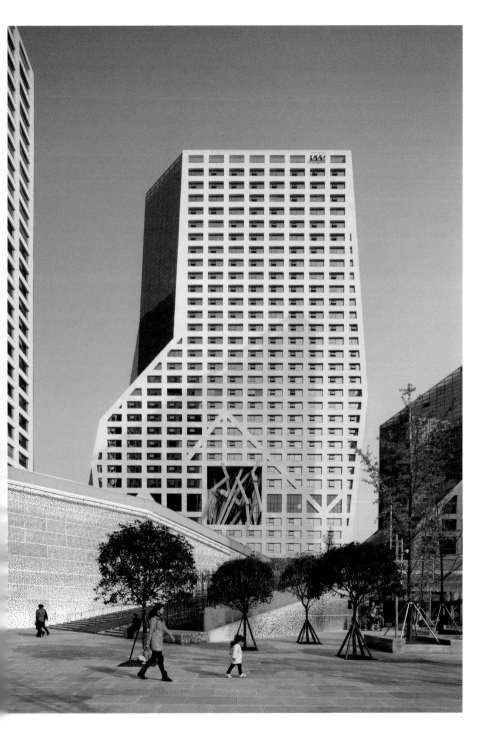

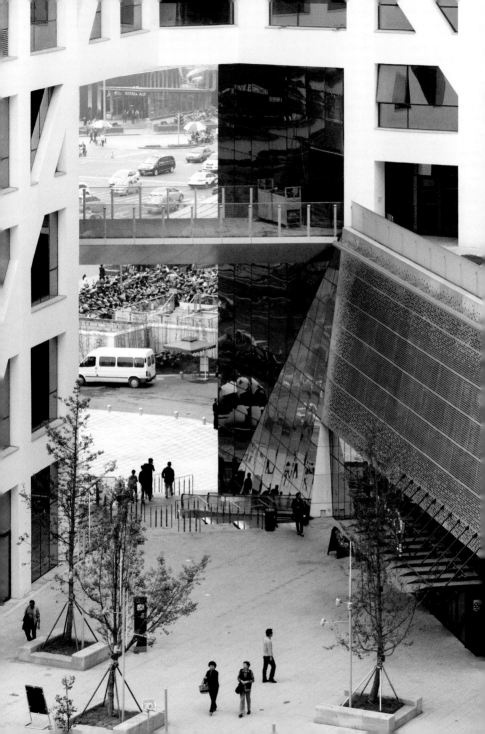

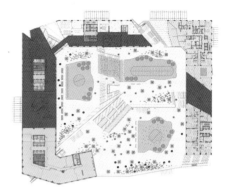

Plans and the image show the irregular water features that form an agreeable central square for the complex.

Die Grundrisse und das Foto zeigen die unregelmäßig gestalteten Wasserflächen, die zu dem einladenden zentralen Platz für die Anlage gehören.

On voit sur les plans et la photo les plans d'eau irréguliers qui forment l'agréable place centrale du complexe.

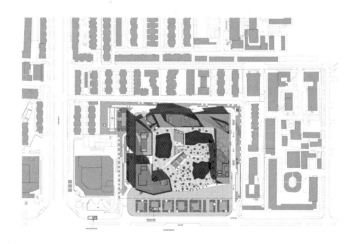

A plan (above) shows how the buildings wrap around the central courtyard with water features, stairways, and green spaces.

Der Plan (oben) zeigt die Anordnung der Gebäude um den zentralen Innenhof mit Wasserbecken, Grünbereichen und Treppen.

Le plan (ci-dessus) montre comment les bâtiments s'enroulent autour de la cour centrale – marquée par la présence d'eau, d'escaliers et d'espaces verts.

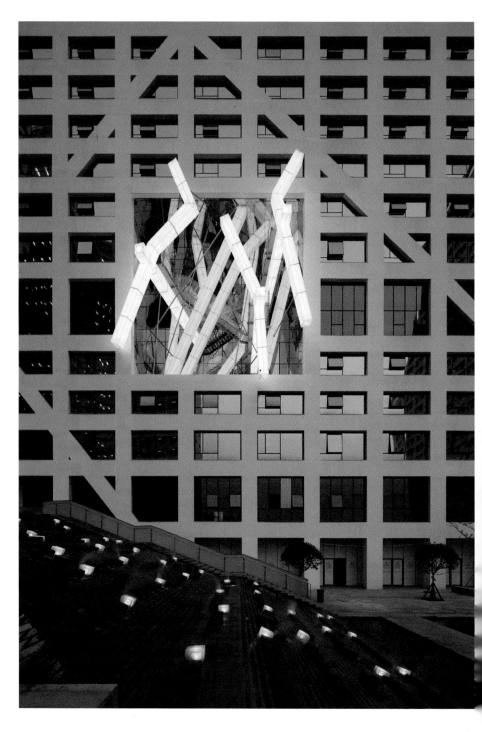

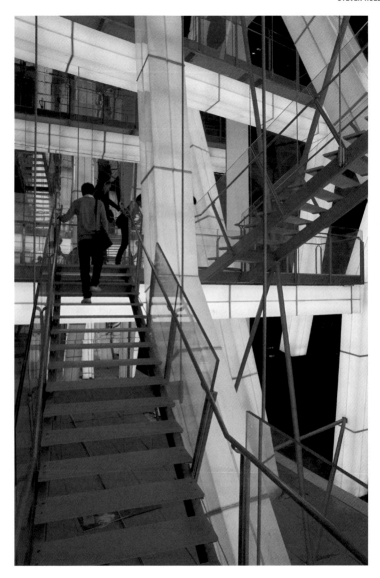

Images show the four-story Light Pavilion by the late architect Lebbeus Woods and the professor and architect Christoph Kumpusch. The design is based on a "deconstruction" of the tower's grid.

Die Abbildungen zeigen den viergeschossigen Lichtpavillon des verstorbenen Architekten Lebbeus Woods und des Professors und Architekten Christoph Kumpusch. Der Entwurf basiert auf einer „Dekonstruktion" des Turmrasters.

Photos du Pavillon de lumière à quatre étages par l'architecte défunt Lebbeus Woods et le professeur et architecte Christoph Kumpusch. Sa conception est basée sur une « déconstruction » de la grille qui recouvre la tour.

CARSTEN HÖLLER
AND MARCEL ODENBACH

CARSTEN HÖLLER is a German artist, born in Brussels in 1961. He has a doctorate in agricultural science from the University of Kiel and he lives and works in Stockholm. Noted projects are his winding, tubular slides such as "Test Site" (Tate Modern, London, UK, 2006) and his Congolese/Western nightclub, bar, and restaurant "The Double Club," created in London with the Prada Foundation (2008). His solo exhibitions include "Divided Divided" (Museum Boijmans Van Beuningen, Rotterdam, the Netherlands, 2010); "SOMA" (Hamburger Bahnhof, Museum für Gegenwart, Berlin, Germany, 2010); and "Carsten Höller: Experience" (New Museum, New York, USA, 2011). **MARCEL ODENBACH** was born in 1953 in Cologne, Germany. He studied architecture and art at the RWTH (Aachen). He is a freelance video artist, surely one of the best known in Germany, who lives and works in Cologne and Ghana, and is a Professor in Film and Video at the Düsseldorf Kunstakademie. His solo exhibitions include "Marcel Odenbach" (New Museum of Contemporary Art, New York, USA, 1999) and "Marcel Odenbach: Works on Paper" (Kunstmuseum, Bonn, Germany, 2013). Together they completed House Turtle (Biriwa, Ghana, 1999–2009, published here).

Der deutsche Künstler **CARSTEN HÖLLER** (geboren 1961 in Brüssel) promovierte in Agrarwissenschaften an der Universität Kiel und lebt und arbeitet in Stockholm. Bekannt gewordene Arbeiten sind etwa seine geschwungenen Röhrenrutschen wie *Test Site* (Tate Modern, London, Großbritannien, 2006) oder sein *Double Club*, ein kongolesisch/westlicher Nachtklub mit Bar und Restaurant, den er in London mit der Prada Foundation realisierte (2008). Zu seinen Einzelausstellungen zählen „Divided Divided" (Museum Boijmans Van Beuningen, Rotterdam, Niederlande, 2010), *SOMA* (Hamburger Bahnhof, Museum für Gegenwart, Berlin, Deutschland, 2010) und „Carsten Höller: Experience" (New Museum, New York, USA, 2011). **MARCEL ODENBACH** (geboren 1953 in Köln) studierte Architektur und Kunst an der RWTH Aachen. Er ist freischaffender Videokünstler, einer der bekanntesten Deutschlands, lebt und arbeitet in Köln und Ghana und ist Professor für Film und Video an der Düsseldorfer Kunstakademie. Zu seinen Einzelausstellungen zählen „Marcel Odenbach" (New Museum of Contemporary Art, New York, USA, 1999) und „Marcel Odenbach: Works on Paper" (Kunstmuseum Bonn, Deutschland, 2013). Gemeinsames Projekt der Künstler ist das House Turtle (Biriwa, Ghana, 1999–2009, hier vorgestellt).

CARSTEN HÖLLER est un artiste allemand, né à Bruxelles en 1961. Docteur en sciences de l'agriculture de l'université de Kiel, il vit et travaille à Stockholm. Parmi ses projets remarqués, on notera ses toboggans tubulaires hélicoïdaux tels le *Test Site* (Tate Modern, Londres, 2006) ainsi que son club, bar et restaurant congolais/occidental *Double Club* crée à Londres avec la Fondation Prada (2008). Ses expositions personnelles incluent « Divided Divided » (Museum Boijmans Van Beuningen, Rotterdam, 2010), « SOMA » (Museum für Gegenwart, Hamburger Bahnhof, Berlin, 2010) et « Carsten Höller : Experience » (New Museum, New York, 2011). **MARCEL ODENBACH**, né en 1953 à Cologne en Allemagne a étudié l'art et l'architecture à l'École supérieure RWTH à Aix-la-Chapelle. Un des plus célèbres artistes vidéo allemands, il vit et travaille à Cologne et au Ghana et enseigne le film et la vidéo à la Kunstakademie de Düsseldorf. Ses expositions personnelles incluent « Marcel Odenbach » (New Museum of Contemporary Art, New York, 1999) et « Marcel Odenbach : Works on Paper » (Kunstmuseum, Bonn, Allemagne, 2013). Ils ont conçu ensemble la House Turtle (Biriwa, Ghana, 1999–2009, publiée ici).

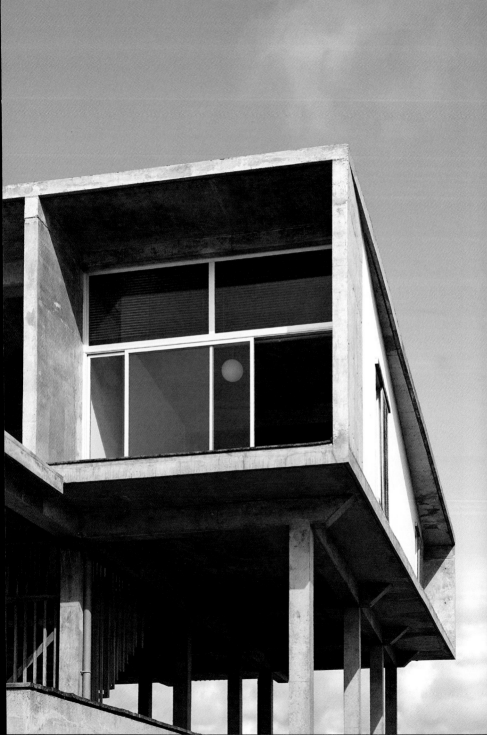

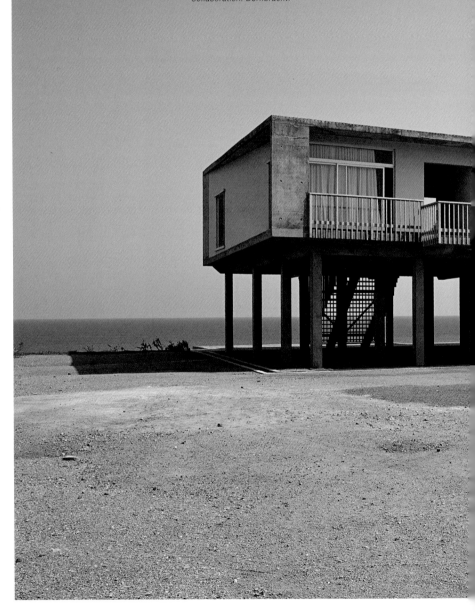

HOUSE TURTLE

Biriwa, Ghana, 1999–2009

Area: 434 m² (not including roof). Client: Carsten Höller and Marcel Odenbach.
Collaboration: Dornbracht.

Standing on its irregular stilts, the house looks from the exterior as though it might be a temporary structure. Like the coastline it looks out on, it is intentionally rough in its appearance and materials.

Das Haus ruht auf unregelmäßigen Stützen und wirkt von außen fast wie ein temporärer Bau. Wie die Küste, zu der es sich öffnet, ist es in Erscheinung und Materialwahl bewusst rau.

Posée sur des pilotis plantés de façon irrégulière, la maison fait penser à une structure temporaire. Comme la côte rocheuse sur laquelle elle donne, elle a adopté un aspect brut qu'expriment bien ses matériaux.

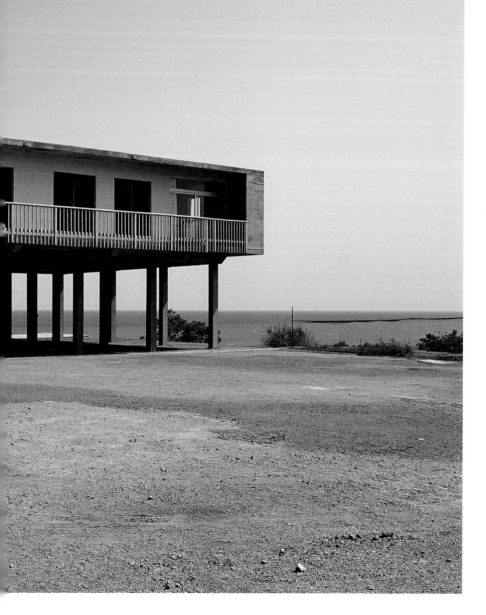

According to Carsten Höller, the **HOUSE TURTLE**, located near Cape Coast (Ghana) on the Gulf of Guinea in the town of Biriwa "was designed with the following considerations: a) to have a maximum of air flow through and under the ouse to avoid the necessity of air conditioning; b) to make the construction unattractive for mosquitos and keep animals, including snakes, at bay; c) to favor 87° or 93° angles over 90° angles, in order to increase/decrease the perception of distance and straightness; d) to collect rainwater from the roof and the terraces underground; e) to make the house look 'unfinished.'" The house is made up of parallelograms as opposed to rectangles. The artists' rooms are located at opposite ends of the house, with a shared living area and kitchen between. "We are like dilettante architects, and we made so many mistakes [...] But since this is Africa, it takes ages to build anything, so we had time to think about the mistakes and find the right solutions," says Höller in the online magazine *WWD* ("Cliff Hanger," 2012). They encountered numerous difficulties due to the administrative complications and the site, which is not located on any road.

Laut Carsten Höller wurde das **HOUSE TURTLE** in Biriwa, unweit von Cape Coast (Ghana) am Golf von Guinea „unter Berücksichtigung folgender Kriterien geplant: a) maximale Luftzirkulation durch und unter dem Haus, um auf Klimatisierung verzichten zu können, b) Schutzmaßnahmen gegen Moskitos und andere Tiere wie Schlangen, c) Planung von 87°- oder 93°-Winkeln statt der üblichen 90°-Winkel, um das Empfinden von Raumtiefe und Geradwinkligkeit zu verstärken/mindern, d) Sammeln von Regenwasser über das Dach und unterhalb der Terrassen, e) das Haus ‚unfertig' erscheinen zu lassen." Das Haus basiert auf Parallelogrammen statt auf Rechtecken. Die Quartiere der beiden Künstler liegen an den entgegengesetzten Enden des Hauses, dazwischen befinden sich ein gemeinsamer Wohnbereich und eine Küche. „Wir sind dilettantische Architekten, haben alles Mögliche falsch gemacht", so Carsten Höller in dem Online-magazin *WWD* („Cliff Hanger", 2012). „Aber hier in Afrika dauert es ewig, etwas zu bauen, weshalb genug Zeit blieb, unsere Fehler zu analysieren und bessere Lösungen zu finden." Es waren zahlreiche Schwierigkeiten zu bewältigen: bürokratischer Natur ebenso wie im Hinblick auf den Bauplatz, der alles andere als gewöhnlich ist.

Selon Carsten Höller, la **HOUSE TURTLE**, située près de Cape Coast (Ghana) sur le golfe de Guinée dans la ville de Biriwa « a été conçue à partir des considérations suivantes : a) disposer d'une circulation d'air maximum à travers et sous la maison pour éviter toute climatisation mécanique ; b) rendre la construction aussi peu attirante que possible pour les moustiques et garder à distance les autres animaux, serpents compris ; c) favoriser les angles à 87 ou 93° par rapport à l'angle droit pour augmenter/diminuer la perception des distances et de l'aspect rectiligne ; d) collecter l'eau de pluie du toit et des terrasses en sous-sol ; e) donner à la maison un aspect « non achevé ». La maison se compose de parallélogrammes et non de rectangles. Les chambres des artistes sont disposées aux deux extrémités, séparées par un séjour et une cuisine communes. « Nous sommes un peu des architectes dilettantes et avons fait beaucoup d'erreurs, mais comme nous sommes en Afrique et qu'il faut des années pour construire quoi que ce soit, nous avons eu le temps de réfléchir à nos fautes et de trouver des solutions », déclare Höller pour le magazine en ligne *WWD* (« Cliff Hanger », 2012). Les deux artistes ont également rencontré de multiples difficultés d'ordre administratif ou d'autres dues à la nature du site, non relié à une route.

*Spaces in the house are largely
open to the exterior, providing shel-
tered areas that are neither entirely
inside, nor really outside.*

*Die Räume sind überwiegend offen
gehalten. So entstehen geschützte
Bereiche, die weder ganz Innen-
noch ganz Außenraum sind.*

*Les pièces de la maison largement
ouvertes sur l'extérieur sont des
espaces à vivre ni entièrement inté-
rieurs ni vraiment extérieurs.*

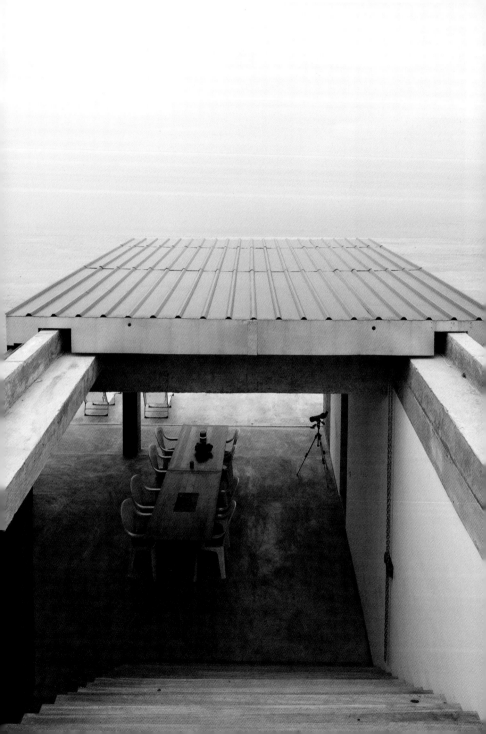

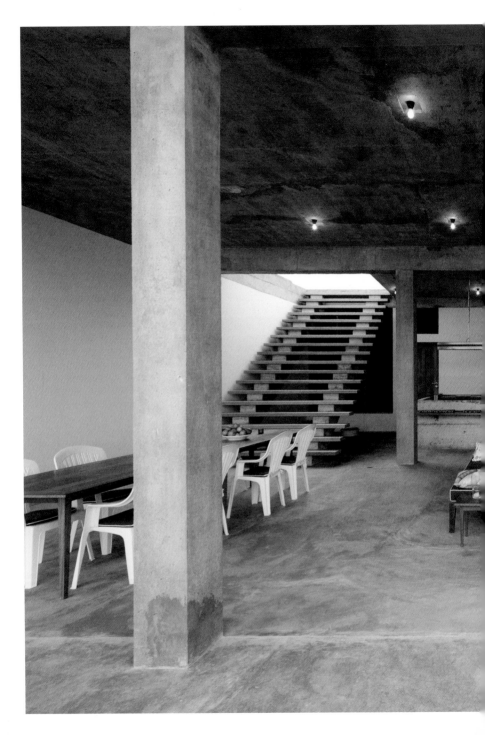

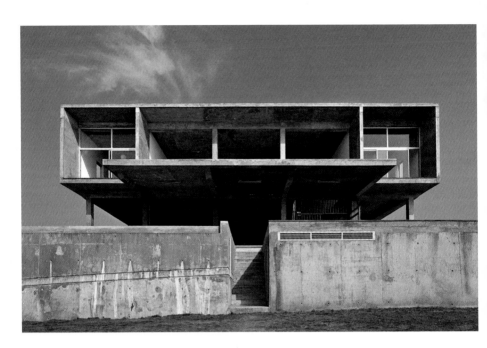

The weathering of the concrete gives an enigmatic appearance to the house—though its forms are modern, it looks as though it might have been there forever. Right, a wooden terrace with a pool in front of the house.

Die Verwitterung des Sichtbetons gibt dem Haus etwas Rätselhaftes – trotz moderner Formensprache wirkt es, als sei es schon immer da gewesen. Rechts eine Holzterrasse mit Pool vor dem Haus.

La patine du béton confère à la maison son aspect un peu énigmatique. Bien que ses formes soient modernes, elle semble avoir toujours été là. À droite, une terrasse en bois et une piscine prolongent le séjour.

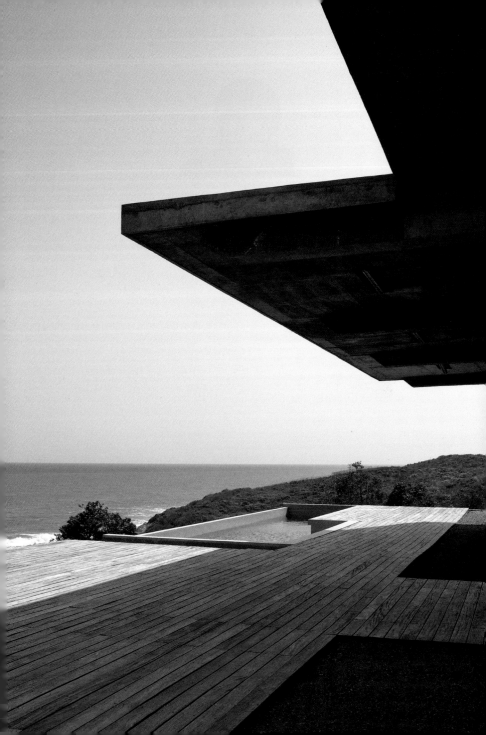

TOYO ITO

Born in 1941 in Seoul, South Korea, **TOYO ITO** graduated from the University of Tokyo in 1965 and worked in the office of Kiyonori Kikutake until 1969. He created his own office, Urban Robot (URBOT), in Tokyo in 1971, assuming the name of Toyo Ito & Associates, Architects in 1979. He was awarded the Golden Lion for Lifetime Achievement from the 8th International Venice Architecture Biennale in 2002, the RIBA Gold Medal in 2006, and the Pritzker Prize in 2013. One of his most successful and widely published projects, the Sendai Mediatheque, was completed in 2001, while in 2002 he designed a temporary Pavilion for the Serpentine Gallery in London (UK). More recently, he has completed TOD'S Omotesando Building (Shibuya-ku, Tokyo, Japan, 2002–04); the Island City Central Park Grin Grin (Fukuoka, Japan, 2002–05); the Tama Art University Library (Hachioji City, Tokyo, Japan, 2004–07); the Za-Koenji Public Theater (Tokyo, Japan, 2005–08); the Main Stadium for the World Games 2009 (Kaohsiung, Taiwan, 2006–09); the Toyo Ito Museum of Architecture (Imabari, Ehime, Japan, 2011); and the Taichung Metropolitan Opera House (Taichung, Taiwan, 2005–14).

TOYO ITO, geboren 1941 in Seoul, Südkorea, machte 1965 seinen Abschluss an der Universität Tokio und arbeitete dann bis 1969 im Büro von Kiyonori Kikutake. Mit Urban Robot (URBOT) gründete er 1971 sein eigenes Büro in Tokio und änderte den Namen 1979 in Toyo Ito & Associates. Auf der VIII. Internationalen Architekturbiennale 2002 in Venedig erhielt er einen Goldenen Löwen für sein Lebenswerk, 2006 die RIBA-Goldmedaille und 2013 den Pritzker-Preis. Eines seiner erfolgreichsten und bekanntesten Projekte, die Mediathek von Sendai, Japan, wurde 2001 fertiggestellt, 2002 entwarf er einen temporären Pavillon für die Serpentine Gallery in London, Großbritannien. In jüngerer Zeit hat er das Omotesando-Gebäude von TOD'S (Shibuya-ku, Tokio, Japan, 2002–04), das Island City Central Park Grin Grin (Fukuoka, Japan, 2002–05), die Bibliothek der Kunsthochschule Tama (Hachioji, Tokio, Japan, 2004–07), das Theater Za-Koenji (Tokio, 2005–08), das Hauptstadion der World Games 2009 (Kaohsiung, Taiwan, 2006–09), das Toyo-Ito-Architekturmuseum (Imabari, Ehime, Japan, 2011) und das Städtische Opernhaus Taichung (Taichung, Taiwan, 2005–14) realisiert.

Né en 1941 à Séoul, **TOYO ITO** est diplômé de l'université de Tokyo (1965) et a travaillé dans l'agence de Kiyonori Kikutake jusqu'en 1969. Il a fondé son agence, Urban Robot (URBOT) à Tokyo en 1971 et a repris le nom Toyo Ito & Associates, Architects en 1979. Il a gagné le Lion d'or pour l'ensemble de son oeuvre à la VIIIe Biennale internationale d'architecture de Venise en 2002, la médaille d'or du RIBA en 2006 et le prix Pritzker en 2013. L'un de ses projets les plus célèbres et largement publiés, la médiathèque de Sendai, a été achevé en 2001, et il a créé un pavillon temporaire pour la Serpentine Gallery de Londres en 2002. Plus récemment, il a réalisé l'immeuble TOD'S d'Omotesando (Shibuya-ku, Tokyo, Japon, 2002–04) ; le parc Grin Grin de l'île de Fukuoka (Fukuoka, Japon, 2002–05) ; la bibliothèque universitaire d'art de Tama (Hachioji City, Tokyo, Japon, 2004–07) ; le théâtre public Za-Koenji (Tokyo, Japon, 2005–08) ; le stade des Jeux mondiaux 2009 (Kaohsiung, Taiwan, 2006–09) ; le musée d'architecture Toyo Ito (Imabari, Ehime, Japon, 2011) ; et l'Opéra de Taichung (Taiwan, 2005–14).

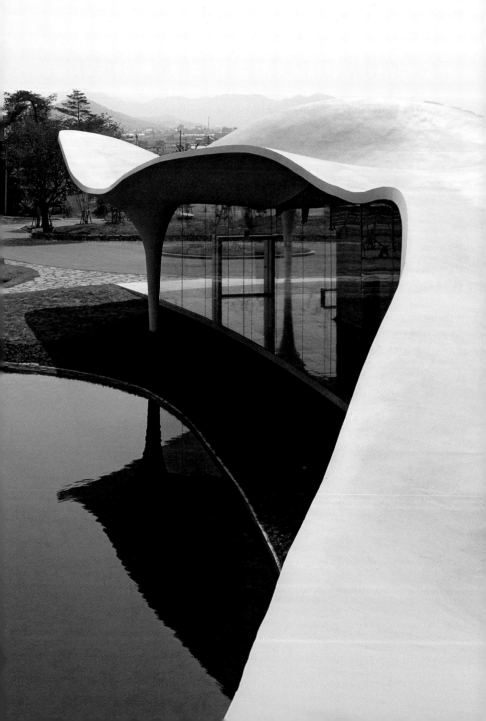

MEISO NO MORI
MUNICIPAL FUNERAL HALL

Kakamigahara, Gifu, Japan, 2005–06

Floor area: 2264 m². Client: City of Kakamigahara.

The undulation of the roof takes on a natural configuration, bringing to mind images of clouds.

Die eine natürliche Gestalt annehmende, gewellte Form des Dachs erinnert an Bilder von Wolken.

L'ondulation du toit emprunte une configuration naturelle qui évoque des nuages.

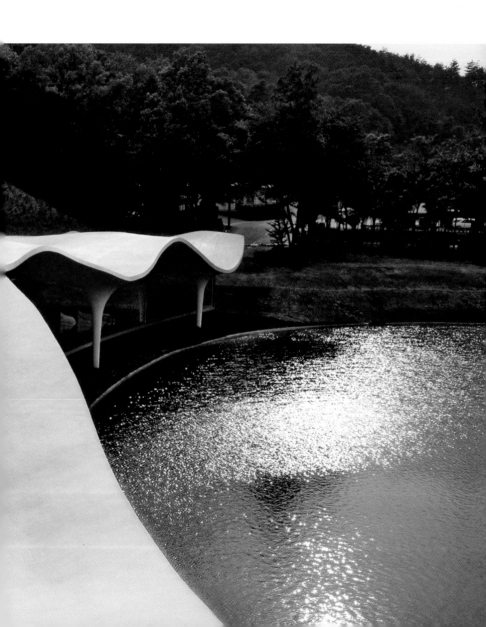

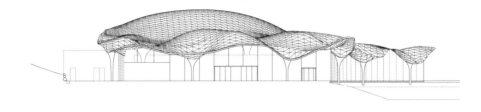

The most surprising feature of this crematorium, rebuilt in a cemetery in the city of Kakamigahara, in the central Japanese prefecture of Gifu, is undoubtedly its "spacious roof floating above the site like slowly drifting clouds creating a soft field." As the architect explains, "We investigated a freely curved reinforced-concrete shell structure to construct a roof characterized by concavities and convexities. The shape of the roof structure was determined by an algorithm intended to generate the optimum structural solution. Since this type of structural analysis resembles the growth patterns of plants that keep transforming themselves following simple natural rules, the process is called 'evolution.' Several hundred such evolutionary cycles produced the final shape. The curved line becomes landscape, in harmony with the edge silhouette of the surrounding mountains." The gently curving roof also determines the shape of the interior ceiling, and an indirect natural light suffuses the whole space during the day. Set on a 6696-square-meter site, the two-story **MEISO NO MORI MUNICIPAL FUNERAL HALL** has a maximum height of 11.5 meters and a floor area of 2264 square meters. Working with a building type usually noted for its extreme austerity or heaviness, Toyo Ito has sought and obtained lightness and what must be a comforting space for the families and friends of the deceased.

Die überraschendste Besonderheit dieses Krematoriums, das auf einem Friedhof der Stadt Kakamigahara in der zentraljapanischen Präfektur Gifu umgebaut wurde, ist fraglos sein „weiträumiges, gleich langsam dahinziehenden Wolken über dem Baugrund schwebendes Dach". Der Architekt erläutert: „Wir beschäftigten uns mit einem frei gekrümmten Stahlbetonschalenbau, um ein von konkaven und konvexen Wölbungen gestaltetes Dach zu konzipieren. Die Dachform wurde von einem Algorithmus berechnet, der die optimale konstruktive Lösung erbringen sollte. Da dieser Typ der konstruktiven Analyse dem Wachstum von Pflanzen ähnelt, die sich einfachen Naturgesetzen folgend beständig verändern, bezeichnet man diesen Vorgang als ‚Evolution'. Hunderte solcher evolutionären Zyklen ergaben die endgültige Form. Die gebogene Linie wird zur Landschaft, in Einklang mit der Silhouette der sie umgebenden Hügelketten." Das sanft gebogene Dach bestimmt darüber hinaus die Form der inneren Decke. Tagsüber ist der gesamte Raum von indirektem Licht durchflutet. Die auf einem 6696 m² großen Grundstück stehende zweigeschossige **MEISO NO MORI MUNICIPAL FUNERAL HALL** hat eine maximale Höhe von 11,5 m und eine Bodenfläche von 2264 m². Jenseits des in der Regel für seine extreme Nüchternheit oder Schwere bekannten Bautyps gelang Toyo Ito die von ihm angestrebte Leichtigkeit und ein vermutlich für Familien und Freunde der Verstorbenen trostreicher Raum.

La caractéristique la plus surprenante de ce crématorium, reconstruit dans un cimetière de la ville de Kakamigahara dans la préfecture de Gifu au centre du Japon, est certainement son « vaste toit flottant au-dessus du site comme des nuages s'étirant lentement en créant un paysage adouci ». L'architecte présente ainsi son projet : « Nous avons étudié une structure en coquille de béton armé à courbes libres pour constituer ce toit caractérisé par des concavités et des convexités. Cette forme a été déterminée par un algorithme qui doit générer une solution structurelle optimale. Comme ce type d'analyse structurelle fait penser au processus de croissance des plantes qui ne cessent de se transformer en fonction de règles naturelles simples, nous l'avons appelée "évolution". Plusieurs centaines de cycles évolutifs ont abouti à la forme finale. La ligne incurvée est un paysage en harmonie avec la silhouette effilée des montagnes environnantes. » Le toit et ses courbes douces déterminent également la forme du plafond intérieur. L'ensemble du **MEISO NO MORI MUNICIPAL FUNERAL HALL** est éclairé le jour par une lumière naturelle indirecte. Implantée sur un terrain de 6696 m², cette construction sur deux niveaux présente une hauteur maximum de 11,5 m et une surface au sol de 2264 m². Intervenant sur un type de construction généralement caractérisé par son extrême austérité ou sa lourdeur, Toyo Ito a cherché et obtenu un vaste espace d'une grande légèreté, dont l'atmosphère est sans doute plus réconfortante pour les familles et les amis des disparus.

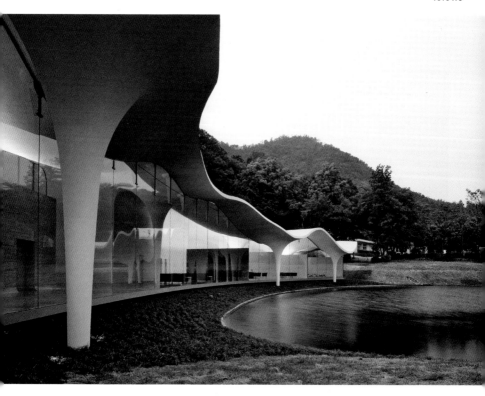

The floating canopy that covers the complex appears clearly in the drawing on the left. This is the defining element of the design.

Auf der Zeichnung links ist das „schwebende" Schutzdach über dem Komplex deutlich zu sehen. Es ist das bestimmende Element des Entwurfs.

Élément qui personnalise ce projet, une sorte de canopée flottante recouvre le complexe. Elle apparaît clairement dans le dessin à gauche.

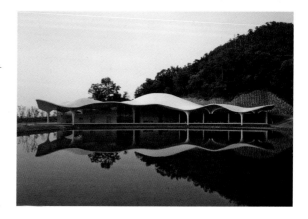

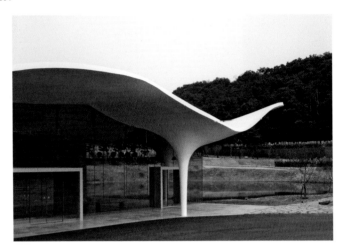

Toyo Ito is known for the lightness of his architecture, but it appears that his mature work assumes an even more ethereal quality than some of his earlier attempts to achieve a kind of architectural "weightlessness."

Toyo Ito ist bekannt für die Leichtigkeit seiner Bauten, aber es scheint, als sei der Charakter seiner ausgereiften Bauten noch ätherischer als seine früheren Versuche mit einer „schwerelosen" Architektur.

Toyo Ito est connu pour la légèreté de son architecture, mais il semble que les réalisations de sa maturité tendent à développer un aspect encore plus éthéré que ses recherches antérieures avec une sorte « d'absence de poids » architecturale.

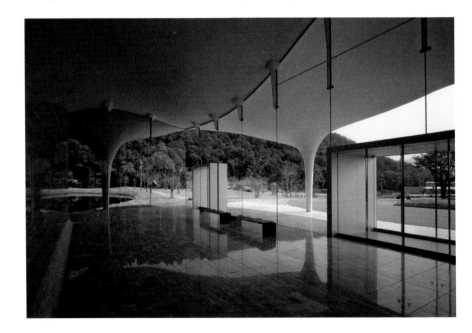

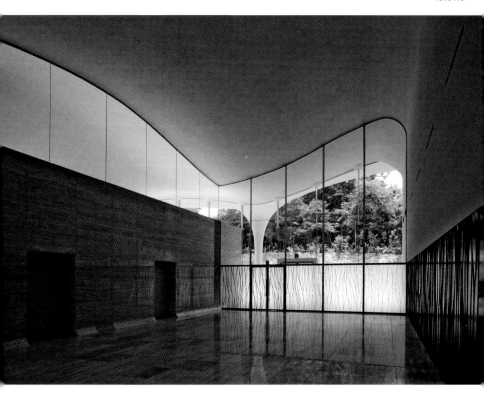

Conforming to the natural topogra-
phy of the site, as the site plan to
the right shows, the building enclos-
es a series of relatively traditional
rectangular volumes.

Wie auf dem Lageplan rechts
zu sehen, umfasst der sich den
natürlichen Gegebenheiten des
Geländes anpassende Komplex
eine Reihe relativ traditioneller
rechtwinkliger Baukörper.

Prenant en compte la configuration
naturelle du site, comme le montre
le plan de situation de droite, le bâti-
ment réunit une série de volumes rec-
tangulaires relativement traditionnels.

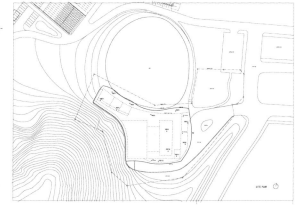

IZQUIERDO LEHMANN

LUIS IZQUIERDO WACHHOLTZ was born in 1954 in Santiago de Chile. **ANTONIA LEHMANN SCASSI-BUFFA** was born in 1955 in Santiago. They both graduated as architects from the Pontificia Universidad Católica de Chile (UC) in 1980 and 1981 respectively. Until 1984, when they established Izquierdo Lehmann Arquitectos in Santiago, they worked with the architect Christian de Groote. They were winners of the Chilean National Prize for Architecture in 2004. Their recent work includes the Patricia Ready Art Gallery (Vitacura, Santiago, 2007–08); the Cruz del Sur Office Building (Apoquindo, Santiago, 2008–09, published here); House in Santiago 2 (Santiago, 2010); House in Zapallar (Zapallar, 2011); House in Vitacura (Santiago, 2010–12, also published here); House in Santiago 3 (Santiago, 2013); and House in Ranco (Ranco, 2013), all in Chile.

LUIS IZQUIERDO WACHHOLTZ wurde 1954 in Santiago de Chile, **ANTONIA LEHMANN SCASSI-BUFFA** 1955 in Santiago geboren. Sie beendeten ihr Architekturstudium an der Pontificia Universidad Católica de Chile (UC) 1980 bzw. 1981. Bis 1984, als sie Izquierdo Lehmann Arquitectos in Santiago gründeten, arbeiteten sie bei dem Architekten Christian de Groote. Sie gewannen 2004 den chilenischen Nationalpreis für Architektur. Zu ihren neueren Projekten zählen die Kunstgalerie Patricia Ready (Vitacura, Santiago, 2007–08), das Bürogebäude Cruz del Sur (Apoquindo, Santiago, 2008–09, hier vorgestellt), ein Wohnhaus in Santiago 2 (2010), ein Wohnhaus in Zapallar (2011), ein Wohn-haus in Vitacura (Santiago, 2010–12, ebenfalls hier vorgestellt), ein Wohnhaus in Santiago 3 (2013) und ein Wohnhaus in Ranco (2013), alle in Chile.

LUIS IZQUIERDO WACHHOLTZ est né en 1954 à Santiago de Chile. **ANTONIA LEHMANN SCASSI-BUFFA** est née en 1955 à Santiago. Ils sont tous les deux architectes diplômés (1980 et 1981) de l'Université catholique pontificale du Chili (UC). Avant de fonder Izquierdo Lehmann Arquitectos à Santiago en 1984, ils ont travaillé avec l'architecte Christian de Groote. Ils ont remporté le Prix national d'architecture du Chili en 2004. Leurs réalisations récentes comprennent la galerie d'art Patricia Ready (Vitacura, Santiago, 2007–08) ; l'immeuble de bureaux Cruz del Sur (Apoquindo, Santiago, 2008–09, publié ici) ; une maison à Santiago 2 (2010) ; une maison à Zapallar (2011) ; une maison à Vitacura (Santiago, 2010–12, également publiée ici) ; une maison à Santiago 3 (Santiago, 2013) et une maison à Ranco (2013), toutes au Chili.

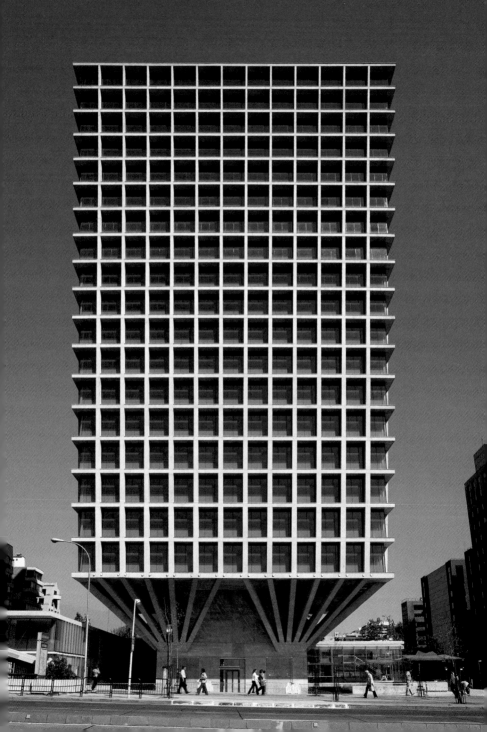

CRUZ DEL SUR OFFICE BUILDING

Apoquindo, Santiago, Chile, 2008–09

Area: 3987 m². Collaboration: Mirene Elton, Mauricio Léniz.

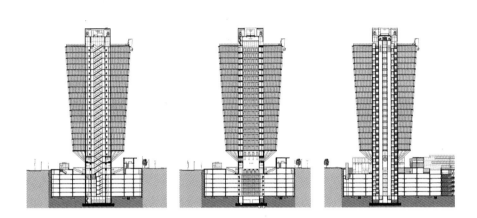

The 21-story **CRUZ DEL SUR OFFICE BUILDING**, with a commercial complex in its base, stands at the intersection of Apoquindo Avenue, Santiago's main axis, and Vespucio Avenue, the capital's circular beltway. Despite its urban importance, this site is poorly laid out, as a cloverleaf intersection surrounded by several buildings of varying height and quality. The site has immediate access to a metro station. The roughly square site is open on three sides. The architects state: "Given the high pedestrian density of the area, our first decision was to clear the ground level as much as possible, freeing up the site as an extension of the public space. This was made possible by hiding underground a major part of the program's commercial area and withdrawing the rest of the complex's structure to the borders at the back of the property, so as to allow an interior corner square." Continuous full-height glazing was installed, with a setback and silkscreen pattern to reduce heat gain.

Das 21-geschossige **CRUZ DEL SUR BÜROHAUS** mit Geschäften an der Basis liegt an der Kreuzung der Apoquindo Avenue, der Hauptachse von Santiago, mit der Vespucio Avenue, der hauptstädtischen Ringstraße. Trotz seiner städtebaulichen Bedeutung ist dieser Platz nur unzureichend als Kleeblattkreuz angelegt und von Bauten unterschiedlicher Höhe und Qualität umgeben. Vom Grundstück besteht ein direkter Zugang zur Metro. Der fast quadratische Bauplatz ist nach drei Seiten offen. Die Architekten führen aus: „Angesichts der vielen Fußgänger in diesem Bereich entschieden wir uns zuerst, die Straßenebene soweit wie möglich freizuhalten und das Grundstück als Erweiterung des öffentlichen Bereichs zu gestalten. Dies wurde ermöglicht, indem wir einen großen Teil der kommerziellen Einrichtungen ins Untergeschoss und den übrigen Teil des Gebäudes an den hinteren Rand des Geländes verlegten, damit ein interner Eckplatz entstehen konnte." Durchgehend geschosshohe, zurückgesetzte Siebdruck-Verglasung soll die Temperaturen im Gebäude niedrig halten.

La **TOUR DE BUREAUX CRUZ DEL SUR** de 21 étages dont le bas accueille un complexe commercial est située à l'intersection de l'avenue Apoquindo, le principal axe de Santiago, et de l'avenue Vespucio, le périphérique de la capitale. Malgré son importance dans la ville, le lieu est peu aménagé, simple croisement en trèfle entouré par plusieurs bâtiments de hauteurs et qualités différentes. Le site possède un accès direct à une station de métro, il forme un carré approximatif ouvert sur trois côtés. Les architectes déclarent : « Étant donné la forte densité piétonne de la zone, notre premier choix a été de dégager le plus possible le niveau du sol pour libérer le bâtiment et en faire un prolongement de l'espace public. Pour cela, nous avons dissimulé sous la terre la plus grande partie de l'espace commercial prévu et reculé le reste de la structure aux limites arrière du terrain afin de former une place intérieure. » Le vitrage ininterrompu sur toute la hauteur a été disposé en retrait selon un motif sérigraphié afin de diminuer l'apport de chaleur.

With its slight outward slant and otherwise regular grid, the building rises from a relatively narrow base and stands out against the background of more "ordinary" buildings.

Mit seiner leichten Neigung nach außen und dem ansonsten gleichmäßigen Raster steht das Gebäude auf einer relativ schmalen Basis und hebt sich vom Hintergrund der „gewöhnlicheren" Bebauung ab.

Légèrement incliné vers l'extérieur, l'immeuble à la grille sinon régulière se dresse sur une base relativement étroite et se détache sur son arrière-plan de bâtiments plus « ordinaires ».

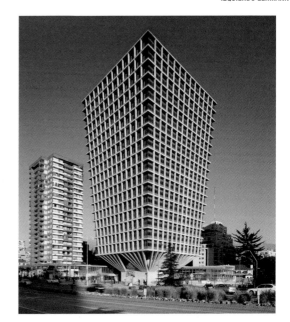

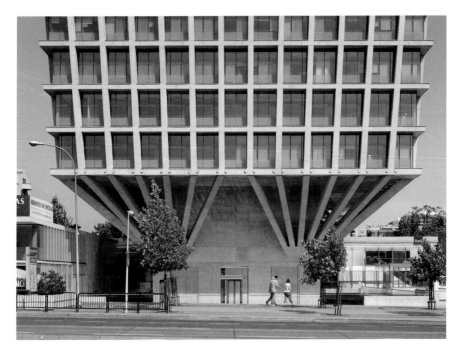

HOUSE IN VITACURA
Santiago, Chile, 2010–12

Area: 983 m².

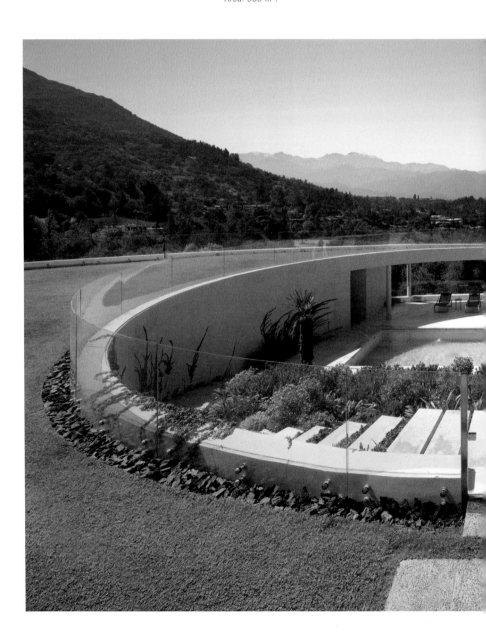

A round pool area is sunken into the lawn in front of the house, offering a spectacular view of the city in the distance. Vitacura is one of the most fashionable and expensive areas in Santiago.

Von einem runden, in den Rasen versenkten Pool vor dem Haus bieten sich spektakuläre Aussichten auf die entfernte City. Vitacura ist eins der attraktivsten und teuersten Gebiete von Santiago.

Une piscine ronde est creusée dans la pelouse devant la maison et offre une vue splendide de la ville au loin. Vitacura est l'un des quartiers de Santiago les plus à la mode et les plus chers.

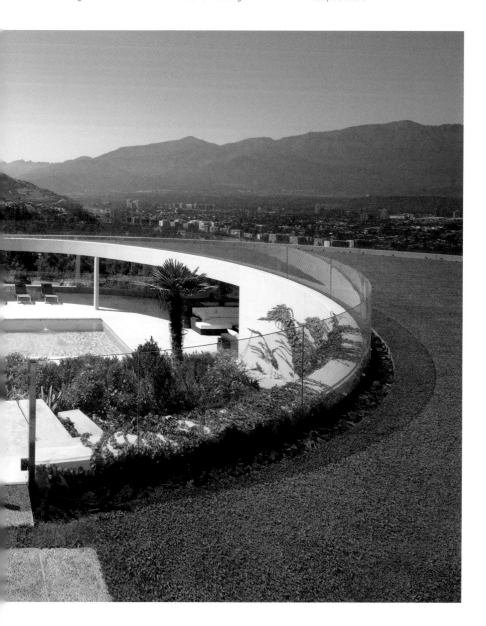

312

The large **HOUSE IN VITACURA** was designed for a wealthy older couple and their extended family. Set on a hilltop, it offers magnificent views of Santiago and the Andes. The living rooms, dining room, kitchen, and a bedroom wing were placed on a single flat level, along with the entrance patio and garage, at the upper part of the site. A basement beneath the main floor contains a playroom and an interior pool at a lower side of the site, with views in a southern direction over the city valley. The building is made of fine-finished beige-tinted concrete, exposed on the exterior and insulated on the white-painted interiors. The architects explain: "It was made using a patented building method of our own, consisting of prefabricated structural wall panels that integrate a rigid structural wire cage and lightweight plywood forms that are fastened directly to it."

Dieses großzügige **WOHNHAUS IN VITACURA** wurde für ein wohlhabendes, älteres Ehepaar mit großer Familie geplant. Es steht auf einem Hugel und bietet großartige Ausblicke auf Santiago und die Anden. Im oberen Bereich des Grundstücks sind Wohnräume, Esszimmer, Küche und ein Schlaftrakt auf nur einer Ebene im Flachbau angeordnet, ebenso wie der Eingangspatio und die Garage. Ein Untergeschoss unter dem Hauptgeschoss enthält ein Spielzimmer und einen Innenpool auf der tiefer liegenden Seite des Geländes mit Ausblick nach Süden über das Tal der Stadt. Das Gebäude besteht aus veredeltem, beigefarbenem Beton, außen als Sichtbeton belassen und mit weiß gestrichenen isolierten Wänden innen. Die Architekten erläutern: „Wir wendeten eine eigene, patentierte Baumethode an, die aus vorfabrizierten, tragenden Wandplatten besteht, welche einen starren, tragenden Drahtkäfig einfassen, sowie aus leichten Sperrholzschalungen, die direkt daran angebracht werden."

Cette grande **MAISON À VITACURA** a été créée pour un couple âgé fortuné et leur famille élargie. Située au sommet d'une colline, elle offre des vues splendides sur Santiago et les Andes. Les salons, la salle à manger, la cuisine et une aile de chambres ont été construites de plain-pied avec le patio d'entrée et le garage, dans la partie supérieure du terrain. Un sous-sol abrite une salle de jeu et une piscine couverte, à un niveau plus bas du site qui donne sur le sud et a vue sur la vallée de Santiago. Le bâtiment est en béton teinté beige aux finitions raffinées, nu à l'extérieur et isolé pour les intérieurs peints en blanc. Les architectes expliquent : « Nous avons utilisé une méthode de construction brevetée qui nous est propre, faite de panneaux muraux structurels préfabriqués dans lesquels une cage structurelle rigide de câbles est intégrée et de moules légers en contreplaqué qui y sont directement fixés. »

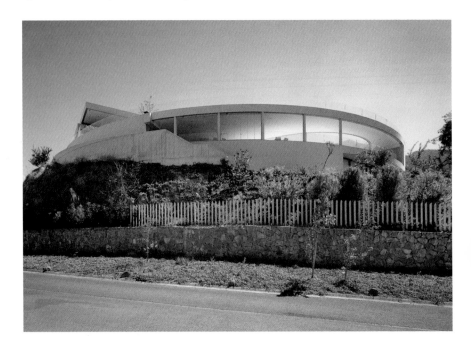

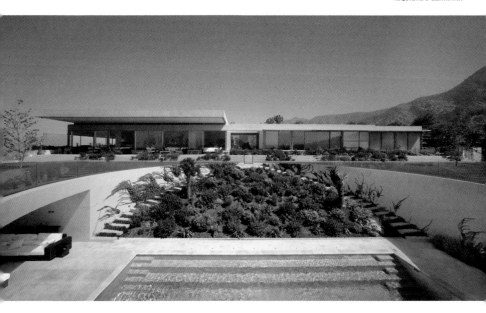

A sweeping roof offers shade near the pool and a view up to the main house.

Ein geschwungenes Dach bietet Schatten neben dem Pool und einen Blick auf das Haupthaus.

Un large toit circulaire procure de l'ombre à côté de la piscine et la vue sur la maison principale, plus haut.

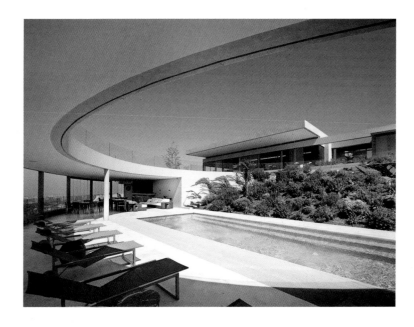

MATHIAS KLOTZ +
ALVANO & RIQUELME

MATHIAS KLOTZ was born in 1965 in Viña del Mar, Chile. He received his architecture degree from the Pontificia Universidad Católica de Chile (UC) in 1991. He created his own office in Santiago the same year. He has taught at several Chilean universities and was Director of the School of Architecture of the Universidad Diego Portales in Santiago (2001–03) and Dean since 2004. His work includes the Viejo House in Santiago de Chile (2001–02); the 11 Mujeres House (Cachagua, 2007); Raul House (Aculeo, 2007); Bitran House (Cachagua, 2010), all in Chile; Casa L (2011); and the Buildings Department San Isidro (both in Buenos Aires, Argentina, 2011–12). The Vitacura 3565 building (Santiago, Chile, 2011–12, published here) was designed in collaboration with **ALVANO & RIQUELME**, founded in 2003 by Renzo Alvano and Pablo Riquelme, former members of his office. Other recent work includes the Soda Haus building (Buenos Aires, Argentina, 2013); and the Perez Maggi House (Santiago, Chile, 2013).

MATHIAS KLOTZ wurde 1965 in Viña del Mar, Chile, geboren. Sein Architekturdiplom machte er 1991 an der Pontificia Universidad Católica de Chile (UC). Im gleichen Jahr gründete er sein eigenes Büro in Santiago. Er hat an verschiedenen chilenischen Universitäten gelehrt und war Direktor der Architekturabteilung der Universidad Diego Portales in Santiago (2001–03); seit 2004 ist er dort Dekan. Zu seinen Projekten zählen: das Haus Viejo in Santiago de Chile (2001–02), das Haus 11 Mujeres (Cachagua, 2007); das Haus Raul (Aculeo, 2007), das Haus Bitran (Cachagua, 2010), alle in Chile, das Haus L (2011) und die Bauabteilung San Isidro (beide in Buenos Aires, Argentinien, 2011–12). Das Gebäude Vitacura 3565 (Santiago, Chile, 2011–12, hier vorgestellt) wurde in Zusammenarbeit mit dem Büro **ALVANO & RIQUELME** geplant, das 2003 von seinen früheren Mitarbeitern Renzo Alvano und Pablo Riquelme gegründet wurde. Weitere neue Bauten sind: das Soda Haus (Buenos Aires, Argentinien 2013) und das Haus Perez Maggi (Santiago, Chile, 2013).

MATHIAS KLOTZ est né en 1965 à Viña del Mar, au Chili. Il a obtenu son diplôme d'architecture à l'Université catholique pontificale du Chili (UC) en 1991 et a créé son agence à Santiago la même année. Il a enseigné dans plusieurs universités chiliennes et a dirigé l'École d'architecture de l'université Diego Portales de Santiago (2001–03) dont il est le doyen depuis 2004. Ses réalisations comptent la maison Viejo à Santiago de Chile (2001–02) ; la maison 11 Mujeres (Cachagua, 2007) ; la maison Raul (Aculeo, 2007) ; la maison Bitran (Cachagua, 2010), le tout au Chili ; la Casa L (2011) et le service de la construction de San Isidro (les deux aux Buenos Aires, Argentine, 2011–12). Le bâtiment Vitacura 3565 (Santiago, 2011–12, publié ici) a été conçu en collaboration avec **ALVANO & RIQUELME**, agence fondée en 2003 par Renzo Alvano et Pablo Riquelme, anciens membres de son cabinet. Parmi ses autres projets récents figurent le bâtiment Soda Haus (Buenos Aires, Argentine, 2013) et la maison Perez Maggi (Santiago, Chili, 2013).

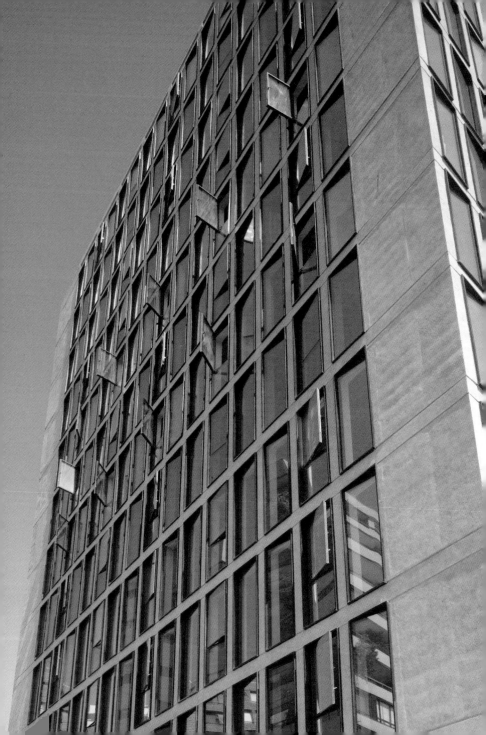

VITACURA 3565

Santiago, Chile, 2011–12

Area: 7298 m². Client: Sur Invest. Cost: $4 million.

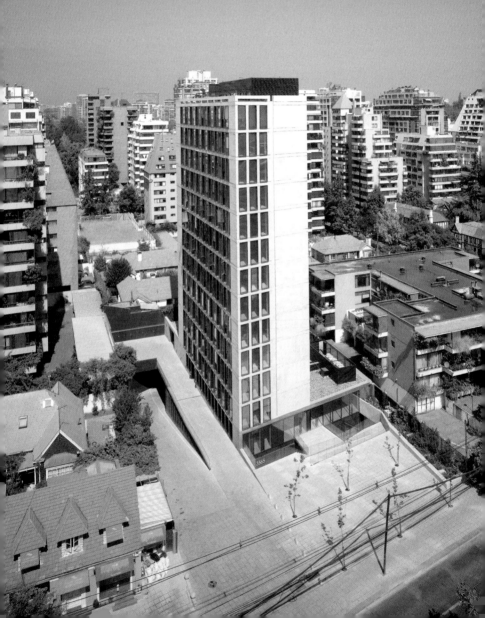

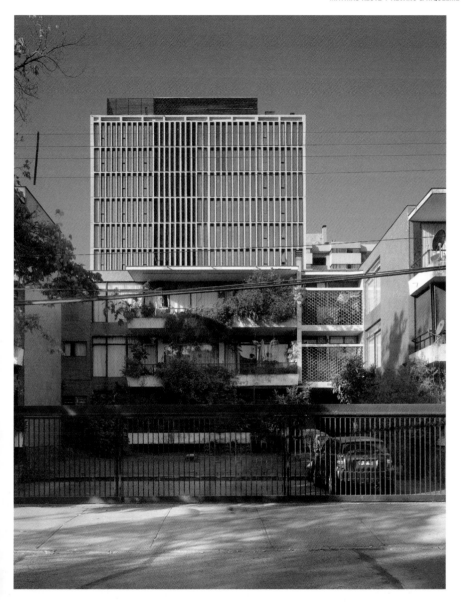

The slim, elegant silhouette of the building stands out against its neighborhood (left). Verticality is stressed by the form of the windows as seen in the image above.

Die schlanke, elegante Silhouette des Gebäudes hebt sich von seiner Nachbarschaft ab (links). Die Vertikalität wird durch die Form der Fenster betont, wie die obere Abbildung zeigt.

La silhouette svelte et élégante du bâtiment se détache nettement de son voisinage (à gauche). La verticalité en est encore soulignée par la forme des fenêtres ci-dessus.

Designed by Mathias Klotz with Renzo Alvano and Pablo Riquelme (former members of his studio), the tower **VITACURA 3565** was originally intended as a hotel, until the investors decided offices would be a better option. The architects explain that the main challenge of the project was to make the materials for the structure and finishes match, and to maximize the efficiency of each floor, thus minimizing the cost of construction. They explain: "Fortunately, the regulations obliged us to build a very deep and narrow building set apart from its neighbors, a characteristic we sought to exaggerate in the design, dividing the volume in two and treating the façades differently with the aim of optimizing their design in relation to their orientation."

Dieses von Mathias Klotz in Zusammenarbeit mit Renzo Alvano und Pablo Riquelme (früheren Mitarbeitern seines Büros) geplante Hochhaus **VITACURA 3565** war ursprünglich als Hotel gedacht, bevor die Investoren Büros für eine bessere Option hielten. Die Architekten erläutern, dass die große Herausforderung bei diesem Projekt darin bestand, die Materialien für Tragwerk und Außengestaltung passend zu machen sowie die Effizienz jedes Geschosses zu erhöhen und dadurch die Baukosten zu senken. Sie erklären: „Glücklicherweise zwangen die Bauvorschriften uns, ein sehr tiefes und schmales Gebäude mit Abstand zu seinen Nachbarn zu errichten. Wir versuchten, diese charakteristischen Elemente im Entwurf hervorzuheben, indem wir die Baumasse in zwei Volumen aufteilten und die Fassaden unterschiedlich behandelten mit dem Ziel, ihre Gestaltung mit Bezug auf ihre Orientierung zu optimieren."

La tour **VITACURA 3565**, conçue par Mathias Klotz en collaboration avec Renzo Alvano et Pablo Riquelme (anciens membres de son agence), devait au départ être un hôtel, jusqu'à ce que les investisseurs préfèrent l'option des bureaux. Les architectes expliquent que le principal enjeu a consisté à assortir les matériaux de la structure et des finitions et à optimiser l'efficacité de chaque étage afin de minimiser les coûts de construction. Ils racontent : « Par chance, nous avons été contraints par le règlement en vigueur de construire un bâtiment très profond et étroit à l'écart des immeubles voisins, et nous avons cherché à exacerber cette caractéristique dans notre design en divisant le volume en deux et traitant chaque façade différemment afin d'optimiser leur design par rapport à leur orientation. »

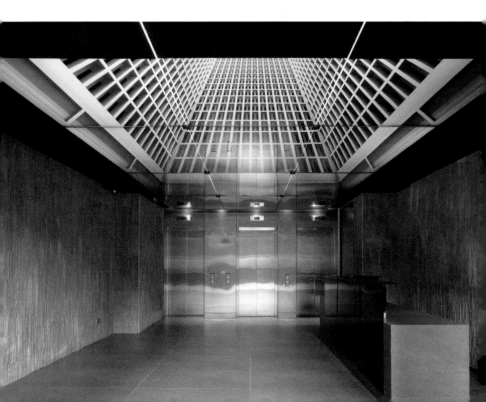

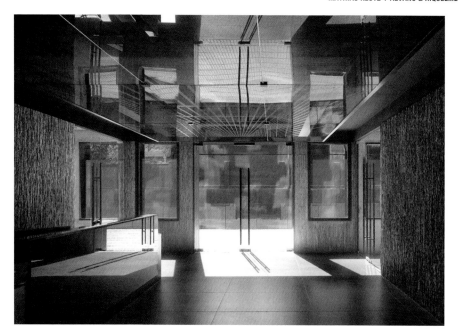

The strict, classic lines of the exterior are echoed in the interior design where concrete, stone, black metal window frames, and glazing are present.

Die strengen, klassischen Linien der Außenform wiederholen sich im Inneren, wo Beton, Naturstein, Fensterrahmen aus schwarzem Metall und Glas präsent sind.

Les lignes classiques et rigoureuses de l'extérieur trouvent un écho dans l'architecture intérieure avec la présence de béton, de pierre, de cadres de fenêtres en métal noir et de verre.

KSP JÜRGEN ENGEL

JÜRGEN ENGEL was born in 1954. He studied at the Technische Universität of Braunschweig, the ETH in Zurich, the Rheinisch-Westfälische Technische Hochschule in Aachen (1974–80), and at MIT (1980–82). He worked as Head of the office of O.M. Ungers in Frankfurt/Main (1986–89), before cofounding KSP in 1990. The firm currently has approximately 200 employees and seven branch offices. They offer general contract management, urban design, consulting, and product development. They completed the Dorma Headquarters in Ennepetal (2001–04); Philips Headquarters in Hamburg (2002–05); the WestendDuo in Frankfurt am Main (2001–06); and the Bergen-Belsen Documentation and Information Center (Celle, 2005–07, published here), all in Germany. More recent work includes the Neue Burg Residential Complex (Wolfsburg, 2011); the Abest Headquarters (Beijing, China, 2011); a medical clinic in Freiburg (2012); and an office building on the Boulevard Grande Duchesse Charlotte (Luxembourg, 2013), all in Germany unless stated otherwise. They are currently wor on the Great Mosque in Algiers (2015); and the firm won first prize in the design competition for the Air China Blue Sky Tower (Chengdu, China, 2012).

JÜRGEN ENGEL, geboren 1954, studierte an der Technischen Universität Braunschweig, der ETH in Zürich, der Rheinisch-Westfälischen Technischen Hochschule Aachen (1974–80) und am Massachusetts Institute of Technology (1980–82). Von 1986 bis 1989 war Engel Büroleiter bei O. M. Ungers in Frankfurt am Main, im Anschluss war er 1990 Mitgründer von KSP. Gegenwärtig beschäftigt das Unternehmen 200 Mitarbeiter in sieben Niederlassungen. Neben den traditionelleren Aufgaben der Gebäudeplanung bietet das Büro auch allgemeine baubegleitende Dienstleistungen, Stadtplanung, Consulting und Produktdesign an. Von KSP stammen die Zentrale der Firma Dorma in Ennepetal (2001–04), der Philips-Standort Hamburg (2002–05), das WestendDuo in Frankfurt am Main (2001–06) und das hier vorgestellte Dokumentations- und Informationszentrum für die Gedenkstätte Bergen-Belsen (Kreis Celle, 2005–07). Zu den neueren Bauten zählen die Wohnanlage Neue Burg (Wolfsburg, 2011), der Hauptsitz von Abest (Peking, China, 2011), eine Klinik in Freiburg (2012) und ein Bürogebäude am Boulevard Grande Duchesse Charlotte (Luxemburg, 2013), alle in Deutschland, soweit nicht anders vermerkt. Gegenwärtig arbeitet KSP an der Großen Moschee in Algier (2015) und gewann den ersten Preis im Wettbewerb für den Air China Blue Sky Tower (Chengdu, China, 2012).

JÜRGEN ENGEL est né en 1954. Il a étudié à la Technische Universität de Braunschweig, à l'ETH de Zurich, à la Rheinisch-Westfälische Technische Hochschule à Aix-la-Chapelle (1974–80) et au MIT (1980–82). Il a dirigé l'agence de O. M. Ungers à Francfort sur le Main (1986–89), avant de créer KSP Partnership en 1990. Leur agence compte actuellement environ 200 collaborateurs et sept agences filiales. En dehors des interventions classiques d'architecture, l'agence propose celles de gestion de chantiers, d'urbanisme, de conseil et de développement de produits. Elle a réalisé le siège social de Dorma à Ennepetal (2001–04); le siège de Philips à Hambourg (2002–05); le WestendDuo à Francfort-sur-le-Main (2001–06) et le Centre de documentation et d'information de Bergen-Belsen (Celle, 2005–07, publié ici), tous en Allemagne. Ses réalisations plus récentes comprennent le complexe résidentiel Neue Burg (Wolfsburg, 2011); le siège d'Abest (Pékin, Chine, 2011); une clinique à Fribourg en Brisgau (2012) et un immeuble de bureaux sur le boulevard Grande Duchesse Charlotte (Luxembourg, 2013), toutes en Allemagne sauf si spécifié. L'agence travaille actuellement à la grande mosquée d'Alger (2015) et a gagné le premier prix du concours pour la tour Blue Sky d'Air China (Chengdu, Chine, 2012).

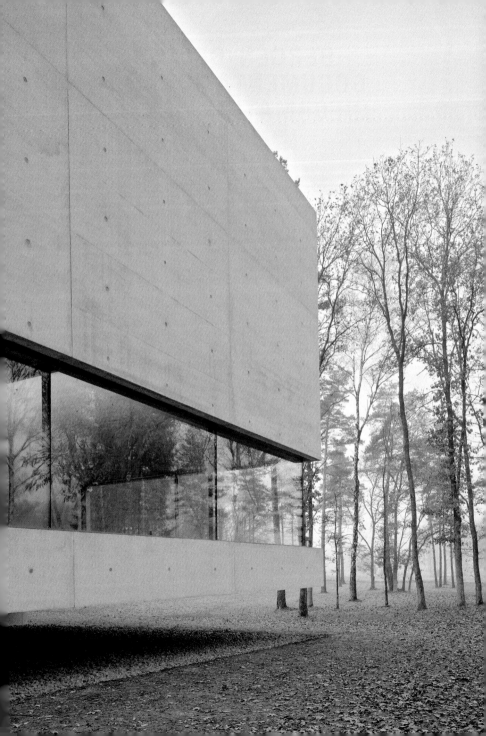

BERGEN-BELSEN DOCUMENTATION AND INFORMATION CENTER

Celle, Germany, 2005–07

Floor area: 3300 m². Client: Lower Saxony Monument Foundation.
Cost: €9 million. Collaboration: Ulrich Gremmelspacher, Michael Reitt, Konstanze Beelitz, Ilonner Winkelmüller, Hermann Timpe, Alexander Gelhorn, Volker Ziro; sinai – Faust.Schroll.Schwarz, Berlin (Landscape Architect); Hans Dieter Schaal, Attenweiler (Exhibition Design); Wetzel & von Seht, Hamburg (Structural Engineering).

Bergen-Belsen was a Nazi concentration and prisoner-of-war camp, southwest of the town of Bergen near Celle, where more than 70 000 people, including Anne Frank, lost their lives. The new **DOCUMENTATION AND INFORMATION CENTER BERGEN-BELSEN** is a two-story building, 18 meters wide and 200 meters long. The architects write that the building, "stringently structured in terms of function, lies like a dynamically extended walk-in sculpture in the forest on the edge of the former concentration camp. Its extraordinary cubature, the radical limitation to just a few monochrome materials, the lack of any detailed ornamentation, as well as the physical presence of the large shape with minimalist recesses and openings, merge into a powerful, meaningful piece of architecture." The design is conceived in terms of two paths: one, leading through the building, rises gently through the exhibition areas leading to a broad window that marks the front of the building. The second route, called the "stony path," leads through the length of the structure without any entry. Past a central courtyard, visitors are confronted with high concrete walls where the path opens to the actual grounds of the camp. The edge of the building is markedly cantilevered over the ground, beginning at the boundary of the former camp, as the architects explain, "out of respect for this place," because the former grounds of the camp are today a cemetery.

Im Konzentrationslager Bergen-Belsen, südwestlich von Bergen in der Nähe des niedersächsischen Celle, kamen mehr als 70 000 Menschen ums Leben, unter ihnen auch Anne Frank. Das neue **DOKUMENTATIONS- UND INFORMATIONSZENTRUM BERGEN-BELSEN** ist ein zweigeschossiges, 200 m langes und 18 m breites Gebäude. Die Architekten erläutern den Gebäudeaufbau wie folgt: „Der streng funktional gegliederte Bau liegt wie eine dynamisch gestreckte, begehbare Skulptur mitten im Wald am Rand des ehemaligen Konzentrationslagers. Seine außergewöhnliche Kubatur, die radikale Beschränkung auf wenige, monochrome Materialien, der Verzicht auf besondere Detailausbildungen sowie die physische Präsenz der großen Form mit minimalistischen Einschnitten und Öffnungen verdichten sich zu einer kraftvollen, aussagestarken Architektur." Der Bau erschließt sich über zwei Wege: Der eine führt sacht ansteigend in das Gebäude hinein und durch die Ausstellungsbereiche bis zu einem großen Fenster an der Stirnseite. Der andere, sogenannte steinerne Weg leitet die Besucher quer durch den Bau hindurch, ohne ins Gebäudeinnere hineinzuführen. Hinter einem zentralen Hof werden die Besucher mit hohen Betonwänden konfrontiert, wo der Pfad auf das ehemalige Lagergelände führt. An dieser Stelle, die die ehemalige Lagergrenze markiert, kragt das Gebäude über dem Boden aus, „aus Respekt vor dem Ort", wie die Architekten erklären. Heute befindet sich hier ein Friedhof.

Bergen-Belsen fut un camp de concentration nazi, au sud-ouest de la ville de Bergen près de Celle. Plus de 70 000 personnes, dont Anne Frank, y trouvèrent la mort. Le nouveau **CENTRE DE DOCUMENTATION ET D'INFORMATION BERGEN-BELSEN** est un bâtiment de deux niveaux, 18 m de large et 200 m de long. Les architectes décrivent ainsi leur projet : « Rigoureusement structuré en termes de fonctions, il se développe comme une sculpture pénétrable dynamique au milieu d'une forêt, à la limite de l'ancien camp de concentration. Son extraordinaire volume, sa limitation radicale à simplement quelques matériaux monochromes, l'absence de tout détail ornemental ainsi que la présence physique de cette grande forme aux retraits et ouvertures minimalistes, donnent naissance à une œuvre architecturale puissante et significative. » La conception repose sur deux cheminements : l'un, traversant le bâtiment, passe par les salles d'expositions pour aboutir à une grande baie donnant sur le camp, l'autre, appelé « le chemin pierreux » conduit les visiteurs à marcher le long du Centre, sans y entrer. Au-delà de la cour centrale, ils sont confrontés à de hauts murs de béton avant d'arriver au camp lui-même. L'extrémité du bâtiment décrit un grand porte-à-faux pour ne pas toucher à la limite du camp « par respect du lieu » car l'ancien camp est aujourd'hui considéré comme un cimetière.

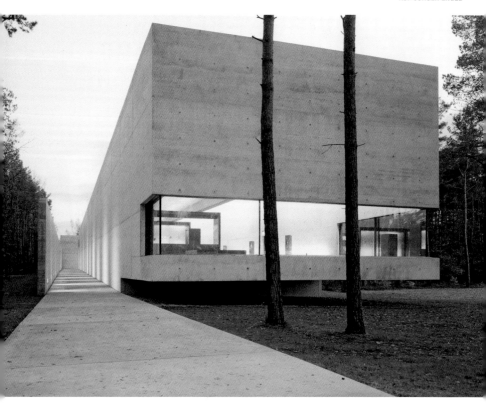

The unadorned concrete of the
structure contrasts with a band
of sober windows. Set low in the
cantilevered volume seen above,
these windows do little to alleviate
a willful impression of heaviness.

*Ein nüchternes Fensterband
kontrastiert mit dem schmucklosen
Beton des Bauwerks. Die in dem
auskragenden Gebäudeteil tief
angebrachten Fenster (Abbildung
oben) mildern den gewünschten
Eindruck der Schwere kaum ab.*

*Le béton nu du bâtiment contraste
avec le sobre bandeau des fenêtres.
Ouvertes en partie basse du
volume en porte-à-faux (ci-dessus),
ces baies n'allègent qu'à peine
l'impression voulue de lourdeur.*

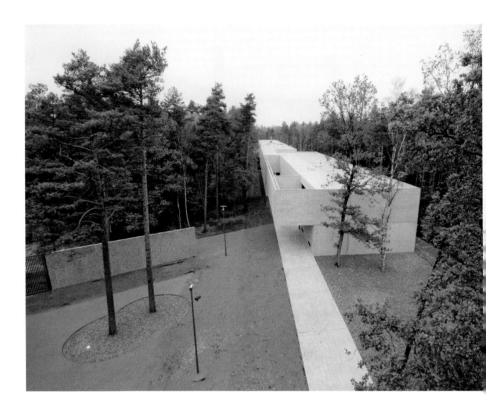

The powerful axial design of the "stony path" that leads past the building and into the former camp grounds heightens the understand-ing that this location was the stage for events that should never occur again.

Die imposante axiale Anlage des „steinernen Wegs", der bis auf den ehemaligen Lagerplatz führt, vermittelt eindringlich, dass man sich an dem einstigen Schauplatz von Geschehnissen befindet, die sich niemals wiederholen dürfen.

L'axe puissant tracé par le « chemin pierreux », qui longe le bâtiment pour conduire à l'ancien camp, contribue vivement à l'évocation de ce lieu comme théâtre d'événements qui ne doivent jamais se reproduire.

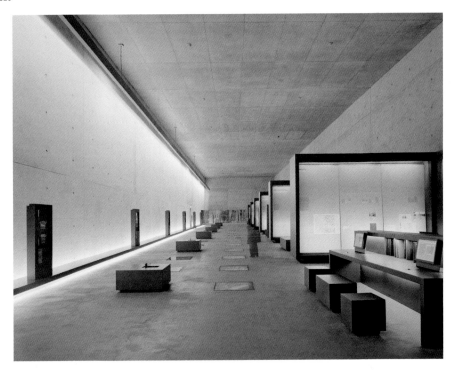

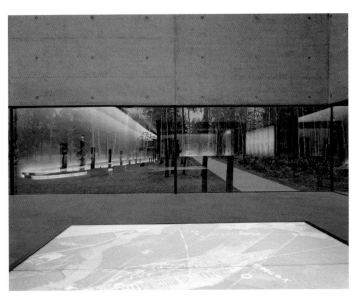

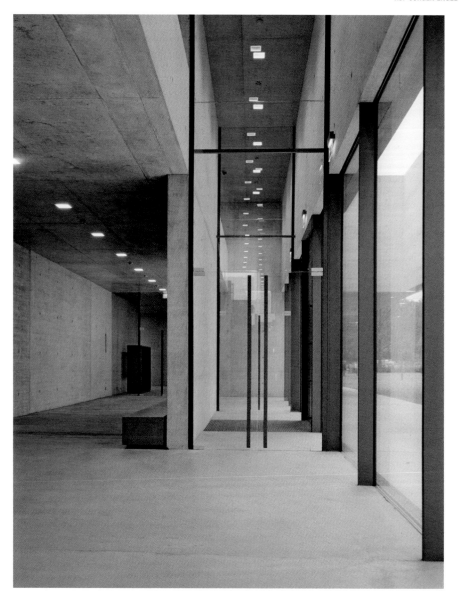

The very sober design of the building is continued in the interiors—dark metal, glass, and concrete dominate the palette of materials.

Der äußerst sachliche Charakter des Gebäudes setzt sich im Innenbereich fort – dunkles Metall, Glas und Beton sind die dominierenden Materialien.

La très sobre conception du bâtiment se retrouve à l'intérieur. Le métal sombre, le verre et le béton dominent la palette des matériaux.

MARTE.MARTE

BERNHARD MARTE was born in 1966 in Dornbirn, Vorarlberg, Austria, and his brother, **STEFAN MARTE**, was born in the same locality in 1967. They obtained their M.Arch degrees from the Technical University of Innsbruck. Stefan Marte worked in the office of Gohm + Hiessberger in Feldkirch until Marte.Marte was created in Weiler in 1993. Their work includes the Schanerloch Bridge (Dornbirn, 2005, published here); State Pathology Hospital (Feldkirch, 2003–08); Alfenz Bridge (Lorüns, 2009–10); Grieskirchen School Center (Grieskirchen, 2003–11); Special Pedagogical Center (Dornbirn, 2008–11); Kärnten Diocesan Museum (Fresach, 2010–11); Mountain Cabin in the Laternser Valley (Laterns, 2010–11); Maiden Tower (Dafins, 2011–12); and a tourism school (Villach, 2011–13), all in Austria.

BERNHARD MARTE wurde 1966 in Dornbirn im österreichischen Vorarlberg geboren, sein Bruder **STEFAN MARTE** 1967 im selben Ort. Sie machten ihren M. Arch. an der Technischen Universität Innsbruck. Stefan Marte arbeitete im Büro Gohm + Hiessberger in Feldkirch, bis sie beide 1993 Marte.Marte in Weiler gründeten. Zu ihren ausgeführten Bauten zählen: die Schanerloch-Brücke (Dornbirn, 2005, hier vorgestellt), das Pathologie-Gebäude des Landeskranken-hauses in Feldkirch (2003–08), die Alfenz-Brücke (Lorüns, 2009–10), das Schulzentrum Grieskirchen (Grieskirchen, 2003–11), ein Sonderschulzentrum (Dornbirn, 2008–11), das Kärntner Diözesanmuseum (Fresach, 2010–11), eine Berghütte im Laternser Tal (Laterns, 2010–11), der Mädchenturm (Dafins, 2011–12) und eine Tourismusschule (Villach, 2011–13), alle in Österreich.

BERNHARD MARTE est né en 1966 à Dornbirn, dans le Vorarlberg (Autriche), ainsi que son frère **STEFAN MARTE** en 1967. Ils sont tous les deux titulaires d'un M.Arch. de l'Université technique d'Innsbruck. Stefan Marte a travaillé dans l'agence Gohm + Hiessberger à Feldkirch avant la création de Marte.Marte à Weiler en 1993. Leurs réalisations comprennent le pont de Schanerloch (Dornbirn, 2005, publié ici) ; l'hôpital régional de pathologie (Feldkirch, 2003–08) ; le pont d'Alfenz (Lorüns, 2009–10) ; le Centre scolaire de Grieskirchen (2003–11) ; le Centre pédagogique spécial (Dornbirn, 2008–11) ; le Musée diocésain de Carinthie (Fresach, 2010–11) ; un refuge de montagne dans la vallée de Laterns (Laterns, 2010–11) ; la Maiden Tower (Dafins, 2011–12) et une école de tourisme (Villach, 2011–13), toutes en Autriche.

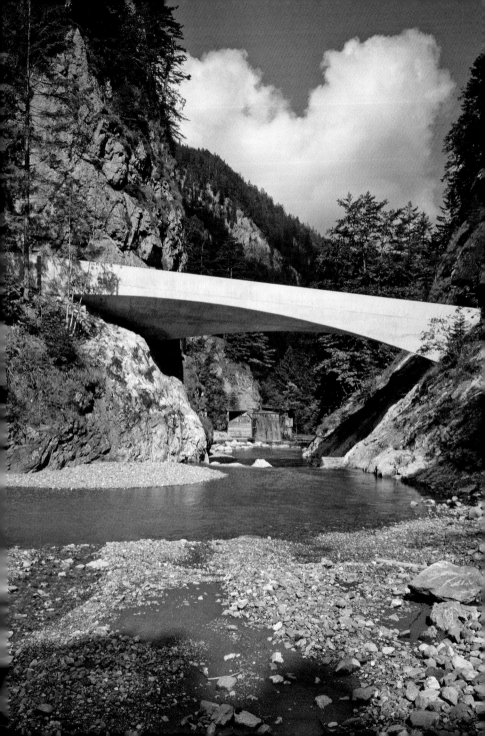

SCHANERLOCH BRIDGE

Dornbirn, Austria, 2005

Area: 23 m (length). Client: City of Dornbirn.
Cost: €220 000.

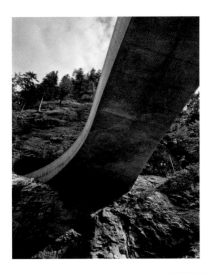

With a minimum thickness of just 35 centimeters, this bridge crosses the **SCHANERLOCH** gorge. The architects explain: "The spectacular route to this ancient settlement area is characterized by a series of natural rock tunnels and stone bridges... The reduction of the arch rise to a statically necessary minimum is combined with a twist along one axis... The result is a concrete sculpture that might look unspectacular in plan and from the driver's point of view, but from the shore of the river winding through the gorge it unveils its compelling fascination: it playfully mimes the frozen dynamic of the mountain road and captures the dramatic place in reinforced concrete." Although they present themselves as architects, Marte.Marte achieve a feat of engineering here and demonstrate the flexibility and potential of concrete in bridge design.

Diese Brücke mit einer minimalen Stärke von nur 35 cm überquert die **SCHANERLOCH**-Schlucht. Die Architekten erläutern: „Die spektakuläre Straße zu dieser frühen Ansiedlung kennzeichnen mehrere natürliche Felstunnel und steinerne Brücken ... Die Reduktion der Bogenstichhöhe auf das statisch unverzichtbare Minimum wurde verbunden mit einer Drehung entlang der Achse ... Das Ergebnis ist eine Betonskulptur, die auf dem Plan und aus der Sicht des Fahrers unspektakulär aussehen mag, aber sich vom Flussufer durch die Schlucht windet und ihre außergewöhnliche Faszination auslöst. Spielerisch nimmt sie die erstarrte Dynamik der Bergstraße auf und fasst den dramatischen Ort in Stahlbeton." Obgleich Marte.Marte sich selbst als Architekten bezeichnen, erreichen sie hier eine ingenieurtechnische Höchstleistung und demonstrieren die Flexibilität und das Potenzial des Betons in der Brückengestaltung.

Ce pont d'une épaisseur minimale d'à peine 35 cm traverse les gorges de **SCHANERLOCH**. Les architectes racontent : « La route spectaculaire qui mène à cette ancienne zone de peuplement est marquée par une série de tunnels rocheux naturels et ponts de pierre... La réduction de la hauteur de l'arche à un minimum statiquement nécessaire est associée à une torsion le long d'un axe... Il en résulte une sculpture en béton sans rien d'exceptionnel en apparence au vu du plan et pour les automobilistes, mais qui dévoile une incontestable fascination depuis la berge de la rivière qui serpente dans la gorge : il imite de manière ludique la dynamique pétrifiée de la route montagneuse et enferme ce lieu extraordinaire dans le béton armé. » Bien qu'ils se présentent comme architectes, Marte.Marte a ici réalisé un exploit d'ingénieur et démontré la souplesse et le potentiel du béton pour la construction de ponts.

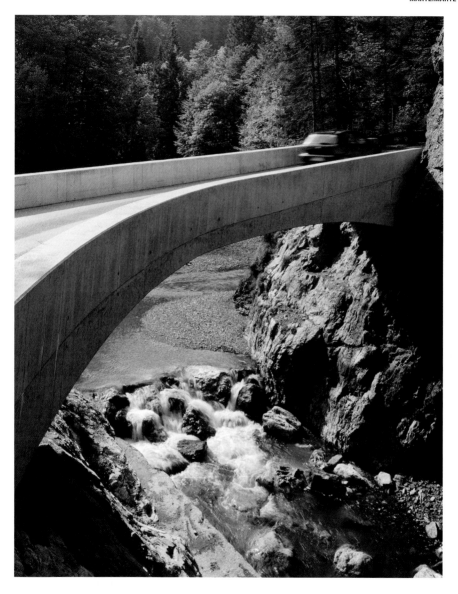

The remarkable "flexibility" of concrete designs is demonstrated in this thin curving bridge that arches above the stream without any apparent means of physical support.

Die bemerkenswerte „Flexibilität" von Betonkonstruktionen demonstriert diese dünne, gebogene Brücke, die ohne erkennbare tragende Elemente über den Fluss führt.

Ce pont fin qui infléchit ses courbes au-dessus de la rivière sans aucun support physique apparent apporte la preuve de la remarquable « souplesse » du béton.

RICHARD MEIER

RICHARD MEIER was born in Newark, New Jersey, in 1934. He received his architectural training at Cornell University, and worked in the office of Marcel Breuer (1960–63), before establishing his own practice in 1963. In 1984, he became the youngest winner of the Pritzker Prize, and he received the 1988 RIBA Gold Medal. His notable buildings include the Atheneum (New Harmony, Indiana, USA, 1975–79); High Museum of Art (Atlanta, Georgia, USA, 1980–83); Museum of Decorative Arts (Frankfurt, Germany, 1979–84); Canal Plus Headquarters (Paris, France, 1988–91); Barcelona Museum of Contemporary Art (Barcelona, Spain, 1988–95); City Hall and Library (The Hague, the Netherlands, 1990–95); and the Getty Center (Los Angeles, California, USA, 1984–97). Recent work includes the US Courthouse and Federal Building (Phoenix, Arizona, USA, 1995–2000); Jubilee Church (Rome, Italy, 1996–2003, published here); Ara Pacis Museum (Rome, Italy, 1995–2006); 165 Charles Street (New York, USA, 2003–06); and the Arp Museum (Rolandseck, Germany, 1997–2007). More recently he has completed the ECM City Tower (Pankrác, Prague, Czech Republic, 2001–08); US Courthouse (San Diego, California, USA, 2003–13); the Rothschild Tower (Tel Aviv, Israel, 2007–14); and the Leblon Offices (Rio de Janeiro, Brazil, 2011–14).

RICHARD MEIER wurde 1934 in Newark, New Jersey, geboren. Er absolvierte sein Architekturstudium an der Cornell University und arbeitete im Büro von Marcel Breuer (1960–63), bevor er 1963 seine eigene Firma gründete. 1984 war er der bis dato jüngste Empfänger des Pritzker-Preises, 1988 erhielt er die RIBA-Goldmedaille. Zu seinen wichtigsten Projekten gehören das Atheneum (New Harmony, Indiana, USA, 1975–79), das High Museum of Art (Atlanta, Georgia, USA, 1980–83), das Museum für Angewandte Kunst (Frankfurt am Main, Deutschland, 1979–84), der Hauptsitz von Canal Plus (Paris, Frankreich, 1988–91), das Museum für zeitgenössische Kunst MACBA (Barcelona, Spanien, 1988–95), Rathaus und Bibliothek in Den Haag (Niederlande, 1990–95) sowie das Getty Center (Los Angeles, Kalifornien, USA, 1984–97). Jüngere Arbeiten sind u. a. das US Courthouse and Federal Building in Phoenix (Arizona, USA, 1995–2000), die Jubiläumskirche (Rom, Italien, 1996–2003, hier vorgestellt), das Ara-Pacis-Museum (Rom, Italien, 1995–2006), 165 Charles Street (New York, USA, 2003–06) und das Arp Museum (Rolandseck, Deutschland, 1997–2007). In der jüngeren Vergangenheit abgeschlossene Projekte sind der ECM City Tower (Pankrác, Prag, Tschechien, 2001–08), das US Courthouse (San Diego, Kalifornien, USA, 2003–13), der Rothschild Tower (Tel Aviv, Israel, 2007–14) und die Leblon Büros (Rio de Janeiro, Brasilien, 2011–14).

RICHARD MEIER est né à Newark, New Jersey, en 1934. Il fait ses études d'architecture à l'université Cornell et travaille dans le bureau de Marcel Breuer (1960–63) avant d'ouvrir son agence en 1963. En 1984, il devient le plus jeune récipiendaire du prix Pritzker et reçoit la médaille d'or du RIBA en 1988. Ses bâtiments les plus remarquables sont l'Atheneum (New Harmony, Indiana, États-Unis, 1975–79) ; le High Museum of Art (Atlanta, Georgie, 1980–83) ; le Musée des arts décoratifs (Francfort, Allemagne, 1979–84) ; le siège de Canal+ (Paris, France, 1988–91) ; le Musée d'art contemporain de Barcelone (Barcelone, 1988–95) ; l'hôtel de ville et la bibliothèque de La Haye (Pays-Bas, 1990–95) et le Getty Center (Los Angeles, Californie, 1984–97). Les réalisations plus récents comprennent le Palais de justice et bâtiment fédéral de Phoenix (Arizona, 1995–2000) ; l'église du Jubilé (Rome, Italie, 1996–2003, présenté ici) ; le musée de l'Ara Pacis (Rome, Italie, 1995–2006) ; 165 Charles Street (New York, 2003–06) et le Arp Museum (Rolandseck, Allemagne, 1997–2007). Plus récemment, il a achevé la tour ECM (Pankrác, Prague, Czechia, 2001–08) ; le Palais de justice américain (San Diego, Californie, 2003–13) ; la tour Rothschild (Tel Aviv, Israel, 2007–14) et les bureaux Leblon (Rio de Janeiro, Brésil, 2011–14).

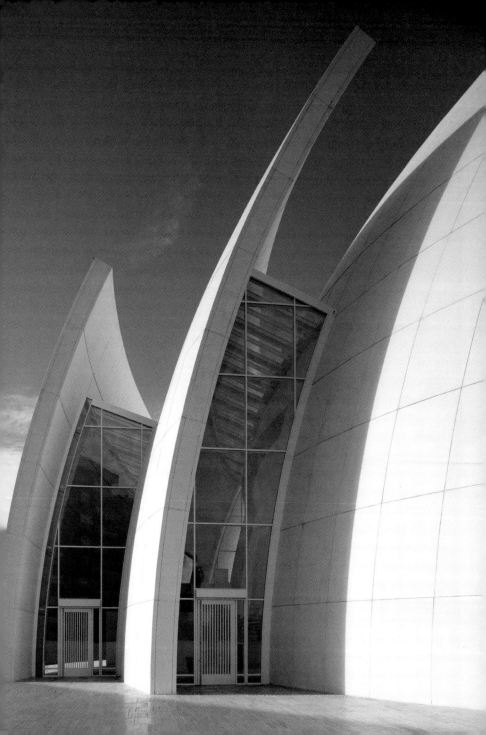

JUBILEE CHURCH

(Dio Padre Misericordioso), Tor Tre Teste, Rome, Italy, 1996–2003

Floor area: 830 m² (church), 1450 m² (community center), 10 000 m² (site).
Client: Vicariato of Rome.

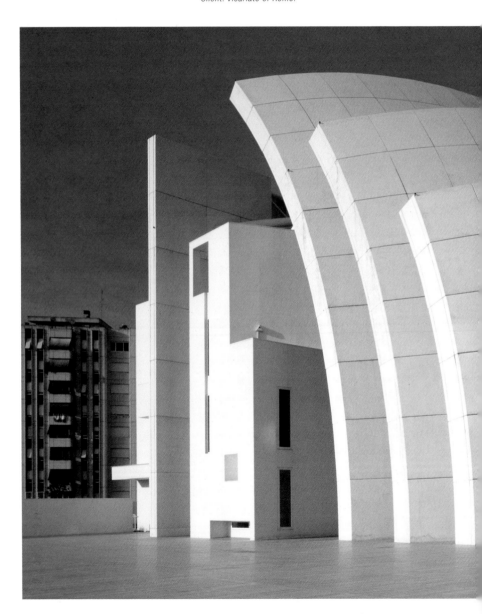

The photo shows the successive shells that form the most visible exterior aspect of the design. The person passing in front shows that the scale of the building is quite reasonable.

Das Foto zeigt die aneinandergereihten Schalen, die den äußeren Eindruck des Gebäudes maßgeblich bestimmen. Die Person im Vordergrund beweist, dass das Gebäude nicht überdimensioniert ist.

La photo montre les coques successives qui forment l'aspect extérieur le plus visible de l'ensemble. Le passant devant le bâtiment prouve que l'échelle reste raisonnable.

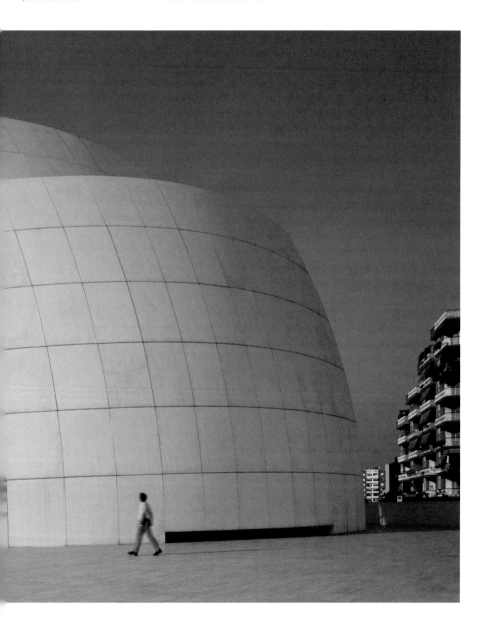

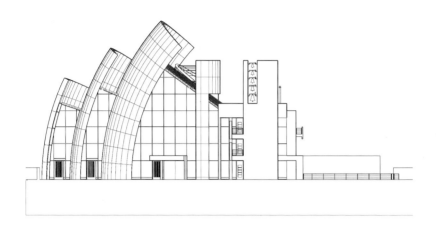

Combining his trademark white tile surfaces with large curving forms, Richard Meier renews the often rectilinear or purely circular vocabulary that he is best known for.

Durch die Verbindung seiner für ihn typischen, weiß gefliesten Flächen mit großen, gekrümmten Formen erneuert Richard Meier sein häufig geradliniges oder kreisförmiges Vokabular, für das er bekannt ist.

Avec l'association des surfaces recouvertes de carreaux blancs qui sont sa marque de fabrique et des vastes courbes, Richard Meier renouvelle le langage souvent rectiligne ou purement circulaire pour lequel il est surtout connu.

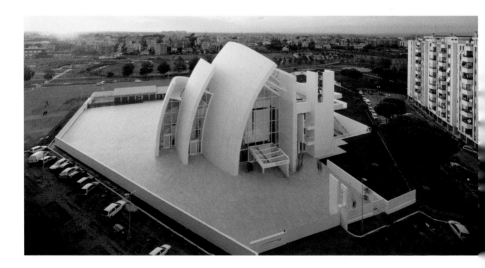

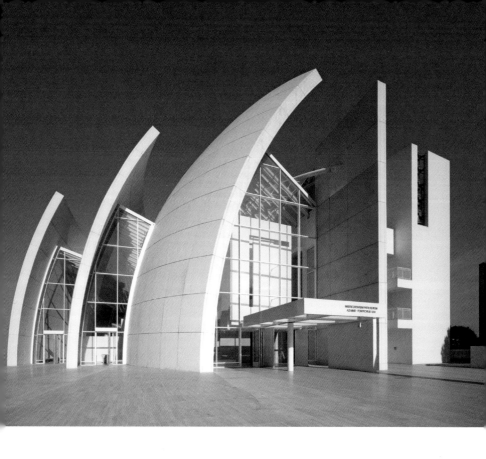

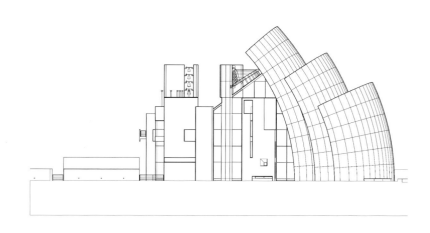

Commissioned by the Vicariato of Rome, this church is set on a triangular site on the boundary of a public park surrounded by 10-story apartment buildings in a community of approximately 30 000 residents. Using concrete, stucco, travertine, and glass, the project features three dramatic shells or arcs that evoke billowing white sails. Unprecedented in Meier's work, the concrete arcs are graduated in height from 17 to 27 meters. Construction began in 1998, and although the architect has designed the Hartford Seminary in Connecticut (1981) and the International Center for Possibility Thinking at the Crystal Cathedral in Southern California (2003), this was his first church. As always, Richard Meier places an emphasis on light. "Light is the protagonist of our understanding and reading of space. Light is the means by which we are able to experience what we call sacred. Light is at the origins of this building," he says. Commenting on the fact that he may be the first Jewish architect asked to design a Catholic church, Meier says, "I feel extremely proud that I was the one chosen to design this church. It is very clear that the Catholic Church chose my design based on its merits, not because of a need to make a statement in regard to their relationship to Jews throughout history. Three of the architects in the competition were Jewish. They were chosen to compete because they were among the top architects of our time." His sources of inspiration, he says, were "the churches in which the presence of the sacred could be felt: Alvar Aalto's churches in Finland, Lloyd Wright's Wayfarer's Chapel in the United States along with the Chapel at Ronchamp and La Tourette by Le Corbusier." The **JUBILEE CHURCH** was inaugurated on October 26, 2003, to mark the 25th anniversary of the Pontificate of John Paul II.

Die vom Vicariato in Rom in Auftrag gegebene Jubiläumskirche gehört zu einer Gemeinde mit ca. 30 000 Einwohnern. Sie steht auf einem dreiseitigen Grundstück am Rand eines öffentlichen Parks und ist von zehnstöckigen Wohnblocks umgeben. Ein besonderes Gestaltungsmerkmal des mit Beton, Gipsputz, Travertin und Glas ausgestatteten Bauwerks sind drei dramatisch geformte Halbschalen, die an Segel denken lassen, die sich im Wind blähen. Diese in Meiers Werk neuen Betonformen sind der Höhe nach von 17 bis 27 m gestaffelt. Mit den Bauarbeiten wurde 1998 begonnen, und obwohl der Architekt zuvor das Hartford Priesterseminar in Connecticut (1981) und das International Center for Possibility Thinking der Crystal Cathedral in Südkalifornien (2003) geplant hatte, ist dies sein erster Sakralbau. Wie immer hebt Richard Meier in seinem Entwurf speziell das Licht hervor: „Licht ist der Träger unseres Verständnisses und unserer Auffassung von Raum. Das Licht ist das Medium, durch welches wir das erleben können, was wir heilig nennen. Licht ist der Ursprung dieses Gebäudes." Zu der Tatsache, dass er vermutlich der erste jüdische Architekt ist, der mit der Gestaltung einer katholischen Kirche betraut wurde, sagt Meier: „Ich bin ungeheuer stolz darauf, dass ich ausgewählt wurde, um diese Kirche zu entwerfen. Dabei ist ganz klar, dass die katholische Kirche meinen Entwurf aufgrund seiner Vorzüge wählte, und nicht weil sie eine Aussage über ihr Verhältnis zu Juden machen wollte. Drei der Architekten des Wettbewerbs sind jüdisch. Sie wurden zu dem Wettbewerb eingeladen, weil sie zu den besten Architekten unserer Zeit gehören." Seine Inspirationsquelle, erläutert Meier, waren „Kirchen, in denen man die Präsenz des Heiligen fühlen kann: Alvar Aaltos Kirchen in Finnland, Lloyd Wrights Wayfarer's Chapel in den USA und die Wallfahrtskirche zu Ronchamp sowie das Kloster La Tourette von Le Corbusier." Die **JUBILÄUMSKIRCHE** wurde zur Feier des 25-jährigen Pontifikats von Johannes Paul II. am 26. Oktober 2003 eingeweiht.

L'église est implantée sur un terrain triangulaire en bordure d'un parc public entouré d'immeubles de logements de 10 étages dans un ensemble qui compte environ 30 000 résidents. Le projet qui fait appel au béton, au stuc, au travertin et au verre se caractérise par trois coques ou arcs spectaculaires qui évoquent des voiles blanches et gonflées. Motif sans précédent dans l'œuvre de Meier, ces arcs de béton s'étagent de 17 à 27 m. C'était son premier projet d'église même s'il avait déjà conçu le séminaire de Hartford (Connecticut, 1981) puis l'International Center for Possibility Thinking de la Crystal Cathedral (Californie du Sud, 2003). Le chantier débuta en 1998. Comme toujours, Meier a mis l'accent sur la lumière : « La lumière est le protagoniste qui nous fait comprendre et lire l'espace. La lumière est le moyen par lequel nous sommes en mesure de faire l'expérience de ce que nous appelons le sacré. La lumière est à l'origine de ce projet. » Commentant le fait qu'il est peut-être le premier architecte juif à concevoir une église, il ajoute : « Je me sens extrêmement fier d'avoir été choisi… il est clair que l'Église catholique a retenu mon projet pour ses mérites, et non pas pour marquer une position par rapport à sa relation avec les Juifs au cours de l'histoire. Trois des architectes invités étaient juifs. Ils avaient été sélectionnés parce qu'ils faisaient partie des tout premiers architectes de notre temps. » Ses sources d'inspiration ont été « des églises dans lesquelles ont peut sentir la présence du sacré : celles d'Alvar Aalto en Finlande, la Wayfarer's Chapel de Lloyd Wright aux États-Unis, la chapelle de Ronchamp et le couvent de La Tourette par Le Corbusier ». **L'ÉGLISE DU JUBILÉ** a été inaugurée le 26 octobre 2003, pour marquer le 25e anniversaire du pontificat de Jean-Paul II.

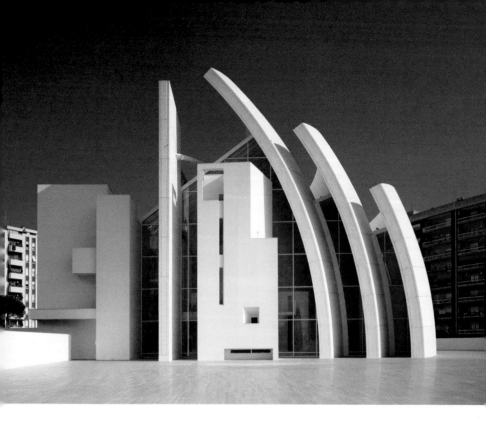

A plan and a photo taken from the side confirm the use of unexpected angles in plan and curves in section.

Ein Plan und ein von der Seite aufgenommenes Foto bestätigen die Verwendung ungewöhnlicher Winkel im Grundriss und von Kurven im Schnitt.

Le plan et la photo prise depuis le côté confirment l'usage d'angles inattendus dans le plan et les courbes en coupe.

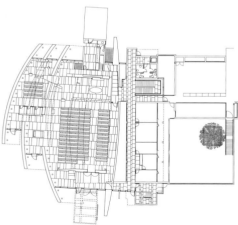

340

The interior of the church benefits
from Richard Meier's continuing
fascination with natural light. White
surfaces are offset by an extensive
use of wood for furnishings and the
lining of the wall to the right.

Der Innenraum der Kirche gewinnt
durch Richard Meiers anhaltende
Faszination von natürlichem Licht.
Weiße Flächen stehen im Kontrast
zur reichlichen Verwendung von Holz
für die Möblierung und zur Verklei-
dung der rechten Wand.

L'intérieur de l'église atteste
aussi de la fascination qu'exerce
depuis toujours la lumière naturelle
sur Richard Meier. Les surfaces
blanches sont équilibrées par
l'usage extensif du bois pour
le mobilier et le mur de droite.

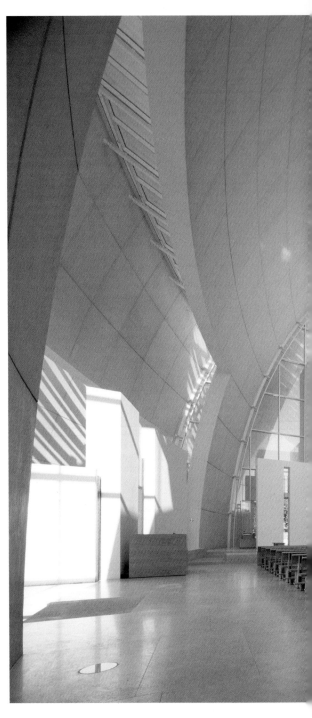

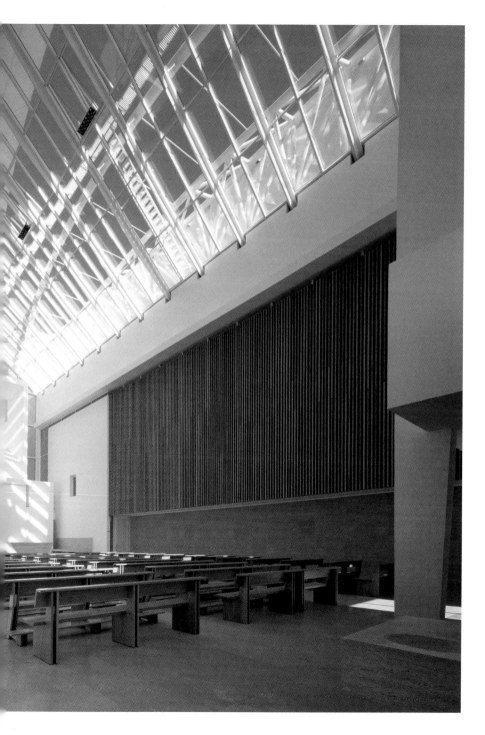

PAULO MENDES DA ROCHA

PAULO MENDES DA ROCHA was born in 1928 in the city of Vitória, capital of the state of Espírito Santo in Brazil. He completed his studies at the FAU-Mackenzie in São Paulo in 1954. Paulo Mendes da Rocha was the 2006 winner of the Pritzker Prize. His first project outside Brazil was the Brazilian Pavilion for the International Expo in Osaka, Japan (1970). One of his best-known projects is the Brazilian Museum of Sculpture (São Paulo, 1987–92). His Patriarch Plaza and Viaduct do Cha (São Paulo, 1992), with its great curving wing canopy, is one of the more visible architectural monuments of Brazil's largest city. Recent projects include Leme Gallery (São Paulo, 2004, published here); the Portuguese Language Museum (São Paulo, 2003–06); the Museum and Theater at the Enseada do Suá (Vitória, Espírito Santo, 2007); Central Mill Park (Piracicaba, São Paulo, 2007); and the Quay of Arts (in collaboration with Metro Arquitetos; Vitória, Espírito Santo, 2010–14, see page 356), all in Brazil.

PAULO MENDES DA ROCHA wurde 1928 in Vitória, der Hauptstadt des Staats Espírito Santo in Brasilien, geboren. Er beendete 1954 sein Studium an der FAU-Mackenzie in São Paulo. Paulo Mendes da Rocha war 2006 Gewinner des Pritzker-Preises. Sein erstes Projekt außerhalb von Brasilien war der Brasilianische Pavillon auf der Weltausstellung in Osaka (Japan, 1970). Eines seiner bekanntesten Bauwerke ist das Brasilianische Skulpturenmuseum (São Paulo, 1987–92). Seine Bauten für die Patriarch Plaza und der Viaduct do Cha (São Paulo, 1992) mit seinem großen, geschwungenen Kragdach gehören zu den eindrucksvollen Bauwerken in Brasiliens größter Stadt. Zu seinen weiteren Projekten zählen: die Galerie Leme (São Paulo, 2004, hier vorgestellt), das Museum für portugiesische Sprache (São Paulo, 2003–06), das Museum und Theater an der Ensada do Suá (Vitória, Espírito Santo, 2007), der Park Central Mill (Piracibaba, São Paulo, 2007) und der Kunstkai (in Zusammenarbeit mit Metro Arquitetos; Vitória, Espírito Santo, 2010–14, siehe Seite 356), alle in Brasilien.

PAULO MENDES DA ROCHA est né en 1928 dans la ville de Vitória, capitale de l'État brésilien d'Espírito Santo. Il a fait ses études à la FAU-Mackenzie de São Paulo jusqu'en 1954. Il a remporté le prix Pritzker en 2006. Son premier projet hors du Brésil a été le Pavillon brésilien pour l'Exposition universelle d'Osaka (1970). L'un de ses bâtiments les plus connus est le Musée brésilien de la sculpture (São Paulo, 1987–92). Sa place du Patriarche traversée par le viaduc do Cha (São Paulo, 1992) et la courbe de son vaste dais ailé est l'un des monuments architecturaux les plus visibles de la plus grande ville du Brésil. Ses projets récents comprennent la galerie Leme (São Paulo, 2004, publiée ici) ; le Musée de la langue portugaise (São Paulo, 2003–06) ; le musée et théâtre de l'Enseada do Suá (Vitória, Espírito Santo, 2007) ; le Central Mill Park (Piracicaba, São Paulo, 2007) et le Quai des arts (en collaboration avec Metro Arquitetos ; Vitória, Espírito Santo, 2010–14, voir page 356), tous au Brésil.

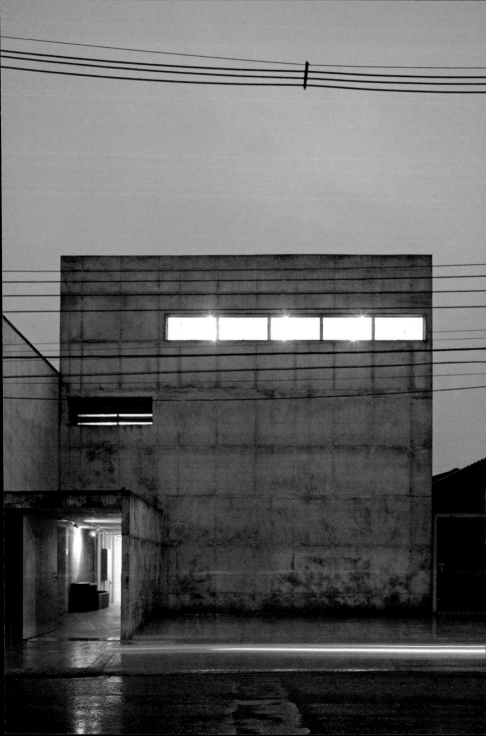

LEME GALLERY

São Paulo, Brazil, 2004

Floor area: 375 m². Client: Eduardo Leme.
Collaborators: Martin Corullon, Anna Ferrari, Gustavo Cedroni.

Located in the Butantã area of São Paulo, **LEME GALLERY** is one of the best-known contemporary art galleries in the city. Unlike most "clean" gallery spaces, Leme Gallery was designed entirely in unpolished concrete by Paulo Mendes da Rocha. There are 150 square meters of exhibition space, and the gallery is lit in good part by a 9-meter-high skylight. Space on this scale allows Eduardo Leme to show large-scale works and to indulge his "new expansive take on leading manifestations in art that propose an aesthetics of substance." Although numerous well-known architects have tried their hands at designing galleries of contemporary art, often in carefully rebuilt industrial spaces, such as those so popular in the Chelsea area of Manhattan, it would seem that Mendes da Rocha, in collaboration with Leme, has hit upon a different way of associating cutting-edge art with contemporary architecture at the highest level.

Bei der im Butantã-Viertel von São Paulo gelegenen **GALERIE LEME** handelt es sich um eine der bekanntesten Galerien für zeitgenössische Kunst in der Stadt. Im Gegensatz zu den vielen „sterilen" Galerieräumen wurde die Galerie Leme von Paulo Mendes da Rocha zur Gänze aus unpoliertem Beton errichtet. Der 150 m² große Ausstellungsraum erhält Licht in erster Linie durch ein 9 m hoch liegendes Oberlicht. Räume dieser Größe ermöglichen es Eduardo Leme, großformatige Werke zu zeigen und seiner „neuen, ausgreifenden Interpretation von bedeutenden Kunstwerken, die eine Ästhetik des Wesentlichen vertreten", zu frönen. Obgleich zahlreiche namhafte Architekten sich in der Gestaltung von Galerien für moderne Kunst versuchten, oft in umgebauten Industrieräumen, wie sie sich in der Gegend von Chelsea in Manhattan zu großer Beliebtheit erfreuen, scheint es, als habe Mendes da Rocha in Zusammenarbeit mit Leme einen anderen Weg gefunden, neueste Kunst mit zeitgenössischer Architektur auf hohem Niveau in Einklang zu bringen.

Située dans le quartier de Butantã à São Paulo, la **GALERIE LEME** est l'une des galeries d'art contemporain les plus connues de la ville. À la différence de tant d'espaces d'exposition « propres » elle est entièrement en béton brut. La surface consacrée aux expositions est de 150 m² et la galerie est en grande partie éclairée par une verrière située à 9 m de haut. Un volume d'une telle échelle permet à Eduardo Leme de présenter des œuvres de grandes dimensions et de se prêter « à cette nouvelle tendance de manifestations artistiques qui propose une esthétique de la substance ». Bien que de nombreux architectes connus se soient essayés à la conception de galeries d'art contemporain, souvent dans d'anciens lieux industriels rénovés, comme ceux si populaires du quartier de Chelsea à Manhattan, Mendes da Rocha, en collaboration avec Eduardo Leme, a opté pour une voie différente dans l'association de l'art d'avant-garde et d'une architecture contemporaine du plus haut niveau.

Mendes da Rocha's powerful concrete forms are certainly urban in nature, and yet even as they fit into the enormous city, they also stand out.

Der Charakter der machtvollen Beton-formen von Mendes da Rocha kann gewiss als urban gelten. Obgleich sie sich in die riesige Stadtlandschaft ein-fügen, stehen sie doch für sich.

Les formes puissantes créées par Mendes da Rocha sont certainement de nature urbaine, mais s'en dis-tinguent néanmoins, même quand elles s'insèrent dans une ville gigantesque.

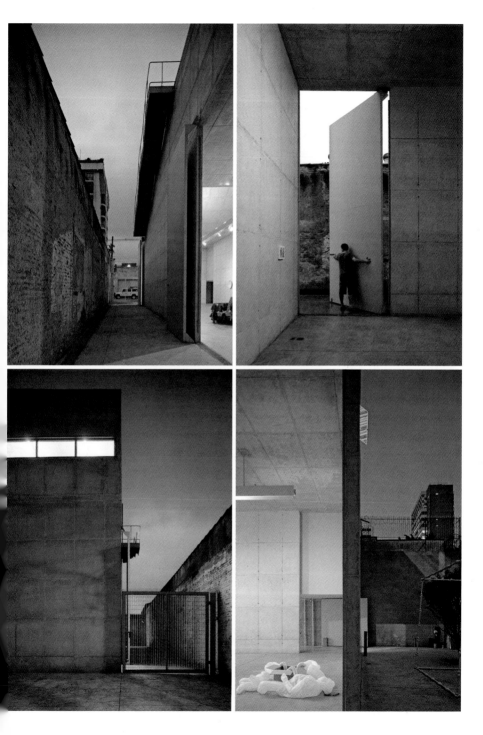

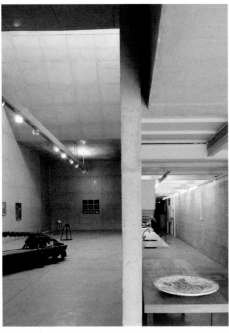 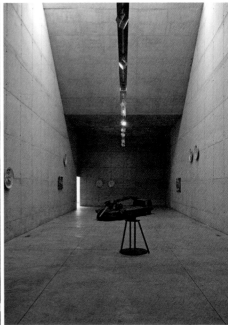

Clearly the client and the architect have found a way of working together and created a space adapted to the unusual approach of Leme Gallery.

Offensichtlich fanden Auftraggeber und Architekt einen Modus der Zusammenarbeit und schufen einen dem besonderen Ansatz der Galerie Leme entsprechenden Raum.

Le client et son architecte ont su collaborer pour créer un espace adapté à l'approche artistique particulière de la galerie Leme.

With its strictly controlled natural light and rather cavernous exhibition space, this is not an indifferent "white box" style of gallery.

Mit ihrem genau dosierten Tageslicht und dem höhlenartigen Ausstellungsraum gehört die Galerie nicht zu den üblichen weißen Schachteln.

Espace d'expositions presque caverneux, éclairage naturel strictement contrôlé, il ne s'agit pas ici de l'habituelle galerie dans le style du « cube blanc ».

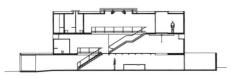 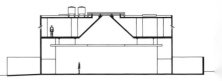

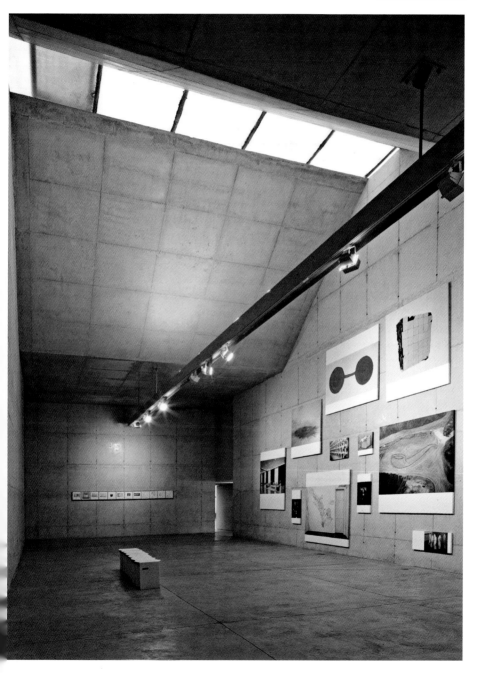

FERNANDO MENIS

Born in Santa Cruz de Tenerife (Canary Islands, Spain) in 1951, **FERNANDO MENIS** studied architecture in Barcelona, obtaining his degree in 1975 from the ETSA. He went on to study urban planning at the same school. In 1981, he participated in the creation of Artengo, Menis, Pastrana Arquitectos (AMP Arquitectos). In 2004 Menis then created his own office, Menis Arquitectos. His work includes the offices of the President of the Government (Santa Cruz de Tenerife, 1997–99); a swimming pool on the Spree (Berlin, Germany, 2003–04); the Magma Conference and Art Center (Adeje, Tenerife, 1998–2005); Church of the Holy Redeemer (Tenerife, first phase, 2007, published here); and the CKK Jordanki Congress and Cultural Center (Torun, Poland, 2013–15), all in Spain, unless otherwise stated. Current work includes the Agora Garden Luxury Condos (Calcutta, India, 2010); Bürchen Mystik (Switzerland, 2015); and Wine Cellars (Crimea, in progress).

FERNANDO MENIS, geboren 1951 in Santa Cruz de Tenerife (Kanarische Inseln, Spanien), studierte Architektur in Barcelona und machte 1975 seinen Abschluss an der dortigen Technischen Hochschule, wo er anschließend auch Stadtplanung studierte. 1981 war er Mitbegründer der Firma Artengo, Menis, Pastrana Arquitectos (AMP Arquitectos). 2004 gründete Menis sein eigenes Büro, Menis Arquitectos. Zu seinen Werken zählen die Büros des Regierungspräsidenten (Santa Cruz de Tenerife, Spanien, 1997 bis 1999), ein Schwimmbad an der Spree (Berlin, Deutschland, 2003–04), das Kongresszentrum Magma (Adeje, Teneriffa, Spanien, 1998–2005), die Kirche des heiligen Erlösers (Teneriffa, Spanien, erste Baustufe, 2007, hier vorgestellt) und das Kongress- und Kulturzentrum CKK Jordanki (Thorn, Polen, 2013–15). Aktuelle Werke sind die Agora Garden Luxury Condos (Kalkutta, Indien, 2010), Bürchen Mystik (Schweiz, 2015) und Wine Cellars (Crimea, im Bau).

Né à Santa Cruz de Tenerife (îles Canaries, Espagne) en 1951, **FERNANDO MENIS** a fait des études d'architecture à Barcelone où il a obtenu le diplôme de l'ETSA en 1975. Il a ensuite étudié l'urbanisme dans la même école. Il a participé à la création de l'agence Artengo, Menis, Pastrana Arquitectos (AMP Arquitectos) en 1981, avant d'ouvrir la sienne, Menis Arquitectos en 2004. Parmi ses projets figurent les bureaux du président du gouvernement (Santa Cruz de Tenerife, Espagne,1997–99) ; une piscine sur la Spree (Berlin, Allemagne, 2003–04) ; le centre de congrès Magma (Adeje, Tenerife, Espagne, 1998–2005) ; l'église du Saint-Rédempteur (Tenerife, Espagne, première phase, 2007, publiée ici) et le palais des congrès et centre culturel CKK Jordanki (Torun, Pologne, 2013–15), tous en Espagne sauf si précisé. Il travaille actuellement au Agora Garden Luxury Condos (Calcutta, Inde, 2010) ; au complexe Bürchen Mystik (Suisse, 2015) et à une cave à vins (Crimée, en cours).

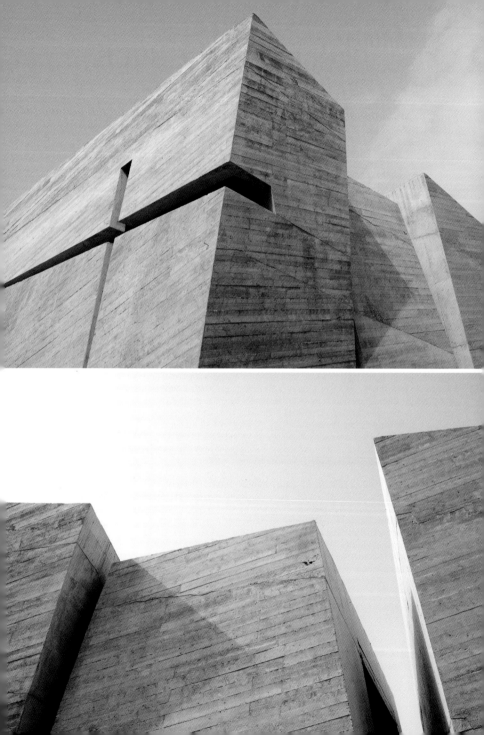

CHURCH OF THE HOLY REDEEMER

San Cristóbal de La Laguna, Tenerife, Spain, 2005–07 / ongoing

Area: 1600 m².

The first phase of the **CHURCH OF THE HOLY REDEEMER** was built between 2005 and 2007, but the structure is still not complete. The architect explains: "The project starts from a big piece of concrete that is broken in four volumes, being separated from one another, as a result of these cuts made to the original piece and the relative movement of each piece independently. The light penetrates through these cuts giving a special meaning, designed from the point of view of rationality and endowed with profound theological roots." The austere concrete structure is energy efficient because of its thickness. Lapilli, the substance that falls from the air after a volcanic eruption, is added to the concrete, contributing to its unusual texture. Menis emphasizes that "exterior, interior, structure, form, material, and texture are joined inextricably by a complex study of the concrete." He refers to concrete as "liquid stone" that produces "waterfalls of light," in particular the light that emanates from behind the cross in the early hours of the day, striking the baptismal font: "The transition from darkness to light, from death to life."

Der erste Bauabschnitt der **KIRCHE DES HEILIGEN ERLÖSERS** wurde zwischen 2005 und 2007 ausgeführt, aber das Gebäude ist immer noch nicht fertiggestellt. Der Architekt erklärt: „Das Projekt beginnt mit einem großen Betonblock, der in vier Volumen aufgebrochen wird; durch die Einschnitte in den ursprünglichen Block und die relativ unabhängige Bewegung jedes einzelnen Stücks sind die Volumen voneinander getrennt. Das Licht dringt durch diese Einschnitte und verleiht ihnen eine besondere Bedeutung, gestaltet aus rationalen Erwägungen und basierend auf tiefgründigem theologischem Gedankengut." Der strenge Betonbau ist aufgrund seiner Stärke energieeffizient. Lapilli, die Substanz, die bei Vulkanausbrüchen in die Luft geschleudert wird, wurde dem Beton beigefügt und trägt zu seiner ungewöhnlichen Struktur bei. Menis betont, dass „Äußeres, Inneres, Konstruktion, Form, Material und Struktur durch gründliches Studium des Betons untrennbar miteinander verbunden" seien. Er bezeichnet Beton als „flüssigen Stein", der Sturzbäche aus Licht" produziere, vor allem das Licht, das frühmorgens hinter dem Kreuz auf das Taufbecken fällt: „der Übergang von der Dunkelheit zum Licht, vom Tod zum Leben".

La première phase du l'**ÉGLISE DU SAINT-RÉDEMPTEUR** a été édifiée entre 2005 et 2007, mais la structure n'est toujours pas achevée. L'architecte explique : « Tout a commencé avec un gros bloc de béton brisé en quatre volumes distincts, résultat de coupes pratiquées dans l'élément d'origine et du mouvement relatif de chaque morceau indépendamment des autres. La lumière pénètre par ces découpures et prend une signification particulière, conçue du point de vue de la rationalité mais dotée de profondes racines théologiques. » Du fait de son épaisseur, l'austère structure de béton est écoénergétique. Des lapilli, les cendres qui retombent après une éruption volcanique, ont été ajoutés au béton et lui confèrent en partie une texture inédite. Menis souligne que « l'extérieur, l'intérieur, la structure, la forme, la matière et la texture sont inextricablement mêlés par une étude complexe du béton ». Il parle du matériau comme d'une « pierre liquide » qui produit des « cascades de lumière », notamment les rayons qui surgissent derrière la croix aux premières heures du jour et frappent les fonts baptismaux : « Le passage de l'obscurité à la lumière, de la mort à la vie. »

Although this church has not been completed, its very powerful concrete forms have attracted the attention of numerous photographers.

Obgleich diese Kirche noch nicht fertiggestellt ist, haben ihre kraftvollen Betonformen bereits das Interesse zahlreicher Fotografen auf sich gezogen.

Bien qu'inachevée, l'église aux formes massives de béton a déjà attiré l'attention de nombreux photographes.

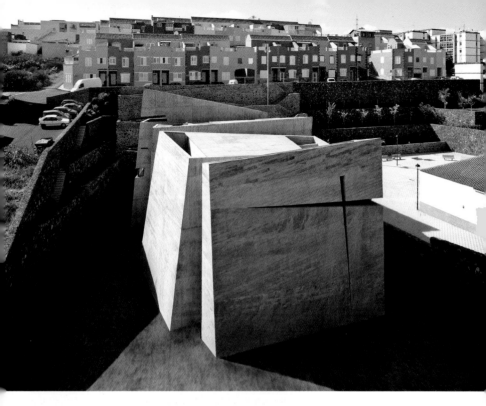

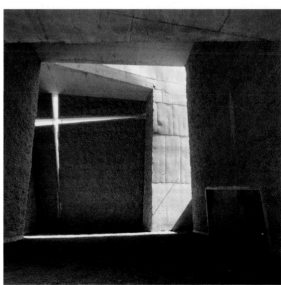

A stylized cross slices through the concrete, adding to the natural light that comes in through the open "joints" of the massive slabs that form the building.

Ein stilisiertes Kreuz durchschneidet den Beton und führt neben dem natürlichen Licht, das durch die offenen „Fugen" der massiven, das Gebäude bildenden Platten eindringt, zu weiterer Helligkeit im Raum.

Une croix stylisée fend le béton et ajoute à la lumière naturelle qui pénètre par les « joints » ouverts entre les blocs massifs avec lesquels le bâtiment est construit.

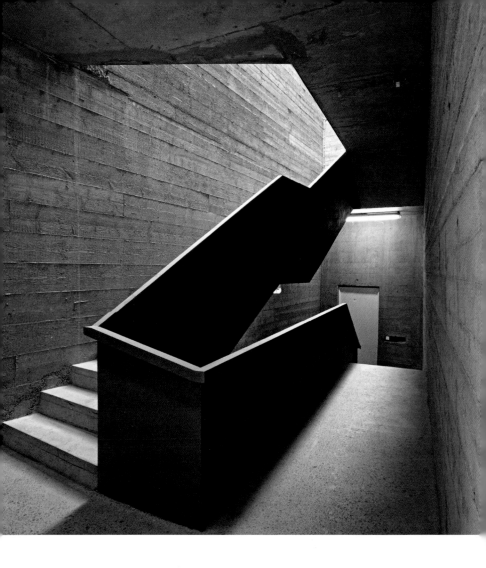

The architect uses blank concrete walls with skill—shedding natural light on the traces of the formwork as can be seen above. Right page, details of the admission of natural light, and plans of the church.

Der Architekt macht geschickten Gebrauch von den Betonwänden, indem er natürliches Licht auf die Spuren der Schalung lenkt – wie auf dem Foto oben zu sehen. Rechte Seite: Details der natürlichen Lichtquellen und Grundrisse.

L'architecte a parfaitement maîtrisé l'usage des murs de béton nu pour éclairer les traces du coffrage comme on le voit ci-dessus. Page de droite, détails de la manière dont la lumière naturelle pénètre et plans de l'église.

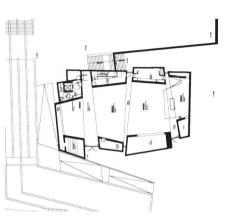
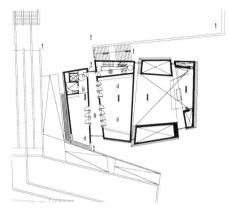

METRO &
PAULO MENDES DA ROCHA

MARTIN CORULLON was born in Argentina in 1973. He received his architecture degree from the FAUUSP (São Paulo, Brazil) in 2000, when he founded Metro Arquitetos Associados. Since 1994, Corullon has been a close collaborator of Paulo Mendes da Rocha. In 2008 and 2009, he worked at Foster + Partners in London. **ANNA FERRARI** was born in São Paulo, Brazil, in 1978. She received her architecture degree from the FAU-Mackenzie in São Paulo (2000). She was a collaborator of the office from the time of its creation and became a partner in 2005; between 2011 and 2012 she worked at Herzog & de Meuron (Basel), later returning to Metro. **GUSTAVO CEDRONI** was born in São Paulo in 1978. He received his degree at the Fundação Armando Alvares Penteado (FAAP) in São Paulo in 2000. He worked with Pedro Paulo de Melo Saraiva (1999) and Eduardo Colonelli (2000), before joining Metro in 2002. He became a Partner in 2005. In 2013, they completed the Art Pavilion (São Paulo, Brazil, published here). Metro collaborated with **PAULO MENDES DA ROCHA** (biography on page 342) on the Quay of Arts (Vitória, Espírito Santo, 2010–14, also published here).

MARTIN CORULLON wurde 1973 in Argentinien geboren. Er machte 2000 sein Diplom an der Fakultät für Architektur und Städtebau der Universität São Paulo (FAU-USP, Brasilien) und gründete im gleichen Jahr Metro Arquitetos Associados. Seit 1994 arbeitet Corullon eng mit Paulo Mendes da Rocha zusammen. 2008 und 2009 war er für Foster + Partners in London tätig. **ANNA FERRARI** wurde 1978 in São Paulo geboren und machte ihr Diplom an der FAU-Mackenzie in São Paulo (2000). Sie war Mitarbeiterin des Büros seit seiner Gründung und wurde 2005 Partnerin. Von 2011 bis 2012 arbeitete sie bei Herzog & de Meuron (Basel), danach kehrte sie zu Metro zurück. **GUSTAVO CEDRONI** wurde 1978 in São Paulo geboren und machte 2000 sein Diplom an der Fundação Armando Alvares Penteado (FAAP) in São Paulo. Er arbeitete bei Pedro Paulo de Melo Saraiva (1999) und Eduardo Colonelli (2000), bevor er sich 2000 Metro anschloss und 2005 Partner wurde. 2013 errichteten sie den hier vorgestellten Kunstpavillon (São Paulo, Brasilien). Metro arbeitete mit **PAULO MENDES DA ROCHA** (Biografie auf Seite 342) am Kunstkai (Vitória, Espirito Santo, Brasilien 2010–14, ebenfalls hier vorgestellt) zusammen.

MARTIN CORULLON est né en Argentine en 1973. Il a obtenu son diplôme en architecture à la FAUUSP (São Paulo, Brésil) en 2000 et a fondé Metro Arquitetos Associados la même année. Corullon est un collaborateur proche de Paulo Mendes da Rocha depuis 1994. Il a travaillé pour Foster + Partners à Londres en 2008 et 2009. **ANNA FERRARI** est née à São Paulo en 1978. Elle est diplômée en architecture de la FAU-Mackenzie de São Paulo (2000). Elle collabore avec l'agence depuis sa création et en est devenue l'une des associées en 2005 ; elle a travaillé chez Herzog & de Meuron (Bâle) de 2011 à 2012, avant de revenir à Metro. **GUSTAVO CEDRONI** est né à São Paulo en 1978. Il est diplômé (2000) de la Fundação Armando Alvares Penteado (FAAP) de São Paulo. Il a travaillé avec Pedro Paulo de Melo Saraiva (1999) et Eduardo Colonelli (2000) avant de rejoindre Metro en 2002. Il en est l'un des associés depuis 2005. Ils ont achevé le Pavillon d'art publié ici en 2013 (São Paulo). Metro ont collaboré avec **PAULO MENDES DA ROCHA** (Biographie à la page 342) au Quai des arts (Vitória, 2010–14, également publié ici).

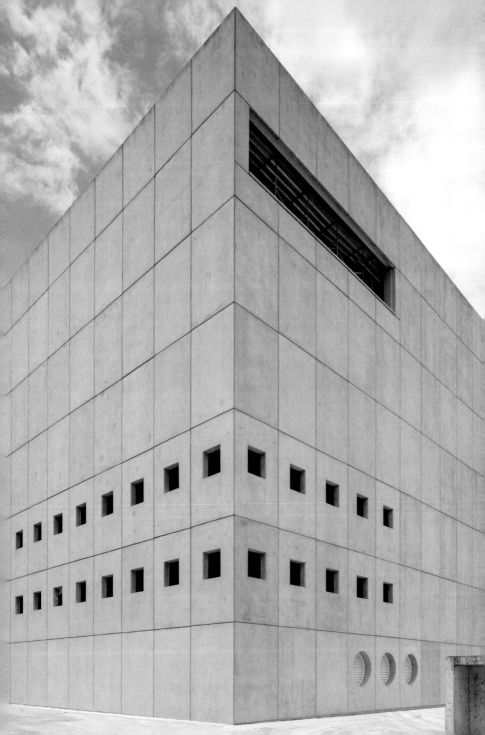

QUAY OF ARTS

Vitória, Espírito Santo, Brazil, 2010–14

Area: 32 000 m².
Client: Governo do Espírito Santo.

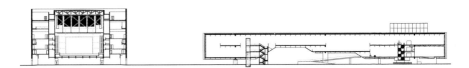

Called **CAIS DAS ARTES** in Portuguese, this museum and theater project is a collaboration between Paolo Mendes da Rocha and the younger team of Metro. The architects took into account the landscape and historical surroundings of the city. Located on Suá Bay, it is described by them as a "confrontation between nature and construction." The buildings are suspended high above the site in order to allow the creation of generous public space near the ocean. The museum has a 3000-square-meter exhibition area and the theater can seat 1300 people. The museum building is formed by two large parallel beams made of prestressed reinforced concrete. Seven meters high, these beams have only three points of support each, with 20 meters between them. The halls, with a standard width of 20 meters and different lengths, are located between the beams and distributed on three main levels. The halls are primarily intended for exhibitions, while the rest of the program is concentrated in a tower annex that measures 22 x 22 meters and is 23 meters high, connected to the main volume via bridges. Like the museum, the theater is suspended above the ground.

Dieses Museums- und Theaterprojekt, auf Portugiesisch **CAIS DAS ARTES**, ist das Ergebnis einer Zusammenarbeit von Paolo Mendes da Rocha mit dem jüngeren Team von Metro. Die Architekten nahmen Rücksicht auf die landschaftliche und historische Umgebung der Stadt. Sie bezeichnen die an der Praia do Suá gelegene Anlage als „Konfrontation von Natur und Konstruktion". Die Gebäude sind über dem Gelände hoch aufgeständert, um einen großzügigen, offenen Bereich am Meer zu schaffen. Das Museum hat 3000 m² Ausstellungsfläche und das Theater 1300 Sitzplätze. Der Museumsbau besteht aus zwei großen, parallelen Trägern aus vorgespanntem Stahlbeton. Diese 7 m hohen Tragbalken haben jeweils nur drei Auflager, der Abstand zwischen ihnen beträgt 20 m. Die Säle mit einer Standardbreite von 20 m und unterschiedlichen Längen sind auf drei Ebenen zwischen den Trägern angeordnet. Sie sollen in erster Linie für Ausstellungszwecke genutzt werden, während die übrigen Funktionen in einem anschließenden Turm zusammengefasst sind, der 22 x 22 m im Grundriss und 23 m in der Höhe misst und über Brücken mit dem Hauptbau verbunden ist. Ebenso wie das Museum ist auch das Theater über Geländeniveau aufgehängt.

Ce projet de musée et théâtre, appelé **CAIS DAS ARTES** en portugais, est le fruit d'une collaboration entre Paolo Mendes da Rocha et la jeune équipe de Metro. Les architectes ont tenu compte du paysage et du décor historique de la ville. Situé dans la baie Suá, ils le décrivent comme une « confrontation entre nature et construction ». Les bâtiments sont suspendus très haut pour ouvrir un vaste espace public près de l'océan. Le musée dispose de 3000 m² et le théâtre de 1300 places. Le bâtiment du musée est formé de deux grandes poutres parallèles en béton armé précontraint. Hautes de 7 m, elles n'ont chacune que trois points d'appui séparés de 20 m. Les salles, d'une largeur standard de 20 m pour des longueurs variables, occupent l'espace entre les poutres, réparties sur trois étages principaux. Elles sont destinées en premier lieu à des expositions, les autres activités sont regroupées dans une tour annexe de 22 x 22 m pour 23 m de haut, reliée au volume principal par des passerelles. Comme le musée, le théâtre est suspendu au-dessus du sol.

On this page, drawings show that the building is in good part lifted off the ground with long openings forming usable, protected outdoor space.

Die Zeichnungen auf dieser Seite zeigen, dass das Gebäude zum großen Teil aufgeständert ist: Die langen Öffnungen bilden nutzbare, geschützte Freibereiche.

Les schémas ci-dessous montrent que le bâtiment est en grande partie suspendu au-dessus du sol, des ouvertures allongées formant un espace extérieur abrité.

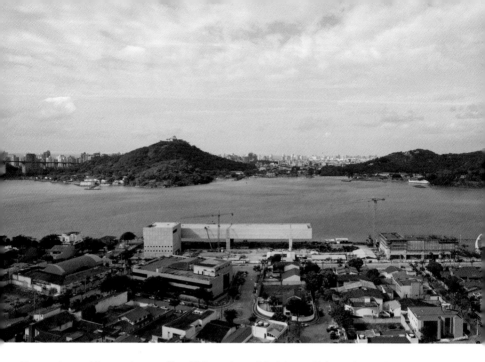

Above, an image of the complex seen from above on the edge of the Suá Bay. The strongly horizontal concrete design stands out from its environment in both color and form.

Oben: Blick von oben auf die Anlage an der Praia do Suá. Das betont horizontale Betongebäude hebt sich in Farbe und Form aus seinem Umfeld hervor.

Ci-dessus, le complexe au bord de la baie Suá vu d'en haut. La construction de béton d'une grande horizontalité se distingue de son environnement à la fois par sa couleur et par sa forme.

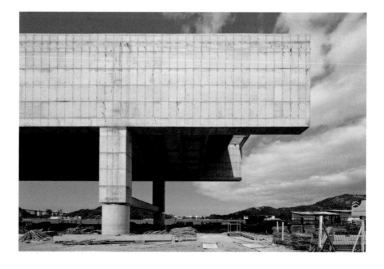

ART PAVILION

São Paulo, Brazil, 2012–13

Area: 250 m². Cost: $1 million.

Carried forward by Metro Arquitetos only, without Mendes da Rocha, this project is made up essentially of two concrete walls with a steel roof and is intended to house a private contemporary art collection. There are three rooms, one for storage and two for exhibiting the collection, with a variety of spatial and light conditions to allow different experiences and to be able to accommodate works of various media in a proper manner. A separate concrete box serves as a guesthouse but is also used as an open-air video projection wall. The **ART PAVILION** is part of a larger garden, also designed by Metro, in a residential neighborhood of São Paulo.

Dieses nur von Metro Arquitetos, ohne Mendes de Rocha, ausgeführte Projekt besteht im Wesentlichen aus zwei Betonmauern mit einem Stahldach und soll der Unterbringung einer privaten Sammlung zeitgenössischer Kunst dienen. Der Bau hat drei Räume, einen zur Lagerung und zwei zum Ausstellen der Sammlung, und zeichnet sich durch vielfältige Raum- und Lichtverhältnisse aus, die unterschiedliche Eindrücke auslösen und Kunstwerke verschiedener Medien in geeigneter Form präsentieren lassen. Ein abgetrennter Betonblock dient als Gästehaus, kann aber auch als Video-Projektionswand im Freien genutzt werden. Der **KUNSTPAVILLON** liegt in einem größeren, ebenfalls von Metro gestalteten Park in einem Wohngebiet von São Paulo.

Ce projet, mené à bien par Metro Arquitetos seul, sans Mendes da Rocha, est essentiellement composé de deux murs de béton sous une toiture en acier et est destiné à abriter une collection privée d'art contemporain. L'ensemble comporte trois salles, une pour le stockage et deux pour exposer la collection, ces dernières présentent des espaces et éclairages très diversifiés afin de permettre différentes expériences et de pouvoir accueillir comme il se doit des œuvres sur divers médias. Un cube en béton à part sert de maison d'hôtes, mais est aussi utilisé comme mur de projection vidéo en plein air. Le **PAVILLON D'ART** fait partie d'un vaste jardin, également conçu par Metro, dans une banlieue résidentielle de São Paulo.

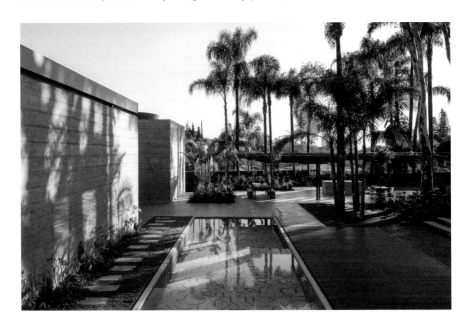

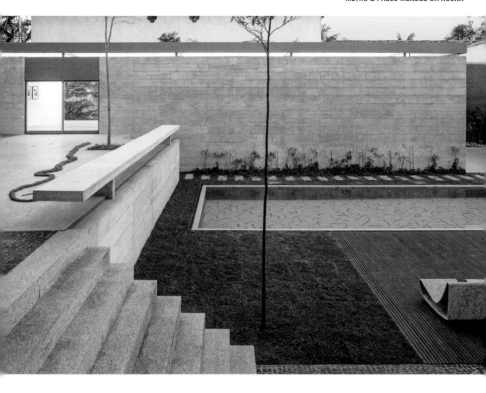

The image above and the draw-ings below show how strict and rectilinear the design is. Metro has mastered the use of concrete work-ing with Paulo Mendes da Rocha.

Die Abbildung oben und die Zeichnungen unten zeigen, wie streng und geradlinig der Entwurf ist. Metro hat diesen Betonbau gemeinsam mit Paulo Mendes da Rocha geplant.

On voit parfaitement sur la photo ci-dessus et les plans ci-dessous à quel point la conception est recti-ligne et rigoureuse. Metro a travaillé avec Paulo Mendes da Rocha et maîtrisé l'usage du béton.

LUCIO MORINI + GGMPU

LUCIO MORINI was born in Córdoba, Argentina, in 1970. He studied architecture at the Universidad Católica de Córdoba (1989–96) and at the Harvard GSD (1998–2000), receiving an M.Arch II degree. From 2001 to 2003, he worked in the office of Herzog & de Meuron in Basel. Between 2006 and 2013, he worked in association with GGMPU Arquitectos, later creating an office with **SARA GRAMATICA** and **JORGE MORINI**, two of the partners at GGMPU, in 2013: MGM y Asociados. The other partners in GGMPU are **JOSÉ PISANI** and **EDUARDO URTUBEY**. Their work includes the Emilio Caraffa Provincial Museum (Córdoba, 2007); Pavilion of the Province of Córdoba (Chongqing, China, 2011); the Bicentennial Civic Center (Córdoba, 2010–12, published here); Villa Maria Stadium (Córdoba, 2012); Sky and Earth Pavilion, Las Tejas Park (Córdoba, 2012); and Casa Fernández (Córdoba, 2012), all in Argentina unless indicated otherwise.

LUCIO MORINI wurde 1970 in Córdoba, Argentinien, geboren. Er studierte Architektur an der Universidad Católica de Córdoba (1989–96) und an der Harvard Graduate School of Design (GSD, 1998–2000), wo er einen M.Arch. II erwarb. Von 2001 bis 2003 arbeitete er im Büro Herzog & de Meuron in Basel. Zwischen 2006 und 2013 war er für GGMPU Arquitectos tätig. 2013 gründete er mit **SARA GRAMATICA** und **JORGE MORINI**, zwei der Partner von GGMPU, ein eigenes Büro: MGM y Asociados. Die anderen Partner von GGMPU sind **JOSÉ PISANI** und **EDUARDO URTUBEY**. Zu ihren ausgeführten Projekten gehören: das Provinzmuseum Emilio Caraffa (Córdoba, 2007), der Pavillon der Provinz Córdoba (Chongqing, China, 2011), das Centro Cívico del Bicentenario (Córdoba, 2010–12, hier vorgestellt), das Stadion Villa Maria (Córdoba, 2012), der Pabellón Cielo y Tierra im Park Las Tejas (Córdoba, 2012) und die Casa Fernández (Córdoba, 2012), alle in Argentinien, sofern nicht anders angegeben.

LUCIO MORINI est né à Córdoba (Argentine) en 1970. Il a fait des études d'architecture à l'Université catholique de Córdoba (1989–96) et à la Harvard GSD (1998–2000) et est titulaire d'un M.Arch. II. Il a travaillé de 2001 à 2003 dans l'agence Herzog & de Meuron à Bâle puis, de 2006 à 2013, en association avec GGMPU Arquitectos, avant de créer l'agence MGM y Asociados avec **SARA GRAMATICA** et **JORGE MORINI**, deux des partenaires de GGMPU, en 2013. Les deux autres partenaire de GGMPU sont **JOSÉ PISANI** et **EDUARDO URTUBEY**. Leurs réalisations comprennent le musée provincial Emilio Caraffa (Córdoba, 2007) ; le pavillon de la province de Córdoba (Chongqing, Chine, 2011) ; le Centre administratif du Bicentenaire (Córdoba, 2010–12, publié ici) ; le stade Villa Maria (Córdoba, 2012) ; le pavillon Cielo y Tierra dans le parc Las Tejas (Córdoba, 2012) et la Casa Fernández (Córdoba, 2012), toutes en Argentine sauf si spécifié.

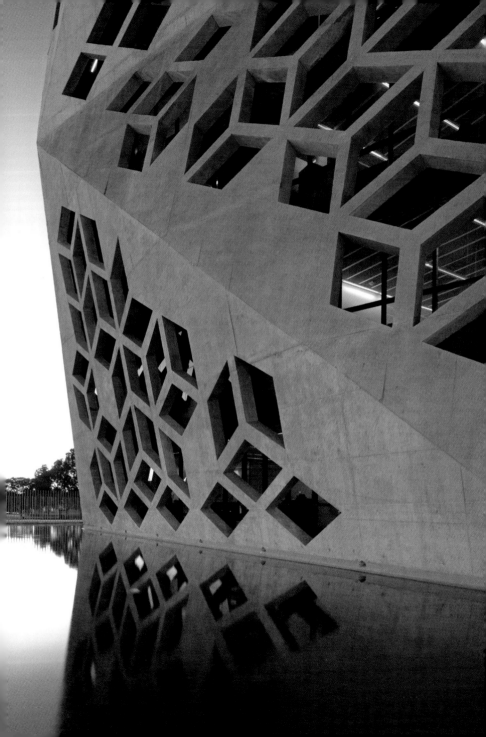

BICENTENNIAL CIVIC CENTER

Córdoba, Argentina, 2010–12

Area: 24 781 m². Client: Government of the Province, Córdoba.
Collaboration: Guillermo Pozzobón (Project Manager).

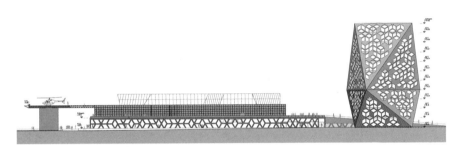

The **BICENTENNIAL CIVIC CENTER** is the first purpose-designed administrative complex in the Province of Córdoba, Argentina. It is located on the edge of the historic center of the city, on a site formerly occupied by railway tracks. One of its sides, measuring more than 700 meters in length, is adjacent to the Suquia River. Two bridges across the river were built to enhance communication between different parts of the city, while landscaping along the river was also completed. Phase 1 of the overall Civic Center project has been completed and is comprised of two buildings. Building A is a medium-rise structure housing ministry offices. It is a concrete, faceted prism based on a cubic form 45 meters high that is rotated by 20 degrees. Building B is a horizontal slab for administrative offices. It has a concrete base with a parking area and is also based on a rhomboidal design. A green volume enclosed by metal mesh tops this structure. At the same level as the green roof, the governor's house is a single-story mirror-glass-clad structure. Phase 2 will involve additional administrative space, while Phase 3 will be a partially buried convention center in the shape of an artificial grass-covered hill.

Das **CENTRO CÍVICO DEL BICENTENARIO** ist der erste zweckgebunden geplante Verwaltungskomplex in der Provinz Córdoba, Argentinien. Er liegt am Rand des historischen Stadtzentrums auf einem früher von Bahngleisen bedeckten Gelände. Eine der über 700 m langen Fassaden liegt am Fluss Suquia, über den zwei Brücken gebaut wurden, um die Verbindung zwischen den Stadtteilen zu verbessern. Auch das Flussufer wurde neu gestaltet. Der erste Bauabschnitt der Gesamtplanung ist fertiggestellt und besteht aus zwei Gebäuden. Bau A ist von mittlerer Größe und beherbergt Ministerialbüros. Mit 45 m Höhe hat er die Form eines auf einem Kubus basierenden Prismas, das um 20 Grad gedreht wurde. Bau B ist eine horizontale Scheibe für die Büros der Verwaltung. Er hat einen Sockel aus Beton, der als Parkhaus dient, und basiert ebenfalls auf einer rhomboiden Form: Ein grünes, von einem Metallgeflecht umgebenes Volumen schließt diesen Bau oben ab. Auf gleicher Ebene wie das grüne Dach liegt die Wohnung des Gouverneurs: ein eingeschossiger, mit Spiegelglas verkleideter Baukörper. Die zweite Bauphase wird weitere Verwaltungsräume enthalten, während die dritte aus einem teilweise unterirdisch untergebrachten Kongresszentrum in Form eines künstlichen, mit Gras bedeckten Hügels bestehen soll.

Le **CENTRE ADMINISTRATIF DU BICENTENAIRE** est le premier complexe administratif spécialement conçu à cet effet dans la province de Córdoba, en Argentine. À la lisière du centre-ville historique, il occupe un site que traversait auparavant une voie ferrée. L'un de ses côtés, long de plus de 700 m, longe la rivière Suquia. Deux ponts ont été construits sur la rivière pour une meilleure communication entre les différentes parties de la ville, tandis que l'aménagement des berges a été parachevé. La première phase du projet global est terminée, elle comprend deux bâtiments. Le bâtiment A est une structure de hauteur moyenne pour les bureaux des ministères, c'est un prisme à facettes en béton basé sur une forme cubique haute de 45 m qui a subi une rotation de 20 degrés. Le bâtiment B est un bloc horizontal pour les services administratifs. Il possède un socle en béton avec un parking et est également basé sur une forme rhomboïdale surmontée d'un volume végétalisé enclos d'un maillage métallique. Au même niveau que le toit végétalisé, la maison du gouverneur de la province est une structure à un étage revêtue de verre miroir. La phase 2 comprendra l'ajout d'espace administratif, la phase 3 verra la construction d'un centre de congrès partiellement enterré en forme de colline artificielle recouverte d'herbe.

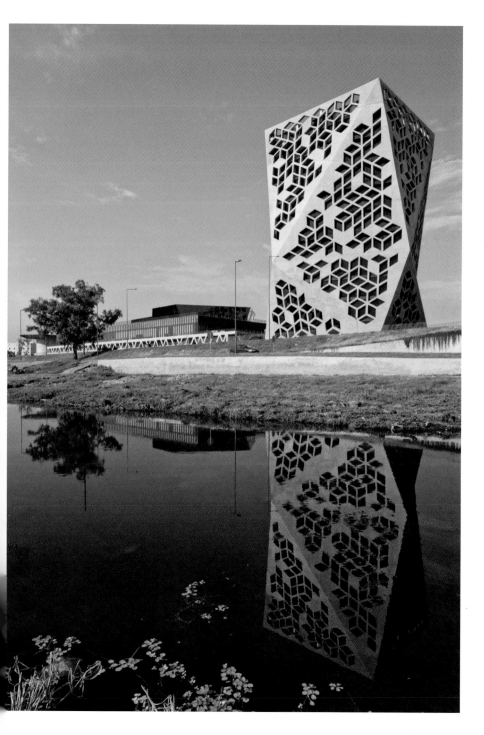

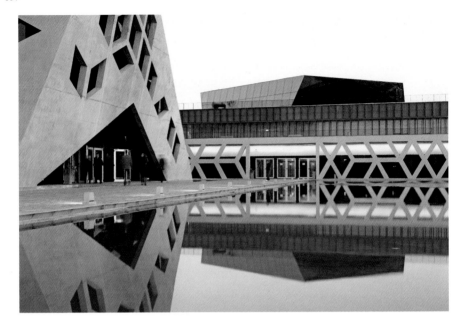

The entrance to the ministerial tower is seen in the image above, and the administrative building is behind it to the right.

Der Eingang zum Ministeriumsbau ist auf der Abbildung oben zu sehen, rechts dahinter das Verwaltungsgebäude.

Ci-dessus, on voit l'entrée de la tour ministérielle avec le bâtiment administratif derrière.

Just as the tower has a cutout appearance, so too the concrete façade pattern developed for the administrative building (seen on the right) echoes the pattern of openings albeit in a more open mode.

Ebenso wie für die Ausschnitte der Turmfassade gilt auch für die Betonfassade des Verwaltungsgebäudes das von den Architekten entwickelte System der Öffnungen (rechts), wenn auch in freierer Form.

De même que la tour semble ajourée, le motif en béton développé pour la façade du bâtiment administratif (à droite) reprend le thème découpé, mais sur un mode plus ouvert.

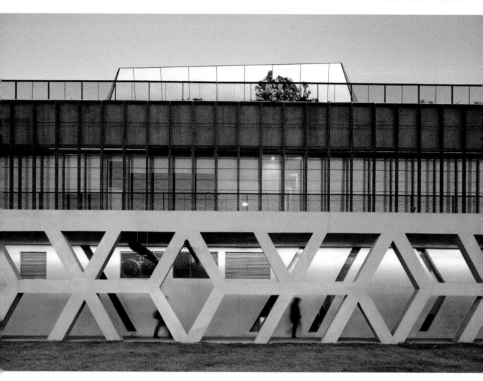

MORPHOSIS

Morphosis Principal **THOM MAYNE**, born in Connecticut in 1944, received his B.Arch in 1968 from the University of Southern California, Los Angeles, and his M.Arch degree from Harvard in 1978. He created Morphosis in 1979. He has taught at UCLA, Harvard, Yale, and SCI-Arc, of which he was a founding board member. Thom Mayne was the winner of the 2005 Pritzker Prize. Some of the main buildings by Morphosis are Cedars-Sinai Comprehensive Cancer Care Center (Beverly Hills, California, 1987); the Blades Residence (Santa Barbara, California, 1992–97); and International Elementary School (Long Beach, California, 1997–99). Besides his work includes the NOAA Satellite Operation Facility in Suitland (Maryland, 2001–05); San Francisco Federal Building (San Francisco, California, 2003–07); 41 Cooper Square (New York, 2006–09), all in the USA; and the Giant Interactive Group Corporate Headquarters (Shanghai, China, 2006–10).They have also completed the Perot Museum of Nature and Science (Dallas, 2010–12, published here) and the Bloomberg Center at Cornell University (Ithaca, New York, 2015–17). Ongoing work at the time of writing this publication included the Casablanca Finance City Tower (Morocco, 2014–18); and the Hanking Center Tower (Shenzhen, China, 2014–18), all in the USA unless stated otherwise.

THOM MAYNE, Direktor von Morphosis, wurde 1944 in Connecticut geboren. Seine Studien schloss er 1968 mit einem B.Arch. an der University of Southern California, Los Angeles, sowie 1978 mit einem M.Arch. in Harvard ab. 1979 gründete er Morphosis. Mayne lehrte an der UCLA, in Harvard, in Yale und am Sci-Arc, zu dessen Gründungsmitgliedern er zählt. 2005 wurde Mayne mit dem Pritzker-Preis ausgezeichnet. Ausgewählte Bauten von Morphosis sind u. a. die Cedars-Sinai Krebsklinik (Beverly Hills, Kalifornien, 1987), Blades Residence (Santa Barbara, Kalifornien, 1992–97) sowie die International Elementary School (Long Beach, Kalifornien, 1997–99). Weitere Arbeiten sind u. a. das NOAA Satellitenzentrum in Suitland (Maryland, 2001–05), das San Francisco Federal Building (San Fransisco, Kalifornien, 2003–07), 41 Cooper Square (New York, 2006–09), alle in den USA, und der Hauptsitz der Giant Interactive Group (Schanghai, China, 2006–10). Das Büro entwarf außerdem das Perot Museum of Nature and Science (Dallas, Texas, 2010–12, hier vorgestellt) und das Bloomberg Center at Cornell University (Ithaca, New York, 2015–17). Zur Zeit der Publikation errichtete Bauten sind der Casablanca Finance City Tower (Marokko, 2014–18) sowie der Hanking Center Tower (Shenzhen, China, 2014–18), alle in den USA sofern nicht anders angegeben.

Directeur de l'agence Morphosis, **THOM MAYNE**, né dans le Connecticut en 1944, est titulaire d'un B.Arch. de l'université de Californie du Sud-Los Angeles (1968) d'un M.Arch. de Harvard (1978), et a fondé l'agence en 1979. Il a enseigné à l'UCLA, Harvard, Yale et SCI-Arc dont il est l'un des fondateurs. Il a reçu le prix Pritzker en 2005. Parmi ses principales réalisations : le Centre anticancéreux de Cedars-Sinai (Beverly Hills, Californie, 1987) ; la résidence Blades (Santa Barbara, Californie, 1992–97) et l'école élémentaire internationale de Long Beach (Californie, 1997–99). En plus, il a construit le Centre opérationnel de communication par satellites NOAA (Suitland, Maryland, 2001–05) ; le San Francisco Federal Building (Californie, 2003–07) ; l'immeuble 41 Cooper Square (New York, 2006–09), le tout aux États-Unis, et le siège social du Giant Interactive Group (Shanghai, Chine, 2006–10). De puis l'agence a construit le Musée Perot Museum of Nature and Science (Dallas, Texas, 2010–12, publié ici) et le Bloomberg Centre de la Cornell Universitée (Ithaca, New York, 2015–17). Les réalisation qui étaient en cours de réalisation au moment de la publication comptent : le Casablance Finance City Tower (Morocco, 2014–18) et le Hanking Center Tower (Shenzhen, Chine, 2014 –18) tous en États-Unis sauf si spécifié.

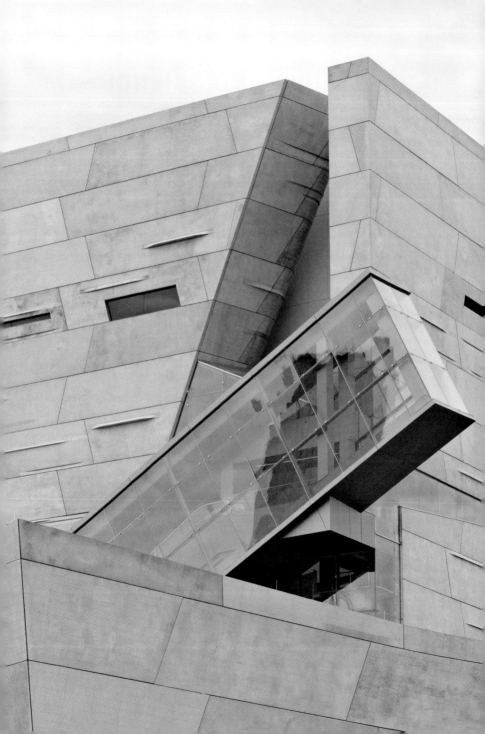

PEROT MUSEUM OF NATURE AND SCIENCE

Dallas, Texas, USA, 2010–12

Area: 16 723 m². Client: Museum of Nature and Science.
Collaboration: Arne Emerson (Project Architect), Brandon Welling (Project Manager),
Kim Groves (Project Principal).

Visitors to the **PEROT MUSEUM OF NATURE AND SCIENCE** are greeted by a "forest of large native canopy trees and a terrace of native desert xeriscaping (landscaping without the need for irrigation)." The terrace slopes up to connect with the museum's stone roof. According to the architects: "The overall building mass is conceived as a large cube floating over the site's landscaped plinth. An acre of undulating 'roofscape,' comprised of rock and native drought-resistant grasses, reflects Dallas's indigenous geology and demonstrates a living system that will evolve naturally over time." These areas intersect at the main entry plaza "connecting the natural with the man-made." A large atrium houses stairs, escalators, and elevators, and visitors are guided to the top level of the structure where a view of downtown Dallas awaits them. Visitors descend from this point through the museum. "The visitor becomes part of the architecture," say the architects, "as the eastern facing corner of the building opens up toward downtown Dallas to reveal the activity within. The museum is, thus, a fundamentally public building—a building that opens up, belongs to, and activates the city; ultimately, the public is as integral to the museum as the museum is to the city."

Die Besucher des **PEROT MUSEUM OF NATURE AND SCIENCE** werden von einem „Wald mit großen einheimischen Baumkronen und einer Terrasse mit lokaler Xeriscape-Landschaft (Bepflanzung, die nicht bewässert werden muss)" empfangen. Die Terrasse steigt an bis auf die Höhe des mit Naturstein gedeckten Dachs. Die Architekten erläutern: „Die gesamte Masse des Gebäudes ist als großer, über dem landschaftlich gestalteten Sockel schwebender Kubus konzipiert. Über 4000 m² wellenförmige ‚Dachlandschaft' aus Fels und einheimischem, dürreresistentem Gras demonstrieren die lokale Geologie von Dallas und bilden ein lebendiges System, das sich im Lauf der Zeit ganz natürlich entwickeln wird." Diese Bereiche treffen auf der großen Eingangsplaza aufeinander und „verbinden das Natürliche mit dem von Menschen Gemachten". Ein großes Atrium enthält Treppen, Rolltreppen und Aufzüge, welche die Besucher bis ins oberste Geschoss führen, wo sie ein Blick auf die Innenstadt von Dallas erwartet. Von hier aus gehen sie hinunter ins Museum. „Der Besucher wird zum Teil der Architektur", sagen die Architekten, „wenn sich die nach Osten orientierte Ecke des Gebäudes zur Innenstadt von Dallas öffnet und die im Innern stattfindenden Aktivitäten zur Schau stellt. Das Museum wird dadurch zu einem öffentlichen Gebäude – einem Gebäude, das sich zur Stadt öffnet, zu ihr gehört und sie belebt. Letztlich ist das Publikum ebenso ein Teil des Museums wie das Museum ein Teil der Stadt."

Les visiteurs du **PEROT MUSEUM OF NATURE AND SCIENCE** sont accueillis par une « forêt d'arbres locaux à large cime et une terrasse xéropaysagiste (aménagement paysager sans irrigation) du désert environnant ». La terrasse est inclinée et monte pour rejoindre le toit en pierre du musée. Selon les architectes : « La masse globale du bâtiment est conçue comme un immense cube flottant sur son socle paysager. Un demi hectare de toit paysager vallonné, composé de rochers et d'herbes indigènes résistantes à la sécheresse, reflète la géologie de Dallas et présente un système vivant appelé à évoluer naturellement avec le temps. » Les différents domaines se croisent à la place de l'entrée principale et font « communiquer le naturel et l'artificiel ». Un vaste atrium contient les escaliers, escalators et ascenseurs, les visiteurs sont guidés vers le niveau supérieur d'où une vue sur le centre de Dallas les attend. Ils redescendent ensuite en traversant le musée. « Le visiteur devient un élément d'architecture, expliquent les architectes, au fur et à mesure que l'angle du bâtiment qui fait face à l'est s'ouvre vers le centre de Dallas pour révéler l'activité de l'intérieur. Le musée est donc un bâtiment fondamentalement public, un bâtiment qui s'ouvre à la cité, lui appartient et l'active ; en fin de compte, le public fait partie intégrante du musée comme le musée fait partie intégrante de la ville. »

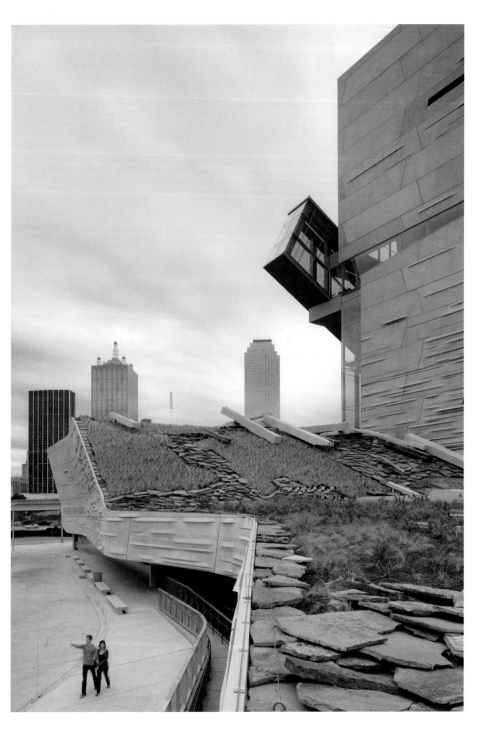

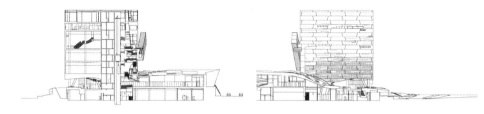

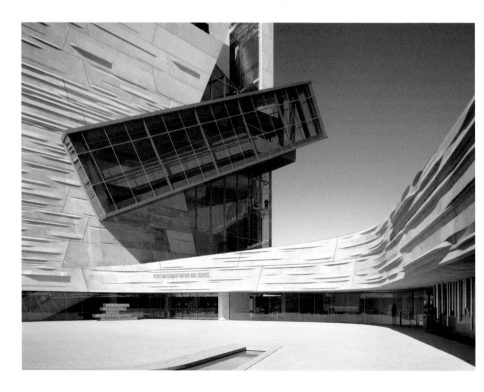

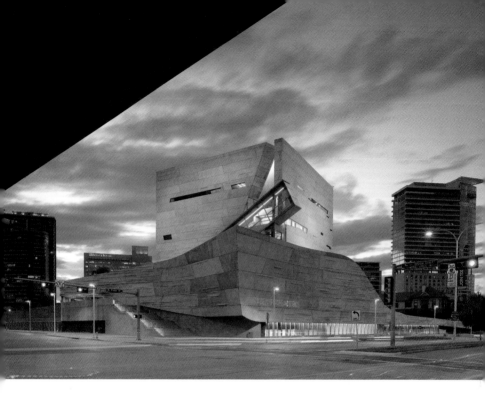

The dramatic forms of the building are accentuated by the steeply angled glass rectangle that contains an escalator. Above left and below, section and elevation drawings.

Die eindrucksvollen Formen des Gebäudes werden vom steilen Winkel des gläsernen Rechtecks betont, das eine Rolltreppe beinhaltet. Oben links und unten: Schnitte und Ansichten.

Les formes spectaculaires du bâtiment sont encore accentuées par le rectangle de verre fortement incliné qui contient un escalator. En haut à gauche et ci-dessous, plans en coupe et en élévation.

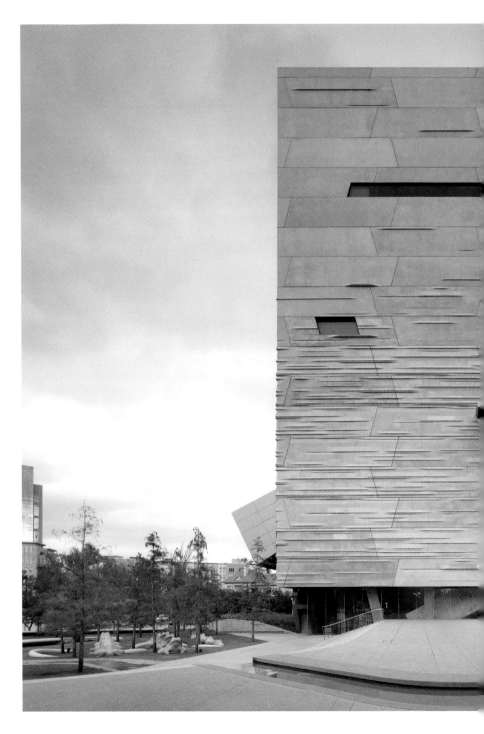

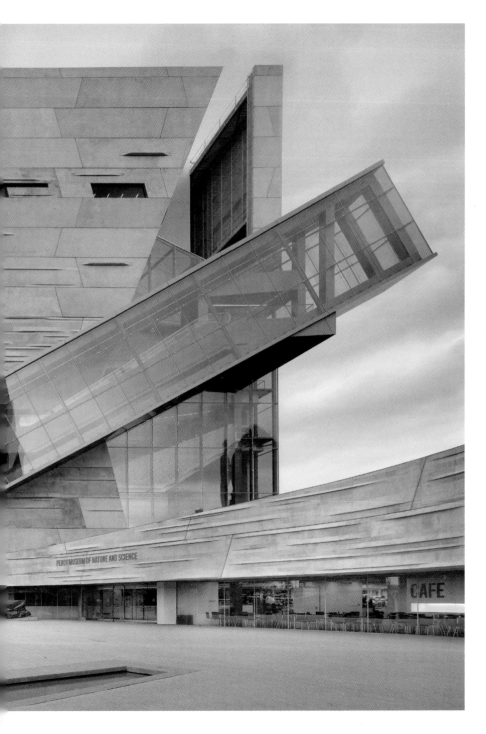

OSCAR NIEMEYER

Born in Rio de Janeiro in 1907, **OSCAR NIEMEYER** studied at the Escola Nacional de Belas Artes. He graduated in 1934 and joined a team of Brazilian architects collaborating with Le Corbusier on a new Ministry of Education and Health in Rio de Janeiro. In 1956, Niemeyer was appointed architectural adviser to Nova Cap—an organization responsible for implementing Lucio Costa's plans for Brazil's new capital, Brasília. The following year, he became its chief architect, designing most of the city's important buildings. In 1964, he sought exile in France for political reasons. There, among other structures, he designed the building for the French Communist Party, in Paris. With the end of the dictatorship, he returned to Brazil. He was awarded the Gold Medal of the American Institute of Architecture in 1970 and the 1988 Pritzker Prize. Even as he approached his 100th birthday in 2007, Niemeyer continued to work on numerous large projects, including the Administrative Center for the province of Minas Gerais in Belo Horizonte; the Auditorium completed in 2005 to celebrate the 50th anniversary of his Ibirapuera Park in São Paulo (published here); and the Cultural Center in Goiânia completed in 2007; all in Brazil. Oscar Niemeyer died in 2012.

Der 1907 in Rio de Janeiro geborene **OSCAR NIEMEYER** studierte an der Escola Nacional de Belas Artes. Er machte seinen Abschluss 1934 und schloss sich einem Team brasilianischer Architekten an, die mit Le Corbusier beim Bau eines neuen Ministeriums für Erziehung und Gesundheit zusammenarbeiteten. 1956 wurde Niemeyer zum architektonischen Berater von Nova Cap berufen – einer Organisation, die für die Umsetzung von Lucio Costas Plänen für Brasília, die neue Hauptstadt Brasiliens, verantwortlich war. Im folgenden Jahr wurde er leitender Architekt von Nova Cap und entwarf die meisten wichtigen Bauten der Stadt. Aus politischen Gründen ging er 1964 ins Exil nach Frankreich. Dort entwarf er u. a. das Gebäude der Kommunistischen Partei Frankreichs in Paris. Nach dem Ende der Diktatur in Brasilien kehrte er dorthin zurück. 1970 erhielt er die Goldmedaille des American Institute of Architecture und 1988 den Pritzker-Preis. Sogar kurz vor seinem 100. Geburtstag 2007 arbeitete Niemeyer noch an zahlreichen Großprojekten, u. a. am Verwaltungszentrum für die Provinz Minas Gerais in Belo Horizonte sowie am 2005 zum 50. Jahrestag seines Ibirapuera-Parks in São Paulo fertiggestellten Auditorium (hier vorgestellt) und am Kulturzentrum in Goiânia, dessen Bau 2007 beendet wurde; alle in Brasilien. Oscar Niemeyer starb 2012.

Né à Rio de Janeiro en 1907, **OSCAR NIEMEYER** étudie à la Escola Nacional de Belas Artes. Diplômé en 1934, il fait partie de l'équipe d'architectes brésiliens qui collabore avec Le Corbusier sur le projet du nouveau ministère de l'Éducation et de la Santé à Rio. En 1956, il est nommé conseiller pour l'architecture de Nova Cap, organisme chargé de la mise en œuvre des plans de Costa pour la nouvelle capitale, Brasília. L'année suivante, il en devient l'architecte en chef, dessinant la plupart de ses bâtiments importants. En 1964, il s'exile en France pour des raisons politiques, où il construit entre autres le siège du parti communiste à Paris. À la fin de la dictature, il retourne au Brésil. Il reçoit la médaille d'or de l'American Institute of Architecture en 1970 et le prix Pritzker en 1988. En 2007, alors même qu'il approchait de son 100e anniversaire, Niemeyer continuait de travailler à plusieurs projets d'envergure parmi lesquels le Centre administratif de la province de Minas Gerais à Belo Horizonte ; l'auditorium (publié ici) achevé en 2005 pour célébrer le 50e anniversaire de son parc d'Ibirapuera à São Paulo et le Centre culturel de Goiânia, terminé en 2007 ; tous au Brésil. Oscar Niemeyer est mort en 2012.

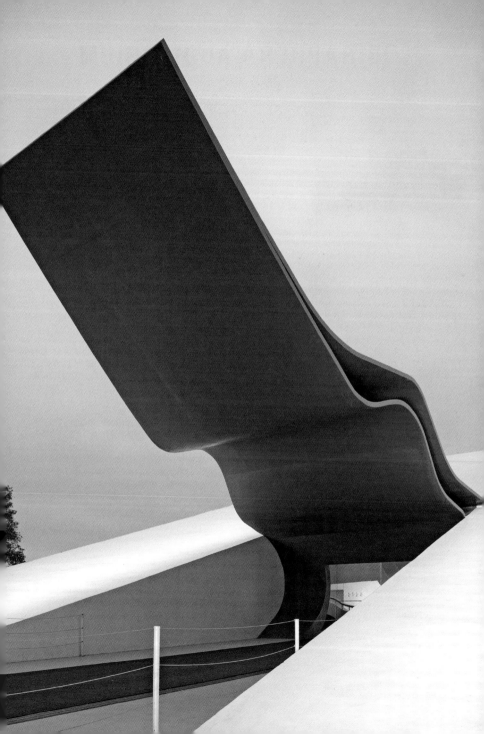

IBIRAPUERA AUDITORIUM

São Paulo, Brazil, 2004–05

Area: 7000 m². Sponsors: TIM (Telecom Italia Mobile) and Municipality of São Paulo.
Cost: €11 million. Collaboration: Ana Elisa Niemeyer, Jair Varela (Architects); José Carlos Sussekind,
Carlos Henrique da Cruz Lima/Casuarina Consultoria Ltda. (Structure); Anna Maria Niemeyer (Furniture).

In 1951, Oscar Niemeyer and the landscape architect Roberto Burle Marx were commissioned to create the Ibirapuera Park planned to commemorate the 400th anniversary of the city of São Paulo. Inaugurated on August 21, 1954, Ibirapuera Park included several structures—a Palace of the Arts, Palace of Nations, Palace of Agriculture, and Palace of Industry, all linked by a curvilinear concrete canopy. The former Palace of Industry, a 250 x 50-meter rectangle, is the location for the celebrated São Paulo Biennale, the largest contemporary art event in Latin America. In 2004, 50 years after the inauguration of Ibirapuera Park, a final element—an auditorium that had been part of Niemeyer's original plan was built, thanks to the generosity of Italian telephone company TIM. Shaped like a wedge, the **IBIRAPUERA AUDITORIUM** seats 850 people and has a generous rear opening, allowing outdoor performances for several thousand spectators. As he often did elsewhere, the architect created a building that resembles an object more than it does a theater in any traditional sense. Indeed, he wrote of the "necessity to add a triangular building to guarantee the white purity of the complex." Restored in part by the talented Brazilian architect Paulo Mendes da Rocha, the Ibirapuera Park complex still clearly reflects the audacious plan of Niemeyer, despite the addition of later structures. Tomie Ohtake, a noted Brazilian artist and mother of the architect Ruy Ohtake, was responsible for the gigantic red sculptural door, a work that continues inside the theater.

1951 erhielten Oscar Niemeyer und der Landschaftsarchitekt Roberto Burle Marx den Auftrag zur Gestaltung des Ibirapuera-Parks, mit dem des 400-jährigen Bestehens von São Paulo gedacht werden sollte. Der am 21. August 1954 eingeweihte Park umfasste mehrere Bauwerke – einen Palast der Künste, Palast der Nationen, Palast der Landwirtschaft und einen Palast der Industrie, die alle durch ein gewundenes Schutzdach aus Beton verbunden waren. Der frühere Palast der Industrie, ein Rechteck von 250 x 50 m, ist der Schauplatz der berühmten Biennale von São Paulo, der größten Schau zeitgenössischer Kunst in Lateinamerika. 50 Jahre nach der Einweihung des Ibirapuera-Parks wurde dank der Großzügigkeit von TIM, einer italienischen Telefongesellschaft, 2004 das bis dahin fehlende Auditorium gebaut, das Bestandteil von Niemeyers ursprünglichem Plan war. Das wie ein Keil geformte **IBIRAPUERA AUDITORIUM** bietet 850 Zuschauern Platz und verfügt über eine sehr großzügig dimensionierte rückwärtige Öffnung, die Aufführungen im Freien für mehrere Tausend Besucher ermöglicht. Wie so häufig schuf der Architekt ein Gebäude, das eher einem Objekt als einem Theater im herkömmlichen Sinn gleicht. In der Tat schrieb er von der „Notwendigkeit, ein dreieckiges Gebäude hinzuzufügen, um die weiße Reinheit der Anlage zu gewährleisten". Der z. T. von dem talentierten brasilianischen Architekten Paulo Mendes da Rocha restaurierte Ibirapuera-Park-Komplex lässt trotz später hinzugekommener Bauten immer noch die kühne Planung Niemeyers erkennen. Tomie Ohtake, eine bekannte brasilianische Künstlerin und Mutter des Architekten Ruy Ohtake, zeichnet verantwortlich für das riesige rote Tor, ein skulpturales Werk, das sich im Inneren des Theaters fortsetzt.

En 1951, Oscar Niemeyer et l'architecte-paysagiste Roberto Burle Marx avaient été chargés de la conception du parc d'Ibirapuera dans le cadre des commémorations du 400ᵉ anniversaire de la fondation de São Paulo. Inauguré le 21 août 1954, ce parc compte plusieurs constructions : un palais des Arts, le palais des Nations, le palais de l'Agriculture et un palais de l'Industrie, reliés par une allée incurvée couverte par un auvent en béton. C'est dans l'ancien palais de l'Industrie, bâtiment rectangulaire de 250 x 50 m que se déroule la célèbre Biennale de São Paulo, plus grande manifestation d'art contemporain d'Amérique du Sud. En 2004, cinquante ans après l'inauguration, un auditorium qui faisait partie des plans d'origine de Niemeyer a été construit grâce au mécénat de la société italienne de téléphones mobiles TIM. En forme de trapèze fermé, l'**IBIRAPUERA AUDITORIUM** de 850 places présente en partie arrière une très grande ouverture qui permet d'organiser des spectacles en plein air pour plusieurs milliers de spectateurs. Comme il l'a souvent fait ailleurs, l'architecte a créé ici une construction qui évoque davantage un objet qu'un théâtre traditionnel. Il a d'ailleurs parlé de « la nécessité d'ajouter à ce projet [de parc] une construction triangulaire qui confirme la pureté immaculée du complexe ». En partie restauré par le talentueux architecte brésilien Paulo Mendes da Rocha, le complexe du parc Ibirapuera reflète toujours l'audacieux plan de son créateur, malgré l'adjonction de quelques autres constructions. Tomie Ohtake, artiste brésilienne connue et mère de l'architecte Ruy Ohtake, a créé la gigantesque porte sculpturale rouge qui se poursuit à l'intérieur du théâtre lui-même.

The new auditorium is essentially a large white wedge set among the other buildings designed by Niemeyer in the Ibirapuera Park 50 years ago.

Das neue Auditorium gleicht im Grunde einem großen, weißen Keil, der inmitten der von Niemeyer vor 50 Jahren entworfenen, anderen Gebäude im Ibirapuera-Park steht.

Le nouvel auditorium se présente essentiellement sous forme d'un grand triangle blanc, inséré parmi d'autres bâtiments conçus par Niemeyer pour le parc d'Ibirapuera cinquante ans plus tôt.

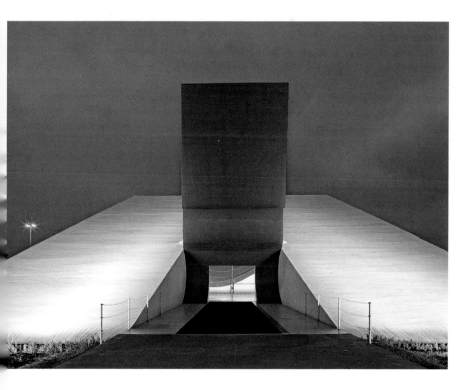

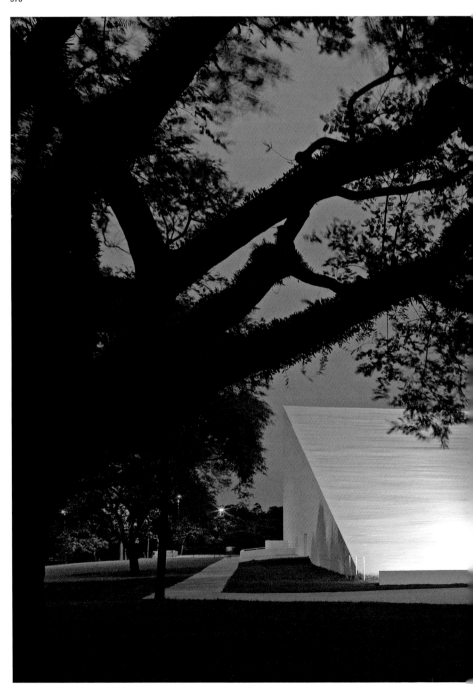

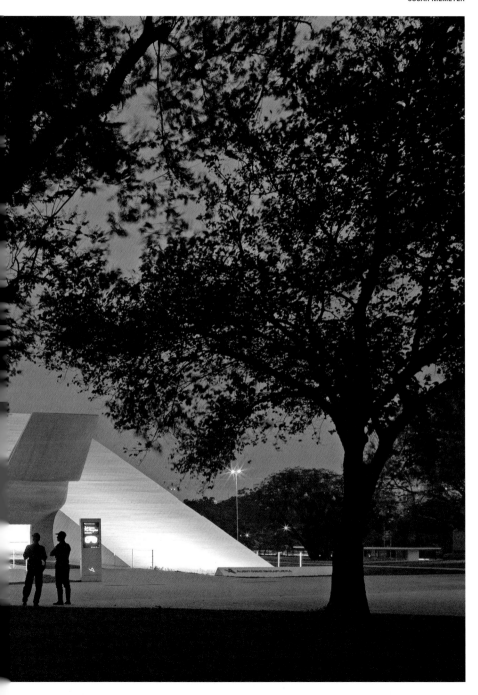

An enormous door to the rear of the stage opening out into the gardens allows for far larger audiences and breaks with the fundamentally closed nature of the architecture.

Ein großes Tor im hinteren Teil der Bühne, das sich zu den Gärten öffnet, ermöglicht weit höhere Besucherzahlen und durchbricht den geschlossenen Charakter der Architektur.

À l'arrière de la scène, une énorme porte s'ouvre sur les jardins, permettant d'accueillir un nombre de spectateurs beaucoup plus grand, rompant le caractère fermé de l'architecture.

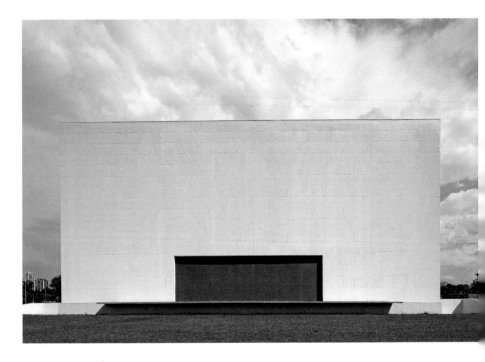

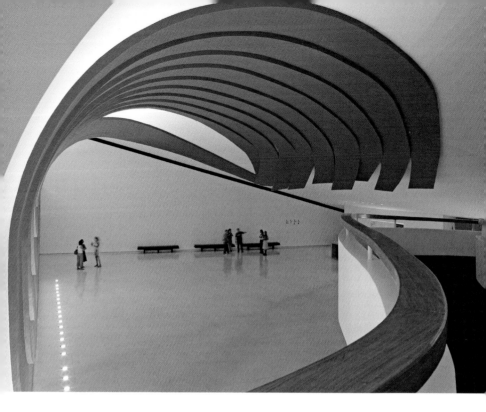

The red forms imagined by the noted artist Tomie Ohtake sweep from the main exterior door into the lobby of the auditorium where Niemeyer has installed one of his signature spiral ramps.

Die von der bekannten Künstlerin Tomie Ohtake erdachten roten Formen geleiten vom Haupteingang in die Lobby des Auditoriums, wo Niemeyer eine seiner typischen Wendeltreppen einbaute.

Les inserts rouges imaginés par l'artiste Tomie Ohtake partent de la porte principale et se développent dans le hall de l'auditorium où Niemeyer a implanté l'une de ses célèbres rampes en spirale.

NIETO SOBEJANO

FUENSANTA NIETO and **ENRIQUE SOBEJANO** graduated as architects from the ETSA Madrid and the Graduate School of Architecture at Columbia University in New York. They are currently teaching at the Universidad Europea de Madrid (UEM) and at the University of the Arts (UdK) in Berlin, and are the managing Partners of Nieto Sobejano Arquitectos. Both have been visiting critics and/or teachers at the GSD at Harvard University, University of Arizona, Technical University (Munich), ETSA Barcelona, University of Turin, University of Stuttgart, UdK in Berlin, University of Cottbus, Columbia University, and the University of Texas (Austin). Their work has been exhibited, among other locations, at the Museum of Modern Art in New York: "On Site: New Architecture in Spain" (2006). They won the National Prize for Conservation and Restoration of Cultural Patrimony for their extension of the National Sculpture Museum (Valladolid, Spain, 2007); and have recently completed the Madinat al-Zahra Museum and Research Center (Córdoba, Spain, 2005–08); the Moritzburg Museum Extension (Halle, Saale, Germany, 2006–08); Plaza Santa Bárbara (Madrid, Spain, 2009); and the Contemporary Art Center Córdoba (Córdoba, Spain, 2008–13, published here).

FUENSANTA NIETO und **ENRIQUE SOBEJANO** studierten an der Escuela Técnica Superior de Arquitectura (ETSA) in Madrid und an der Graduate School of Architecture der Columbia University in New York. Gegenwärtig lehren sie an der Universidad Europea de Madrid (UEM) sowie der Universität der Künste (UdK) in Berlin und sind geschäftsführende Partner von Nieto Sobejano Arquitectos. Beide haben als Gastkritiker und/oder -lehrer an der Graduate School of Design der Harvard University, der University of Arizona, der Technischen Universität München, der ETSA Barcelona, der Universität Turin, der Universität Stuttgart, der UdK in Berlin, der Universität Cottbus, der Columbia University und der University of Texas (Austin) gearbeitet. Ihre Arbeiten wurden an verschiedenen Orten und auch im Museum of Modern Art in New York in der Ausstellung „On Site: New Architecture in Spain" (2006) gezeigt. Sie gewannen den spanischen Nationalpreis für Denkmalpflege für ihre Erweiterung des staatlichen Skulpturenmuseums (Valladolid, Spanien, 2007) und haben vor Kurzem fertiggestellt: das Museum und Forschungszentrum Madinat-al-Zahra (Córdoba, Spanien, 2005–08), die Erweiterung des Museums Moritzburg in Halle (Deutschland, 2006–08), die Plaza Santa Bárbara (Madrid, Spanien, 2009) und das Zentrum für zeitgenössische Kunst Córdoba (Córdoba, Spanien, 2008–13, hier vorgestellt).

FUENSANTA NIETO et **ENRIQUE SOBEJANO** sont architectes diplômés de l'ETSA Madrid et de la Graduate School of Architecture à l'université Columbia de New York. Ils enseignent actuellement à l'Universidad Europea de Madrid (UEM) et à l'Université des arts (UdK) de Berlin, tout en étant les partenaires et dirigeants de Nieto Sobejano Arquitectos. Ils ont tous les deux été critiques associés et/ou enseignants à la Harvard GSD, l'université d'Arizona, l'Université technique (Munich), l'ETSA Barcelona, l'université de Turin, l'université de Stuttgart, l'UdK de Berlin, l'université de Cottbus, l'université Columbia et l'université du Texas (Austin). Leur travail a été exposé, notamment au Musée d'art moderne de New York : « On Site: New Architecture in Spain » (2006). Ils ont remporté le prix national de conservation et restauration du patrimoine culturel pour leur extension du Musée national de sculpture (Valladolid, Espagne, 2007) et ont achevé récemment le musée et centre de recherches Madinat al-Zahra (Cordoue, Espagne, 2005–08) ; l'extension du musée Moritzburg (Halle, Saale, Allemagne, 2006–08) ; la Plaza Santa Bárbara (Madrid, Espangne, 2009) et le Centre d'art contemporain de Cordoue (2008–13, Espangne, publié ici).

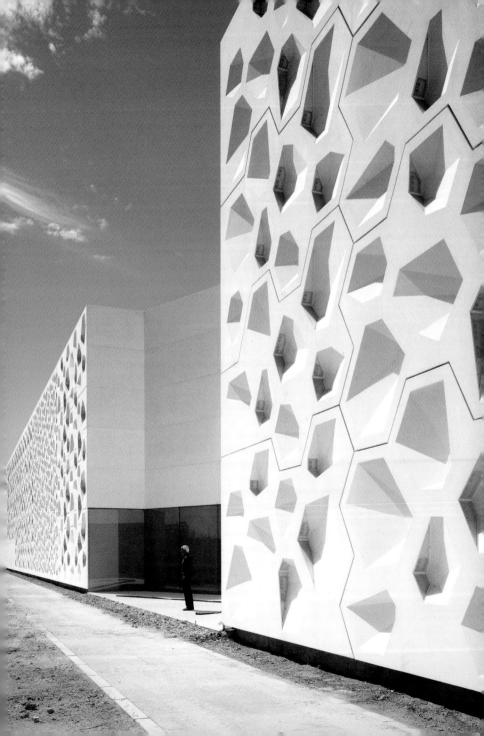

CONTEMPORARY
ART CENTER CÓRDOBA

Córdoba, Spain, 2008–13

*Area: 10 000 m². Client: Government of Andalucia. Cost: €26 612 162.
Collaboration: Vanesa Manrique (Project Architect), realities:united
(Communicative Façade Lighting).*

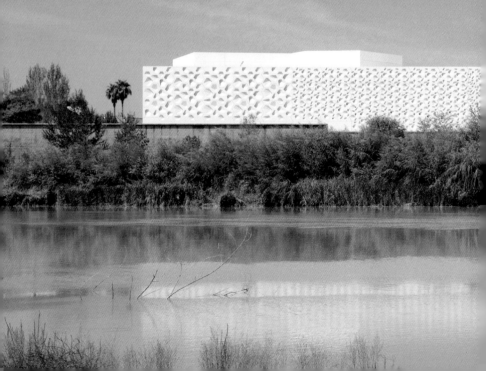

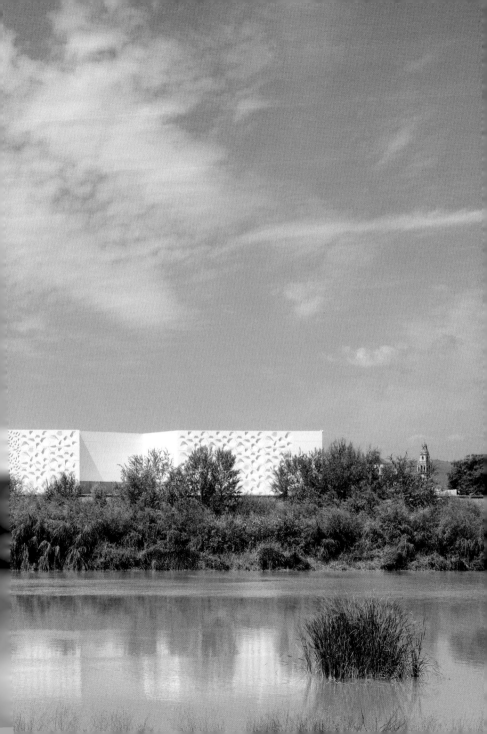

The architects were the winners of a 2005 competition for the design of the **CONTEMPORARY ART CENTER CÓRDOBA**. Their project is intended not to be a centralized building, but rather one in which "a sequence of precincts (are) linked to a public space, onto which all the different functions of the building flow. Conceived as a place for interaction, it is a common space in which one can express and exchange ideas, see an installation, access exhibitions, visit the cafeteria, spend time in the media library, wait for a performance to begin in the black box, or maybe simply look out onto the Guadalquivir River." Bare walls, concrete, and continuous paved flooring were chosen "to achieve an art factory character." Prefabricated concrete fiberglass panels (GRC) are used for the exterior cladding. The architects conclude: "The building will be a gathering place for artists, visitors, experts, researchers, and onlookers, as in a contemporary cultural souk, with no evident spatial hierarchies."

Die Architekten waren die Sieger im Wettbewerb von 2005 für das **ZENTRUM FÜR ZEITGENÖSSISCHE KUNST CÓRDOBA**. Ihr Entwurf sollte kein zentral orientierter Bau sein, vielmehr einer, in dem „eine Folge von Räumen mit einem öffentlichen Bereich verbunden ist, auf den alle unterschiedlichen Funktionen des Gebäudes zulaufen. Es wurde als Ort für Interaktionen konzipiert, als gemeinschaftlicher Bereich, in dem man Ideen ausdrücken und austauschen, eine Installation betrachten, Ausstellungen besuchen, die Cafeteria aufsuchen, Zeit in der Medienbibliothek verbringen, auf den Beginn einer Vorführung in der Blackbox warten oder einfach nur auf den Fluss Guadalquivir schauen kann." Nackte Wände, Beton und durchgehend gepflasterter Boden wurden gewählt, „um den Charakter einer Kunstfabrik zu erreichen". Vorfabrizierte GRC-Platten aus Beton und Glasfaser wurden für die Außenverkleidung verwendet. Die Architekten erklären abschließend: „Das Gebäude wird ein Ort der Begegnung sein für Künstler, Besucher, Fachleute, Forscher und Zuschauer, wie in einem zeitgenössischen kulturellen Souk, mit keinerlei räumlichen Hierarchien."

Les architectes ont remporté un concours organisé en 2005 pour la construction du **CENTRE D'ART CONTEMPORAIN DE CORDOUE**. Leur concept se veut, non un bâtiment centralisé, mais plutôt un bâtiment dans lequel « une suite d'enceintes sont reliées à un espace public vers lequel convergent les différentes fonctions. Conçu comme un lieu interactif, c'est un espace commun où s'exprimer et échanger des idées, voir une installation, accéder à des expositions, boire un verre à la cafétéria, passer du temps dans la médiathèque, attendre qu'une performance commence dans la boîte noire ou simplement contempler le Guadalquivir au dehors ». Les murs nus, le béton et le sol pavé uniforme ont été choisis pour « donner à l'ensemble un caractère de type art factory ». Le revêtement extérieur est en panneaux préfabriqués de béton renforcé de fibre de verre (CCV). Les architectes concluent : « Le bâtiment sera un lieu de rassemblement pour les artistes, les visiteurs, les experts, les chercheurs et les spectateurs, à l'image d'un souk culturel contemporain, sans aucune hiérarchie spatiale évidente. »

The cutout prefabricated concrete fiberglass panels used for the façade are varied in the degree of their openings, with some surfaces tending to the opaque as seen above.

Die für die Fassade verwendeten vorfabrizierten Platten aus Glasfaserbeton haben unterschiedlich viele Öffnungen, während einige Flächen auch fast geschlossen bleiben, wie oben zu sehen ist.

Les panneaux préfabriqués de béton renforcé de fibres de verre découpés utilisés pour la façade du bâtiment présentent des degrés d'ouverture variables, certaines surfaces sont presque opaques, comme ici en haut.

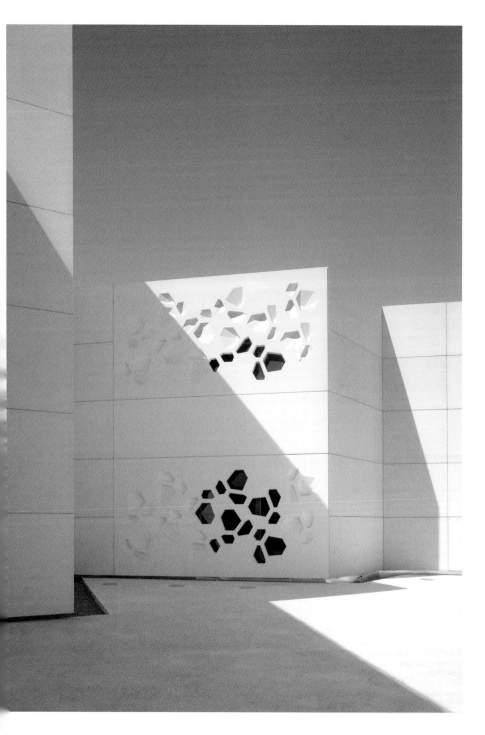

388

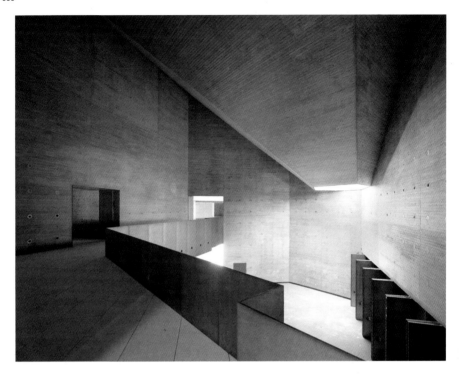

The strong, unusually angled concrete surfaces inside the center are contrasted with openings for natural light or fully glazed surfaces.

Die kräftigen, ungewöhnlich abgewinkelten Betonflächen im Innern des Gebäudes kontrastieren mit Öffnungen zur natürlichen Belichtung oder voll verglasten Flächen.

À l'intérieur du Centre, les solides surfaces de béton aux angles surprenants contrastent avec des ouvertures qui laissent entrer la lumière du jour ou d'autres surfaces entièrement vitrées.

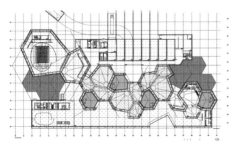
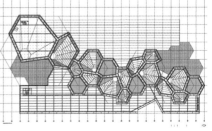

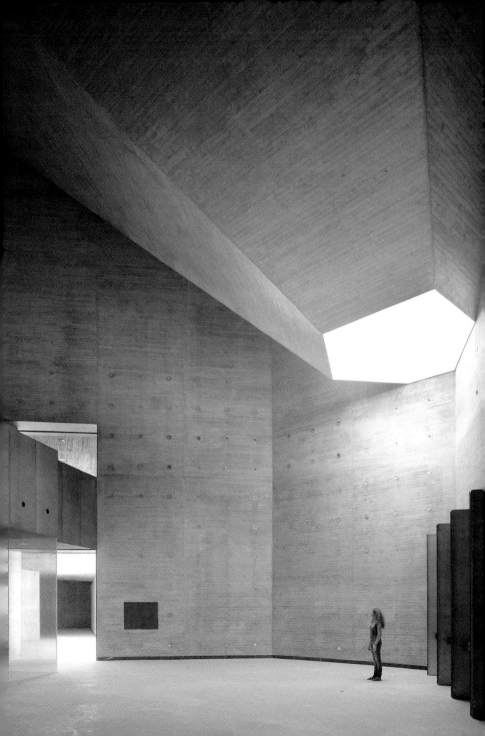

RYUE NISHIZAWA

RYUE NISHIZAWA was born in Tokyo, Japan, in 1966. He graduated from Yokohama National University with an M.Arch in 1990, and joined the office of Kazuyo Sejima & Associates in Tokyo the same year. In 1995, he established SANAA with Kazuyo Sejima, and two years later his own practice, the Office of Ryue Nishizawa. He has worked on all the significant projects of SANAA and has been a Visiting Professor at Yokohama National University (2001–), the University of Singapore (2003), Princeton (2006), and the Harvard GSD (2007). His work outside SANAA includes a Weekend House (Gunma, 1998); the N Museum (Kagawa, 2005); the Moriyama House (Tokyo, 2006); House A (East Japan, 2006); Towada Art Center (Aomori, 2006–08); the Teshima Art Museum (Teshima Island, Kagawa, 2009–10, published here); Garden and House (Tokyo, 2010–11); and the Hiroshi Senju Museum (Karuizawa, Nagano, 2011), all in Japan.

RYUE NISHIZAWA wurde 1966 in Tokio geboren und schloss sein Studium 1990 mit einem M.Arch. an der Nationaluniversität in Yokohama ab. Noch im selben Jahr schloss er sich dem Büro von Kazuyo Sejima & Associates in Tokio an. Gemeinsam mit Kazuyo Sejima gründete er 1995 SANAA, zwei Jahre später sein eigenes Büro Ryue Nishizawa. Er war an sämtlichen Schlüsselprojekten von SANAA beteiligt und hatte Gastprofessuren an der National-universität Yokohama (seit 2001), der Universität von Singapur (2003), in Princeton (2006) sowie an der Harvard GSD (2007). Zu seinen Projekten unabhängig von SANAA zählen ein Wochenendhaus (Gunma, 1998), das N Museum (Kagawa, 2005), das Haus Moriyama (Tokio, 2006), das Haus A (Ostjapan, 2006), das Towada Art Center (Aomori, 2006–08), das Kunstmuseum auf Teshima (Teshima, Kagawa, 2009–10, hier vorgestellt), Garten und Haus (Tokio, 2010–11) und das Hiroshi Senju Museum (Karuizawa, Nagano, 2011), alle in Japan.

RYUE NISHIZAWA, né à Tokyo en 1966, a obtenu son M.Arch. à l'Université nationale de Yokohama (1990). Il a commencé à travailler dans l'agence de Kazuyo Sejima & Associates à Tokyo la même année, avant qu'ils ne fondent ensemble SANAA en 1995 et sa propre agence Office of Ryue Nishizawa deux ans plus tard. Il a été professeur invité à l'Université nationale de Yokohama (2001–), aux universités de Singapour (2003), Princeton (2006) et la Harvard GSD (2007). Il est intervenu sur tous les grands projets de SANAA. Son œuvre personnelle comprend une maison de week-end (Gunma, 1998) ; le musée N (Kagawa, 2005) ; la maison Moriyama (Tokyo, 2006) ; la maison A (Japon oriental, 2006) ; le Centre d'art Towada (Aomori, 2006–08) ; le Musée d'art de Teshima (île de Teshima, Kagawa, 2009–10, publié ici) ; un jardin et maison (Tokyo, 2010–11) ; et le musée Hiroshi Senju (Karuizawa, Nagano, 2011), tout au Japon.

TESHIMA ART MUSEUM

Teshima Island, Kagawa, Japan, 2009–10

Area: 2335 m². Client: Naoshima Fukutake Art Museum Foundation.
Collaboration: Rei Naito (Artist).

Teshima is a small island located in Japan's Seto Inland Sea, not far from Naoshima, where Tadao Ando has worked for over 20 years on various projects. The same client commissioned Ryue Nishizawa to build the **TESHIMA ART MUSEUM**. "We proposed an architectural design composed of free curves, echoing the shape of a water drop," says the architect. "Our idea was that the curved drop-like form would create a powerful architectural space in harmony with the undulating landforms around it." The remarkable thin concrete shell of the structure reaches over four meters at its maximum ceiling height, "creating a large, organic interior space," but remains very horizontal inside. Openings in the shell let light, air, and rain inside. Rei Naito's subtle work is based on water, and Nishizawa concludes: "Our goal is to generate a fusion of the environment, art, and architecture, and we hope these three elements work together as a single entity."

Teshima ist eine kleine Insel in der Seto-Inlandsee, unweit von Naoshima, wo Tadao Ando seit über 20 Jahren an einer Reihe von Projekten arbeitet. Derselbe Bauherr beauftragte Ryue Nishizawa mit dem Bau des **KUNSTMUSEUM AUF TESHIMA**. „Wir entwickelten einen Entwurf aus frei geformten Kurven, die der Form eines Wassertropfens nachempfunden sind", erklärt der Architekt. „Unsere Idee war es, durch die geschwungene, tropfenartige Form einen eindringlichen architektonischen Raum zu schaffen, der mit der Hügellandschaft harmoniert." Die erstaunlich dünnwandige Betonschale des Baus erreicht an ihrem höchsten Punkt eine Höhe von über 4 m, wodurch „ein großer, organischer Innenraum entsteht". Im Innern dominieren jedoch horizontale Formen. Öffnungen in der Gebäudeschale lassen Licht, Luft und Regen in den Bau. Die feinsinnige Kunst der Bildhauerin Rei Naito kreist um Wasser, und Nishizawa fasst zusammen: „Unser Ziel ist eine Verschmelzung von Umwelt, Kunst und Architektur; wir hoffen, diese drei Elemente zu einer Einheit zusammenzuführen."

Teshima est une petite île de la mer Intérieure du Japon, non loin de Naoshima où Tadao Ando a travaillé pendant plus de 20 ans sur divers projets. Le même client a demandé à Ryue Nishizawa de construire le **MUSÉE D'ART DE TESHIMA**. «Nous avons proposé un projet en courbes libres qui rappelle la forme d'une goutte d'eau», explique l'architecte. «Notre idée était que cette forme en goutte crée un espace architectural fort en harmonie avec les formes du terrain tout autour.» L'étonnante coque mince en béton s'élève à plus de 4 m en son point culminant, «déterminant un vaste volume organique intérieur» au-dessus d'un plan horizontal. Des ouvertures pratiquées dans la coque laissent passer la lumière, l'air et la pluie. Le subtil travail de l'artiste présentée, Rei Naito, s'inspire de l'eau. «Notre objectif est de fusionner l'environnement, l'art et l'architecture pour que ces trois éléments fonctionnent en une entité unique», conclut l'architecte.

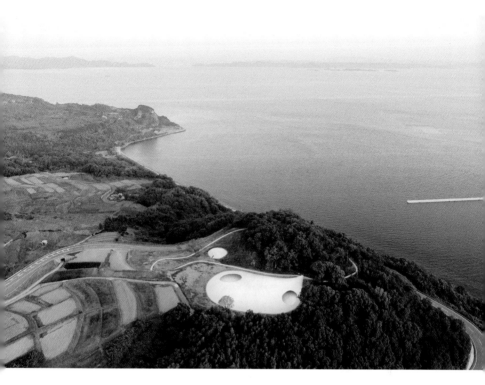

The Teshima Art Museum is in many senses set into its environment, as can be seen in the topographical site plan (left) and the photos on this page.

Das Kunstmuseum von Teshima ist in vieler Hinsicht in sein Umfeld eingebunden, wie der topografische Lageplan zeigt (links bzw. Aufnahmen auf dieser Seite).

Le Musée d'art de Teshima est à de nombreux égards totalement intégré à son environnement, comme le montrent le plan topographique à gauche ainsi que les photos.

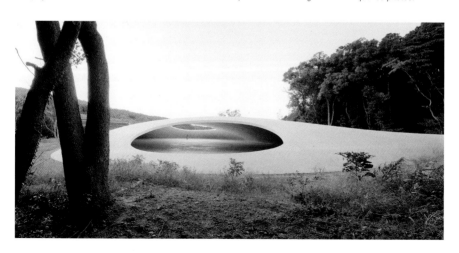

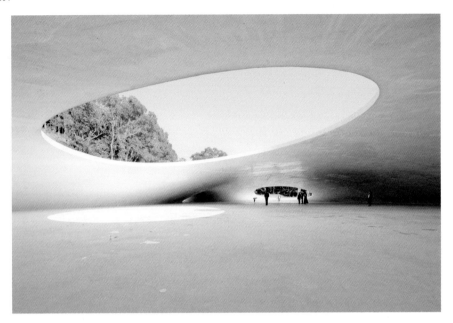

Shaped like a drop of water, the structure has several large, round openings that allow natural light to enter it, and, indeed, for rain to come in as well.

Der wie ein Wassertropfen geformte Bau hat mehrere runde Öffnungen, durch die Tageslicht einfällt – ebenso wie Regen.

En forme de goutte d'eau, le musée est percé de plusieurs ouvertures rondes qui laissent pénétrer le soleil et la pluie.

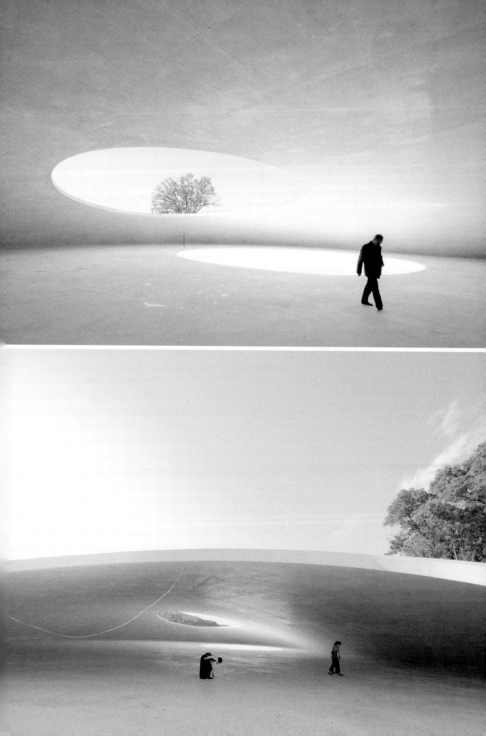

VALERIO OLGIATI

VALERIO OLGIATI was born in Chur, Switzerland, in 1958. He studied architecture at the ETH in Zurich, and in 1986 he created his own architectural office in the same city. From 1993 to 1995 he collaborated with Frank Escher in Los Angeles. Escher is a specialist in the work of the architect John Lautner (1911–94). Since 1998 he has been teaching at the ETH Zurich and has served as Guest Lecturer at the Architectural Association (AA) in London and at Cornell University (Ithaca, New York). Since 2002, he has been a full Professor at the Accademia di Architettura at the Università della Svizzera Italiana in Mendrisio (Switzerland). In 2009 he held the Kenzo Tange Chair at Harvard University (Cambridge, Massachusetts). He has built a number of private homes and participated in numerous competitions. Three of his recent projects—the Peak Gornergrat, the University of Lucerne, and the Perm Museum XXI—were competition-winning entries, but have not been built. He completed Atelier Bardill (Scharans, Switzerland, 2006–07, published here) and the Office in Flims (Switzerland, 2007), before opening his new office there in 2008, and finished the Swiss National Park Visitor Center the same year (Zernez, Switzerland, 2006–08). In 2010, he completed the Plantahof Auditorium (Landquart, Switzerland).

VALERIO OLGIATI wurde 1958 in Chur, Schweiz, geboren und studierte Architektur an der Eidgenössischen Technischen Hochschule in Zürich. 1986 gründete er dort sein eigenes Büro. Von 1993 bis 1995 arbeitete er zusammen mit Frank Escher in Los Angeles. Escher ist Spezialist für die Bauten des Architekten John Lautner (1911–94). Olgiati lehrt seit 1998 an der ETH Zürich und war Gastdozent an der Architectural Association (AA) in London und an der Cornell University (Ithaca, New York). Seit 2002 hat er eine ordentliche Professur an der Accademia di Architettura der Università della Svizzera Italiana in Mendrisio (Tessin). 2009 hatte er den Kenzo-Tange-Lehrstuhl an der Harvard University (Cambridge, Massachusetts) inne. Er hat zahlreiche Einfamilienhäuser gebaut und an vielen Wettbewerben teilgenommen. Drei seiner jüngeren Projekte, der Peak Gornergrat, die Universität Luzern und das Perm Museum XXI, waren preisgekrönte Wettbewerbsentwürfe, wurden aber nie realisiert. Kürzlich ausgeführte Bauten sind das Atelier Bardill im schweizerischen Scharans (2006–07, hier vorgestellt) und das Bürogebäude in Flims (Schweiz, 2007), in dem er 2008 sein eigenes neues Büro eröffnete, sowie das Besucherzentrum im Schweizer Nationalpark (Zernez, 2006–08). 2010 wurde das Auditorium Plantahof (Landquart, Schweiz) fertig.

VALERIO OLGIATI, né à Chur (Suisse) en 1958, a étudié l'architecture à l'ETH de Zurich où il ouvre son agence en 1986. De 1993 à 1995, il collabore avec Frank Escher à Los Angeles, spécialiste de l'œuvre de l'architecte John Lautner (1911–94). Depuis 1998, il enseigne à l'ETH et est conférencier invité à l'Architectural Association de Londres (AA) et à l'université Cornell (Ithaca, New York). Depuis 2002, il est professeur titulaire à l'Accademia di Architettura de l'Universita della Svizzera Italiana à Mendrisio et a été nommé en 2009 titulaire de la Kenzo Tange Chair à l'université Harvard (Cambridge, Massachusetts). Il a réalisé un certain nombre de résidences privées et participé à de nombreux concours. Trois de ses projets récents, le Pic de Gornergrat, l'université de Lucerne et le Museum XXI de Perm ont remporté des prix mais n'ont pas été réalisés. Il a achevé l'atelier Bardill (Scharans, Suisse, 2006–07, publié ici) et les bureaux à Flims (Suisse, 2007) avant d'y ouvrir sa nouvelle agence en 2008 et d'achever le Centre d'accueil des visiteurs du Parc national suisse de Zernez la même année (Zernez, Suisse, 2006–08). En 2010, il a achevé l'auditorium Plantahof (Landquart, Suisse).

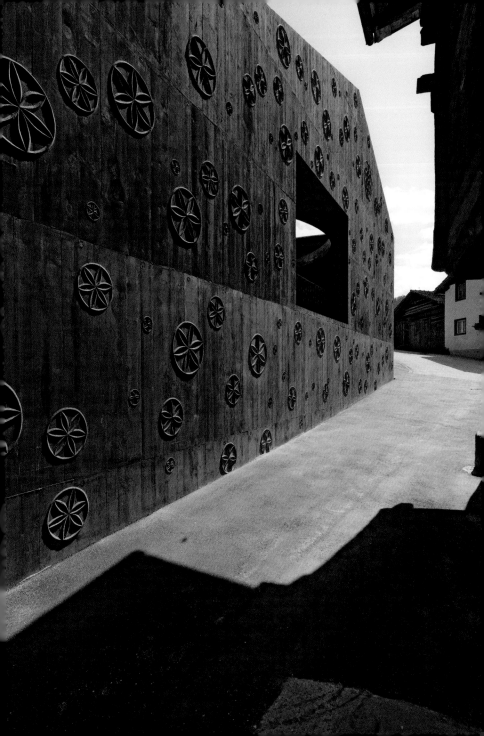

ATELIER BARDILL

Scharans, Switzerland, 2006–07

Floor area: 70 m² (atelier); 65 m² (garage, storage, technical). Client: Linard Bardill.
Collaborators: Nathan Ghiringhelli, Nikolai Müller, Mario Beeli (Project Managers);
Linard Bardill (Construction Supervisor); Patrick Gartmann, Conzett, Bronzini,
Gartmann AG, Chur (Structural Engineer).

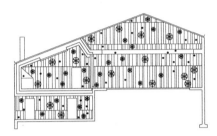

Scharans is an old town with a population of about 800 people located in the Graubünden region of Switzerland. This private atelier for the musician and poet Linard Bardill replaces an old barn in the protected center of the town. Building permission was granted by local authorities on the condition that the new structure would be the same color as the barn. Indeed, Olgiati's design also assumes the shape of the former barn, with its rather blank austerity. Rather than old wood, however, it is made of red poured-in-place concrete, steel, and copper. The only variations in the surface of the concrete are due to the wood of the casting forms and to a repeated, irregular low-relief pinwheel pattern that is typical of local decorative designs. A courtyard with a large oval opening to the sky allows the architecture to attain "greatness and clearness in contrast to the arbitrary geometry of its external appearance and to the small-scale environment of the village." Despite its austerity and simplicity, the **ATELIER BARDILL** is both surprising and challenging in the sense that it is located in the heart of an old Swiss village.

Scharans ist eine alte Gemeinde mit rund 800 Einwohnern im Schweizer Kanton Graubünden. Im geschützten Dorfkern, am früheren Standort eines alten Stalls, baute Olgiati ein Atelier für den Dichter und Musiker Linard Bardill. Die Baugenehmigung war von der Gemeindeverwaltung unter der Bedingung erteilt worden, dass die neue Konstruktion die gleiche Farbe wie die alte haben müsse. Zwar übernahm Olgiati in seinem karg-nüchternen Entwurf die Form des Stalls, anstelle von altem Holz verwendete er jedoch rot gefärbten Ortbeton, Stahl und Kupfer. Dass die Oberflächenstruktur des Betons nicht durchgängig glatt ist, liegt zum einen an den Spuren, die die Holzschalungen hinterlassen haben, zum anderen an den unregelmäßig verteilten Flachrelief-Rosetten, deren Muster sich in der Region häufig als Dekor findet. Durch einen Innenhof mit einer ovalen Öffnung zum Himmel erhält die Architektur „eine Größe und Klarheit, die einen Gegensatz zu der willkürlichen Geometrie ihrer äußeren Erscheinung und der überschaubaren dörflichen Umgebung bildet". Trotz seiner kargen Schlichtheit und der Tatsache, dass er sich im Herzen eines alten Schweizer Dorfes befindet, ist Olgiatis **ATELIER BARDILL** so ungewöhnlich wie herausfordernd.

Scharans est un ancien village de 800 habitants environ situé dans le canton des Grisons suisse. L'atelier conçu pour le musicien et poète Linard Bardill occupe l'emplacement d'une vieille grange dans le centre classé du village. Le permis de construire a été accordé à condition que la nouvelle structure conserve la couleur de l'ancienne. Le projet d'Olgiati reprend la forme de la grange dans sa sévère austérité, mais au lieu du bois, il a utilisé le béton coulé en place teinté rouge, acier et cuivre. Les seuls effets de surface du béton sont dus au bois des coffrages et à un motif répétitif irrégulier d'étoile en bas-relief, typique de la région. Une cour qui ouvre sur le ciel par une grande ouverture ovale permet à l'architecture d'atteindre « une grandeur et une clarté qui contraste avec la géométrie arbitraire de son aspect extérieur et l'environnement à petite échelle du village ». Malgré cette austérité et cette simplicité, l'**ATELIER BARDILL** est à la fois surprenant et provocant par sa position au cœur même d'un vieux village suisse.

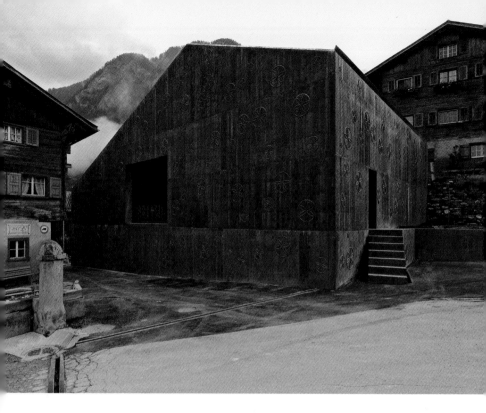

The Atelier Bardill stands out against its old-village setting and yet it is very much inspired by local designs, even if the concrete employed is less than traditional.

Das Atelier Bardill sticht zwar aus der Kulisse des alten Dorfes heraus, dennoch orientiert es sich – wenngleich der verwendete Beton alles andere als traditionell ist – deutlich an lokalen Bautraditionen.

L'atelier Bardill se singularise par rapport à son cadre de village ancien, tout en étant très inspiré par les formes vernaculaires locales, même si le béton employé est bien loin des matériaux traditionnels.

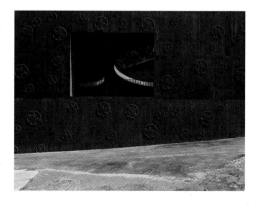

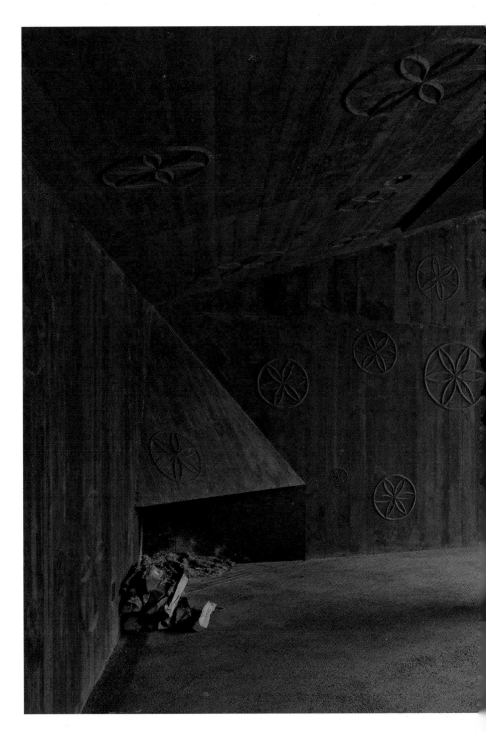

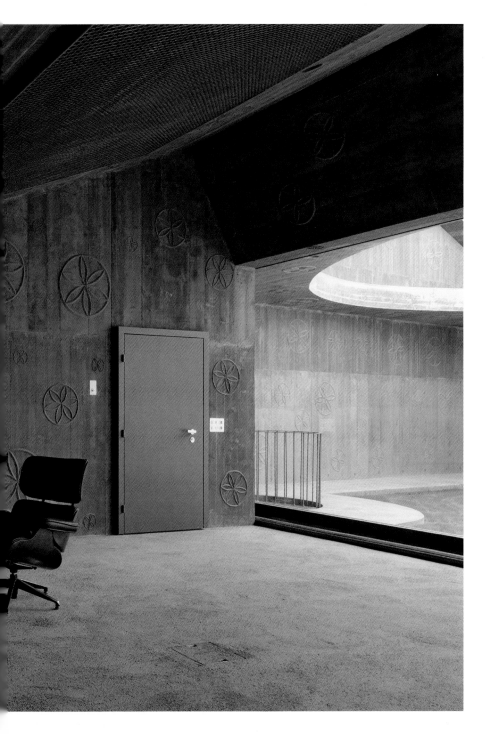

PEZO VON ELLRICHSHAUSEN

Pezo Von Ellrichshausen Arquitectos was founded in Buenos Aires in 2001 by Mauricio Pezo and Sofía Von Ellrich-shausen. **MAURICIO PEZO** was born in Chile in 1973 and completed his M.Arch degree at the Catholic University of Chile (Santiago, 1998). He graduated from the University of Bío-Bío (Concepción, 1999). He is a visual artist and director of the Movimiento Artista del Sur (MAS). **SOFÍA VON ELLRICHSHAUSEN** was born in Argentina in 1976. She holds a degree in architecture from the University of Buenos Aires (Buenos Aires, 2002). They were awarded the Commended Prize at the AR Awards for Emerging Architecture (London, 2005) and the Best Work by Young Architects Prize at the fifth Iberoameri-can Architecture Biennial (Montevideo, 2006). Their built work includes XYZ Pavilions (Concepción, 2001); Rivo House (Valdivia, 2003); 120 Doors Pavilion (Concepción, 2003); Poli House (Coliumo, 2005); Wolf House (Andalue, 2006–07); Parr House (Chiguayante, 2008); Fosc House (San Pedro, 2008–09, published here); and several public art projects. Their more recent work includes the Arco (2010) and Cien (2009–11) Houses (both in Concepción); and the Gold Building (Concepción, 2011), all in Chile. Their Solo House (Cretas, Spain) and Blue Pavilion (London, UK) both date from 2013.

Pezo Von Ellrichshausen Arquitectos wurde 2001 in Buenos Aires von Mauricio Pezo und Sofía Von Ellrichshausen gegründet. **MAURICIO PEZO** wurde 1973 in Chile geboren, erlangte seinen M.Arch. an der Universidad Católica de Chile (Santiago, 1998) und schloss sein Studium an der Universidad del Bío-Bío (Concepción, 1999) ab. Er ist bildender Künstler und Direktor des Movimiento Artista del Sur (MAS). **SOFÍA VON ELLRICHSHAUSEN** wurde 1976 in Argentinien geboren. Ihr Architekturstudium schloss sie an der Universität Buenos Aires ab (2002). Ausgezeichnet wurde das Team mit dem Empfehlungspreis bei den AR Awards for Emerging Architecture (London, 2005) sowie als bestes Projekt junger Architekten auf der fünften Iberoamerikanischen Architekturbiennale (Montevideo, 2006). Zu ihren realisierten Bauten, alle in Chile, zählen u. a. die XYZ-Pavillons (Concepción, 2001), das Haus Rivo (Valdivia, 2003), der 120-Türen-Pavillon (Concepción, 2003), das Haus Poli (Coliumo, 2005), das Haus Wolf (Andalue, 2006–07), das Haus Parr (Chiguayante, 2008), das Haus Fosc (San Pedro, 2008–09, hier vorgestellt) sowie verschiedene öffentliche Kunstprojekte. Weitere Projekte sind das Haus Arco (2010) und das Haus Cien (2009–11) sowie das Gold-Gebäude (2011), alle drei in Concepción. Ihr Haus Solo (Cretas, Spanien) und der Blue Pavilion (London) wurden 2013 fertiggestellt.

L'agence Pezo Von Ellrichshausen Arquitectos a été fondée à Buenos Aires en 2001 par Mauricio Pezo et Sofía von Ellrichshausen. **MAURICIO PEZO**, né au Chili en 1973, a obtenu son diplôme de M.Arch. à l'Université catholique du Chili (Santiago, 1998) et est diplômé de l'université Bío-Bío (Concepción, 1999). Artiste plasticien, il est directeur du Movimiento Artista del Sur (MAS). **SOFÍA VON ELLRICHSHAUSEN**, née en Argentine en 1976, est diplômée en archi-tecture de l'université de Buenos Aires (2002). Ils ont reçu le prix de l'Architectural Review pour l'architecture émergente (Londres, 2005) et le prix de la meilleure œuvre de jeunes architectes à la Vᵉ Biennale d'architecture ibéro-améri-caine (Montevideo, 2006). Parmi leurs réalisations, toutes au Chili : les pavillons XYZ (Concepción, 2001) ; la maison Rivo (Valdivia, 2003) ; le pavillon des 120 portes (Concepción, 2003) ; la maison Poli (Coliumo, 2005) ; la maison Wolf (Andalue, 2006–07) ; la maison Parr (Chiguayante, 2008) ; la maison Fosc (San Pedro, 2008–09, publiée ici) et plusieurs projets artistiques publics. Plus récemment, ils ont réalisé les maisons Arco (2010) et Cien (2009–11) et l'immeuble Gold (2011), toutes à Concepción. Leur maison Solo (Cretas, Espagne) et le Blue Pavilion (Londres) datent de 2013.

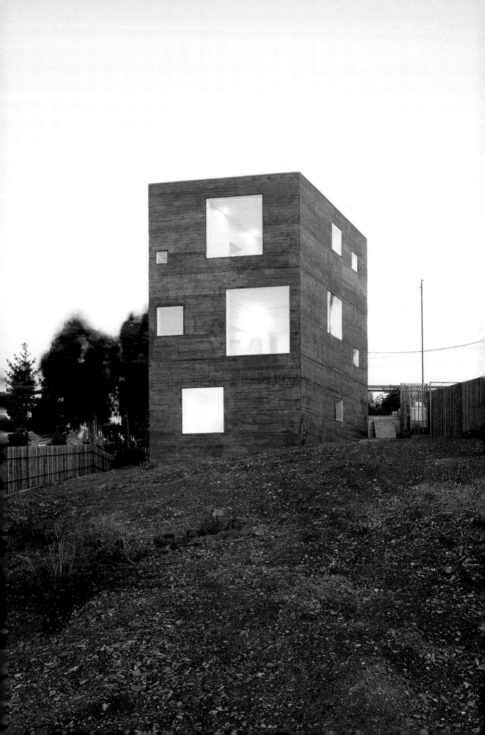

FOSC HOUSE

San Pedro, Chile, 2008–09

Area: 160 m².

Located on a 597-square-meter site, this is a reinforced-concrete structure with aluminum window frames. Interiors are finished in painted concrete, or wood, with wood and stone floors. Intended for a family with four children (five bedrooms, three bathrooms, family room, studio, etc.), the **FOSC HOUSE** has three levels. Bedrooms are located on the ground and top floors. The public spaces are set on the intermediate level. A thin, folded-steel sheet, vertical circulation shaft with wooden steps links the spaces. The poured-in-place concrete walls are dyed green and coated with copper oxide. The architects state: "The owners of the house, involved in contemporary art, once showed us the rusted and aged pedestals of monuments found in local squares. The oxide drippings, we thought, imprint the surfaces with an elusive natural quality, always halfway between mineral and vegetal."

Der Stahlbetonbau mit Aluminiumfenstern liegt auf einem 597 m² großen Grundstück. Materialien in den Innenräumen sind gestrichener Beton bzw. Holz sowie Holz- und Steinböden. Das für eine Familie mit vier Kindern geplante **FOSC HAUS** (fünf Schlafzimmer, drei Bäder, Wohnzimmer, Atelier etc.) hat drei Ebenen. Die Schlafzimmer liegen im Erdgeschoss und im obersten Geschoss, während die öffentlichen Bereiche im mittleren Geschoss untergebracht sind. Ein schmaler Treppenschacht aus dünnen gefalteten Metallplatten und Holzstufen verbindet die Ebenen. Die Wände aus Ortbeton wurden grün eingefärbt und mit Kupferoxid überzogen. Die Architekten erklären: „Die im Bereich zeitgenössischer Kunst tätigen Bauherren zeigten uns einmal verrostete und verwitterte Denkmalsockel, die man auf manchen Dorfplätzen findet. Uns schien es, als würde die Oberfläche durch die Tropfspuren des oxidierenden Metalls eine schwer zu beschreibende Natürlichkeit gewinnen, die irgendwo zwischen mineralisch und pflanzlich liegt."

Implantée sur un terrain de 597 m², cette maison en béton armé à châssis de fenêtres en aluminium est de construction simple. L'intérieur est en béton peint ou en bois, les sols en bois ou en pierre. Prévue pour une famille de quatre enfants (cinq chambres, trois salles de bains, un séjour familial, un atelier, etc.), la **MAISON FOSC** s'étend sur trois niveaux. Les chambres sont au rez-de-chaussée et au dernier étage. Les espaces communs sont au niveau intermédiaire. Un puits de circulation vertical est occupé par un escalier en bois entouré d'une cage en tôle d'acier qui relie les différents volumes. Les murs en béton coulé en place sont teints en vert et enduits d'oxyde de cuivre. « Les propriétaires de la maison, qui s'intéressent à l'art contemporain, nous avaient montré un jour les piédestaux patinés et rouillés issus de monuments publics. Nous avons pensé que les coulures d'oxyde donneraient aux surfaces une qualité presque naturelle, entre le minéral et le végétal », expliquent les architectes.

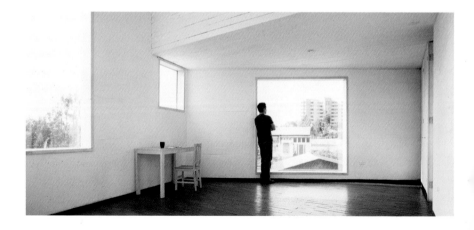

The exterior of the house has a patinated and fairly closed appearance. Its rectilinear structure is punctuated in an irregular way by windows and an angled door.

Die patinierte Fassade des Hauses wirkt eher geschlossen. Der geradlinige Bau ist unregelmäßig von Fensteröffnungen und einer schräg in die Fassade gesetzten Tür unterbrochen.

L'extérieur de la maison présente un aspect patiné et un caractère d'une certaine opacité. La structure rectiligne est irrégulièrement ponctuée de fenêtres et d'une porte d'angle.

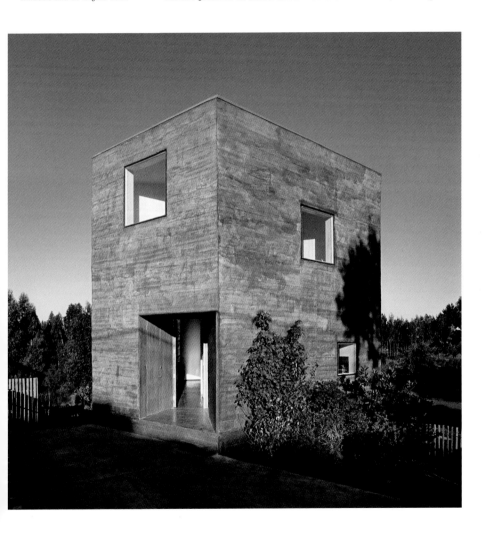

An interior view shows how the openings are articulated in a way that allows ample light to penetrate the space and gives residents broad views to the outside.

Die Innenansicht zeigt, dass die Fassadenöffnungen so angeordnet wurden, dass Tageslicht großzügig einfallen kann und die Bewohner einen weiten Ausblick genießen.

Une vue de l'intérieur montre comment les ouvertures s'articulent pour faciliter la pénétration de la lumière et offrir d'amples perspectives sur l'extérieur.

406

San Nicola Stadium

RENZO PIANO

RENZO PIANO was born in 1937 in Genoa, Italy. He studied at the University of Florence and at Milan's Polytechnic Institute (1964). He formed his own practice (Studio Piano) in 1965, associated with Richard Rogers (Piano & Rogers, 1971–78)—completing the Pompidou Center in Paris in 1977—and then worked with Peter Rice (Piano & Rice Associates, 1978–80), before creating the Renzo Piano Building Workshop in 1981 in Genoa and Paris. Piano received the RIBA Gold Medal in 1989. His built work includes Jean-Marie Tjibaou Cultural Center (New Caledonia, 1992–98); Maison Hermès (Tokyo, Japan, 1998–2001); the Woodruff Arts Center Expansion (Atlanta, Georgia, USA, 1999–2005); and the New York Times Building (New York, USA, 2005–07). More completed work includes the California Academy of Sciences (San Francisco, California, USA, 2008; the Modern Wing of the Art Institute of Chicago (Chicago, Illinois, USA, 2005–09); St. Giles Court mixed-use development (London, UK, 2002–10); the London Bridge Tower (London, UK, 2009–12); Kimbell Art Museum Expansion (Fort Worth, Texas, USA, 2010–13); renovation and expansion of Harvard Art Museums (Boston, Massachusetts, USA, 2010–14); the Whitney Museum at Gansevoort (New York, USA, 2007–15); Valletta City Gate (Valletta, Malta, 2008–15); the Botín Art Center (Santander, Spain, 2010–17) and the Tribunal de Paris (Paris, France, 2017).

RENZO PIANO wurde 1937 in Genua geboren. Er studierte an der Universität von Florenz und am Polytechnischen Institut von Mailand (1964). 1965 gründete er Studio Piano, später schloss er sich mit Richard Rogers zusammen (Piano & Rogers, 1971–78), mit dem er 1977 das Centre Pompidou in Paris realisierte. Im Anschluss arbeitete er mit Peter Rice (Piano & Rice Associates, 1978–80), bevor er 1981 sein Büro Renzo Piano Building Workshop mit Sitz in Genua und Paris gründete. Piano erhielt 1989 die RIBA-Goldmedaille. Zu seinen Arbeiten zählen u. a. das Kulturzentrum Jean-Marie Tjibaou (Neukaledonien, 1992–98), die Maison Hermès (Tokio, Japan, 1998–2001), eine Erweiterung des Woodruff Arts Center (Atlanta, Georgia, USA, 1999–2005), sowie das New York Times Building (New York, USA, 2005–07). Weitere Arbeiten sind u. a. die California Academy of Sciences (San Francisco, Kalifornien, USA, 2008), ein Flügel für moderne Kunst am Art Institute of Chicago (Chicago, Illinois, USA, 2005–09), der London Bridge Tower (London, Großbritannien, 2009–12) die Erweiterung des Kimbell Art Museum (Fort Worth, Texas, USA, 2010–13), die Restaurierung und Erweiterung der Harvard Art Museums (Boston, Massachusetts, USA, 2010–14), das Whitney Museum Gansevoort Street (New York, USA, 2007–15), das Stadttor Valletta (Malta, 2008–15) und das Tribunal de Paris (Paris, Frankreich, 2017).

Né en 1937 à Gênes, en Italie, **RENZO PIANO** fait ses études à l'université de Florence et à l'École polytechnique de Milan (1964). Il s'établit (Studio Piano) en 1965, s'associe avec Richard Rogers (Piano & Rogers, 1971–78) – terminant le Centre Pompidou à Paris en 1977 – puis travaille avec Peter Rice (Piano & Rice Associates, 1978–80) avant de créer Renzo Piano Building Workshop, en 1981, à Gênes et Paris. Piano reçoit la médaille d'or du RIBA en 1989. Parmi ses réalisations, on trouve le Centre culturel Jean-Marie Tjibaou (Nouvelle-Calédonie, 1992–98), la Maison Hermès (Tokyo, Japon, 1998–2001) ; l'extension du Woodruff Arts Center (Atlanta, Géorgie, États-Unis, 1999–2005) ; et la tour du New York Times (New York, États-Unis, 2005–07). Parmi les projets terminés, on trouve la California Academy of Sciences (San Francisco, États-Unis, 2008) ; l'aile moderne de l'Art Institute of Chicago (Chicago, États-Unis, 2005–09) ; la London Bridge Tower (Londres, Royaume-Uni, 2009–12) ; l'extension du Kimbell Art Museum (Fort Worth, Texas, États-Unis, 2010–13) ; la rénovation et l'extension des Harvard Art Museums (Boston, Massachusetts, États-Unis, 2010–14) ; le Whitney Museum de Gansevoort (New York, États-Unis, 2007–15) ; la porte de ville Valetta (Malta, 2008–15) ; et le Tribunal de Paris (Paris, France, 2017).

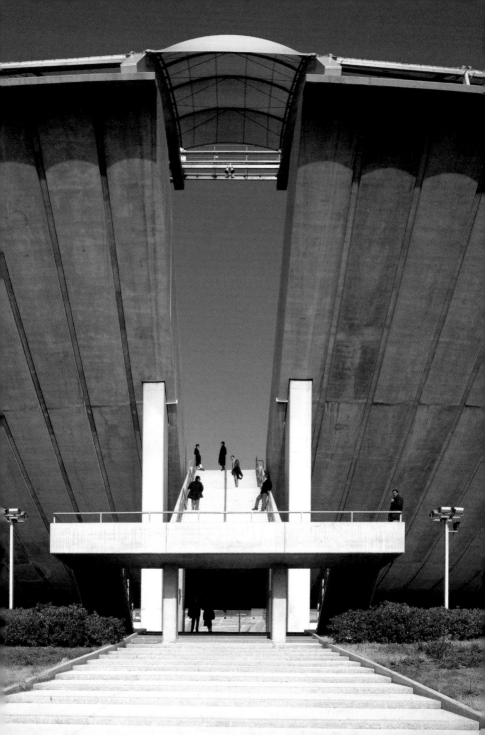

SAN NICOLA STADIUM

Bari, Italy, 1987–90

Area: 533 000 m². Client: Municipality of Bari. Collaboration: O. Di Blasi (Architect in Charge),
S. Ishida (Associate Architect), F. Marano, L. Pellini with D. Cavagna and G. Sacchi (Models).

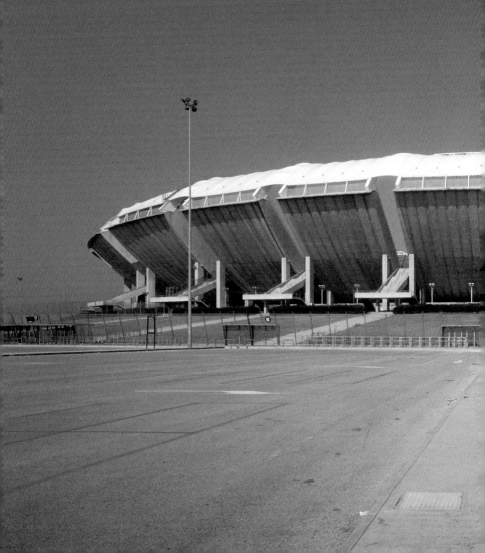

Seen from the exterior, the San Nicola Stadium has a surprisingly light appearance despite its large size. It seems to have just landed, or to be about to take off.

Von außen sieht das Stadion San Nicola trotz seiner Größe überraschend leicht aus. Es scheint gerade gelandet oder im Abflug begriffen zu sein.

Vu de l'extérieur, le stade San Nicola offre une apparence étonnamment légère malgré ses dimensions imposantes. Il semble venir d'atterrir, ou être prêt à décoller.

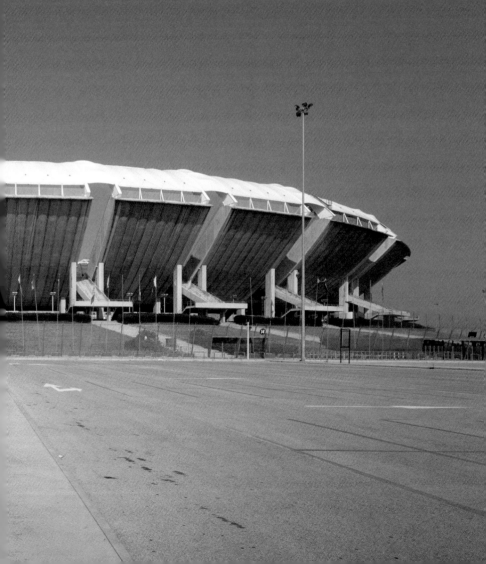

Built for the 1990 World Cup Soccer Championship that was held in Italy, the **SAN NICOLA FOOTBALL STADIUM** was designed to seat 60 000 spectators. Compared both to a flying saucer and to an opening flower, the structure was built with 310 prefabricated concrete beams designed to be easily lowered into place by a 50-meter crane. The elegant crescent-shaped beams and curving Teflon-coated roof avoid the often block-like appearance of more traditional structures, while the steep outward angling of the seats gives a dynamic element to this design, which was conceived with the help of Peter Rice. Gentle slopes leading to the edges of the stadium and the setting of the football field slightly below the original grade serve to reduce the profile of the stadium from a distance. In southern Italy, the sloping approach, curving roof and hollowed-out center also bring to mind the image of a volcano. An effort was made to conserve the typical pine and olive trees in the areas leading up to the facility which is set six kilometers from the center of this southern Italian city. The colors of the empty stadium interior, ranging from the greens and yellows of the seats to the actual field and surrounding track, create a harmonious elegance confirmed by the tentlike covers arching over the upper-level seats. Great care was taken to design the facility with the prevention of crowd violence in mind. Clearly the architect resolved the practical questions related to stadium design in an efficient, inexpensive way. Through a combination of grading and structural design, Renzo Piano reconciles the rooting of the stadium in the earth of Bari with an impression of movement or even flight.

Das **STADION SAN NICOLA** ist eigens für die Fußballweltmeisterschaften von 1990 mit Sitzplätzen für 60 000 Zuschauer gebaut worden. Die mit einer fliegenden Untertasse oder mit einer sich öffnenden Blüte verglichene Konstruktion besteht aus 310 vorgefertigten Betonträgern, die so geformt sind, dass sie von einem 50 m hohen Baukran leicht in Position gebracht werden konnten. Die eleganten halbmondförmigen Träger und das mit Teflon beschichtete geschwungene Dach sind weit von den herkömmlichen kastenförmigen Stadionbauten entfernt. Die steile Neigung der Ränge nach außen verleiht dem Entwurf, der mithilfe von Peter Rice geplant wurde, zusätzliche Dynamik. Sanft ansteigende Böschungen am Außenrand des Stadions und die Absenkung des Spielfelds etwas unter das natürliche Bodenniveau tragen dazu bei, die Größe des Gebäudes aus der Entfernung optisch zu reduzieren. In Süditalien erinnern die schräge Anfahrt, der Schwung des Dachs und die ausgehöhlte Mitte an die Form eines Vulkans. Besondere Anstrengungen wurden unternommen, die ortstypischen Pinien und Olivenbäume vor dem Stadion zu erhalten, das 6 km vom Stadtzentrum von Bari entfernt liegt. Die Farben im Innern des unbesetzten Stadions – vom Grün und Gelb der Sitze bis zu denen des Spielfelds und der Laufbahnen sorgen für ein harmonisches, elegantes Erscheinungsbild, „gekrönt" von den zeltartigen Baldachinen über den oberen Rängen. Bei der Entwurfsarbeit wurde auch die Prävention von gewalttätigen Ausschreitungen berücksichtigt. Der Architekt löste die praktischen Fragen des Stadionentwurfs offensichtlich auf effiziente, kostensparende Weise. Durch die Abstufung und den konstruktiven Entwurf hat Piano trotz der Verankerung des Stadions im Boden den Eindruck von Bewegtheit, ja sogar vom Fliegen erzeugt.

Construit pour le Championnat du monde de football de 1990, le **STADE SAN NICOLA** était destiné à 60 000 spectateurs. Comparé à une soucoupe volante ou à une fleur qui s'ouvre, il fut édifié à partir de 310 poutres de béton préfabriquées conçues pour être mises en place aisément par une grue de 50 m de portée. Ces élégantes poutres et la toiture incurvée recouverte de Téflon évitent l'aspect massif de structures plus traditionnelles, tandis que la forte inclinaison des tribunes donne une dynamique à ce projet conçu en collaboration avec Peter Rice. Les pentes aménagées autour du stade et le creusement de la pelouse en dessous du niveau du sol ont permis de réduire l'importance du profil de la construction lorsque celle-ci est vue de loin. Dans cette région du Sud de l'Italie, ces pentes, ce toit et le centre en cratère font également penser à un volcan. On a par ailleurs tenté de conserver le maximum d'oliviers et de pins aux alentours de cet équipement majeur construit à 6 km du centre de Bari. Les couleurs du stade vide, qui vont du vert et du jaune des sièges à la pelouse et aux pistes, créent une impression d'élégance harmonieuse que renforcent les toiles tendues au-dessus des rangées de sièges les plus élevées pour les protéger du soleil. La prévention de la violence a aussi fait l'objet d'une attention particulière de la part des concepteurs. L'architecte a résolu les questions pratiques dans un esprit d'économie et d'efficacité. Grâce à l'étagement des gradins et à la conception de la structure, Renzo Piano a concilié une impression d'enracinement et de jaillissement, voire d'envol.

The outwardly leaning concrete shell of the stands is visible in the sketch (page 413) and even more dramatically in the photo to the right where the volumes seem to have no visible means of support.

Die nach außen gewölbte Betonschale der Tribüne ist in der Zeichnung (Seite 413) und noch dramatischer auf dem Foto rechts erkennbar, wo die Volumen weit über die Stützen auskragen.

La coque de béton inclinée vers l'extérieur des tribunes est bien visible sur le croquis (page 413) et encore plus sur la photo de droite où les volumes semblent dénués de tout appui apparent.

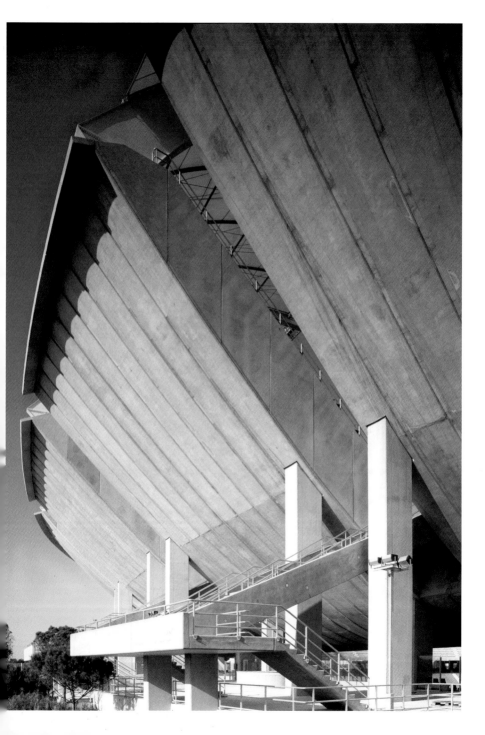

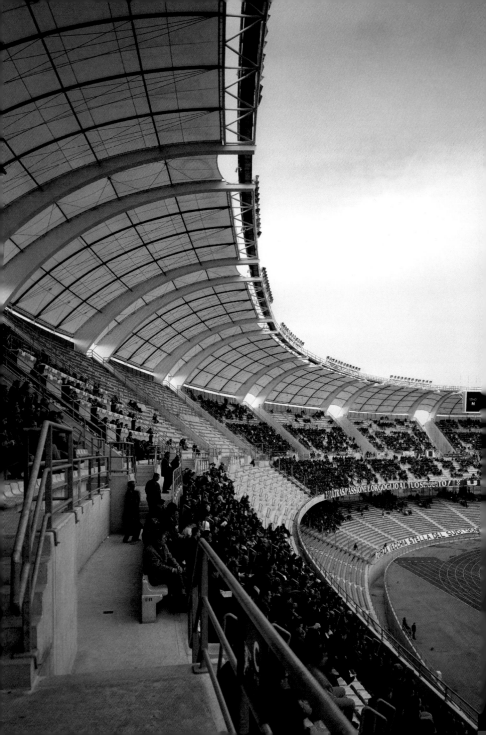

The light volume of the stadium's shell-like stands is emphasized in the sketch and drawing below and in the photos on these two pages.

Die Leichtigkeit der schalen- ähnlichen Tribüne des Stadions betonen diese Skizze und die Zeichnung unten sowie die Fotos auf dieser Doppelseite.

La légèreté du volume des tribunes en coque du stade est mise en valeur dans le croquis et le schéma ci-dessous comme sur les photos de cette double page.

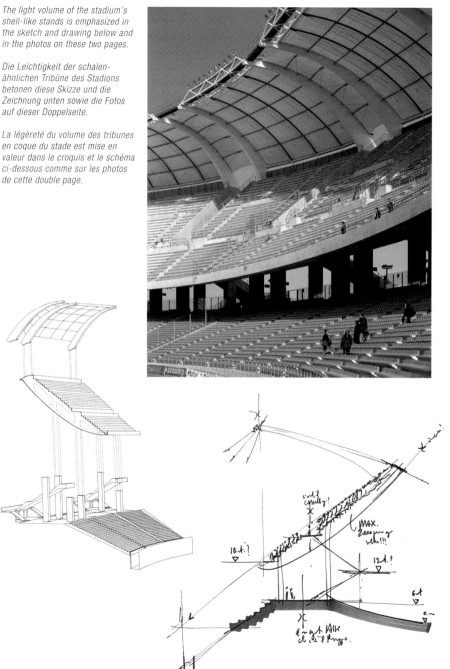

REIULF RAMSTAD

REIULF DANIEL RAMSTAD was born in 1962 in Oslo, Norway. He received his Doctorate in Architecture at the IUAV University in Venice (Italy, 1985–91) and created his own firm in 1995. **ANJA HOLE STRANDSKOGEN** was born in Oslo in 1972. She received an M.Arch from the Oslo School of Architecture and Design (AHO, 1993–2000) and joined the firm in 2000. **CHRISTIAN SKRAM FUGLSET** was born in 1976 in Molde, Norway. He studied architecture at the École Spéciale d'Architecture (Paris, 2003–04) and received his Master's degree from the AHO in 2005. He has worked with Reiulf Ramstad since 2006. **KANOG-ANONG NIMAKORN** was born in 1973 and studied at Chulalongkorn University (Bangkok, 1991–96), the AA (London, 1998–99), and at the University of Washington (Seattle, 1999–2001), where she obtained her M.Arch. She also joined the firm in 2006. Their work includes the Fagerborg Kindergarten (Fagerborg, Oslo, 2010); Troll Wall Visitor Center (Trollveggen, Møre og Romsdal, 2011); Holmenkollen Metro Station (Holmenkollen, Oslo, 2011, published here); Selvika National Tourist Route (Havøysund, Finnmark, 2012, also published here); and the Trollstigen National Tourist Route (Rauma, Møre og Romsdal, 2012, also published here) which won the European Concrete Award in 2014, all in Norway.

REIULF DANIEL RAMSTAD wurde 1962 in Oslo geboren. Seinen Doktor in Architektur machte er am Istituto Universitario di Architettura di Venezia (IUAV; 1985–89) und gründete 1995 sein eigenes Büro. **ANJA HOLE STRANDSKOGEN** wurde 1972 in Oslo geboren. Sie erwarb ihren M.Arch. an der Architektur- und Designhochschule Oslo (AHO, 1993–2000) und trat 2000 in die Firma ein. **CHRISTIAN SKRAM FUGLSET** wurde 1976 in Molde, Norwegen, geboren. Er studierte Architektur an der Ecole Spéciale d'Architecture (Paris, 2003–04) und machte 2005 seinen Master an der AHO. Seit 2006 arbeitet er bei Reiulf Ramstad. **KANOG-ANONG NIMAKORN** wurde 1973 geboren und studierte an der Chulalongkorn-Universität (Bangkok, 1991–96), der Architectural Association (London, 1998–99) und der University of Washington (Seattle, 1999–2001), wo sie ihren M.Arch. machte. Auch sie trat 2006 in das Büro ein. Zu dessen Projekten zählen: ein Kindergarten in Fagerborg (Oslo, 2010), das Besucherzentrum Trollmauer (Trollveggen, Møre og Romsdal, 2011), die Metro-Station Holmenkollen (Oslo, 2011, hier vorgestellt), die nationale Touristenroute Selvika (Havøysund, Finnmark, 2012, ebenfalls hier vorgestellt) und die nationale Touristenroute Trollstigen (Rauma, Møre og Romsdal, 2012, ebenfalls hier vorgestellt), die 2014 mit dem European Concrete Award ausgezeichnet wurde, alle in Norwegen.

REIULF DANIEL RAMSTAD est né en 1962 à Oslo. Il est titulaire d'un doctorat en architecture de l'université IUAV de Venise (1985–91) et a créé son entreprise en 1995. **ANJA HOLE STRANDSKOGEN** est née à Oslo en 1972. Elle possède un M.Arch. de l'École d'architecture et design d'Oslo (AHO, 1993–2000) et a rejoint l'agence en 2000. **CHRISTIAN SKRAM FUGLSET** est né en 1976 à Molde, en Norvège. Il a fait des études d'architecture à l'École spéciale d'architecture (Paris, 2003–04) et a obtenu un master à l'AHO en 2005. Il travaille avec Reiulf Ramstad depuis 2006. **KANOG-ANONG NIMAKORN** est née en 1973 et a fait ses études à l'université Chulalongkorn (Bangkok, 1991–96), l'AA (Londres, 1998–99) et l'université de Washington (Seattle, 1999–2001) dont elle possède un M.Arch. Elle a également rejoint l'agence en 2006. Leurs réalisations comprennent le jardin d'enfants de Fagerborg (Oslo, 2010); le Centre d'accueil des visiteurs du Mur du troll (Trollveggen, Møre og Romsdal, 2011); une station du métro d'Holmenkollen (Holmenkollen, Oslo, 2011, publiée ici); l'aire de repos de Selvika sur la route nationale touristique de Havøysund (Havøysund, Finnmark, 2012, également publiée ici) et la route touristique nationale de Trollstigen (Rauma, Møre og Romsdal, 2012, également publiée ici) qui a gagné le European Concrete Award en 2014, tous en Norvège.

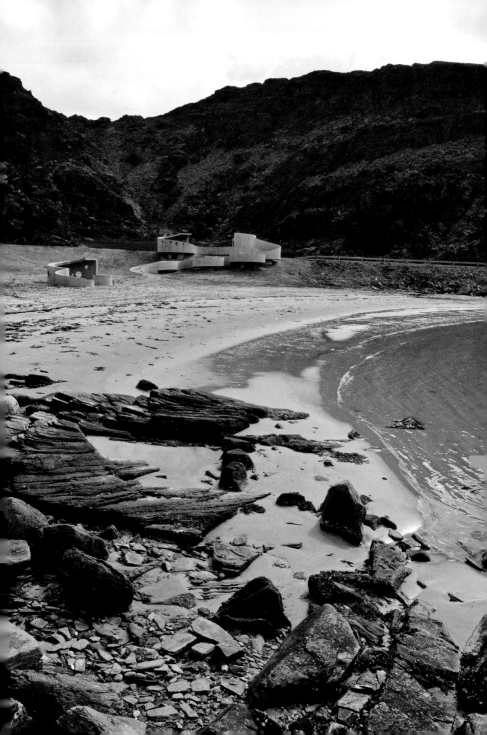

SELVIKA NATIONAL TOURIST ROUTE

Havøysund, Finnmark, Norway, 2012

Area: 5000 m² (total planned area).
Client: Norwegian Public Roads Administration. Cost: €1.4 million.

This roadside stop intended mainly for tourists is a part of the development of the **NATIONAL TOURIST ROUTE** between Kokelv and Havøysund. The route follows the Arctic Ocean shoreline and meanders through a rugged landscape of cliffs and otherwise untamed nature. The architects explain: "The meandering walkway from the road toward the beach provides the framework to experience nature and the location from different viewpoints. The walk ends at a focal point and gathering place with a fireplace, outdoor kitchen, and benches." At the car park, the project includes sheltered bicycle racks and an information point, as well as a small service building with toilet facilities. Disabled access was provided for as required. The *in situ* concrete employed uses locally sourced aggregate and is pigmented white with titanium dioxide. The vertical timber formwork used as few tie holes as possible, and these were positioned by the architect. The holes were made using sections of industrial pipes and placed "according to direction and position." Reiulf Ramstad Architects were granted a direct commission for this project in 2007.

Dieser vorwiegend für Touristen bestimmte Rastplatz ist Teil der Entwicklung der **NATIONALEN TOURISMUSROUTE** von Kokelv nach Havøysund. Die Straße folgt der Küste des Nordpolarmeers und windet sich durch eine zerklüftete und unwirtliche Landschaft. Die Architekten erläutern: „Der mäandernde Fußweg von der Straße zum Strand liefert den Rahmen, um die Natur und den Standort von verschiedenen Standpunkten aus zu erleben. Der Weg endet an einem Kristallisations- und Treffpunkt mit Feuerstelle, Außenküche und Bänken." Auf dem Parkplatz befinden sich auch geschützte Fahrradständer und ein Informationspunkt sowie ein kleiner Versorgungsbau mit Toiletten. Auch für Behinderte ist bei Bedarf gesorgt. Der verwendete Ortbeton wurde mit örtlich verfügbaren Zuschlägen hergestellt und mit weißem Titaniumoxid gefärbt. Die vertikale Holzschalung hatte nur die unbedingt erforderlichen Verankerungslöcher, deren Position von den Architekten bestimmt wurde. Dafür verwendeten sie Querschnitte von Industrierohren, die „ihrer Richtung und Position entsprechend" platziert wurden. Reiulf Ramstad erhielten 2007 einen Direktauftrag für dieses Projekt.

Cette halte au bord de la route, essentiellement destinée aux touristes, fait partie du développement de la **ROUTE NATIONALE TOURISTIQUE** entre Kokelv et Havøysund. Elle longe la côte de l'océan Arctique et traverse en serpentant un paysage accidenté de falaise et de nature sauvage intacte. Les architectes expliquent : « Le chemin qui sinue de la route vers la plage fournit le cadre pour aborder la nature et le site de différents points de vue. Il aboutit à un point central et lieu de rassemblement avec un foyer, une cuisine en plein air et des bancs. » Le projet comprend également des râteliers à bicyclettes abrités et un point d'information sur le parking, ainsi qu'un petit bâtiment technique avec des toilettes. Un accès handicapés a été prévu comme demandé. Le béton in situ utilisé est composé d'un agrégat d'origine locale et pigmenté en blanc au dioxyde de titane. Le coffrage vertical en bois a été percé du moins possible de trous de banches, positionnés par l'architecte. Ils ont été pratiqués à l'aide de conduites industrielles sectionnées et placés « en fonction de la direction et de la position ». Reiulf Ramstad Architects a bénéficié d'un mandat direct pour ce projet en 2007.

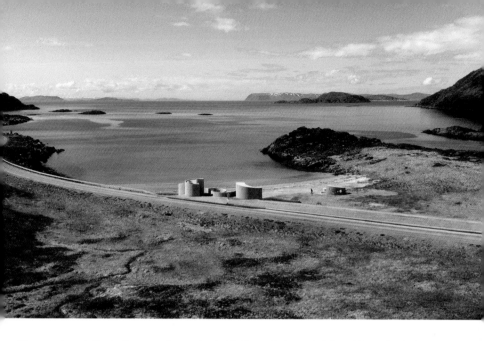

The concrete roadside stop imag-
ined by the architects is meant to
offer a place to view the natural
setting. Modestly scaled, its forms
seem inspired by nature without
any effort to imitate.

Der von den Architekten geplante
Haltepunkt an der Straße soll auch
ein Ort sein, von dem aus man die
Landschaft betrachtet. Die beschei-
den bemessenen Formen scheinen
von der Natur inspiriert zu sein,
ohne sie jedoch zu imitieren.

La halte en béton au bord de la route
imaginée par les architectes est desti-
née à fournir un endroit pour admirer
le paysage naturel. De taille modeste,
ses formes semblent inspirées par la
nature alors même qu'aucun effort
d'imitation dans ce sens n'a été fait.

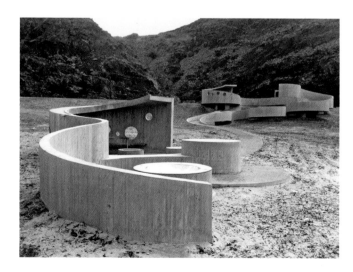

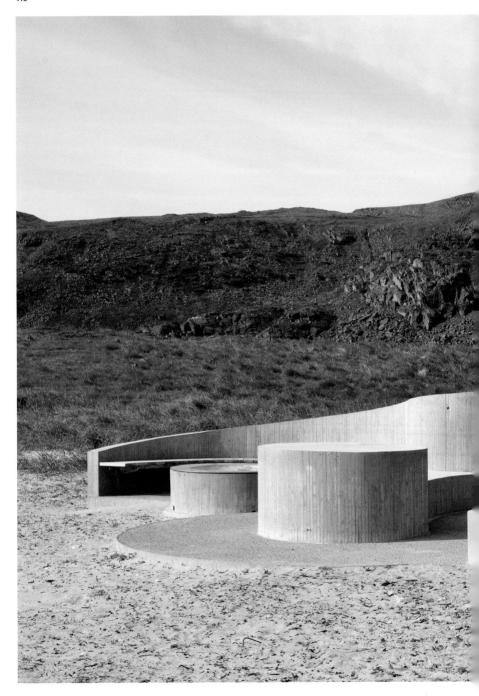

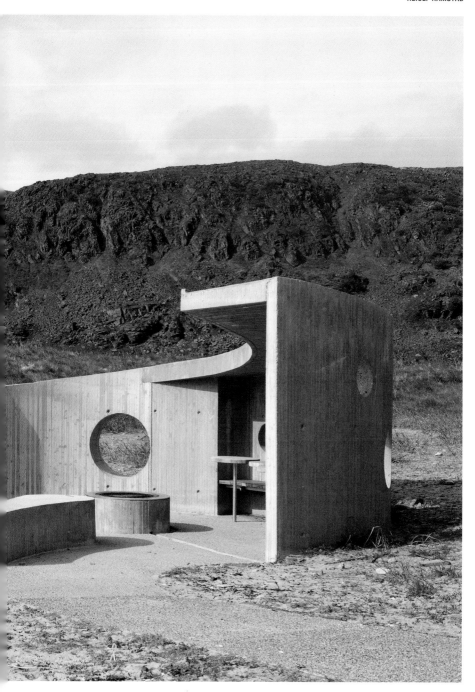

A low snaking pattern of concrete walls obliges visitors to view the setting from different angles as they progress.

Ein System aus niedrigen, gewundenen Betonmauern zwingt die Besucher zur Betrachtung der Umgebung aus verschiedenen Blickwinkeln.

Le long mur en béton au motif sinueux permet aux visiteurs de voir le paysage sous différents angles au fur et à mesure qu'ils avancent.

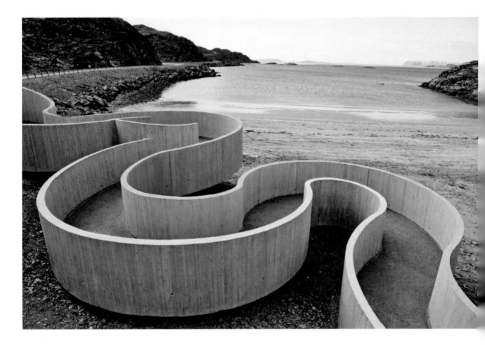

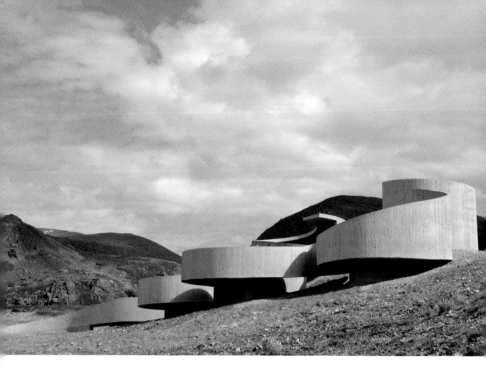

The shapes imagined by the architects have a decidedly sculptural aspect. The concrete they use is, of course, made with sand and locally sourced aggregate.

Die von den Architekten erdachten Formen wirken ausgesprochen skulptural. Der verwendete Beton wurde selbstverständlich mit lokalem Sand und vor Ort gewonnenen Zuschlägen hergestellt.

Les formes imaginées par les architectes sont résolument sculpturales. Bien sûr, ils ont choisi du béton fait de sable et d'un agrégat d'origine locale.

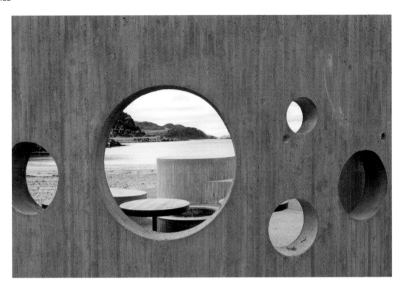

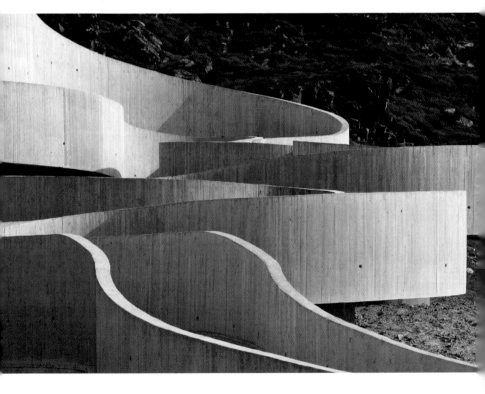

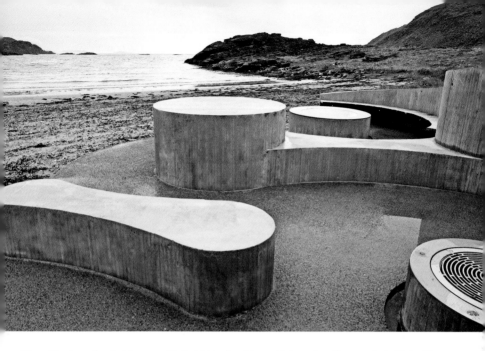

The architects used vertical form-work, held in place in as few points as possible, as can be seen in these images. The overall impression is one of sculpture or perhaps of natural erosion at work.

Die Architekten benutzten vertikale Schalung, die – wie diese Abbildungen zeigen – nur an möglichst wenigen Punkten befestigt wurde. Der Gesamteindruck ist der einer Skulptur oder vielleicht von natürlich erodierten Objekten.

Le coffrage vertical utilisé a été maintenu en place en moins de points possible, comme on le voit ici. L'impression globale est celle d'une sculpture, ou alors d'un travail d'érosion naturelle.

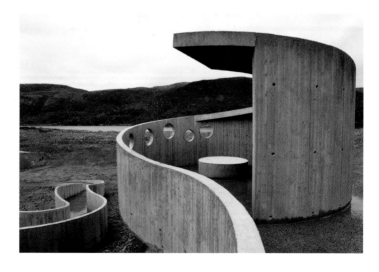

TROLLSTIGEN NATIONAL TOURIST ROUTE

Rauma, Møre og Romsdal, Norway, 2012

Area: 150 000 m² (total planning area); 1200 m² (buildings).
Client: Norwegian Public Roads Administration. Cost: €25 million.

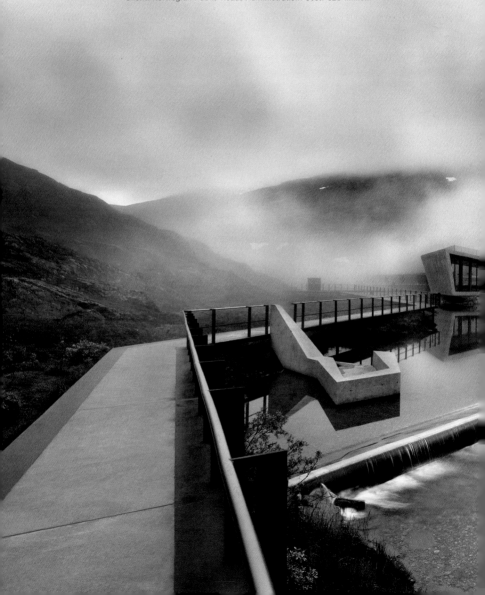

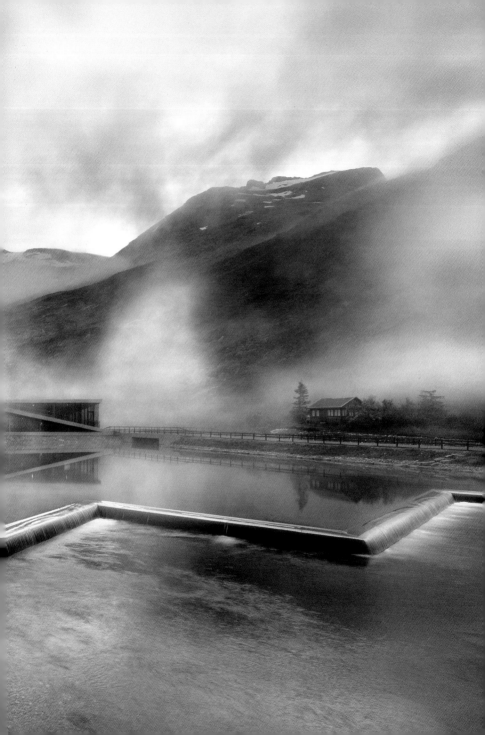

In 2004 the architects participated in an invited competition for this project. They won first prize in collaboration with Multiconsult 13.3 Landscaping. The project includes an 800-square-meter visitor center with a restaurant and gallery, as well as a 950-square-meter flood barrier structure. The main materials employed are Cor-ten steel and *in situ* concrete. The concrete was treated with several different techniques: polished, steel troweled, flushed, brushed, spot hammered, or cast in different types of formwork. Located on Norway's west coast, **TROLLSTIGEN** is situated in a pass between the fjords that characterize the region. Both construction and visits are limited to the summer months due to severe winter weather. The architects explain: "Despite, or perhaps because of, the inaccessible nature of the site, the project entails designing an entire visitor environment ranging from a mountain lodge with restaurant and gallery to flood barriers, water cascades, bridges and paths, to outdoor furniture, pavilions, and platforms meant for viewing the scenery. All of these elements are molded into the landscape so that the visitor's experience of the place seems even more intimate. The architectural intervention is respectfully delicate, and was conceived as a thin thread that guides visitors from one stunning outlook to another." About 600 000 people visit the site during the summer months, placing a strain on the logistical planning of the architects. Low energy and sustainable solutions were employed, and the elements, in the form of very heavy winter snow loads or major floods, were also taken into account in the design.

Die Architekten nahmen 2004 an einem beschränkten Wettbewerb für dieses Projekt teil. Sie gewannen, in Zusammenarbeit mit Multiconsult 13.3 Landscaping, den ersten Preis. Der Entwurf beinhaltet ein 800 m² großes Besucherzentrum mit Restaurant und Galerie sowie einen 950 m² großen Hochwasserschutzbau. Die hauptsächlich verwendeten Materialien sind Cor-Ten-Stahl und Ortbeton. Letzterer wurde in unterschiedlichen Techniken behandelt: poliert, mit der Stahlkelle geglättet, geschlämmt, besengestrichen, punktgehämmert oder in unterschiedliche Schalungen gegossen. **TROLLSTIGEN** liegt an der norwegischen Westküste auf einem Sattel zwischen den für diese Region typischen Fjorden. Sowohl das Bauen als auch Besuche sind, wegen der strengen Winter, auf die Sommermonate beschränkt. Die Architekten erläutern: „Trotz oder vielleicht auch wegen der unzugänglichen Natur des Geländes erforderte das Projekt die Gestaltung eines ganzen Besucherumfelds von einer Berghütte mit Restaurant und Galerie bis zum Hochwasserschutz, Wasserfällen, Brücken und Fußwegen, bis zu Außenmobiliar, Pavillons und Aussichtsplattformen. All diese Elemente sind in die Landschaft eingebunden und sollen dadurch dem Besucher das Erlebnis dieses Ortes noch näher bringen. Der architektonische Eingriff ist rücksichts- und respektvoll; er wurde wie ein Faden konzipiert, der die Besucher von einem überwältigenden Ausblick zum nächsten führt." Etwa 600 000 Personen besuchen das Gebiet während der Sommermonate – eine Herausforderung für die logistische Planung der Architekten. Energiesparende und nachhaltige Lösungen wurden bevorzugt und auch die Auswirkungen des Klimas, das heißt große Schneelasten im Winter oder Hochwasser, in der Planung berücksichtigt.

Pour ce projet, les architectes ont participé à un concours organisé en 2004. Ils ont gagné le premier prix en collaboration avec Multiconsult 13.3 Landscaping. Le complexe comprend un centre d'accueil des visiteurs de 800 m² avec un restaurant et une galerie, ainsi qu'une structure anti-tempête de 950 m². Les principaux matériaux sont l'acier Cor-Ten et le béton in situ. Ce dernier a été traité à l'aide de plusieurs techniques différentes : polissage, lissage à la truelle, arasage, brossage, martelage et coulage dans différents types de coffrages. **TROLLSTIGEN**, sur la côte Ouest de la Norvège, est située à un col entre les fjords caractéristiques de la région. La construction et les visites y sont uniquement possibles pendant les mois d'été car l'hiver est trop rigoureux. Les architectes expliquent : « Malgré, ou peut-être à cause de la nature inaccessible du site, le projet comprend la création d'un environnement complet destiné aux visiteurs, d'un gîte de montagne avec restaurant et galerie à des ouvrages de défense contre les inondations, des chutes d'eau, passerelles et sentiers, ainsi que du mobilier extérieur, des pavillons et plates-formes panoramiques. Tous ces éléments sont moulés dans le paysage pour permettre aux visiteurs une approche plus intime de l'endroit. L'intervention de l'architecture est marquée par le respect et la délicatesse, elle a été conçue comme un mince fil qui guide les visiteurs d'une perspective remarquable à la suivante. » Le site accueille près de 600 000 visiteurs pendant les mois d'été, de sorte que les architectes ont été soumis à une forte pression en ce qui concerne les aspects logistiques. Ils ont opté pour des solutions durables à faible consommation d'énergie et ont tenu compte d'éléments telles les très fortes charges de neige en hiver ou les fortes inondations.

The building lies low on its site, as though to make it perfectly clear that the architects are assuming a modest position in such a powerful natural environment.

Das Gebäude steht flach auf dem Gelände, als wollte es deutlich machen, dass die Architekten in einer derart eindrucksvollen natürlichen Umgebung nur eine bescheidene Rolle spielen.

Le bâtiment est très bas, comme pour bien faire comprendre la position modeste des architectes dans un cadre naturel aussi imposant.

The architects' brief included not only the angled, glazed building seen here, but also the walkways and exterior terraces visible in these mages.

Die Aufgabe der Architekten umfasste nicht nur die Planung des hier abgebildeten scharfkantigen, verglasten Gebäudes, sondern auch der Fußwege und Außenterrassen.

En plus du bâtiment vitré et anguleux que l'on voit ici, les sentiers et terrasses ont aussi été confiées aux architectes.

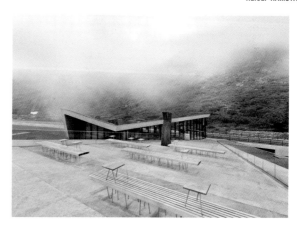

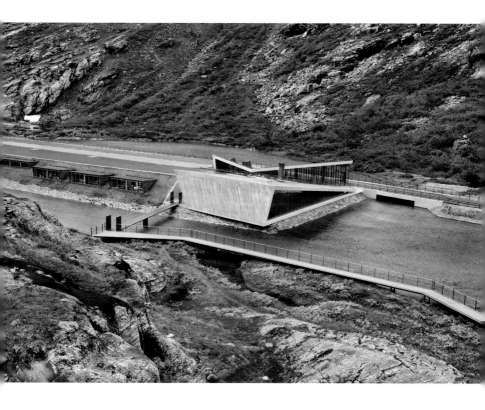

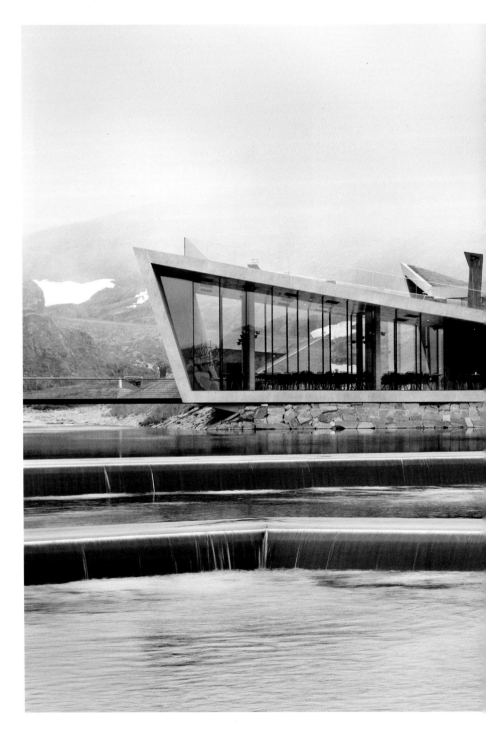

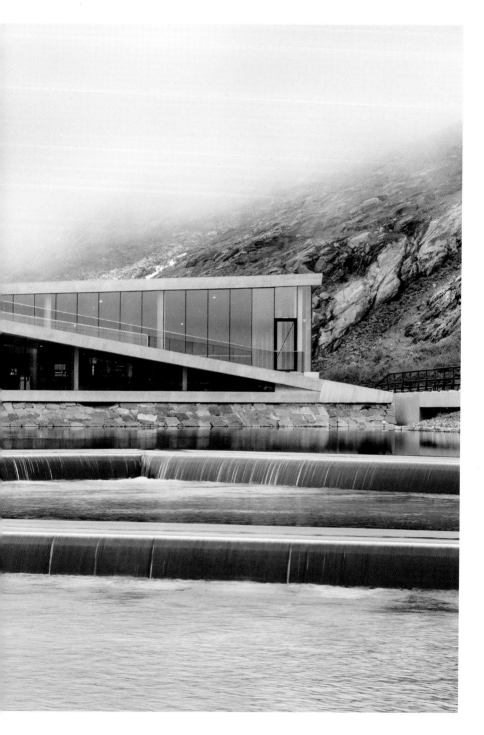

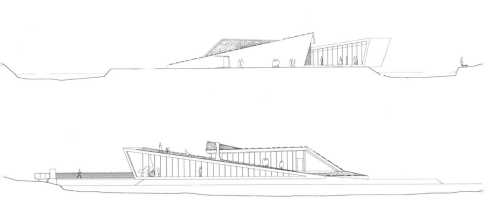

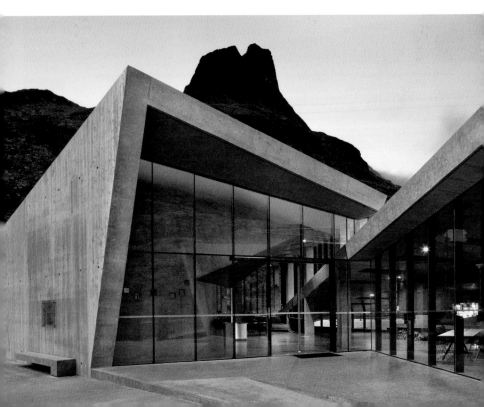

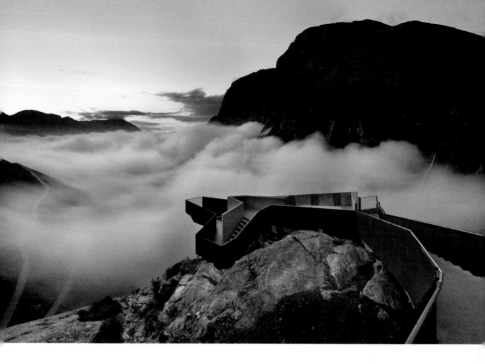

The angled concrete shell of the building echoes surrounding mountains in a geometric vein. Above, one of the walkways situated nearby, also designed by the architects.

Die kantige Betonhülle des Gebäudes nimmt mit ihrer Geometrie Bezug auf die Berge der Umgebung. Oben: Einer der nahe gelegenen Fußwege, der ebenfalls von den Architekten gestaltet wurde.

La coque anguleuse en béton du bâtiment fait écho aux montagnes environnantes sur un mode géométrique. Ci-dessus, l'un des sentiers à proximité, également conçu par les architectes.

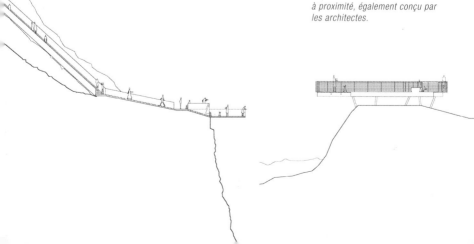

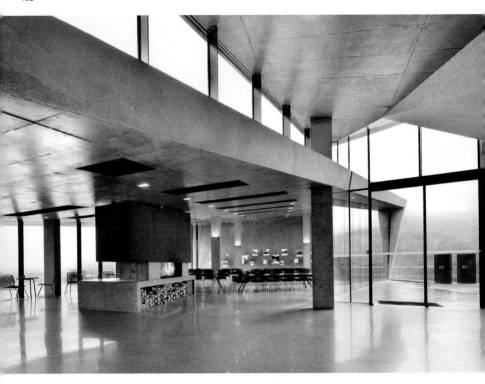

Angled concrete slabs appear to almost float above the glazing of the visitor building in the image above. Below, the building seen in plan and section.

Auf der Abbildung oben scheinen die eckigen Betonplatten über der Verglasung des Besucherzentrums zu schweben. Unten: Grundriss und Schnitt des Gebäudes.

Des plaques de béton aux arêtes vives semblent presque flotter au-dessus des vitres du centre d'accueil des visiteurs. Ci-dessous, plan et vue en coupe du bâtiment.

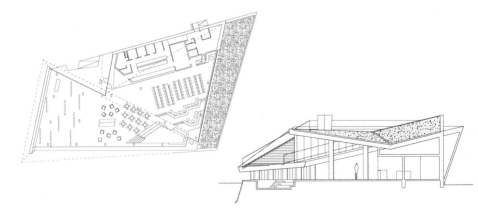

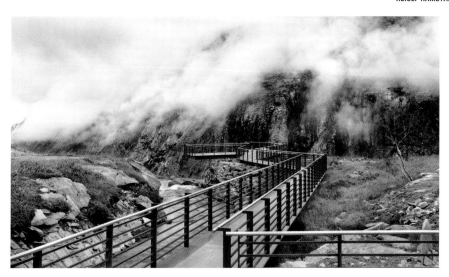

Walkways and vantage points allow the numerous summer visitors to enjoy the natural beauty of the site while not actually setting foot in the delicate terrain.

Fußwege und Aussichtspunkte ermöglichen es im Sommer den zahlreichen Besuchern, die natürliche Schönheit des Geländes zu genießen, ohne wirklich einen Fuß auf das sensible Terrain zu setzen.

Les sentiers et perspectives remarquables aménagées permettent aux nombreux visiteurs de profiter de la beauté naturelle du site pendant les mois d'été sans poser le pied sur le terrain fragile.

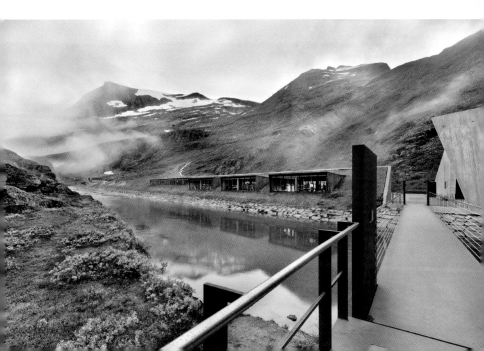

HOLMENKOLLEN METRO STATION

Holmenkollen, Oslo, Norway, 2011

Area: 2500 m². Client: Oslo Public Transportation System KTP.
Cost: €7.6 million. Collaboration: Anders Tjønneland.

The architects were the winners of a 2008 invited competition to expand the **HOLMENKOLLEN METRO STATION** located in an area undergoing substantial restructuring, and to improve its functionality, while still maintaining the original 1880s station. The architects state: "The geometrical organization of the new station area composes the elements of the site, creating a sense of functional calm and clarified order." *In situ* concrete was the main material for the new construction. The old red-and-white station is lifted substantially off the ground and new areas marked by bands of glazing and concrete are placed beneath it. Concrete ramps, passages, and stairways were also added in a relatively discreet manner, leaving the "starring role" to the old structure.

Die Architekten gewannen 2008 den geladenen Wettbewerbs zur Erweiterung der **HOLMENKOLLEN METROSTATION** in einem Gebiet, in dem erhebliche Umstrukturierungen stattfinden. Die Funktionalität des Bahnhofs sollte verbessert werden, aber das Originalgebäude von 1880 erhalten bleiben. Die Architekten erklären: „Die geometrische Organisation des neuen Bahnhofsbereichs fügt die Elemente des Standorts zusammen und erzeugt ein Gefühl funktionierender Ruhe und geregelter Ordnung." Ortbeton war das Hauptmaterial für den Neubau. Der alte, rotweiße Bahnhof wurde ein Stück vom Boden angehoben; die neuen Bereiche sind darunter angeordnet und durch Fensterbänder und Beton gekennzeichnet. Auch Betonrampen, Passagen und Treppen wurden auf relativ unaufdringliche Weise hinzugefügt und haben dem Altbau seine „Starrolle" belassen.

Les architectes ont remporté un concours lancé en 2008 pour agrandir le **STATION DE MÉTRO HOLMENKOLLEN** située dans une zone en forte restructuration et la rendre plus fonctionnelle, tout en conservant la station originale des années 1880. Ils expliquent : «L'organisation géométrique de la nouvelle station donne la composition du site et de ses éléments en créant une impression de calme fonctionnel et d'ordre clarifié.» Le béton in situ est le principal matériau utilisé pour la nouvelle construction. L'ancienne station rouge et blanche a été surélevée haut au-dessus du sol et le nouvel espace marqué par des bandes alternées de vitres et de béton a été placé en dessous. Des rampes, passages et escaliers en béton ont également été ajoutés mais restent plutôt discrets et laissent la vedette à l'ancienne structure.

The idea of placing an old, rather traditional station on top of a modern concrete structure is, to say the least, a bold one, but the conservation of the 1880s building was part of their program.

Die Idee, ein altes, eher herkömmliches Stationsgebäude auf einen modernen Betonbau zu setzen, ist, gelinde gesagt, mutig; die Erhaltung des Bauwerks aus den 1880er-Jahren war jedoch Bestandteil der Ausschreibung.

L'idée de placer une ancienne station de métro plutôt traditionnelle au-dessus d'une structure moderne en béton est pour le moins osée, mais le cahier des charges imposait de conserver le bâtiment des années 1880.

RIZOMA

MARIA PAZ was born in 1985 in Belo Horizonte, Brazil. She received her B.A. in Architecture and Urbanism in 2009, from FUMEC University (Belo Horizonte), and her M.A. in Architecture and Discourse in 2011, from Cornell University (Ithaca, New York). She worked as an intern at Jo Coenen & Co in Luxembourg (2007) and has been Partner and Principal of Rizoma since 2008. **THOMAZ REGATOS** was born in 1981 in Belo Horizonte. He received his B.A. in Architecture and Urbanism in 2004 from the Centro Metodista Izabela Hendrix (Belo Horizonte), and his M.A. in Theory and Practice of Architectural Projects in 2008 from the Universitat Politècnica de Catalunya (Barcelona, Spain, 2008). Thomaz Regatos worked with the Spanish architect Emilio Donato in 2006 and has been Partner and Principal of Rizoma since 2008. Their recent and current work includes the Inhotim reception area (Brumadinho, 2010); Oiticica Restaurant (Inhotim, Brumadinho, 2010, published here); Lygia Pape Gallery (Inhotim, Brumadinho, 2011); a Botanical Shop (Inhotim, Brumadinho, 2011); Filadelfia Advertising Company (Belo Horizonte, 2011); a music school (Inhotim, Brumadinho, 2011); and Tunga Gallery (Inhotim, Brumadinho, 2011), all in Brazil.

MARIA PAZ wurde 1985 in Belo Horizonte, Brasilien, geboren. Sie machte ihren B.A. in Architektur und Stadtplanung 2009 an der Universität FUMEC (Belo Horizonte) und einen M.A. in Architektur und Diskurs 2011 an der Cornell University (Ithaca, New York). Nach einem Praktikum bei Jo Coenen & Co in Luxemburg (2007) ist sie seit 2008 leitende Partnerin bei Rizoma. **THOMAZ REGATOS** wurde 1981 in Belo Horizonte geboren. Er schloss sein Studium 2004 mit einem B.A. in Architektur und Stadtplanung am Centro Metodista Izabela Hendrix (Belo Horizonte) ab und machte 2008 einen M.A. in Theorie und Praxis architektonischer Projektplanung an der Universitat Politècnica de Catalunya (Barcelona, 2008). Thomaz Regatos arbeitete 2006 für den spanischen Architekten Emilio Donato und ist seit 2008 leitender Partner bei Rizoma. Jüngere und aktuelle Projekte des Teams sind der Empfangsbereich des Inhotim (Brumadinho, 2010), das Restaurant Oiticica (Inhotim, Brumadinho, 2010, hier vorgestellt), die Lygia-Pape-Galerie (Inhotim, Brumadinho, 2011), ein Geschäft für Pflanzen und Gartenbedarf (Inhotim, Brumadinho, 2011), die Werbeagentur Filadelfia (Belo Horizonte, 2011), eine Musikschule (Inhotim, Brumadinho, 2011) und die Tunga-Galerie (Inhotim, Brumadinho, 2011), alle in Brasilien.

MARIA PAZ est née en 1985 à Belo Horizonte, au Brésil. Elle a obtenu son B.A. en architecture et urbanisme en 2009 à l'université FUMEC (Belo Horizonte) et son M.A. en architecture et traité architectural en 2011 à l'université Cornell (Ithaca, New York). Elle a effectué un stage chez Jo Coenen & Co à Luxembourg (2007) et est partenaire et directrice de Rizoma depuis 2008. **THOMAZ REGATOS** est né en 1981 à Belo Horizonte. Il a obtenu son B.A. en architecture et urbanisme en 2004 au Centre universitaire méthodiste Izabela Hendrix (Belo Horizonte) et son M.A. en théorie et pratique de projets architecturaux en 2008 à l'Université polytechnique de Catalogne (Barcelone, 2008). Thomaz Regatos a travaillé avec l'architecte espagnol Emilio Donato en 2006 et est partenaire et directeur de Rizoma depuis 2008. Leurs réalisations récentes et actuelles comprennent l'espace de réception d'Inhotim (Brumadinho, 2010) ; le restaurant Oiticica (Inhotim, Brumadinho, 2010, publié ici) ; la galerie Lygia Pape (Inhotim, Brumadinho, 2011) ; un magasin botanique (Inhotim, Brumadinho, 2011) ; la société de publicité Filadelfia (Belo Horizonte, 2011) ; une école de musique (Inhotim, Brumadinho, 2011) et la galerie Tunga (Inhotim, Brumadinho, 2011), toutes au Brésil.

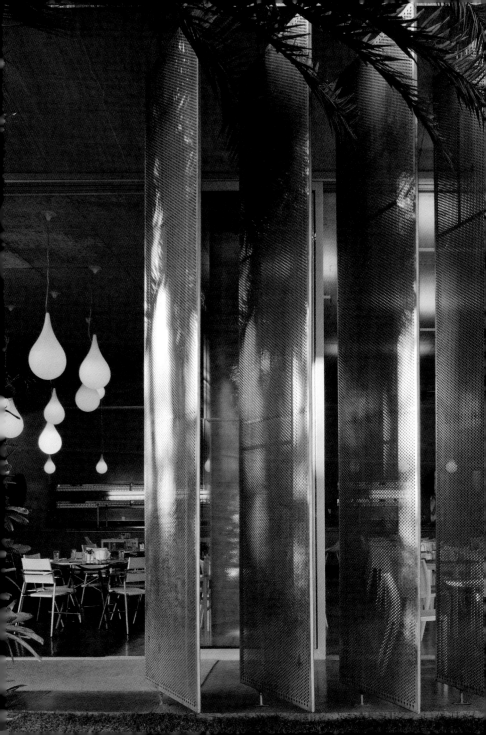

OITICICA RESTAURANT

Inhotim, Brumadinho, Minas Gerais, Brazil, 2010

Area: 704 m². Client: Inhotim.
Cost: $435 000. Collaboration: Virginia Paz.

Inhotim is a contemporary art center created by the entrepreneur Bernardo de Mello Paz in the mid 1980s. A botanical garden was created in 2005, and the center committed itself to the social welfare of the population of Brumadinho and its region. Located in the state of Minas Gerais, Brumadinho is part of the metropolitan region of Belo Horizonte, and is about 60 kilometers from the city. The 320-seat **OITICICA RESTAURANT** was conceived as a low-cost building, making maximum use of brise-soleils and natural ventilation. Existing vegetation on the site was protected, making the structure blend smoothly into its setting. The architects state: "The openings of the restaurant to the park, with its colors, textures, and shapes, permeates the interior, transforming the visitor's stay into an even more pleasant one." The structure was built in just three months.

Inhotim ist ein Zentrum für zeitgenössische Kunst und wurde Mitte der 1980er-Jahre von dem Unternehmer Bernardo de Mello Paz gegründet. 2005 wurde ein botanischer Garten angelegt, das Zentrum selbst hat sich dem gesellschaftlichen Wohl der Bevölkerung von Brumadinho und seiner Region verschrieben. Das im Staat Minas Gerais gelegene Brumadinho ist Teil der Großstadtregion von Belo Horizonte und liegt rund 60 km von der Stadt entfernt. Das **RESTAURANT OITICICA** mit 320 Plätzen, ein kostengünstiger Bau, profitiert maßgeblich von den Sonnenschutzblenden und der natürlichen Belüftung. Die bestehende Vegetation des Grundstücks wurde erhalten und lässt den Bau mit seiner Umgebung verschmelzen. Die Architekten erklären: „Die Öffnungen des Restaurants zum Park und dessen Farben, Texturen und Formen durchdringen und prägen die Innenarchitektur und machen den Aufenthalt für die Besucher umso angenehmer." Der Bau wurde in nur drei Monaten realisiert.

Inhotim est un centre d'art contemporain créé par l'entrepreneur Bernardo de Mello Paz au milieu des années 1980. Un jardin botanique y a été ouvert en 2005 et le centre est voué à la sécurité sociale de la population de Brumadinho et de sa région. Située dans l'État du Minas Gerais, Brumadinho appartient à la zone métropolitaine de Belo Horizonte dont elle est éloignée de 60 km environ. Le **RESTAURANT OITICICA** de 320 places a été conçu comme un bâtiment peu onéreux faisant un usage optimal des brise-soleil et de la ventilation naturelle. La végétation sur le site a été protégée pour intégrer l'ensemble au décor tout en douceur. Les architectes constatent que «les ouvertures du restaurant sur le parc, ses couleurs, textures et formes, se répercutent sur l'intérieur pour rendre le séjour des visiteurs encore plus agréable». La structure a été construite en seulement trois mois.

The very simple lines of the restaurant can be seen in the image and in the section drawings. Concrete and glass are the essential materials.

Auf der Ansicht und den Querschnitten sind die äußerst schlichten Linien des Restaurants deutlich zu erkennen. Zentrale Materialien sind Beton und Glas.

Les lignes très simples du restaurant sont visibles sur le photo et les plans en coupe. Le béton et le verre sont les principaux matériaux utilisés.

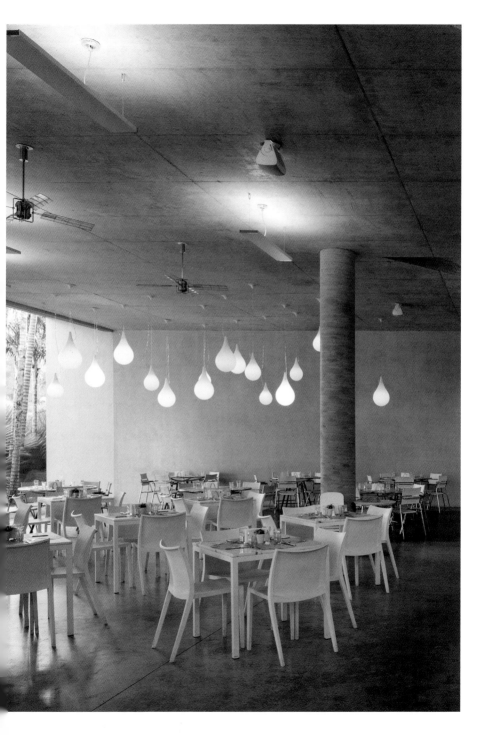

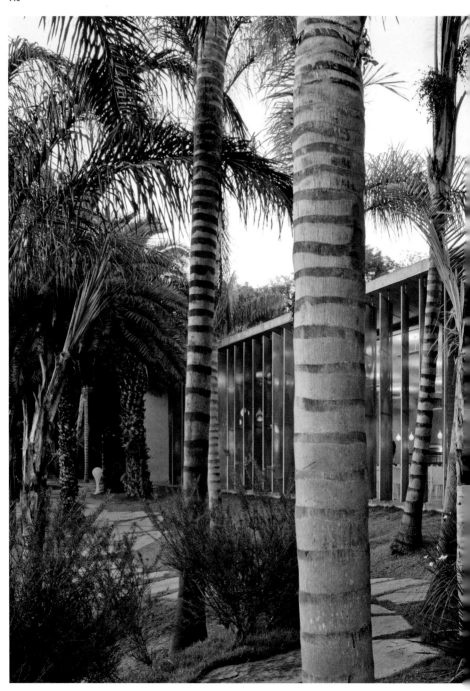

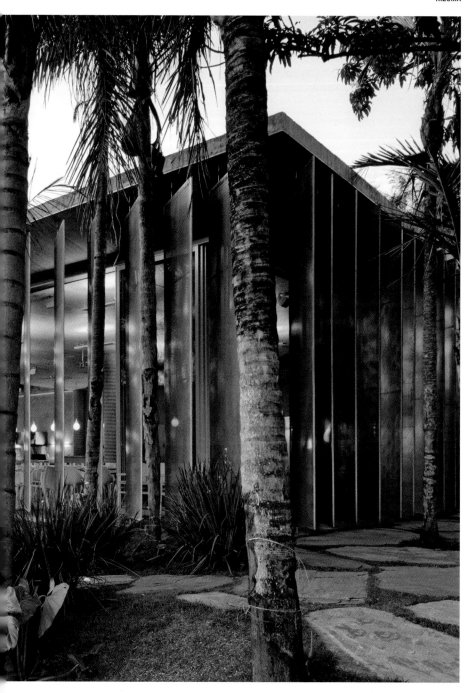

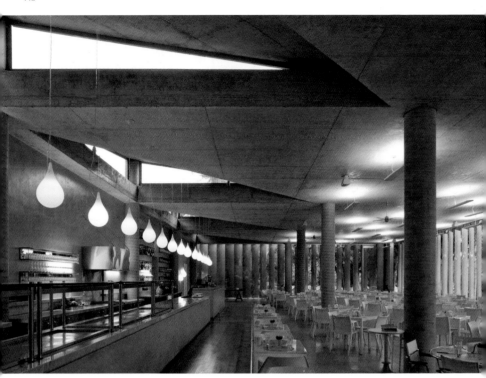

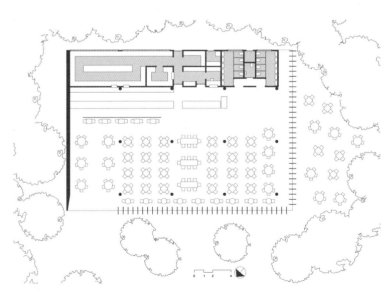

A floor plan shows the simple outlines of the building. The teardrop lighting fixtures add curved forms to the otherwise rectilinear design.

Ein Grundriss zeigt die schlichten Konturen des Baus. Die tränenförmigen Leuchten bringen geschwungene Formen in das ansonsten geradlinige Design.

Le plan au sol montre le tracé très simple du bâtiment. Les lampes en gouttes d'eau ajoutent des courbes au design sinon rectiligne.

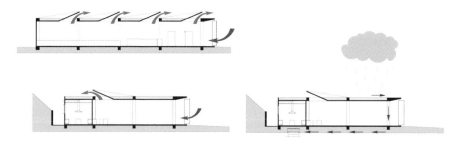

Section drawings show the movement of air and rainwater through and around the structure.

Querschnitte illustrieren die Zirkulation von Luftströmen und Regenwasser rund um das Gebäude.

Les coupes illustrent la circulation de l'air et de l'eau de pluie dans et autour de l'ensemble.

MOSHE SAFDIE

Born in Haifa, Israel, in 1938, **MOSHE SAFDIE** moved with his family to Canada in 1953. He received his degree in Architecture from McGill University (Montreal, 1961). He worked as an apprentice in the office of Louis Kahn in Philadelphia, and, in 1964, he created his own firm to realize Habitat '67 at the 1967 World Exhibition in Montreal. A well-known figure in the world of architecture since the time of Habitat '67, Safdie is a winner of the Gold Medal of the Royal Architectural Institute of Canada (1995). Other significant projects include the National Gallery of Canada (Ottawa, Canada, 1983–88); Salt Lake City Public Library (Salt Lake City, Utah, USA, 1999–2003); Yad Vashem Holocaust History Museum (Jerusalem, Israel, 1997–2005); Khalsa Heritage Center (Anandpur Sahib, Punjab, India, 1998–2011); Kauffman Center for the Performing Arts (Kansas City, Missouri, USA, 2000–11); United States Institute of Peace Headquarters (Washington, D.C., USA, 2001–11); Crystal Bridges Museum of American Art (Bentonville, Arkansas, USA, 2005–11); Marina Bay Sands Integrated Resort (Singapore, 2005–11, published here); and the Skirball Cultural Center (Los Angeles, California, USA, 1986–2013).

Der 1938 in Haifa geborene **MOSHE SAFDIE** zog 1953 mit seiner Familie nach Kanada. Dort machte er sein Diplom für Architektur an der McGill University (Montreal, 1961). Er arbeitete als Volontär im Büro von Louis Kahn in Philadelphia und machte sich 1964 selbstständig, um Habitat '67 für die Weltausstellung 1967 in Montreal zu realisieren. Seit dieser Zeit wurde Safdie zu einer bekannten Figur in der Welt der Architektur. 1995 gewann er die Goldmedaille des Royal Architectural Institute of Canada. Zu seinen weiteren wichtigen Projekten zählen: die National Gallery of Canada (Ottawa, Kanada, 1983–88), die öffentliche Bibliothek von Salt Lake City (Utah, USA, 1999–2003), das Museum zur Geschichte des Holocaust Yad Vashem (Jerusalem, Israel, 1997–2005), das Khalsa Heritage Center (Anandpur Sahib, Pandschab, Indien, 1998–2011), das Kauffman Center for the Performing Arts (Kansas City, Missouri, USA, 2000–11), die Hauptverwaltung des United States Institute of Peace (Washington, D. C., USA, 2001–11), das Crystal Bridges Museum of American Art (Bentonville, Arkansas, USA, 2005–11), das Marina Bay Sands Integrated Resort (Singapur, 2005–11, hier vorgestellt) und das Kulturzentrum Skirball (Los Angeles, Kalifornien, 1USA, 986–2013).

Né à Haïfa (Israël) en 1938, **MOSHE SAFDIE** est parti au Canada avec sa famille en 1953. Il est diplômé en architecture de l'université McGill (Montréal, 1961). Il a été apprenti dans l'agence de Louis Kahn à Philadelphie et a fondé la sienne en 1964 pour réaliser Habitat '67 à l'Exposition universelle de Montréal en 1967. Très connu dans le monde de l'architecture depuis, Safdie a remporté la médaille d'or du Royal Architectural Institute of Canada (1995). Ses autres projets significatifs comprennent la National Gallery of Canada (Ottawa, Canada, 1983–88) ; la bibliothèque publique de Salt Lake City (Salt Lake City, Utah, États-Unie, 1999–2003) ; le Musée historique de l'Holocauste de Yad Vashem (Jérusalem, Israel, 1997–2005) ; le Khalsa Heritage Center (Anandpur Sahib, Panjab, Inde, 1998–2011) ; le centre Kauffman des arts du spectacle (Kansas City, Missouri, États-Unie, 2000–11) ; le siège du United States Institute of Peace (Washington, DC, États-Unie, 2001–11) ; le musée de l'art américain Crystal Bridges (Bentonville, Arkansas, États-Unie, 2005–11) ; la station balnéaire intégrée du Marina Bay Sands (Singapour, 2005–11, publiée ici) et le Centre culturel Skirball (Los Angeles, États-Unie, 1986–2013).

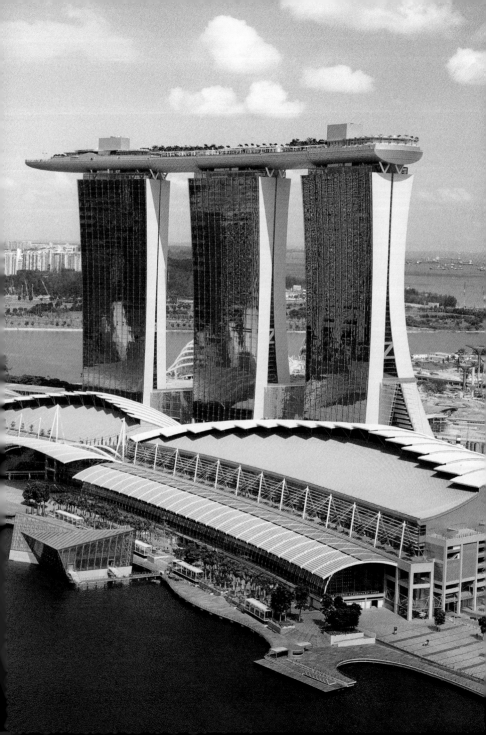

MARINA BAY SANDS INTEGRATED RESORT

Singapore, 2005–11

Area: 845 000 m². Client: Las Vegas Sands Corporation.
Cost: $5.7 billion (including land).

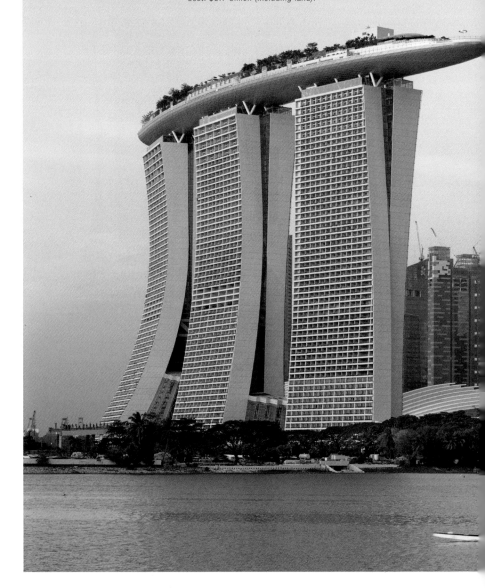

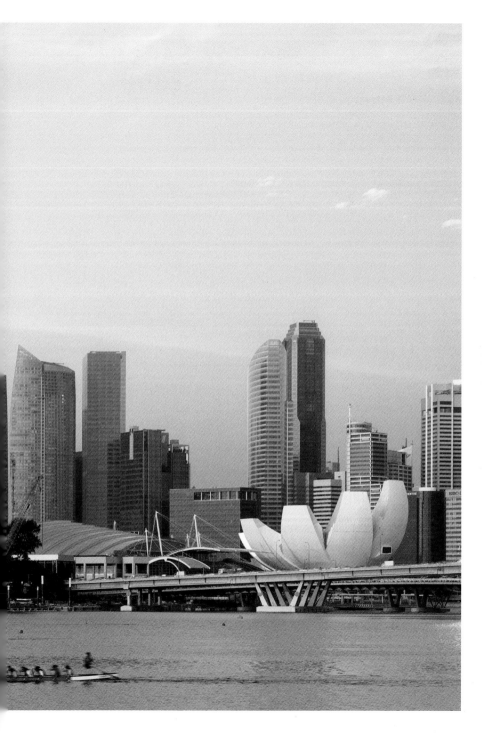

MARINA BAY SANDS, situated on the Marina Bay waterfront in Singapore, is a 16-hectare mixed-use "integrated resort." It combines more than 121 000 square meters of convention and exhibition facilities, with three 55-story hotel towers containing a total of more than 2560 rooms. The 1.2-hectare Sands SkyPark caps the towers, offering 360-degree views of the city and sea along with outdoor facilities for the hotel, including a swimming pool, restaurants, and gardens. This unexpected feature has made Marina Bay Sands one of the most frequently published architectural projects of the past few years. An ArtScience Museum on the promontory, two theaters accommodating up to 4000 people, a casino, a wide variety of shopping and dining outlets, and an outdoor event plaza along the promenade complete this very large project.

MARINA BAY SANDS, am Ufer der Marina Bay in Singapur gelegen, ist ein 16 ha großer „integrierter Erholungsort" mit Mischnutzung. Er vereint über 121 000 m² Kongress- und Ausstellungsbereiche und drei 55-geschossige Hoteltürme, die insgesamt mehr als 2560 Zimmer enthalten. Der 1,2 ha große Sands SkyPark krönt die Hochhäuser und bietet einen Panoramablick auf die Stadt und das Meer, mit Außenbereichen für das Hotel, einem Swimmingpool, Restaurants und Gärten. Diese erstaunliche Anlage hat Marina Bay Sands zu einem der am häufigsten publizierten Architekturprojekte der vergangenen Jahre gemacht. Ein ArtScience-Museum auf der Landspitze, zwei Theater mit bis zu 4000 Sitzplätzen, ein Kasino, eine Vielzahl von Einkaufsstätten und Speiselokalen und ein Eventbereich im Freien an der Promenade ergänzen dieses sehr große Projekt.

MARINA BAY SANDS, sur le front de mer de Marina Bay, à Singapour, est une « station balnéaire intégrée » mixte de 16 hectares. Elle associe un centre des congrès et des espaces d'exposition de plus de 121 000 m² aux trois tours de 55 étages d'un hôtel de 2560 chambres. Le Sands SkyPark de 1,2 hectares coiffe les tours et offre une vue à 360° sur la ville et la mer, ainsi que des équipements extérieurs à l'hôtel, notamment une piscine, des restaurants et des jardins. L'originalité de cette construction a fait de Marina Bay Sands l'un des projets architecturaux les plus publiés de ces dernières années. Un musée d'art et de science sur le promontoire, deux théâtres de 4000 places, un casino, des possibilités multiples de faire du shopping et de se restaurer et une place pour des spectacles extérieurs le long de la promenade complètent ce projet de très large envergure.

Few recent buildings have the "iconic" impact of Marina Bay Sands. With its curving roof element, called SkyPark, uniting the three splayed towers beneath, it is a practical demonstration of the possibilities of concrete in construction.

Nur wenige neuere Bauten haben die „ikonische" Wirkung von Marina Bay Sands. Das SkyPark genannte Dachelement verbindet die drei auswärts gebogenen Türme – eine praktische Demonstration dessen, was mit Beton im Bauwesen möglich ist.

Peu de constructions récentes ont eu un impact aussi emblématique que Marina Bay Sands. Avec sa toiture courbe, le SkyPark, qui relie les trois tours évasées en dessous, c'est une démonstration pratique des possibilités du béton dans la construction.

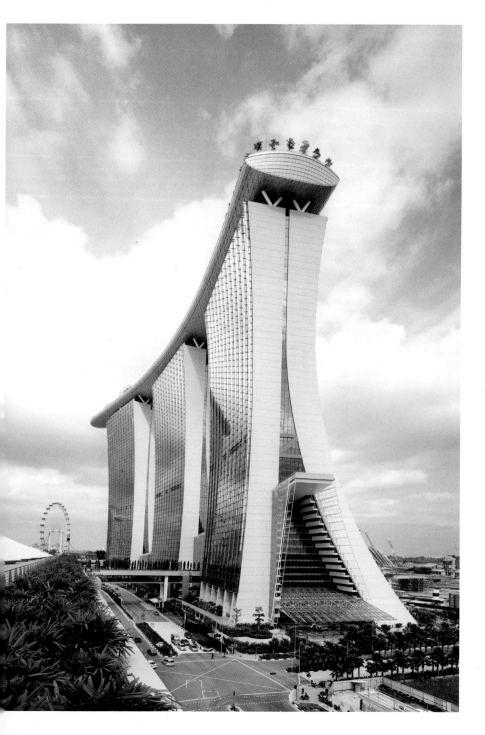

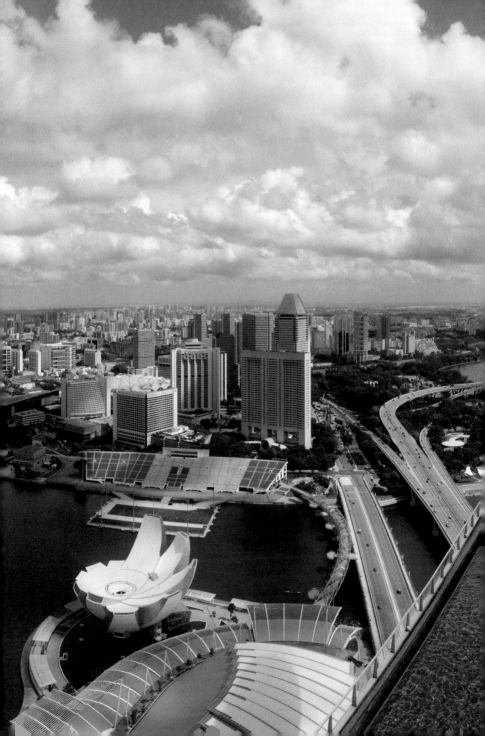

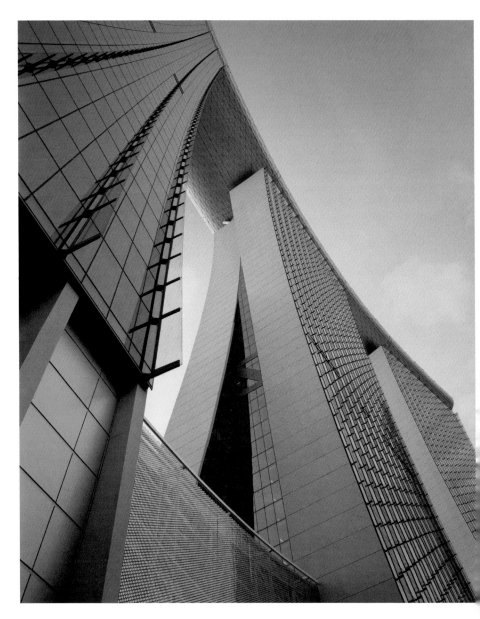

Reinforced concrete shear walls varying in thickness from 71 centimeters at the base to 51 centimeters on higher floors serve as the primary vertical and transverse structural system of the buildings.

Wandscheiben aus Stahlbeton, deren Stärke von 71 cm an der Basis bis zu 51 cm auf den oberen Geschossen variiert, bilden das primäre vertikale und horizontale Tragsystem der Gebäude.

Des murs de cisaillement en béton armé, dont l'épaisseur varie de 71 cm à la base à 51 cm aux étages supérieurs, constituent la structure verticale et transversale primaire des bâtiments.

The soaring atrium of the Marina Bay Sands Hotel echoes the unexpected exterior forms of the complex.

Das hohe Atrium des Marina Bay Sands Hotels folgt den ungewöhnlichen Außenformen der Anlage.

L'atrium à la hauteur vertigineuse de l'hôtel Marina Bay Sands se veut un écho des surprenantes formes extérieures du complexe.

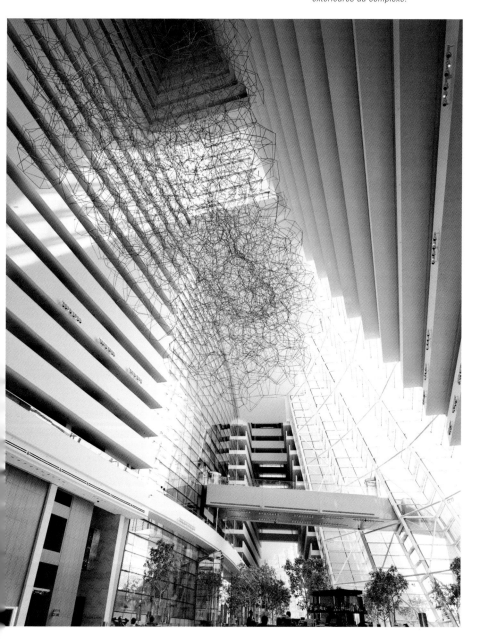

454

SCHNEIDER & SCHNEIDER

THOMAS SCHNEIDER was born in Aarau, Switzerland, in 1965. He studied at the ETH Zurich and obtained his diploma in 1993. He worked at Furrer + Fasnacht (Basel, 1994) and H. P. Ammann + P. Baumann (Zug, 1994–96). He began his collaboration with Beat Schneider in 1997. **BEAT SCHNEIDER** was born 1968 in Aarau. He also studied at the ETH Zurich, obtaining his diploma in 1996. He worked with Ackermann & Friedli (Basel, 1992–95) during his studies. Their work includes a Village Center and a Multipurpose Sports Hall (Reiden, 2005–07); Emergency and Intensive Care Unit, Frauenfeld Canton Hospital (Frauenfeld, 2005–08); extension of Wasserflue Retirement Home (Küttigen, 2008–10); a Residence in Aarau (2010–11, published here); an apartment building (Sandstrasse, Neuenhof, 2010–12); a church (Zofingen, 2014–15); and the refurbishment of the Eye Clinic of the Lucerne Canton Hospital (Lucerne, 2012–16). Work currently under construction includes the "Projekt Horizont," Frauenfeld Canton Hospital (Frauenfeld, 2013–20), all in Switzerland.

THOMAS SCHNEIDER wurde 1965 in Aarau in der Schweiz geboren. Er studierte an der ETH Zürich und machte 1993 sein Diplom. Er arbeitete bei Furrer + Fasnacht (Basel, 1994) und H. P. Ammann + P. Baumann (Zug, 1994–96). Seit 1997 arbeitet er mit **BEAT SCHNEIDER** zusammen, der 1968 in Aarau geboren wurde. Schneider studierte ebenfalls an der ETH Zürich und machte sein Diplom 1996. Während des Studiums arbeitete er bei Ackermann & Friedli (Basel, 1992–95). Zu ihren Arbeiten gehören eine Mehrzweckhalle mit Außenanlagen und Dorfplatz (Reiden, 2005–07), die Notaufnahme und Intensivstation des Kantonsspitals Frauenfeld (2005–08), die Erweiterung des Seniorenzentrums Wasserflue (Küttigen, 2008–10), ein Wohnhaus in Aarau (2010–11, hier vorgestellt), ein Apartmenthaus (Sandstrasse, Neuenhof, 2010–12), eine Kirche (Zofingen, 2014–15) und die Gesamtsanierung der Augenklinik des Kantonsspitals Luzern (2012–16). Zu den laufenden Projekten im Bau zählt das „Projekt Horizont", Kantonsspital Frauenfeld (2013–20), alle in der Schweiz.

THOMAS SCHNEIDER est né à Aarau, en Suisse, en 1965. Il a fait des études à l'ETH de Zurich et a obtenu son diplôme en 1993. Il a travaillé chez Furrer + Fasnacht (Bâle, 1994) et H. P. Ammann + P. Baumann (Zoug, 1994–96) avant de commencer à collaborer avec Beat Schneider en 1997. **BEAT SCHNEIDER** est né en 1968 à Aarau. Il a également fait ses études à l'ETH de Zurich et a obtenu son diplôme en 1996. Pendant ses études, il a travaillé avec Ackermann & Friedli (Bâle, 1992–95). Leurs réalisations comprennent un centre de village et une salle de sports polyvalente (Reiden, 2005–07) ; un service d'urgences et de soins intensifs à l'hôpital cantonal de Frauenfeld (Frauenfeld, 2005–08) ; l'extension de la maison de retraite de Wasserflue (Küttigen, 2008–10) ; une résidence à Aarau (2010–11, publiée ici) ; un immeuble d'appartements (Sandstrasse, Neuenhof, 2010–12) ; une église (Zofingen, 2014–15) et le réaménagement de la clinique ophtalmologique de l'hôpital cantonal de Lucerne (Lucerne, 2012–16). Parmi les travaux en construction figure le « Projekt Horizont » à l'hôpital cantonal de Frauenfeld (Frauenfeld, 2013–20), tous en Suisse.

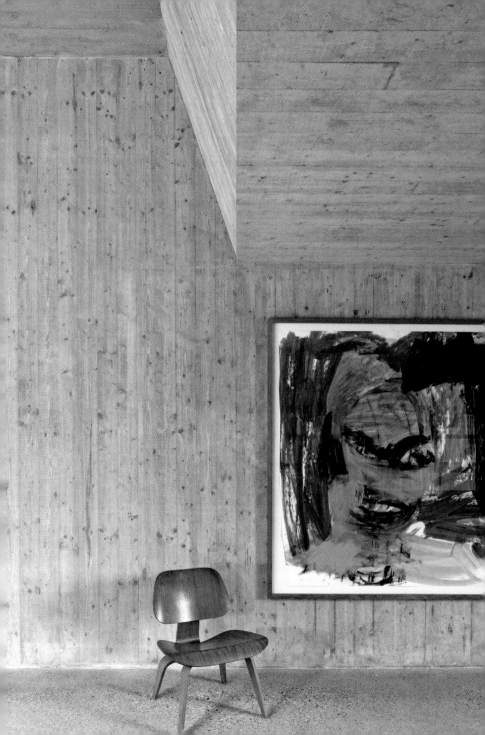

RESIDENCE IN AARAU

Aarau, Switzerland, 2010–11

Area: 170 m². Collaboration: Tobias Sager (Architect),
Müller Illien, Zurich (Landscape Design).

The architects sought in this instance to "reinterpret the conventional layout of a single-family house." The interior of the **RESIDENCE IN AARAU** is completely lined in fair-faced concrete. The rough-sawed texture of the timber formwork is visible in the walls and ceiling, but the concrete floor has been polished smooth. The dark reddish wood of the doors and built-in furniture create a warm atmosphere that enhances the contrast with the rough concrete surfaces. The façades are externally insulated, and clad with blackened wood boards that echo the rhythm and format of the interior formwork. Large windows mirror the neighboring forest, appearing as a reflected image in the black façade.

Das Ansinnen der Architekten war es hier, „den konventionellen Entwurf eines Einfamilienhauses ganz neu zu denken". Die Innenräume der **RESIDENZ IN AARAU** sind vollständig in Sichtbeton gehalten. Die Struktur der rau gesägten Schalung ist an Wänden und Decken sichtbar, aber der Betonfußboden wurde glatt poliert. Der dunkle rötliche Farbton der Türen und Einbaumöbel sorgt für eine warme Atmosphäre, die den Kontrast mit dem rohen Beton verstärkt. Die Fassaden sind von außen wärmegedämmt und mit geschwärzten Holzpanelen verkleidet, die Rhythmus und Aufbau der Formensprache im Innern aufgreifen. In großen Fenstern spiegelt sich der angrenzende Wald, der als Reflexion auch auf der schwarzen Fassade erscheint.

Les architectes ont ici cherché à «réinterpréter le plan traditionnel d'une maison individuelle». L'intérieur de la **RÉSIDENCE EN AARAU** est entièrement garni de béton de parement. La texture brute de sciage du coffrage en bois est visible dans les murs et le plafond, tandis que le sol de béton, lui, a été poli et lissé. Le bois brun rouge sombre des portes et meubles encastrés crée une atmosphère chaleureuse qui souligne le contraste avec les surfaces de béton brut. Les façades sont isolées à l'extérieur et revêtues de panneaux de bois noircis qui font écho au rythme et au format du coffrage intérieur. De larges fenêtres réfléchissent la forêt voisine qui apparaît en reflet sur la façade noire.

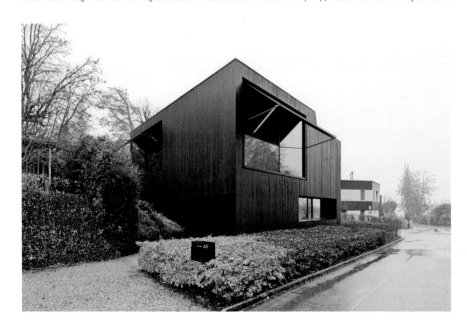

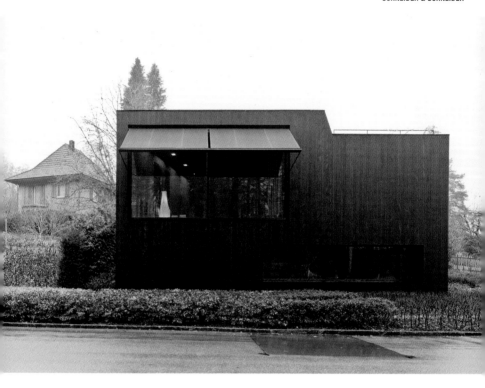

The dark vertical wood cladding of the building gives way to large windows with an awning extended in the images shown here. Below, section drawings of the residence.

Die dunkle, vertikale Holzverkleidung des Gebäudes macht großen Fenstern mit einem Sonnendach Platz, das auf den hier gezeigten Bildern aufgeklappt ist. Unten Schnittzeichnungen des Wohnhauses.

Le revêtement vertical de bois sombre fait place à de larges fenêtres avec un auvent qu'on voit ici. Ci-dessous, plan en coupe de la résidence.

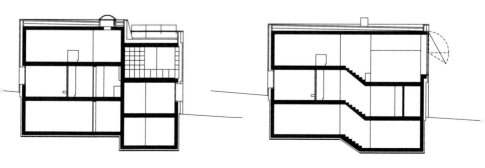

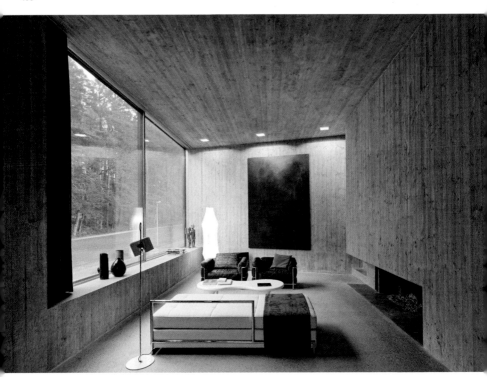

Interiors are essentially rendered in concrete with sparse, modern furnishing. Below, floor plans reveal the truncated triangular design.

Die Innenräume sind im Wesentlichen in Beton gehalten und sparsam modern möbliert. Unten zeigen Grundrisse die gestutzte Dreiecksform des Entwurfs.

Les intérieurs sont essentiellement construits en béton avec un mobilier rare et moderne. Ci-dessous, les plans au sol mettent en évidence le design de triangle tronqué.

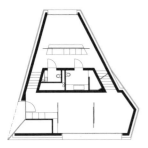
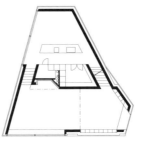

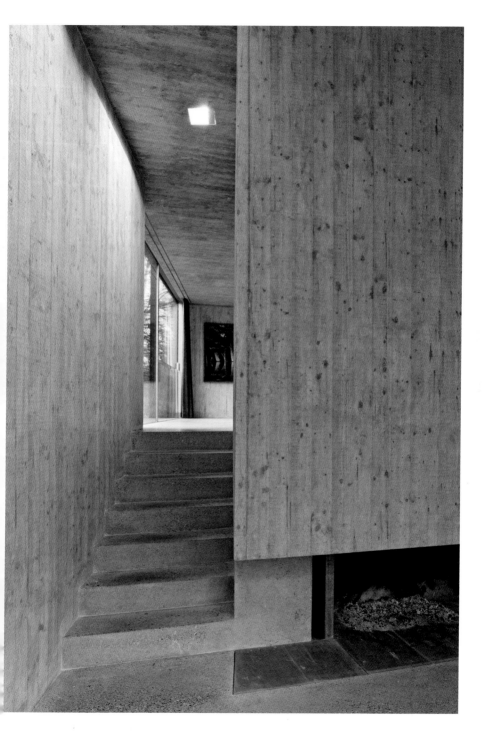

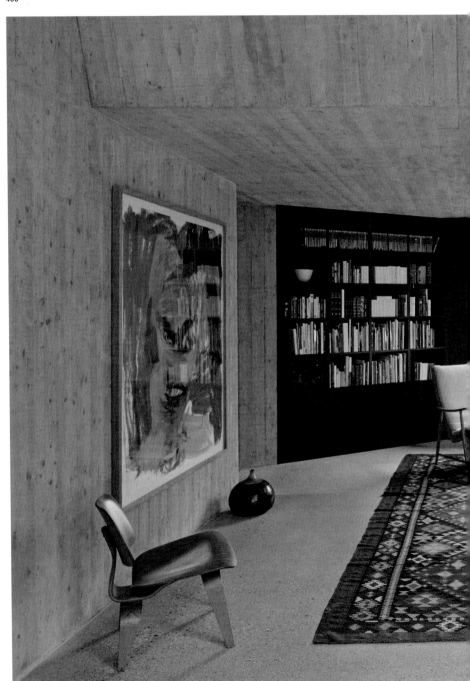

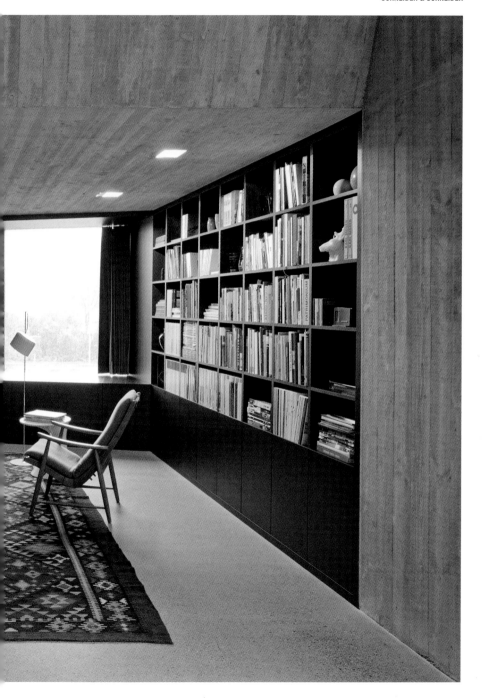

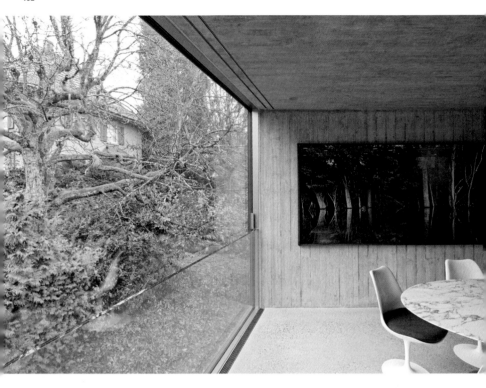

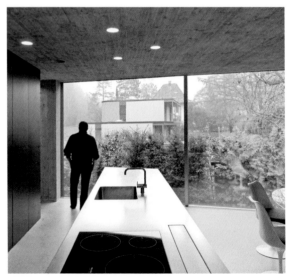

The kitchen area offers space that is neither entirely inside nor completely outside, with a retractable glass wall. Left, the same space seen from an-other angle. Right, a bedroom with carefully aligned works of art.

Die Glaswand im Küchenbereich lässt sich öffnen, damit scheint der Raum weder ganz innen noch vollständig draußen zu sein. Links: Derselbe Raum aus einer anderen Perspektive. Rechts ein Schlafzimmer mit sorgsam angeordneten Kunstwerken.

La cuisine occupe un espace ni entièrement dedans, ni entièrement dehors, avec une paroi vitrée rétractable. À gauche, le même endroit vu d'un autre angle. À droite, une chambre avec des œuvres d'art soigneusement alignées.

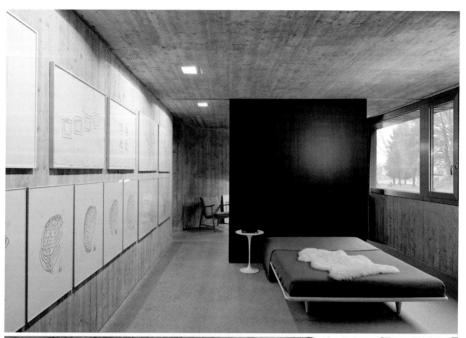

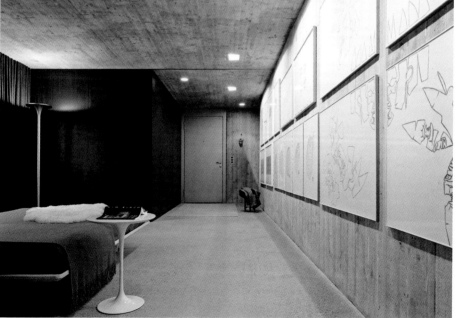

464

Cliff House

FRAN SILVESTRE

Fran Silvestre Arquitectos was founded in Valencia by the architect **FRAN SILVESTRE** in 2005. Born in 1976, Silvestre graduated from the ETSA of Valencia in 2001. He then studied urban planning at the Eindhoven Technical University, before working in the studio of Álvaro Siza in Porto. The architect acknowledges the influence of Siza and of the sculptor Andreu Alfaro. Aside from the Atrium House (Godella, Valencia, 2008–09) and the Cliff House (Calpe, Alicante, 2010–12, published here), Fran Silvestre has built the House on the Castle Mountainside (Ayora, Valencia, 2010), and such works as Blanc L'Antic Colonial Showroom (Villareal, 2013), all in Spain, again showing his fondness for white, seen quite clearly in the house published in this volume.

Fran Silvestre Arquitectos wurde 2005 in Valencia vom 1976 geborenen Architekten **FRAN SILVESTRE** gegründet. Er beendete 2001 sein Studium an der Escuela Tecnica Superior de Arquitectura (ETSA) in Valencia. Danach studierte er Stadtplanung an der Technischen Universität Eindhoven und arbeitete anschließend im Atelier von Álvaro Siza in Porto. Silvestre bekennt, von Siza und von dem Bildhauer Andreu Alfaro beeinflusst zu sein. Außer dem Atriumhaus (Godella, Valencia, 2008–09) und dem Haus auf der Klippe (Calpe, Alicante, 2010–12, hier vorgestellt), hat Fran Silvestre u. a. noch das Haus an einem Burgberg (Ayora, Valencia, 2010) und den Showroom Blanc L'Antic Colonial (Villareal, 2013), alle in Spanien, realisiert. Alle seine ausgeführten Projekte zeigen seine Vorliebe für die Farbe Weiß, wie an dem hier vorgestellten Haus zu sehen ist.

Fran Silvestre Arquitectos a été fondé à Valence, en Espagne, par l'architecte **FRAN SILVESTRE** en 2005. Né en 1976, il est diplômé de l'ETSA de Valence (2001). Il a ensuite étudié l'urbanisme à l'université technique d'Eindhoven avant de travailler dans l'agence d'Álvaro Siza à Porto. Il admet l'influence de Siza et du sculpteur Andreu Alfaro. En plus de la maison Atrium (Godella, Valence, 2008–09) et de la Maison dans la falaise (Calpe, Alicante, 2010–12, publiée ici), Fran Silvestre a construit la Maison sur le versant du château (Ayora, Valence, 2010) et l'espace d'exposition colonial Blanc L'Antic (Villareal, 2013), tous en Espagne, qui témoignent une fois encore de son goût pour le blanc qu'on retrouve aussi dans le maison publiée ici.

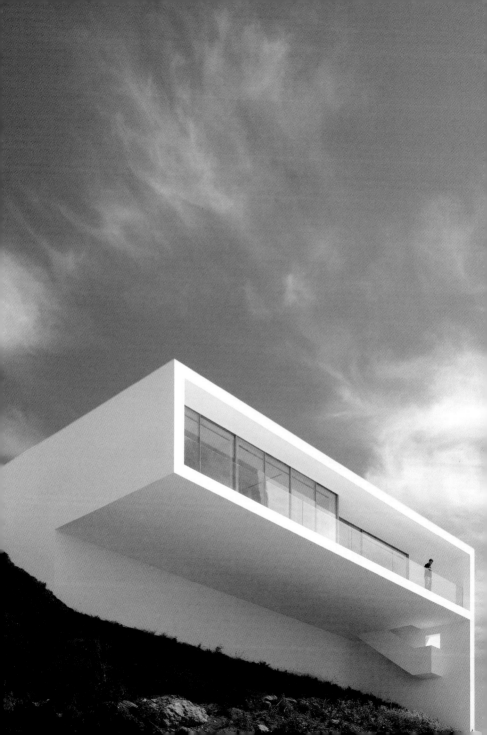

CLIFF HOUSE

Calpe, Alicante, Spain, 2010–12

Area: 242 m². Cost: €650 000.
Collaboration: Alfaro Hofmann (Interior Design).

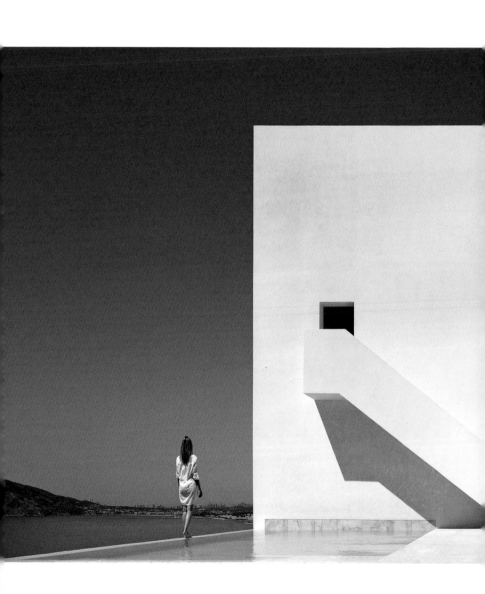

The sharply cut white forms of the house yield to shade but also to the blue of the sea and the sky.

Die scharf geschnittenen, weißen Formen des Hauses greifen die Schatten, aber auch das Blau des Meeres und des Himmels auf.

Les formes blanches tranchées de la maison reculent devant l'ombre, mais aussi le bleu du ciel et de la mer.

Perched above the Mediterranean on a steep slope, **CLIFF HOUSE** is a one-story structure. The architect states that "a three-dimensional structure of reinforced-concrete slabs and screens adapting to the plot's topography was chosen, thus minimizing the earthwork. This monolithic, stone-anchored structure generates a horizontal platform from the accessing level, where the house itself is located." Made up of strictly rectangular volumes, the house is partially inserted into the hillside at the rear and cantilevers over the hill toward the sea. The concrete is covered with smooth, white lime stucco. White is also the color of choice for the pavement and roof gravel. The swimming pool is placed at a lower level where the site offers some flat space.

Das eingeschossige **HAUS AUF DER KLIPPE** thront auf einem steilen Hang über dem Mittelmeer. Der Architekt erklärt, dass er sich „für einen dreidimensionalen Bau aus Stahlbetonplatten und -trennwänden entschied, der sich der Topografie des Geländes anpasst, wodurch nur minimale Erdarbeiten erforderlich waren. Dieses monolithische, im Fels verankerte Gebäude bildet auf der Eingangsebene eine horizontale Plattform, auf der das ganze Haus steht." Es besteht aus streng rechteckigen Volumen, ist an der Rückseite zum Teil in den Hang gebaut und kragt zum Meer hin aus. Der Beton ist mit glattem, weißem Kalkputz überzogen. Weiß ist auch die Farbe der Wahl für die Pflasterung oder den Bedachungskies. Der Swimmingpool liegt auf einem tieferen Niveau, wo das Gelände etwas flacher ist.

La **MAISON SUR LA FALAISE** perchée sur une pente escarpée qui surplombe la Méditerranée n'a qu'un étage. L'architecte explique qu'il «a choisi une structure tridimensionnelle à base de plaques et d'écrans de béton armé adaptée à la topographie du site afin de minimiser les travaux de terrassement. L'ensemble monolithique ancré dans le roc forme une plate-forme horizontale à partir du niveau d'accès où la maison elle-même est placée». Composée de volumes strictement rectangulaires, elle est partiellement intégrée au coteau à l'arrière et s'avance en surplomb du côté de la mer. Le béton est recouvert de stuc calcaire lisse et blanc. Le blanc est aussi la couleur qui a été choisie pour le pavage et le gravier sur le toit. La piscine a été creusée en contrebas, là où le terrain était plus plat.

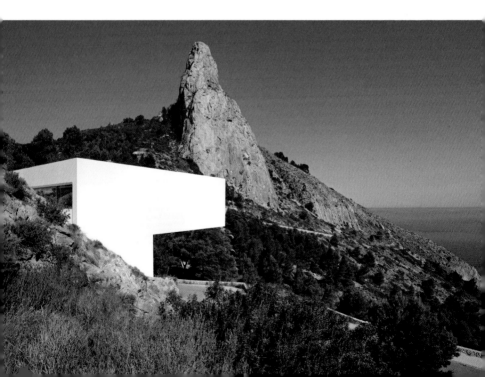

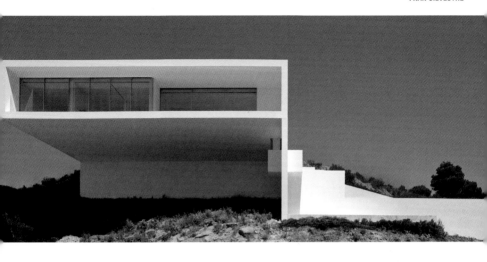

The abrupt white shape of the house certainly contrasts with the stone and greenery of the surroundings, but it is designed to allow its owners better views of nature.

Die blendend weiße Form des Hauses bildet einen scharfen Gegensatz zum Fels und Grün der Umgebung, doch es wurde so gebaut, dass es seinen Bewohnern schöne Ausblicke in die Natur gewährt.

La forme blanche très sommaire de la maison contraste incontestablement avec la pierre et la verdure des environs, elle a pourtant été conçue pour permettre à ses habitants de mieux regarder la nature.

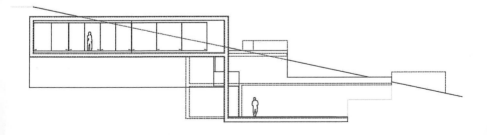

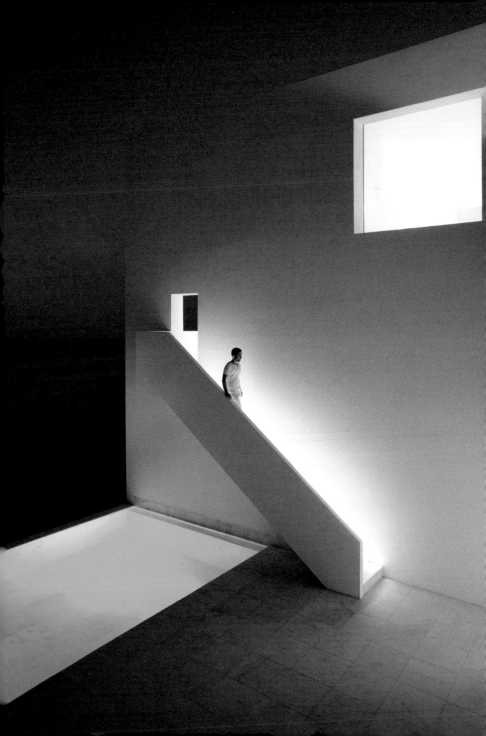

Seen at night, the house also clearly projects an image of splendid isolation overlooking the sea. Light floods out of its few openings.

Bei Nacht bietet das Haus ein Bild großartiger Abgeschiedenheit oberhalb der Küste. Das Licht strahlt aus den wenigen Öffnungen.

La nuit aussi, la maison renvoie clairement l'image d'un splendide isolement en surplomb de la mer. La lumière se déverse par ses rares ouvertures.

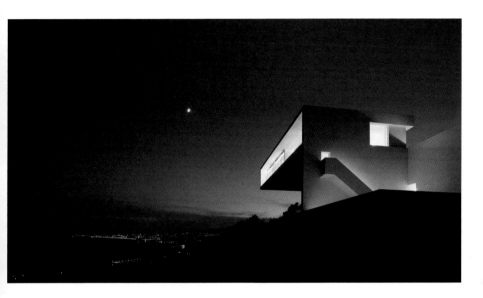

Left page, at night as during the day, bright areas contrast with relative shadow and the blue color of the pool. Below, section drawings.

Linke Seite: Bei Nacht wie am Tag kontrastieren helle Bereiche mit relativ schattigen und dem Blau des Pools. Unten: Schnitte.

Page de gauche, la nuit comme le jour, les zones claires contrastent avec celles plus ombragées et le bleu de la piscine. Ci-dessous, schémas en coupe.

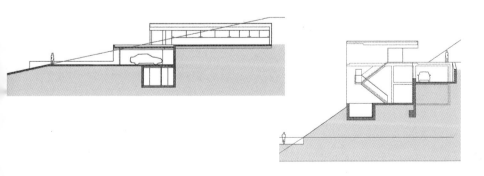

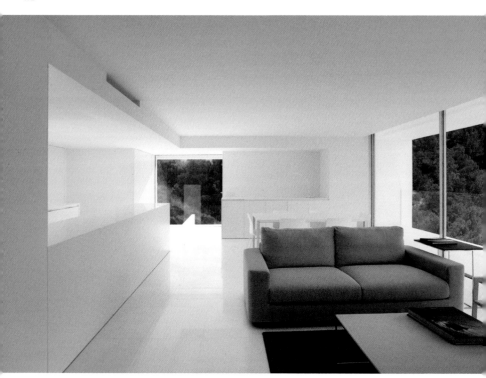

Living and kitchen spaces project the same image of white simplicity as the exterior of the house. Openings are carefully carved from what might appear to be a unified white mass.

Der Wohn- und Küchenbereich zeigen sich in derselben weißen Schlichtheit wie das Äußere des Hauses. Die Öffnungen sind sorgfältig aus der einheitlich wirkenden, weißen Masse herausgeschnitten.

Les espaces séjour et cuisine se montrent dans la même simplicité blanche que l'extérieur de la maison. Les ouvertures ont été découpées avec soin dans ce qui peut apparaître comme une masse blanche uniforme.

A view of the sea is privileged
(right). Left below: Plans showing
the topographic lines of the site.

*Der Blick auf das Meer ist fan-
tastisch (rechts). Links unten: Die
Grundrisse zeigen die topografi-
schen Linien des Geländes.*

*La vue sur la mer est privilégiée
(à droite). Les plans ci-dessous à
gauche montrent les lignes topogra-
phiques du site.*

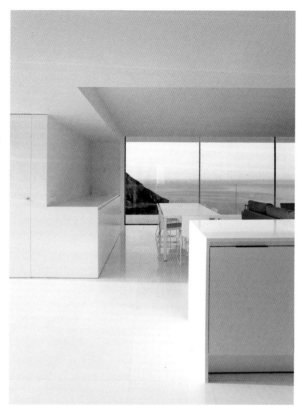

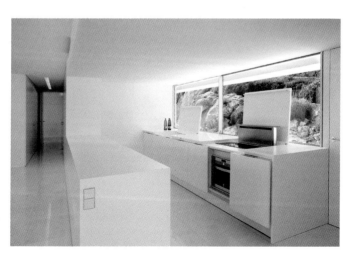

474

Iberê Camargo Foundation

ÁLVARO SIZA

Born in Matosinhos, Portugal, in 1933, **ÁLVARO SIZA** studied at the University of Porto School of Architecture (1949–55). He created his own practice in 1954, and worked with Fernando Tavora from 1955 to 1958. He received the European Community's Mies van der Rohe Prize in 1988 and the Pritzker Prize in 1992. He built a large number of small-scale projects in Portugal, and worked on the restructuring of the Chiado in Lisbon (Portugal, 1989–); the Meteorology Center in Barcelona (Spain, 1989–92); the Vitra Furniture Factory (Weil am Rhein, Germany, 1991–94); the Porto School of Architecture, Porto University (Portugal, 1986–95); the University of Aveiro Library (Aveiro, Portugal, 1988–95); the Portuguese Pavilion for the 1998 Lisbon World's Fair (with Eduardo Souto de Moura); and the Serralves Foundation (Porto, Portugal, 1996–99); and House in Oudenburg (Belgium, 1995–2001). More recent projects include the Adega Mayor Winery (Campo Maior, Portugal, 2005–06); the Museum for the Iberê Camargo Foundation (Porto Alegre, Brazil, 1998–2008, published here); a house in Mallorca (Mallorca, Spain, 2004–08); laboratory and office building, Novartis Campus (Basel, Switzerland, 2008–11); and the Theater/ Auditorium of Llinars del Vallès (with Aresta, Barcelona, Spain, 2012–15).

ÁLVARO SIZA wurde 1933 in Matosinhos, Portugal, geboren und studierte an der Architekturfakultät der Universität Porto (1949–55). Er eröffnete 1954 sein eigenes Büro und arbeitete von 1955 bis 1958 mit Fernando Tavora zusammen. 1988 erhielt er den Mies-van-der-Rohe-Preis der Europäischen Gemeinschaft, 1992 den Pritzker-Preis. In Portugal hat er eine Vielzahl kleinerer Projekte realisiert und war bei der Restaurierung des Chiado-Viertels in Lissabon tätig (seit 1989). Zu seinen weiteren Projekten gehören das Zentrum für Meteorologie in Barcelona (1989–92), die Vitra-Fabrikhalle (Weil am Rhein, Deutschland, 1991–94), die Architekturfakultät der Universität Porto (Portugal, 1986–95), die Universitätsbibliothek von Aveiro (Aveiro, Portugal, 1988–95), der Portugiesische Pavillon der Weltaus- stellung 1998 in Lissabon (gemeinsam mit Eduardo Souto de Moura), die Serralves-Stiftung (Porto, Portugal, 1996–99) und das Haus in Oudenburg (Belgien, 1995–2001). Zu den jüngeren Projekten zählen u. a. die Weinkellerei Adega Mayor (Campo Maior, Portugal, 2005–06), das Museum der Stiftung Iberê Camargo (Porto Alegre, Brasilien, 1998–2008, hier veröffentlicht), ein Haus auf Mallorca (Spanien, 2004–08), ein Labor- und Bürogebäude auf dem Novartis-Campus (Basel, Schweiz, 2008–11) und das Theater/Auditorium von Llinars del Vallès (mit Aresta, Barcelona, Spanien, 2012–15).

Né à Matosinhos, Portugal, en 1933, **ÁLVARO SIZA** a fait ses études à l'École d'architecture de l'université de Porto (1949–55). Il a ouvert son agence en 1954 et a travaillé avec Fernando Tavora de 1955 à 1958. Il a reçu le prix Mies van der Rohe de la Communauté européenne en 1988 et le prix Pritzker en 1992. Au Portugal, il a réalisé beaucoup de petits projets et a travaillé à la restructuration du quartier du Chiado à Lisbonne (1989–) ; ainsi qu'au Centre météorologique de Barcelone (Espagne, 1989–92) ; à l'usine de meubles Vitra (Weil am Rhein, Allemagne, 1991–94) ; à l'École d'architecture de l'université de Porto (Portugal, 1986–95) ; à la bibliothèque de l'université d'Aveiro (Portugal, 1988–95) ; au pavillon du Portugal de l'Exposition universelle de Lisbonne 1998 (avec Eduardo Souto de Moura) ; à la fondation Serralves (Porto, 1996–99) et à la maison à Oudenburg (Belgique, 1995–2001). Ses projets plus récents comprennent le vignoble Adega Mayor (Campo Maior, Portugal, 2005–06) ; le musée de la Fondation Iberê Camargo (Porto Alegre, Brésil, 1998–2008, publié ici); une maison à Mallorca (Espagne, 2004–08) ; un laboratoire et un immeuble de bureaux du campus Novartis (Bâle, Suisse, 2008–11) ; et le théâtre/auditorium de Llinars del Vallès (avec Arestes, Barcelone, Espagne, 2012–15).

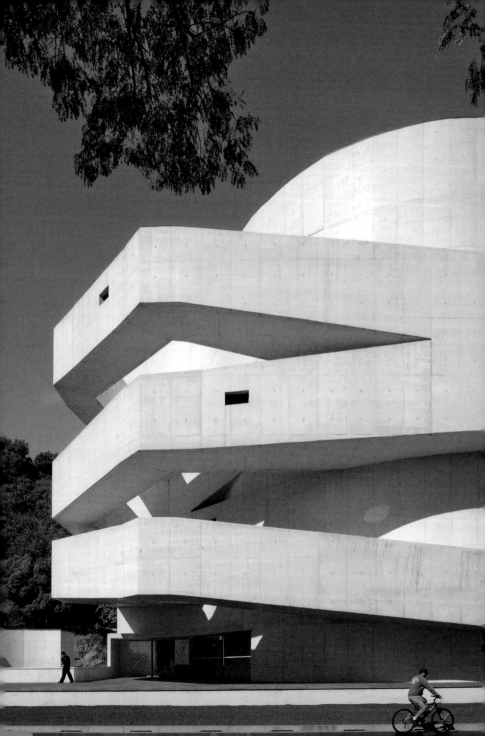

IBERÊ CAMARGO FOUNDATION

Porto Alegre, Rio Grande do Sul, Brazil, 1998–2008

Floor area: 960.38 m². Client: Iberê Camargo Foundation.
Principals in Charge: Bárbara Rangel, Pedro Polónia.

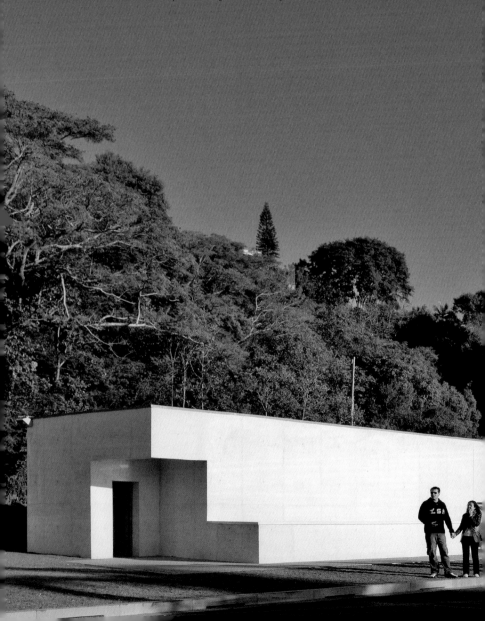

The Iberê Camargo Foundation is inserted into a cliff side near the water, but also at the edge of a street. The architect's signature white forms become more lyrical here than usual.

Die Stiftung Iberê Camargo ist in einen Felshang nahe am Wasser eingefügt, liegt aber auch an einer Straße. Die für die Handschrift des Architekten typischen weißen Formen sind hier poetischer als üblich ausgefallen.

Le bâtiment de la Fondation Iberê Camargo est enchâssé dans une falaise tout près de l'eau, mais aussi au bord d'une rue. Les formes blanches qui sont la signature de l'architecte prennent ici un caractère plus lyrique que de coutume.

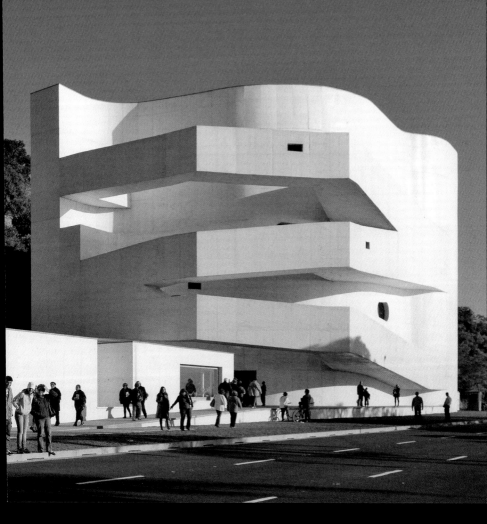

Designed beginning in 1998, this new museum has been described as the "masterpiece" of Álvaro Siza. It received a Golden Lion Award at the 2002 Venice Architecture Biennale. It is located in Porto Alegre, one of the largest cities in Brazil, and capital of the state of Rio Grande do Sul. This building, set between Padre Cacique Avenue and a cliff, is intended for the exhibition of the **IBERÊ CAMARGO FOUNDATION**'s collection of 4000 works by local artist Iberê Camargo, and for housing archives, a library and video library, bookstore, café, and small auditorium, but also administrative offices, and artists' workshops. The main volume of the structure appears to be carved out of the cliff, assuming an undulating form on the north and east, with orthogonal walls on the south and west. An atrium, surrounded by exhibition galleries, marks the entrance. No distinction is made between the temporary and permanent exhibition areas that can be opened into the atrium space with four-meter-high movable panels. There is natural overhead light available on the top floor, and the other galleries can receive light from the atrium depending on the positioning of the dividing panels. External ramps and a terrace at the lowest level define the exterior form, together with the undulating wall, and allow for visitors to have the carefully selected views of the natural scenery that Siza has always favored.

Álvaro Sizas neues Museum, an dem der Architekt seit 1998 gearbeitet hat, wurde als sein „Meisterstück" bezeichnet. 2002 erhielt es den Goldenen Löwen der Architekturbiennale von Venedig. Es befindet sich im brasilianischen Porto Alegre, einer der größten Städte des Landes und zugleich Hauptstadt des Bundesstaates Rio Grande do Sul, wo es zwischen der Avenida Padre Cacique und einer Klippe angelegt wurde. Zusätzlich zu der Sammlung der **FUNDAÇÃO IBERÊ CAMARGO**, die 4000 Werke des aus der Region stammenden Künstlers umfasst, bietet das Museum Archive, eine Bibliothek, eine Videothek, einen Buchladen, ein Café und einen kleinen Vortragssaal, aber auch Raum für Verwaltungsbüros und Künstlerwerkstätten. Der Hauptteil des Gebäudes wirkt wie aus der Klippe herausgeschnitten und hat auf seiner Nord- und Ostseite eine gewellte Form, während die Außenmauern auf der südlichen und westlichen Seite rechtwinklig sind. Den Eingangsbereich bildet ein von Ausstellungsgalerien umfasstes Atrium. Die Räume für Sonderschauen sind nicht von den Sälen mit den Dauerausstellungen abgetrennt, die sich mithilfe von beweglichen, 4 m hohen Wandelementen zum Atrium hin öffnen lassen. Im Obergeschoss fällt natürliches Licht durch die Decke ein, die übrigen Ausstellungsräume werden je nach Ausrichtung der Trennwände über das Atrium mit Licht versorgt. Die außerhalb des Gebäudes verlaufenden Rampen und eine Terrasse auf der untersten Ebene bestimmen im Verbund mit der gewellten Fassade die äußere Gestalt des Museums und bieten Besuchern sorgfältig ausgewählte Ausblicke in die Naturkulisse, der Siza von jeher besondere Bedeutung beimisst.

Conçu début 1998, ce nouveau musée a pu être qualifié de « chef-d'œuvre » d'Álvaro Siza. Il a reçu un Lion d'or à la Biennale d'architecture de Venise en 2002. Situé à Porto Alegre, l'une des plus grandes villes du Brésil et capitale de l'État du Rio Grande do Sul, il est implanté entre l'avenue Padre Cacique et une falaise. Il regroupe une collection de la **FONDATION IBERÊ CAMARGO** de 4000 œuvres de l'artiste local, des archives, une bibliothèque, une vidéothèque, une librairie, un café, un petit auditorium, des bureaux administratifs et des ateliers d'artiste. Le volume principal, de forme ondulée au nord et à l'est et orthogonale au sud et à l'ouest, semble sculpté dans la falaise. L'entrée est suivie d'un atrium entouré de galeries d'exposition. Aucune distinction n'est faite entre les espaces d'expositions temporaires ou permanentes qui ouvrent sur cet atrium par des panneaux mobiles de 4 m de haut. Le niveau supérieur est éclairé zénithalement et les autres galeries reçoivent la lumière de l'atrium en fonction de la position des panneaux de partition. Au niveau inférieur, des rampes externes et une terrasse participent à la définition de la forme extérieure et permettent aux visiteurs de bénéficier de vues choisies sur le paysage naturel que Siza privilégie toujours.

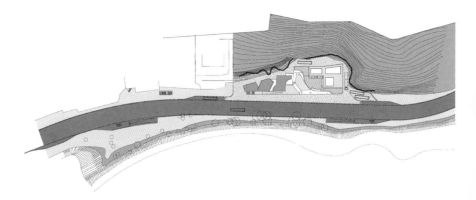

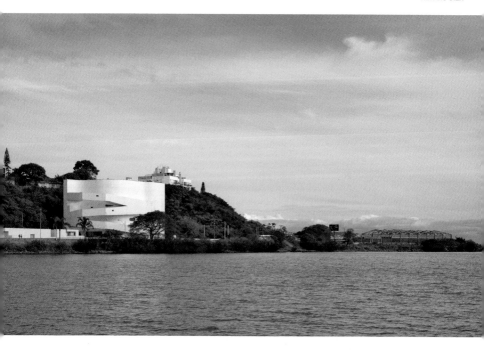

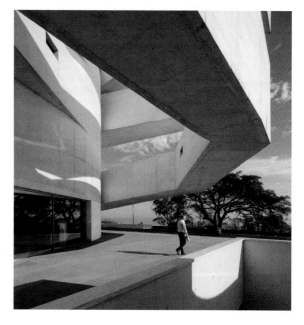

The building seen from the water (above) seems to wrap into its hilly site. An external ramp overhangs a terrace, and a site plan shows the shoreline and the location of the building.

Vom Wasser aus betrachtet (oben), wirkt das Gebäude wie eingehüllt vom hügeligen Gelände. Eine Außenrampe kragt über eine Terrasse vor. Der Lageplan zeigt den Uferverlauf und den Standort des Gebäudes.

Vu depuis l'eau (ci-dessus), le bâtiment semble enveloppé dans le site de collines. Une rampe extérieure surplombe une terrasse. Le plan de situation montre l'emplacement du bâtiment sur le littoral.

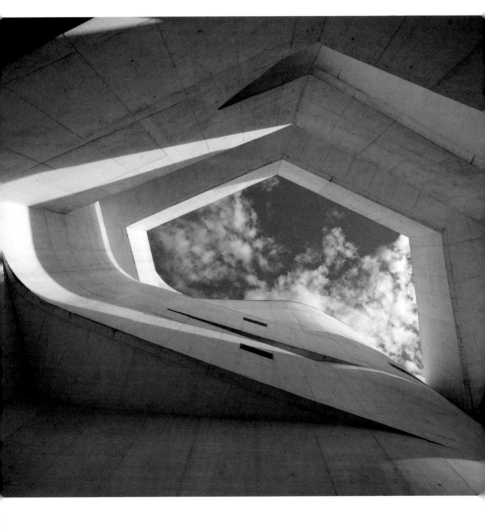

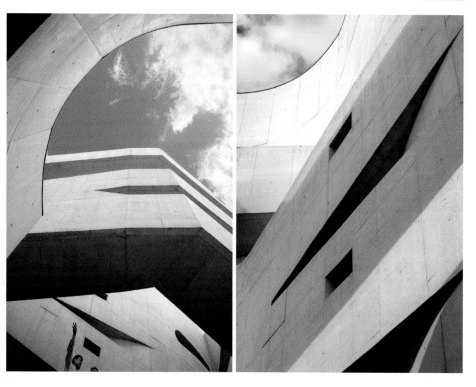

As the plan on the opposite page and the section drawing below demonstrate, the architect creates a fully usable interior volume despite the more surprising curves and openings seen in the images here.

Wie der Plan auf der gegenüberliegenden Seite und der Schnitt unten zeigen, erzeugt der Architekt einen voll funktionalen Innenbereich trotz der eher überraschenden Krümmungen und Öffnungen, die auf den Abbildungen sichtbar sind.

Comme on le voit sur le plan page de gauche et le schéma en coupe ci-dessous, l'architecte a créé un volume intérieur parfaitement utilisable malgré les courbes et ouvertures surprenantes qu'on voit ici.

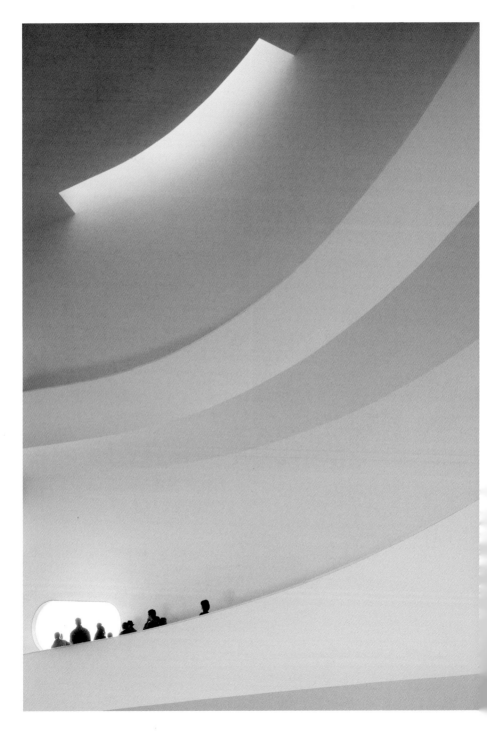

Interiors display the kind of relative complexity seen in earlier work by Siza, but here the mastery of space and light achieves a new high point for the architect.

Diese Innenaufnahmen zeigen die entsprechende Komplexität, die auch früheren Bauten Sizas eigen ist. Aber hier erreicht seine meisterhafte Beherrschung des Raumes und des Lichtes einen neuen Höhepunkt.

L'intérieur affiche la complexité relative qu'on retrouve dans des œuvres antérieures de Siza, mais l'architecte atteint ici un sommet encore inégalé dans sa maîtrise de l'espace et de la lumière.

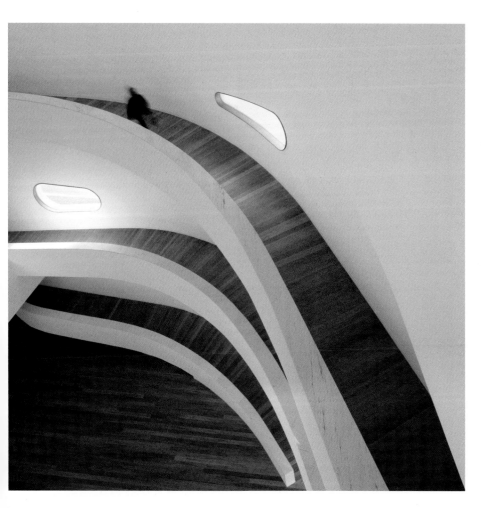

Though some may see an echo of Frank Lloyd Wright's Guggenheim Museum in New York in these ramps, Siza is operating in a different register, that of his own flowing modernity.

Obgleich manche beim Anblick dieser Rampen vielleicht an Frank Lloyd Wrights Guggenheim-Museum in New York erinnert werden, zieht Siza hier andere Register – diejenigen seiner eigenen, schwungvollen Moderne.

Certains verront peut-être dans ces rampes un écho du musée Guggenheim de Frank Lloyd Wright à New York, mais Siza opère dans un registre différent, celui de sa propre modernité fluide.

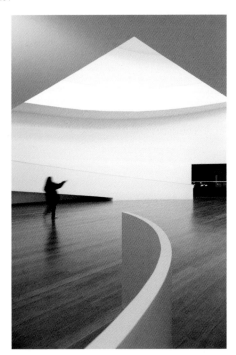

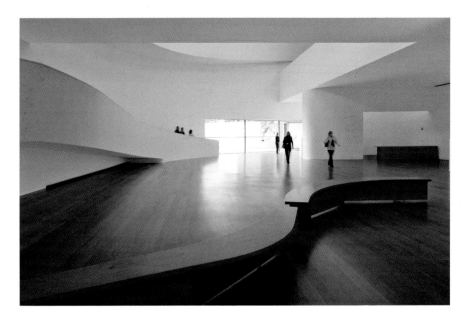

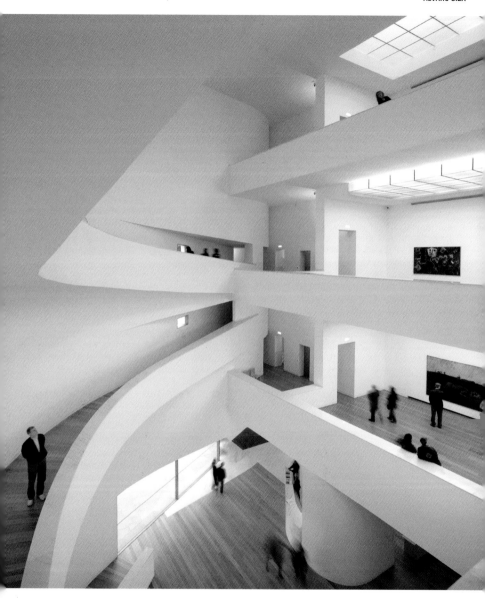

Siza has opted neither for a rectilinear design nor for completely curved spaces, rather he integrates the two approaches in a perfectly natural way.

Siza hat sich weder für einen geradlinigen Entwurf noch für komplett gekrümmte Räume entschieden; vielmehr integriert er beide Lösungsformen auf völlig natürliche Weise.

Siza n'a opté ni pour un design rectiligne, ni pour des espaces entièrement courbes, il a préféré intégrer les deux approches d'une manière parfaitement naturelle.

MIMESIS MUSEUM

Paju Book City, South Korea, 2006–10

Total area: 3663 m². Client: Open Books Publishing Co.
Collaboration: Carlos Castanheira, Kim June-song.

Álvaro Siza carried out the **MIMESIS MUSEUM** in collaboration with the architect Carlos Castanheira. As Siza explains, he does not really feel up to making frequent trips to Korea, so his associate was the one to do the traveling. Castanheira states that the plan for this structure resembles a drawing of a cat. As he relates, the older architect listened to his description of the site and program and then, "in a single gesture, a cat appeared. The Mimesis is a cat. A cat that is curled up but is also stretching and yawning." Broad curves form the inner lines of the museum, perhaps broader and more sustained curves than Siza has employed in the past. Archives and a service area are located in the basement level, together with a possible extension for the exhibition areas. The entrance hall, temporary exhibition spaces, and a café are on the ground floor. Administrative spaces are on the mezzanine and the top floor is given over to exhibition areas. Castanheira states: "Light, always light, carefully studied, both natural and artificial, was considered essential to the project, allowing one to see without being seen. We made models and more models, some of which were big enough to enter, and also 3D drawings."

Álvaro Siza realisierte das **MIMESIS MUSEUM** mit Carlos Castanheira, der einen Großteil der erforderlichen Reisen übernahm, da Siza sich nicht in der Lage sah, häufig nach Korea zu reisen. Castanheira vergleicht den Grundriss des Baus mit der Skizze einer Katze. Er erinnert sich, wie ihm der ältere Architekt zuhörte, als er Grundstück und Programm beschrieb und plötzlich, „mit einer einzigen Geste, zeichnete er eine Katze. Das Mimesis ist eine Katze: eine Katze, die sich zusammenrollt, sich streckt und gähnt." Die innere Kontur des Museumsbaus wird von imposanten Schwüngen definiert – größeren und konstanteren Schwüngen, als Siza bis dato eingesetzt hat. Magazine und Haustechnik wurden im Untergeschoss untergebracht, ebenso wie potenzielle Erweiterungen für die Ausstellungsbereiche. Das Foyer, Flächen für Sonderausstellungen und ein Café befinden sich im Erdgeschoss. Verwaltungsräume liegen im Zwischengeschoss, während das Obergeschoss vollständig weiteren Ausstellungsflächen vorbehalten ist. Castanheira führt aus: „Licht, immer wieder Licht – sorgsam studiert, natürliches wie künstliches – war von grundlegender Bedeutung für dieses Projekt, Licht, das einem erlaubt zu sehen, ohne gesehen zu werden. Wir bauten Modell um Modell, einige groß genug, um sie zu begehen, und fertigten außerdem 3-D-Zeichnungen an."

Álvaro Siza a réalisé le **MIMESIS MUSEUM** en collaboration avec l'architecte Carlos Castanheira. Il a expliqué qu'il n'avait pas envie de multiplier les déplacements en Corée et a chargé son associé d'effectuer les voyages nécessaires. Castanheira raconte que le plan de ce musée ressemble au dessin d'un chat. Siza a écouté sa description du terrain et du programme puis « dans un simple geste, un chat est apparu. Le Mimesis est un chat. Un chat qui se met en boule mais aussi s'étire et baille ». Les axes intérieurs du musée dessinent des courbes généreuses, peut-être plus amples et plus tendues que celles utilisées par Siza dans le passé. Le sous-sol abrite les archives et une zone de services en attendant l'extension éventuelle des salles d'exposition. Le hall d'entrée, des salles d'expositions temporaires et un café occupent le rez-de-chaussée. Les bureaux administratifs sont en mezzanine et le dernier niveau est consacré à des espaces d'exposition. « La lumière, toujours la lumière, soigneusement étudiée, à la fois naturelle et artificielle, a joué un rôle essentiel dans ce projet, permettant de voir sans être vu. Nous avons réalisé des maquettes et encore des maquettes, dont certaines assez grandes pour y entrer, mais aussi beaucoup de perspectives en 3D », précise Castanheira.

Undulating lines seen in some earlier Siza structures are dominant here, with a contrast between the blankness of the upper walls and the openings at ground level.

Hier dominieren geschwungene Linien, bekannt aus frühen Projekten Sizas. Die Geschlossenheit der oberen Fassade und die Öffnungen in der Sockelzone sorgen für Kontraste.

Les ondulations vues dans certaines réalisations antérieures de Siza dominent ici, de même que le contraste entre l'aspect fermé de la façade supérieure et les ouvertures au ras du sol.

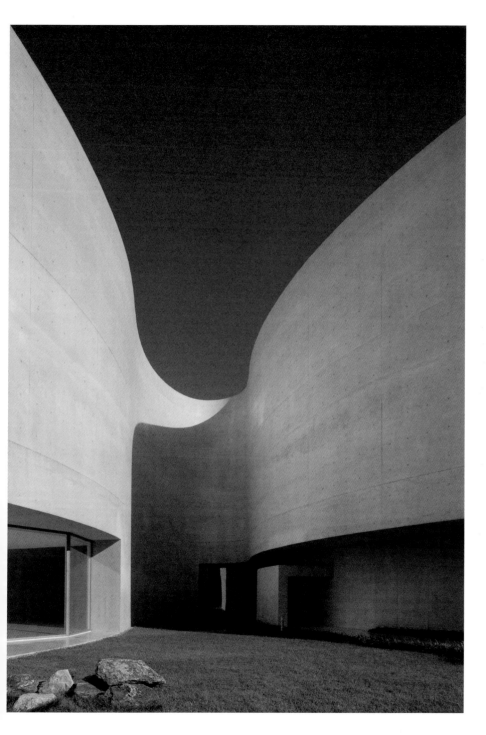

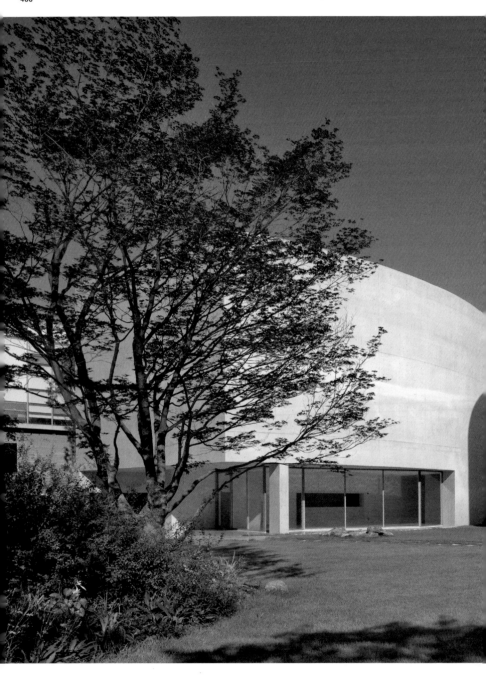

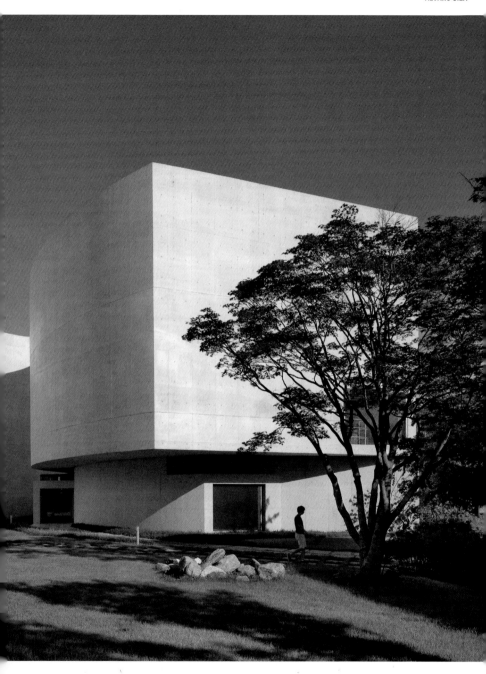

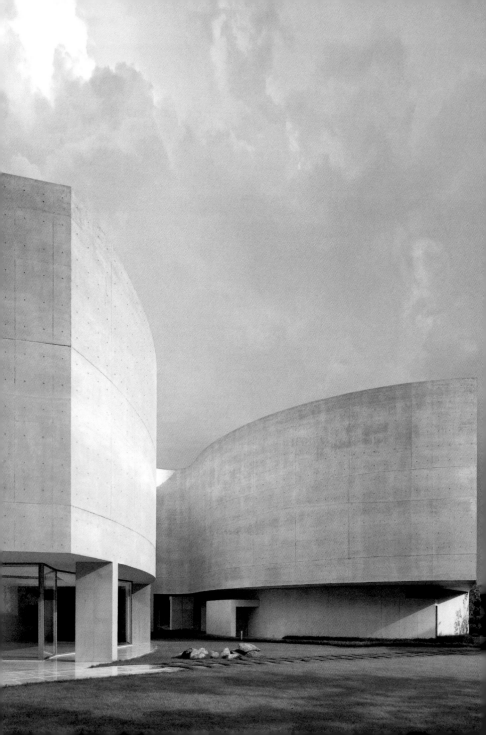

A plan shows how curves are concentrated on one side of the building, with two straight façades on the other. These curves and the overhangs they create at the base of the building are visible in the images on these two pages.

Der Plan zeigt die Konzentration der Krümmungen auf einer Seite des Gebäudes und zwei gerade Fassaden auf der anderen. Diese Krümmungen und die Überstände, die sie an der Basis des Gebäudes bilden, sind auf den Abbildungen dieser Doppelseite erkennbar.

Le plan montre comment les courbes sont regroupées d'un seul côté du bâtiment, l'autre étant marqué par deux façades droites. On voit sur les photos de cette double page ces arrondis et les surplombs qu'ils créent au pied du bâtiment.

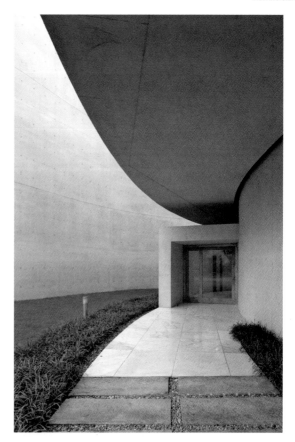

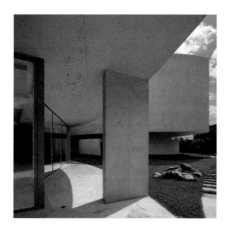

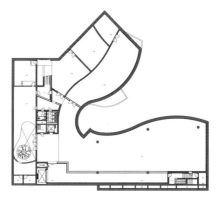

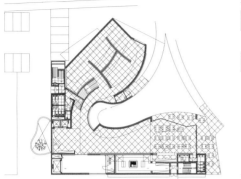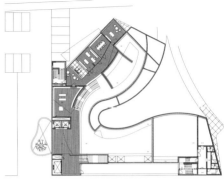

Curves are, in fact, very present in the design, both inside and out, as seen in the courtyard with a single tree (right) or the plans above.

Kurven sind im Entwurf innen wie außen auffällig präsent, wie der Hof mit einem einzelnen Baum (rechte Seite) oder die Pläne oben belegen.

Les courbes sont en fait très présentes dans le projet, aussi bien à l'extérieur qu'à l'intérieur, comme le montre cette cour et son arbre (page de droite) ou les plans ci-dessus.

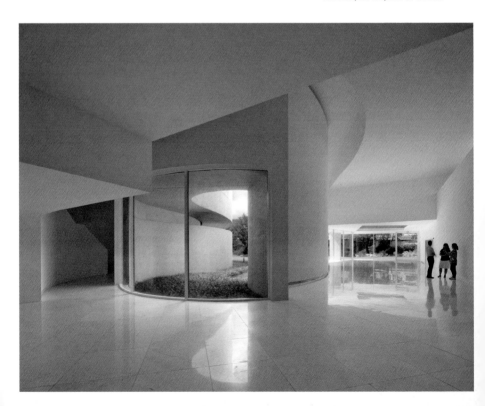

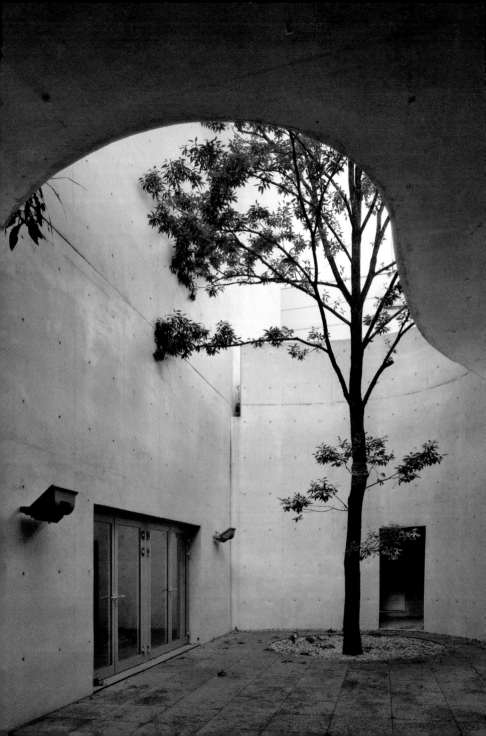

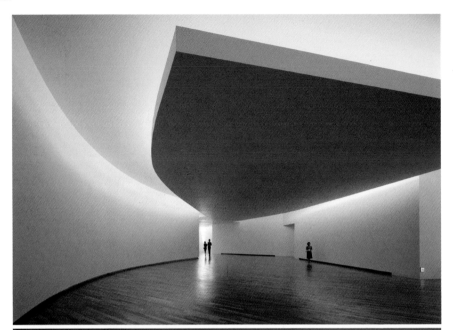

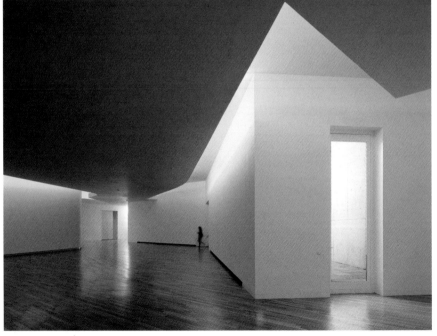

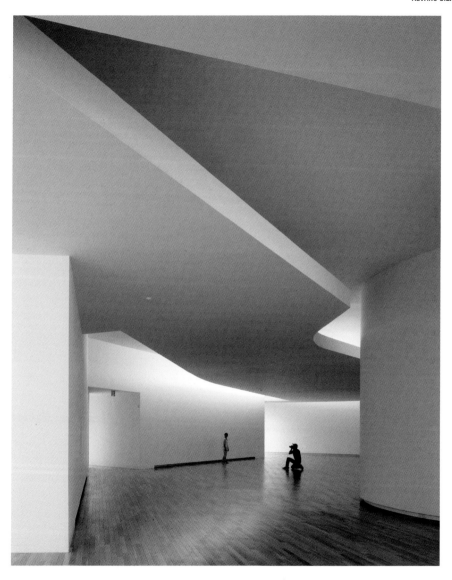

Siza's interiors take on a degree of complexity that does not belie his earlier work but develops on his themes of indirect light, wooden floors, and white walls.

Sizas Interieurs sind von einer Komplexität, die nicht im Widerspruch zu früheren Entwürfen steht, sondern eine Weiterentwicklung von Motiven wie indirektem Licht, Holzböden oder weißen Wänden sind.

Les espaces intérieurs de Siza parviennent ici à un degré de complexité qui reste dans l'axe de ses interventions antérieures mais explore encore davantage ses thèmes de prédilection : la lumière indirecte, les parquets de bois, les murs blancs.

SPBR

ANGELO BUCCI was born in Orlândia (Brazil) in 1963. He received his degree in Architecture from the FAUUSP in São Paulo in 1987. He went on to obtain a Master's (1998) and then a Ph.D. (2005), also at the University of São Paulo. Having become a Partner at MMBB Architects in São Paulo, he founded SPBR in 2003. He has been a Professor at the FAUUSP since 2001. Recent projects include an apartment building (Silves, Portugal, 2008); the Ubatuba House (Ubatuba, São Paulo, Brazil, 2007–09, published here); an apartment building in Lugano (Lugano, Switzerland, 2009–10); a weekend house (São Paulo, Brazil, 2010–12); and a house in Itaipava (Itaipava, Rio de Janeiro, Brazil, 2010–12).

ANGELO BUCCI wurde 1963 in Orlândia, Brasilien, geboren. Sein Diplom für Architektur erwarb er 1987 an der Fakultät für Architektur und Städtebau der Universidad São Paulo (FAUUSP). Danach machte er seinen Master (1998) und promovierte (2005) an der gleichen Universität. Nachdem er Partner bei MMBB Architects in São Paulo geworden war, gründete er 2003 SPBR. Seit 2001 hat er eine Professur an der FAUUSP. Zu seinen neueren Projekten zählen ein Appartementhaus (Silves, Portugal, 2008), ein Wohnhaus in Ubatuba (São Paulo, Brasilien, 2007–09, hier vorgestellt), ein Appartementhaus in Lugano (Schweiz, 2009–10), ein Wochenendhaus (São Paulo, Brasilien, 2010–12) und ein Wohnhaus in Itaipava (Rio de Janeiro, Brasilien, 2010–12).

ANGELO BUCCI est né à Orlândia (Brésil) en 1963. Il est diplômé en architecture de la FAUUSP de São Paulo (1987) et a poursuivi ses études jusqu'au master (1998), puis au doctorat (2005), toujours à l'université de São Paulo. Partenaire de MMBB Architects à São Paulo, il a fondé SPBR en 2003. Il est professeur à la FAUUSP depuis 2001. Ses projets récents comprennent un immeuble d'appartements (Silves, Portugal, 2008) ; la maison Ubatuba (Ubatuba, São Paulo, Brésil, 2007–09, publiée ici) ; un immeuble d'appartements à Lugano (Suisse, 2009–10) ; la maison de week-end (São Paulo, Brésil, 2010–12) et la maison à Itaipava (Rio de Janeiro, Brésil, 2010–12).

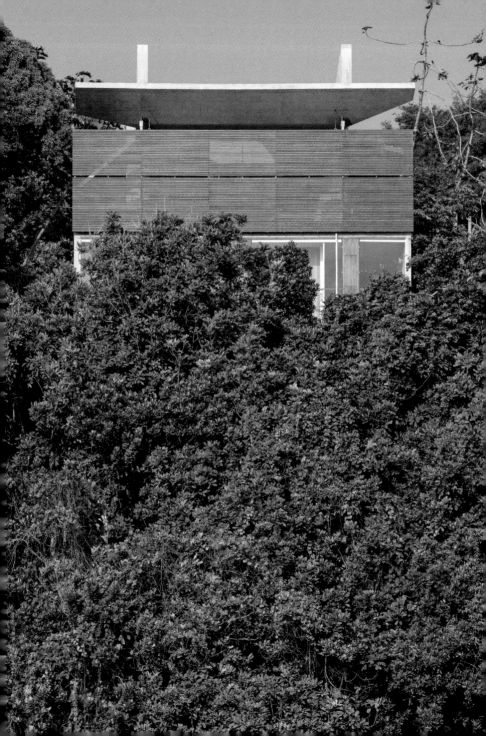

UBATUBA HOUSE

Ubatuba, São Paulo, Brazil, 2007–09

Area: 346 m².

The 55 x 16-meter sloped site of this house is located on Tenório Beach. The steep area is forested and both the hill and the trees are protected by environmental laws. The **UBATUBA HOUSE** is supported by three reinforced-concrete columns. Rejecting the use of large steel beams for cost reasons, the architects decided to build the whole structure in reinforced concrete. The terrace on top of the house is at the same level as the street. Because of the slope, a bridge connects the street to the main entrance where a swimming pool is located. The clients had originally wanted to live in the house, but now it is used as a vacation house for their son and daughter. For that reason the bedrooms are placed in two separate blocks. The architects explain: "Besides preserving the natural landscape, this hanging house actually floats among the trees."

Das 55 x 16 m große Hanggrundstück dieses Hauses liegt am Tenório-Strand. Das steile Gelände ist bewaldet, und sowohl der Hügel als auch die Bäume stehen unter Naturschutz. Das **UBATUBA HAUS** steht auf drei Stahlbetonstützen. Die Architekten verzichteten aus Kostengründen auf schwere Stahlträger und entschieden sich für eine Gesamtkonstruktion aus armiertem Beton. Die Dachterrasse liegt auf einer Höhe mit der Straße. Aufgrund des abfallenden Geländes führt eine Brücke von der Straße zum Haupteingang und zum Swimmingpool. Die Auftraggeber wollten ursprünglich in dem Haus leben, jetzt wird es aber als Ferienhaus für ihren Sohn und ihre Tochter genutzt. Aus diesem Grund wurden die Schlafräume in zwei getrennten Trakten untergebracht. Die Architekten erläutern: „Dieses hängende Haus bewahrt die natürliche Landschaft und schwebt eigentlich zwischen den Bäumen."

Le terrain en pente de 55 x 16 m occupé par la maison est situé sur la plage de Tenório. La zone escarpée est plantée d'arbres qui, comme la colline elle-même, sont protégés par la législation en matière d'environnement. La **MAISON UBATUBA** s'appuie sur trois colonnes en béton armé. Les architectes, ayant rejeté l'idée de larges poutres en acier pour des raisons financières, ont choisi de construire l'ensemble de la structure en béton armé. La terrasse en haut de la maison est au niveau de la rue. La pente a nécessité de construire une passerelle entre la rue et l'entrée principale où se trouve une piscine. Les clients souhaitaient habiter la maison mais l'utilisent en fin de compte comme villégiature pour leur fils et leur fille. C'est pour cette raison que les chambres à coucher sont placées dans deux blocs distincts. Pour les architectes : « En plus de préserver le paysage naturel, cette maison suspendue flotte véritablement parmi les arbres. »

Right, the architect alternates translucent surfaces with concrete solidity or broad openings. Above, a section drawing shows how the house is set up on its sloped site.

Rechts: Der Architekt wechselt durchsichtige Flächen mit massivem Beton und weiten Öffnungen ab. Oben: Der Schnitt zeigt, wie das Haus auf dem abfallenden Gelände steht.

À droite, l'architecte a fait alterner les surfaces translucides et la solidité du béton ou de larges ouvertures. Ci-dessus, un plan en coupe montre comment la maison est construite sur le terrain en pente.

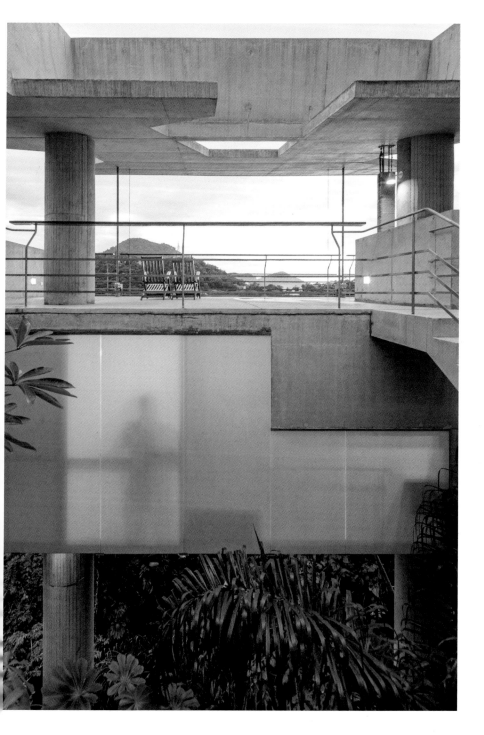

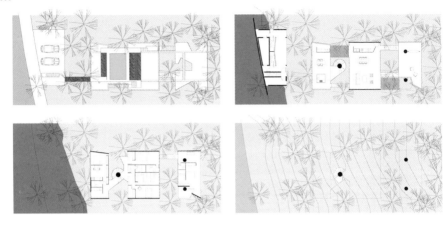

The architect shows his mastery of thin concrete surfaces as seen in the suspended stairway to the right. The heart of the house is clad in wood giving an impression of greater warmth within.

Der Architekt beherrscht den Umgang mit dünnen Betonflächen, wie an der freitragenden Treppe rechts zu sehen ist. Das Zentrum des Hauses ist mit Holz verkleidet und wirkt dadurch wärmer.

L'escalier suspendu illustre la parfaite maîtrise que possède l'architecte des fines surfaces de béton. Le cœur de la maison est revêtu de bois qui lui confère une impression plus chaleureuse à l'intérieur.

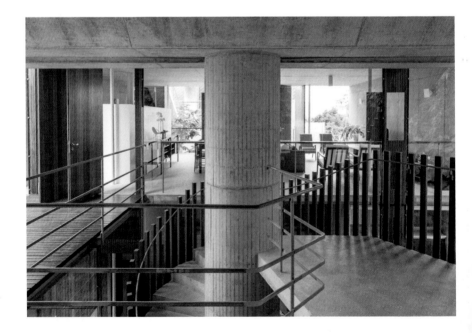

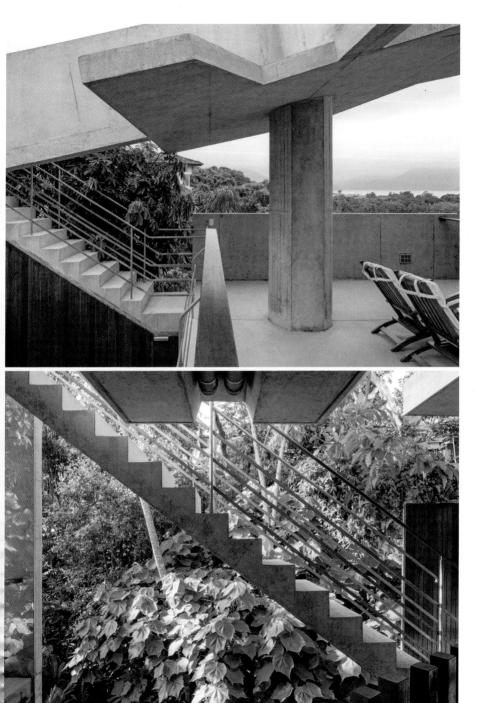

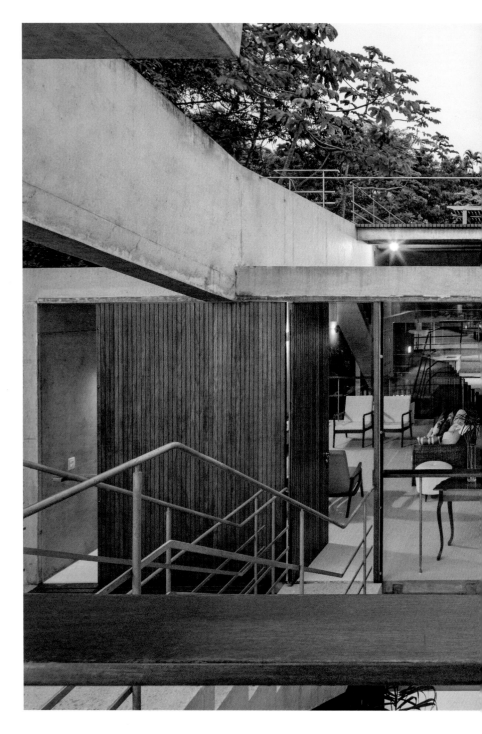

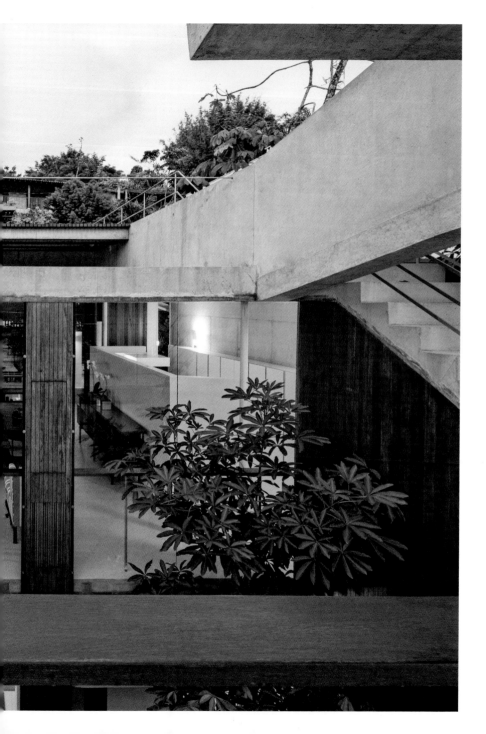

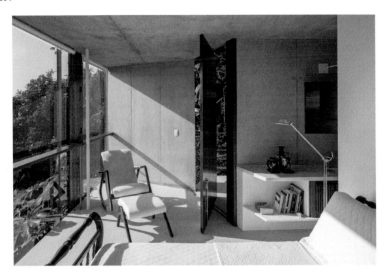

Wooden louvers and doors are al-
ternated with concrete and plaster.
Full-height glazing is employed in
the bedroom seen on this page.

Holzlamellen oder Türen im Wechsel
mit Beton und Verputz. Im Schlaf-
raum auf dieser Seite kommt eine
raumhohe Verglasung zum Einsatz.

Des persiennes ou des portes en
bois alternent avec le béton et le
plâtre. La chambre photographiée
sur cette page est vitrée sur toute
sa hauteur.

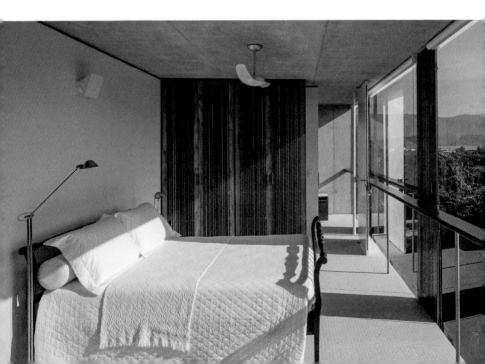

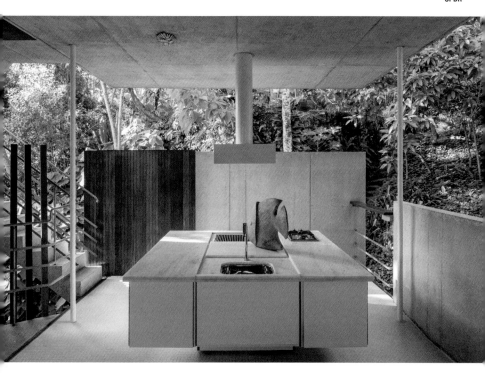

A stairway with wooden and metal railings is seen above. The kitchen seems to float in a protected green environment. Below, sliding wooden louvers open to reveal a generous view of the shoreline.

Die Treppe mit einem Geländer aus Holz und Metall ist oben zu sehen. Die Küche scheint in einem geschützten grünen Umfeld zu schweben. Unten: Verschiebbare hölzerne Lamellen öffnen sich zu einem großartigen Ausblick auf die Küste.

En haut, un escalier à rampe en bois et métal. La cuisine semble flotter dans un décor de verdure protégé. Ci-dessous, des volets coulissants en bois ouvrent sur une large vue du littoral.

SPEECH

SPEECH, founded in 2006, is one of the leading architectural firms in Russia, with a total of nearly 200 employees. **SERGEI TCHOBAN**, born in Leningrad (St. Petersburg) in 1962, studied architecture at the Repin State Academic Institute (St. Petersburg, 1980–86). He worked first as an architect in Russia, and then in Hamburg, opening his own office, Tchoban & Partners, in Moscow in 2003. He has been the managing partner at SPEECH since 2006. **SERGEY KUZNETSOV** was born in Moscow in 1977. He obtained his degree as an architect from the Moscow Architectural Institute (1995–2001). He was a Partner and CEO of S.P. Project in Moscow beginning in 2003. He was the managing partner of SPEECH from 2006 to 2012, and he became the Chief Architect and Deputy Chairman of the Moscow Committee for Architecture and Urban Development after leaving SPEECH in 2012. Their work includes an office building on Leninsky Prospekt (Moscow, Russia, 2008–11); the VTB Group Office (Moscow, 2010–11); Universiade-2013 Palace of Water Sports (Kazan City, Russia, 2010–12); the Exhibition for the Russian Pavilion at the XIII Architecture Biennale (Venice, Italy, 2012); and the Museum for Architectural Drawing (Berlin, Germany, 2011–13, published here).

SPEECH, 2006 gegründet, ist eines der führenden Architekturbüros in Russland mit insgesamt fast 200 Mitarbeitern. **SERGEI TCHOBAN** wurde 1962 in Leningrad (heute St. Petersburg) geboren und studierte Architektur an der Staatlichen Repin-Akademie (Leningrad, 1980–86). Er arbeitete zuerst als Architekt in Russland und dann in Hamburg, bis er 2003 sein eigenes Büro, Tchoban & Partner, in Moskau eröffnete. Seit 2006 ist er geschäftsführender Partner von SPEECH. **SERGEY KUZNETSOV** wurde 1977 in Moskau geboren. Er erwarb sein Diplom für Architektur am Architekturinstitut Moskau (1995–2001). Ab 2003 war er Partner und geschäftsführender Vorstand von S. P. Project in Moskau, von 2006 bis 2012 geschäftsführender Partner von SPEECH und ist seit Aufgabe dieses Postens 2012 Chefarchitekt und Vorsitzender der Geschäftsführung des Moskauer Komitees für Architektur und Stadtentwicklung. Zu den ausgeführten Projekten des Büros zählen ein Bürogebäude am Leninsky-Prospekt (Moskau, 2008–11), das Bürogebäude der Firmengruppe VTB (Moskau, Russland, 2010–11), der Palast für Wassersport der Universiade 2013 (Kasan, Russland, 2010–12), die Ausstellung für den Russischen Pavillon auf der XIII. Architekturbiennale (Venedig, Italien, 2012) und das Museum für Architekturzeichnung (Berlin, Deutschland, 2011–13, hier vorgestellt).

SPEECH, fondé en 2006, est aujourd'hui l'une des premières sociétés d'architecture de Russie avec presque 200 employés. **SERGEI TCHOBAN**, né à Leningrad (Saint-Pétersbourg) en 1962, a fait des études d'architecture à l'Institut académique d'État Repin (Saint-Pétersbourg, 1980–86). Il a d'abord travaillé en Russie, puis à Hambourg, et a ouvert son agence, Tchoban & Partners, à Moscou en 2003. Il est partenaire et directeur de SPEECH depuis 2006. **SERGEY KUZNETSOV** est né en 1977 à Moscou. Il est diplômé en architecture de l'Institut architectural de Moscou (1995–2001). Il est l'un des partenaires et le directeur général de S.P. Project à Moscou depuis 2003. Il est partenaire de SPEECH qu'il a dirigé de 2006 à 2012 et qu'il a quitté en 2012, pour devenir l'architecte en chef et vice-président du Comité moscovite pour l'architecture et le développement urbain. Leurs réalisations comprennent un immeuble de bureaux sur la perspective Leninsky (Moscou, 2008–11) ; les bureaux du groupe VTB (Moscou, Russie, 2010–11) ; le Palais des sports aquatiques pour l'Universiade d'été 2013 (Kazan, Russie, 2010–12) ; l'exposition pour le pavillon de la Russie à la XIIIe Biennale d'architecture de Venise (Italie, 2012) et le Musée du dessin d'architecture (Berlin, Allemagne, 2011–13, publié ici).

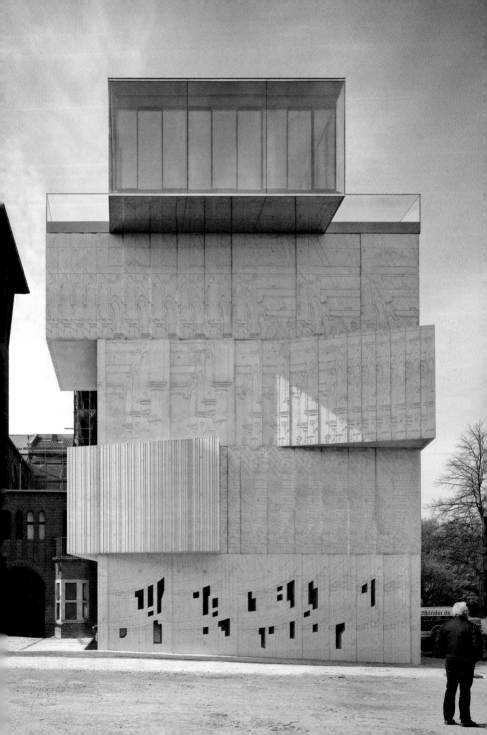

MUSEUM FOR ARCHITECTURAL DRAWING

Berlin, Germany, 2011–13

Area: 498 m². Client: The Tchoban Foundation.
Collaboration: Philipp Bauer, Ulrike Graefenhain.

The **MUSEUM FOR ARCHITECTURAL DRAWING** is intended for the exhibition of the collections of the Tchoban Foundation, founded in 2009 for the purpose of the popularization of architectural graphics as well as for exhibitions from different institutions, including Sir John Soane's Museum in London and the École des Beaux-Arts in Paris. The Foundation purchased a small lot in the former Pfefferberg factory complex, where the Aedes architecture gallery and artists' workshops are located. Adjacent to a four-story residential building, the museum site implied an "irregular space planning arrangement." The five-story structure has a cantilevered upper glass block. The lower four floors have concrete walls with their surface covered with "relief drawings of architectural motifs." On the first and third floors on the side of Christinenstrasse, the massive concrete walls are alternated with large paintings on glass signaling the main entrance. Aside from the entrance hall, the first floor houses a library. Two galleries for drawing exhibitions and an archive are on the upper floors.

Im **MUSEUM FÜR ARCHITEKTURZEICHNUNG** sollen die Sammlungen der 2009 gegründeten Tchoban Foundation ausgestellt werden, um dem Publikum Architekturzeichnungen nahezubringen und auch Ausstellungen anderer Institutionen, etwa des Sir John Soane's Museum in London und der École des Beaux-Arts in Paris, zu präsentieren. Die Stiftung erwarb ein kleines Grundstück auf dem Gelände der früheren Pfefferberg-Fabrik, wo sich auch die Architektur-galerie Aedes und Künstlerateliers befinden. Der neben einem viergeschossigen Wohngebäude liegende Bauplatz erforderte eine „ungleichmäßige Ausrichtung des Lageplans". Der fünfgeschossige Bau hat oben ein auskragendes, verglastes Geschoss. Die unteren vier Stockwerke haben Betonwände, deren Oberfläche mit „Reliefdarstellungen architektonischer Motive" bedeckt ist. Im ersten und dritten Stock an der Christinenstraße wechseln die massiven Beton-mauern mit großen, bemalten Glaswänden ab, welche die Eingangsseite markieren. Außer der Eingangshalle enthält die erste Ebene eine Bibliothek. Zwei Ausstellungssäle und ein Archiv befinden sich in den oberen Etagen.

Le **MUSÉE DU DESSIN D'ARCHITECTURE** est destiné à exposer les collections de la Fondation Tchoban, fondée en 2009 dans l'objectif de populariser le dessin d'architecture, et à accueillir les expositions d'autres institutions, parmi lesquelles le musée de Sir John Soane à Londres et de l'École des beaux-arts de Paris. La Fondation a acquis une petite parcelle dans l'ancien complexe industriel Pfefferberg, qui accueille déjà la galerie d'architecture Aedes et des ateliers d'artistes. Le site, adjacent à un immeuble résidentiel de quatre niveaux, nécessitait une « disposition irrégu-lière de l'espace ». La construction de cinq niveaux se termine par un bloc de verre en encorbellement, tandis que les murs des quatre niveaux inférieurs sont en béton et leur surface recouverte de « reliefs de motifs architecturaux ». Aux premier et troisième étages côté Christinenstrasse, les parois massives de béton alternent avec d'immenses peintures sur verre qui marquent l'entrée principale. En plus du hall d'entrée, le premier étage abrite une bibliothèque, les étages supérieurs deux galeries d'expositions et des archives.

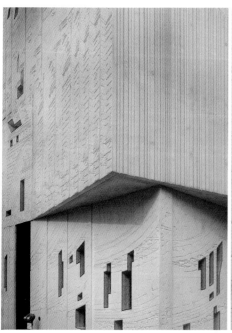

Located next to the studio of the artist Olafur Eliasson, the museum appears to be made up of an accumulation of textured concrete blocks. Above, details of the architectural drawings inscribed in some of the surfaces.

Das neben dem Atelier des Künstlers Olafur Eliasson gelegene Museum scheint aus einer Anhäufung strukturierter Betonblöcke zu bestehen. Oben: Details aus Architekturzeichnungen sind in einige Wände eingeschrieben.

Situé à proximité de l'atelier de l'artiste Olafur Eliasson, le musée semble un amas de blocs de béton texturé. Ci-dessus, détails des dessins architecturaux inscrits sur certaines des surfaces.

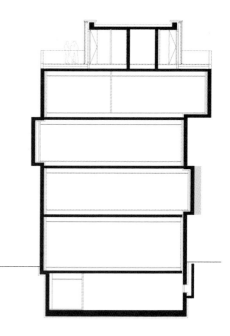

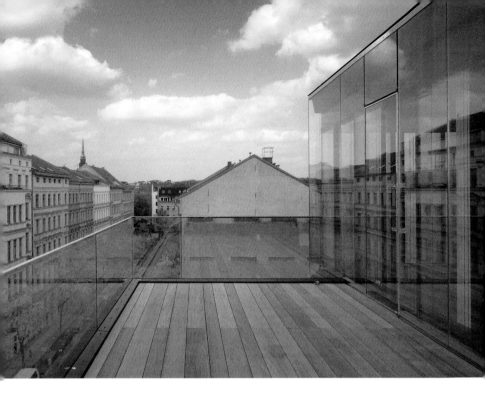

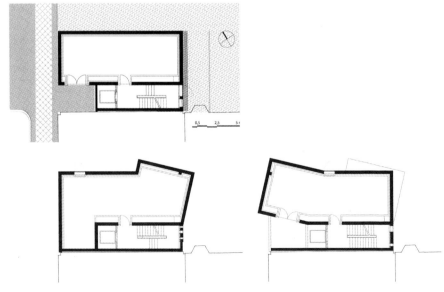

0,5 2,5 5 r

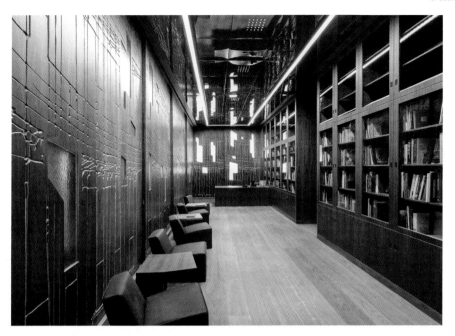

Above, the entrance area with its dark brown walnut wall paneling and incised decor. Left, the main stairway made predominantly of concrete, and floor plans of the building on the opposite page.

Oben der Eingangsbereich mit seiner dunklen, mit Reliefs dekorierten Walnussvertäfelung; links die vorwiegend aus Beton bestehende Haupttreppe sowie Grundrisse des Gebäudes auf der Seite gegenüber.

Ci-dessus, l'entrée aux panneaux muraux de noyer brun foncé au décor gravé. À gauche, l'escalier principal, où le béton domine, et des plans au sol du bâtiment à la page opposée.

STUDIO MK27

Born in 1952, **MARCIO KOGAN** graduated in 1976 from the FAU-Mackenzie in São Paulo. He received an IAB (Brazilian Architects Institute) Award for UMA Stores (1999 and 2002); Coser Studio (2002); Gama Issa House (2002); and Quinta House (2004). He also received the Record House Award for Du Plessis House (2004) and BR House (2005). Kogan is known for his use of boxlike forms, together with wooden shutters, trellises, and exposed stone. Among Kogan's residential projects are the Cury House (São Paulo, 2004–06); the Primetime Nursery (São Paulo, 2005–07); the E-Home, a "super-technological" house (Santander, Spain, 2007); an "extreme house" on an island in Paraty (Rio de Janeiro, 2007); MiCasa Vol. B (São Paulo, 2007, published here); Warbler House (Los Angeles, California, USA, 2008); a villa in Milan (Italy, 2008); House 53 (São Paulo, 2008); and two other houses in Brasília, all in Brazil unless stated otherwise. More recently he has completed Bahia House (Salvador, Bahia, Brazil, 2010); L'AND Vineyards, near Évora (Alentejo, Portugal, 2011); Casa Cubo (São Paulo, 2008–12, also published here); and the greened roof Plenar House in Porto Feliz (Brazil, 2018).

Der 1952 geborene **MARCIO KOGAN** beendete 1976 sein Studium an der Universität FAU-Mackenzie in São Paulo in Brasilien. Das Brasilianische Architekturinstitut zeichnete ihn für die UMA-Geschäfte (1999 und 2002), das Atelier Coser (2002), das Haus Gama Issa (2002) und das Haus Quinta (2004) aus. Auch wurde ihm der Record House Award für das Haus Du Plessis (2004) und das BR House (2005) verliehen. Kogan ist bekannt für seine kistenähnlichen Bauformen mit hölzernen Fensterläden, Gittern und unverputztem Stein. Zu Kogans Wohnhausprojekten zählen das Haus Cury (São Paulo, 2004–06), die Kinderkrippe Primetime (São Paulo, 2005–07), das E-Home, ein „supertechno-logisches" Wohnhaus (Santander, Spanien, 2007), ein „extremes Haus" auf einer Insel in Paraty (Rio de Janeiro, 2007), MiCasa Vol. B (São Paulo, 2007, hier vorgestellt), das Haus Warbler (Los Angeles, USA, 2008), eine Villa in Mailand (Italien, 2008), das Haus 53 (São Paulo, 2008) und zwei weitere Wohnhäuser in Brasilia, alle in Brasilien, soweit nicht anders vermerkt. In jüngerer Zeit hat er das Haus Bahia (Salvador, Bahia, Brasilien, 2010), die Kellerei L'AND bei Evora (Portugal, 2011), die Casa Cubo (São Paulo, Brasilien, 2008–12, ebenfalls hier vorgestellt) ausgeführt und Plenar House in Porto Feliz (Brasilien, 2018), mit begrüntem Dach.

Né en 1952, **MARCIO KOGAN** est diplômé (1976) de la FAU-Mackenzie de São Paulo. Il a reçu un prix de l'IAB (Institut des architectes brésiliens) pour les magasins UMA (1999 et 2002) ; l'atelier Coser (2002) ; la maison Gama Issa (2002) et la maison Quinta (2004). Il a également remporté le Record House Award pour la maison Du Plessis (2004) et la maison BR (2005). Kogan est connu pour son emploi des formes rappelant des boîtes, des volets en bois, des treillages et de la pierre apparente. Parmi ses projets résidentiels figurent la maison Cury (São Paulo, 2004–06) ; l'école maternelle Primetime (São Paulo, 2005–07) ; l'E-Home, une maison «super technologique» (Santander, Espagne, 2007) ; une «maison extrême» sur une île à Paraty (Rio de Janeiro, 2007) ; le magasin MiCasa Vol. B (São Paulo, 2007, publié ici) ; la maison Warbler (Los Angeles, 2008) ; une villa à Milan (2008) ; la maison 53 (São Paulo, 2008) et deux maisons à Brasília, tous au Brésil sauf si spécifié. Il a récemment achevé la maison Bahia (Salvador, Bahia, Brésil, 2010) ; le domaine viticole L'AND près d'Évora (Alentejo, Portugal, 2011) ; la Casa Cubo (São Paulo, 2008–12, également publiée ici) et le toit vert de la Plenar House a Porto Feliz (Brésil, 2018).

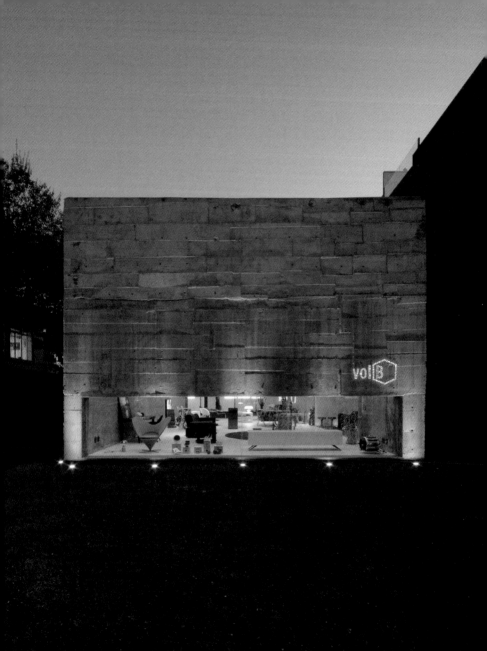

MICASA VOL. B

São Paulo, Brazil, 2007

Area: 250 m². Client: MiCasa.
Collaboration: Bruno Gomes (Co-Architect)

MICASA VOL. B is an annex of an existing store. A small tunnel connects the entrance to the MiCasa annex to the showroom of the original shop. The annex interior ground plan has a large span, conceived to house the Vitra product line, which MiCasa sells. Façades are made of exposed reinforced concrete. New lumber was used for the formwork, with some wood not removed after curing. The architect explains that this "rustic" method recalls Brazilian brutalism. In the same spirit, brise-soleils were made with a net of rebars. The workers' notations or X marks remain on the new windows, and there is no paint or finishing on the inner walls.

MICASA VOL. B ist ein Anbau an ein bestehendes Geschäft. Ein kleiner Tunnel führt vom Eingang zum MiCasa-Anbau mit dem Ausstellungsraum für den ursprünglichen Laden. Der Grundriss des Neubaus ist großzügig bemessen, um die Produktion der Firma Vitra auszustellen, die von MiCasa vertrieben wird. Die Fassaden sind aus armiertem Sichtbeton. Für die Schalung wurde neues Holz verwendet, wovon ein Teil nach dem Härten nicht entfernt wurde. Der Architekt erläutert, dass diese „rustikale" Methode an den brasilianischen Brutalismus erinnere. Im gleichen Stil wurde der Sonnenschutz als Gitter aus Bewehrungsstäben gefertigt. Die Markierungen der Arbeiter blieben auf den neuen Fenstern, und die Innenwände sind unbehandelt und nicht gestrichen.

MICASA VOL. B est une annexe d'un magasin existant. Elle est reliée au showroom du premier magasin par un petit tunnel à l'entrée. Le plan de l'intérieur présente une large travée destinée à accueillir l'espace d'exposition des produits Vitra vendus par MiCasa. Les façades sont en béton armé apparent. Les coffrages sont en bois neuf qui n'a pas été entièrement retiré après séchage. L'architecte explique que ce procédé « rustique » évoque le brutalisme brésilien. Dans le même esprit, des brise-soleil sont faits d'un réseau de barres d'armature. De même, les nouvelles fenêtres gardent des notes de chantier ou marques et les murs intérieurs ne portent aucune peinture ni finition.

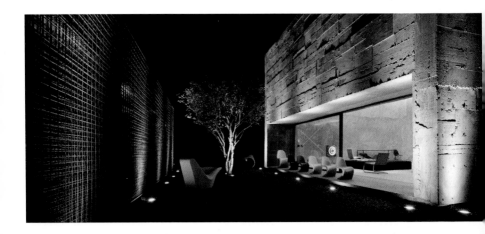

The rough concrete façade of the structure is what immediately attracts attention. A long window reveals the articles on display inside.

Die grobe Betonfassade des Gebäudes erregt sofort Aufmerksamkeit. Durch ein langes Fenster sind die darin ausgestellten Objekte zu sehen.

La façade en béton brut attire immédiatement l'attention. Une vitrine allongée dévoile les articles exposés à l'intérieur.

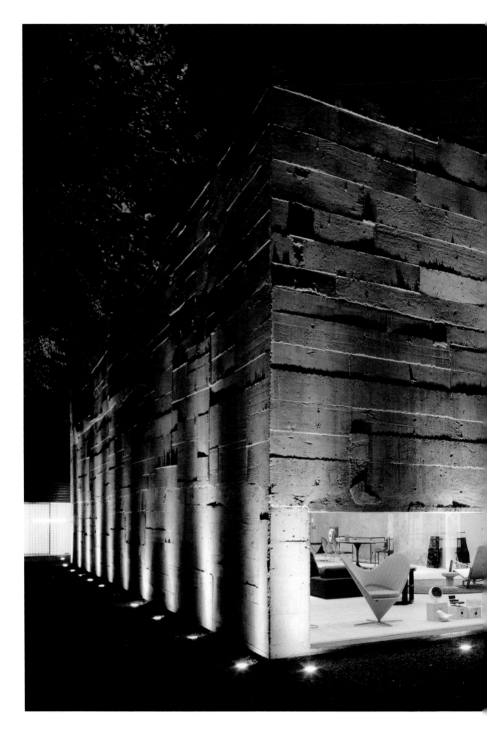

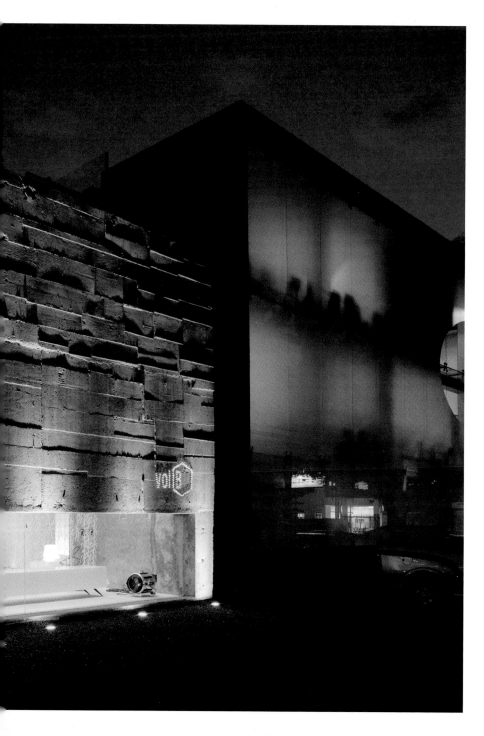

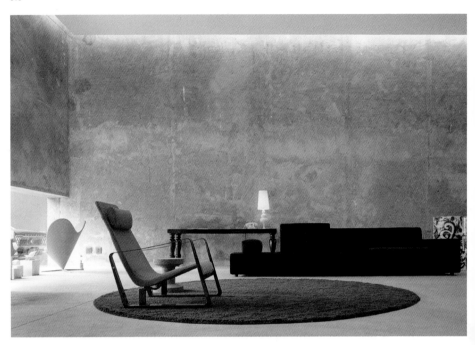

Concrete is used in a broad un-
apologetic way to better contrast
with the colorful, unusual forms
of the Vitra design objects sold
by the store.

Der Beton ist hier in ungeschminkter
Weise verarbeitet, um einen stärkeren
Kontrast zu den farbigen, unge-
wöhnlichen Formen der Design-
objekte von Vitra herzustellen, die
hier verkauft werden.

Le béton est très largement utilisé
sans aucune mise en valeur afin de
mieux contraster avec les formes
colorées et inédites des objets
design Vitra vendus.

Die Architekten erklären: „Wir verwendeten das Material in seiner extremen Beschaffenheit, etwa als Sichtbeton ohne jegliche Rücksicht auf Präzision oder weitere Behandlung." Oben: Schnittzeichnung.

The architects state: "We used the materials in their extreme condition, such as visible concrete executed without any concern about precision or finishing." Above, section drawing.

Les architectes déclarent « avoir utilisé les matériaux dans leur état le plus extrême, comme le béton apparent, sans aucun souci de précision ou de finitions ». Ci-dessus, schéma en coupe.

CASA CUBO

São Paulo, Brazil, 2008–12

Area: 540 m². Collaboration: Suzana Glogowski (Co-Architect),
Diana Radomysler (Interior Design).

This nearly monolithic cube of concrete, with some openings or perforated metallic panels, makes ample room for open indoor space in keeping with the Brazilian climate. Windows are provided in the bedrooms, television room, and office, but the solidity of the cube remains apparent. A small outdoor living area and garden terrace are situated on the upper floor. The architect states: "Like its simple volumes, **CASA CUBO** uses few architectural materials. The façades are comprised of rough concrete, shaped using a handcrafted wooden mold, and metallic panels, whose color is reminiscent of the concrete itself. The inside is structured by a specially designed ceramic tile floor that forms a continuous fabric in the common area… A monolithic volume that, in its empty interior, contains other volumes."

Dieser fast monolithische Kubus aus Beton mit einigen Öffnungen und perforierten Metallplatten enthält reichlich offenen Innenraum, was dem brasilianischen Klima entgegenkommt. Schlafzimmer, Fernsehraum und Büro haben Fenster, aber das massive Erscheinungsbild des Kubus bleibt erhalten. Ein kleiner Wohnbereich im Freien und eine Gartenterrasse liegen im Obergeschoss. Der Architekt erklärt: „Ihren schlichten Volumen entsprechend, wurden für die **CASA CUBO** nur wenige Baumaterialien verwendet. Die Fassaden bestehen aus rauem Beton, der mittels einer handgefertigten Holzschalung geformt wurde, sowie Metallplatten, deren Farbe an die des Betons erinnert. Das Innere wird von einem Boden aus speziell entworfenen Keramikfliesen strukturiert, die dem Gemeinschaftsbereich ein durchgängiges Gefüge geben … Ein monolithisches Volumen, das in seinem leeren Innenraum weitere Körper enthält."

Ce cube de béton quasi-monolithique marqué de quelques ouvertures ou panneaux métalliques perforés ouvre un vaste espace intérieur dégagé qui convient au climat brésilien. Des fenêtres sont pratiquées dans les chambres à coucher, la salle de télévision et le bureau, mais le cube massif impose malgré tout sa présence visible. Un petit salon extérieur et une terrasse jardin sont situés au niveau supérieur. L'architecte déclare : « À l'image de ses volumes très simples, **CASA CUBO** a nécessité peu de matériaux architecturaux. Les façades sont en béton brut – formé à l'aide d'un moule artisanal en bois – et panneaux métalliques dont la couleur rappelle le béton. L'intérieur est structuré par un sol en carreaux de céramique spécialement conçu qui forme un ensemble continu dans les pièces communes… Un volume monolithique vide à l'intérieur qui contient d'autres volumes. »

The architects again use concrete in a strong, nearly unadorned form; the openings are irregular and a covered area offers protected space outdoors (right).

Auch hier verwenden die Architekten Beton in kraftvoller, schnörkelloser Form. Die Öffnungen sind ungleichmäßig, und ein überdachter Bereich bildet einen geschützten Raum im Freien (rechts).

Les architectes ont, là encore, choisi du béton sous une forme puissante et presque dénuée de tout ornement ; les ouvertures sont irrégulières et une partie couverte fournit un espace extérieur abrité (à droite).

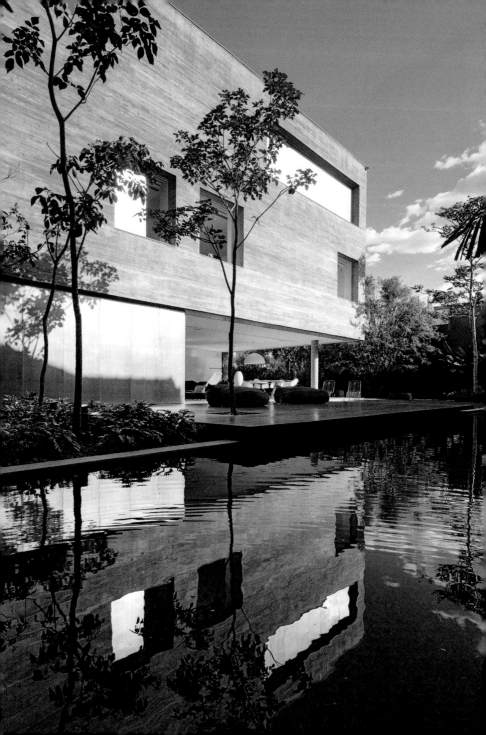

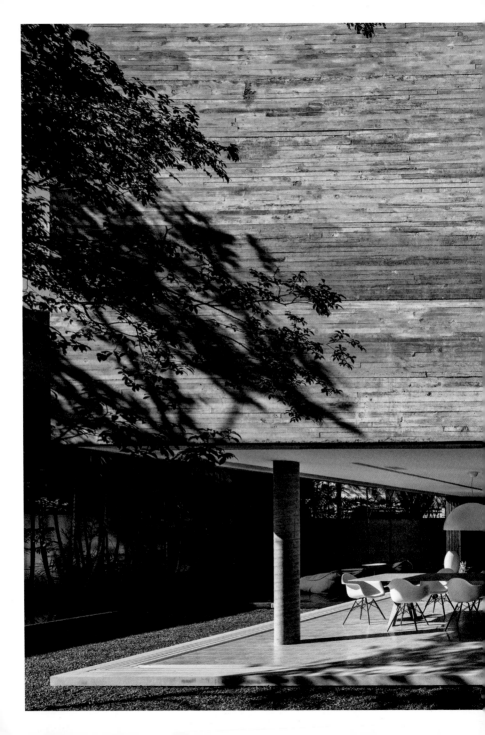

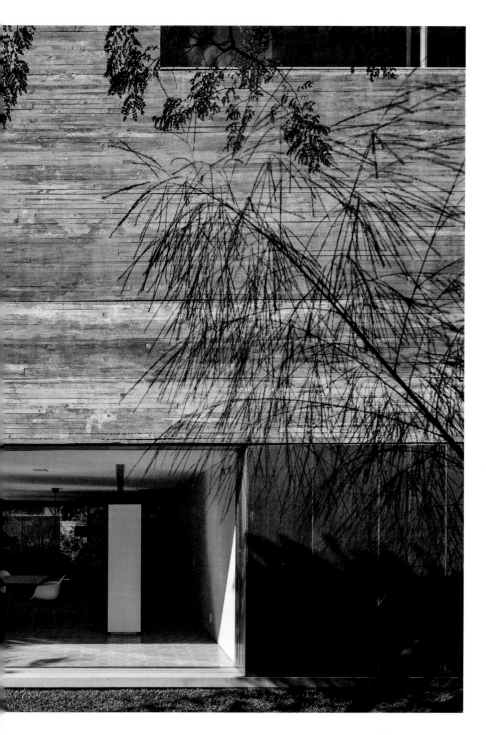

On this page, the marked formwork of the house gives an impression of relating the concrete more closely to the green surroundings. The weight of the structural block seems to hover on thin columns.

Auf dieser Seite lässt die raue Schalung das Haus wirken, als nehme der Beton unmittelbar Bezug auf das grüne Umfeld. Das Gewicht des Baukörpers scheint über den schlanken Stützen zu schweben.

La marque du coffrage sur la maison donne l'impression de rapprocher encore plus le béton de la verdure environnante. Le poids du bloc structurel semble flotter sur de fines colonnes.

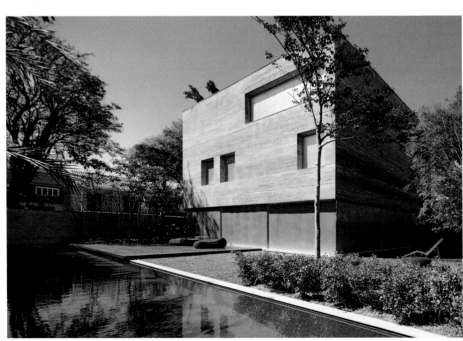

Interiors are quite simple with a combination of concrete, white wood, and ceramic tile or natural wood floors. Below, plans of the residence. Right page, top: two section drawings of the house.

Die Innenräume sind sehr schlicht gestaltet in einer Kombination aus Beton, weißem Holz und Böden aus Keramikfliesen oder Naturholz. Unten: Grundrisse des Wohnhauses. Rechte Seite, oben: Zwei Schnitte durch das Haus.

L'intérieur est plutôt simple et associe le béton, le bois blanc et des sols en carreaux de céramique ou en bois naturel. Ci-dessous, plans de la maison. Page de droite, en haut, deux schémas en coupe de la maison.

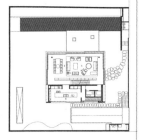
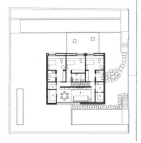
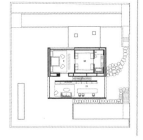

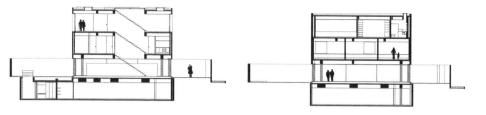

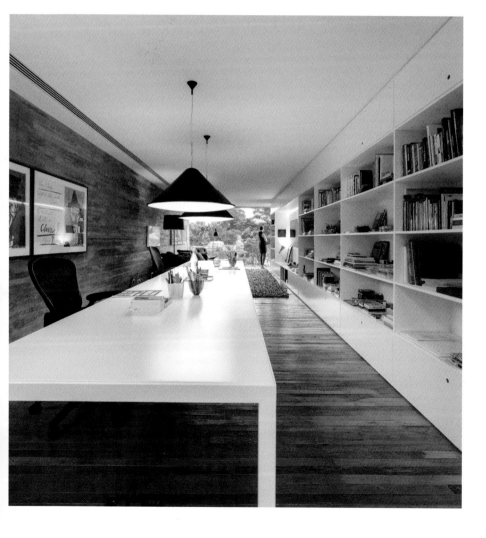

STUDIO PEI-ZHU

ZHU PEI was born in Beijing in 1962. He received his M.Arch degree from Tsinghua University, and Master of Architecture and Urban Design degree from the University of California at Berkeley. He has worked with the large American firm RTKL Associates, and as an Associate Professor at Tsinghua University. He is the Principal architect and founder of Studio Pei-Zhu (which he views as a platform for researching the relationship between traditional Chinese philosophy and contemporary architecture) and, prior to opening this office in 2005 in Beijing, he was a founding partner and design Principal of URBANUS (2001–04). He has been involved in major projects in the United States, as well as projects in China, such as Shanghai Science Land, a science museum; Guggenheim Art Pavilion in Abu Dhabi (design 2006–07); the Guggenheim Museum in Beijing (design 2007); Cai Guo-Qiang Courtyard House Renovation (Beijing, 2007); and the Digital Beijing, Control Center for the 2008 Olympics (Beijing, 2005–08). Recent and current work includes the OCT Design Museum (Shenzhen, 2009–11, published here); the Ningbo Art Center (Ningbo, 2012–13); Minsheng Contemporary Art Museum (Beijing, 2013–14); and Impression Dali Performance Art Center (Dali, 2013–14), all in China.

ZHU PEI wurde 1962 in Peking geboren. Er machte seinen M.Arch. an der Universität Tsinghua und den Master für Architektur und Städtebau an der University of California in Berkeley. Er hat bei der großen amerikanischen Firma RTKL Associates und als Assistenzprofessor an der Universität Tsinghua gearbeitet. Er ist Chefarchitekt und Gründer des Studios Pei-Zhu (das er als Plattform zur Erforschung der Beziehung zwischen traditioneller chinesischer Philosophie und moderner Architektur betrachtet) und war vor der Eröffnung dieses Büros 2005 in Peking Gründungspartner und Planungschef von URBANUS (2001–04). Er war an großen Projekten in den Vereinigten Staaten wie auch in China beteiligt, so am Wissenschaftsmuseum Shanghai Science Land, dem Guggenheim Art Pavilion in Abu Dhabi (Entwurf 2006–07), dem Guggenheim-Museum in Peking (Entwurf 2007), der Sanierung des Gartenhofhauses von Cai Guo-Qiang (Peking, 2007) und an Digital Beijing, dem Kontrollzentrum für die Olympischen Spiele 2008 (Peking, 2005–08). Zu neueren und aktuellen Projekten zählen das OCT Design Museum (Shenzhen, 2009–11, hier vorgestellt), das Kunstzentrum in Ningbo (2012–13), das Minsheng Museum für zeitgenössische Kunst (Peking 2013–14) und das Impression Dali Performance Art Center (Dali, 2013–14), alle in China.

ZHU PEI est né à Pékin en 1962. Il est titulaire d'un M.Arch. de l'université Tsinghua et d'un master en architecture et urbanisme de l'université de Californie (Berkeley). Il a travaillé avec la grande société américaine RTKL Associates et a été professeur associé à l'université Tsinghua. Il est le fondateur et le principal architecte de Studio Pei-Zhu (qu'il considère comme une plate-forme pour rechercher le lien entre la philosophie chinoise traditionnelle et l'architecture contemporaine) qu'il a ouvert en 2005 à Pékin et a été auparavant l'un des partenaires fondateurs et le directeur du design d'URBANUS (2001–04). Il a participé à des projets de grande envergure aux États-Unis et en Chine, notamment le musée scientifique Shanghai Science Land ; le pavillon d'art Guggenheim à Abou Dhabi (conception 2006–07) ; le musée Guggenheim de Pékin (conception 2007) ; la rénovation de la maison à cours Cai Guo-Qiang (Pékin, 2007) et le centre de contrôle Digital Beijing des Jeux olympiques de 2008 (2005–08). Ses projets récents et en cours comprennent le Musée du design OCT (Shenzhen, 2009–11, publié ici) ; le Centre d'art de Ningbo (2012–13) ; le Musée d'art contemporain Minsheng (Pékin, 2013–14) et le Centre de l'art performance Impression de Dali (2013–14), tous en Chine.

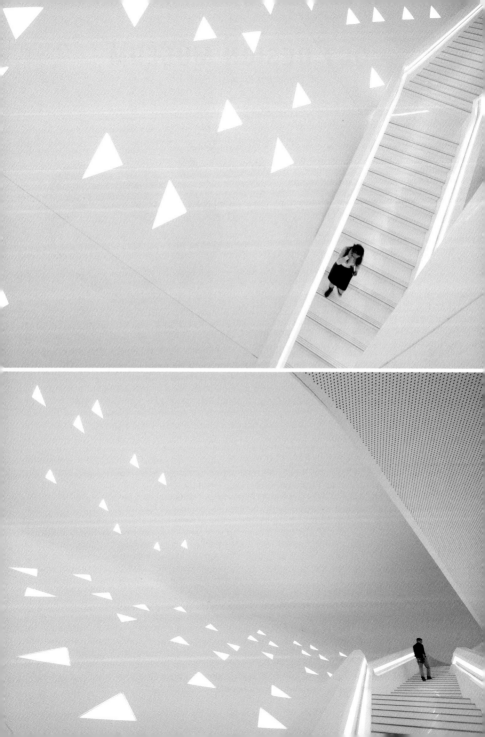

OCT DESIGN MUSEUM

Shenzhen, China, 2009–11

Area: 5000 m². Cost: $20.9 million.

Intended for fashion shows, product design exhibitions, and automotive shows, this structure—also known as the **OCT** Creative Exhibition Center—stands close to Shenzhen Bay. Zhu Pei explains: "The design of the interior relies on a continuous white curving surface that casts no shadows and has no depth. The result is a surreal borderless space that seems to go on into the infinite, similar to the feeling of a James Turrell installation." The first floor contains the entry lobby and a café, with the exhibition areas on the two upper levels, where movable walls allow for flexible use of the spaces. The exterior shape of the building is related to the curved volumes inside. The architect states: "Set into its landscape, the building's form seems to float above the ground, as if it were not from this planet. Being 300 meters from the ocean, we took inspiration in the smooth stones found along the beach. It is like a purely smooth stone cast into an overly saturated urban setting."

Dieses für Modeschauen, Produktdesignausstellungen und Automessen vorgesehene Gebäude – auch bekannt als das **OCT** Creative Exhibition Center – liegt nahe der Bucht von Shenzhen. Zhu Pei erläutert: „Die Gestaltung des Innenbereichs beruht auf einer durchgehenden, weißen, gekrümmten Oberfläche, die keine Schatten wirft und keine Tiefe hat. Das Ergebnis ist ein surrealer, unbegrenzter Raum, der sich scheinbar bis ins Unendliche erstreckt, die Wirkung ähnelt der einer Installation von James Turrell." Die erste Ebene enthält die Eingangslobby und ein Café, auf den beiden oberen Geschossen befinden sich die Ausstellungsbereiche, in denen bewegliche Wände eine flexible Nutzung des Raumes gestatten. Die äußere Gestalt des Gebäudes nimmt Bezug auf die gekrümmten Volumen im Innern. Der Architekt erklärt: „Die in die Landschaft gestellte Form des Museums scheint über der Erde zu schweben, als wäre sie nicht von dieser Welt. Für den 300 m vom Ozean entfernten Standort ließen wir uns von den glatten Steinen am Strand inspirieren. Der Bau gleicht einem ganz glatten Stein, der in eine übersättigte städtische Umgebung geworfen wurde."

Destiné à accueillir des défilés de mode, expositions de design et présentations automobiles, le complexe – également connu sous le nom de Centre créatif d'exposition **OCT** – est proche de la baie de Shenzhen. Zhu Pei explique : « La conception de l'intérieur est basée sur une surface blanche courbe et continue qui ne fait aucune ombre et n'a aucune profondeur. Il en résulte un espace irréel non délimité qui semble s'étendre à l'infini, pour une impression proche de celle que donnent les installations de James Turrell. » Le premier niveau comprend le hall d'entrée et un café, les expositions sont logées aux deux étages supérieurs où des cloisons mobiles permettent une organisation souple de l'espace. La forme extérieure correspond aux volumes arrondis de l'intérieur. L'architecte déclare : « Dans ce décor, le bâtiment semble flotter au-dessus du sol, comme s'il venait d'une autre planète. Situé à 300 m de l'océan, il s'inspire des galets qu'on trouve sur la plage. Nous avons posé un galet pur et lisse dans un décor urbain sursaturé. »

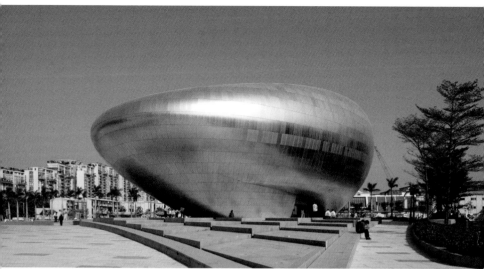

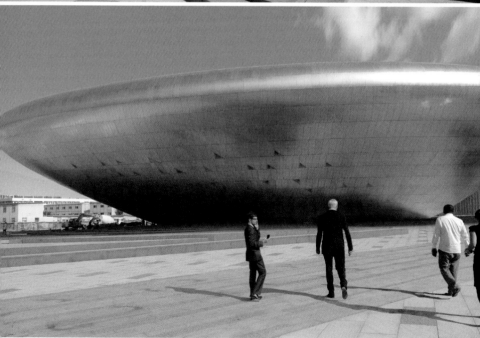

The structural system of the OCT Design Museum consists of a concrete core with a steel shell.

Das Tragwerk des OCT Design Museum besteht aus einem Betonkern mit einer stählernen Hülle.

Le système structurel du Musée du design OCT se compose d'un cœur en béton recouvert d'une coque en acier.

The architect states: "The goal was to create a space that is surreal in the subject matter but also transcendental in surrounding and feeling."

Der Architekt erklärt: „Das Ziel war es, einen thematisch surrealen, aber im Hinblick auf seine Umgebung und Wirkung auch transzendentalen Raum zu schaffen."

L'architecte explique « avoir voulu créer un espace surréaliste en ce qui concerne le contenu, mais aussi transcendantal en ce qui concerne l'environnement et la sensation ».

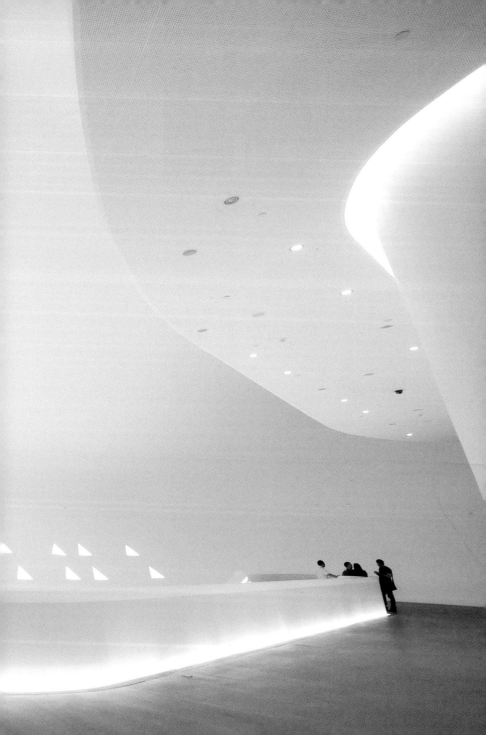

TDA

SERGIO FANEGO INSFRAN was born in Asunción, Paraguay, in 1969. He studied architecture at the National University of Asunción (1988–91), before obtaining his degree as an architect from the Our Lady of Asunción Catholic University (1992–93). He has been a Manager and Associate of Taller de Arquitectura since 2004. **MIGUEL ANGEL DUARTE ESPINOLA** was born in 1980 in Asunción. He graduated from the National University of Asunción in 2006, and worked in 2001 and 2002 with the architectural firm East Benitez, and then in 2003 with Javier Corvalan, before cofounding TDA in 2004. **LARISSA CECILIA ROJAS BENITEZ** was born in 1980 in Asunción. She also studied at the National University of Asunción (1999–2006). Their built work includes the House in the Air (Luque, Paraguay, 2009–11, published here) and a number of other residences.

SERGIO FANEGO INSFRAN wurde 1969 in Asunción, Paraguay, geboren. Er studierte Architektur an der Staatlichen Universität Asunción (1988–91) und machte dann sein Diplom an der Staatlichen Universität Asunción de la Asunción (1992–93). Seit 2004 ist er Leiter und Partner von Taller de Arquitectura. **MIGUEL ANGEL DUARTE ESPINOLA** wurde 1980 in Asunción geboren. 2006 beendet er sein Studium an der Staatlichen Universität Asunción und arbeitete 2001 bis 2002 beim Architekturbüro East Benitez und 2003 bei Javier Corvalan, bis er 2004 TDA mitgründete. **LARISSA CECILIA ROJAS BENITEZ** wurde 1980 in Asunción geboren. Auch sie studierte an der Staatlichen Universität Asunción (1999–2006). Zu den ausgeführten Projekten des Büros gehört das House in the Air (Luque, Paraguay, 2009–11, hier vorgestellt), sowie verschiedene weitere Wohnhäuser.

SERGIO FANEGO INSFRAN est né à Asunción, au Paraguay, en 1969. Il a fait des études d'architecture à l'Université nationale d'Asunción (1988–91) avant d'obtenir son diplôme d'architecte de l'université catholique Notre-Dame d'Asunción (1992–93). Il dirige Taller de Arquitectura dont il est l'un des associés depuis 2004. **MIGUEL ANGEL DUARTE ESPINOLA** est né en 1980 à Asunción. Il est diplômé de l'Université nationale d'Asunción (2006) et a travaillé en 2001 et 2002 avec la société d'architecture East Benitez, puis en 2003 avec Javier Corvalan, avant de fonder TDA en 2004. **LARISSA CECILIA ROJAS BENITEZ** est née en 1980 à Asunción. Elle a aussi fait ses études à l'Université nationale d'Asunción (1999–2006). La Maison en l'air (Luque, Paraguay, 2009–11, publiée ici) est l'un de leurs projets construits. Ils ont créé de nombreuses autres résidences.

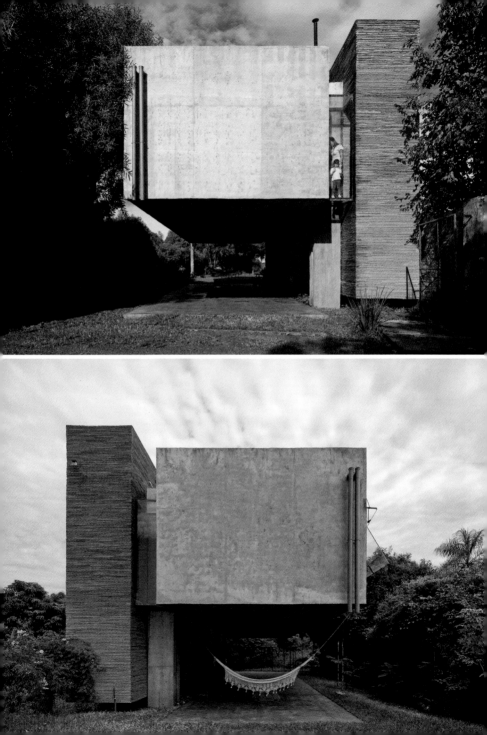

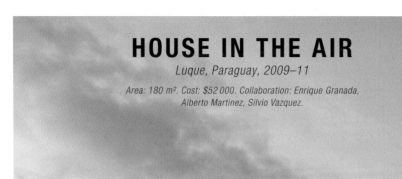

HOUSE IN THE AIR

Luque, Paraguay, 2009–11

Area: 180 m². Cost: $52 000. Collaboration: Enrique Granada,
Alberto Martinez, Silvio Vazquez.

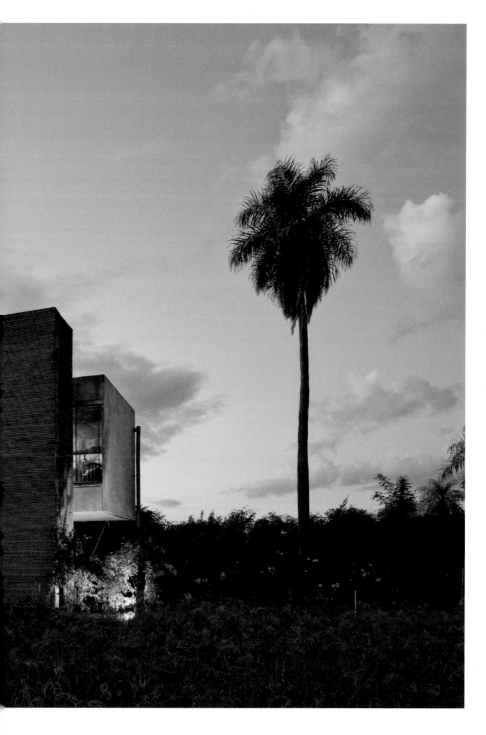

The clients of the **HOUSE IN THE AIR** were a young couple with a small child. Their main concerns were economy and practicality. The architects state: "The lack of economic resources is often the tool that drives us to reformulate solutions to problems that with a bigger budget we could not even imagine." An 80-square-meter horizontal concrete plane is formed beneath the house, which allows space for parking and a small grill. Four pairs of pillars support the main structure and leave the ground level largely free. Two suspended blocks with an area of 11 square meters each, elevated 80 centimeters off the ground, enclose the staircase and service rooms. The architects explain: "These slabs, suspended by metal clamps, are lined with a wall of ceramic pieces commonly used in roofs, cut and arranged in horizontal form and thus building a hollow section, which provides thermal and acoustic insulation." The main volume suspended 2.8 meters above the ground contains the house itself. The concrete box is opened on the north and south, and closed on the east and west. A wooden deck was added above, using the original concrete formwork, serving to obviate the need for any air conditioning.

Die Bauherren des **HOUSE IN THE AIR** waren ein junges Paar mit einem kleinen Kind. Ihre wichtigsten Anliegen waren Wirtschaftlichkeit und Praktikabilität. Die Architekten erläutern: „Bescheidene Etats sind häufig der Anlass, um Lösungen für Probleme zu finden, die wir uns mit einem höheren Budget gar nicht erst vorstellen könnten." Unter dem Haus gibt es eine 80 m² große Betonfläche, wo Autos parken können und ein kleiner Grill untergebracht ist. Vier Stützenpaare tragen den Hauptbau und belassen das Erdgeschoss weitgehend frei. Zwei aufgehängte Baukörper mit einer Grundfläche von jeweils 11 m² sind 80 cm vom Boden abgehoben und enthalten das Treppenhaus und Versorgungsräume. Die Architekten erklären: „Diese an Bauklammern aus Metall aufgehängten Scheiben sind mit einer Wand aus Keramikelementen verkleidet, wie sie üblicherweise für Dächer verwendet werden; sie wurden geschnitten und horizontal angeordnet, wodurch ein Hohlraum entsteht, der für zusätzliche thermische und akustische Isolierung sorgt." Das große, 2,8 m über Geländehöhe schwebende Volumen enthält das eigentliche Wohnhaus. Die Betonkiste ist nach Süden und Norden geöffnet und an der Ost- und Westseite geschlossen. Darüber wurde eine hölzerne Terrasse angelegt, für die das Holz der Verschalung für den Beton verwendet wurde. Dadurch erübrigt sich jegliche Klimaanlage.

Les clients de la **MAISON EN L'AIR** étaient un jeune couple et leur enfant en bas âge. Leurs principales préoccupations étaient d'ordre économique et pratique. Les architectes déclarent : « Le manque de ressources financières est souvent l'outil qui nous amène à reformuler des solutions à des problèmes que nous n'imaginerions même pas si nous avions un plus gros budget. » Un plan horizontal de 80 m² en béton a été pratiqué sous la maison pour garer des voitures et installer un barbecue sur un espace minimal. Quatre doubles piliers portent la structure principale et laissent le rez-de-chaussée presque vide. Deux blocs suspendus de 11 m² chacun, surélevés à 80 cm au-dessus du sol, contiennent la cage d'escalier et les espaces techniques. Les architectes expliquent : « Ces plaques accrochées à des pinces métalliques sont doublées d'un mur fait d'éléments céramiques plus couramment utilisés pour les toitures, coupés et disposés horizontalement afin de former un creux qui procure une isolation thermique et acoustique. » Le principal volume suspendu contient la maison elle-même, située à 2,8 m au-dessus du sol. Le cube de béton est ouvert au nord et au sud, fermé à l'est et à l'ouest. Une terrasse en bois construite avec le coffrage utilisé pour le béton a été ajoutée en haut et permet d'éviter le recours à l'air conditionné.

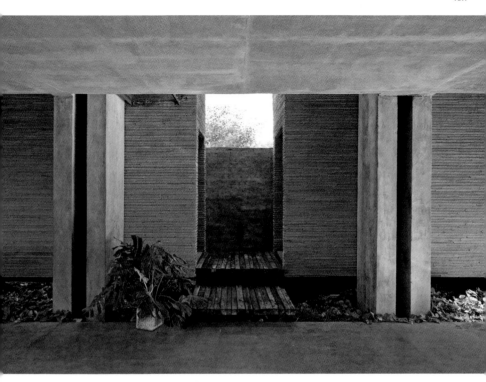

One allure of concrete in con-
struction is that it appears to be
extremely heavy but is not always
as weighty as other materials. Here
the architects cantilever a concrete
box, contradicting the impression
of heaviness.

Ein Vorzug vom Beton als Baumate-
rial ist, dass er extrem schwer wirkt,
aber nicht immer schwerer ist als
andere Baustoffe. Hier lassen die
Architekten eine Betonkiste auskra-
gen und widersprechen damit dem
Eindruck eines großen Gewichts.

L'un des charmes du béton dans
la construction est qu'il semble
extrêmement lourd bien qu'il
pèse souvent moins que d'autres
matériaux. Ici, le bloc de béton
suspendu dément toute impression
de lourdeur.

With blind or opaque east and west elevations, this box opens entirely to the north and south. The interiors seen here appear quite closed.

Diese an der Ost- und der Westseite geschlossene oder lichtundurchlässige Kiste ist an der Nord- und der Südfassade vollkommen geöffnet. Die hier gezeigten Innenräume wirken völlig abgeschlossen.

Aveugle, ou opaque, au niveau des élévations est et ouest, ce cube est entièrement ouvert au nord et au sud. Les intérieurs que l'on voit ici semblent cependant assez clos.

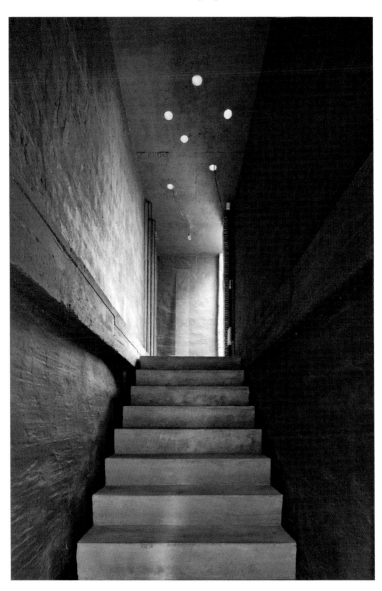

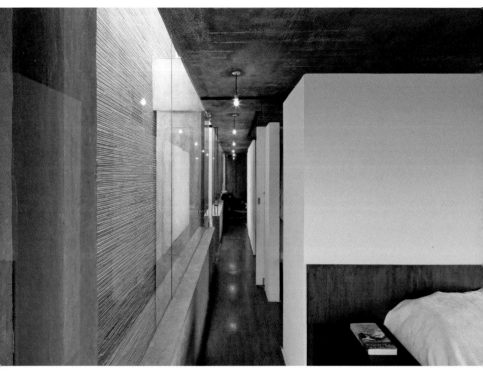

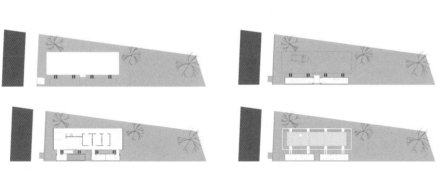

Plans show the different aspects of the house—below left, the stairway and sleeping area, which are seen on these two pages.

Die Pläne zeigen die verschiedenen Elemente des Hauses – unten links das Treppenhaus und die Schlafräume, die auf dieser Doppelseite abgebildet sind.

Les plans illustrent les différents aspects de la maison – en bas à gauche, l'escalier et l'espace chambre que l'on voit sur cette double page.

TENSE ARCHITECTURE NETWORK

Tense Architecture Network was created in 2004 by Tilemachos Andrianopoulos and Kostas Mavros. **KOSTAS MAVROS** was born in Nea Ionia, Magnesia (Greece), in 1974. He received his Diploma in Architecture from the National Technical University of Athens (NTUA, 2001). **TILEMACHOS ANDRIANOPOULOS** was born in Athens, Greece, in 1974 and also received his Diploma in Architecture from the NTUA (2001), a Master's in Architecture and Urban Culture (UPC, 2006), and is a doctoral candidate (NTUA, 2012). Their work includes residences in Heraklion (2010) and Megara (2011), both of which are presently under construction. Aside from the Residence in Sikamino (2010–12, published here), which was shortlisted for the European Union Prize for Contemporary Architecture, Mies Van der Rohe Award 2013, they have completed houses in Kifissia (2011) and Kallitechnoupolis (2012), all in Greece.

Tense Architecture Network wurde 2004 von Tilemachos Andrianopoulos und Kostas Mavros gegründet. **KOSTAS MAVROS** wurde 1974 in Nea Ionia, Magnesia, geboren. Er machte sein Diplom für Architektur an der Staatlichen Technischen Universität Athen (NTUA, 2001). **TILEMACHOS ANDRIANOPOULOS** wurde 1974 in Athen geboren und erwarb sein Diplom für Architektur ebenfalls an der NTUA (2001), dann den Master in Architektur und Stadtkultur (UPC, 2006) und ist nun Doktorand (NTUA, 2012). Sie planten Wohnhäuser in Heraklion (2010) und Megara (2011), die zurzeit im Bau sind. Außer dem Wohnhaus in Sikamino (2010–12, hier vorgestellt), das in die engere Wahl für den Preis der Europäischen Union für zeitgenössische Architektur/Mies-van-der-Rohe-Preis 2013 kam, haben sie Häuser in Kifissia (2011) und Kallitechnoupolis (2012) gebaut, alle in Griechenland.

Tense Architecture Network a été créé en 2004 par Tilemachos Andrianopoulos et Kostas Mavros. **KOSTAS MAVROS** est né à Nea Ionia, en Magnésie (Grèce), en 1974. Il est diplômé en architecture de l'Université technique nationale d'Athènes (NTUA, 2001). **TILEMACHOS ANDRIANOPOULOS** est né à Athènes en 1974, il est également titulaire d'un diplôme en architecture de la NTUA (2001), ainsi que d'un master en architecture et culture urbaine (UPC, 2006), et postule à un doctorat (NTUA, 2012). Leurs réalisations comprennent des résidences à Héraklion (2010) et Megara (2011), toutes les deux en construction. Outre la résidence à Sikamino (2010–12, publiée ici), qui a figuré sur la liste des projets candidats au prix d'architecture contemporaine de l'Union européenne Mies Van der Rohe 2013, ils ont réalisé des maisons à Kifissia (2011) et Kallitechnoupolis (2012), toutes en Grèce.

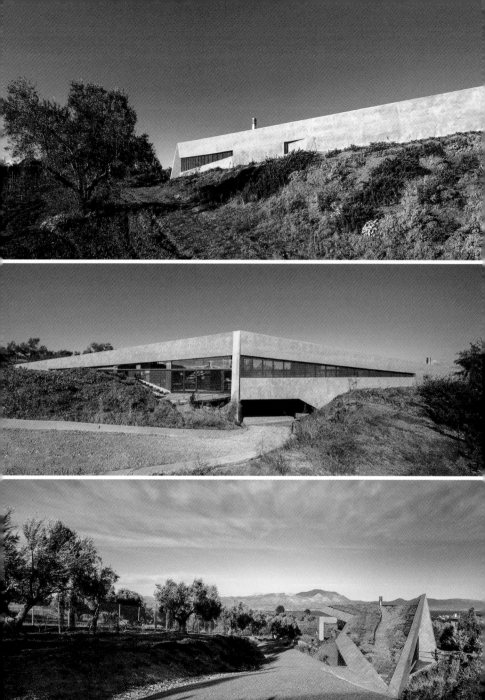

RESIDENCE IN SIKAMINO

Attica, Greece, 2010–12

Area: 400 m².
Collaboration: Thanos Bampanelos, Athanasios Kontizas.

Built in a rural field planted with olive trees, the **RESIDENCE IN SIKAMINO** has a 60-meter-long roof. The architects state: "The residence is its roof… The roof is born from and returns to the ground; it is planted with *helichrysum, drosanthemum*, lavender, gaura, and thyme. The roof's form is rhomboid and the living space is located under its central area of maximum width, while the sleeping quarters occupy the edges." This design goes to great lengths (literally) to incorporate architecture into the site, but the architects insist that it is not a camouflage-building, or a landscape-building: "Its architecture willfully declares its mainly open presence." The green roof and insertion of the house into the earth give it an obvious advantage in conserving passive energy. The building shell is made of reinforced concrete, visible in the roof and walls.

Dieses auf einem Feld mit Olivenbäumen errichtete **WOHNHAUS IN SIKAMINO** hat ein 60 m langes Dach. Die Architekten erklären: „Das Wohnhaus ist sein Dach … Das Dach wächst aus dem Boden und kehrt zu ihm zurück: Es ist mit Strohblumen, Mittagsblumen, Lavendel, Präriekerzen und Thymian bepflanzt. Die Form des Daches ist ein Rhombus, der Wohnbereich in ganzer Breite mittig darunter angeordnet, während die Schlafräume an den Enden liegen." Dieser Entwurf geht (buchstäblich) sehr weit, um die Architektur in das Gelände zu integrieren, aber die Architekten betonen, dass es kein getarntes oder Landschaftsgebäude sei: „Seine Architektur bekennt bewusst seine überwiegend offene Präsenz." Das begrünte Dach und die Einbettung des Hauses in die Erde bieten einen offenkundigen Vorteil zur passiven Energienutzung. Die Gebäudehülle besteht aus Stahlbeton, der auf dem Dach und an den Wänden sichtbar ist.

Construite dans un champ d'oliviers, la **RÉSIDENCE À SIKAMINO** est abritée sous un toit long de 60 m. Les architectes déclarent : « La résidence est toit… Le toit naît du sol et y retourne, il est planté d'immortelles, de drosanthèmes, de lavande, de gaura et de thym. Sa forme est rhomboïdale et l'espace séjour est situé sous sa largeur maximale centrale, tandis que les chambres occupent les bords. » La construction va très loin (au sens propre) pour intégrer l'architecture au paysage, les architectes insistent néanmoins sur le fait qu'il ne s'agit ni de camouflage, ni d'un bâtiment paysager : « Son architecture affirme délibérément sa présence, essentiellement ouverte. » Le toit végétalisé et l'insertion de la maison dans la terre lui donnent un avantage évident en termes de conservation de l'énergie passive. La coque est en béton armé, visible au niveau du toit et des murs.

Angled concrete surfaces and black metal contribute to the relatively austere aspect of this image which shows the openness of the house.

Schiefwinklige Betonflächen und schwarzes Metall wirken hier relativ streng, doch auch die Offenheit des Hauses ist zu erkennen.

Les surfaces de béton anguleuses et le métal noir contribuent au caractère plutôt austère de la photo, qui montre pourtant l'ouverture de la maison.

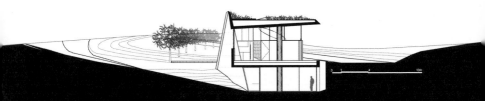

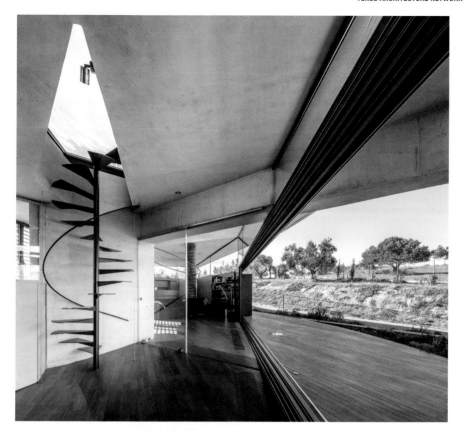

The house, open on one side, is partially dug into its site as the section drawing shows. Concrete surfaces also give the impression of being very much in harmony with the earth.

Das auf einer Seite geöffnete Haus ist partiell in das Gelände eingelassen, wie der Schnitt zeigt. Die Betonflächen scheinen sich sehr harmonisch in den Erdboden einzufügen.

La maison, ouverte sur un côté, est partiellement enterrée comme on le voit sur le schéma en coupe. Le béton donne aussi l'impression d'être parfaitement en harmonie avec la terre.

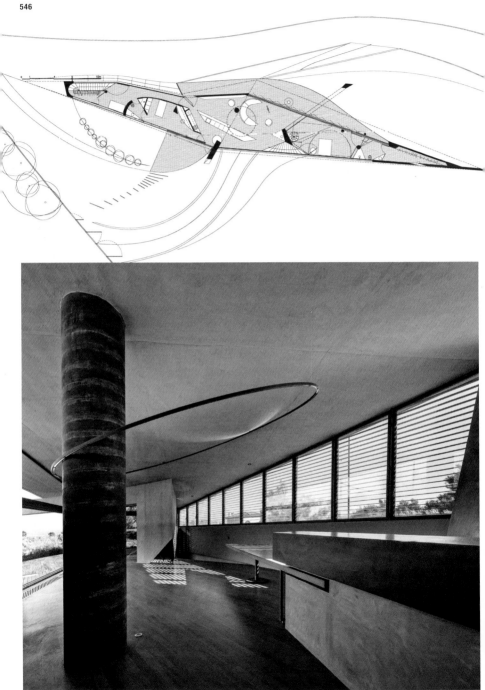

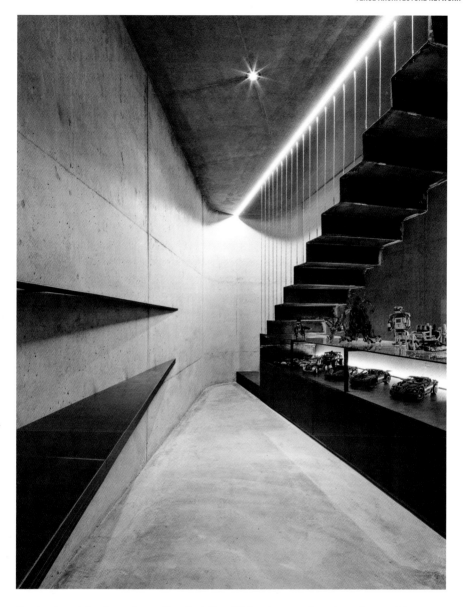

The sharply angled surfaces of the house with its large opening on one side and band windows on the other are seen in the photo on the left page.

Die spitzwinkligen Flächen des Hauses mit einer weiten Öffnung auf der einen und einem Fensterband auf der anderen Seite zeigt das Foto auf der linken Seite.

Page de gauche, on voit les surfaces aux angles aigus de la maison avec sa large ouverture d'un côté et sa bande de fenêtres de l'autre.

BING THOM

BING THOM was born in Hong Kong and received his B.Arch from the University of British Columbia (1966) and his M.Arch from the University of California at Berkeley (1969). He founded Bing Thom Architects in 1982 in Vancouver, Canada, and was its Creative Director until his death in 2016. His Partner **MICHAEL HEENEY** also studied architecture at the University of British Columbia. Their work includes the Arena Stage Theater expansion (Washington, D.C., USA, 2010); Surrey City Center Library (Surrey, British Columbia, Canada, 2011, published here); and the Tarrant County College Downtown Campus (Fort Worth, Texas, USA, 2011). After Thom's death the firm continues to operate under the name Revery Architecture. Current work includes the MacEwan Center for Arts and Culture (Edmonton, Alberta, Canada, 2017); and the Xiqu Center (Hong Kong, China, 2018).

BING THOM wurde in Hongkong geboren. Er machte den B.Arch. an der University of British Columbia (1966) und den M.Arch. an der University of California in Berkeley (1969). Er gründete Bing Thom Architecture 1982 in Vancouver, Kanada, war dort bis zu seinem Tod 2016 Kreativdirektor. Sein Partner **MICHAEL HEENEY**, geschäftsführender Direktor von Bing Thom Architects, studierte ebenfalls Architektur an der University of British Columbia. Zu den ausgeführten Projekten zählen die Erweiterung des Arena Stage Theaters (Washington, D.C., USA, 2010), die Surrey City Center Library (Surrey, Kanada, 2011). Nach Bing Thoms Tod wurde die Firma unter dem Namen Revery Architecture weiter-geführt. Aktuelle Arbeiten sind das MacEwan Center for Arts and Culture (Edmonton, Alberta, Kanada, 2017) und das Xiqu Center (Hongkong, China, 2018).

BING THOM est né à Hong Kong en 1940. Il est titulaire d'un B.Arch. de l'université de Colombie-Britannique (1966) et d'un M.Arch. de l'université de Californie (Berkeley, 1969). Il est directeur créatif de l'agence qu'il a fondée en 1982 à Vancouver, au Canada. Son partenaire **MICHAEL HEENEY**, directeur exécutif de Bing Thom Architects, a également fait des études d'architecture à l'université de Colombie-Britannique. Leurs projets comprennent l'extension du théâtre Arena Stage (Washington, DC, États-Unis, 2010) ; la bibliothèque centrale de Surrey (Colombie-Britannique, Canada, 2011, publiée ici) et le campus du Tarrant County College (Fort Worth, Texas, États-Unís, 2011). Parmi leurs réalisations en cours figurent le Centre d'arts et culture MacEwan (Edmonton, Alberta, Canada, 2017) ; et le Centre Xiqu (Hong Kong, Chine, 2018).

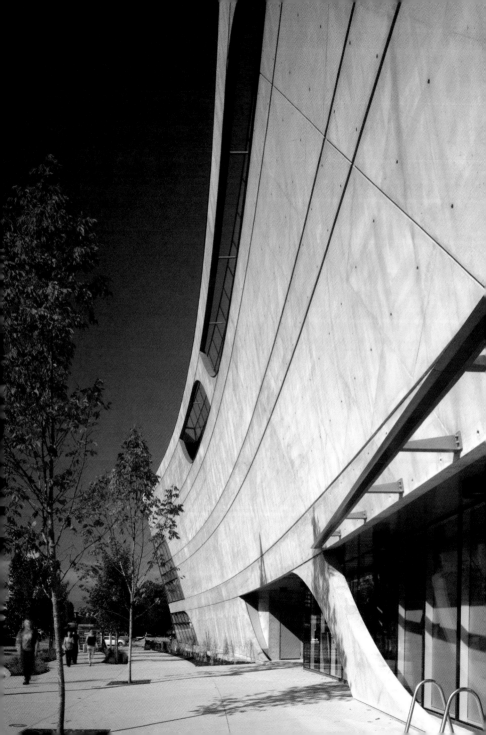

SURREY CITY CENTER LIBRARY

Surrey, British Columbia, Canada, 2011

Area: 7618 m². Client: City of Surrey.
Cost: $26.5 million.

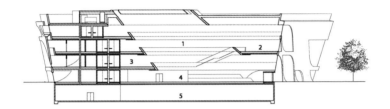

The new **SURREY CITY CENTER LIBRARY** is part of the transformation of downtown Surrey. The architects used computer-modeling software to design the concrete formwork. They state: "Additionally, the exterior concrete structure was carefully detailed as the final surface, thereby eliminating the need for expensive building cladding. Designed to LEED Silver standards, the outward sloped walls also provide solar shading." Conscious of the changing roles and function of public libraries, local authorities worked with the architects to use Facebook, Twitter, and Flickr to engage the local community in the design of the building, "thereby making the City Center Library arguably the first public building in the world to be designed with the aid of social media." The library has a green roof and four floors. It has a café as well as meeting spaces for a variety of community needs, a meditation room, a 12-seat computer learning center, a teen lounge and game room, and a substantial children's section, as well as popular print and online collections.

Die neue **ZENTRALBIBLIOTHEK VON SURREY** ist Teil der innerstädtischen Umgestaltung. Die Architekten planten die Betonschalung mithilfe eines Computerprogramms. Sie erklären: „Außerdem wurden die Außenwände des Betonbaus gleich so sorgfältig gestaltet, dass weitere hohe Kosten für eine Verkleidung entfielen. Die nach außen abgeschrägten Wände des nach dem LEED-Silver-Standard geplanten Gebäudes dienen auch als Sonnenschutz." Die örtlichen Behörden waren sich der veränderten Rolle und Funktion öffentlicher Bibliotheken bewusst; sie arbeiteten mit den Architekten zusammen und nutzten Facebook, Twitter und Flickr, um die Bevölkerung in die Planung des Gebäudes einzubeziehen, „wodurch die City Center Library zum wohl ersten öffentlichen Bauwerk der Welt geworden ist, das mithilfe sozialer Medien geplant wurde". Die Bibliothek hat ein begrüntes Dach und vier Geschosse, ein Café und auch Räumlichkeiten für vielerlei kommunale Veranstaltungen, einen Meditationsraum, einen Computerunterrichtsraum mit zwölf Plätzen, eine Jugendlounge und ein Spielzimmer sowie eine beachtliche Kinderabteilung und auch populäre Druck- und Onlinesammlungen.

La nouvelle **BIBLIOTHÈQUE CENTRALE DE SURREY** est l'un des éléments de la transformation du centre-ville. Les architectes ont créé les coffrages à l'aide de logiciels de modélisation assistée par ordinateur. Ils expliquent : «La structure extérieure en béton a fait l'objet d'un traitement minutieux de la surface définitive, ce qui a rendu inutile tout revêtement onéreux. Conçus selon les critères LEED argent, les murs extérieurs inclinés procurent également de l'ombre.» Conscientes des nouveaux rôles et fonctions des bibliothèques publiques, les autorités locales ont collaboré avec les architectes pour faire participer la population locale à la conception du bâtiment via Facebook, Twitter et Flickr, «faisant ainsi sans doute de la bibliothèque centrale le premier bâtiment public du monde à être construit à l'aide des médias sociaux». La bibliothèque dispose d'un toit végétalisé et de quatre étages. Elle possède un café et des espaces de réunion pour répondre à différents besoins communautaires, une salle de méditation, un centre d'apprentissage de l'informatique de 12 places, un foyer pour adolescents et salle de jeu, une vaste section enfantine et des collections de textes imprimés et en ligne très appréciées.

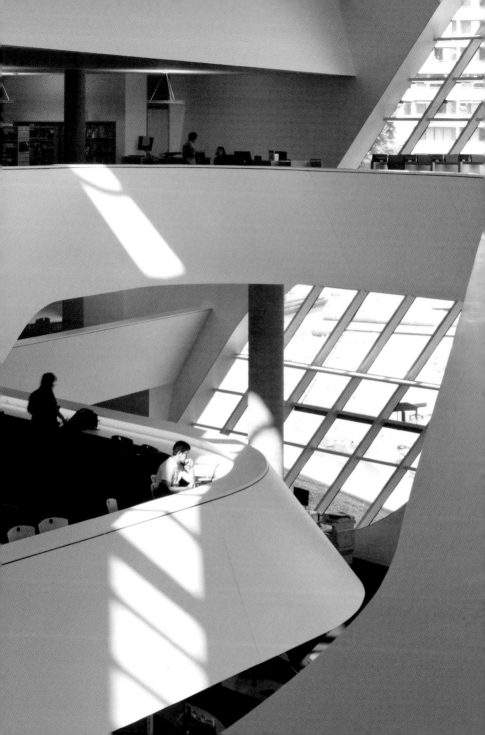

The dramatic forward-leaning angle of the building in the blue hour.

Die dramatisch vorkragende Spitze des Gebäudes zur blauen Stunde.

On voit ici l'extraordinaire angle penché vers l'avant du bâtiment à l'heure bleu.

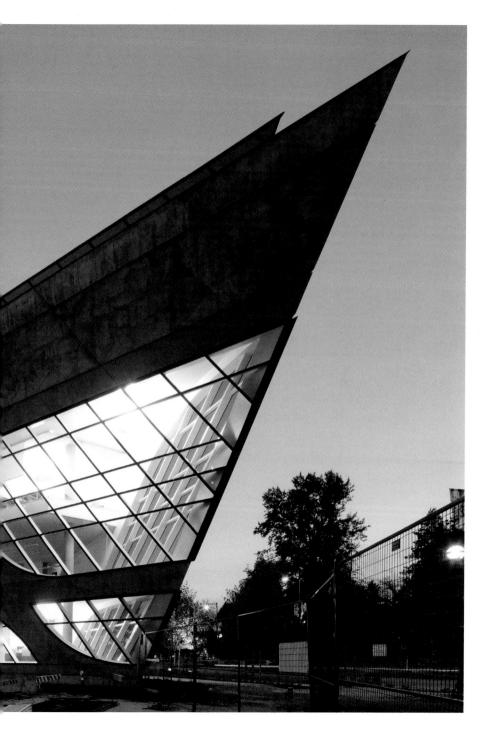

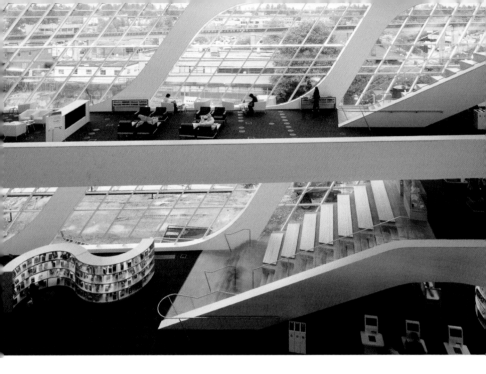

The angling of the windows and a wide-span suspended mezzanine give the interior an impression of movement. Below, floor plans.

Die schrägen Fenster und ein weit gespanntes, abgehängtes Zwischengeschoss verleihen dem Innern den Eindruck von Bewegung. Unten: Grundrisse.

Les angles des fenêtres et une large mezzanine suspendue donnent une impression de mouvement à l'intérieur. Ci-dessous, des plans.

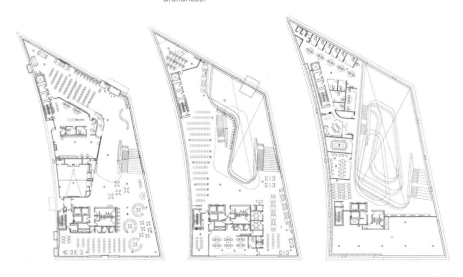

The sweeping curves inside the
building correspond well to its
exterior appearance, here offering
numerous views through the differ-
ent spaces and levels.

*Die schwungvollen Kurven inner-
halb des Gebäudes entsprechen
dem äußeren Erscheinungsbild.
Hier bieten sie zahlreiche Aus-
blicke in die unterschiedlichen
Räume und Ebenen.*

*Les larges courbes de l'intérieur
correspondent parfaitement à
l'aspect extérieur, on voit ici les
vues nombreuses qu'elles per-
mettent à travers les différents
espaces et niveaux.*

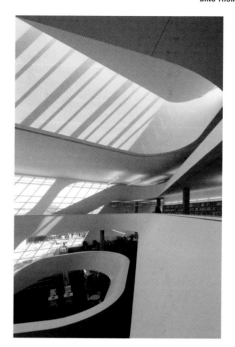

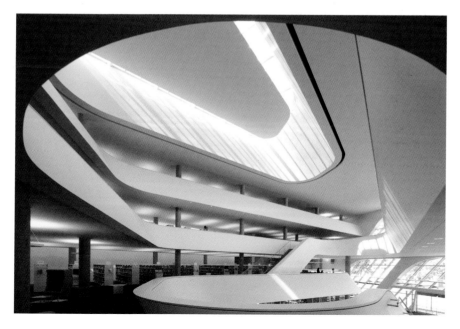

TRAHAN ARCHITECTS

VICTOR TRAHAN was born in Crowley, Louisiana, USA. He received a B.Arch degree from Louisiana State University in 1983. His work includes the LSU Academic Center For Student Athletes, Baton Rouge (Louisiana, 2002); the Holy Rosary Catholic Church Complex (St. Amant, Louisiana, 2000–04, published here), which won a National AIA Honor Award For Excellence In Architectural Design (2005); and the LSU Tiger Stadium East and West Side Expansion, (Baton Rouge, Louisiana, 2005). More recently he has completed the Louisiana State Museum (Natchitoches, Louisiana, 2013); Owensboro-Daviess County Convention Center (Owensboro, Kentucky, 2013); and the Magnolia Mound Visitors Center (Baton Rouge, 2014), all in the USA. The architect is currently working on Fundo Tic Toc (Corcovado National Park, Chile).

VICTOR TRAHAN, geboren in Crowley, Louisiana, machte seinen B.Arch 1983 an der Louisiana State University. Bauten des Büros sind u. a. das LSU Academic Center for Student Athletes in Baton Rouge (Louisiana, 2002), der Holy Rosary Catholic Church Complex in St. Amant, Louisiana (2000–04, hier vorgestellt), der 2005 mit dem National AIA Honor Award für die besondere Qualität des architektonischen Entwurfs ausgezeichnet wurde, sowie die östliche und westliche Erweiterung des LSU Tiger Stadium in Baton Rouge (2005). Erst kürzlich fertiggestellt hat er das Louisiana State Museum (Natchitoches, Louisiana, 2013); das Owensboro-Daviess County Convention Center (Owensboro, Kentucky, 2013) und das Magnolia Mound Visitors Center (Baton Rouge, 2014), alle in den USA. Gegenwärtig arbeitet der Architekt an der Fundo Tic Toc (Nationalpark Corcovado, Chile).

VICTOR TRAHAN, né à Crowley (Louisiane), a obtenu son B.Arch. à l'université d'État de Louisiane (LSU, 1983). Parmi ses réalisations : l'Academic Center for Student Athletes de la LSU, Baton Rouge (Louisiane, 2002) ; le complexe de l'église catholique du Saint-Rosaire de Saint Amant (Louisiane, 2000–04, publié ici), qui lui a valu un prix d'honneur pour l'excellence de la conception architecturale de l'AIA (2005), ainsi que l'extension du Tiger Stadium de la LSU à Baton Rouge (Louisiane, 2005). Plus récemment, il a achevé le Louisiana State Museum (Natchitoches, Louisiane, 2013) ; le palais des congrès du comté d'Owensboro-Daviess (Owensboro, Kentucky, 2013) et le centre d'accueil des visiteurs de Magnolia Mound (Baton Rouge, 2014), tous aux États-Unis. Il travaille actuellement au Fundo Tic Toc (Parc national Corcovado, Chili).

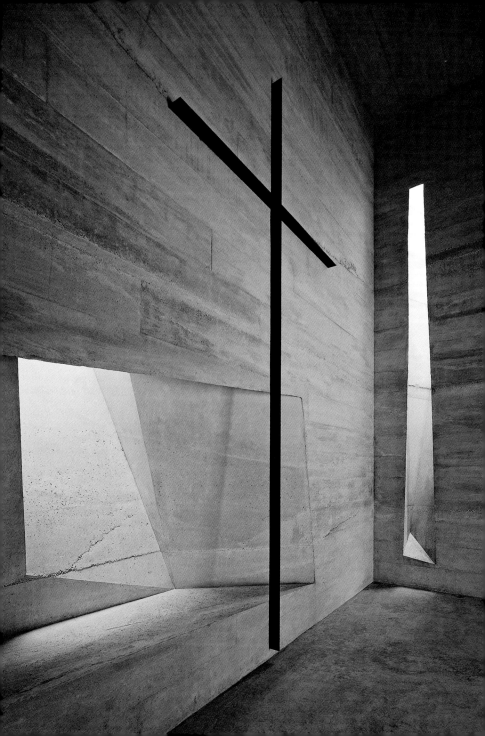

HOLY ROSARY CATHOLIC CHURCH COMPLEX

St. Amant, Louisiana, USA, 2000–04

Floor area: 1586 m². Client: Holy Rosary Catholic Church,
St. Amant, Lousiana. Cost: $2.4 million.

This 1586-square-meter **HOLY ROSARY CATHOLIC CHURCH COMPLEX** was built on a seven-hectare site for a cost of 2.4 million dollars. As the architect explains the program, "The client is a rural Catholic Parish in South Louisiana with a strong French influence. There are three buildings in the first phase of the Holy Rosary Complex—a structure housing the administrative functions of the parish; the religious education building; and the oratory, or chapel, for the celebration of the rites. The oratory is intended for the daily use of small assemblies, less than 50 congregants. The parish desired a relationship between the oratory, the existing church and for there to be a place of prominence for this chapel in the new complex of buildings. The client also required the new complex to play an important role in the community life of the predominantly Catholic residents." Trahan was careful to separate the secular and sacred components of the complex. Inspiration for the cubic oratory comes from the womb and from the Japanese four-and-a-half tatami configuration. The architect explains that "this nonhierarchical system accommodates numerous seating configurations for liturgical purposes." Intentionally limiting the use of costly or rare materials, the complex is built essentially of concrete and glass. Construction began on the Religious Education and Administration Building in 2000 and was completed in 2002. Construction began on the Chapel in 2003 and was completed in 2004.

Die 1586 m² große **ANLAGE DER KATHOLISCHEN KIRCHE DES HEILIGEN ROSENKRANZES** wurde für umgerechnet fast 2 Millionen Euro auf einem 7 ha großen Grundstück errichtet. Die Architekten erklären das Programm wie folgt: „Der Bauherr ist ein ländlicher, katholischer, stark an Frankreich orientierter Pfarrbezirk im Süden Louisianas. Während des ersten Bauabschnitts wurden drei Bauten realisiert: ein Verwaltungsgebäude, eine Religionsschule und ein Andachtsraum bzw. eine Kapelle, in der die religiösen Rituale zelebriert werden. Die Kapelle wird täglich genutzt, weniger als 50 Gläubige versammeln sich hier. Die Gemeinde wünschte einen Bezug zwischen der Kapelle und der bereits vorhandenen Kirche; die Kapelle sollte innerhalb der neuen Anlage einen besonderen Platz einnehmen. Der Bauherr wollte außerdem, dass die Gebäudegruppe im Gemeindeleben der hauptsächlich katholischen Bewohner eine wichtige Rolle spielt." Trahan hat die säkularen und die sakralen Elemente der Anlage sorgfältig voneinander getrennt. Inspirationen für den kubischen Andachtsraum waren der Mutterleib und das japanische Grundmuster aus viereinhalb Tatami-Matten. Dazu der Architekt: „Dieses nicht hierarchische System erlaubt verschiedene Sitzanordnungen, passend zu dem jeweiligen liturgischen Zweck." Die Verwendung von kostbaren oder seltenen Materialien wurde bewusst eingeschränkt, im Wesentlichen besteht der Bau aus Beton und Glas. 2000 wurde mit dem Bau des Schulgebäudes und des Verwaltungsbaus begonnen, die 2002 fertiggestellt waren. Die Kapelle wurde von 2003 bis 2004 gebaut.

L'**ÉGLISE CATHOLIQUE DU SAINT-ROSAIRE DE SAINT AMANT** de 1586 m² a été construit sur un terrain de 7 hectares pour un budget de presque 2 millions d'euros. Comme l'explique l'architecte : « Le client est une paroisse catholique rurale de la Louisiane du Sud, à forte influence française. Trois bâtiments ont été édifiés lors de la première phase : un pour les fonctions administratives de la paroisse, un autre pour l'enseignement religieux et enfin l'oratoire, ou chapelle, pour la célébration des offices. L'oratoire est conçu pour un usage quotidien par de petites assemblées de moins de 50 personnes. La paroisse souhaitait établir une relation entre ce lieu et l'église existante et qu'il occupe une position éminente dans le nouvel ensemble de bâtiments. Elle voulait également que l'ensemble joue un rôle important dans la vie de cette communauté rurale essentiellement catholique. » Trahan a séparé avec soin les composantes sacrées et séculières. La forme cubique de l'oratoire tire son inspiration de l'idée de matrice et de la disposition classique de 4,5 tatamis japonais. « Ce système non hiérarchique s'adapte à la disposition des sièges qui varie en fonction de la liturgie. » Le recours aux matériaux rares ou coûteux a été volontairement limité et le complexe est bâti essentiellement en béton et en verre. La construction a commencé en 2000 par les bâtiments administratifs et d'enseignement et s'est achevée en 2002. La chapelle, dont le chantier a débuté en 2003, a été livrée en 2004.

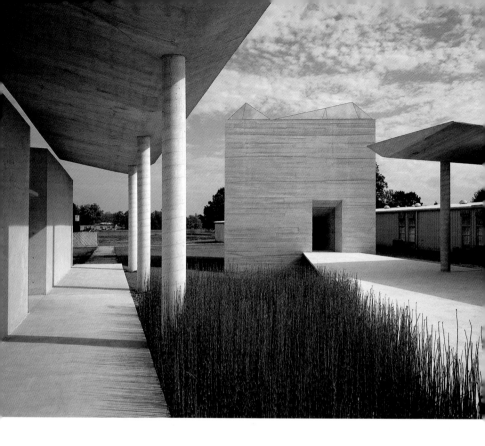

Trahan's strong, simple architecture honors the religious function of this small complex. The lack of color and the subtle landscaping participate in the creation of a religious mood.

Eine kraftvolle, klare Architektur unterstreicht die religiöse Funktion dieses kleinen Komplexes. Durch den Verzicht auf Farbe und die subtile landschaftsplanerische Gestaltung entsteht eine religiöse Stimmung.

L'architecture puissante et simple est un hommage à la fonction religieuse de ce petit complexe. L'absence de couleur et un subtil aménagement paysager contribuent à créer une atmosphère de recueillement.

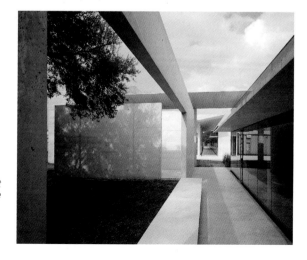

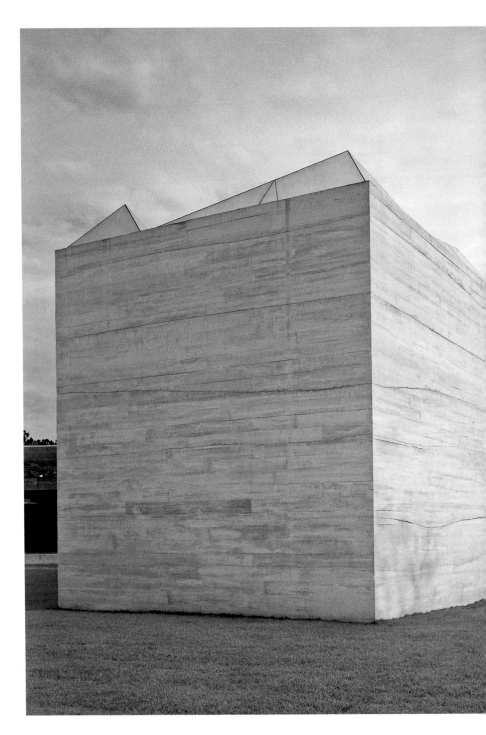

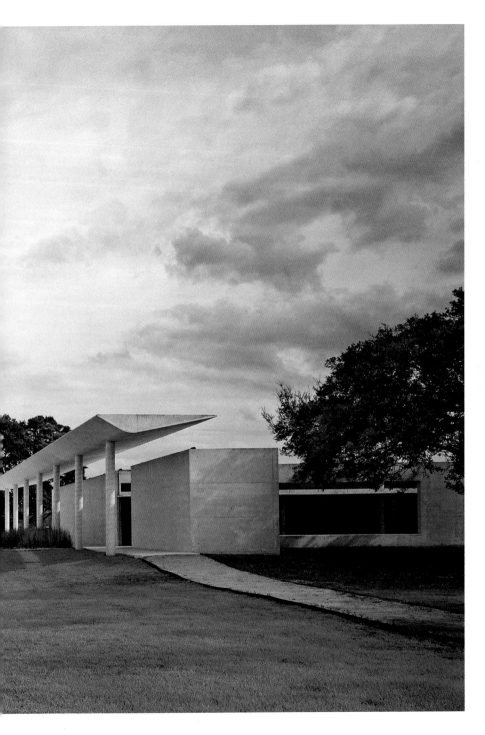

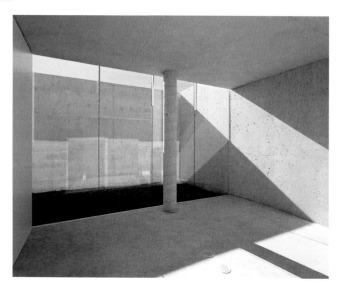

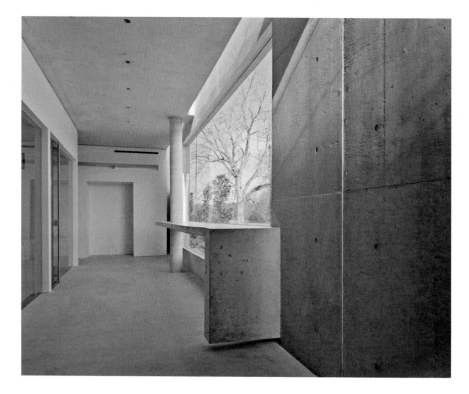

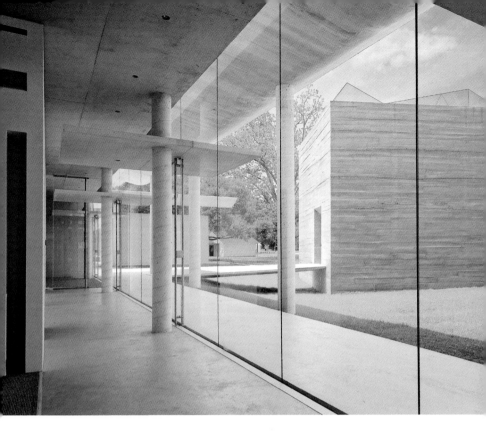

Although it is less ambitious than John Pawson's Nový Dvůr, the Holy Rosary Church shares the bright austerity of its European counterpart.

Die Holy Rosary Church ist weniger ehrgeizig angelegt als John Pawsons Nový-Dvůr-Projekt. Mit ihrem europäischen Gegenstück verbindet sie aber ihre helle Kargheit.

Bien que moins ambitieux que le monastère de Nový Dvůr par John Pawson, le projet de l'église du Saint-Rosaire partage l'austérité lumineuse de l'exemple européen.

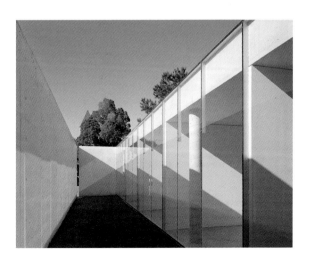

The play of light on concrete gives a more powerful message of religion than might a whole battery of outmoded objects. This is not the strict geometry of Ando, but the influence of Japanese architecture seems to have reached this place.

Das Spiel des Lichts auf dem Beton vermittelt die religiöse Botschaft stärker als eine ganze Batterie unzeitgemäßer Objekte. Dies ist zwar nicht die strenge Geometrie eines Tadao Ando, aber der Einfluss der japanischen Architektur scheint auch diesen Ort erreicht zu haben.

Le jeu de la lumière sur le béton porte un message religieux beaucoup plus fort que la présence de quelques objets démodés. Il ne s'agit pas là de la stricte géométrie d'Ando, mais l'influence de l'architecture japonaise semble avoir touché ce lieu.

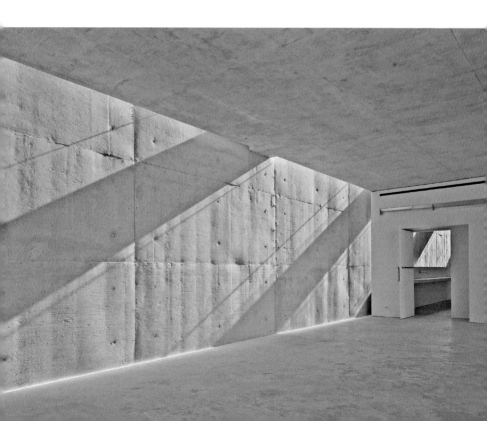

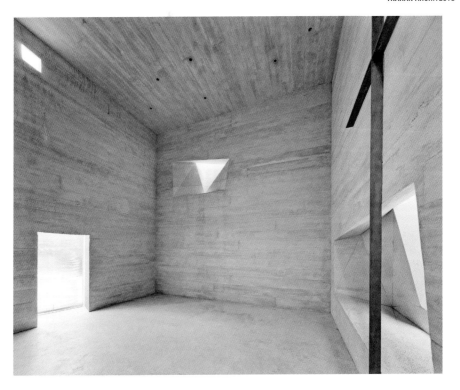

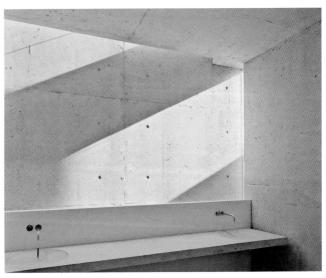

JAMES TURRELL

JAMES TURRELL was born in Los Angeles in 1943. He received a Diploma in Psychology from Pomona College (1965) and in Art from the University of California, Irvine, in 1966. Since that time he has been responsible for a very large number of exhibitions and installations all over the world. His interest is in the perception of light in various forms. Although he does not claim to be an architect, he has shown a consistent interest in the use of space in his work, and in particular in the case of the Roden Crater (near Flagstaff, Arizona, USA), which he purchased in 1977. He conceived the lighting of the Pont du Gard near Nîmes in France, and participated in the exhibition "La beauté" in Avignon (France, 2000). More recently completed work includes "Blue Burn" (FIFA HQ, Zurich, Switzerland, 2012); "Agua de Luz" (Cenote Santa Maria Tixcacaltuyub, Yucatán, Mexico, 2012); "Air Apparent" (Arizona State University, Tempe, Arizona, USA, 2012); and "Aqua Obscura" (Tremenheere Sculpture Gardens, Penzance, Cornwall, UK, 2013). The show "James Turrell," where he installed the work "Aten Reign" (Solomon R. Guggenheim Museum, New York, USA, published here), was held from June 21 to September 25, 2013.

JAMES TURRELL wurde 1943 in Los Angeles geboren. Er machte sein Diplom für Psychologie am Pomona College (1965) und für Kunst an der University of California in Irvine 1966. Seit der Zeit zeichnet er verantwortlich für eine große Zahl von Ausstellungen und Installationen in aller Welt. Sein Anliegen ist die Wahrnehmung von Licht in unterschiedlichen Formen. Obgleich er nicht für sich in Anspruch nimmt, Architekt zu sein, hat er sich in seinen Werken immer wieder mit der Nutzung von Raum auseinandergesetzt, besonders im Roden Crater (bei Flagstaff, Arizona, USA), den er 1977 erwarb. Er entwarf die Beleuchtung des Pont du Gard bei Nîmes in Frankreich und war an der Ausstellung „La beauté" in Avignon (Frankreich 2000) beteiligt. Zu den in neuerer Zeit ausgeführten Projekten gehören „Blue Burn" (FIFA-Hauptquartier, Zürich, Schweiz, 2012), „Agua de Luz" (Cenote Santa Maria Tixcacaltuyub, Yucatán, Mexiko, 2012), „Air Apparent" (Arizona State University, Tempe, USA, 2012) und „Aqua Obscura" (Tremenheere Sculpture Gardens, Penzance, Großbritannien, 2013). Die Ausstellung „James Turrell", auf der er das Werk „Aten Reign" installierte (Solomon R. Guggenheim Museum, New York, USA, hier vorgestellt), wurde vom 21. Juni bis zum 25. September 2013 gezeigt.

JAMES TURRELL est né à Los Angeles en 1943. Il est diplômé en psychologie du Pomona College (1965) et en art de l'université de Californie à Irvine (1966). Depuis, il a été responsable d'un très grand nombre d'expositions et d'installations dans le monde entier. Il s'intéresse avant tout aux diverses formes de perception de la lumière. Bien qu'il ne se prétende pas architecte, il a toujours montré de l'intérêt pour l'exploitation de l'espace dans ses œuvres, en particulier dans le cas du cratère Roden (près de Flagstaff, Arizona, États-Unis) qu'il a acquis en 1977. Il a conçu l'éclairage du pont du Gard près de Nîmes et a participé à l'exposition « La Beauté » en Avignon (France, 2000). Parmi ses projets récemment achevés : *Blue Burn* (siège de la FIFA, Zurich, Suisse, 2012) ; *Agua de Luz* (Cenote Santa Maria Tixcacaltuyub, Yucatán, Mexique, 2012) ; *Air Apparent* (université de l'Arizona, Tempe, États-Unis, 2012) et *Aqua Obscura* (jardins de sculptures de Tremenheere, Penzance, Cornouailles, Royaume-Uni, 2013). L'exposition « James Turrell » au cours de laquelle il a installé l'œuvre *Aten Reign* (musée Solomon R. Guggenheim, New York, États-Unis, publiée ici), a été présentée du 21 juin au 25 septembre 2013.

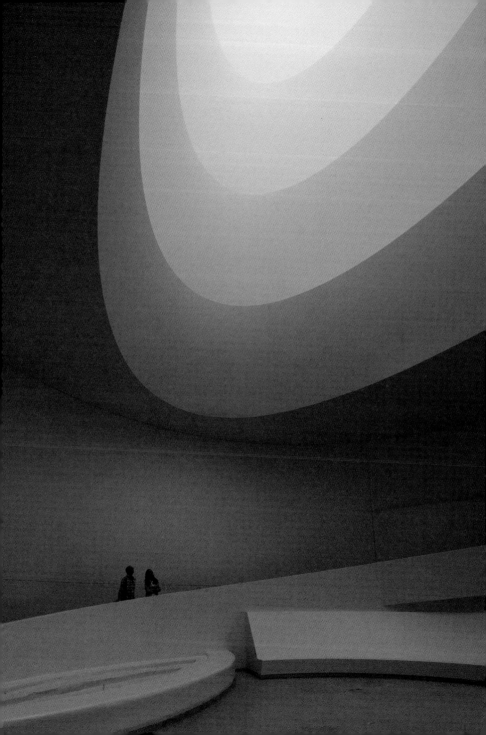

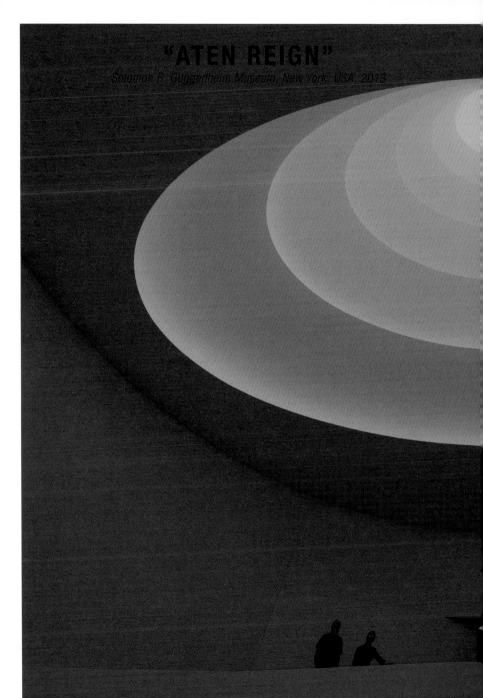

"ATEN REIGN"
Solomon R. Guggenheim Museum, New York, USA, 2013

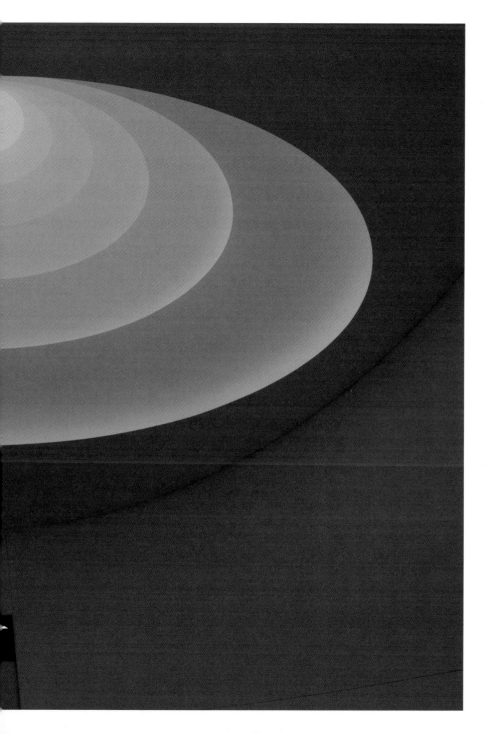

For his first New York museum exhibition since 1980, the artist James Turrell has taken on the transformation of an iconic architectural space, the rotunda of Frank Lloyd Wright's Solomon R. Guggenheim Museum (1959), with its spiraling concrete ramp. As Nat Trotman, Associate Curator, explains: "For his installation in the Guggenheim's rotunda, Turrell has essentially created a very elaborate structure that visitors will enter into from below and newly experience the light and air that fills the void of the museum. The piece is built as a series of cones that proceed through the space, starting about 7.6 meters above the floor of the museum and proceeding almost to the top of the space. Between the viewer and the daylight, there are five concentric rings of LED fixtures that shine upwards, filling five separate conical chambers with slowly changing light. Like many of Turrell's works, the piece is intended to create a contemplative or meditative atmosphere." Although the ramp of the museum was still open to visitors during the show, Turrell's **ATEN REIGN** closed it off almost entirely—the work had to be seen from ground level, looking up. All sense of distance, or height, was obviated by the work, remaking Wright's space in a very unexpected, albeit temporary way.

Für seine erste Ausstellung in einem New Yorker Museum seit 1980 übernahm der Künstler James Turrell die Transformation eines zur Ikone gewordenen architektonischen Raumes, der Rotunde in Frank Lloyd Wrights Solomon R. Guggenheim Museum (1959) mit der spiralförmigen Betonrampe. Nat Trotman, der stellvertretende Kurator, erläutert: „Für seine Installation in der Guggenheim-Rotunde hat Turrell eine ganz besondere, kunstvolle Konstruktion geschaffen, in die Besucher von unten eintreten und das Licht und die Luft, die den Leerraum des Museums erfüllen, auf neuartige Weise erleben. Sie besteht aus mehreren Kegeln, die durch den Raum führen, beginnend etwa 7,6 m über dem Boden und fast bis zur Decke des Raumes reichend. Zwischen dem Betrachter und dem Tageslicht befinden sich fünf konzentrische Kreise aus LED-Leuchten, die nach oben strahlen und fünf getrennte konische Kammern mit langsam wechselndem Licht erfüllen. Wie viele von Turrells Werken soll auch dieses eine meditative Atmosphäre erzeugen." Obgleich die Museumsrampe während der Ausstellung für Besucher geöffnet blieb, schloss Turrells **ATEN REIGN** sie fast vollständig ab – das Kunstwerk musste vom Erdgeschoss hinaufblickend betrachtet werden. Dadurch entfiel jegliches Gefühl für Entfernung oder Höhe, und das veränderte Wrights Raum auf völlig unerwartete, wenngleich vorübergehende Weise.

Pour sa première exposition dans un musée new-yorkais depuis 1980, l'artiste James Turrell a entrepris la transformation d'un espace architectural emblématique : la rotonde du musée Solomon R. Guggenheim et sa rampe de béton en spirale, construite par Frank Lloyd Wright (1959). Comme l'explique Nat Trotman, commissaire adjoint : « Pour son installation dans la rotonde du Guggenheim, Turrell a créé une structure très élaborée dans laquelle les visiteurs pénétreront par en bas afin de ressentir d'une manière nouvelle la lumière et l'air qui emplissent le vide du musée. L'œuvre est constituée d'une série de cônes qui avancent dans l'espace, à partir de 7,6 m au-dessus du sol jusque presque tout en haut. Entre le spectateur et la lumière du jour, cinq anneaux concentriques de LED éclairent vers le haut et emplissent cinq chambres coniques distinctes d'une lumière qui change lentement de couleur. Comme beaucoup des œuvres de Turrell, le but est de créer une atmosphère contemplative ou méditative. » Bien que la rampe soit restée ouverte au public pendant l'exposition, **ATEN REIGN** de Turrell la condamnait presque entièrement : l'œuvre devait être observée depuis le sol en levant la tête. Elle mettait fin à tout sens de la distance ou de la hauteur, recréant l'espace imaginé par Wright d'une manière surprenante, mais temporaire.

Even visitors familiar with the celebrated atrium of Frank Lloyd Wright's Guggenheim in New York were surprised by Turrell's installation which essentially covered the architecture and allowed light of varying colors to suffuse the space.

Sogar Besucher, denen das berühmte Atrium von Frank Lloyd Wrights Guggenheim Museum vertraut ist, waren überrascht von Turrells Installation, die die Architektur nahezu verdeckte und Licht in immer neuen Farben den Raum durchfluten ließ.

Même les visiteurs familiers de la célèbre rotonde de Frank Lloyd Wright au Guggenheim de New York ont été surpris par l'installation de Turrell, essentiellement consacrée à l'architecture, dans laquelle la lumière de couleurs variables envahissait l'espace.

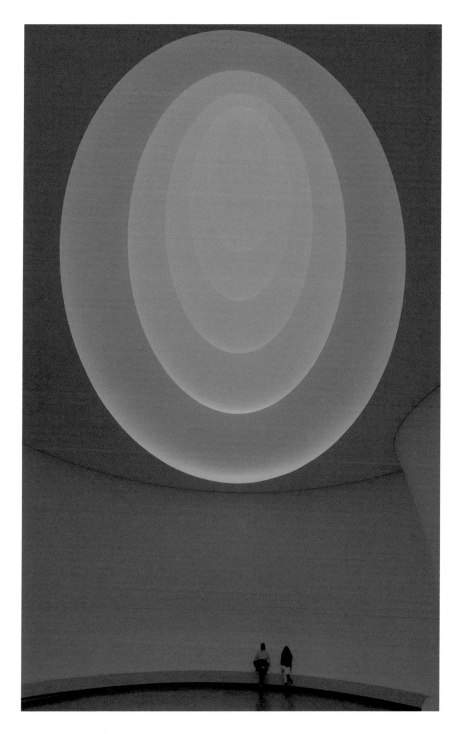

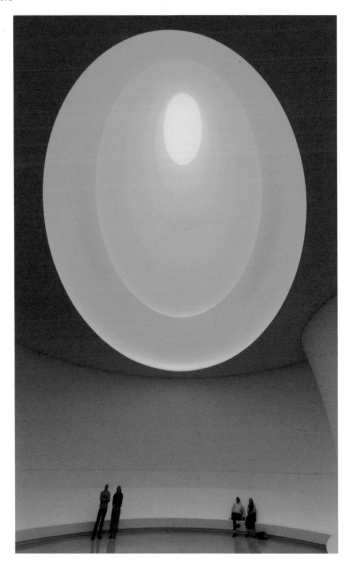

The slow change of colors gave different aspects to the space, as did the precise location of viewers—in any case, looking up, as both these images do, generates an impression of infinite space.

Der langsame Wechsel der Farben und die Standorte der Betrachter verliehen dem Raum unterschiedliche Aspekte. Wie diese Fotos zeigen, vermittelte der Blick nach oben den Eindruck eines unendlichen Raums.

La lente variation des couleurs conférait des aspects différents à l'espace, de même que l'emplacement des spectateurs – regarder vers le haut, comme sur ces images, crée toujours l'impression d'un espace infini.

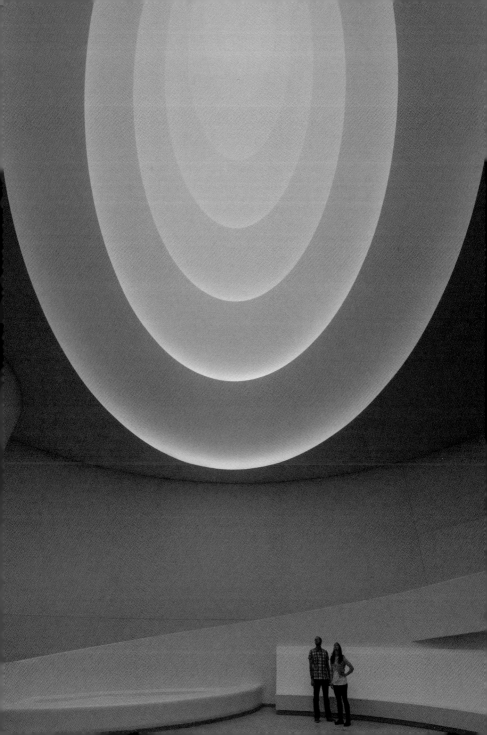

URBANA

KASHEF MAHBOOB CHOWDHURY was born in Dhaka, Bangladesh, in 1970. He received his B.Arch degree from the Bangladesh University of Engineering and Technology (BUET) in 1995. He participated in a Master Class with Glenn Murcutt in Sydney in 2006. He established URBANA in partnership in 1995 but, since 2004, has continued as the sole Principal of the firm. His work includes his own residence (Lalmatia, Dhaka, 1995–2001); BEN Bangladesh Factory Building (EPZ, Dhaka); the Chandgaon Mosque (Chittagong, 2006–07, published here); and a residence (Baridhara, Dhaka, 2007–10). Further work includes the Friendship Training Center, a winner of a 2016 Aga Khan Architecture Award (Gaibandha, 2008–11); the EHL Premium Apartments (Dhaka, 2010–13); and Gulshan Mosque (Dhaka, 2010–17), all in Bangladesh.

KASHEF MAHBOOB CHOWDHURY wurde 1970 in Dhaka, Bangladesch, geboren. Seinen B.Arch. machte er 1995 an der Universität für Ingenieurwissenschaften und Technik von Bangladesch (BUET). 2006 nahm er an einer Meisterklasse bei Glenn Murcutt in Sydney teil. Nachdem er URBANA 1995 zunächst als Partnerschaft gegründet hatte, betreibt er das Büro seit 2004 unter eigener Regie. Zu seinen Projekten zählen sein eigenes Wohnhaus (Lalmatia, Dhaka, 1995–2001), ein Fabrikgebäude für BEN Bangladesh (EPZ, Dhaka), die Chandgaon-Moschee (Chittagong, 2006–07, hier vorgestellt) und ein privater Wohnbau (Baridhara, Dhaka, 2007–10). Weitere Projekte sind u. a. das Friendship Training Center , 2016 mit einem Aga Khan Architecture Award ausgezeichnet (Gaibandha, 2008–11), die EHL Premium Apartments (Dhaka, 2010–13) sowie die Gulshan-Moschee (Dhaka, 2010–17), alle in Bangladesch.

KASHEF MAHBOOB CHOWDHURY, né à Dhaka (Bangladesh) en 1970 a obtenu son B.Arch. à l'Université d'ingénierie et de technologie du Bangladesh (BUET) en 1995. Il a participé à une *master class* animée par Glenn Murcutt à Sydney en 2006. Il a fondé l'agence URBANA en partenariat avec d'autres architectes en 1995, mais est depuis 2004 l'unique dirigeant de l'agence. Parmi ses réalisations, toutes au Bangladesh : sa propre maison (Lalmatia, Dhaka, 1995–2001) ; l'usine BEN Bangladesh (EPZ, Dhaka) ; la mosquée de Chandgaon (Chittagong, 2006–07, publiée ici) et une maison individuelle (Baridhara, Dhaka, 2007–10). Ses projets plus récents comprennent le Friendship Training Center, 2016 recompensé par le Prix Aga Khan Architecture (Gaibandha, 2008–11) ; l'immeuble EHL Premium Apartments (Dhaka, 2010–13) et la mosquée de Gulshan (Dhaka, 2010–17).

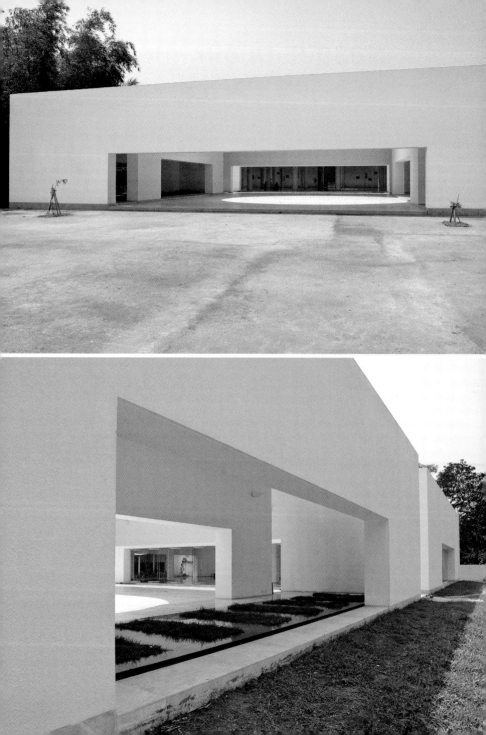

MOSQUE IN CHANDGAON

Chittagong, Bangladesh, 2006–07

Area: 925 m². Client: M. Morshed Khan, Faisal M. Khan and family.
Cost: $285 000.

The architect sought to establish both a place of worship and a place for meditation. He started by identifying the "essential" elements of the **MOSQUE**. "The design," he explains, "consists of two identical cuboid volumes, one as the front court and the mosque proper as the other. The traditional courtyard in front of a mosque, which serves as spillover area during larger congregations, therefore manifests itself in the first structure—open to the elements and offering a preparation before entry to the mosque proper. The design pivots around the tension between the horizontal sweep of the low, wide openings and the gathering people (earthbound) and the vertical reference to zenith of the circular opening or cut dome (spiritual)." The cut dome, open to the sky, differentiates this from most other mosques. The architect has also sought to reinstate this mosque to the traditional role of community gathering place.

Dem Architekten ging es darum, einen Ort des Gottesdienstes und der Meditation zu schaffen. Ausgangspunkt war für ihn die Bestimmung der „wesentlichen" Elemente einer **MOSCHEE**. „Der Entwurf", so der Architekt, „besteht aus zwei identischen kubischen Volumen, einem Vorhof und der eigentlichen Moschee. Der traditionelle Vorhof einer Moschee, der dazu dient, Besucher aufzunehmen, die bei großen Gottesdiensten keinen Platz mehr in der Moschee finden, ist damit das erste bauliche Element – offen den Elementen ausgesetzt und zudem ein Ort der Vorbereitung vor dem Betreten der Moschee. Dreh- und Angelpunkt des Entwurfs ist die Spannung zwischen den horizontal ausgreifenden, niedrigen, weiten Öffnungen und den versammelten Besuchern (erdverbunden) und der vertikalen Referenz zum Zenith durch das runde Oberlicht und die gespaltene Kuppel (spirituell)." Die zum Himmel offene, gespaltene Kuppel unterscheidet den Bau von den meisten Moscheen. Darüber hinaus ging es dem Architekten darum, der Moschee wieder ihre überkommene Rolle als nachbarschaftlichen Versammlungsort zurückzugeben.

L'architecte a cherché à créer ici un lieu de culte qui soit aussi un lieu de méditation. Il a commencé par identifier les éléments qui constituent l'essence de la **MOSQUÉE**. «Le projet, explique-t-il, consiste en deux volumes cuboïdes, l'un étant une cour, l'autre la mosquée proprement dite. La cour que l'on trouve traditionnellement devant une mosquée et qui sert aussi à accueillir les fidèles lors des grandes fêtes religieuses, est ouverte aux éléments et permet d'accomplir les rites qui précèdent l'entrée dans la grande salle. Le projet joue sur la tension entre l'ampleur des vastes ouvertures surbaissées et la réunion des fidèles (la terre) et la référence verticale au zénith par l'ouverture centrale découpée dans la coupole (le spirituel).» Cette coupole tranchée qui s'ouvre sur le ciel, différencie ce projet de la plupart des mosquées existantes. L'architecte a également cherché à redonner au lieu son rôle traditionnel de rassemblement de la communauté des croyants.

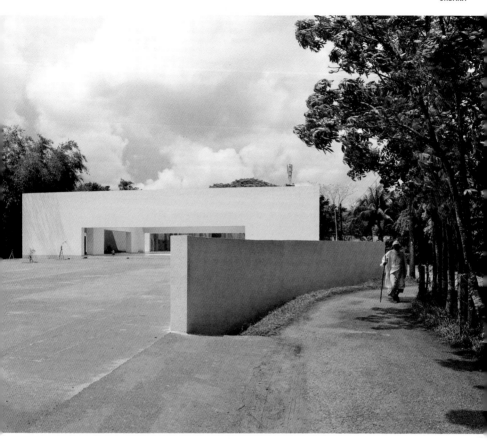

Not readily identifiable as a mosque from the exterior, the structure adopts the configuration of gateways that lead into gardens such as those seen on the right.

Der von außen nicht sofort als Moschee erkennbare Bau wurde als Abfolge verschiedener Torgänge geplant, die u. a. zu Gärten wie rechts im Bild führen.

De prime abord, le bâtiment n'évoque pas une mosquée. Il intègre une série de portails qui mènent vers des jardins, tels ceux visibles à droite.

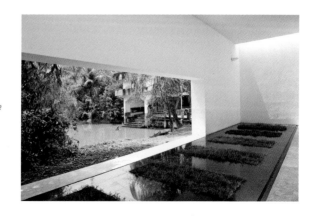

Although mosque architecture is codified to some extent, there is a great deal of leeway which the architect has made use of to create a modern, inspiring space.

Trotz typologischer Vorgaben für den Bau von Moscheen versteht es der Architekt, vorhandene Freiräume zu nutzen und einen modernen, inspirierenden Raum zu schaffen.

Si l'architecture des mosquées est codifiée dans une certaine mesure, il reste une grand liberté d'interprétation, dont l'architecte a profité pour créer un espace moderne et inspiré.

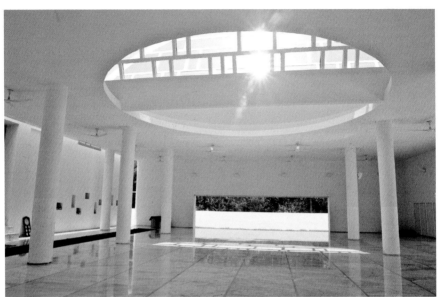

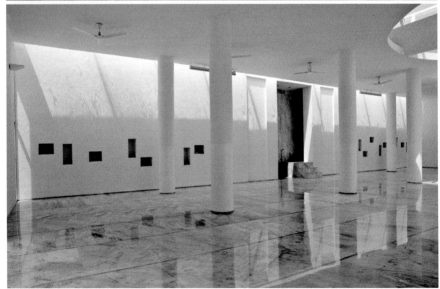

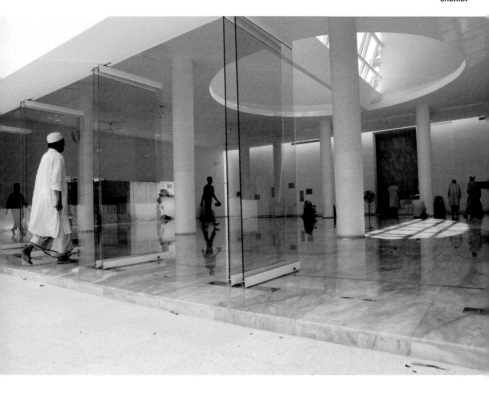

The dome, seen in the elevations below and in the photos on these two pages, brings natural light into the mosque.

Die auf den Aufrissen unten und den Aufnahmen dieser Doppelseite erkennbare Kuppel lässt Tageslicht in die Moschee.

La coupole (coupes ci-dessous et photos de cette double page) laisse pénétrer la lumière naturelle dans l'intérieur de la mosquée.

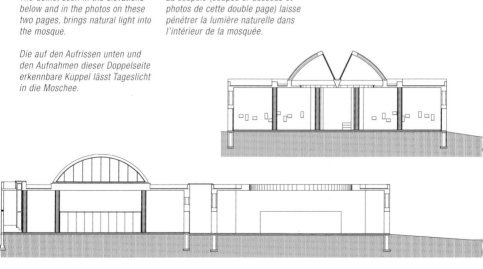

URBANUS

Urbanus was founded in 1999 by Liu Xiaodu, Meng Yan, and Wang Hui. Prior to cofounding Urbanus, **MENG YAN** was a project architect and designer at Kohn Pedersen Fox Associates P.C.; Meltzer Mandl Architects in New York; Brown & Bills Architects in Dayton; and Yongmao Architects and Engineers in Beijing. **LIU XIAODU** was previously a project architect and project designer at Design Group Inc. (Columbus, Ohio) and Stang & Newdow Inc. in Atlanta, Georgia. He received his B.Arch degree from Tsinghua University (1985), and M.Arch from Miami University (Oxford, Ohio, 1997). **WANG HUI** previously worked with Gruzen Samton Architects; Gensler; and Gary Edward Handel + Associates; and, like his two Partners, he was educated at Tsinghua University and Miami University. Their recent works include Shenzhen International Yacht Club (Shenzhen, 2006); Public Art Plaza (Shenzhen, 2006); Shanghai Multimedia Valley Office Park (Shanghai, 2007); Digital Beijing (with Pei Zhu; Beijing, 2007); the Nanyou Shopping Park (Shenzhen, 2007); the Dafen Art Museum (Shenzhen, 2006–08, published here); the Tangshan Urban Planning Museum (Tangshan, 2008–11); Nanshan Marriage Registration Center (Shenzhen, 2009–11); and Wenjing Plaza (Shenzhen, 2012), all in China.

Urbanus wurde 1999 von Liu Xiaodu, Meng Yan und Wang Hui gegründet. Zuvor arbeitete **MENG YAN** als Projektarchitekt und -planer bei Kohn Pedersen Fox Associates P. C., Meltzer Mandl Architects (New York), Brown & Bills Architects (Dayton) und Yongmao Architects and Engineers (Peking). **LIU XIAODU** war zuvor als Projektarchitekt und -planer für die Design Group Inc. (Columbus, Ohio) sowie Stang & Newdow Inc. (Atlanta, Georgia) tätig. Er absolvierte einen B.Arch. an der Tsinghua-Universität (1985) und einen M.Arch. an der Miami University (Oxford, Ohio, 1997). **WANG HUI** arbeitete zunächst für Gruzen Samton Architects, Gensler und Gary Edward Handel + Associates. Ebenso wie seine Partner studierte er an der Tsinghua-Universität und der Miami University. Jüngere Arbeiten des Büros sind u. a. der Shenzhen International Yacht Club (Shenzhen, 2006), die Public Art Plaza (Shenzhen, 2006), der Shanghai Multimedia Valley Office Park (Schanghai, 2007), Digital Beijing (mit Pei Zhu; Peking, 2007), der Nanyou Shopping Park (Shenzhen, 2007), das Dafen Art Museum (Shenzhen, 2006–08, hier vorgestellt), das Museum für Stadtplanung in Tangshan (2008–11), das Standesamt im Stadtteil Nanshan (Shenzhen, 2009–11) und Wenjing Plaza (Shenzhen, 2012), alle in China.

Urbanus est créé en 1999 par Liu Xiaodu, Meng Yan et Wang Hui. Avant de participer à la fondation d'Urbanus, **MENG YAN** a été architecte et concepteur de projets chez Kohn Pedersen Fox Associates P.C., Meltzer Mandl Architects à New York, Brown & Bills Architects à Dayton et Yongmao Architects and Engineers à Pékin. **LIU XIAODU** a été architecte et concepteur de projets chez Design Group Inc. (Columbus, Ohio) et Stang & Newdow Inc. à Atlanta. Il obtient son B.Arch. à l'université Tsinghua en Chine (1985) et son M.Arch. à l'université Miami (Oxford, Ohio, 1997). **WANG HUI** a d'abord travaillé chez Gruzen Samton Architects, Gensler, et Gary Edward Handel + Associates, et, comme ses deux associés, il a fait ses études à l'université Tsinghua et à l'université Miami. Parmi leurs réalisations récentes, l'on peut mentionner le Shenzhen International Yacht Club (Shenzhen, 2006); Public Art Plaza (Shenzhen, 2006); le Shanghai Multimedia Valley Office Park (Shanghai, 2007); Digital Beijing (avec Pei Zhu; Pékin, 2007); le Nanyou Shopping Park (Shenzhen, 2007); le Dafen Art Museum (Shenzhen, 2006–08, présenté ici); le Tangshan Urban Planning Museum (Tangshan, 2008–11); le centre de déclaration des mariages de Nanshan (Shenzhen, 2009–11); et Wenjing Plaza (Shenzhen, 2012), toutes en Chine.

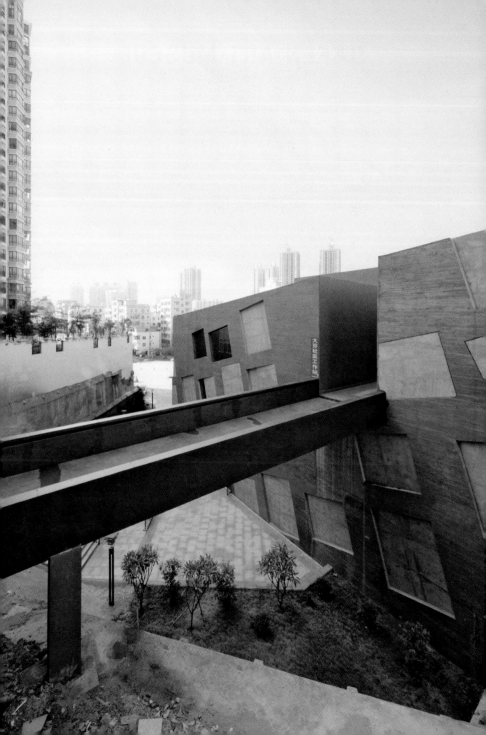

DAFEN ART MUSEUM

Dafen Village, Shenzhen, China, 2006–08

Site area: 11 300 m². Floor area: 16 866 m². Client: Shenzhen Longgang Bureau of Construction.
Cost: €10 million. Collaboration: Liu Xiaodu, Meng Yan (Partners in Charge);
Fu Zhuoheng, Chen Yaoguang (Project Architects).

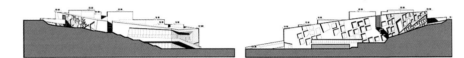

The Dafen Village area is well known in China for its oil painting replica workshops that export to Europe, America, and Asia. What is produced in the area has long been considered to be a "strange mixture of art, bad taste, and commercialism," according to the architects. Their goal has been to reinterpret this image with an innovative approach that seeks to "hybridize" different programs, including oil painting galleries, shops, commercial spaces, and studios. Pathways through the public spaces of **DAFEN ART MUSEUM** encourage interaction with the community. Their strategy of confronting their project with the typical idea of a museum is actually quite daring, as the architects acknowledge. As they write, "The walls of a traditional museum clearly define the boundary between the art world and the outside world. Its exclusiveness protects the museum's content from the reality of daily life on the outside. But here the name 'museum' can hardly describe the contents of the new building, which will be located in Dafen Village, or at least it contains much more than a typical museum is willing or capable of including. The irony is that in a place unimaginable for a typical art museum, we hope it can host the most avant-garde contemporary art shows, and, at the same time, can include the local new vernacular pop art."

Das Stadtviertel Dafen in Shenzhen ist bekannt für seine Malwerkstätten, in denen berühmte Ölgemälde kopiert werden, um sie ins asiatische Ausland und nach Europa und Amerika zu exportieren. Was in Dafen entsteht, wird, so die Architekten, seit Längerem als „eine verquere Mischung aus Kunst, Kommerz und schlechtem Geschmack" beäugt. Urbanus nahm sich vor, dieses Image zu überarbeiten. Die Architekten entschieden sich für einen innovativen Ansatz, bei dem verschiedene Bereiche inklusive Gemäldegalerien, Geschäfte, Gewerberäume und Ateliers „hybridisiert" werden sollten. Die Wege durch die öffentlichen Räume des **DAFEN ART MUSEUM** ermutigen die Interaktion. Wie die Architekten zugeben, ist die Strategie, ihr Projekt mit der typischen Vorstellung eines Museums zu konfrontieren, eigentlich recht gewagt. „Die Mauern des traditionellen Museums", so schreiben sie, „bilden eine Grenze zwischen der Welt der Kunst und der Außenwelt. Seine Exklusivität schützt den Museumsbestand vor der Realität des alltäglichen Lebens auf der anderen Seite. Hier dagegen lässt sich mit dem Begriff ‚Museum' der Inhalt des neuen Gebäudes in Dafen nur schwerlich umschreiben, oder zumindest beinhaltet er hier viel mehr, als das typische Museum willens oder in der Lage ist zu umfassen. Die Ironie besteht darin, dass wir mit einem Ort, der für ein typisches Museum undenkbar wäre, die innovativsten Ausstellungen zeitgenössischer Kunst anzulocken hoffen, einem Ort, der aber ebenso gut Platz für die neue hier entstehende Pop-Art bietet."

La région du village de Dafen est très connue en Chine pour ses ateliers de copies de peintures à l'huile qui s'exportent vers Europe, l'Amérique et l'Asie. Cette production a longtemps été considérée par les architectes comme « un étrange mélange d'art, de mauvais goût et de commerce ». Leur objectif a été de réinterpréter cette image à travers une approche novatrice qui cherche à « hybrider » différents programmes comprenant des galeries de peinture, des boutiques, des espaces commerciaux et des ateliers. Des passages créés à travers les espaces publics du **DAFEN ART MUSEUM** facilitent les interactions. Leur stratégie est en fait assez audacieuse, comme ils le reconnaissent, dans sa confrontation au concept classique de musée : « Les murs d'un musée traditionnel définissent clairement les limites entre le monde de l'art et le monde extérieur. Cette exclusion protège le contenu du musée de la réalité de la vie quotidienne du dehors. Mais, dans ce cas, le terme de musée peut difficilement décrire le contenu de ce nouveau bâtiment situé au cœur du village de Dafen, ou du moins de celui qui contiendra beaucoup plus qu'un musée typique serait prêt à recevoir. L'ironie de la situation est que, dans un lieu inimaginable pour un musée d'art typique, nous espérons qu'il accueillera les expositions d'art contemporain les plus avant-gardistes et, en même temps, s'ouvrira au nouveau pop art vernaculaire. »

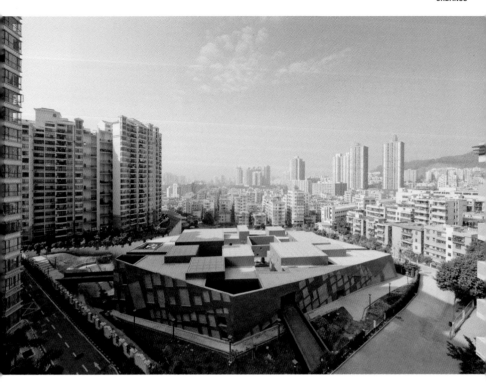

The roof design appears to fit into the juxtaposition of existing buildings, continuing the village-like atmosphere that neighboring towers appear to threaten.

Das Dach scheint sich zwischen die vorhandenen Gebäude einreihen und die dörfliche Atmosphäre fortführen zu wollen, die indes von den umliegenden Hochhäusern bedroht wirkt.

Le dessin du toit s'intègre dans la juxtaposition des constructions existantes, comme pour traduire l'atmosphère de village que les tours environnantes semblent menacer.

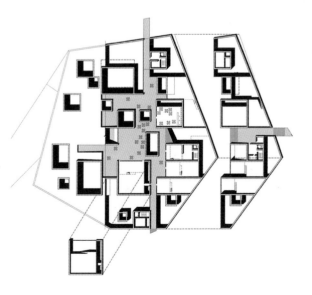

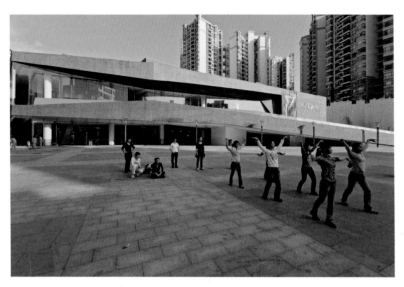

A large square in front of the building serves as a place for local residents to practice early morning Tai-Chi.

Anwohner nutzen den großen Platz vor dem Museum für ihre frühmorgendlichen Tai-Chi-Übungen.

Une grande place aménagée devant le bâtiment sert à la pratique matinale du taï chi par les résidants.

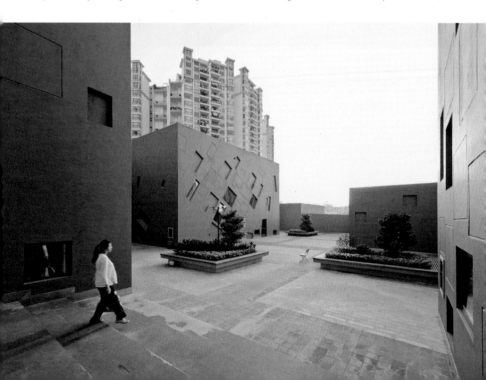

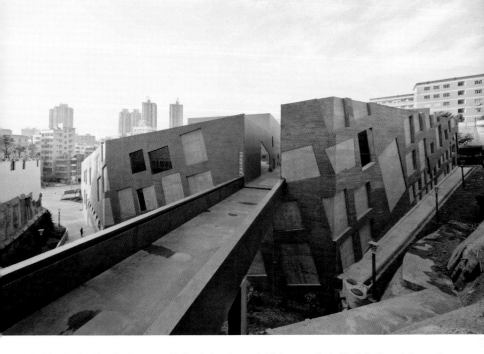

A jumble of real and outlined windows at curious angles again echoes the somewhat chaotic environment of the older residential or gallery buildings in the vicinity.

Ein Durcheinander aus tatsächlichen und angedeuteten Fenstern in seltsamen Winkeln spiegelt die ein wenig chaotische Umgebung aus älteren Wohngebäuden und Galerien in der Nachbarschaft wider.

Un fouillis de fenêtres réelles ou simplement esquissées, disposées selon des inclinaisons curieuses, rappelle à sa façon l'environnement chaotique des constructions résidentielles ou des galeries du voisinage.

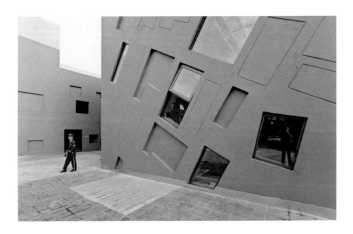

VO TRONG NGHIA

VO TRONG NGHIA was born in Quang Binh Province, Vietnam, in 1976. He attended Ha Noi Architecture University (1994) and received a B.Arch degree from the Nagoya Institute of Technology (Japan, 2002), followed by a Master of Civil Engineering from Tokyo University (2004). His major works are the Ho Chi Minh City University of Architecture (HUA) (with Kazuhiro Kojima and Daisuke Sanuki, Ho Chi Minh City, Mekong Delta, 2006), won by an international design competition in 2006; the wNw Café (Binh Duong, 2006); wNw Bar (Binh Duong, 2008); the Vietnam Pavilion for Shanghai Expo (Shanghai, China, 2010); Stacking Green (Ho Chi Minh City, 2011, published here); Binh Duong School (Binh Duong, 2011); the Stone House (Quangninh, 2012); Dailai Conference Hall (Vinh Phuc, 2012); and Low-Cost House (Dongnai, 2012), all in Vietnam unless stated otherwise. The Stacking Green project was designed in collaboration with **DAISUKE SANUKI**, born in 1975 in Japan and educated at the Tokyo University of Science (degrees in 1998 and 2000), and **SHUNRI NISHIZAWA**, born in 1980 in Japan and educated at Tokyo University (B.Arch 2003, M.Arch 2005) before working in the office of Tadao Ando (Osaka, 2005–09). Both Sanuki and Nishizawa were Partners in the firm of Vo Trong Nghia from 2009 to 2011.

VO TRONG NGHIA wurde 1976 in der Provinz Quang Binh, Vietnam, geboren. Er studierte an der Architekturhochschule von Hanoi (1994) und absolvierte zunächst einen B.Arch an der Technischen Universität Nagoya (Japan, 2002) sowie anschließend einen Master in Bauingenieurwesen an der University of Tokyo (2004). Zu seinen wichtigsten Arbeiten zählen die Architekturschule in Ho Chi Minh City (HUA) (mit Kazuhiro Kojima und Daisuke Sanuki, Ho Chi Minh City, Mekong-Delta, 2006), Preisträger eines Entwurfswettbewerbs 2006, das wNw Café (Binh Duong, 2006), die wNw Bar (Binh Duong, 2008), der Vietnamesische Pavillon für die Expo Shanghai (Schanghai, China, 2010), Stacking Green (Ho Chi Minh City, 2011, hier vorgestellt), die Schule in Binh Duong (2011), das Steinhaus (Quangninh, 2012), der Konferenzsaal Dailai (Vinh Phuc, 2012) und das Niedrigpreishaus (Dongnai, 2012), alle in Vietnam, sofern nicht anders angegeben. Stacking Green entstand in Kollaboration mit **DAISUKE SANUKI**, geboren 1975 in Japan, Studium an der Naturwissenschaftlichen University of Tokyo (Abschlüsse 1998 und 2000), und **SHUNRI NISHIZAWA**, 1980 in Japan geboren, Studium an der University of Tokyo (B.Arch 2003, M.Arch 2005), anschließend tätig bei Tadao Ando (Osaka, 2005–09). Sowohl Sanuki als auch Nishizawa waren von 2009 bis 2011 Partner im Büro von Vo Trong Nghia.

VO TRONG NGHIA, né dans la province de Quang Binh (Viêtnam) en 1976, a étudié à l'Université d'architecture d'Hanoï (1994). Il a obtenu son B.Arch à l'Institut de technologie de Nagoya (Japon, 2002) et un master en ingénierie civile à l'université de Tokyo (2004). Ses réalisations les plus importantes sont l'Université d'architecture d'Hô Chi Minh-Ville (HUA) (avec Kazuhiro Kojima et Daisuke Sanuki, Hô Chi Minh-Ville, delta du Mékong, 2006), projet remporté lors d'un concours international de design en 2006 ; le café wNw (Binh Duong, 2006) ; le bar wNw (Binh Duong, 2008) ; le pavillon du Viêtnam pour l'Expo de Shanghai (Chine, 2010) ; la maison Stacking Green (Hô Chi Minh-Ville, 2011, publiée ici) ; l'école de Binh Duong (2011) ; la Villa de pierre (Quangninh, 2012) ; la salle de conférences Dailai (Vinh Phuc, 2012) et la Maison à bas prix (Dong Nai, 2012), toutes au Viêtnam sauf si spécifié. Le projet Stacking Green a été créé en collaboration avec **DAISUKE SANUKI**, né en 1975 au Japon, qui a fait ses études à l'Université des sciences de Tokyo (diplômes en 1998 et 2000), et **SHUNRI NISHIZAWA**, né en 1980 au Japon, qui a fait ses études à l'université de Tokyo (B.Arch 2003, M.Arch 2005) avant de travailler dans l'agence de Tadao Ando (Osaka, 2005–09). Sanuki comme Nishizawa ont été partenaires dans la société de Vo Trong Nghia de 2009 à 2011.

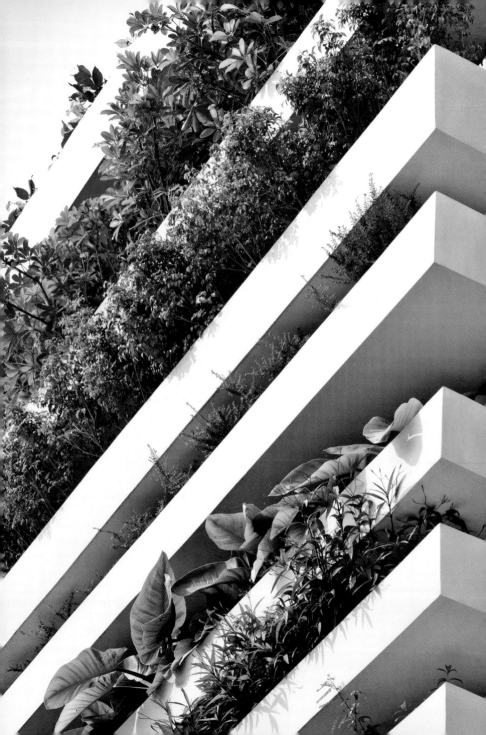

STACKING GREEN

Ho Chi Minh City, Vietnam, 2011

Area: 65 m². Client: Hoang Thi Thu Ha.
Collaboration: Daisuke Sanuki, Shunri Nishizawa,
Thuan Viet JSC, Wind and Water House JSC

The house **STACKING GREEN**, designed for a couple in their 30s and their mother, was built in a narrow lot— 20 meters deep and just four meters wide. The front and back façades are entirely composed of layers of concrete planters cantilevered from two side walls. The distance between the planters and the height of the planters are adjusted according to the height of the plants, which varies from 25 to 40 centimeters. An automatic irrigation system inside the planters provides humidity. There are few partition walls to assure interior fluidity and views of the green façades. Both the green façades and the rooftop garden are intended to shield residents from street noise and pollution. Natural ventilation is provided through the façades and two top openings. The architect states: "We observed the bioclimatic principles of the traditional Vietnamese courtyard house."

Das Haus **STACKING GREEN** entstand für ein Paar in den 30ern und dessen Mutter auf einem schmalen 20 m tiefen aber nur 4 m breiten Grundstück. Die Fassaden wurden an Vorder- und Rückseite mit Schichten von Pflanzkästen aus Beton realisiert, die zwischen den beiden Seitenwänden auskragen. Der Abstand zwischen den Pflanzkästen und deren Höhe orientiert sich an der Höhe der Pflanzen, die von 25 bis 40 cm reicht. Ein automatisches Bewässerungssystem sorgt für ausreichende Feuchtigkeit. Durch nur wenige Trennwände wird der Raumfluss und der Blick auf die grünen Fassaden gewahrt. Die grünen Fassaden und ein Dachgarten dienen nicht zuletzt der Abschirmung der Bewohner von Straßenlärm und Luftverschmutzung. Eine natürliche Durchlüftung ist durch die offenen Fassaden und zwei Dachöffnungen gegeben. Der Architekt erklärt: „Wir haben uns von den bioklimatischen Prinzipien des vietnamesischen Hofhauses anregen lassen."

La maison **STACKING GREEN**, créée pour un couple de trentenaires et leur mère, a été construite sur une parcelle très étroite – 20 m de profondeur pour à peine 4 m de largeur. Les façades avant et arrière sont entièrement composées de jardinières en béton empilées en porte-à-faux par rapport aux deux murs latéraux. L'écart entre les jardinières et leur hauteur est ajusté selon la taille des plantes, qui varie de 25 à 40 cm. Un système automatique d'irrigation à l'intérieur des jardinières apporte de l'humidité. Les cloisons séparatrices sont peu nombreuses afin de garantir une fluidité intérieure et des vues des façades de verdure. Les façades végétalisées et le jardin sur le toit doivent protéger les habitants de la maison des bruits de la rue et de la pollution. Les façades et deux ouvertures en haut fournissent une ventilation naturelle. L'architecte explique « avoir observé les principes bioclimatiques dans les maisons vietnamiennes traditionnelles à cour ».

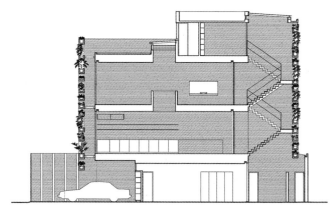

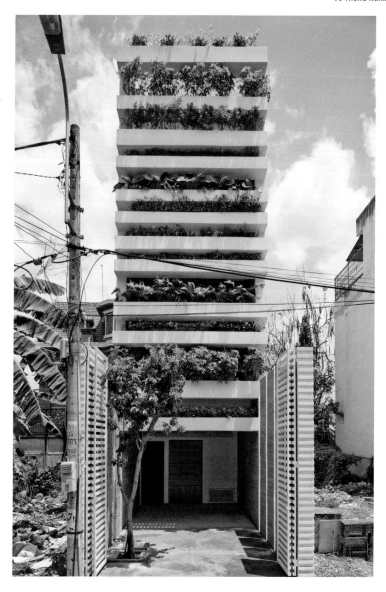

An elevation drawing of the façade (left) and a section show that the building is relatively narrow and deep. Above, the façade is decidedly "green" due to the numerous plants at each level.

Ein Aufriss der Fassade (links) und ein Querschnitt machen deutlich, wie schmal und tief das Gebäude ist. Die Fassade wirkt durch eine Vielzahl von Pflanzen auf den verschiedenen Ebenen auffällig „grün" (oben).

Le schéma en élévation de la façade (à gauche) et la vue en coupe montrent l'étroitesse et la profondeur du bâtiment. Ci-dessus, la façade est résolument « verte » avec ses nombreuses plantes à tous les niveaux.

A drawing shows the relation of
the building to sunlight: plants are
omnipresent, be it on the "stacked"
façade or on the green roof.

Eine Zeichnung veranschaulicht die
Sonneneinstrahlung. Die Begrünung
ist allgegenwärtig, ob nun in Form
der gestaffelten Fassadenbepflan-
zung oder eines begrünten Dachs.

Le schéma montre le bâtiment
par rapport à l'ensoleillement:
les plantes sont omniprésentes,
sur la façade «empilée» ou sur
le toit végétalisé.

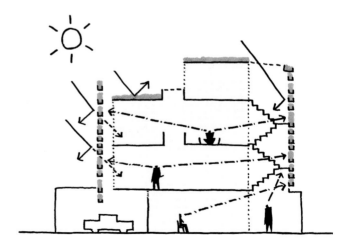

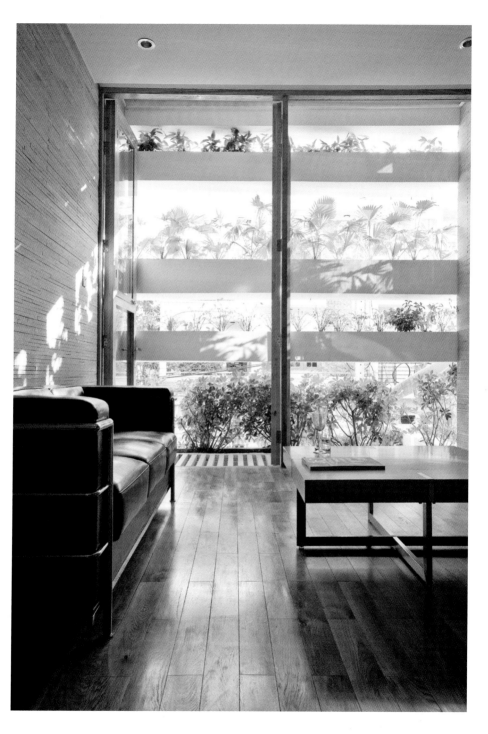

Plans show the long, rectangular shape of the building. Interior spaces are influenced in their light and color by the continuous screen of plants outside.

Auf den Grundrissen ist die gestreckte Rechteckform des Gebäudes zu erkennen. Lichtverhältnisse und Farbeindruck der Innenräume sind vom durchgängigen „Grünschirm" der Fassadenbepflanzung geprägt.

Les plans montrent la forme allongée et rectangulaire du bâtiment. La luminosité et les teintes des espaces intérieurs sont modifiées par l'écran continu de plantes à l'extérieur.

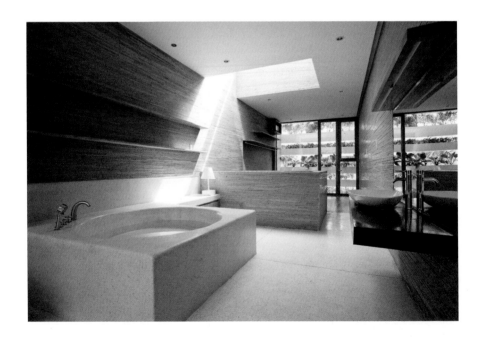

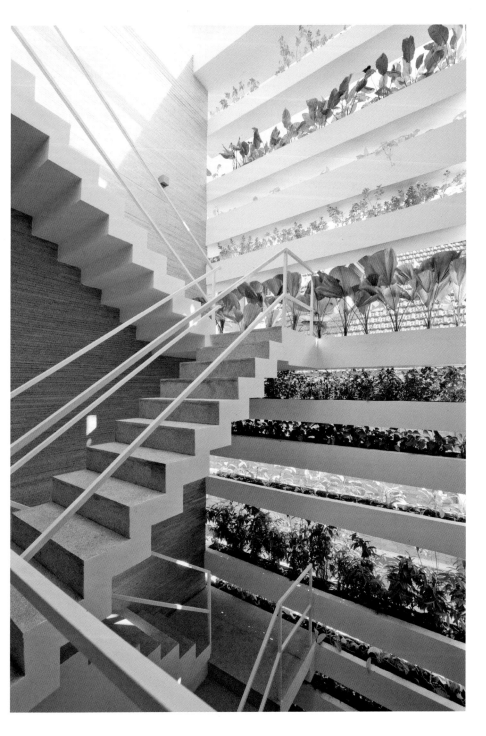

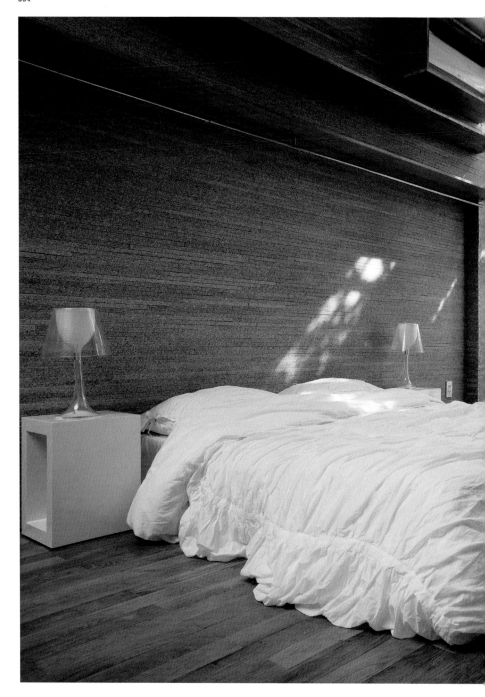

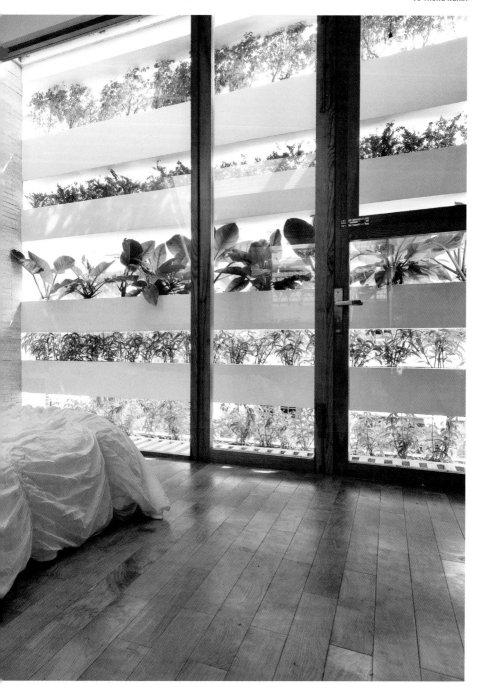

WHY

wHY was founded in Los Angeles in 2004 by **KULAPAT YANTRASAST**. He received his B.Arch degree in Thailand and his M.Arch degree and Ph.D. from the University of Tokyo. Following his studies, Yantrasast became a key member of Tadao Ando's team in Osaka, working on several art museums and cultural projects in the United States and Europe: the Modern Art Museum of Fort Worth, the Armani Teatro in Milan, the François Pinault Foundation for Contemporary Art in Paris, the Calder Museum project in Philadelphia, and the Clark Art Institute in Williamstown, Massachusetts. In 2007, wHY completed the first LEED Gold art museum in the world, Grand Rapids Art Museum (Michigan, 2004–07). Currently, wHY is designing Pomona College's new Studio Art Hall (Claremont, California, 2014); working in collaboration with Renzo Piano at the Harvard Art Museums (Cambridge, Massachusetts, 2014); leading the renovation and expansion of the Speed Art Museum (Louisville, Kentucky, 2016); and working on the new Museum and Conference Center for the Bibliotheca Alexandria (Cairo, Egypt, 2016). Other work includes the Marciano Art Foundation (Los Angeles, California, 2017); and several private residences like the Venice House (Venice, California, 2010–12, published here) in the USA, Thailand, and Japan.

wHY wurde 2004 von **KULAPAT YANTRASAST** in Los Angeles gegründet. Er machte seinen B.Arch. in Thailand und den M.Arch. an der Universität Tokio, wo er auch promovierte. Nach seinem Studium wurde Yantrasast ein wichtiger Mitarbeiter im Team von Tadao Ando in Osaka und arbeitete an verschiedenen Kunstmuseen und Kulturprojekten in den USA und Europa: am Modern Art Museum von Fort Worth, am Armani-Theater in Mailand, an der Fondation François Pinault d'Art Contemporain in Paris, am Entwurf für das Museum Calder in Philadelphia und am Clark Art Institute in Williamstown, Massachusetts. 2007 stellte wHY das Grand Rapids Art Museum (Michigan, 2004–07) fertig, das erste Kunstmuseum weltweit, das mit LEED Gold ausgezeichnet wurde. Zurzeit arbeitet wHY an der neuen Studio Art Hall des Pomona College (Claremont, Kalifornien, 2014), in Zusammenarbeit mit Renzo Piano am Harvard Art Museum (Cambridge, Massachusetts, 2014), wHY leitet die Sanierung und Erweiterung des Speed Art Museum (Louisville, Kentucky, 2016), arbeitet am neuen Museum und Konferenzzentrum der Bibliotheka Alexandria (Kairo, 2016), die Marciano Art Foundation (Los Angeles, Kalifornia, 2017) und an weiteren Privathäusern wie dem Venice House (Venice, Kalifornien, 2010–12, hier vorgestellt) in den USA, Thailand und Japan.

L'agence wHY a été fondée à Los Angeles en 2004 par **KULAPAT YANTRASAST**. Il a obtenu son B.Arch. en Thaïlande et son M.Arch. et son doctorat à l'université de Tokyo. Après ses études, Yantrasast est devenu l'un des principaux collaborateurs de l'équipe de Tadao Ando à Osaka. Il a travaillé sur divers musées d'art et projets culturels aux États-Unis et en Europe : le Musée d'art moderne de Fort Worth, le théâtre Armani à Milan, la Fondation François Pinault pour l'art contemporain à Paris, le projet du musée Calder à Philadelphie et celui du Clark Art Institute à Williamstown, Massachusetts. En 2007, wHY a achevé le Musée d'art de Grand Rapids (Michigan, 2004–07), le premier musée d'art certifié LEED Or au monde. Actuellement, wHY travaille sur le nouveau Studio Art Hall de Pomona College (Claremont, Californie, 2014) ; en collaboration avec Renzo Piano, au Musée d'art de Harvard (Cambridge, Massachusetts, 2014) ; wHY dirige la rénovation et l'expansion du Speed Art Museum (Louisville, Kentucky, 2016) ; travaille au nouveau musée et centre de conférences de la Bibliothèqe Alexandria (Le Caire, Égypte, 2016) ; au Marciano Art Foundation (Los Angeles, Californie, 2017) et diverses résidences privées, telle la Venice House (Venice, Californie, 2010–12, publiée ici) aux États-Unis, en Thaïlande et au Japon.

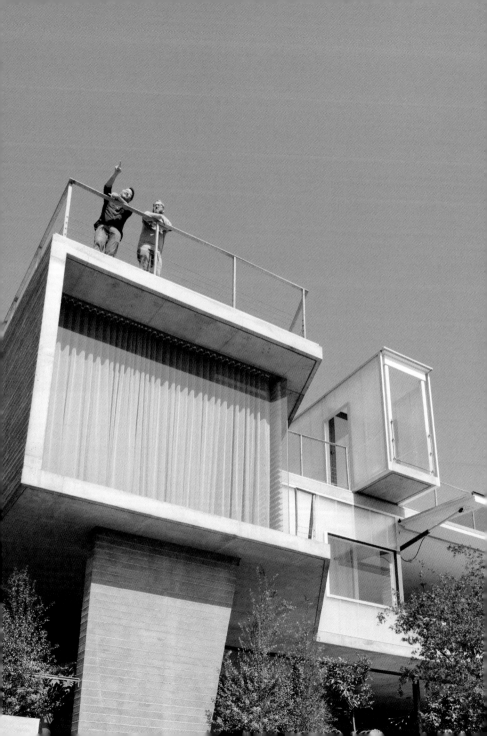

VENICE HOUSE

Venice, California, USA, 2010–12

Area: 4300 m². Cost: $1.2 million.

Located five blocks from Venice Beach, the three-story **VENICE HOUSE** is designed around a swimming pool, located in the center of the small property. The house is almost entirely built with cast-in-place architectural concrete and glass. The formwork was made with 5 x 10 cm (2" x 4") boards stacked horizontally that are reused in the wooden framing of the house. The concrete was lightly sandblasted for "consistency of color and tone, and then secured with a penetrating sealer throughout." The architect explains: "The vision of the space is a waterfront—a double-height monolithic concrete cave with views on the south and west side—which open onto the water, balancing the minimal yet primitive tectonic of space with an expansive connection to the energy of Venice Beach."

Das dreigeschossige, fünf Häuserblocks von Venice Beach entfernt gelegene **VENICE HOUSE** wurde um einen Swimmingpool im Zentrum des kleinen Grundstücks geplant. Es besteht fast ganz aus vor Ort gegossenem Sichtbeton und Glas. Die Schalung wurde aus horizontal geschichteten 5-x-10-cm-Brettern gefertigt, die für den Holzrahmen des Hauses wiederverwendet wurden. Der Beton wurde leicht sandgestrahlt, um eine „Stimmigkeit von Farbe und Wirkung zu erzielen, und danach durchweg imprägniert". Der Architekt erläutert weiterhin: „Die Vision des Raums ist eine Küste – eine doppelgeschossige, monolithische Betonhöhle mit Ausblicken auf der Süd- und der Westseite, die zum Wasser hin geöffnet sind und die minimale und doch primitive Tektonik des Raums durch eine intensive Verbindung zur Energie von Venice Beach ausgleichen."

La maison **VENICE HOUSE** de trois niveaux à cinq rues de Venice Beach est construite autour d'une piscine placée au centre de la petite propriété. Elle est construite presque entièrement en béton architectural coulé sur place et en verre. Le coffrage a été réalisé avec des planches de 5 cm x 10 cm empilées horizontalement qui ont été réutilisées pour la charpente en bois. Le béton a été légèrement sablé pour une meilleure « uniformité de couleur et de ton, puis entièrement sécurisé avec un scellant pénétrant ». L'architecte explique que « la vision de l'espace est celle d'un front de mer – une caverne monolithique de béton double hauteur avec vue au sud et à l'ouest – qui ouvre sur l'eau, équilibrant la tectonique minimale mais primitive de l'espace par une communication intense avec l'énergie de Venice Beach ».

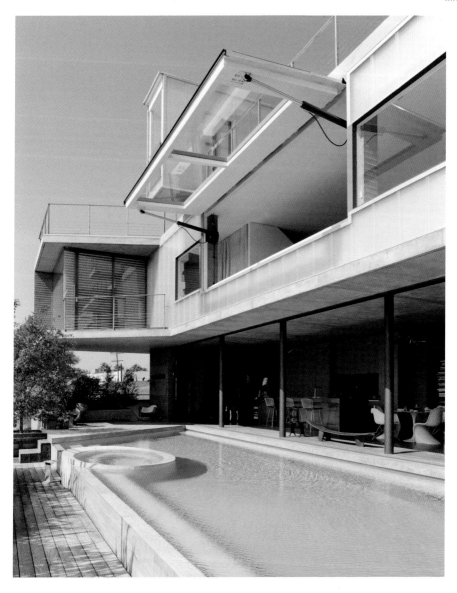

Above, the house overlooking its elongated trapezoidal swimming pool. Left page, the house seen from the street.

Oben: Abbildung des Gebäudes mit Blick auf den langen, trapezförmigen Swimmingpool. Linke Seite: Ansicht des Hauses von der Straße.

Ci-dessus une photo de la maison surplombant la piscine trapézoïdale allongée. Page de gauche, la maison vue de la rue.

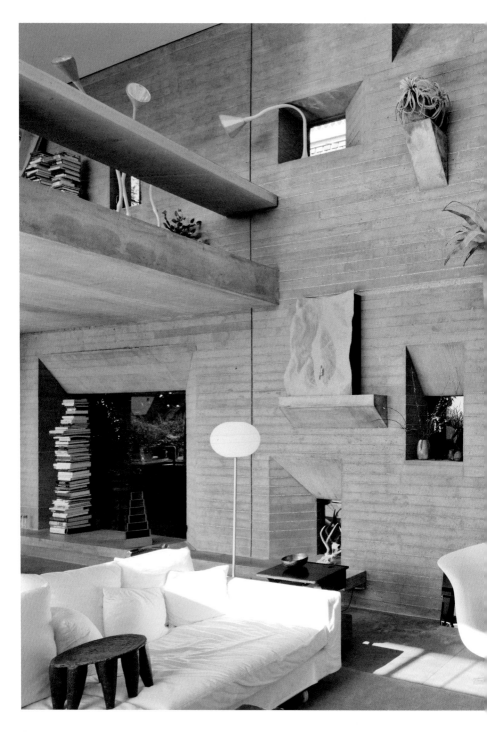

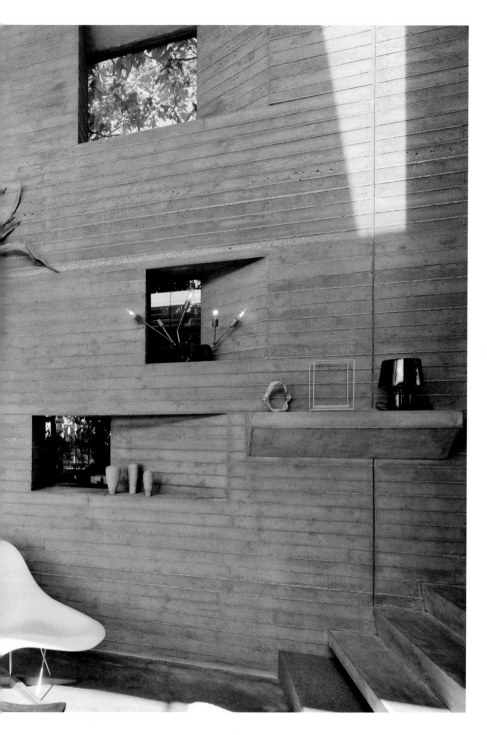

The office mezzanine, seen to the right, with the living room below and the swimming pool directly in front of the open façade of the house. Above, section drawings.

Das Bürozwischengeschoss ist rechts zu sehen, der Wohnraum befindet sich darunter und der Swimmingpool unmittelbar vor der offenen Fassade des Hauses. Oben: Schnitte.

On voit à droite le bureau mezzanine avec le salon en-dessous et la piscine devant la façade ouverte de la maison. Ci-dessus, schémas en coupe.

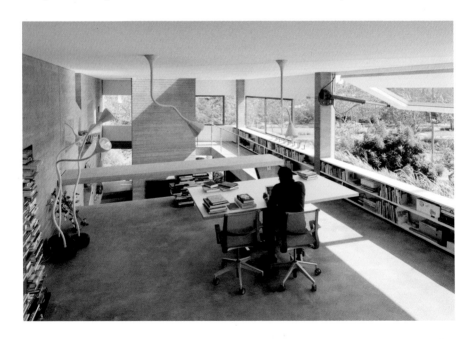

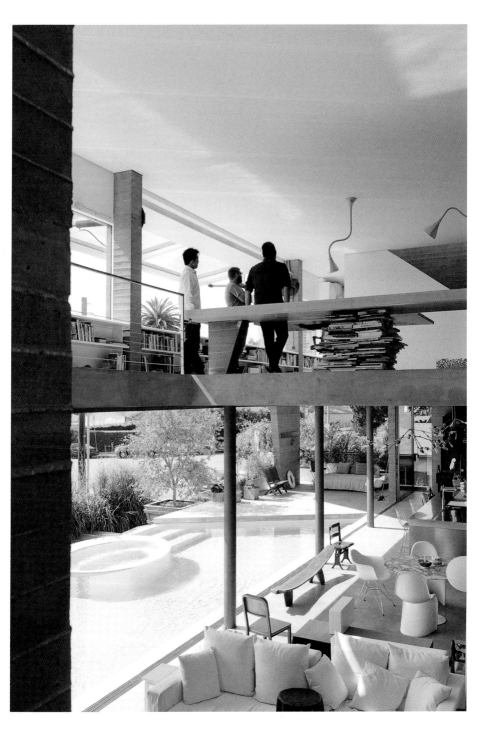

PETER ZUMTHOR

PETER ZUMTHOR was born in 1943 in Basel, Switzerland. In 1958, he worked as an apprentice carpenter. He graduated from the Schule für Gestaltung in Basel in 1963 and then attended the Pratt Institute in New York, studying Architecture and Design. From 1968 to 1977, he worked as an architect for the preservation of historic monuments in the Graubünden region of Switzerland. He served as tutor at the University of Zurich in 1978 and created his own firm in the town of Haldenstein, also in the Graubünden, in 1979. He has taught at SCI-Arc in Santa Monica, the Technische Universität of Munich, Tulane University in New Orleans, and at the Academy of Architecture in Mendrisio, beginning in 1996. Peter Zumthor won the 2009 Pritzker Prize. His major buildings include the Thermal Baths in Vals (Switzerland, 1996); the Kunsthaus in Bregenz (Austria, 1997); and the Swiss Pavilion at Expo 2000 in Hanover (Germany, 2000). He also built a Single-Family House (Graubünden, Switzerland, 1997–2003); and has completed the St. Niklaus von Flüe Chapel (Mechernich-Wachendorf, Germany, 2003–07, published here); the Kolumba Art Museum of the Archdiocese of Cologne (Cologne, Germany, 2003–07); and the Serpentine Gallery Summer Pavilion (Kensington Gardens, London, UK, 2011).

PETER ZUMTHOR wurde 1943 in Basel geboren. Nach einer Lehre als Möbelschreiner Ende der 1950er-Jahre besuchte er zunächst die Schule für Gestaltung in Basel (Abschluss 1963) und anschließend das Pratt Institute in New York, wo er Architektur und Design studierte. Von 1968 bis 1977 arbeitete er als Denkmalpfleger für den Kanton Graubünden. 1978 hatte er einen Lehrauftrag an der Universität Zürich, im darauffolgenden Jahr gründete er in Haldenstein in Graubünden ein eigenes Büro. Ab 1996 unterrichtete Zumthor am Southern California Institute of Architecture in Santa Monica, an der Technischen Universität München, an der Tulane University in New Orleans und an der Accademia di Architettura in Mendrisio im Tessin. Peter Zumthor wurde 2009 der Pritzker Prize verliehen. Zu seinen bedeutendsten Bauten zählen die Therme Vals im gleichnamigen Ort in der Schweiz (1996), das Kunsthaus Bregenz (Österreich, 1997) und der schweizerische Pavillon für die Expo 2000 in Hannover (Deutschland). Ferner hat Zumthor ein Einfamilienhaus in Graubünden (Schweiz, 1997–2003) ausgeführt und eine Niklaus von Flüe gewidmete Kapelle in Mechernich-Wachendorf (Deutschland, 2003–07, hier vorgestellt), das Diözesanmuseum Kolumba in Köln fertiggestellt (Deutschland, 2003–07) sowie den Serpentine Gallery Summer Pavilion (Kensington Gardens, London, Großbritannien, 2011).

PETER ZUMTHOR, né en 1943 à Bâle, Suisse, travaille d'abord comme apprenti-menuisier (1958). Il est diplômé de la Schule für Gestaltung de Bâle en 1963, puis étudie l'architecture et le design au Pratt Institute à New York. De 1968 à 1977, il est architecte spécialisé dans la patrimoine historique dans le canton des Grisons. Il est assistant à l'université de Zurich en 1978 et crée sa propre agence à Haldenstein, également dans les Grisons, en 1979. Il a enseigné à SCI-Arc à Santa Monica, à la Technische Universität de Munich, à Tulane University à la Nouvelle-Orléans et à l'Académie d'architecture de Mendrisio, à partir de 1996. Peter Zumthor a reçu le prix Pritzker en 2009. Parmi ses réalisations majeures, on compte les Thermes de Vals (Suisse, 1996) ; la Kunsthaus de Bregenz (Autriche, 1997) et le pavillon suisse à Hanovre (Allemagne, 2000). Il a également construit une résidence familiale (Grisons, Suisse, 1997–2003) et, plus récemment, la chapelle de St. Niklaus von Flüe (Mechernich-Wachendorf, Allemagne, 2003–07, publiée ici), le musée d'Art Kolumba pour le diocèse de Cologne (Allemagne, 2003–07) et le pavillon d'été de la Serpentine Gallery (Kensington Gardens, Londres, Royaume-Uni, 2011).

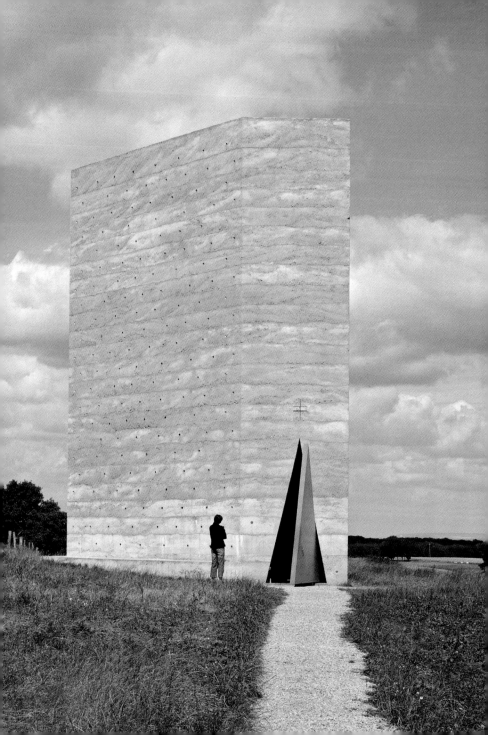

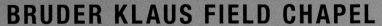

BRUDER KLAUS FIELD CHAPEL

Mechernich-Wachendorf, Germany, 2003–07

Height: 12 m. Client: Trudel and Hermann-Josef Scheidtweiler.
Collaboration: Rainer Weltschies, Michael Hemmi, Frank Furrer,
Pavlina Lucas, Rosa Gonçalves.

The Chapel stands alone, an enigmatic presence that does not immediately reveal its age. This is a modernity that does not lose sight of the past.

Die Kapelle ist ein geheimnisvoller Solitär, dessen Alter nicht sofort zu erraten ist. Hier trifft man auf eine Modernität, die die Vergangenheit nicht aus dem Blick verloren hat.

La chapelle se détache, retirée, présence énigmatique qui ne révèle pas immédiatement son âge. Sa modernité n'a pas rompu avec le passé.

*A simple triangular door leads
into the Chapel, isolated in its
field setting.*

*Die einsam auf einem Feld stehende
Kapelle wird durch eine einfache,
dreieckige Türöffnung betreten.*

*Une simple porte triangulaire
donne accès à la chapelle, isoléc
dans les champs.*

The **BRUDER KLAUS FIELD CHAPEL** is located in the Eifel region of western Germany, not far from Cologne. Built at the same time as the Kolumba Art Museum in Cologne (2003–07), this unusual chapel, entered through a single triangular metal door, contains a five-cornered, windowless space almost 12 meters high, with an opening to the sky at its summit. It is dedicated to St. Niklaus von Flüe (1417–87), also known as Brother Klaus, a Swiss hermit and ascetic who is the patron saint of Switzerland. A small basin collects water, and a channel directs the water out of the building. The rough, dark texture of the walls was obtained by burning the 112 spruce branches used as formwork selected by the architect. Concrete was poured at the rate of one layer a day for a total of 24 layers before the inner branches or trunks were burned. The farmer who commissioned the work built it himself with the help of a few neighbors and artisans.

Peter Zumthors **BRUDER-KLAUS-KAPELLE** in der Eifel im Kreis Euskirchen entstand zwischen 2003 und 2007, im selben Zeitraum wie das Diözesanmuseum Kolumba in Köln. Betritt man die ungewöhnliche Feldkapelle durch ihre dreieckige Stahlpforte, befindet man sich in einem fünfeckigen, knapp 12 m hohen, fensterlosen Raum, der sich an seinem höchsten Punkt zum Himmel hin öffnet. Gewidmet ist die Kapelle dem Einsiedler und Asketen Niklaus von Flüe (1417–87), dem Schutzheiligen der Schweiz, auch bekannt als Bruder Klaus. Ein kleines Bassin im Kapelleninnern fängt Wasser auf, das durch einen Abfluss nach außen geleitet wird. Die dunkle, rußige Beschaffenheit der Wände kam durch ein Gerüst aus 112 Fichtenstämmen, alle vom Architekten ausgewählt, zustande, das zum Abschluss der Bauausführung abgebrannt wurde. Zuvor wurden um die Schalung herum insgesamt 24 Lagen Beton aufgegossen, eine Schicht pro Tag. Die Kapelle wurde vom Bauherrn selbst – einem Landwirt – mit der Hilfe einiger Nachbarn und Handwerker errichtet.

Cette **CHAPELLE DE FRÈRE NICOLAS** se trouve dans la région de l'Eifel, dans l'ouest de l'Allemagne, non loin de Cologne. On pénètre dans ce lieu de prière pentagonal inhabituel, édifié au même moment que le musée d'Art Kolumba de Cologne (2003–07), par une unique porte triangulaire en métal. L'espace sans fenêtres mesure près de 12 m de haut sous une verrière zénithale. Le lieu est dédié à Nicolas de Flue (1417–87), également connu sous le nom de frère Klaus, un ermite et ascète suisse, saint patron de la Suisse. Un petit bassin collecte l'eau de pluie et la dirige vers l'extérieur par un canal. La sombre texture brute des murs a été obtenue par le brûlage de 112 planches d'épicéa qui avaient servi au coffrage, toutes sélectionnées par l'architecte. Le béton a été coulé au rythme d'une couche par jour jusqu'à obtenir 24 couches avant que les branches intérieures ou troncs soient brûlées. Le fermier commanditaire de cette chapelle l'a construite lui-même avec l'aide de quelques voisins et artisans.

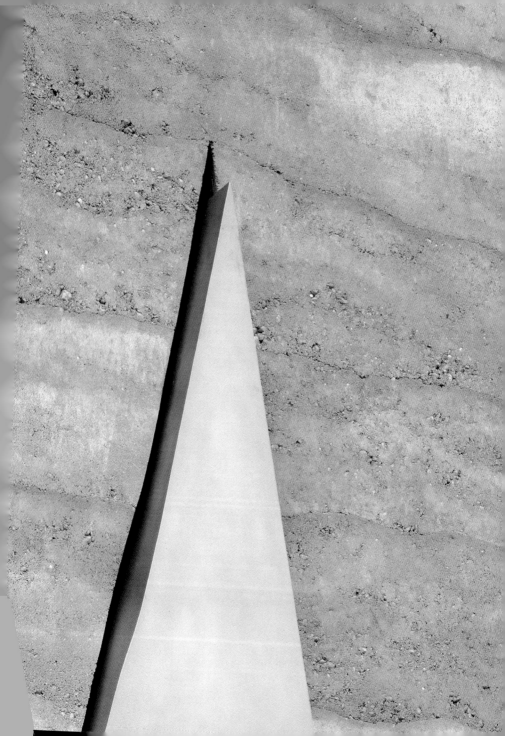

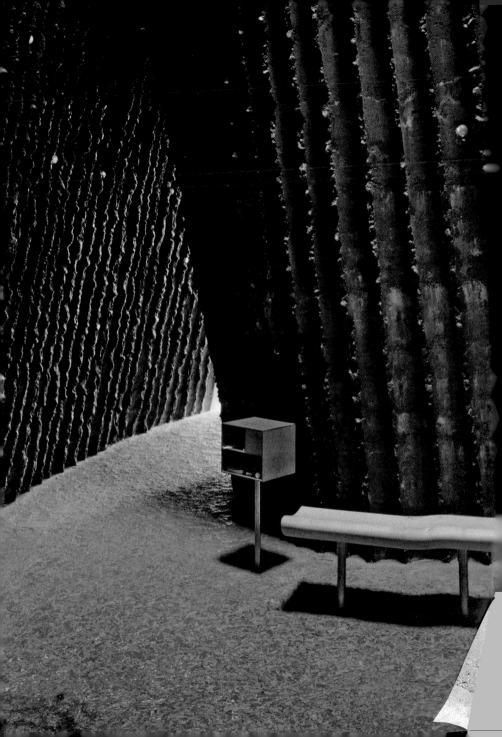

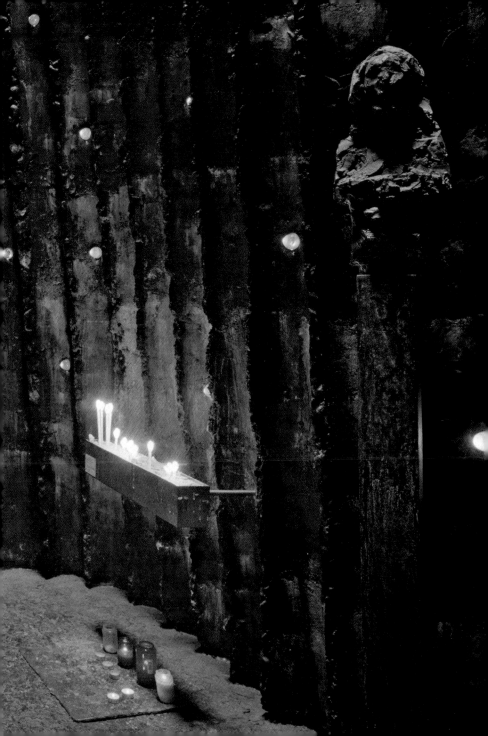

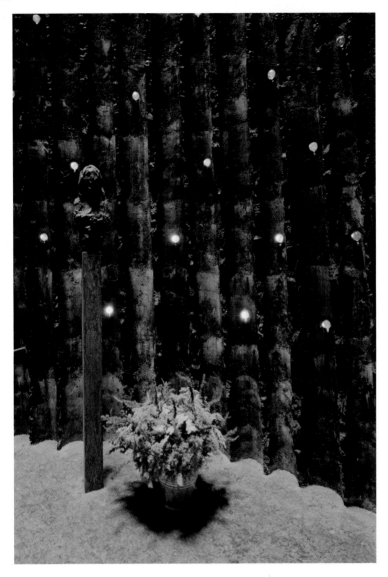

The interior of the Chapel was blackened by burning the formwork used for the exterior concrete walls. An ovoid oculus marks the top of the space and allows natural light in.

Durch das Verbrennen der Holzverschalung für die Betonwände erhielt der Kapellenraum eine schwarze Färbung. Ein ovaler Oculus markiert den höchsten Punkt und lässt natürliches Licht einfallen.

L'intérieur de la chapelle est en bois de coffrage (utilisé pour la construction des murs) dont la surface a été carbonisée. Tout en haut, un oculus ovale admet la lumière du jour.

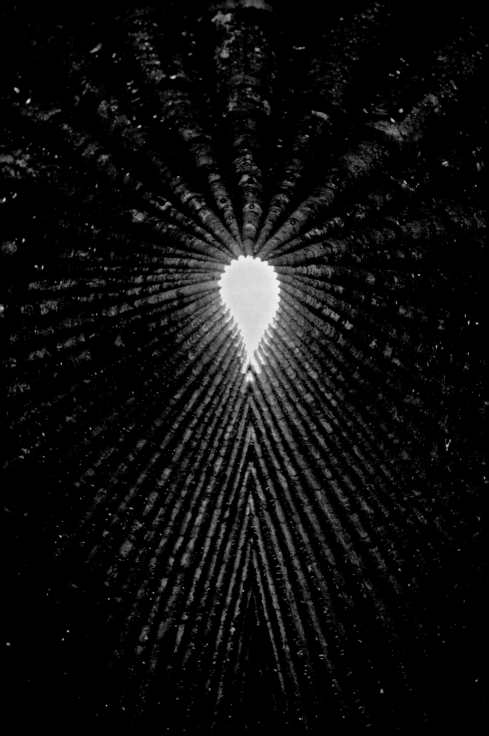

INDEX OF BUILDINGS, NAMES AND PLACES

CREDITS

100 Interiors Around the World

100 Contemporary Houses

100 Contemporary Wood Buildings

Contemporary Concrete Buildings

Julius Shulman

Small Architecture

Green Architecture

Interiors Now!

Tree Houses

Cabins

Bauhaus

**Bookworm's delight:
never bore, always excite!**

TASCHEN
Bibliotheca Universalis

Case Study Houses

Modern Architecture A–Z

Frédéric Chaubin. CCCP

Decorative Art 50s

Decorative Art 60s

Decorative Art 70s

domus 1930s

domus 1940s

domus 1950s

domus 1960s

domus 1970s

Design of the
20th Century

Industrial Design A–Z

The Grand Tour

1000 Chairs

1000 Lights

Scandinavian Design

Living in Mexico

Living in Bali

Living in Morocco

Living in Japan

Architectural Theory

Piranesi.
Complete Etchings

The World
of Ornament

Racinet.
The Costume History

Fashion History

100 Contemporary
Fashion Designers

20th Century Fashion

Illustration Now!
Fashion

Funk & Soul Covers

Jazz Covers

Extraordinary
Records

Tiki Pop

100 Illustrators

Illustration Now!
Portraits

Logo Design.
Global Brands

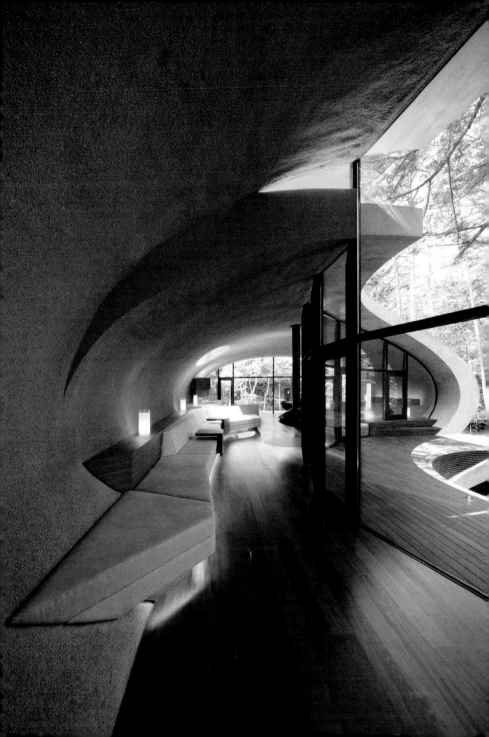

Domestic bliss

Innovative, intimate architecture from China to Chile

Designing private residences has its own very special challenges and nuances for the architect. The scale may be more modest than public projects, the technical fittings less complex than an industrial site, but the preferences, requirements and vision of particular personalities becomes priority. The delicate task is to translate all the emotive associations and practical requirements of "home" into a workable, constructed reality. This publication rounds up 100 of the world's most interesting and pioneering homes designed in the past two decades, featuring a host of talents both new and established, including John Pawson, Richard Meier, Shigeru Ban, Tadao Ando, Zaha Hadid, Herzog & de Meuron, Daniel Libeskind, Alvaro Siza, and Peter Zumthor.

"Take a ride around the world's best new houses with TASCHEN ... From timber shacks to glazed pavilions, there's a weird and wonderful inspiration for all."

—*Grand Designs*, London

100 Contemporary Houses
Philip Jodidio
688 pages

TRILINGUAL EDITIONS IN:
ENGLISH / DEUTSCH / FRANÇAIS &
ESPAÑOL / ITALIANO / PORTUGUÊS

Out on a limb

The sky's the limit with 50 ingenious tree houses around the world

The idea of climbing a tree for shelter, or just to see the earth from another perspective, is as old as humanity. In this neat TASCHEN edition, take a tour of some of our finest arboreal adventures with 50 of the most beautiful, inventive, and enchanting tree houses around the world.

From romantic to contemporary, from famed architects to little-known craftsmen, you'll scale the heights to visit all manner of treetop structures, from a teahouse, restaurant, hotel, and children's playhouse to simple perches from which to contemplate life, enjoy the view, and discover that tree houses take as many forms as the imagination can offer. With an abundance of gorgeous photographs and illustrations, this is an ode to alternative living, where playful imagination meets eco-sensitive finesse.

"A dizzying array of fantastical architectural feats, a bible to alternative living."
— *AnOther*, London

Philip Jodidio

tree houses
baumhäuser | maisons dans les arbres

TASCHEN
Bibliotheca Universalis

Tree Houses. Fairy Tale Castles in the Air
Philip Jodidio
544 pages

TRILINGUAL EDITIONS IN:
ENGLISH / DEUTSCH / FRANÇAIS &
ESPAÑOL / ITALIANO / PORTUGUÊS

Space shapers

An encyclopedia of modern architecture

Explore the A–Z of modern space. From Gio Ponti's colored geometries
to Zaha Hadid's free-flowing futurism, this comprehensive overview features
more than 280 profiles of architects, styles, movements, and trends
that have shaped structures from the 19th to the 21st century.

"A splendid record of
architecture from
the nineteenth century
to the present day."

—*Architectural Review*, London

Modern Architecture A–Z
696 pages
EDITIONS IN: ENGLISH / DEUTSCH /
FRANÇAIS / ESPAÑOL

Timberland

The wooden structures of the 21st century

Travel the world to investigate one of the greatest renaissances in architecture: wood. How has this elemental material come to steal the show at luxury hot spring structures and cutting-edge urban renewal schemes? With 100 projects from China, Chile, and everywhere in between, this global survey explores the technical, environmental, and sensory elements that have inspired a return to timber.

"From a functional tree house
to inspired restaurants,
this collection instructs on
the ecology of wooden
construction, with plenty of
eye candy for architecture
enthusiasts."
— *TIME*, New York

100 Contemporary Wood Buildings
Philip Jodidio
632 pages

TRILINGUAL EDITIONS IN:
ENGLISH / DEUTSCH / FRANÇAIS &
ESPAÑOL / ITALIANO / PORTUGUÊS

YOU CAN FIND TASCHEN STORES IN

Berlin
Schlüterstr. 39

Beverly Hills
354 N. Beverly Drive

Brussels
Place du Grand Sablon /
Grote Zavel 35

Cologne
Neumarkt 3

Hollywood
Farmers Market,
6333 W. 3rd Street, CT-10

Hong Kong
Shop 01-G02 Tai Kwun,
10 Hollywood Road,
Central

London
12 Duke of York Square

London Claridge's
49 Brook Street

Madrid
Calle del Barquillo, 30

Miami
1111 Lincoln Rd.

"If browsing is considered an art form, the TASCHEN store is a masterpiece."
—*Dwell*

Milan
Via Meravigli 17

Paris
2 rue de Buci

EACH AND EVERY TASCHEN BOOK PLANTS A SEED!
TASCHEN is a carbon neutral publisher. Each year, we offset our annual carbon emissions with carbon credits at the Instituto Terra, a reforestation program in Minas Gerais, Brazil, founded by Lélia and Sebastião Salgado. To find out more about this ecological partnership, please check: *www.taschen.com/zerocarbon*
INSPIRATION: UNLIMITED. CARBON FOOTPRINT: ZERO.

To stay informed about TASCHEN and our upcoming titles, please subscribe to our free magazine at *www.taschen.com/ magazine*, follow us on Instagram and Facebook, or e-mail your questions to *contact@taschen.com*.

GERMAN TRANSLATION
Nora Krehl-von Mühlendahl, Ludwigsburg; Kristina Brigitta Köper, Berlin; Christiane Court, Frankfurt; Holger Wölfle, Berlin; Caroline Behlen, Berlin; Karin Haag, Vienna

FRENCH TRANSLATION
Jacques Bosser, Montesquiou; Claire Debard, Freiburg; Blandine Pélissier, Paris

PRINTED IN BOSNIA-HERZEGOVINA
ISBN 978–3-8365–6493–9